EDWARD LUCIE-SMITH

VISUAL ARTS IN THE TWENTIETH CENTURY

Laurence King Publishing

Published 1996 by Laurence King Publishing Ltd
71 Great Russell Street
London WC1B 3BP

A catalogue record for this book is available from the British Library.

ISBN 1–85669–090–3 (h/b)
ISBN 1–85669–091–1 (p/b)

Design by Andrew Shoolbred
Timeline design by Ian Hunt
Picture research by Visual Arts Library

Printed and bound in Singapore

Frontispiece: Nicolas de Staël, *Les Martigues*, 1954. Oil on canvas, 4 ft 9½ in x 3 ft 21¼ in (146 x 97 cm). Kunstmuseum, Winterthur, Germany.

Details: p.16: Gauguin, *The Vision after the Sermon* (see FIG. 1.14). p.50: Rousseau, *The Snake Charmer* (see FIG. 2.10). p.76: Malevich, *Taking in the Rye* (see FIG. 3.21). p.110: Moholy-Nagy, *Construction, Work 4* (see FIG. 4.19). p.150: Mukhina, *Worker and Collective Farm Woman* (see FIG. 5.25) p.182: Bacon, *Three Studies ...* (see FIG. 6.19). p.214: De Staël, *Les Martigues* (see FIG. 7.35). p.250: Auerbach, *Mornington Crescent, Winter* (see FIG. 8.28). p.296: Eggleston, *Memphis* (see FIG. 9.40). p.332: Fischl, *Squirt* (see FIG. 10.17). p.364: Youhan, *Mao and Blonde Girl Analyzed* (see FIG. 11.7).

Author's acknowledgements: My thanks are due to Damian Thompson and Lee Ripley Greenfield of Calmann & King; to Suzie Green, Celestine Dars, and Didier Lenart of the Visual Arts Library (responsible for the picture research); to Robert Stewart, who patiently and tactfully edited my text; and to the ever-helpful staff of the National Art Library at the Victoria & Albert Museum, London. This book would not have come into existence without their efforts, and it is dedicated to all of them.

Contents

Introduction

It goes without saying that the account of twentieth-century visual arts given in this book is a personal one. How could it be otherwise? The amount of material is so vast and the issues are so complex, that much of the material included can only be a matter of personal choice. One aim here, in a brief preliminary statement, is merely to point out that, while the choice of topics, and certainly of examples, contains a strongly personal element, the book does, I believe, have its own internal logic.

The logic I refer to can be deduced from the arrangement. The book, instead of being organized by "styles" and "movements" of art, progresses in chronological order. Each chapter, after the first, deals with a decade. The topics treated within that decade always appear in the same sequence. Architecture is followed by painting, then by sculpture and related activities, such as the making of environments, and finally by photography. This arrangement has both advantages and disadvantages. Arrangement by styles and movements, almost universally adopted until comparatively recently, and still used in histories or partial histories of Modernism (including some written by myself), offers the benefit of tidiness. A particular development can be followed in all its phases, without the distraction of what is happening elsewhere in art.

Artists themselves often acknowledged that they had common aims. During the first half of the century, and arguably until the beginning of the 1970s, the idea of movements in art was not something imposed from outside, for critical convenience. The names of these artistic impulses may often have been invented by critics, sometimes with hostile intent—the labels "Fauvism" and "Cubism" are cases in point. After the event, nevertheless, artists themselves acknowledged, however ruefully, that there was something valid in the classifications that had been invented for them. Picasso, looking back to the pioneering period of Cubism, described himself and Braque as being like "two mountaineers, roped together," as they embarked on their strenuous aesthetic adventure.

Other artists, such as the Italian Futurists and the Surrealists, quite consciously banded together in order to achieve a particular aim, and they issued their manifestos stressing how much they had in common with one another.

Arrangement purely by styles and movements does, however, tend to distort historical truth. It does so because it leaves the reader with an over-simplified idea of the relationship between different impulses. Within a rigidly stylistic framework only two kinds of change seem possible. The style or movement to which the historian accords dominance at one particular moment is, according to this model, displaced by a successor for one of two reasons: either it gives birth to something newer, related but suddenly more vigorous; or else it becomes too rigid, raises up an enemy against itself, and then, after a struggle, succumbs. These are seductive metaphors, but they do not in themselves display how artistic evolution in fact takes place. The progression of art is usually more random.

A further objection to classification by styles is that it tends to leave out the impact made on the visual arts by history itself—by wars, revolutions, economic fluctuations, and the process of social change. Taking its lead from the aesthetic

theories evolved by the Symbolist movement in the late nineteenth century, the interpretation of twentieth-century art has often tended to lay stress on purely formal qualities, as opposed to moral or social content. It is only now, at the end of the century, that the process has suddenly reversed itself. Despite this, there still remains a tendency among certain critics to insist that art should still, as far as possible, be viewed in isolation.

Yet it seems self-evident that art cannot exist in isolation; it is always a response to an audience that already exists or, failing that, to a possible audience that the artist hopes to discover. Furthermore, both the artist as an individual and the audience as a collectivity are inevitably shaped by the circumstances of their time. For this reason, while I have often used stylistic categories, I have also tried to give some idea, in however compressed a way, of the broader context.

Effectively, purely stylistic classifications function less and less efficiently as the century progresses. The dialectic of styles whose pattern unfolds in the following chapters works moderately well during the first half of the century, or—stretching a point—up to the end of the sixties. After that point the mechanism breaks down, for several reasons. One is the growth of multiculturalism, with accompanying stylistic plurality: art is now in dialogue with purely local circumstances and traditions, as well as with the, largely European, tradition of Modernism. Secondly, and closely connected to the first and third reasons, there is the way in which what we call "art" has moved away from the visual. Stylistic classifications, as art historians have traditionally used them, are rooted in visual phenomena. In other words, the dialectic of styles has been disrupted by a radical shift in the definitions we apply to the word "art" itself, to the concepts we link to it, and indeed to our notions of the whole artistic impulse. The third reason is the appearance of the phenomenon we now call Postmodernism, which often involves an ironic, or ambiguously intended, recapitulation of previously established styles (see the definition of Postmodernism below). These borrowed styles exist, not in competition with one another, but in a symbiotic relationship.

Postmodernism has been notoriously difficult to define. We should all be grateful, therefore, for this brilliantly simple and sensible description by a leading contemporary artist, the Russian maker of environments, Ilya Kabakov:

Modernism has to do with an extraordinary confidence on the part of individual artists in their own genius, a confidence that they are revealing some profound truth and that they are doing it for the first time. The postmodern consciousness arises in a society that doesn't need new discoveries, a society that exchanges information, that correlates all possible languages and establishes interrelationships between them. You could say that modernism juxtaposes itself to all that has preceded it in the past, while postmodernism means primarily participation in one unified field or network of artistic life.

The most profound difference is the attitude towards artistic language. Modernists are absolutely certain of their authenticity; they believe they have created a genuine, universal language. For postmodernists, all languages are equally authentic or inauthentic at the same time. The modernist is convinced that he has developed his own universal language, whereas the postmodernist knows that all languages have already been worked out, and he is searching for interrelationships between them. It is a characteristic that before the Second World War it was Cézanne who was especially popular, that is, an artist who had discovered a new language of art. For the postwar, postmodern consciousness, one of the main figures is Duchamp, who worked with readymade materials. Today's postmodernist artist works not only with readymade things but also with readymade artistic languages.[1]

The shift from the effort to invent a single artistic language to the search for relationships among existing languages described by Kabakov has its roots not merely in a philosophical revolution, but in radical technological change. In the course of the century, technology has completely changed how people live and how they communicate with one another. One result of the speed and efficiency of the new systems of communication, undreamed of at the beginning of the century, has been the intermingling of a Modernism that was once purely European with cultural elements rooted in territories that have a heritage very different from that of Europe.

In the years immediately after 1890, the traffic all seemed to be one-way. Europeans borrowed from other cultures, particularly from African art, but were uninterested in what those cultures might in turn borrow from themselves. The search for and cultivation of the supposedly "primitive" by early Modernists such as Picasso in his immediately pre-Cubist phase was part of a more widespread search for otherness. This search has persisted in twentieth-century art, though usually in other forms, such as the cult of urban graffiti, of the art of children or the mentally ill, until the present day. Picasso and his colleagues preferred the art they borrowed from to be impenetrably mysterious, and certainly with no visible influence from Europe, which, for them, would have renderd it "inauthentic" and dissipated its magic.

Very soon, however, there was a significant traffic the other way, outwards from Europe itself. Modernism was an early export to Latin America, where European and Pre-Columbian cultures had intermingled from the sixteenth century onward. By the beginning of the 1920s, Modernist ideas were already manifesting themselves in recognizable form in Mexico, Argentina, and Brazil. Though recognizable, they were also visibly different—the result of a process of hybridization with what was already there. In other parts of the world—China, Japan, Korea, modern Africa itself—the collision between cultures came later, with results that are only now beginning to be fully assessed.

Traditionalist critics, looking for absolute (as they perceived them) standards of quality, and unwilling to acknowledge that these standards were themselves necessarily the product of culturally conditioned subjectivity, saw the intermingling as inevitable, but likely to be disastrous: the end of art as the Western world had known it since the innovations of the Renaissance.

Certainly, one effect of cultural hybridization is likely to be an intensification of Postmodern characteristics. The situation is vividly presented in countries such as Japan and Korea, where artistic endeavor has split into separate but related streams—on the one hand, a continuing tradition of art made using indigenous techniques, on the other, an art which, while incorporating specifically Eastern elements, strives to keep in step with developments in the now globally influential avant-garde.

One thing which is having an increasing impact on the development of art is the actual physical displacement of artist. This is not a new phenomenon. At the beginning of the century, Paris was a magnet for artists from all over Europe—Spaniards such as Picasso, Miró and Juan Gris, Russians such as Chagall. Later, New York was to be equally hospitable to artists who had not been born in the United States, but who became identified with American art. Gorky was originally Armenian, Rothko was Lithuanian, Hans Hofmann was German, and de Kooning was Dutch. Abstract Expressionism, sometimes described as "the triumph of American art," was American by election rather than by blood and birth.

Now artists move between countries with an ease given to few other professions. The fascinating thing about this is the stubbornness with which cultural traditions nevertheless survive. The art of the end of the century is constantly in

dialogue with the multiple pasts of the artistic impulse, and is most unlikely to produce a monolithic, wholly unified result in future.

A text such as this one has to pick its way through conflicting claims and conflicting views concerning the purposes and functions of the art itself, without much hope of being able to resolve all the differences that the material throws up. This is why I must conclude by repeating the warning with which I began this Introduction—what the reader finds here is a personal view. Other views are possible. Some are in direct conflict with mine, and I hope that my text demonstrates, both through the examples cited and the arguments put forward, that in the end these will not stand up. Others exist more or less in parallel. Another writer, using the same or related material in a different way, might arrive at what might be an equally valid result.

1880–1	1882–3	1884–5	1886–7	1888–9

GENERAL EVENTS

1880–1
- France annexes Tahiti
- Nationalist uprising in Egypt
- Death of the British statesman Benjamin Disraeli
- Assassination of Tsar Alexander II

1882–3
- Triple Alliance of Italy, Austria, and Germany
- British troops occupy Cairo
- France gains control of Tunis

1884–5
- German troops occupy South West Africa (now Namibia)
- Defeat and death of General Gordon at Khartoum, India
- Indian National Congress founded
- Mark Twain publishes *Huckleberry Finn*

1886–7
- Gold discovered in South Africa
- Henry James publishes *The Bostonians*
- Golden Jubilee of Queen Victoria

1888–9
- "Jack the Ripper" murders six women in London
- North Dakota, South Dakota, Montana, and Washington become US states; Oklahoma is opened to non-Native American settlement
- Birth of Adolf Hitler, Nazi dictator

Gauguin, The Vision after the Sermon: see p.29

SCIENCE AND TECHNOLOGY

1880–1
- First practical electric lights invented
- Canned foodstuffs first appear on sale
- Electric street lights installed in New York
- Opening of the Natural History Museum, South Kensington, London

1882–3
- Thomas Edison designs first hydroelectric plant
- First synthetic fiber produced

1884–5
- First practical steam turbine engine
- Design of the machine gun perfected
- First single-cylinder automobile engine invented by Daimler

1886–7
- French chemist Henri Moissan produces fluorine
- Celluloid camera film invented

1888–9
- George Eastman perfects "Kodak" box camera
- Pneumatic tyres invented by Dunlop

ART

1880–1
- Auguste Rodin begins work on *The Gates of Hell* (–1920)
- Puvis de Chavannes,*The Poor Fisherman*
- Auguste Renoir, *The Boating Party*
- Edouard Manet begins painting *A Bar at the Folies-Bergère*

Rodin, The Gates of Hell: see p.41

1882–3
- Paul Gauguin abandons his career as a stockbroker in order to paint
- Claude Monet settles at Giverny, where he builds his lily pond

1884–5
- Exhibition society "Les XX" founded in Brussels
- Salon des Indépendents founded in Paris
- Georges Seurat, *La Grande Jatte* (–1886)
- Auguste Rodin, *Burghers of Calais* (–1895)

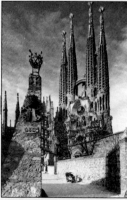

Gaudí, Sagrada Familia Church: see p.25

1886–7
- Auguste Rodin, *The Kiss*
- Jean Moréas publishes a Symbolist manifesto
- Georges Bernard destroys all his Neoimpressionist paintings after a visit to Signac's studio, and moves to Pont-Aven in Brittany
- Edvard Munch, *The Sick Child* (–1889)

1888–9
- Madame Blavatsky publishes *The Secret Doctrine*
- Paul Gauguin, *The Vision after the Sermon*
- Foundation of the Nabis
- Vincent van Gogh goes to Arles and produces *Self-portrait with Bandaged Ear*
- Death of the color theorist, Michel Eugène Chevreul, whose work had influenced Seurat, among others

ARCHITECTURE

1880–1
- Richard Shaw, Bedford Park Church, West London
- Petrus Cuyper, Central Station, Amsterdam

1882–3
- Brooklyn Bridge, New York, opened
- First skyscraper (of 10 stories), Chicago—Le Baron Jenney, Home Insurance Building
- Antonio Gaudí, Sagrada Familia church, Barcelona (–1926)

1884–5
- H.H. Richardson, Marshal Field Wholesale Building, Chicago

1886–7
- Gustave Eiffel, Eiffel Tower, Paris (–1889)
- Work completed on the Statue of Liberty, designed by Frederic Auguste Bartholdi over an armature created by Gustave Eiffel

1888–9
- Daniel Hudson Burnham and John Wellborn Root, Monadnock Building, Chicago
- McKim, Mead, and White begin work on the Boston Public Library (–1892)

Before 1900

1890–1	1892–3	1894–5	1896–7	1898–9

- Massacre of Native American Sioux at Wounded Knee, South Dakota
- Bismarck resigns as chancellor of Germany
- Daughters of the American Revolution founded in Washington D.C.

- World exhibition in Chicago
- Iron and steel workers strike in the United States
- Franco-Russian alliance
- First cans of pineapples

- Uganda becomes a British protectorate
- The Alfred Dreyfus affair reveals widespread corruption and anti-Semitism in the French military establishment
- Cuban war of independence against Spain

Van Gogh, *Self-portrait with Bandaged Ear*: see p.28

- Italian troops defeated in Ethiopia
- France annexes Madagascar
- First modern Olympics held in Athens
- Beginning of Klondike Gold Rush, Bonanza Creek, Canada
- Severe famine in India

- United States declares war on Spain over Cuba
- Spain forced to cede Puerto Rico, Guam, and Philippines to United States
- Outbreak of war between Britain and Boer settlers in South Africa

- United States becomes the world's leading industrial power
- Beginning of wireless telegraphy
- Thomas Edison unveils his "kinetograph" (the first cine camera)

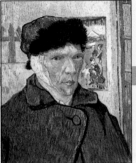

- Viscose invented. Beginning of manufacture of rayon
- First automatic telephone switchboard

- Auguste Lumière invents the cinematograph, enabling film projection of moving images
- Wilhelm Röntgen discovers X-rays
- Guglielmo Marconi invents radio telegraphy

- Malaria bacillus discovered
- William Ramsay discovers helium
- Magnetic detection of electrical waves by Ernest Rutherford

- Dysentery bacillus discovered
- Radium discovered by Marie and Pierre Curie
- First magnetic sound recording
- Ferdinand von Zeppelin produces his airship

- Vincent van Gogh commits suicide
- Paul Cézanne, *The Card Players* (–1895)
- Foundation of "La Revue Blanche"
- Paul Gauguin leaves for Tahiti
- Death of Georges Seurat
- Henri de Toulouse-Lautrec produces his first music hall posters

- Edvard Munch exhibition creates scandal in Berlin
- Foundation of "Linked Ring" group of photographers
- Georges Seurat, *The Bathers, Asnières*
- Edvard Munch, *The Scream*
- Claude Monet begins his series of paintings of Rouen Cathedral

- Paul Cézanne, *Large Bathers* (–1905)
- Art Nouveau style predominates
- First major exhibition of Paul Cézanne's work, organized by Ambroise Vollard

- *Die Jugend* and *Simplicissimus*, two important German art magazines, appear in Munich
- Vienna Secession formed
- Auguste Rodin, plaster maquette for *Balzac* (commissioned 1891, refused 1898)

Lutyens, Munstead Wood: see p.26

- Edouard Vuillard, *Woman in Blue with a Child*
- Secession movement founded in Berlin
- Ambroise Vollard publishes group of lithographs by Odilon Redon

Eiffel, Eiffel Tower: see p.21

- Victor Horta, Hôtel Tassel, Brussels

Seurat, *La Grande Jatte*: see p.27

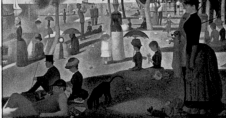

- Otto Wagner, Vienna Stadtbahn, Austria
- Louis Sullivan, Guaranty Buildings, Buffalo, New York

- Edwin Lutyens, Munstead Wood, Surrey, England
- C.F. McKim, Public Library, Boston

- Charles Rennie Macintosh completes Glasgow School of Art
- Hector Guimard, Art Nouveau entrances to Métro stations, Paris (–1904)

- Louis Sullivan, Wainwright Building, St. Louis, Missouri

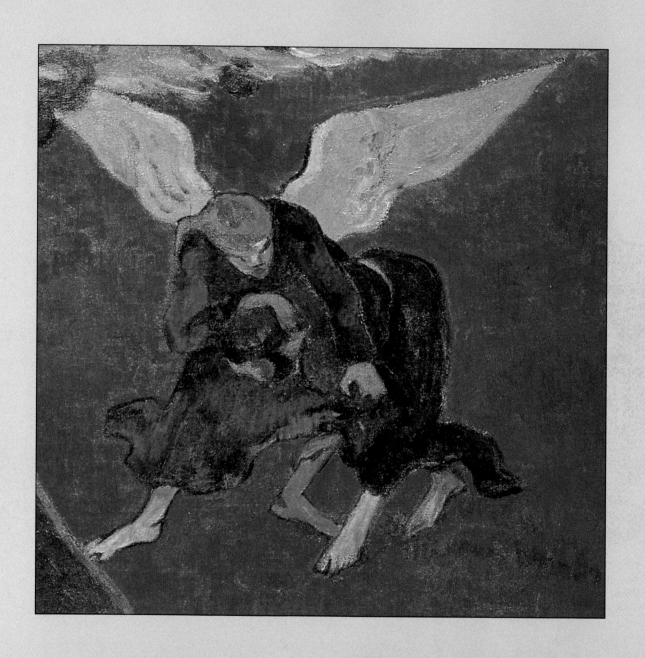

Before 1900

No history of the twentieth-century visual arts can begin with the century itself. Long before the year 1900 there were stirrings, both in art theory and in all forms of visual culture, that anticipated the developments to follow. The twentieth century is not a complete, self-enclosed cultural episode. In many respects, the things that we now believe to be most typical of our own time are, in fact, inherited from the immediate past. A case can be made for the view that, in western Europe and the United States at least, the whole period from the birth of the Industrial Revolution and the Romantic Movement to our own turbulent time is best interpreted as one continuous arc of development.

THE SOCIAL AND INTELLECTUAL BACKGROUND

The Industrial Revolution

The generally accepted date for the beginnings of the Industrial Revolution is around 1770. The first mechanical spinning mill, the invention of an Englishman, Sir Richard Arkwright (1732–92), began operations in 1781. James Watt (1736–1819) perfected the steam-engine in 1775. At the heart of the social and economic transformation wrought by the Industrial Revolution was the factory system of manufacturing with its promise of mass production. Art could not escape its influence.

A good example is the great china factory and workers' village built by Josiah Wedgwood (1730–95) near Stoke-on-Trent in 1769. The name Wedgwood chose for his enterprise—Etruria, the ancient country famous for its clay sculpture—signaled his adherence to the new Neoclassical style. The simple, regular forms of Neo-classicism, associated with printed rather than painted decoration, made it possible to produce inexpensive dinnerwares of good quality in great quantity (FIG. 1.1). Despite their refinement, Wedgwood's products signal the appearance of a new impersonality. Wedgwood often used outside designers, such as the sculptor John Flaxman (1755–1826), whose experience was divorced from the actual processes used. Their employment marked the beginning of the division between concept and execution which has become one of the touchstones of a certain kind of avant-garde art. The drive toward regularity of form, rationalization, and consequent depersonalization, which is one of the hallmarks of the Industrial Revolution, is also prominent in twentieth-century art and architecture.

The Romantic Movement

The reaction against the industrialism of the late eighteenth century was not slow in coming. It manifested itself in the Romantic movement. Romanticism, with its commitment to feeling and to the individual's sovereign right to expression, could not have existed unless the Industrial Revolution had prepared the ground for it. The "dark satanic mills" of the new industry impelled creative artists to assert their individuality against its leveling effects. The damage done to the environment by new manufacturing enterprises also played its part in creating the fervent cult of nature which was one of the distinguishing features of Romanticism.

1.1 John Flaxman, *Apotheosis of Homer Vase*, early nineteenth century. White jasper, mid-blue dip, white bas-relief figures, height (including finial) 18 in (45.7 cm). Wedgwood Museum, Barlaston, England.

This vase is done in the pure Neoclassical style that was characteristic of the firm of Wedgwood. Flaxman was a considerable sculptor and potter, but the use of patterns at the Wedgwood works and other potteries made it possible for mass-produced pottery, the work of skilled artisans, to replace individual works by artists/craftsmen.

Romanticism asserted the paramount rights of the individual, even when these were apparently opposed by society. One of its most important spokesmen, the German philosopher, Georg Wilhelm Friedrich Hegel (1770–1831), was the first to put forward the idea of the divided self, which acquired such fundamental importance for the Modern movement. Hegel described a situation in which individuals became conscious of a fissure within themselves which they could not mend, and which divorced them forever from nature. Central to Hegel's philosophy was the importance of art, which he put on the same level as religion. Creative artists he described as "the masters of the God," beings more powerful than the natural world, and yet, because they were still fundamentally part of it, able to heal the split within themselves and the rest of humankind. These ideas were to have great influence on the development of the visual arts of the twentieth century.

Karl Marx and *The Communist Manifesto*

Hegel exercised a decisive influence over one of the thinkers who did most to form the consciousness of twentieth-century visual artists, Karl Marx (1810–83). Marx was not content merely to describe and to analyze. He wanted radical change in society. In 1848 he and his collaborator Friedrich Engels (1820–95) published a rousing statement of their joint beliefs, *The Communist Manifesto*, in which they proclaimed that

> Modern bourgeois society with its relations of production and exchange and of property, a society that has conjured up such gigantic means of production and exchange, is like the sorcerer, who is no longer able to control the powers of the nether world who he has called up by his spells … The weapons with which the bourgeoisie felled feudalism to the ground are now turned against the bourgeoisie itself.[1]

The *Manifesto* was the precursor of Marx's massive masterwork, *Das Kapital* (vol. I, 1867). This, despite having been published nearly thirty-five years before the twentieth century began, is one of the essential background texts for a comprehension of the century's artistic development. One of the ideas that twentieth-century artists deduced from it was that art was not an absolute, but primarily a product of social interchanges, and could be shaped in such a way as to alter society itself.

Charles Baudelaire and "The Painter of Modern Life"

Among the father figures of twentieth-century aesthetics and of the twentieth-century sensibility in general, there are three other thinkers who must be mentioned. They belong to different generations and their beliefs in some respects are violently opposed. One is the French poet, Charles Baudelaire (1821–67). Baudelaire deserves mention not for his poems, great as these are, but for his work as a critic, and in particular for a long essay devoted to a minor artist, Constantin Guys (1805–92) (FIG. 1.2), called "The Painter of Modern Life" (1863). In that essay Baudelaire attempted to define modernity. "Modernity," he wrote, "is the transitory, the fugitive, the contingent, which is one half of art; the other half is eternal and immutable." "Almost all our orginality," he added, "comes from the imprint which the times give to our sensations." Baudelaire is important for other formulations as well—for example, that "genius is simply childhood rediscovered at will." The notion of the supreme power of the innocent eye, the sensibility untarnished by prior knowledge, was to have vast consequences for the twentieth century.

1.2 Constantin Guys, *Une "demi-mondaine"*, n.d. Watercolor and ink. Private collection, Paris.

Guys, a pioneer of French nine-teenth-century realism, was war artist for the *Illustrated London News*. He is best known, however, for his animated drawings, enlivened by thin washes of color, of scenes of Parisian high and low life.

1.2 Constantin Guys, *Une "demi-mondaine"*, n.d. Watercolor and ink. Private collection, Paris.

Friedrich Nietzsche and Sigmund Freud

Equally important to the attitudes professed by creative artists during the past hundred years were Friedrich Nietzsche (1844–1900) and Sigmund Freud (1856–1939). Nietzsche's most influential book was his first, *The Birth of Tragedy*, published in 1872. In it he stressed the presence of what he called the "Dionysian" element in ancient Greek culture (Dionysius being the god of wine, and thus by extension of all other forms of intoxication). Nietzsche applied the adjective to a frenzied impulse to exceed all human norms. Artists deduced from this that excess, the abandonment of just measure, was sometimes to be actively sought.

Nietzsche gave sanction to Modernist distortion of forms by his theory that the Sublime—in the eighteenth century Edmund Burke had defined this as something which was infinite, and which therefore exceeded the reach of human ratio-nality—was in fact "the artistic conquest of the horrible." He sanctified the over-weening ambition of artists by idealizing the concept of power, which he thought was the only thing which both men and women desired for its own sake. These drives were for him personified at their best in the *Übermensch*, or Superman, who, as the name implies, was of specifically masculine gender. The *Übermensch* was not, for Nietzsche, a dictator or someone outside society, but a member of an elite, rather like the Guardians in Plato's *Republic*, but possessed of even more extraordinary powers, innate rather than acquired. In one sense, therefore, the *Übermensch* was the replacement of God in a materialist universe, the appointed form-giver and creator, and this is how many of the more ambitious artists of the early Modernist period came to think of themselves. Whereas Plato's Guardians could be female, in the Nietzschean cosmos women, if they aspired to be anything other than helpmeets or muses, were seen as potential sources of weakness: mas-culine and feminine roles were sharply distinguished from one another.

Sigmund Freud lived on into the twentieth century, but it was his earlier writ-ings which had most impact on twentieth-century artists. His most seductive text

was the pioneering study, *The Interpretation of Dreams*, published in 1899. For Freud, "wishes originating in infancy" were "the indispensable motive force for the formation of dreams." Dreams expressed things which the dreamer was unable consciously to acknowledge, but which remained present in the dreamer's unconscious. The Freudian unconscious was to be a concept of great importance to many twentieth-century artists, notably to the Surrealists, and so was Freud's exploration of aspects of human sexuality, many of them up to that point forbidden territory.

The Symbolist Movement

Granted that the reputation of twentieth-century art is largely founded on its appetite for innovation, it is fascinating to discover how many of its most important ideas had been formulated before the century began. It is equally fascinating to note that most of these ideas are linked to various aspects of nineteenth-century materialism. At the same time, there was an increasing reaction against materialist assumptions, expressed in the arts and in literature through the Symbolist movement. Symbolism was a development of Romanticism. Its adherents believed first, that art made its effect not directly, but through veiled suggestions and hints—an elaborate network of correspondences and analogies; and secondly that the true artist remained apart from the crowd.

Symbolism was linked to an interest in esoteric doctrines, such as Rosicrucianism (supposedly based on the teachings of a sixteenth-century German mystic named Christian Rosenkreuz), and also in some cases to an exploration of Eastern religions. Theosophy, the creed promulgated by Helena P. Blavatsky (1831–91) in her widely read book, *The Secret Doctrine* (1888), was one of these attempts at cultural syncretism. Among the major artists converted to Theosophy were Kandinsky and Mondrian. The intrinsic tawdriness of Blavatsky's mythology should not blind us to its importance in the early history of Modernism. Influences of this sort helped to give the visual arts of the last two decades of the nineteenth century their distinctively hothouse atmosphere. In the conflict between strict materialism and the desire to escape from it lay the potential for revolutionary change.

Architecture

The significant architecture of the last two decades of the nineteenth century represented a revolt, still only half-conscious, against the historicism which had dominated architectural thinking for longer than most people could remember. The feeling that a change was necessary had three sources. The first was new technical opportunities, and pride in what the new technology could bring about. These technological opportunities included the increasing knowledge of how metal could be used in making buildings and the development of reinforced concrete. The second was the need to create new building types, in order to cope with a rapidly changing way of life. The third, and perhaps the most powerful, was the desire for buildings which would be both more unified aesthetically and at the same time more expressive of the personalities who created them. Architects were getting tired of strutting around in borrowed finery.

Technical Innovation

Perhaps the best example of the exploitation of new technical opportunities, though in this case for purely symbolic purposes, was the Eiffel Tower (FIG. 1.3), brainchild of the engineer and entrepreneur, Gustave Eiffel (1836–1920). The

1.3 Gustave Eiffel, Eiffel Tower, Paris, 1887–9.

Eiffel's great structure, shocking to traditionalists at the time, achieves its monumental effect through sheer height—974 ft (300 m)—and the elegant sweep of its upward thrust. It was built of wrought iron, just at the time that iron was giving way to steel in architecture.

Tower was a gesture of faith in the new technology, erected as a centerpiece for the Paris Universal Exhibition of 1889, which commemorated the centenary of the French Revolution. At 974 feet (300m) high, it was the tallest structure built up to that time. Its metallic construction and use of prefabrication were not novel in themselves—the method chosen was more than a hundred years old: Abraham Darby's all-iron bridge at Coalbrookedale in England had been built in 1779, and Joseph Paxton's Crystal Palace in 1851. What was novel about the Eiffel Tower was its flamboyant use of forms hitherto associated only with engineering rather than with architecture, which was still regarded as being a wholly different sort

of activity. Eiffel himself had been a notable builder of ambitious bridges and viaducts for the expanding French railway system. The tower was effectively an immense pylon, of the kind used to support these viaducts. As such, it offered a deliberate slap in the face to those who thought of architecture as an established form of aesthetic expression, with well-understood rules handed down from the past. When his design was unveiled it evoked frantic protects not only from architects, but from artists and writers. The French government was, however, determined to have something which would echo, in visible form, the changes which the French Revolution had brought about in French society, and Eiffel was given the go-ahead. His soaring tower, undertaken with a fairly modest official subsidy, soon repaid its cost from the fees paid by visitors.

Reinforced concrete construction, perfected in a system invented by the self-educated French builder, François Hennebique, and patented by him in 1892, found no such telling showcase for its qualities, which included the capacity to roof over immense spans, using the cantilever principle. The material was, however, widely used for buildings of the next Universal Exhibition in Paris, which took place in 1900. These buildings differed from the Eiffel Tower by concealing technical novelty within an envelope of traditional academic architecture.

Responses to New Social Needs

If the Eiffel Tower was a calculated demonstration of new technical possibilities in architecture, the practical response to new needs was made most convincingly in the United States. Here gifted architects responded to a new and dynamically innovative society. Their consciousness of the opportunities which American society offered to them was often constrained by a feeling of inferiority to Europe, born of the lack of an established tradition. At the same time, they and their clients had the feeling that America ought to rival, or even outmatch, European architectural achievements.

Louis Sullivan

The American, Louis Sullivan (1856–1924), has an excellent claim to be considered the most important and prophetic pre-Modern architect. Restless and dynamic, he took some time to find his true voice. His architectural education was conventional, but he reacted with impatience to what it had to offer him. He briefly attended both the Massachusetts Institute of Technology—the first professional school for architects to be set up in America—and the Ecole des Beaux-Arts in Paris. Sullivan was not the inventor of the skyscraper (the name had been coined a decade earlier), but he was quick to understand both its social and its technological implications. He was thoroughly in tune with the raw capitalist impulse of his time—as a biographer puts it, Sullivan "respected businessmen's ability to take simple ideas organically and logically to their myriad conclusions"[2]—and he was fascinated by the new tall office building as a type which imposed its own architectural rules. "It must be tall," he said, in an article published in 1896. "It must be every inch a proud and soaring thing, rising in sheer exaltation from bottom to top it is a unit without a single dissenting line."[3]

Sullivan thought that the Wainwright Building in St. Louis was his most important building (FIG. 1.4). He described it as "a

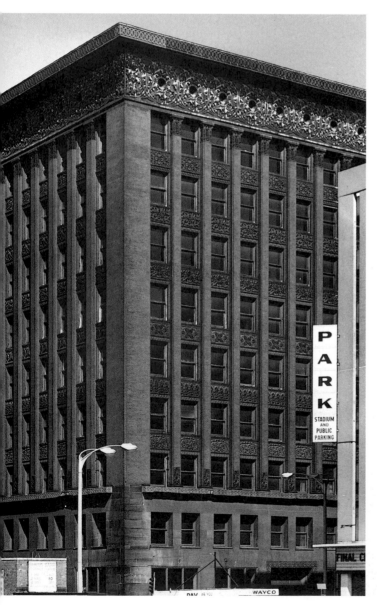

1.4 Louis Sullivan, Wainwright Building, St. Louis, Missouri, 1890.

This building points the way to Modern architecture, though its outward appearance does not yet completely reveal its structure. The masonry corners, for example, stand out from the rest of the façade and the upper cornice is treated to Art Nouveau decoration.

sudden and volcanic design (made literally in three minutes) [which] marks the beginning of a logical and poetic expression of the metal frame construction."[4] He was correct to value it so highly, since it marks the resolution of a fundamental schism in nineteenth-century attitudes between the world of science, industrial technique, and commerical enterprise on the one hand, and the world of the fine arts on the other.

Art Nouveau and the Search for Aesthetic Unity

In Europe, the new architecture of the concluding decades of the century followed several lines of development, all with some significance for the future. Otto Wagner (1841–1918), the most successful architect in turn-of-the-century Vienna, gained lasting importance as an organizer of large-scale projects. His elegant stations for the Vienna Stadtbahn (FIG. 1.5) were part of a reorganization of the city's transport system which called for over two thousand detailed plans. Wagner's huge practical experience led him to the often-quoted conclusion: "Nothing that is not practical can be beautiful."

Wagner's work for the Viennese transport system—a response to architectural needs which had not previously existed—related both to the growth of suburbs as residential areas separate from the places where people worked, and to the

1.5 Otto Wagner, Vienna Stadtbahn, Austria, 1894–7.

Like Hector Guimard's work for the Paris Métro (see FIG. 1.6), Otto Wagner's stations for the Vienna Underground were designed in the then fashionable Art Nouveau style, though with a linear simplicity that points to the future.

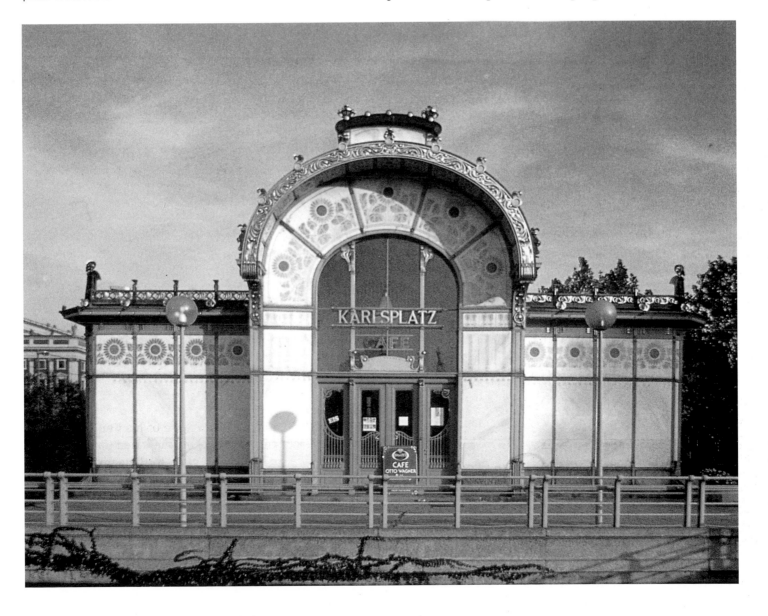

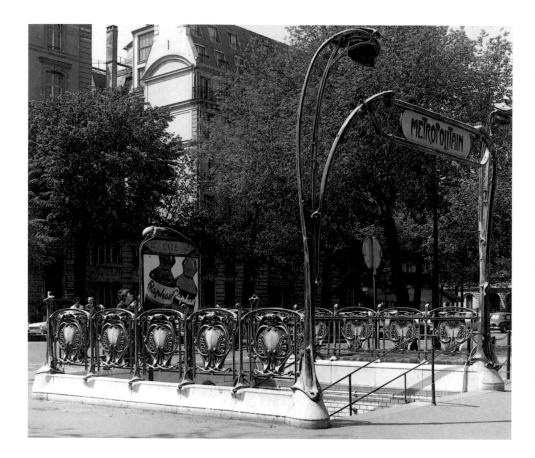

1.6 Hector Guimard, Paris Métro, 1899–1904.

Art Nouveau became as much the rage in France as in Belgium at the end of the nineteenth century. As Guimard's designs for the Paris Métro show, iron was a superb medium for the graceful, flowing ornamentation characteristic of the style.

1.7 (*below*) Victor Horta, Hôtel Tassel, Brussels, 1892–3.

Horta's buildings show the open planning made possible by new construction methods. The central hall of the Hôtel Tassel became a kind of conservatory space, with the exposed cast-iron supports taking on stylized vegetable forms. Like Sullivan in America, Horta was fascinated by the opportunity offered by Art Nouveau for "botanical" decoration.

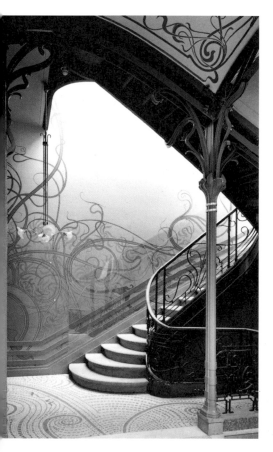

sophistication of mechanical transport. It may be compared to the daring work of Hector Guimard (1867–1942) for the Paris Métro (FIG. 1.6). Guimard's ironwork flourishes and curlicues, placed to mark the entrances to an otherwise largely invisible network binding a great capital city together, are quintessential examples of Art Nouveau, the architectural and decorative style which challenged historicism throughout Europe during the final decade of the nineteenth century.

Victor Horta and Antonio Gaudí

Art Nouveau took its name from a shop opened in Paris in 1895 to sell decorative objects in a "modern" style—"modern" meaning that they were free of any period imitation. Though the style presented itself as daringly novel, it was in fact rooted in the British Arts and Crafts Movement begun by William Morris and others in the 1860s. Other influences were the "japonisme" sparked off by the opening of Japan to trade with the West in the 1850s, and the Victorian fashion for "naturalistic" designs (designs taken directly from forms found in nature). Percolating first through the decorative arts, these influences took a long time to express themselves in architecture. When they did so, they unexpectedly allied themselves with the new industrial technology, especially with metal. One striking example is the work of the Belgian architect, Victor Horta (1861–1947), a major influence on Guimard. Horta's Hôtel Tassel (FIG. 1.7) in Brussels makes lavish use of exposed ironwork in the interior, and this ironwork has a sinuous ornamental naturalism. More important than the decorative convention, however, is the way in which Horta exploits the iron structure so as to provide a flexible plan and throw a flood of light on a constricted urban site. The Art Nouveau style had political significance in a nation then subject to severe political and social tensions. Because of its rejection of the past, it was the choice of the liberal, secular, and socialist elements in Belgian society, as opposed to the conservative and Catholic factions.

Brussels in the late nineteenth century had much in common with another city where Art Nouveau architecture flourished—Barcelona. Like Brussels, Barcelona was expanding extremely rapidly, thanks to the growth of new industries. Between 1850 and 1900 its population rose from 150,000 to 600,000. This expansion was accompanied by a general loss of confidence in established cultural models and the search for a new identity. The most important architect of the period in Barcelona was Antonio Gaudí (1852–1926). Gaudí and Horta had much in common. Each of them worked for a clientele of merchant princes, who gave them the means to realize ambitious schemes. (These patrons belonged to a new entrepreneurial class which was making its appearance all over Europe, and which was to have important consequences for the Modern movement as a whole.) Each of them, too, was a disciple of the French architect and theoretician, Eugène-Emmanuel Viollet-le-Duc (1814–79). It was Viollet-le-Duc who put forward the idea that Gothic architecture could be regarded in a new way, not simply as a historical exemplar to be slavishly copied, but as an intellectual model. He pointed out that ambitious Gothic buildings were autonomous systems, with a strict correlation between the supporting structure and the final form; and he noted that it was a logical step from Gothic systems of skeleton construction in stone to nineteenth-century methods of construction in metal.

Gaudí's early buildings were entirely Gothic in style, and it was only with the commission for the church of the Sagrada Familia (FIG. 1.8) in 1883, that the mature creator emerged. Left unfinished at Gaudí's death, this has a complex and esoteric allegorical program, expressed in a multitude of details—geometrical symbols, animals, and plants—and in the actual form of the building itself. The density and intricacy of the work can make it seem, at least at first glance, alien to the general spirit of twentieth-century architecture. It is only later that one realizes the prophetic nature of Gaudí's achievement—prophetic because it wrenches architecture out of the collective frame, and turns it into a purely personal means of expression.

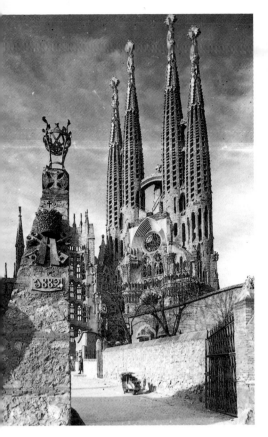

1.8 Antonio Gaudí, Sagrada Familia Church, Barcelona, Spain, 1882–1926.

1.9 Charles Rennie Mackintosh, Glasgow School of Art, 1897–9. North front.

Charles Rennie Mackintosh

Much the same thing can be said about the work of the Glasgow architect, Charles Rennie Mackintosh (1868–1928), especially about his most famous building, the Glasgow School of Art (Mackintosh won the competition for this in 1896, and added a second wing to the building in 1907–9). In keeping with its Scottish setting, the Glasgow School of Art (FIG. 1.9) is much plainer and more apparently straightforward than Gaudí's flamboyant constructions. The two ranges of wide studio windows on the entrance front of the building are direct expressions of its function. The linear detail of the fairly sparse ironwork accentuates the basic forms without threatening to overwhelm them, as happens with Gaudí. The ornamental use of wrought iron nevertheless serves as a reminder of the Arts and Crafts pedigree of both architects. Just as Gaudí's work looked back to Gothic, and sometimes also to Moorish influences, Mackintosh called on elements of the Scottish vernacular tradition to produce a result that is very much of its own time and place.

Edwin Lutyens

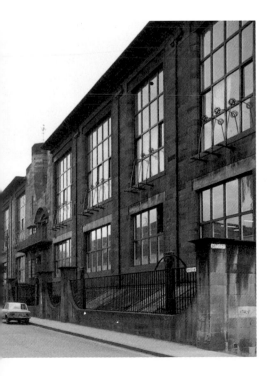

Another British architect who turned to the vernacular tradition for inspiration was Edwin Lutyens (1869–1944). In the earliest phase of what was to prove an extremely long career, Lutyens was a builder of country houses for well-off but not aristocratic patrons. Munstead Wood, near Godalming, in Surrey, designed for his collaborator, the garden-designer Gertrude Jekyll, is an example (FIG. 1.10). Though Lutyens used recognizably "period" details, choosing a style derived

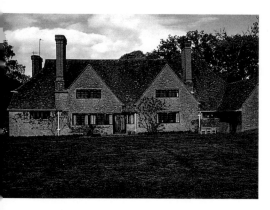

1.10 Edwin Lutyens, Munstead Wood, Surrey, England, 1896.

Making subtly original use of traditional domestic forms and materials, Lutyens designed this house for his frequent collaborator, the garden designer Gertrude Jekyll. With its marriage of the picturesque and the utilitarian, it quickly became a mecca for Arts and Crafts architects.

from Tudor and Stuart buildings, his houses are novel because of their simplicity, naturalness, and directness of expression, and still more so because of the aspirations they embody. The theme of respect for natural surroundings, of protection for the ecology, of life lived in harmony with nature, resounds through the whole history of twentieth-century visual arts, and is often identified, as here, with the lifestyle of a liberal, prosperous middle class, unwilling to sacrifice practicality and comfort completely to the demands of conscience and idealism.

In many ways the architects of the immediately pre-modern period were more complex and more interesting creatively than their immediate successors, and this accounts for the revival of interest in them today. It is, nevertheless, sobering to realize how comparatively few of them continued successfully into the modern epoch. Horta and Lutyens became "official" figures, while Gaudí more and more tended to concentrate all his energies on the Sagrada Familia. Sullivan and Mackintosh offer classic examples of broken careers.

Painting

There are several ways of approaching the notion of the pre-Modern in painting. One is through the work of certain celebrated individuals. Another is through the appearance of key institutional structures. A third is through the rise, not of individuals, but of identifiable groups.

The New Exhibiting Societies

The second of these approaches can be expeditiously dealt with. The year 1884 is a key date in the history of pre-Modern art because it saw the foundation of two exhibiting societies. One was "Les XX" in Brussels; the other was the Salon des Artistes Indépendants in Paris. Both offered places and occasions where the new art could be seen and judged, outside the control of official institutions. Though Paris was, and remained for a long time to come, the center of innovation in art, "Les XX" was in some ways more important because it was more selective. To be invited to show with "Les XX" was a kind of consecration for any radical or experimental painter. In addition, it represented a species of international recognition, not simply (as was the case with the Indépendants) recognition within France itself, which could be dismissed as the work of a cabal. It also, paradoxically, gained from its semi-official character, since the works chosen were shown in the Palais des Beaux-Arts in Brussels.

THE GREAT FORERUNNERS

Vincent van Gogh

Two artists whose early reputation owed much to recognition offered by "Les XX" were Georges Seurat (1859–91) and Vincent van Gogh (1853–90). Though now often seen as lying at opposite ends of the spectrum in art, Seurat and Van Gogh had important things in common. Each in his own way was representative of the new system of values which was beginning to emerge in the mid-1880s—something polemically anti-naturalist in character, though that is not immediately obvious from Seurat's masterpiece, *Un Dimanche d'été sur l'Ile de la Grande Jatte* (see FIG. 1.11). Whereas little is known about Seurat's personality, Van Gogh's personal legend now rivals those of the great artists of the Renaissance. This is due, in part at least, to the survival of the painter's eloquent and often anguished letters to his brother, Theo, which describe both his struggle to become an artist and his tragic descent into madness.

Georges Seurat: *La Grande Jatte*

Georges Seurat's masterpiece, *Un Dimanche d'été sur l'Ile de la Grande Jatte* (FIG. 1.11), is an infinitely laborious demonstration of the optical theories of nineteenth-century scientists such as Michel-Eugène Chevreul (1786–1889). One of the subjects which interested Chevreul was the way in which the apparent hue of objects was modified by lights of different colors falling upon them. Seurat renders this effect by using an almost infinite number of tiny touches of pure color, which blend optically on the retina—the so-called *pointilliste* or "divisionist" technique.

The painting is a number of other things as well. It is a commentary on the French society of its day—La Grande Jatte was a place of amusement on the outskirts of town to which the Parisian bourgeoisie took, not their wives, but their mistresses. Despite this, it is not informal, as a picture of the same subject by one of the Impressionists might have been, but severe and formal. Most of the figures, for example, are exactly in profile to the viewer, like those in an Egyptian tomb-painting. There are allegorical touches, like the monkey which the woman in the right foreground holds on a lead: apes and monkeys were age-old symbols of lust in European art—a fact of which Seurat was well aware.

The otherworldly atmosphere of the work is emphasized by one feature in particular: the impassively still figures are not in correct proportion to one another. The monumental pair in the right foreground loom much larger than they should. This helps to give La Grande Jatte

the removed, dreamlike atmosphere which has fascinated observers ever since it was painted. It has a hieratic quality which seems to proclaim that art belongs to a separate world from the one which ordinary human beings inhabit. This search for impersonal order was to become an important theme in twentieth-century art.

When the painting was first exhibited at the Impressionist exhibition of 1886, in the face of opposition from several of the original members of the Impressionist movement, it was much mocked. One critic compared it to the *faux-naif* work of the English illustrator of children's books, Kate Greenaway. However, the critic of the influential Belgian publication, *L'Art Moderne*, called Seurat the "Messiah of a

new art,"[*] and when the painting was shown at Les XX in Brussels in the following year, Seurat's colleague and friend, Paul Signac, reported that it was "practically invisible, it was impossible to get near it, so thick was the crowd."[†]

[*]John Rewald, *Post-Impressionism: from Van Gogh to Gauguin*, New York, 1941, p. 101.
[†]*Ibid.*, p. 104.

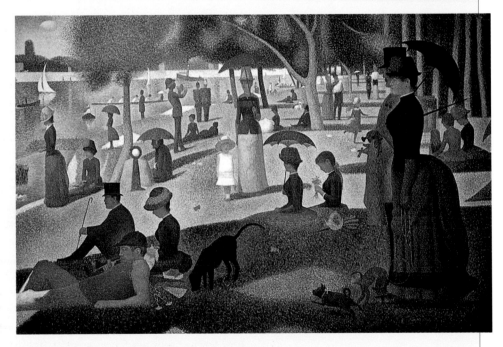

1.11 Georges Seurat, *Un Dimanche d'été sur l'Ile de la Grande Jatte*, 1884–6. Oil on canvas, 6 ft 9½ in x 10 ft 1 in (2.07 x 3.08m). Art Institute of Chicago, Illinois.

One crucial influence on Van Gogh's development was fundamentalist Protestantism. His father was a minister of the Dutch Reformed Church and both his family background and his later reading of the Bible encouraged Van Gogh to think of art as a route to personal salvation. He came to painting late, after failing to make a career as a missionary among the coalfield workers of the Borinage, the poorest region of Belgium. During his student days in Antwerp and in Paris he was in constant rebellion against the academic rules laid down for him, and even admiring contemporaries tended to think of him as a kind of primitive, or at best as being only half-trained.

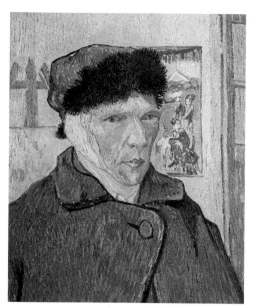

1.12 Vincent van Gogh, *Self-portrait with Bandaged Ear*, 1889. Oil on canvas, 24 x 19¾ in (60.9 x 50 cm). Courtauld Institute Galleries, London.

During his early student days in Antwerp, Van Gogh discovered Japanese *ukioye* prints. *Ukioye*—which means "pictures of the floating world"—was the popular art of the seventeenth century to the nineteenth in Japan, and evoked the life of the *yoshiwara* (brothel) quarter of Edo, now Tokyo. This discovery was not original to Van Gogh (the fashion for things Japanese swept over Europe in the 1880s), but the bold, arbitrary designs of artists like Hokusai (1766–1849) and Hiroshige (1797–1858) influenced him greatly. Later, when he moved to Paris, he came into contact with the work of the Impressionists. His mature style, which he achieved in around 1886, shows lingering traces of Impressionist influence, but is in fact fundamentally different from standard Impressionist practice. Van Gogh's brushwork is supremely bold, the paint is thickly layered on the canvas, the color contrasts are violent.

His work reached new heights of intensity after he settled in Arles in February, 1888. The pictures he then painted have a hallucinatory quality which expresses his own agitation. They nevertheless continue to represent real objects, real places, and real people, and any use of symbols is kept to a very simple level.

In many respects Van Gogh was a completely new type of artist. For arguably the first time, the expression of personal temperament took precedence over conventional technical facility. While the Romantic movement had allowed the privilege of madness to poets, this was not usually extended to creators working in other media. Yet Van Gogh's chronic depression, and his aggressive and suicidal impulses, came to be recognized as integral to what he painted. He emphasized the essential link between his own flawed temperament and his achievement as an artist in a long series of self-portraits. Some of the most moving show him with his ear bandaged, after he had made an attempt to slice it off (he succeeded only in severing the lobe) during his first attack of mania (FIG. 1.12). In these paintings he seems estranged from himself: they record his search for a route back to his own personality. In January, 1890 (the year of his death), Van Gogh was asked to exhibit with "Les XX" in Brussels, the ultimate accolade for an "advanced" artist of the period. The invitation marked the first general recognition of a new attitude toward art.

Paul Gauguin and the Cult of the Primitive

Paul Gauguin (1848–1903) has frequently been linked to Van Gogh, if only because of the disastrous period they spent together in Arles—the period which culminated in Van Gogh's first attack of mania. The two artists had certain important things in common. Chief among them were that they were both late starters, and both came from outside the ranks of the professional art world. Gauguin began even later, and more hesitantly, than Van Gogh. He was an amateur artist— it must be said an unusually competent one—working on the fringes of the Impressionist movement, until he was in his mid-thirties. In 1882, he lost his job with a stockbroking firm, and became a full-time painter. His first fully independent period was spent in Brittany, in and around the village of Pont-Aven, a picturesque spot which attracted artists of many different persuasions. Here he met an art student called Emile Bernard (1868–1941), a lively-minded young man who was interested in all the intellectual fashions of the time, especially those which were in any way connected with the Symbolist movement, then affecting not only literature, where it had originally begun, but the visual arts as well.

Bernard had just painted *Breton Women in a Green Pasture* (FIG. 1.13), which reflected some of these new impulses. It consisted of flat color areas bounded by firm black outlines, and showed a deliberate rejection of conventional perspective and modeling. These characteristics were symptomatic of Bernard's desire to achieve something which Symbolist doctrine recommended—the creation of a

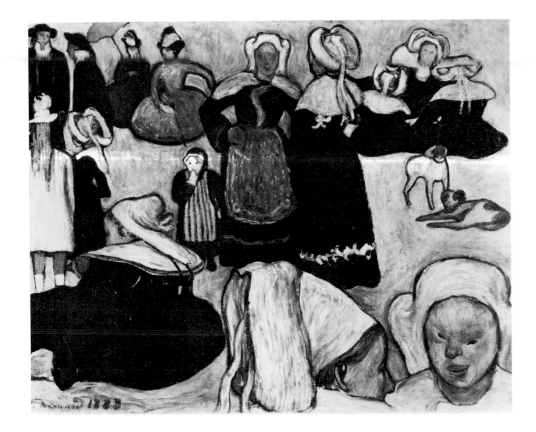

synthesis of perceptions, and the translation of these into a new and coherent language peculiar to creative art, deliberately removed from ordinary life. It was no longer enough simply to record visual perceptions, as the Impressionists had done. Having seen Bernard's painting, Gauguin decided to go one better. He painted *The Vision after the Sermon* (FIG. 1.14), which added another element—a narrative subtext. He, too, painted Breton women, but they are people who have just come out of church, where they have been listening to a sermon about Jacob

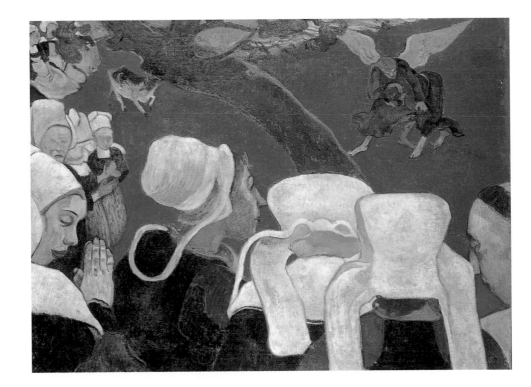

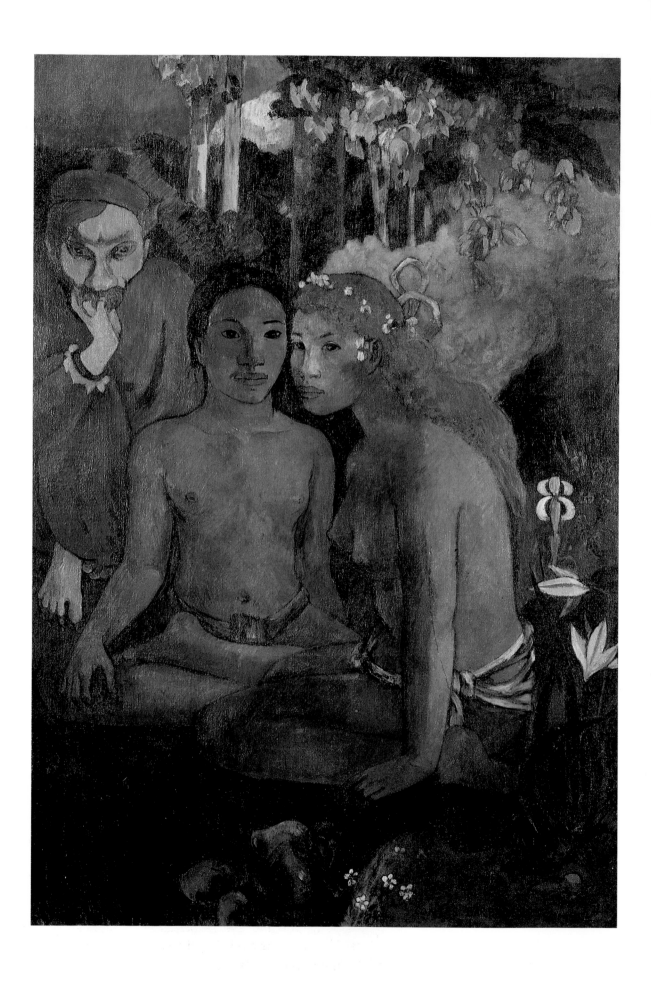

1.15 (*opposite*) Paul Gauguin, *Primitive Tales*, 1902. Oil on canvas 51¾ x 35½ in (131.5 x 90.5 cm). Folkwang Museum, Essen, Germany.

This is an early example of Modernist borrowing from exotic and supposedly "primitive" cultures, one of the South Seas paintings that mark Gauguin out as a progenitor of the Modern movement. The influences are not, however, all Polynesian. The yogalike pose of the central figure is taken directly from Javanese sculpture, which Gauguin did not know first-hand. The demonic figure with hand to chin is a caricature of his friend and fellow painter Emile Shuffnecker (1851–1934), and has nothing to do with anything Gauguin saw in Oceania.

wrestling with the angel. This image is still vividly in their minds, and therefore appears in the picture on the same level of reality as the main figures.

This and other paintings of a similar kind brought Gauguin, who had a powerful personal charisma, a band of young disciples. He was seen as the leader of a new and radical group of artists who had succeeded in going beyond Impressionism. In 1889 he was the central figure in an avant-garde show held in connection with the Universal Exhibition in Paris (the exhibition for which the Eiffel Tower was created). It brought him celebrity, but no increase in material success. In 1891 the young critic, Albert Aurier, published an important article about his work in the *Mercure de France*. Using Gauguin as his example, Aurier announced what a work of art should be.

1. Ideative, since its sole aim should be the expression of the Idea.

2. Symbolist, since it must express this idea in forms.

3. Synthetic, since it will express those forms and signs in a way which is generally comprehensible.

4. Subjective, since the object will never be considered merely as an object, but as an indication of the idea perceived by the subject.

5. (in consequence) Decorative, since decorative painting, properly speaking, as it was conceived of by the Egyptians, and very probably by the Greeks and the Primitives, is nothing more than an art at once synthetic, symbolist, and ideative.

Gauguin in the South Seas

Almost immediately after Aurier's article appeared, Gauguin left on his first voyage to the South Seas. He had always been possessed by a restless desire to travel, and by an impatience with Western civilization which was part of the intellectual climate of the time. Between visits to Brittany he had already made a voyage to Panama and Martinique. Now he determined to travel still further and make a new life in Tahiti. His first visit to Oceania ended in 1893; his second, which took him as far as the Marquesas, lasted from 1895 until his death in 1903. It is the paintings produced during these two periods of residence in the Pacific which now sustain his reputation both as a central figure in the Symbolist movement and as an initiator of the Modern movement—the progenitor, indeed, of one of its most important and now most controversial features, the cult of the "primitive" and the supposedly barbarous.

The appropriately named late masterpiece, *Primitive Tales* (FIG. 1.15), shows some of the complexities of his work during this final epoch. It is certainly not a transcription of anything Gauguin observed in Polynesia. Much of it derives from ideas and experiences which arrived there with him, as part of his mental baggage. The pose of the central figure, for instance, is borrowed from a Javanese Buddhist temple sculpture which Gauguin knew only from photographs. The narrative content is deliberately vague—the figures exist in a kind of timeless trance, and the "tales" of the title (the original French word *conte* implies a kind of folk-story or fairy-story) flow around and through them, and also through each separate consciousness which comes in to contact with the image, always with a different meaning. The timelessness and ambiguity are the essence of Symbolist aesthetics. Meanwhile, the emphasis on a supposedly primitive way of life, expressed through radical simplification of form, points forward to even more radical approaches to art.

1.16 Paul Cézanne, *A Modern Olympia*, 1873–4. Oil on canvas, 18⅛ x 21⅞ in (46 x 55.5 cm). Musée d'Orsay, Paris.

Cézanne here parodies Manet's controversial reworking (see FIG. 1.17) of a subject famously painted by Titian and Ingres, and adds a self-portrait in the foreground.

1.17 (*below*) Edouard Manet, *Olympia*, 1863. Oil on canvas, 4 ft 3½ in x 6 ft 2¾ in (1.31 x 1.9 m). Musée d'Orsay, Paris.

When first exhibited, this painting, a reworking of Titian, caused great offence because it suggested that a prostitute could be a self-possessed individual and a worthy subject for painting. Formerly, courtesans were rendered exotic and thereby idealized. Here, the absence of idealization is enhanced by the harsh lighting that flattens the forms and by the unashamedly direct gaze of the sitter.

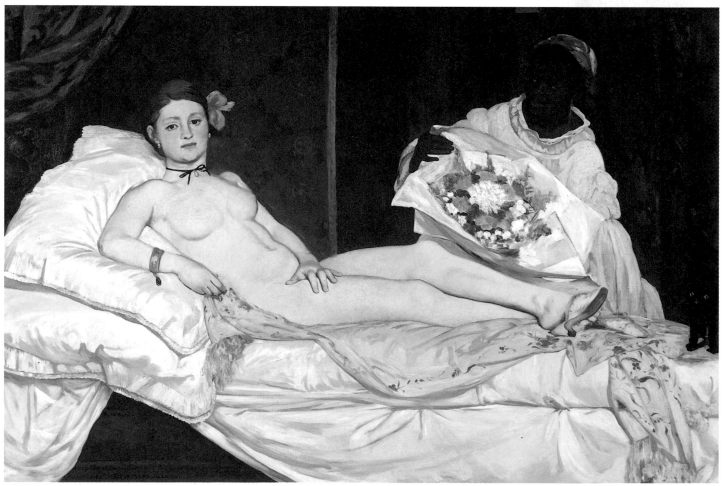

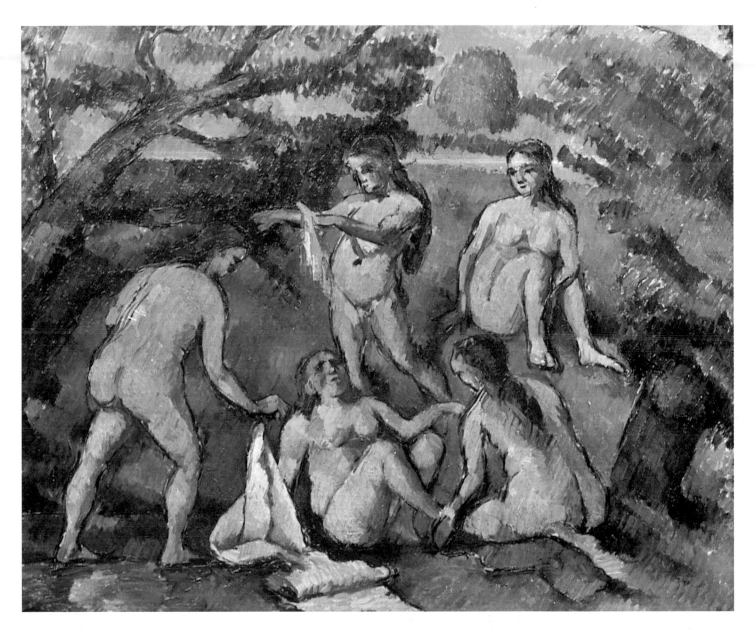

1.18 Paul Cézanne, *Five Bathers*, 1877–8. Oil on canvas, 18⅛ x 21⅞ in (46 x 55.7 cm). Musée Picasso, Paris.

From 1875 until his death Cézanne worked on a series of paintings of bathers, inspired by the Neoclassical tradition of the seventeenth and eighteenth centuries and by his wish, as he put it, to "redo Poussin after nature."

Paul Cézanne

Two other important precursors of Modernism both survived into the twentieth century, though in one case by only a few years. Essentially, however, their most significant achievements belong to its predecessor. Paul Cézanne (1839–1906) began his career as a violently expressive artist whose early work was even more opposed to prevailing norms than that of Van Gogh. His *A Modern Olympia* (FIG. 1.16) was painted at the height of the Impressionist period and shown in the First Impressionist Exhibition of 1874. This is the reaction it elicited from a contemporary critic: "A fantastic figure appearing to an opium smoker in an opium-laden sky. This naked, rosy apparition, driven on by a kind of demon in the cloudy empyrean, in which is hatched this fragment of an artificial paradise, like a vision of voluptuous pleasure, has stifled even the bravest … and M. Cézanne seems no more than a kind of madman, with the fit on him, painting the fantasies of delirium tremens."[5] The title alludes to Edouard Manet's celebrated *Olympia* (FIG. 1.17), but its real subject is Cézanne's own exacerbated sexuality. The male figure sitting on a sofa and gaping at the woman curled up on her bed is a clear self-portrait.

Cézanne was, however, to reinvent the idea of Classicism in an even more radical way than Seurat. The series of *Bathers* (FIG. 1.18) which he began in 1875,

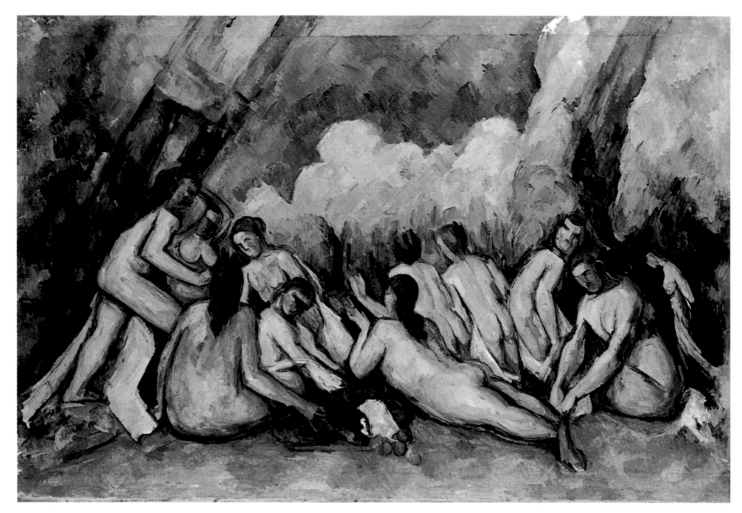

1.19 Paul Cézanne, *Large Bathers*, 1894–1905. Oil on canvas, 4 ft 3¼ in x 6 ft 4 in (1.3 x 1.93 m). National Gallery, London

The formal composition of this scene, with its repetition of pyramidal shapes both in the clusters of the figures and of the tree trunks that frame them, are evidence of Cézanne's drift away from figuration toward a more abstract attention to forms and colors.

1.20 (*opposite*) Edvard Munch, *Puberty*, 1895. Oil on canvas, 4 ft 11⅞ in x 3 ft 7¼ in (1.52 x 1.1 m). National Gallery, Oslo.

This depiction of the sexual awakening of a young girl is characteristic of the morbid sexual obsession of much of the art of its period. Munch, one of the fathers of Expressionism, never sacrificed form to ideas, but he used livid colors— violent reds, black, ethereal blues— and simplified line drawing to great emotional effect.

almost immediately after completing *A Modern Olympia*, was an attempt, as he said, to "redo Poussin after nature." Nature, however, was something which he defined very much in his own way, since he was too inhibited to ask female models to the studio. The final, and most ambitious, paintings in the series, such as the *Large Bathers* (FIG. 1.19), are quasi-abstract constructions of planes and forms which foreshadow the development of certain kinds of fully abstract art in the twentieth century.

Edvard Munch

The Norwegian artist, Edvard Munch (1863–1944), seems to combine elements taken from Van Gogh, Gauguin, and Cézanne. Like Van Gogh, his character was formed by a fundamentalist Protestant upbringing. His father was a doctor who suffered from religious anxiety almost amounting to mania. Many of Munch's early images are based on the family tragedies of his youth. Later Munch recalled the gloom of these early years: "In my childhood I always felt I was treated unjustly, without a mother, sick, and with the threat of punishment in Hell hanging over my head."[6] Munch's other, less personal, problem was the cultural provincialism of the Norwegian environment, but this he soon overcame. In 1885 he made his first visit to Paris, where he was deeply impressed by the work of Manet. He returned there on several occasions, at the end of the 1880s and the beginning of the 1890s. In the second half of the 1890s he wandered restlessly throughout Europe. During these years he produced the majority of the images for which he is now best remembered.

One of Munch's preoccupations during the years of wandering which turned

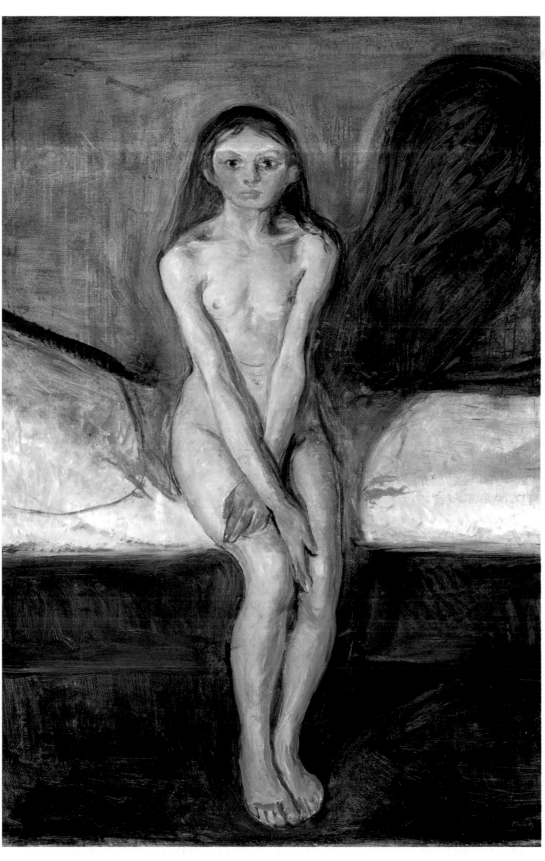

him into a major artist was sexuality—female sexuality in particular. In *Puberty*, which is typical of his work in this period, the subject is a young girl's discovery that she is no longer a child but a woman. (FIG. 1.20). The terror of sex which it conveys is not that of the girl alone, but that of the artist: in this respect there is a

1.21 Paul Sérusier, *The Talisman*, 1888. Oil on wood, 10⅝ x 8¼ in (27 x 21 cm). Musée d'Orsay, Paris.

Done under Gauguin's direction at Pont-Aven in Brittany, this small painting, with the simple forms and flat colors of the Synthetist manner, triggered the foundation of the Nabis group. "A picture," the Nabis leader, Maurice Denis, said in a famous statement, "before being a war-horse, a nude woman, or some sort of anecdote, is essentially a flat surface covered with colors arranged in a certain order."

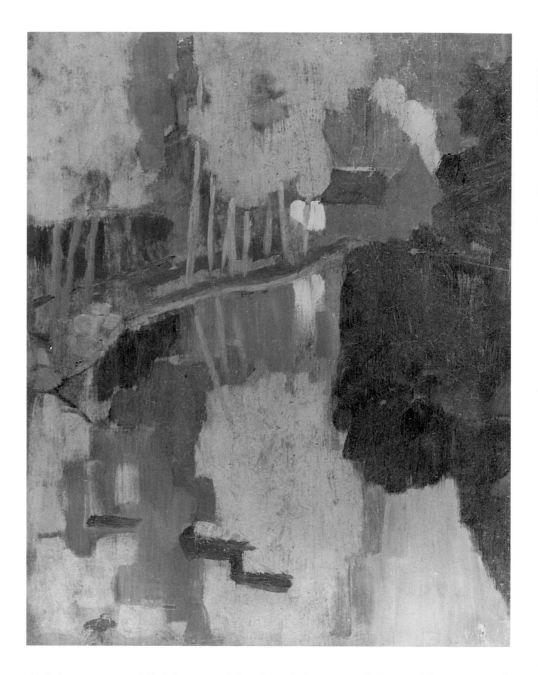

slightly unexpected link between Munch and the young Cézanne. The emotional climate of the painting is reminiscent of the dramas being written at the same time by the Swedish playwright, August Strindberg (1849–1912), whom Munch knew in Berlin.

The subjective element already visible in the work of Van Gogh, Gauguin, Cézanne, and even to some extent Seurat, is carried to extremes in the paintings of Munch's first and greatest period, which lasted until his alcohol-induced nervous breakdown of 1908. He was really the first European artist who was able to make the claim that his art and his life were essentially indivisible (it had only been made previously by certain Chinese and Japanese scholar-painters). He was also the first—certainly since the Neo-classical epoch—to be a fully international figure. His native Norway remained intensely important to him, and this was where he spent the second and much longer part of his career. In his years of wandering, however, his identity was not that of a representative of Norwegian culture, but of the prophet of a new kind of art.

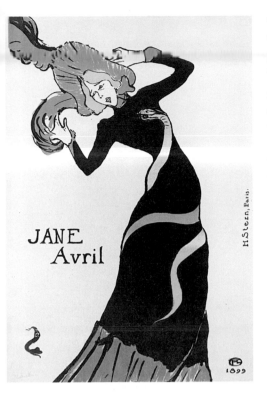

1.22 Henri de Toulouse-Lautrec, *Jane Avril*, 1899. Lithograph, 22 x 14 in (55.8 x 35.5 cm). Museum of Modern Art, New York.

Toulouse-Lautrec's exuberant poster designs, notable for the flatness of the figures and of the space they inhabit, brought avant-garde art to the streets of Paris.

1.23 Edouard Vuillard, *Woman in Blue with a Child*, 1899. Oil on cardboard, 19⅛ x 22¼ in (48.6 x 56.5 cm). Glasgow Museums: Art Gallery and Museum, Kelingrove, Scotland.

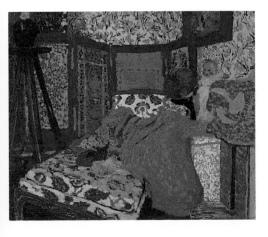

The Nabis

The artists whose work has so far been described were all individualists. Even Seurat, the chief figure in what has been called Neo-Impressionism, did not belong to an art movement in the sense in which we now use that term. The artists from the concluding years of the nineteenth century who most clearly anticipated the twentieth-century passion for discrete artistic movements and groups were the Nabis.

In 1888 Gauguin was briefly in contact, during one of his visits to Brittany, with a young painter called Paul Sérusier (1865–1927). Under Gauguin's tuition, Sérusier painted a small landscape using the new Synthetist technique. The lesson struck the young artist with the force of a revelation. He took his picture back to Paris, where it was promptly baptized *The Talisman* (FIG. 1.21), and started preaching the new artistic doctrine to friends of his own generation. Eventually he was to organize them into what amounted to a secret society. "Nabi" was the Hebrew word for prophet. Among their number were Maurice Denis (1870–1943), Paul Ranson (1862–1909), K.X. Roussel (1867–1944), Pierre Bonnard (1867–1947), and Edouard Vuillard (1868–1940). It soon turned out, however, that the members of the Nabis were very different from one another. Sérusier and Denis were serious, mystical, and philosophical, drawn toward the Catholic revival which was increasingly influential at the time. Bonnard and Vuillard, the two most gifted of the group, were by contrast fascinated by what happened in the world of everyday experience.

Henri de Toulouse-Lautrec

In the early work of the Nabis, there is a parallel with the art of Henri de Toulouse-Lautrec (1864–1901), who sometimes frequented the same Symbolist circles, and portrayed their inhabitants, but who was never specifically a Nabis. Toulouse-Lautrec's preferred subject matter was Parisian nightlife in its more raucous and sordid aspects, especially the cabarets and dance halls of Montmartre. His portrayal of these helped to fix the image of the *fin de siècle* in the popular imagination. In addition to making paintings, drawings, and portfolios of prints addressed to a market of art collectors, Toulouse-Lautrec was a designer of posters (FIG. 1.22)—his designs show the impact of the Japanese art which was currently so popular, in addition to demonstrating his links with the illustrators and caricaturists who made their headquarters at another cabaret, Le Chat Noir.

Illustration and (especially) caricature were a fecund source of inspiration for the young artists of the late 1880s and the 1890s, Toulouse-Lautrec and the young Nabis among them. Caricature, which relied on exaggeration and on allegorical and symbolic modes of representation, helped them to find new ways of seeing things. They were also affected by the generally rebellious spirit of the time. Maurice Denis, one of the more solemn of the Nabis, recollected the spirit of their beginnings in an article written two decades later: "The fact is that we were turning back to childhood, we were acting stupidly, and there is no doubt that at this time this was the most intelligent thing to do."[7]

Pierre Bonnard and Edouard Vuillard

Gradually, however, the Nabis were drawn back into quieter and more respectable, if still experimental, circles. Bonnard and Vuillard were closely linked to the Symbolist periodical, *La Revue Blanche*, founded in 1891 by the brothers Alfred, Thadée, and Alexandre Natanson. Vuillard was especially fascinated by the beautiful Misia, the Polish wife of Thadée, and many of his paintings of the epoch represent the Natansons and their domestic circle (FIG. 1.23). What he did with especial skill was to capture the overcrowded, hothouse quality of the

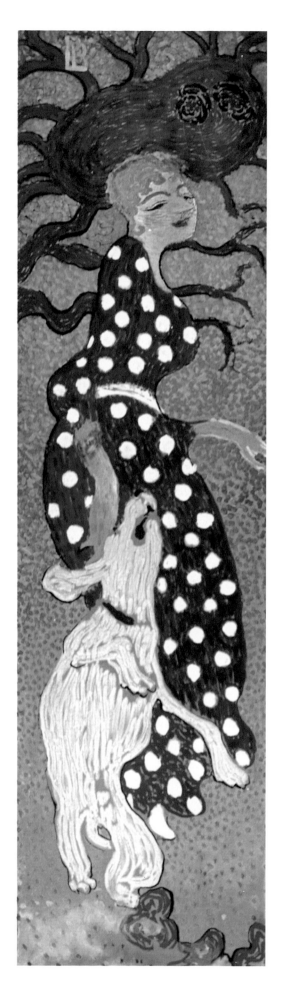
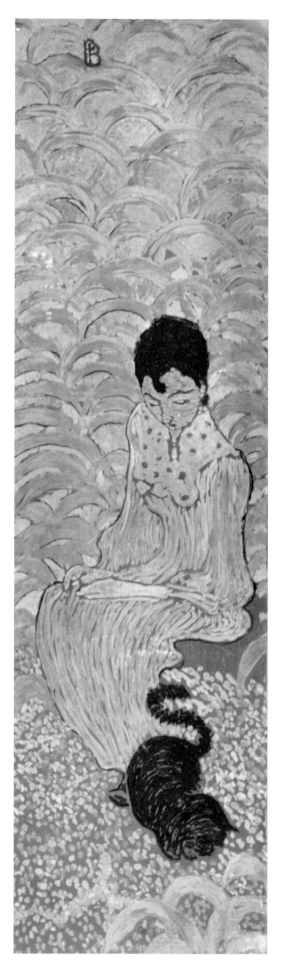

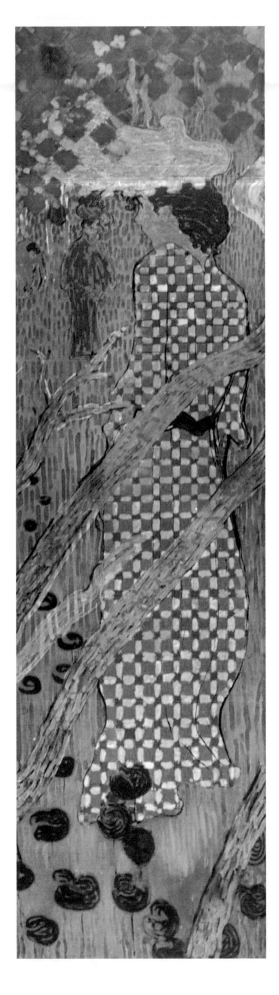
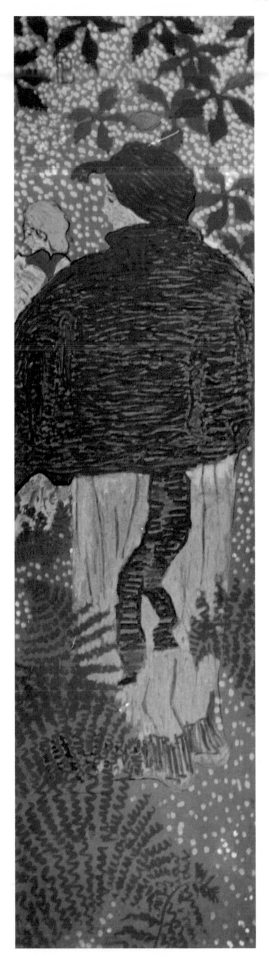

1.24 (*previous spread*) Pierre Bonnard, *Women in a Garden (Panels I-IV)*, 1891. Tempera on paper, 63 x 18⅞ in (160 x 48 cm) (two panels). Musée d'Orsay, Paris.

These exquisite, sparsely filled panels show Bonnard at his most decorative and most Japanese, though right from the beginning he delighted in the texture and luminosity of paint.

domestic interiors inhabited by rich and cultivated people. He was a master of pattern-on-pattern, and often chose such unexpected viewpoints for his compositions that it is difficult, at first glance, to make out what is represented. Bonnard, at this period, worked in a similar way, often producing work in which subject-matter was deliberately reduced to a minimum. An example is the set of four panels (FIG. 1.24) which are clearly modeled on Japanese *kakemonos* (scroll paintings). The "decorative" aspect of Symbolism is deliberately stressed, to the point where the result borders on abstraction.

One thing which helped to lead the Nabis in this direction was their connection with the ethos of the Arts and Crafts Movement. They formed a kind of French offshoot of this, making stained glass and designs for wallpapers and textiles as well as paintings, drawings, prints, posters, and book illustrations. It was only much later, after the turn of the century, that surviving members of the group began to be regarded as the conservative wing of French art. Even then, the judgement was true only in some cases. If Vuillard's work gradually ossified, that of his colleague, Bonnard, remained creatively experimental throughout a long and glorious career, to the point where Matisse declared that he was an artist superior to himself.

Sculpture

Auguste Rodin

The dominant figure in the sculpture of the concluding years of the nineteenth century was the Frenchman, Auguste Rodin (1840–1917). The tradition which Rodin inherited made life peculiarly difficult for the creative and experimental sculptor. First, there was the fact that almost throughout the nineteenth century sculpture had taken second place to painting. There had been no sculptor with a major European reputation since the death of the great Neo-classicist, Antonio Canova (1757–1822). Secondly, there was sculpture's position as being *par excél-*

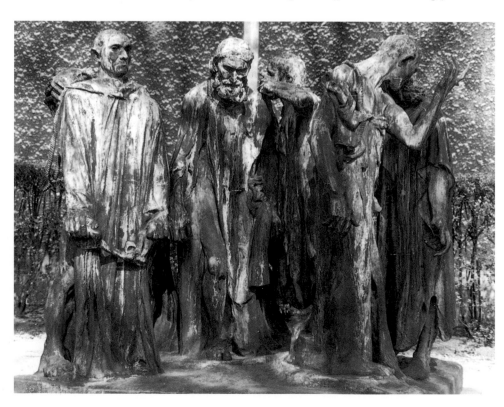

1.25 Auguste Rodin, *The Burghers of Calais*, 1885–95. Bronze, 6 ft 10½ in x 7 ft 11 in x 6 ft 6 in (2 x 2.4 x 1.9 m). Musée Rodin, Paris.

Auguste Rodin: *The Gates of Hell*

Rodin's *The Gates of Hell* (FIG. 1.26) were originally intended to form the entrance to a new Museum of Decorative Arts in Paris. The artist's model seems to have been the fifteenth-century *Gates of Paradise* made by the Renaissance sculptor, Lorenzo Ghiberti (1378–1455) for the Baptistery in Florence. Rather than arranging the gates as separate panels, as Ghiberti did, Rodin, though unsuccessfully, tried to unify the whole composition. The real subject, typical of the time when the project was first conceived, is the alienated, ambiguous nature of the human condition in modern society, and the futile regrets which men and women feel, in an increasingly non-religious society, over mistakes and sins which cannot be atoned for or otherwise remedied. That is, the program Rodin set himself is in essence profoundly pessimistic, and this may be the main reason that he never succeeded in carrying the commission to completion. Nevertheless, he continued to work fitfully on the *Gates* even after their original purpose was superseded by the French government's decision to house the Museum of Decorative Arts in one

wing of the Louvre. The *Gates* have a central place in Rodin's work, not for their own sake, but as an inexhaustible quarry of motifs and ideas. They are the primary source of many of the deliberately fragmentary sculptures which form a large part of his production. These suggestive fragments, such as the boldly erotic *Iris, Messenger of the Gods* (1890) force the spectator to imagine what the completed figure might have been like, and in consequence to become closely engaged with the image. While fragmentary classical sculptures, such as the *Torso Belvedere* in Rome, had long been widely admired, Rodin was the first sculptor to create "incomplete" figures of this sort and show them as finished works. In addition, Rodin would often combine figures taken from different parts of the project to make groups with entirely new meanings. Thus two figures known as the *Crouching Woman* and the *Fallen Man* come together to make *The Abduction*, and *The Martyr* becomes Lust in another group representing *Avarice and Lust*. The *Gates* thus directly reflect the psychological turmoil of contemporary existence.

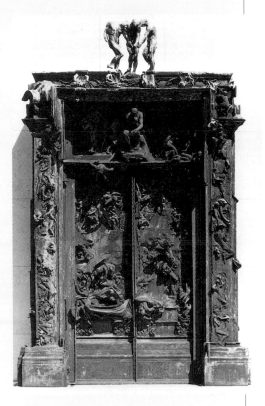

1.26 Auguste Rodin, *The Gates of Hell*, 1880–1920. Bronze, 250¾ x 158 x 33⅜ in (636.9 x 401 x 84.8 cm). Musée Rodin, Paris.

lence an official art form, dependent on governmental and municipal, rather than private, patronage. What had enabled the Impressionist painters to survive and make their way was their ability to find an alternative market among private collectors. The great Impressionist masterpieces we know today were never government commissions, or even government purchases from official exhibitions such as the annual Salons. They passed through private hands on their way to the museums in which we now admire them. Thirdly, there was the existing technical tradition, which put the sculptor very much in the hands of his assistants. The work, once conceived in clay or plaster, had to pass through many processes before it reached its final form in bronze or marble. The connection between the creative artist and many of these processes might be tenuous—most sculptors, for example, Rodin among them, had their work in marble produced by specialist carvers.

Perhaps because there was so much to unlearn as well as to learn, Rodin's art matured slowly. His early development incorporates a number of the major tendencies to be discovered in nineteenth-century art. In his early career, when he worked as an assistant in the studio of Albert-Ernest Carrier-Belleuse (1824–87), now best remembered for his splendid bronze figures carrying *torchères* designed for Charles Garnier's Paris Opera, he was touched by the revival of eighteenth-century taste—some early sculptures are close to Rococo equivalents (the same

impulse can also be seen at work in many of Renoir's paintings). Rodin began to receive public commissions in the 1880s, most importantly for the entrance to a proposed new Museum of Decorative Art in Paris (see FIG. 1.26) and for *The Burghers of Calais* (FIG. 1.25), a monument to the leading citizens of Calais who in 1347 delivered themselves to Edward III of England, clad in sackcloth with ropes around their necks, in order to induce him to lift his siege of their town. The fact that, in the *Burghers*, Rodin was dealing with a group, not a single heroic individual, meant that he had to find a new, untraditional way of organizing the composition. His solution was to abolish the expected high bases, and to show the hostages as individuals, each reacting in a different way to the crisis created by their situation.

Medardo Rosso

The only sculptor who approaches Rodin in historical importance in the closing years of the nineteenth century is the Italian, Medardo Rosso (1858–1928). Rosso is a slightly mysterious figure—he emerged fully formed as an artist in around 1882. In many respects his aims were much more radical than those of Rodin. Often he wanted to contradict the normal approach to the three-dimensional medium by forcing the spectator to look at the work from a single viewpoint, chosen by the artist himself. He did not work in bronze, but from 1883 onward used a layer of wax over a core of plaster. The wax was translucent, and enabled Rosso to offer a sculptural equivalent to the vibration of light over a surface—the kind of effect so often attempted in Impressionist painting. Like the Impressionists, he deliberately took his subjects from everyday life—*The Concierge* is a case in point (FIG. 1.27).

Rosso's importance lies in the fact that his sculpture is so different from almost everything else made at the same period. It has nothing monumental about it—the small scale and the fragility of the materials meant that it could be exhibited only in a gallery or, better still, a domestic setting. This was a direction much avant-garde sculpture was to take during the first half of the twentieth century. By abandoning their ambition to make grandiose public statements, sculptors set themselves free to experiment as they liked. For many of them, however, the consequent restriction of scale was a keenly felt deprivation.

THE POSITION OF WOMEN ARTISTS

One question to be considered is the position of women in the avant-garde of the 1880s and 1890s. During the second half of the nineteenth century women were gradually making a more considerable position for themselves in the visual arts. This was true even of sculpture, where it was much more difficult for women to establish a foothold, because of the pattern of patronage outlined above. Of the 1,047 sculptors who exhibited in the Salon of 1883, 101, or just under ten per cent, were women.[8] The price these women artists paid for acceptance was rigid adherence to the artistic conventions of their time—something which was true of women artists in general, whether painters or sculptors.

Despite the presence of women in the ranks of the Impressionists, chief among them Berthe Morisot (1841–95) and Mary Cassatt (1844–1926), the female artists of the nineteenth century tended to feel that their sex was a sufficient disadvantage in making a career, without adding the further burden of being labeled avant-garde or *outré*. Both Morisot and Cassatt were at least partly protected by the fact that they came from good backgrounds and had a private income. As the issue of

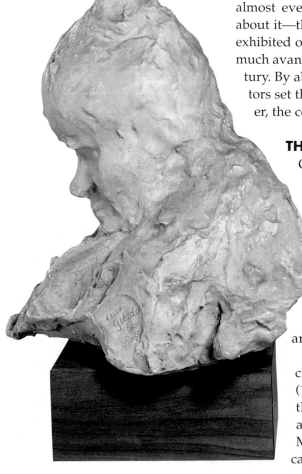

1.27 Medardo Rosso, *The Concierge*, 1883. Wax over plaster, Height 14½ in (36.8 cm). Museum of Modern Art, New York.

By using translucent wax over plaster as his medium, Rosso was able to achieve effects of light that give his small genre figures the illusion of movement.

avant-gardism became more acute in the closing decades of the century, the participation of women in experimental artistic activity tended to diminish rather than increase.

Photography

THE BIRTH OF THE SNAPSHOT CAMERA

The 1870s and 1880s saw rapid advances in photographic technology, and these affected not only the way in which photographs were taken, but also who took them. Magazine cameras for flexible gelatine film were introduced in 1881; in 1888 George Eastman launched his Kodak camera. Small and simple, with a fixed-focus lens, one speed, and one stop, it incorporated a roll of film which allowed the taking of a hundred pictures without reloading. The result of Eastman's invention was an enormous proliferation of images by amateur photographers.

PHOTOGRAPHY AS A PROFESSION

The photographs which rose above this undifferentiated flood, and which have caught the attention of posterity, are of several kinds. There are, first of all, those made by photographic professionals, usually in the studio, using better and more sophisticated equipment than was availabile to the average amateur. By the early 1880s there were nearly 10,000 such photographers in the United States, more than 7,500 in Britain, and more than 6,000 in Germany. Professional photography attracted women as well as men. By 1891, a quarter of professional photographers were female.[9] Most of these practitioners were journeymen and journeywomen, producing uninspired portraits and other types of commercial work.

DOCUMENTARY PHOTOGRAPHY

Photographs which have tended to retain attention today, in addition to the like-

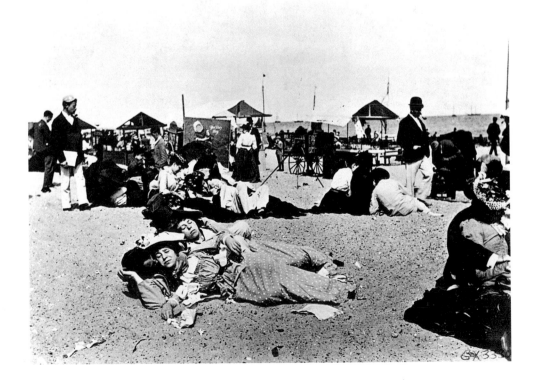

1.28 Paul Martin, *Beach at Yarmouth*, 1892. Platinum print. Victoria and Albert Museum, London.

This is an example of the new "snapshot" photography made possible by the rapid technical progress in cameras in the late nineteenth century.

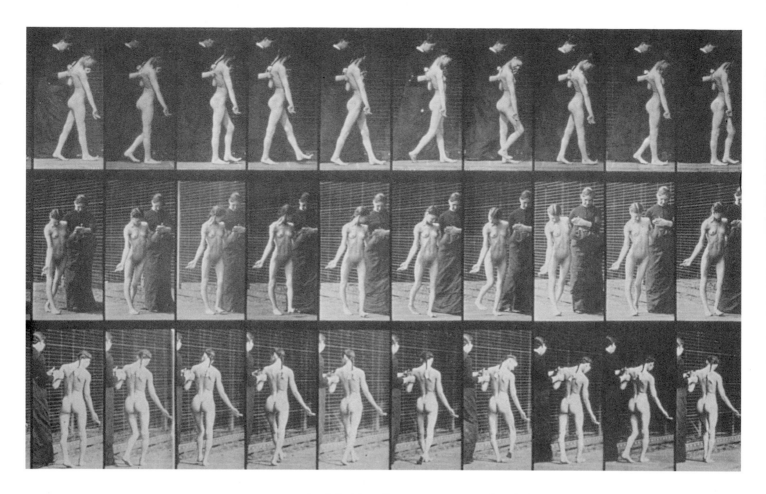

1.29 Eadweard Muybridge, *Scientific Investigations of Movement—Spastic Walking*, 1885. Calotype. Philadelphia Museum of Art, Pennsylvania.

Muybridge's sequential photographs, showing animals and human beings in motion, revealed details of rapid movement that were not discernible to the naked eye. Artists realized, for example, that the traditional way of showing horses galloping, with all four legs outstretched, was a posture that never occurred in nature. People were, however, often initially reluctant to accept the evidence of the camera, preferring familiar visual conventions.

nesses of celebrities, lie at opposite ends of the spectrum: documentary images, which record some particular situation or event, and so-called "pictorialist" photographs, where the aim was, from the beginning, to produce something in which aesthetic qualities were paramount. Documentary images were the product of a range of motivations. One was simple curiosity and delight in what the camera could now do, especially when the photographer remained unobserved. This motive was the mainspring of the astonishingly informal pictures made by the British photographer, Paul Martin (1864–1942), in the 1890s, in the streets of London, and on the beach at Yarmouth (FIG. 1.28). There were also scientific investigations of movement, of the sort made by Eadweard Muybridge (1830–1904) (FIG. 1.29), Etienne-Jules Marey (1830–1904), and the American painter, Thomas Eakins (1844–1906) in the mid-1880s. Finally, there were photographs which documented the social conditions of the time, notably those made by Jacob Riis (1849–1914) (FIG. 1.30) and various collaborators in the slums of New York. Martin's photographs undoubtedly spring from both an aesthetic and a voyeuristic impulse, but the primary aim of most documentary photographers was to record information. Scientific photographs, in particular, made it plain that the camera could record facts that the human eye had been quite unable to perceive.

PICTORIALIST PHOTOGRAPHY

There were, however, photographers at work in the nineteenth century who were moved by an aesthetic impulse. In 1889 this way of thinking was revived, after a period of decline, by the publication of Philip Henry Emerson's *Naturalistic Photography for Students of the Art*. Emerson (1856–1936) was perhaps the first to note what now seems self-evident—that the vision of the camera does not operate in the same way as human vision. The lens records everything in sharp detail;

the eye scans what is placed in front of it and emphasizes individual features or objects either because they interest the spectator more, or because they are especially prominent, brightly lit, or brilliant in hue. Emerson advised photographers to manipulate photographic technique in a subjective way, following established conventions of picture-making. Instead of looking to the Old Masters for models, however, the new school of pictorialists (as they came to be called) turned to the Impressionists, to the Japanese, and perhaps most frequently to the work of James Abbott McNeill Whistler (1834–1903). Whistler was a particularly attractive model because his work, unlike that of the core group of Impressionists, remained predominantly tonal, and this was still a period when color photography was in its infancy.

One of the things the pictorialists wanted to do was to separate their activity from that of the thousands of casual makers of snapshots. They did this not only by the kind of subjects they chose, and the way in which they photographed them, but by increasingly elaborate technical manipulation in the darkroom. A whole range of printing processes was employed—carbon (producing deep blacks and clear whites, without half-tones), platinum, gum-bichromate (which enabled the photographer to omit details and change tonal values at will), and bromoil. The negative made by the camera was now merely a starting point—

1.30 Jacob Riis, *Slept in the Cellar for Four Months*, c. 1890. Gelatin silver print. Museum of the City of New York.

Jacob Riis's photographs of New York slum-dwellers were taken purely as social documents, without aesthetic or "pictorialist" intention, though in a crusading, reformist spirit. He said of his camera: "I had a use for it, and beyond that I never went."

1.31 Philip Henry Emerson, *Norfolk Landscape. Snipe shooting*, 1886. Platinum print. Houston Museum of Fine Arts, Texas.

Emerson used his camera to produce equivalents to the watercolor landscapes painted earlier in the nineteenth century by artists such as Peter de Wint. The chief point of interest in a picture, he believed, should be slightly out of focus, "just as sharp as the eye sees it and no sharper."

photography was no longer something which, whether the photographer liked it or not, presented what at least seemed to be objective truth.

THE IMPORTANCE OF THE "AMATEUR" PHOTOGRAPHER

A mildly ironic feature of the new movement was that many of the leaders were themselves amateur rather than professional photographers—they pursued these experiments for their own sake, not as a means of making a livelihood. They tended to band themselves together in groups which emphasized their separateness from the rest of the photographic community. One of the most influential of these groups was the Linked Ring, founded in 1892 when a group of leading photographers split from the Royal Photographic Society in London. Similar organization soon appeared elsewhere—the Photo Club de Paris, the Vienna Camera Club, and, in 1902, the Photo-Secession in New York. By then, the Linked Ring had ceased to be purely British, and had come to include most of the leading French, German, Austrian, and American pictorial photographers.

SUBJECT-MATTER AND PICTORIALIST PHOTOGRAPHY

The homogeneity of the pictorialist photography of the 1880s and 1890s was ensured by, among other things, its limited and distinctive range of subject-matter. There were empty landscapes, like Emerson's own beautiful views of the Norfolk Broads (FIG. 1.31). There were dignified rural scenes. There were mysterious interiors, like those made by Frederick Evans (1852–1943) at the chapter house of Wells Cathedral, England (FIG. 1.32). There were also, less successfully and less remembered today, direct imitations of works of art in other media—a temptation to which photography remained open throughout the century.

1.32 Frederick Evans, *Sea of Steps*, no date. Gelatin silver print. George Eastman House Collection, Rochester, New York.

Evans's beautifully composed and lit interiors take on mysterious symbolic force, giving his images a significance which extends beyond the architectural facts that they record.

The pictorialist impulse had not exhausted its energy when the century ended. The man who was to take it further, and to change its character in the process, was the American, Alfred Stieglitz (1864–1946). It was in Stieglitz's hands that the leadership in photographic experiment and innovation was to pass to the United States.

1900	1901	1902	1903	1904

GENERAL EVENTS

1900
- Boxer Rising in China against the foreign population
- Creation of the Commonwealth of Australia

1901
- Cuba becomes US protectorate
- Death of Queen Victoria, accession of Edward VII
- Theodore Roosevelt elected US president

1902
- Boer War ends
- Death of Emile Zola

Dedication of Rodin's *The Thinker* in front of the Pantheon, Paris

1903
- British troops complete conquest of Nigeria
- First motorized taxis in London
- First crossing coast-to-coast by automobile (65 days)

1904
- Outbreak of Russo-Japanese War
- France and England reach *Entente Cordiale*
- Conference on the white slave trade held in Paris

SCIENCE AND TECHNOLOGY

1900
- First Zeppelin flight
- Human speech first transmitted by radio wave
- Sigmund Freud publishes *The Interpretation of Dreams*

1901
- Guglielmo Marconi sends first telegraphic radio messages across Atlantic
- First prototype motorcycles

1902
- Aswan Dam inaugurated

Cézanne with his painting *The Great Bathers*

1903
- Wilbur and Orville Wright make first powered aeroplane flight
- *The Great Train Robbery*, first narrative cinematic film and the longest to date (12 mins)
- Marie Curie and Henri Becquerel win the Nobel Prize for their research into radium

1904
- First practical photoelectric cell
- First ultraviolet lamps
- First telegraphic transmission of photographs
- Silicones discovered
- Work begins on Panama Canal
- Freud publishes *The Psychopathology of Everyday Life*

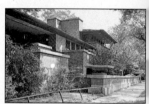

Wright, Robie House: see p.55

ART

1900
- Paris holds World's Fair
- Death of John Ruskin
- Claude Monet exhibits first *Waterlilies* paintings

1901
- First exhibition of Impressionist paintings in Russia, organized by Sergei Diaghilev
- Death of Arnold Böcklin

1902
- Major retrospective of Toulouse-Lautrec, Brussels

McKim, Mead, and White, Pennsylvania Station: see p.52

1903
- Death of Paul Gauguin in Tahiti
- Deaths of James McNeill Whistler and Camille Pissarro

1904
- Henri Matisse, first solo show
- Paul Cézanne show triumphs at the Salon d'Automne
- Pablo Picasso settles into the Bateau Lavoir in Montmartre, Paris

ARCHITECTURE

1900
- Giuseppe Sommaruga, Palazzo Castiglione, Milan, Italy

1901
- Victor Horta, "Innovation" department store, Brussels
- Frank Lloyd Wright publishes plans for the Willits House in the *Ladies Home Journal*

1902
- Daniel Hudson Burnham, Flatiron Building, New York
- Otto Wagner's building for *Die Zeit* in Vienna

1903
- Auguste Peret completes the first concrete apartment building at 25 Rue Franklin, Paris

1904
- Frank Lloyd Wright, Martin Building, Buffalo, New York
- Otto Wagner, Post Office Savings Bank, Vienna

1905 | 1906 | 1907 | 1908 | 1909

- Russo-Japanese War ends in Japanese victory. Demonstrations and general strike throughout Russia

- Canadian provinces of Saskatchewan and Alberta are formed

- US troops occupy Cuba

- Death of playwright Henrik Ibsen

- Earthquake in San Francisco, killing 700

- Oklahoma becomes 46th state

- Austria occupies Bosnia and Herzegovina

- London witnesses Suffragette demonstrations over the right of women to vote

- Foundation of Tel-Aviv

- Blériot completes first flight across English Channel

- Expedition led by Robert E. Peary reaches North Pole

- Albert Einstein begins work on his Theory of Relativity

- First radio programme with voices and music broadcast in United States

- Invention of slow-motion film by Auguste Musger

- Louis Lumière invents color photography

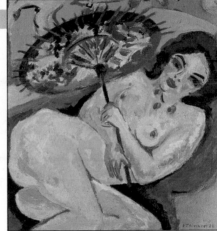

Kirchner: *Girl Under a Japanese Sunshade*: see p.66

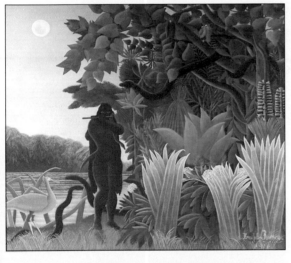

Rousseau, *The Snake Charmer*: see p.60

- Invention of Bakelite (first modern plastic)

- Henry Ford produces first Model-T car

- Paul Ehrlich prepares Salvarsan for cure of syphilis

- English aviator Henri Farman completes first 100-mile flight

- Fauves show as a group at Salon d'Automne, Paris

- Die Brücke founded— holds first group exhibition in Dresden

- Death of Paul Cézanne

- Edouard Manet's *Dejeuner sur l'Herbe* (rejected by the Paris Salon of 1863) goes on display at the Louvre

- Auguste Rodin's *The Thinker* installed outside the Pantheon, Paris

- Discovery of African art

- Henri Bergson publishes *Creative Evolution*

- Pablo Picasso, *Les Demoiselles d'Avignon*

- Gustave Klimt, *Danae*

- Henri Rousseau, *The Snake Charmer*

- Death of Paula Modersohn-Becker

- The term "cubism" coined by the critic Louis Vauxcelles, reviewing a show of Braque landscapes

- Exhibition of the Eight (the Ashcan School) at the Macbeth Galleries, New York

- Neue Künslervreinigung founded in Berlin. Similar group founded in Munich

- Publication of "Foundation and First Manifesto of Futurism" on front page of *Le Figaro*, 20 February

- Piet Mondrian, *The Red Tree*

The Greene brothers, Gamble House: see p.54

- Frank Lloyd Wright, Robie House, Oak Park, Chicago (–1909)

- Peter Behrens, Turbine Factory for AEG, Berlin (–1909)

- Bernard Maybeck, First Church of Christ Scientist, Berkeley, CA (–1911)

- Josef Hoffmann, Palais Stoclet, Brussels (–1910)

- McKim, Mead, and White, Pennsylvania Station, New York (–1919)

- Charles and Henry Greene, Gamble House, Pasadena (–1908)

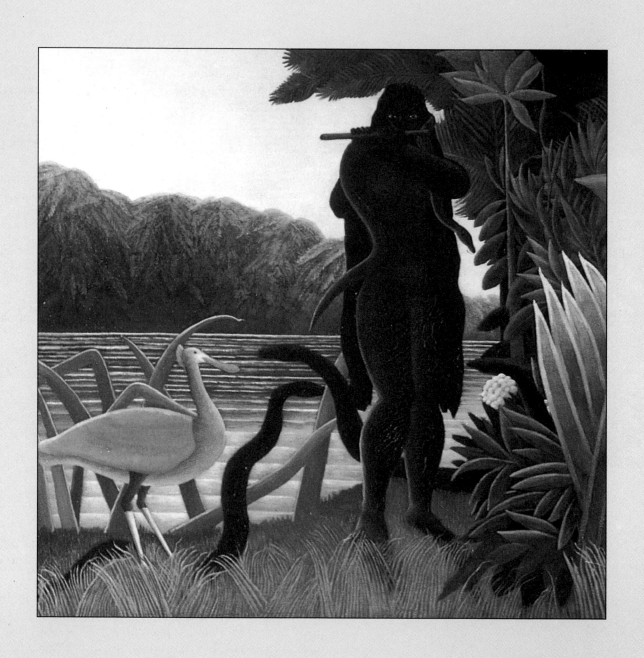

1900–1909

The first decade of the twentieth century witnessed the appearance of major artistic innovations. The intellectual and social background to these had nevertheless been created in the closing years of the nineteenth. There was, it is true, an increasing sense of unease—a feeling that there was, somewhere, a fatal flaw in the workings of European society. But people could not as yet put a finger on its precise location. In intellectual terms, the decade saw a falling off, rather than an increase, in creative energy. Philosophers and social scientists were busy absorbing the major ideas produced by their great predecessors, such as Hegel, Marx, and Nietzsche. Freud continued to pursue his revolutionary researches into the nature of the human psyche—the year 1904 saw the publication of *The Psychopathology of Everyday Life*. As yet, however, these researches were known to only a small elite circle, few members of which were closely affiliated to the contemporary arts scene.

A much more immediate impact was made by Henri Bergson's *Creative Evolution*, which appeared in 1907. Bergson (1851–1941) saw the life of the universe as a process of continuous creation, undetermined and therefore unpredictable, but still the work of some kind of divine consciousness (a belief which made him an opponent of strict nineteenth-century materialism of the kind espoused by Marx and Freud). He saw human history as being driven forward by what he called *"élan vital"* the "life drive," which, struggling against the resistance of matter, was responsible for producing higher and higher states of intelligence and creativity. This optimistic creed owed something to Nietzsche's advocacy of the Dionysiac element as a mainspring of human creativity, but placed the forces of ecstatic energy in a less threatening and, by implication, more easily controllable context. It is not surprising that Bergson's ideas appealed to many avant-garde artists. Stripped of his subtlety of expression, Bergsonian formulations became linked to an impatience with the refinement and preciosity of Symbolism, and then, in a more general way, to an impatience with what seemed the burdensome elaboration of Western civilization, of a kind already expressed in the later paintings of Gauguin.

TECHNOLOGICAL ADVANCES

The advances being made by Western technology, meanwhile, seemed to promise a drastic speeding-up of the pace of life. The innovation which drew most public attention, because it embodied a long-held human fantasy, was the conquest of flight. Men had been able to rise into the air using balloons since the eighteenth century. Now they learned how to guide lighter-than-air machines—the Zeppelin airship made its maiden flight in 1900—then, very shortly afterwards, how to make practicable heavier-than-air conveyances. The American brothers, Wilbur and Orville Wright, made the first airplane flight at Kittyhawk in 1903; and in 1909 the French aviator, Louis Blériot, successfully crossed the English Channel in his monoplane. Almost equally significant for the future were advances in communication. In 1901 the Italian inventor, Guglielmo Marconi, sent the first tele-

graphic radio message from Cornwall to Newfoundland; in 1904 photographic images were first transmitted telegraphically.

INTERNATIONAL TENSIONS

If these innovations were cause for optimism about the future, international politics darkened. Colonial and economic rivalries between the great powers became more acute. Two ominous events were the Russo-Japanese War of 1904–5, in which the Russian fleet and army were comprehensively humiliated by an Asiatic power which had remained isolated in a feudal time-warp until the middle of the nineteenth century, and the occupation of Bosnia-Herzegovina by the Austro-Hungarian Empire in 1908. The first of these events showed that the rapid Westernization and industrialization of Russia then taking place barely concealed deep political and economic malaise. Indeed, industrialization itself led to a proliferation of strikes in which the strikers learned of the weakness of the Tsarist government. The immediate aftermath was the abortive revolution of 1905. The second event was to lead directly to the outbreak of World War I in 1914—a catharsis which some members of the visual arts avant-garde already seemed to anticipate.

Architecture

ARCHITECTURE IN THE UNITED STATES

During the first decade of the new century, architecture mirrored the way in which American society was developing, perhaps in an even more complete and accurate way than it had previously. The contrasts between architectural styles were often striking, but the choices made by architects of very different backgrounds were all, in one way or another, related to a vision of what America was, or aspired to be. The historians of Modernism have not, on the whole, been kind to the grandiose Classical creations of the New York firm of McKim, Mead & White. Nevertheless, buildings like Pennsylvania Station in New York were eloquent of a certain vision of the nation (FIG. 2.1). This, and the other great railway

2.1 McKim, Mead & White, Pennsylvania Station, New York, 1906–19.

The grandiose Classical style of this building made no concessions to the new architecture coming out of Chicago, but it symbolized the growing economic and cultural self-confidence of the United States in the early decades of the twentieth century.

termini of the time, celebrated the way in which a vast continent had been bound together by the construction of the railroads. The monumental façade, stretching along Seventh Avenue for three complete blocks, featured thirty-two freestanding, unfluted Doric columns, each 68 feet (22m) in height. The main waiting-room was inspired by the great hall in the imperial Roman Baths of Caracalla, but was even larger. The glass roof which covered the concourse consisted of a series of intersecting trusses, more complex in form and far more elegant in effect than the train sheds devised in earlier years by engineers with no architectural training. The building was both a celebration of the romance of travel, and a paradigm of the rational orderliness which many Americans saw as the future of their society. Two decades earlier, Joseph Wells (1853–90), then McKim, Mead & White's chief designer, had spoken of his passion for Classical forms, which he admired for moral as well as purely practical reasons: "The classical ideal suggests clearness, simplicity, grandeur, and philosophical calm—consequently it delights my soul. The medieval ideal suggests superstition, ignorance, vulgarity, restlessness, cruelty and religion—all of which fill my soul with horror and loathing."[1] Pennsylvania Station was both a visible expression of that credo and a forceful statement about the nation's confidence in its future and its intention to rival the great civilizations of the past.

The Greene Brothers and Bernard Maybeck

On the other coast of America, in California, a very different kind of architecture was evolving. The houses built by the brothers, Charles Sumner Greene (1868–1957) and Henry Mather Greene (1870–1954), and the buildings of Bernard Maybeck (1862–1955), tend to strike present-day beholders as willfully idiosyncratic. Regularity and moderation are not part of their aesthetic. The paradox is that the Greenes and Maybeck were well acquainted with the academic Beaux-Arts tradition which stood behind the work of McKim, Mead & White. The Greene brothers, like Louis Sullivan before them, and for a somewhat longer period, studied at the Massachusetts Institute of Technology's School of Architecture; Maybeck attended the Ecole des Beaux-Arts in Paris. What drew their architecture into a different orbit was their immersion in the Arts and Crafts tradition—

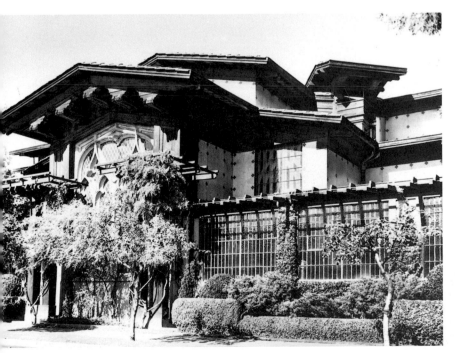

2.2 Bernard Maybeck, First Church of Christ Scientist, Berkeley, California, 1909–11.

This building is notable for its mixture of handcraftsmanship and industrial materials, thus bringing into play two of the most important strands of architecture inherited from the late nineteenth century.

Maybeck was the son of a professional woodcarver; the Greenes, before they went to M.I.T., studied at the Manual Training High School in St. Louis. Californian culture, with its strong emphasis on the crafts, drew from them a response which emphasized the craft elements in building, and the Greene brothers' artisan background ensured that they used these in a much more direct and personal way than, for example, Edwin Lutyens in England.

There were other important factors. Maybeck's best-known building, the First Church of Christ Scientist at Berkeley, California (FIG. 2.2), mixes what seem on the face of it to be incompatible materials—on the one hand carved wooden brackets and hand-made clay roof tiles; on the other metal factory windows and asbestos boarding. The *ad hoc* quality of the mixture was to resurface in the American architecture of the final decades of the century.

The Greene brothers were not afraid to min-

2.3 Charles & Henry Greene, Gamble House, Pasadena, California, 1907–8.

The building shows the influence of a number of cultures—Scandinavian, Tibetan, and Japanese—woven together in the "aesthetic style" that achieved great popularity in the United States through the Rookwood Pottery in Cincinnati and the glassware of Louis Comfort Tiffany.

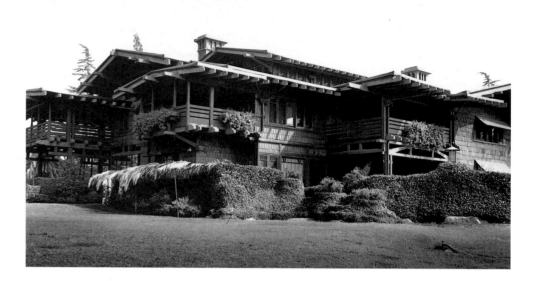

gle exotic with basic vernacular elements. Their Gamble House in Pasadena, an enlargement and elaboration of the typical suburban bungalows of the period, shows the influence of Scandinavian, Tibetan, and most of all Japanese architecture—the latter an acknowledgement not only of the influence of "japonisme" on the Arts and Crafts ethos, but of California's geographical position on the Pacific Rim (FIG. 2.3).

The Early Work of Frank Lloyd Wright

The most important American architect of the time was Frank Lloyd Wright (1867–1959). Wright began his career in the office of Louis Sullivan, with whom he worked until 1893, when he started his own practice. Wright's breakthrough into a completely personal style coincided with the beginning of the century. It announced itself in house plans designed for the *Ladies' Home Journal* in 1900 and 1901, and in a lecture, "The Art and Craft of the Machine," delivered in Chicago in 1901. In this Wright envisaged the city—specifically Chicago—as a giant machine rescued from the ravages of industrialization by the genius of architecture. Two major influences on the work which Wright now began to produce were Japanese architecture, which he used in a more organized fashion than the Greene Brothers, and the level landscape of the midwestern prairies. His interpretation of these influences was, of course, tempered by his immediate circumstances. Much of his early work, for example, was done in the Chicago suburb of Oak Park, Illinois. Wright's suburban houses, like the justly famous Robie House, extend outward into the landscape from a central core (FIG. 2.4). Their gridded plans are extensions in miniature of the complex grid-patterns of suburban streets, and they are anchored to their setting by boundary walls which extend beyond the main structure.

A portfolio of Wright's designs was published in Europe in 1910 by the German firm of Wasmuth, and had a considerable impact on progressive European architects. His immediate influence on his American contemporaries was less marked, not least because of his egotistical tendency to distance himself from other architects.

2.4 Frank Lloyd Wright, Robie House, Oak Park, Chicago, 1908 ↓.

This early masterpiece by Wright, in his so-called "Prairie" style, was influenced by the level lines of the midwestern landscape. The outward-pushing cantilevered roof (with internal steel beams) carries the internal living space directly on to the exterior terraces.

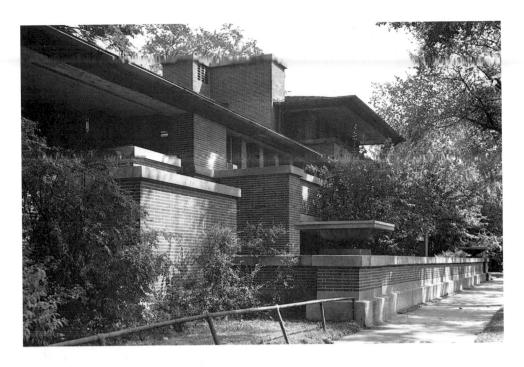

ARCHITECTURE IN EUROPE

Otto Wagner

The most significant European architecture of the first decade of the century was done, not in France, which maintained its primacy in painting and sculpture, but in Germany and Austria. Otto Wagner, the leading architect of the Viennese school, and a chief figure in the Vienna Secession (one of the earliest anti-academic art movements in Central Europe), built the Post Office Savings Bank in Vienna (FIG. 2.5) in 1904. The remarkable thing about this edifice was its combination of a slightly mannered, classicizing elegance of form and ornament with an unabashed use of industrial materials. The exterior was faced with thin sheets

2.5 Otto Wagner, Post Office Savings Bank, Vienna, 1904.

In this building, notable for its glass-vaulted banking hall, Wagner combined Classical forms with industrial materials and broke free of all Art Nouveau and other contemporary influences with astonishing originality.

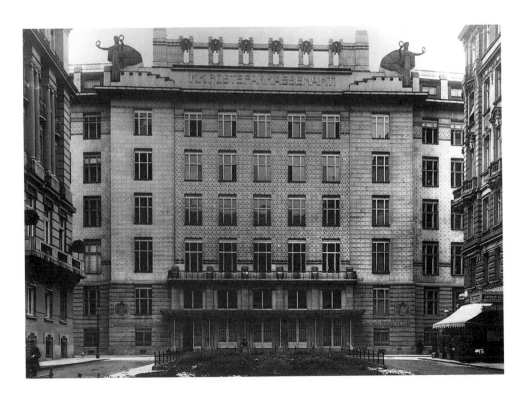

of white marble, anchored to the façade with aluminum rivets. The rest of the metal trim was also aluminum. In the main banking hall, the facing was ceramic, and much of the structure was exposed steel. Glass lenses were set into the concrete floor, to illuminate the space beneath. Yet the Post Office Savings Bank used Classical forms and made sparing use of Classical ornamentation. For example, the façade was ornamented with winged Victories, with arms raised toward the sky. Effectively, what Wagner did was to rework the Classical style inherited from the great nineteenth-century German architect, Karl Friedrich Schinkel (1781–1841). Schinkel's simplicity of form was drastically changed by stripping away its plasticity and in the process its play of light and shade. What Schinkel rendered in terms of volume, Wagner expressed by means of lines inscribed on a flat surface.

Josef Hoffman

A similar linear quality can be found in the work of one of Wagner's pupils, Josef Hoffman (1870–1956). Hoffman's best-known building, the sumptuous Palais Stoclet in Brussels (FIG. 2.6), also makes use of a thin white marble facing held in place by metal seams. Unlike most structures of its size, it seems intent on concealing its structure and mass. The walls appear to be thin sheets stretched tight between equally thin metal bands, and it is difficult to form any idea of the building's actual scale. It has often been compared to an immensely enlarged jewel box. In view of the celebrated and eclectic accumulation of art works it once contained, it seems likely that this effect was deliberately calculated.

2.6 Josef Hoffman, Palais Stoclet, Brussels, 1905–10.

Hoffman's design for this elegant jewel-box of a house retains Art Nouveau vestiges, but it is interesting for the overall "geometric" feel given to it by the unadorned and boldly trimmed exterior walls. The car port and the dramatic stair tower contribute to its audacious asymmetry, itself thoroughly in tune with Hoffman's ambition, through his craft association, the Wiener Werkstätte, to confront the conservatism of Austrian and German art and architecture.

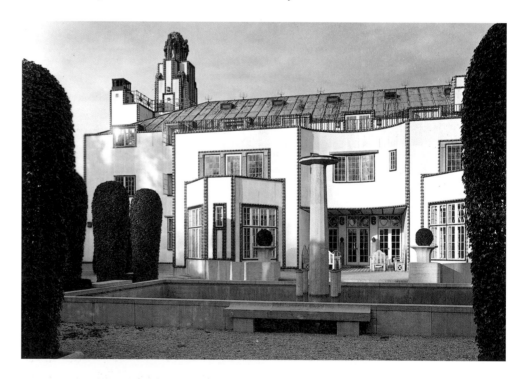

Peter Behrens and AEG

In 1907 the German architect, Peter Behrens (1868–1940), was appointed architect and designer to the great German electrical firm, AEG (Allgemeine Elektricitäts Gesellchaft), which had been founded in 1883. This appointment was a symbol of Germany's determination to raise the quality of her industrial production as a way of competing with foreign nations, especially Great Britain. It was one of Behrens's qualifications that he was closely associated with the men who had come together to found the *Deutsche Werkbund* ("German Work Federation") in

Peter Behrens: *The Turbine Factory*

For Peter Behrens, the rapid rise of German industry during the first decade of the century was part of the new German Empire's manifest destiny. Unlike nineteenth-century industrial buildings, which were the work of engineers rather than architects, and completely neutral in their attitude to industry, the Turbine factory in Berlin that he designed for AEG (FIG. 2.7) makes a sophisticated statement about the nature of industrial production and its place in modern life. Interestingly, the building's basic metaphor is a traditional one—that of a great barn, where the harvest is gathered safely in. It is stated most clearly in the faceted gable roof.

The rest of the structure is a deliberate play of contradictions. The massive corner elements are treated in a way which makes it plain that they have no load-bearing function. The roof is held up by the light steel frames in the center of the facade and running along each side.

Glazed, these admit a flood of light, necessary for efficient operations within. By these simple means Behrens suggests that the building is concerned chiefly with immensely powerful, but essentially invisible, energies.

The Turbine Hall was a building of great significance because it represented a first step in an intellectualizing process which was to bring industry and the avant-garde arts closer and closer together during the opening decades of the century. it is therefore in a sense ironic that it was a European rather than an American product, since American culture was to be the chief beneficiary in the long run (and also perhaps the chief victim) of inexorable industrial advances.

Yet the intellectualization it represents was also to be more characteristic of the European than the American contribution to architecture, certainly during the first half of the century. American architects,

even Frank Lloyd Wright, built to solve immediate, tangible problems. European architects were always more concerned with theory, though they were frequently denied the opportunity to build what they imagined.

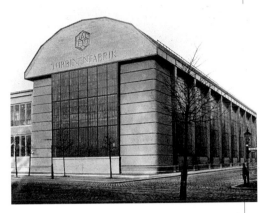

2.7 Peter Behrens, Turbine Factory, Berlin, 1908–9.

the same year. A late offshoot of the Arts and Crafts Movement, the *Werkbund* had as its avowed aim to raise the quality of the applied arts in Germany. Its members accepted that they would have to cooperate with industry in order to do this, rather than bear the hostility toward it displayed by many English and American disciples of William Morris. Behrens's best-known industrial building, the Turbine Factory (see FIG. 2.7) he built for AEG in Berlin, was a direct expression of his belief that the rapid rise of German industry during the first decade of the century was evidence of the new German Empire's manifest destiny.

Painting

PAINTING IN EUROPE

The Survival of Art Nouveau: Gustav Klimt

It is a temptation to see 1900 as a turning-point—as marking an immediate cultural break. In fact this is far from being the case. In the opening years of the new century the most significant new painting and sculpture had strong links to the Symbolist ethos which had dominated the closing decades of its predecessor. Innovative artists continued to look at Symbolist sources for inspiration. Despite the decadence of its political institutions, Vienna, the capital of the Austro-Hungarian Empire, remained a center for innovation in all the arts—literature, music, and architecture. In painting, the dominant figure was Gustav Klimt (1862–1918). Klimt began his career as a well-regarded "official" artist, the des-

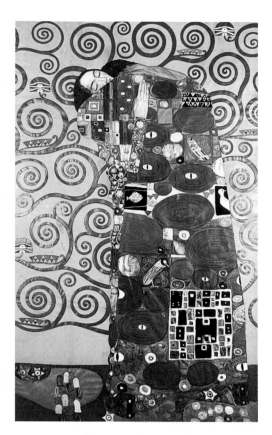

2.8 Gustav Klimt, *The Kiss*, 1909. Watercolor gouache on paper on wood, 6 ft 3⅝ in x 3 ft 10½ in (1.92 x 1.18 m). Musée d'Art Moderne, Strasbourg, France.

Art Nouveau eroticism is here linked with an impulse toward abstraction, a direction pointed to in this and others of Klimt's paintings by his handling of patterns. Along with Egon Schiele, Klimt was a forceful opponent of the academic conservatism prevalent in established Viennese art circles.

tined successor to the hugely successful and wholly conventional Hans Makart (1840–84). But he fell out with the authorities over his paintings for the Great Hall of the new Vienna University.

The quarrel about these, especially about their unsuitably erotic content, opened the door to Klimt's exit from an official career. In 1897 he was a founder-member of the Vienna Secession, originally intended simply as a ginger group within a long-established exhibiting society, the Genossenschaftbildener Künstler Wiens. In 1898 the Secession became an independent group of progressive artists, one of the first of its kind in Europe. The Secession proved too confining for Klimt, who resigned in 1903, and helped to found a new group, the Kunstschau Wien.

The work which Klimt produced from around 1900 onward has been described by a hostile critic as "positively grotesque." "Drawing upon the late period of English Pre-Raphaelitism, Jan Toorop's Belgian Symbolism, Mackintosh's Glasgow decorative style, and the Munich Jugendstil, he superimposed pompous decorative effects on the Classical decorative style."[2] This is harsh, but it focuses on the fact that the novelty of Klimt's work consisted in the free amalgamation of pre-existing stylistic elements. While it is the eroticism of his work that has tended to fascinate recent commentators (many have seen in this element a parallel with the work of Klimt's Viennese contemporary, Sigmund Freud), its most striking aspects are its emphasis on decoration (and thus on the stylistic language, not on the actual content) and its approach to a kind of abstraction. A painting like *The Kiss* is difficult to construe, because it puts so much emphasis on the rhythm of outlines and forms, rather than on what these are actually meant to represent (FIG. 2.8). In following this path, Klimt was in tune with the aspect of Art Nouveau which stressed the idea that the visual arts should abandon their separate identities and form a synthesis. Klimt's isolation from the main avant-garde currents in the painting of his time stands in contrast to his strong links to the most progressive aspects of early twentieth-century architecture and design.

Picasso: The Blue Period

Another artist who manifested a continuing preoccupation with Symbolism was Pablo Picasso (1881–1973). Picasso received his artistic education in Barcelona, and spent the opening years of the century shuttling between that city and Paris, where he was finally to settle for good in 1904. The artistic milieu which he frequented in Barcelona, then one of the most progressive cities in Europe, was heavily permeated with Symbolist ideas, and artists such as Toulouse-Lautrec and Gauguin were among those who most appealed to him. He combined their influence with that of Spanish masters such as Luis de Morales (c. 1509–c. 1586) and El Greco (1541–1614) to create his first fully independent style, that of the "Blue Period". The culminating work of this phase was the large allegorical composition, *La Vie* (see FIG. 2.9).

Henri Rousseau, called Le Douanier

One of Picasso's associates during his earliest years in Paris was the self-taught painter, Henri Rousseau (1844–1910), who had until his retirement worked as a minor functionary in the French customs and excise system. Rousseau was by no means a newcomer. He owed his entry into the art world to his friendship with a number of official Salon artists, including Albert Dubois-Pillet (1845–90), who recruited him for the new Salon des Indépendants. He showed first at the second Salon, in 1886, and regularly thereafter. Throughout these early years his work was treated with a surprising amount of critical respect, given his completely untutored status. After the turn of the century Rousseau became something of a cult figure with the new avant-garde, and at the same time attracted increasing

Pablo Picasso: *La Vie*

The crowning work of Picasso's so-called "Blue Period" (the artist's earliest mature style, named for the pervasive blue tone which fills the compositions), is the large allegorical composition, *La Vie* ("The Life") (FIG. 2.9).

Painted in Barcelona in 1903, it shows the mournful, emaciated figures and almost monochromatic color-scale which were at that time characteristic of his work. Picasso drew on a wide variety of sources in creating this painting and others related to it. He was, for example, influenced by the work of El Greco (1541–1614), and also, perhaps, by that of the English Pre-Raphaelite, Edward Burne-Jones (1861–1926), which was well known in artistic circles in Barcelona at this time. *La Vie* is, however, more complex than other works of the same period, even though, at first sight, it simply looks like a group of figures in the studio, with a couple of unframed paintings tacked up on the wall behind them. There is a hidden autobiographical element—the male figure on the left is a portrait of the artist's Catalan friend, Carlos Casemegas, who had killed himself in Paris two years previously, an event which disturbed Picasso greatly and for which he seems to have felt partly responsible. Casamegas's suicide was triggered by sexual impotence,

so that the context in which Picasso placed him—clinging to a young woman and pointing to a mother holding a baby—was especially poignant. It is a

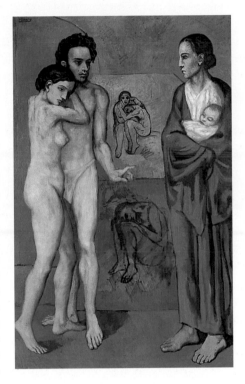

2.9 Pablo Picasso, *La Vie*, 1903. Oil on canvas, 6 ft 5⅜ in x 4 ft 2⅞ in (1.97 x 1.29 m) Cleveland Museum of Art, Ohio.

savage touch of irony that the mother-figure was almost certainly inspired by the prostitutes imprisoned with their infants whom Picasso drew in the Paris prison of Saint-Lazare. Even the two paintings on the wall contribute to the overall theme: the upper one shows a pair of lovers, the lower a figure apparently plunged in deep despair. In addition to the purely personal elements there are borrowings from the occultism fashionable in Symbolist circles at the time. The pointing gesture made by the male figure has been traced to a knowledge of the Tarot, which Picasso most likely gained from another close friend, the French poet, Max Jacob.

The overall effect of the work is entirely Symbolist: it hints at deep mysteries, but does not allow any straightforward explanation. Like many such works touched by the Symbolist movement, it has a moralistic, even political, aspect. it seems to side with the poor and underprivileged, so that there is a social message as well as a purely artistic one. This was something which the new art would rapidly leave behind, in favor of explorations which were for the most part purely stylistic. Picasso was not to return to politics until the creation of *Guernica* (see FIG. 5.22).

mockery from conservative critics. Amongst his supporters were Picasso and the poet and critic, Guillaume Apollinaire (1880–1918), who were largely responsible for organizing a banquet in his honor in 1908, a burlesque occasion with an undercurrent of seriousness which was long remembered as one of the first occasions on which the new Modernist avant-garde asserted its identity as an important cultural phenomenon.

Though Rousseau fits uneasily into the catalogue of styles which is the usual way of organizing the history of early Modernism, he is important for several reasons. One is that the recognition accorded to his work, though sometimes mocking and ironic, marked an increasing acceptance of the idea that an artist could, so to speak, be made entirely by nature. Even Gauguin, though a late starter in art, apprenticed himself to an existing tradition, and painted pictures in an Impressionist style before arriving at his own manner, in which the "primitive" element was something deliberately assumed. Secondly, though Rousseau might have denied this, what he painted belonged largely to an imaginary realm, with little reference to reality. This is especially true of his magnificent jungle scenes

2.10 Henri Rousseau, *The Snake Charmer*, 1907. Oil on canvas, 5 ft 6½ in x 6 ft 2⅝ in (1.69 x 1.90 m). Musée d'Orsay, Paris.

Rousseau, though often cited as a "primitive" painter because of his total lack of artistic education, was a gifted inventor of concise symbolic forms, which are more convincing and authoritative than naturalistic representations of the same objects. His imaginative scenes, often dream-like, emerge from his subconscious in a manner that foreshadows Surrealism.

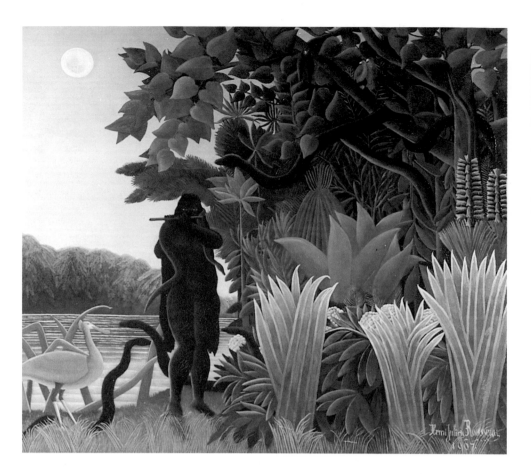

(FIG. 2.10). Rousseau sometimes claimed to have fought as a French soldier in Mexico, during the Emperor Napoleon III's ill-fated attempt to establish the Austrian Archduke Maximilian there as Emperor. In fact he never left France. He got much of his imagery from visits to the Jardin des Plantes in Paris. Thirdly, and most important, he was perhaps the first Western artist since the Renaissance to reduce external reality to a series of conceptual signs. Each element in his paintings is essentially an emblem rather than a representation. Critics have rightly seen a resemblance to some of the simplifications used by Seurat in *La Grande Jatte* (see FIG. 1.11), but Rousseau, because of his total lack of academic skills, simplifies in a much more radical way. The recognition accorded to Rousseau was a sign of a fundamental change in attitudes to the visual arts and the way in which they functioned. In particular it laid an axe to the roots of the notion that artists, whatever their quirks, were essentially bourgeois professionals.

The Fauves

The appearance of a new climate in art was not, however, announced by Rousseau, but by a group of younger artists, the Fauves, who made a sensational joint appearance in the Salon d'Automne of 1905. They owed their name to a quip made by the critic, Louis Vauxcelles, who was amused by the fact that their paintings were hung in a room which also contained a rather bland sculpture in the neo-Renaissance style. "Donatello among the wild beasts" (in French, *fauves*) was his verdict.

Fauvism, generally reckoned as the first major avant-garde style of the twentieth century, was also a very brief phenomenon. It occupied only the period from 1904 to 1907, and after that was a completely spent force, with the various participants going their separate ways.

In keeping with their self-adopted stance as rebels the Fauves saw themselves

2.11 André Derain, *The Pool of London*, 1906. Oil on canvas, 25⅞ x 39 in (65.7 x 99 cm). Tate Gallery, London.

The young Derain here tackled a subject that had already attracted the great Impressionist, Claude Monet. But whereas the Impressionists liked to harmonize hues, the Fauves sought the clash of vibrant colors, liberated from mere representational purpose, in what Derain called "deliberate disharmonies."

2.12 Maurice de Vlaminck, *House at Chatou*, 1903. Oil on canvas, 31⅞ x 39⅜ in (81.9 x 100.3 cm). Art Institute of Chicago, Illinois.

This is a typical canvas from the artist's Fauvist phase, its vibrating quality achieved by a mixture of short, choppy strokes and more bricklike ones, in the neo-Impressionist manner.

as anti-clerical, anti-militarist, anti-conformist, but not necessarily as "leftist" in the sense in which we would now use the term. Maurice de Vlaminck (1876–1958) and his close friend, André Derain (1880–1954), in particular sometimes used an anarchist vocabulary when talking about their art. Derain spoke of colors as "sticks of dynamite." Both artists were participants in the cult of Nietzsche, who became widely known in France after 1900, when his sister started posthumously to publish his work. Nietzsche speaks, in *Thus Spake Zarathustra*, of "a taste, a new appetite, a new gift for seeing colors, of hearing sounds, of experiencing emotions that had hitherto neither been seen, heard or felt." Bergson, also much discussed at this time, considered artists to be visionaries, lyricists able to reveal the true reality beneath the surface. It is not surprising that the young experimental artists of the period accepted this flattering identification. Though their work still took hints from the Impressionist movement, they saw themselves as opposed to its naturalist and momentary approach to the physical world.

The most radical achievement of the Fauves was not their violent unnatural color schemes (though this was the aspect of their work which caught the attention of both critics and the public) but their destruction of the traditional concept of space. This is clearly visible in Derain's views of London (FIG. 2.11), deliberately intended to rival Monet's depictions of the same city, and Vlaminck's landscapes painted at Chatou in the suburbs of Paris (FIG. 2.12), which were influenced by Van Gogh. The color patches, often interspersed with patches of bare canvas (a technique borrowed from Cézanne), no longer make any attempt to construct the box-like picture-space required by traditional perspective systems.

Yet there was also something deeply conservative about the Fauves. Their instincts were cool and systematic even if their paintings seemed violent. Maurice Denis (1870–1945), a leading member of the Nabis and an acute critic, once said to Henri Matisse (1869–1964),

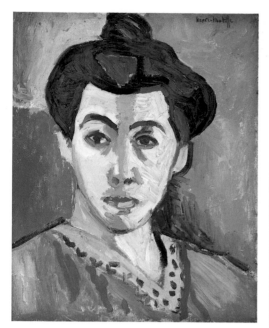

2.13 (*above*) Henri Matisse, *Portrait of Madame Matisse*, 1905. Oil and tempera on canvas, 16 x 12¾ in (40.5 x 32.5 cm). National Museum of Art, Copenhagen.

Shown at the Salon d'Automne of 1905, this portrait became notorious for the bright green streak on the sitter's face. "A work of art," Matisse wrote in 1908, "must carry in itself its complete significance and impose itself upon the beholder even before he can identify the subject matter." That was one of the first overt claims that an artist's responsibility is only to himself and that he is bound by no rules in seeking to express himself.

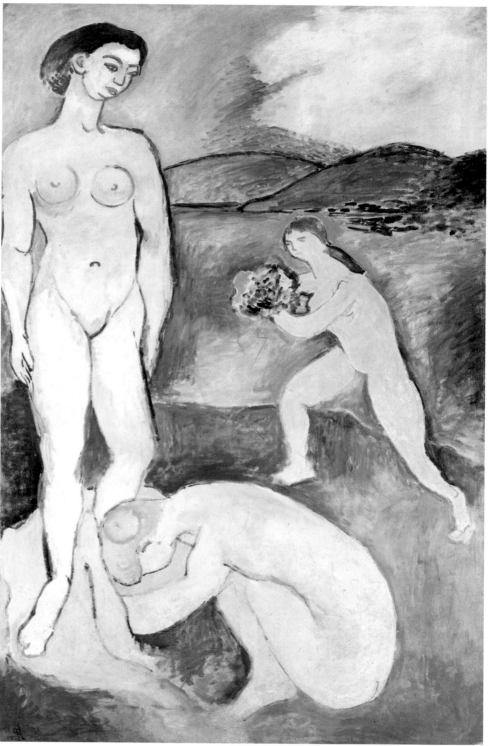

the acknowledged leader of the Fauves: "You are never satisfied until every feature of your work is intelligible. Nothing must remain conditioned or accidental in your universe."[3]

Henri Matisse

Matisse's personal progression is extremely significant in this respect. The works he showed in the Salon d'Automne of 1905, such as the portrait of Madame Matisse with a green streak down her face (FIG. 2.13), were mainly intended to show the possibilities of the new method of pictorial construction by means of

2.14 (*opposite*) Henri Matisse, *Le Luxe I*, 1907. Oil on canvas, 6 ft 10⅜ in x 4 ft 6⅜ in (2.1 x 1.38 m). Musée National d'Art Moderne, Paris.

This vision of an idyllic world demonstrates the link between Gauguin and Matisse and, in its reliance on careful line drawing, shows Matisse to be leaving Fauvism behind.

2.15 Georges Braque, *Houses at l'Estaque*, 1908. Oil on canvas, 28¾ in x 23⅜ in (73 x 59.5 cm). Museum of Art, Berne.

The cubelike architectural forms in this and other paintings by Braque of the same date inspired the label "Cubist." Here Braque opens the volumes of the buildings, and pushes them upward along the picture plane, rather than allowing them to recede into a semblance of distance.

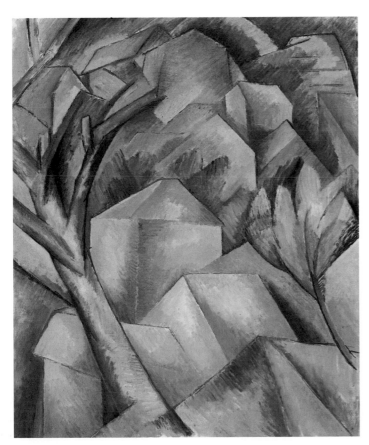

color. By 1907, with painting such as *Le Luxe I* (FIG. 2.14), he had moved toward the creation of an idealized, heavily stylized Mediterranean world, taking hints from the work of Gauguin and also from that of the leading Symbolist painter, Pierre Puvis de Chavannes (1824–98). His creation of this world can be seen as a reassertion of traditional cultural values.

Matisse was the only member of the group whose work continued to develop throughout a long career. With the others, such as Vlaminck and Derain, one gets the feeling that they soon lost direction because they became frightened by the consequences of their own daring. Nevertheless, the appearance of Fauvism was an important breakthrough, as Matisse himself remarked: "Fauve painting isn't everything, but it is the foundation of everything."[4]

Cubism

Cubism, the next development in avant-garde art, in some respects seemed to continue the dialogue begun by the Fauves and in some respects seemed to contradict it. Fauvism and Cubism were alike in one fundamental respect: each attempted to replace conceptual by perceptual reality, but the Cubists tried to do so in a much more systematic fashion. The two pioneers were Picasso and Georges Braque (1882–1963), who had originally been a junior member of the Fauve group.

Like Fauvism, Cubism began as a mixture of preexisting elements. Fauvism had been a synthesis of Impressionism, the divisionism of Seurat, the decorative rhythms of Gauguin, and the proto-Expressionism of Van Gogh. The chief influences on Cubism were Cézanne (a major retrospective was held at the Salon d'Automne in 1907) and tribal sculpture, particularly African. From these elements, however, Picasso and Braque created something much more completely self-contained than Fauvism—an entirely new pictorial language. The result has been described as "perhaps the most important and certainly the most complete and radical artistic revolution since the Renaissance."[5] The first fully Cubist paintings were produced in the summer of 1908 by Braque at l'Estaque (FIG. 2.15). They were rejected by the Salon d'Automne and exhibited that November at the private gallery of Daniel-Henri Kahnweiler (1884–1976), the progressive German-born dealer who was to be one of the chief supporters of the new school. The name of the movement was once again coined by Vauxcelles, who referred to "cubes" in his brief review of the Braque show, and then, in a later article, to what he called "bizarreries cubiques."

Because of their landscape subject-matter, Braque's paintings were comparatively simple. The way forward was shown as much by African sculpture as it was by anything in European art. The discovery of tribal art (which had already begun to interest Fauves such as Matisse and Derain) was especially important to Picasso. As the poet and critic, André Salmon, said, Picasso "was struck by the fact that Negro artists had attempted to make a true representation of a human being, and not just present the idea, usually sentimental, that we have of him."[6] He worked on his reactions to this fact in a major painting, *Les Demoiselles d'Avignon*. While not yet fully Cubist, in the sense that

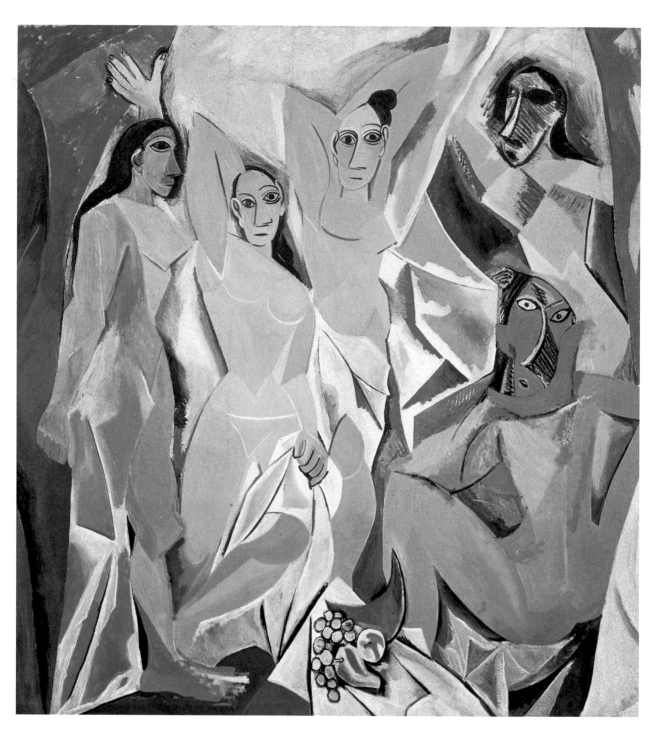

2.16 (*above*) Pablo Picasso, *Les Demoiselles d'Avignon*, 1907. Oil on canvas, 8 ft ½ in x 7 ft 6½ in (2.45 x 2.3 m). Museum of Modern Art, New York.

Jokingly named for a low-class brothel in the Calle d'Avignon in Barcelona, this painting, one of the most influential in the genesis of Modernism, plays havoc with traditional depictions of the female nude. The scarred mask-like faces of the two figures on the right show the impact made on Picasso by African art.

2.17 (*opposite above*) Georges Braque, *Violin and Jug*, 1910. Oil on canvas, 46 x 29 in (117 x 73.5 cm). Kunstmuseum Basel, Switzerland.

The objects presented in this painting appear to have been viewed from several different angles, a characteristic effect of the Cubist breaking-down of forms.

2.18 (*opposite*) Paula Modersohn-Becker, *Self-portrait on her Sixth Wedding Day*, 1906. Oil on board, 40 x 27⅝ in (101.5 x 70.2 cm). Ludwig-Roselius Collection, Bremen, Germany.

In its sensuous exploration of feeling, this painting fulfills the criterion laid down in the manifesto of the Die Brücke group (though she was never a member) that anyone who "renders inner convictions ... with spontaneity and sincerity is one of us."

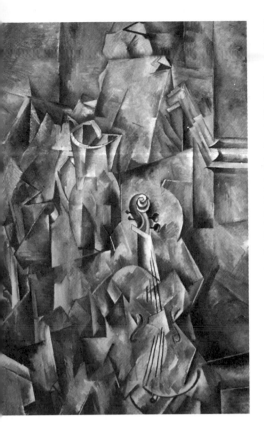

Braque's landscapes are, this represented a violent revolt against the traditional treatment of form (FIG. 2.16).

Because Cubism was such a novel, and ultimately very complex, visual language, the tendency was to perceive Cubist pictures as a move away from reality. Guillaume Apollinaire, one of the chief journalistic supporters of the new style, saw complete abstraction as the goal of Cubist art.[7] Yet the opposite was the case. The early Cubism, sometime called Analytical Cubism, of Braque and Picasso was an attempt to render reality more completely than it had ever been rendered before. The spectator was to be offered the sensation of actually walking round a person or a group of objects, of seeing them in all their aspects. Braque's monumental still life, *Violin and Jug* (FIG. 2.17), which dates from 1910, is a good example. It also illustrates how Cubist painting introduced an element of time. The spectator does not see what is depicted in a single all-comprehensive glance, but apprehends what is there piece by piece, looking at it from different points of view, at slightly different moments.

In order to achieve this extremely penetrating and detailed presentation of form the Cubists had to make certain sacrifices. One was an immediately comprehensible image. Another was complex subject-matter—the subject in a Cubist painting is really completely unimportant, the way of presenting it being what counts. In a Cubist portrait, for instance, little or no comment is made about the personality of the sitter. The third and most conspicuous sacrifice is color. In contrast to the intense chromatic brilliance of Fauve paintings, early Cubist ones tend to be almost monochromatic.

Paula Modersohn-Becker

In the first decade of the century Germany was a place of curious contrasts. On the one hand, it offered a stuffily bourgeois and philistine society, heavily under the influence of nationalist ideas inherited from Bismarck, who had been dismissed from his post as German Chancellor in 1890. On the other hand, it was a center for innovation, scientific, technical, and artistic. Innovation in the visual arts often received a warmer welcome in the great German cities than in Paris.

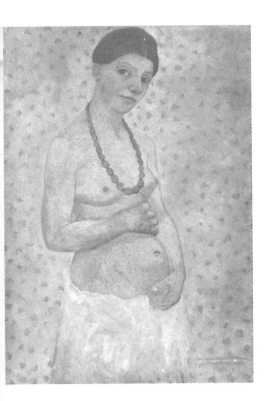

The first German artist who was fully in tune with the new artistic currents of the time was a woman, the tragically short-lived Paula Modersohn-Becker (1876–1907). Her work was prophetic of what was to come later because, as she said of herself, "the principal thing is my personal feeling." Modersohn-Becker, married to another painter, Otto Modersohn, escaped from the slightly stifling atmosphere of the rural artists' colony at Worpswede, near Bremen, where her husband lived and worked, and spent increasing amounts of time on her own in Paris. She was aware of and was influenced by all the great figures of the immediately previous generation—Van Gogh, Gauguin, and, perhaps above all, Cézanne, whom she called "one of three of four forces in painting that have affected me like a thunderstorm."[8] From these exemplars she forged a uniquely personal art, deeply concerned with the ideas of motherhood and female destiny. One of her most remarkable paintings is a self-portrait in which she is shown heavily pregnant (FIG. 2.18). It was painted before the pregnancy which put an end to her life had actually declared itself.

Throughout her brief career, Modersohn-Becker was bitterly aware of the misogynistic climate which hampered the efforts of any woman artist. In a letter from Paris, she wryly tells a story about her experiences at the Académie Julian, the "free academy," which she frequented with a number of other women painters less ambitious than herself: "A Russian asked me if I really see things the way I paint them, and who taught me. I lied and said proudly, 'Mon mari.' 'Oh, you paint the way your husband paints.' That you paint the way you see things

yourself, that they would never assume."[9] The misogyny with which she had to contend was deeply rooted not merely in the general society of the time, but in the artistic avant-garde itself. Many of the thinkers who exercised most influence over the experimental artists of the period, Nietzsche among them, were outspokenly antagonistic toward the idea of female creativity. Artistic experiment was identified as a masculine privilege. Remarkable as Modersohn-Becker was, her gender alone was enough to prevent her from being the founder or leader of a new school of German artists.

Die Brücke

The first German avant–garde group of the new century, Die Brücke ("The Bridge"), was therefore an entirely masculine affair. It has sometimes been seen simply as a German extension of French Fauvism. However, the group, which came together in Dresden in 1905, seems at its beginnings to have had little direct knowledge of what was taking place in France, and resemblance between the work of its members and that of the Fauves seems to have been largely coincidental. More immediate influences on their art were Van Gogh, Edvard Munch, German Gothic art, especially the bold, crude woodcuts made by the printmakers of the late fifteenth century, and the collection of African wood carvings in the

2.19 (below) Edvard Munch, *The Scream*, 1895. Lithograph, 20 x 15 in (50.8 x 38.1 cm). Art Institute of Chicago, Illinois.

This celebrated painting anticipates the fully developed Expressionism of ten and more years later. The suppressed details of the face and landscape, which heighten the bleak terror of the message, are characteristic of much of Munch's work.

2.20 (right) Ernst Kirchner, *Girl Under a Japanese Sunshade*, c. 1909. Oil on canvas, 36⅜ x 31¾ in (92.5 x 80.5 cm). Kunstsammlung Nordrhein Westfalen, Düsseldorf, Germany.

A subject that would have appealed to the Impressionists is here treated in a very different spirit. The figurative elements are pushed flat against the picture plane, creating patterns of splashed Fauvist color.

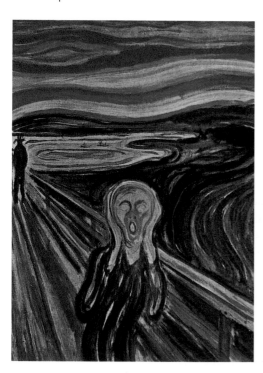

2.21 Emil Nolde, *The Last Supper*, 1909. Oil on canvas, 33⅞ x 42⅛ in (86 x 107 cm). National Museum of Art, Copenhagen.

This early example of Nolde's visionary religious paintings has an intense, personal drama far removed from the calm of most Renaissance treatments of the subject. The compression of the figures, squashed against themselves and against the picture plane, heightens the intensity.

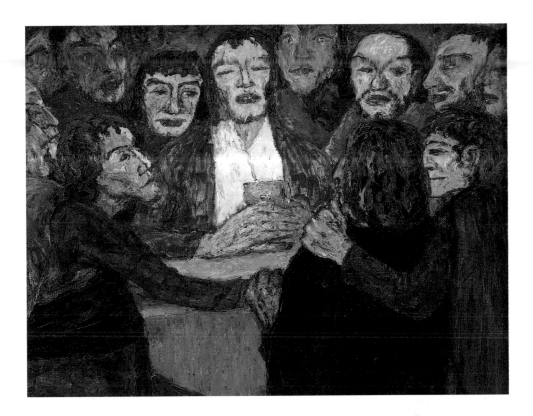

ethnographic department of Dresden's Zwinger Museum. That is, they combined influences which had had an impact on the Fauves with others which now seem more typical of Cubism. In addition, the Expressionists, as they came to be called (the precise origin of the term is uncertain), were very much the heirs of late-eighteenth and early-nineteenth century Romanticism. They shared with the German Romantics of that epoch a taste for emotional excess, and their art expressed emotion through bold and dramatic gestures. Their near-contemporary, Munch, whose influence was much stronger in Germany than it ever was in France, also encouraged them to think that art could go to hitherto undreamed-of extremes of subjectivity in its pursuit of emotional truth (FIG. 2.19).

Die Brücke, as a result, has sometimes been described as "a group without a style."[10] Its members were interested in their own psychology, not in the invention of a coherent and logical visual language—the enterprise which preoccupied Matisse, followed by his successors and rivals, the Cubists. One theme in early Expressionist art is a frantic eroticism, of the kind to be found in *Girl Under a Japanese Sunshade* (FIG. 2.20) by the young Ernst Ludwig Kirchner (1880–1938). He refers to this not only in the nudity of the model herself (the female nude was, after all, a traditional theme in Western art), but in the sexual antics of the small figures who decorate the screen behind her. Another is a search for truth at the expense of what might be considered dignified, or traditionally appropriate. Emil Nolde (Emil Hansen, 1867–1956), who painted a number of powerful biblical scenes at this time, among them *The Last Supper* (FIG. 2.21), deliberately stresses the Jewish physiognomy of his New Testament figures. Whereas French Fauvism, for all its violence of color, has at its center a kind of detachment, with an accompanying emotional coldness, the German artists of the period remained wedded to the idea that subject-matter was significant in itself.

The Russian Avant-garde

During the years immediately preceding World War I, Russia, despite its recent humiliating defeat at the hands of the Japanese, experienced a continuing indus-

2.22 Pavel Kusnetsov, *Evening on the Steppe*, 1908. Tempera on canvas with pastels, 29⅞ in x 31½ in (76 x 80 cm). Russian Museum, St Petersburg.

2.23 (*below*) Natalia Goncharova, *Gardening*, 1908. Oil on canvas, 3 ft 4½ in x 4 ft ⅜ in (1.03 x 1.23 m). Tate Gallery, London.

This garden scene shows Goncharova's debt to Russian folk art. It also demonstrates her superb decorative gift, which made her one of the most successful designers for Sergei Diaghilev's innovative *Ballet Russes*, which had a major impact on fashion and interior design in the years just before World War I.

trial boom, largely based on the construction of railways. This produced a new class of wealthy collectors, forward-looking plutocrats rather than conservative aristocrats. The two most important were merchant-princes of Moscow, Sergei Shchukin and Ivan Morosov. Shchukin and Morosov were enthusiastic collectors of the new French art, especially Matisse, and Shchukin also built up an important group of Picassos, making his first purchases in 1908.

Both of these major collections of new French art were made accessible to Russian artists—Shchukin opened his house to the public on Saturday afternoons—and young painters were not slow to make use of the opportunity offered them. Moscow rather than St. Petersburg became the focus for a new generation of Russian painters. The transition was marked by the foundation of the "Blue Rose" group in December, 1906. A leading figure in this was Pavel Kusnetsov (1878–1968). Kusnetsov's *Evening on the Steppe* is indicative of the period when the dreamy Symbolism which had till then been dominant in Russian painting gave way to something more earthy and direct (FIG. 2.22). Kusnetsov and his peers were soon challenged by a generation not much younger than themselves, led by Mikhail Larionov (1881–1964) and Natalia Goncharova (1881–1962). Both Larionov and Goncharova were influenced by Russian popular prints, or *lubok*—religious images, and illustrations to popular songs. Admiration for these was part of the surge of nationalism in Russia after the defeat by Japan. Another influence, particularly on Goncharova, was the conceptual abstraction of Russian icon painting (FIG. 2.23). There was also, however, a healthy measure of rebellion, a kind of deliberate "rudeness" (as Camilla Gray calls it) in the work of the Russian avant-garde. This reaction against convention and bourgeois hypocrisy is especially evident in Larionov's *Soldier* sequence (FIG. 2.24), which features scribbled, bawdy remarks on the canvas and a gleeful use of caricature.

2.24 Mikhail Larionov, *Soldier on a Horse*, c. 1911. Oil on canvas, 34¼ x 39 in (87 x 99.1 cm). Tate Gallery, London.

Larionov's "Soldier" paintings, with their scribbled lettering, have a deliberate roughness and bawdiness.

2.25 (*above*) Robert Henri, *John Sloan*, 1904. Oil on canvas, 4 ft 8¾ in x 3 ft 5 in (1.44 x 1.04 m). Corcoran Gallery, Washington, D.C.

In the portraits that he painted very early in the century, Henri experimented with modern "European" brushwork techniques, though his general aim was to find a new form of "democratic" art that would capture the experience of ordinary American life.

2.26 (*right*) John Sloan, *Hairdresser's Window*, 1907. Oil on canvas, 31⅞ x 26 in (80.9 x 66 cm). Wadsworth Atheneum, Hartford, Connecticut (Ella Gallup Sumner & Mary Catlin Sumner Collection Fund).

The good-humor and optimism of this vignette of New York street life is typical of the best of Sloan. The informal poses of the figures show the influence of his work as a newspaper illustrator.

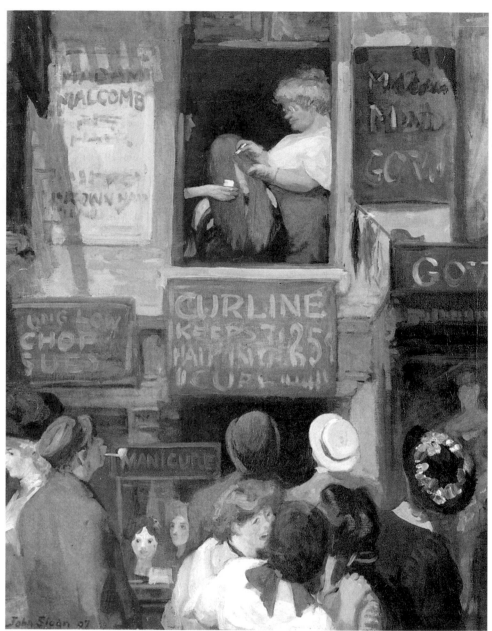

PAINTING IN THE UNITED STATES

The Ashcan School

The American art of the earliest years of the century was much more conservative than what was being produced in Europe. In some ways the situation of American painters was comparable to that of the Russians. They too were trying to express a new sense of national identity. However, Symbolism had exerted much less impact in the United States than it had in Russia, and American artists did not have the early access to new developments in France provided by Shchuckin and Morosov. The leading progressive artists of the day were a group of realists who later came to be known as the "Ashcan School"—a term which did not come into use until 1934. Their subject-matter was urban life, often in its grimier aspect. The acknowledged leader of the group was Robert Henri (1865–1929), who can be seen as the direct heir of Thomas Eakins (1844–1916), the great American realist of the nineteenth century. Henri differs from Eakins largely through the debt he owed to the great Spanish and Flemish masters of the seven-

2.27 William Glackens, *Chez Mouquin*, 1905. Oil on canvas, 48 x 36 in (122 x 92 cm). Art Institute of Chicago, Illinois.

This couple, really a portrait pair set in a genre scene (a bohemian New York restaurant frequented by members of the Ashcan School), are rather more fashionable than the subjects typically painted by the school.

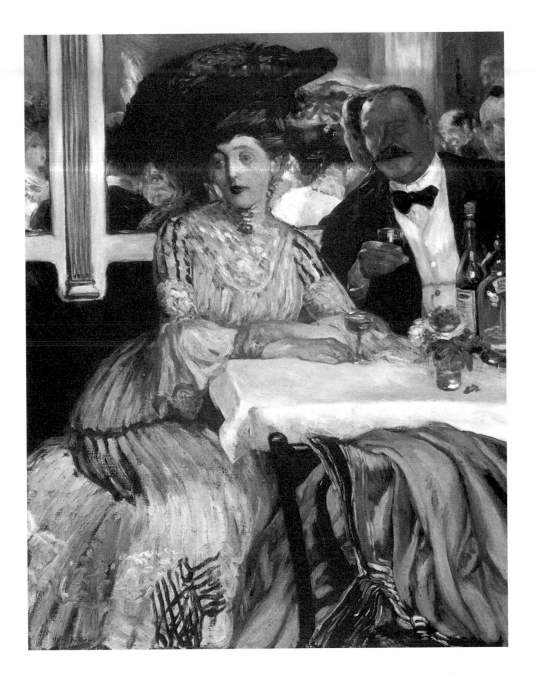

teenth century, notably Hals and Velásquez, and to Manet. Figure 2.25 is a conflation of all these influences, with Manet predominant. It suffers in comparison with the work of his disciples because of its lack of immediacy.

The painters who followed in Henri's footsteps, among them John Sloan (1871–1951) and William Glackens (1870–1938), all began their careers as newspaper artists in Philadelphia, profiting from the brief period when newspapers could reproduce drawings but not yet photographs. Their work gave them an appetite for contemporary life, and taught them great speed and certainty of observation. The epoch of the newspaper-artist was soon over: it began in around 1890, and did not last beyond 1900. When it closed, the members of the group, who were all on friendly terms, moved to New York, where they became independent painters. Paintings like Sloan's *Hairdresser's Window* (FIG. 2.26) or William Glackens's *Chez Mouquin* (FIG. 2.27) give a vivid impression of different slices of city life. The group made a tremendous impact on the public with a collective exhibition held at the Macbeth Galleries in New York in 1908, but was eclipsed by the Armory Show of 1913, whose effects will be discussed in the next chapter.

2.28 (*right*) Henri Matisse, *The Back, I*, 1909. Bronze relief, 74¾ x 45⅝ x 7½ in (190 x 116 x 19 cm). Houston Museum of Art, Texas.

Matisse's four reliefs of this subject—this was the first; the last was not done until 1930—are his major works in sculpture. The female form that was the subject of them gradually became more and more abstract. This version is heavily influenced by Cézanne's *Bathers* (see FIG. 1.18, particularly the figure on the extreme left).

2.29 (*far right*) Pablo Picasso, *Head of a Woman (Fernande Olivier)*, 1909. Bronze, 16 x 9½ x 10¼ in (40.5 x 24 x 26 cm). Musée Picasso, Paris.

In this attempt at Cubist sculpture, characterization is subordinated to design. The sculptural masses of the head are broken down into planes in a manner that is suggestive of later assemblages, or constructed sculpture.

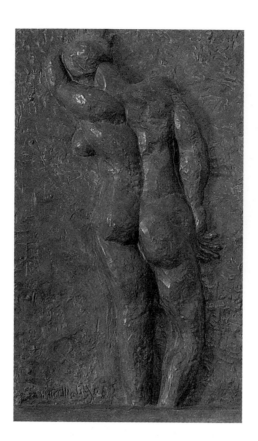

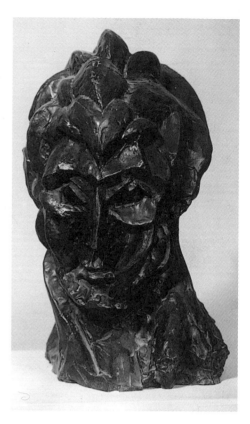

Sculpture

The Painter-Sculptors and Maillol

It is one of the peculiarities of the development of the Modern movement that sculpture lagged considerably behind painting. The earliest significant experimental sculptures were in fact made by painters, notably Matisse and Picasso. Matisse discovered African sculpture before Picasso and, according to the writer and collector, Gertrude Stein, introduced him to it. Both artists made three-dimensional work, often on a small scale, as a way of clarifying formal problems in painting. Matisse's early experiments in this direction culminated in the first version of his monumental relief, *The Back, I* (FIG. 2.28). It was done in 1909, the year in which Picasso made his *Head of a Woman* (FIG. 2.29), a portrait of his mistress, Fernande Olivier, and the first important Cubist work in three dimensions. Compared with these, the work being done by Aristide Maillol (1861–1944) looks almost insistently traditional. Maillol was a late starter in sculpture—he had originally been a maker of tapestries until the work began to affect his eyesight. In his days as a tapestry-maker he had been closely associated with the Nabis group, but the sculptures belong to the heritage of Rodin. There are nevertheless significant differences. Maillol's surfaces are much less restless, the forms smooth, heavy, and rounded. These characteristics are related to the fact that Maillol's sole subject is the female nude.

Indeed, one of his strongest claims to originality is not immediately obvious. By concentrating on the female nude to the exclusion of all else, Maillol effectively because a quasi-abstract artist. Rodin's *The Burghers of Calais* (see FIG. 1.25) is a representation of a specific historical incident. Maillol's monument to the politician, Louis-Auguste Blanqui, *Action in Chains* (FIG. 2.30), which dates from only a few years later, is simply another variation on an already established theme, in which the element of direct reference to the career and personality of the person it commemorates is minimal. Maillol's monuments—this among them—aroused

almost as much controversy as similar public projects by Rodin, and the thing which aroused the ire of his opponents was not the stylistic characteristics of the work, but what was, at least in their eyes, its wilful lack of relevance. Maillol was in fact the first maker of public monuments to declare the right of the artist to ignore any kind of imposed subject-matter.

Photography

PICTORIALISM

Stieglitz and the Photo-Secession

The pictorialist impulse had not exhausted its energy when the century ended. The man who was to take it further, and to change its character in the process, was the American, Alfred Stieglitz (1864–1946). It was in Stieglitz's hands that the leadership in photographic experiment and innovation was to pass to the United States. Stieglitz, in addition to being a major creative photographer, was an organizer of genius. In 1902 he founded the Photo-Secession, the most militantly elitist body which photography had yet produced. Membership depended on Stieglitz's whim, and he made certain that all of the group behaved as a unit. Stieglitz insisted that the work submitted by members be shown together, as a whole, and without deletions. He published the beautiful magazine, *Camera Work* (it begun publication in January, 1903), and in 1905 he founded his own gallery in New York, the Little Galleries of the Photo-Secession, later to be known simply as 291, from its address on Fifth Avenue. Many of the principles which Stieglitz embraced at this period were still Symbolist—*Camera Work* consistently stressed the analogy between the visual arts and music. Photographs became quasi-abstract images, evocative of a mood or a state of being, as in *Moonrise— Mamaroneck, New York* (FIG. 2.31) by Edward Steichen (1879–1973). Stieglitz's own work, like his picture of New York's Flatiron Building under snow (FIG. 2.32) attempted to catch the essence of urban life—his images are self-consciously

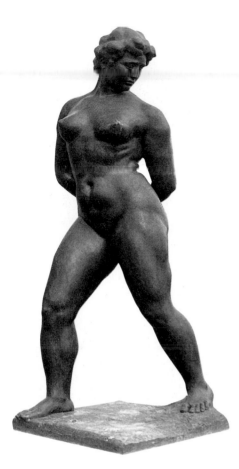

2.30 Aristide Maillol, *Monument to Louis-Auguste Blanqui* or *Action in Chains*, 1905. Bronze, Height 7 ft ⅞ in (2.15 m). Musée Maillol, Paris.

Maillol's monuments were often condemned by contemporaries because they were unspecific and devoid of literary meaning. His generalized female figures invite such a wide variety of different readings that they seem to have little real connection with the person or event they are intended to commemorate. In this sense, they anticipate some characteristics of purely abstract monumental sculpture, of a kind familiar in the second half of the twentieth century.

2.31 Edward Steichen, *Moonrise— Mamaroneck, New York*, 1904. Silver print. Metropolitan Museum of Art, New York.

In this misty, poetic photograph, Steichen attempted to evoke a mood in the tradition of late-nineteenth-century Symbolist landscape painting. New development techniques, such as the use of specially tinted and coated paper, enabled photographers to highlight or suppress details in order to achieve aesthetic effects.

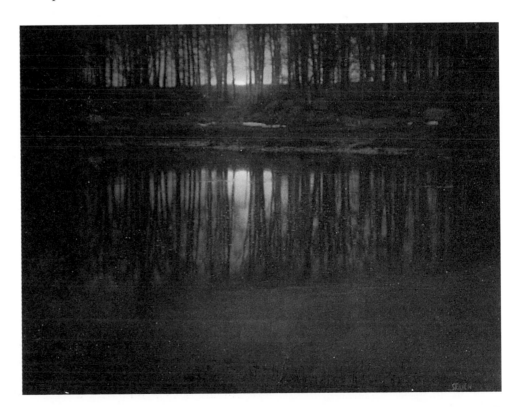

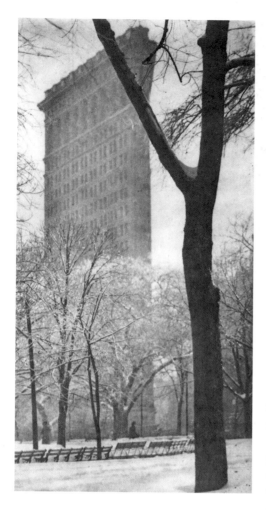

2.32 Alfred Stieglitz, *Flatiron Building under Snow*, 1903. Photogravure on vellum. National Gallery, Washington, D.C.

Stieglitz's early photographs of New York are some of his most evocative images. Here he takes an image of modernity—a skyscraper—and imbues it with Symbolist quietism.

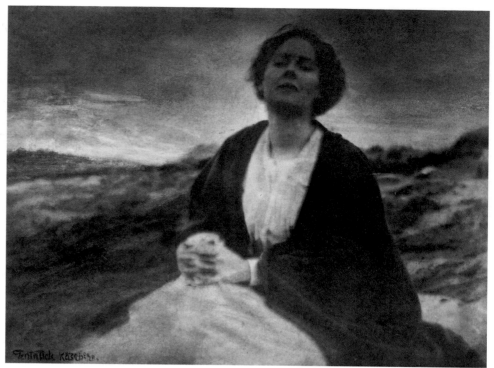

refined and poetic compared to the rumbustious urban scenes being painted by members of the Ashcan School.

Being a "new" art, photography offered greater opportunities to women than more traditional forms of expression. A number of the leading pictorialist photographers were women, among them Gertrude Käsebier (1852–1934). Käsebier's *The Heritage of Motherhood* demonstrates some of the weaknesses as well as the strengths of the pictorialist position (FIG. 2.33). While it undoubtedly shows great technical skill, both in making the image itself and in subsequently manipulating the printing process in order to produce a consciously "artistic" result, it is deeply sentimental and backward-looking. Its aesthetic roots can be traced back to the rural realism of the mid-nineteenth-century French realist painter, Jean-Baptiste Millet (1819–1906), whose popularity was then at its height with wealthy American collectors.

ALTERNATIVES TO PICTORIALISM

Pictorialist photography came under siege from several directions. There were the insouciant amateurs, who belonged to no group, but used the camera fluidly and freely to record their daily lives. These attracted no publicity at the time, but are among the best-known photographers of the period today. One of the most famous is Jacques-Henri Lartigue (1896–1986) whose images, made when he was still only a child, offer a delectable vision of Parisian *haut-bourgeois* life (FIG. 2.34). There were also the documentary photographers, such as the American Lewis Hine (1874–1940), by profession a sociologist, who in 1905 took up photography to record the plight of poor European immigrants after their arrival at Ellis Island and who went on to record the exploitation of children in factories (FIG. 2.35). His intentions were not aesthetic, but his photographs are especially valued today for their aesthetic and emotive qualities—more so than most of those produced by the pictorialists.

Finally there was the hostility of avant-garde painters, above all the Fauves. They aimed to expunge from painting all those accidental effects associated with Impressionism (which they knew had been influenced by the camera) and they

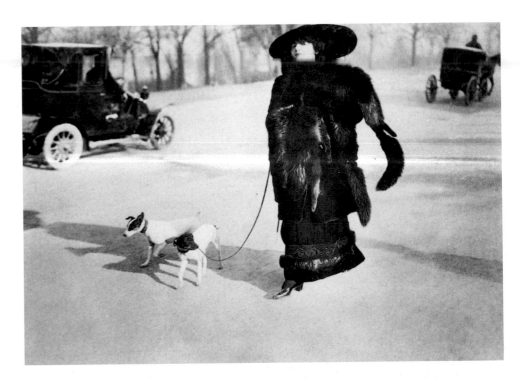

2.33 (*opposite*) Gertrude Käsebier, *The Heritage of Motherhood*, c. 1905. Gum bichromate on platinum. Museum of Modern Art, New York (Gift of Mrs. Hermione M. Turner).

This photograph was probably inspired by the work of the French realist painter, Jean-Baptiste Millet, who was enormously popular in America at this time. Motherhood was one of Käsebier's recurrent themes, which she gave a tender, somewhat sentimental, treatment by slight blurring of the image.

2.34 (*right*) Jacques-Henri Lartigue, *Avenue du Bois de Boulogne*, 1911. Gelatin silver print. Association Lartigue.

The photographs taken by Lartigue when he was still only a child evoke pre-World War I Paris with unique vividness. Lartigue used the new fast-action, hand-held camera (invented in 1888) to take photographs purely for pleasure. He was not "discovered" until the 1960s, when he was hailed as a precursor of Cartier-Bresson.

were disenchanted with the kind of synaesthetic mysticism that the more ambitious kind of photography seemed to espouse, which they associated with Symbolism—as much an enemy, in their eyes, as Impressionism. Quite simply, the avant-garde had not yet found a way of incorporating the photographic image into its own armory of technical devices, and its claim to be art was therefore still regarded as a form of trespass.

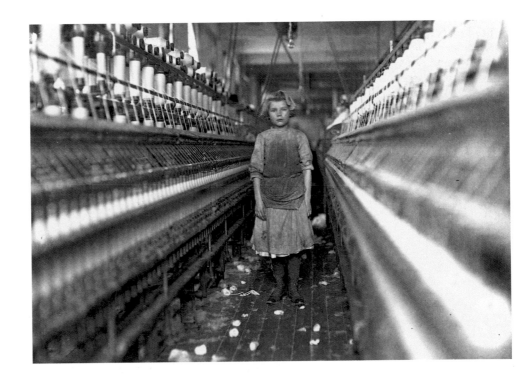

2.35 Lewis Hine, *Little Spinner in Mill, Augusta, Georgia*, no date. Gelatin silver print. George Eastman House Collection, Rochester, New York.

The documentary photographs of Lewis Hine were, like those made earlier by Jacob Riis (see FIG. 1.30), intended to record social conditions, especially among the poor and the dispossessed. They were also meant to stir an emotional response in the viewer.

1910	1911	1912	1913	1914

GENERAL EVENTS

Malevich, *Taking in the Rye*: see p.95

- Japan annexes Korea
- China abolishes slavery
- Union of South Africa established
- Death of Edward VII, succession of George V

- Arrival of German gunboat off Morocco creates international crisis
- Revolution in Central China, Chinese Republic proclaimed

- Thomas Mann publishes *Death in Venice*
- Claude Debussy, *Prelude à l'apres-midi d'un faune* performed by the Russian Ballet
- *Titanic* sinks on maiden voyage

Münter, *Black Mask amid Roses*: see p.91

- First and Second Balkan Wars
- First production of Igor Stravinsky's *The Rite of Spring* in Paris provokes a riot in the theater
- First film roles for Charlie Chaplin

- Assassination of Austrian Archduke Franz Ferdinand and his wife in Sarajevo
- World War I begins
- German advance halted at Battle of the Marne, France, 9–15 September
- First successful heart surgery (performed on a dog)
- James Joyce publishes *Dubliners*

SCIENCE AND TECHNOLOGY

- First crystal radio set transmission

- First practical electric self-starter for automobiles invented
- Ernest Rutherford propounds his theory of atomic structure
- Expedition led by Roald Amundsen reaches South Pole

- Kasimir Funk coins the word "vitamin"
- Cellophane first manufactured

- First domestic refrigerator in Chicago
- Henry Ford introduces assembly line method of production

- First use of radium to treat cancer
- Panama Canal is opened

ART

- Roger Fry coins the term "Postimpressionist"
- Vassily Kandinsky paints first abstract watercolors
- Death of Henri Rousseau
- Henri Matisse, *Dance* and *Music*
- Picasso, *Portrait of Ambroise Vollard*
- Robert Delaunay, *The Eiffel Tower*

- "Der Blaue Reiter" group formed in Berlin
- *Mona Lisa* stolen from the Louvre (possibly by the art critic Guillaime Apollinaire's secretary)
- Vassily Kandinsky publishes *About the Spiritual in Art*

Bacon, Lincoln Memorial: see p.80

- Robert Delaunay, *Simultaneous Open Windows*
- Pablo Picasso and Georges Braque produce first collages
- First Picasso exhibition in Great Britain, at the Stafford Gallery, London
- Egon Schiele briefly imprisoned on charges of producing pornography

- Marcel Duchamp, *Nude Descending a Staircase*, and the first ready-mades
- Armory Show in New York, introducing America to modern art
- Constantin Brancusi, *Mademoiselle Pogany*
- Umberto Boccioni, *Unique Forms of Continuity in Space* (sculpture)

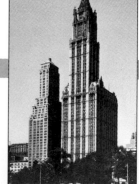

Gilbert, Woolworth Building: see p.80

- Robert Delaunay, *Homage to Blériot*

ARCHITECTURE

- Adolf Loos, Steiner House, Vienna
- Antonio Gaudí, Casa Mila, Barcelona

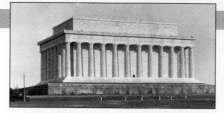

- Walter Gropius and Hans Meyer, Fagus shoe-factory, Alfeld-an-der-Leine, Germany

- Henry Bacon, Lincoln Memorial, Washington, DC (–1922)

- Cass Gilbert, Woolworth Building, New York

- Irving Gill and Walter Luther, Dodge House, Hollywood (–1916)
- Bruno Taut, Glass Pavilion, Werkbund Exhibition, Cologne, Germany
- Antonio Gaudí, Park Guëll, Barcelona

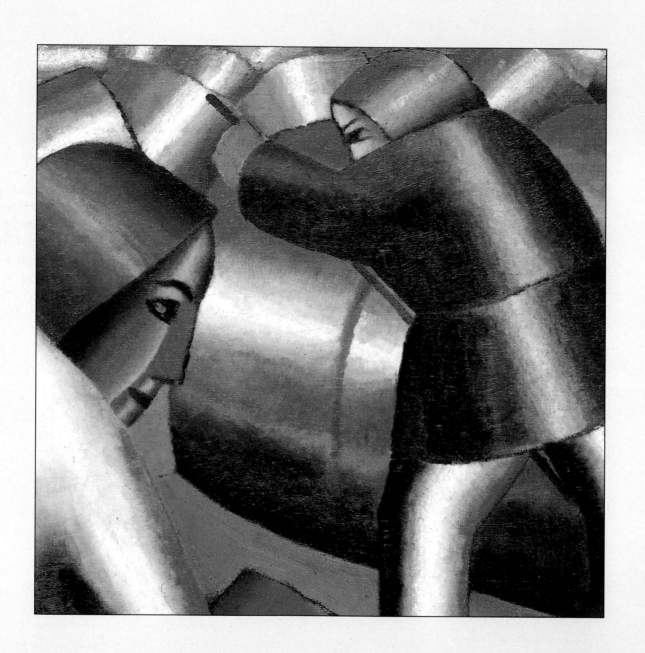

1910–1919

World War I, welcomed by some as a means of destroying what seemed a claustrophobically over-elaborate culture, changed the face of the world, of Europe in particular, in ways that no one could have anticipated. New nations were created in eastern Europe from the ruins of the old Austro-Hungarian Empire. America entered, somewhat reluctantly, into a role as a world power. The Bolshevik regime in the Soviet Union embarked on a social experiment based on Marxist principles which was designed to drag a vast, still primitive, and largely agrarian country into a position of industrial parity with the more developed nations of the West.

The petty wars in the Balkans which preceded the outbreak of war in 1914 gave war itself a kind of glamor in the eyes of some artists. This was the epoch in which the military metaphor implicit in the term "avant-garde" seemed most appropriate to many forms of experimental artistic activity. Artists tended to think of themselves as a chosen elite, and where they concerned themselves with politics, they often identified themselves with the right wing rather than the left. This was the case, for example, with the Italian Futurists. Even those who thought of themselves as anarchists, as some of the Fauves momentarily did, had little commitment to fundamental social reform.

The war brought with it a massive feeling of disillusionment, and one feature of avant-garde activity in the war years was the sense of nihilism which it expressed. The various Dada movements which flourished on the fringes of the conflict—in Zurich, New York, and Barcelona—gave forceful expression to this. It was the October Revolution of 1917, however, and the near-collapse of the German economic and social system after the armistice of 1918, which tended to swing artists toward an alliance with the left. This alliance, though at times extremely uneasy, was to persist for the remainder of the century, and is now usually taken as a "given" in most discussions of the twentieth-century visual arts.

Architecture

ARCHITECTURE IN THE UNITED STATES

The United States did not enter the World War until 1917, and the conflict did not take place on its territory. This means that the United States is the one area where there is a history of continuous architectural development during the second decade of the century. Curiously enough, this did not give America the leadership in architectural experimentation. On the contrary, American architects continued to use accustomed styles. One of the finest products of the American Classical Revival which had been going on since the 1880s is the Lincoln Memorial in Washington, D.C., designed by Henry Bacon (1866–1924) in 1912, and completed in 1922. While this makes use of both Greek and Roman precedents (it is a Greek Doric temple crowned with a Roman attic) it is a work in such pure Neo-classical style that it might have been designed at any time from the late eighteenth century onward. What justifies the building is its success as a symbol of important aspects of American history and American life. It was no accident, for instance,

3.1 Henry Bacon, Lincoln Memorial, 1912–22, Washington D.C.

Modernism did not carry all before it. Bacon's memorial to the American president is a fine example of restrained classicism, with features borrowed from both Greek and Roman architecture.

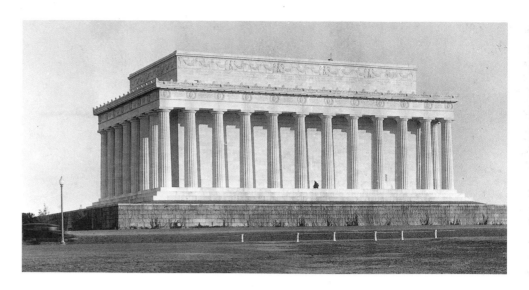

that the 1963 March on Washington which marked one of the culminating moments of the Civil Rights movement chose as its terminus the shrine to Lincoln which Bacon had created (FIG. 3.1).

Skyscrapers, rather than developing the ideas of Louis Sullivan for treatment of this new and peculiarly American building type, reverted to historical fancy dress. Since the idea of soaring height was already implicit in much Gothic architecture, Gothic was often the preferred mode—a good example is the Woolworth Building in New York (FIG. 3.2), designed by Cass Gilbert (1859–1934).

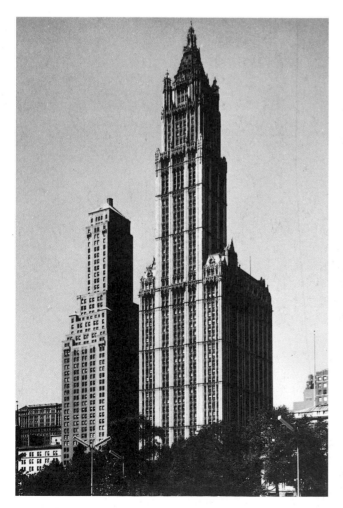

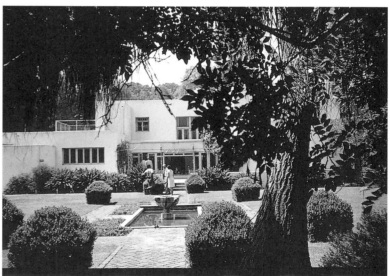

3.3 (*above*) Irving Gill, Walter Luther Dodge House, Los Angeles, California, 1914–16.

Traditional architectural styles remained predominant in American architecture until after World War I. This house was an exception, anticipating the International Style in architecture.

3.2 (*left*) Cass Gilbert, Woolworth Building, New York, 1913.

Gilbert here sheathed a metal frame in Gothic ornamentation, creating a kind of fantasy building much admired later by the Postmodernists. The clarity and lucidity of the early Chicago skyscrapers has vanished.

Only occasionally did America produce a building which seemed to prophesy the birth of the so-called International Style which was to dominate world architecture from the 1920s to the 1960s. One instance is the Walter Luther Dodge House (FIG. 3.3) by Irving Gill (1870–1936), a man who, apart from two years spent in Louis Sullivan's Chicago office in the 1890s, had no formal architectural training. With its simple cubic forms and flat roof this anticipates some of the houses which Rudolf Schindler (1887–1953) and Richard Neutra (1892–1970) were to build in the same part of California during the next decade.

Frank Lloyd Wright and the Imperial Hotel in Tokyo

One reason for the erratic progress of American architecture during the decade may have been a break in the career of Frank Lloyd Wright, due to his liaison with a married woman. Wright, his work in the Midwest brought to a halt by the social ostracism which followed, was rescued by a Japanese commission. From 1916 to 1922, the chief focus of his creative activity was the Imperial Hotel in Tokyo (FIG. 3.4). This vast, castle-like structure made of concrete slabs carried on concrete piles did wonders for Lloyd Wright's professional reputation by surviving the great Tokyo earthquake of 1923. The building itself, demolished in the 1960s, was a curious sport. Its dense geometric ornament, derived more from Aztec than Japanese sources, made it exotic in Western, as well as local, terms. Japan, however, was too culturally isolated for it to make much impression on architects in the United States and in Europe.

3.4 Frank Lloyd Wright, Imperial Hotel, Tokyo, 1916–22.

This is the most substantial and ornate of the buildings designed by Wright in a brief decorative period of his career. The hotel was demolished in the 1960s.

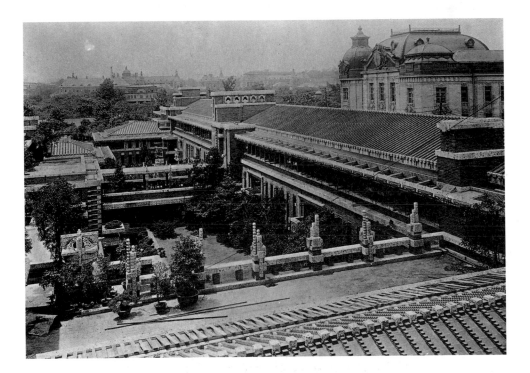

ARCHITECTURE IN EUROPE

European architecture in the years immediately before World War I is in some ways more notable for abortive projects and visionary designs than for actual buildings, most startlingly so in the unrealized projects of Antonio Sant'Elia (1888–1916), who was killed in the war. Sant'Elia envisioned a dynamic "New City" which would respond directly to the conditions of modern life:

> We must invent and rebuild *ex novo* our modern city like an immense and tumultuous shipyard, active, mobile and everywhere dynamic, and the modern building like a gigantic machine. Lifts must no longer hide away like soli-

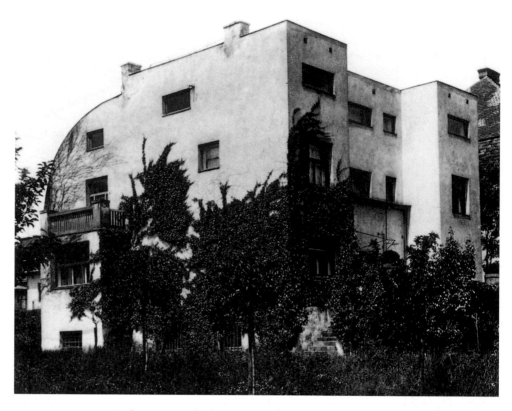

3.5 Adolf Loos, Steiner House, Vienna, 1910.

The utter severity of line and symmetrical simplicity of the proportions of this house make it a near-perfect realization of Loos's theories: "The lower the standard of a people," he wrote in an attack on Art Nouveau, "the more lavish are its ornaments. To find beauty in form instead of making it depend on ornament is the goal toward which humanity is aspiring."

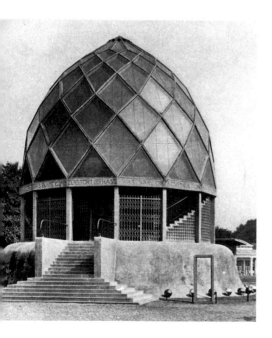

3.6 Bruno Taut, Small Circular Pavilion, Werkbund Exhibition, Cologne, Germany, 1914.

This ephemeral building is of seminal importance in the history of modern architecture for its visionary experiment in the use of glass.

tary worms in the stairwells, but the stairs—now useless—must be abolished, and the lifts must swarm up the façades like serpents of glass and iron. The house of cement, iron and glass, without carved or painted ornament, rich only in the inherent beauty of its lines and modeling, extraordinary brutish in its mechanical simplicity, as big as need dictates, and not merely as zoning rules permit, must rise from the brink of a tumultuous abyss: the street which itself, will no longer be like a doormat at the level of the thresholds but plunge storeys deep into the earth, gathering up the traffic of the metropolis connected for necessary transfers to metal catwalks and high-speed conveyor belts.[1]

Alfred Loos and Peter Behrens

If the most telling blast of theory came from Italy, the most important practical achievements were emerging in the German-speaking lands—both Germany itself and Austria—where the visual arts and architectural avant-gardes remained integrated with one another in a fashion unknown in France, Great Britain, or the United States.

In Vienna, a notable contribution was made by Adolf Loos (1870–1933), a gifted polemicist who coined the often-quoted but much misunderstood slogan, "ornament is crime." Loos argued for a practical, totally unpretentious architecture. "Only a very small part of architecture belongs to art: the tomb and the monument. Everything else, everything that serves a purpose, should be excluded from the realms of art."[2] What Loos meant by this was demonstrated in his Steiner House (FIG. 3.5). Here a deliberately plain, unadorned exterior (like Irving Gill's Dodge House of four years later) conceals a complex plan. Like Gill's work, Loos's Viennese villas of this period anticipate the development of the postwar International Style.

Behrens's exploration of the meanings of industrial architecture was pushed a step forward in the Fagus shoe factory at Alfeld-an-der-Leine (FIG. 3.7), designed by two young architects who had worked in Behrens's office, Walter Gropius

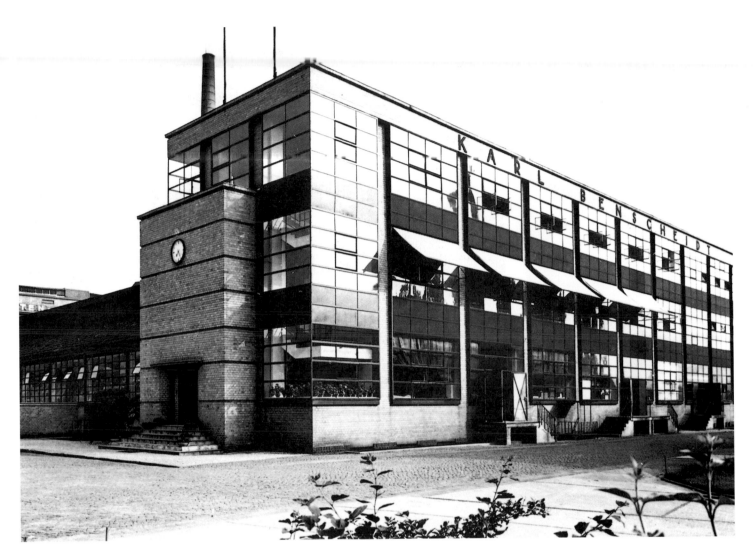

3.7 Walter Gropius and Adolf Meyer, Fagus shoe factory, Alfeld-an-der-Leine, Germany, 1911.

This startlingly original design took modern architecture a step forward from Behrens's Turbine Factory (see FIG. 2.7). The walls are conceived in glass—the "etherealization" of architecture, in Frank Lloyd Wright's phrase—with only narrow brick piers for support. And the corners are left bare, without support, a device repeated over and over by later architects.

(1883–1969) and Adolf Meyer (1881–1929). The solid corner piers which were such a striking feature of Behrens's design for AEG are omitted, and the glass cladding, with storey levels indicated only by solid rather than clear panels, suggests that the building is to be read, not as a series of large windows pierced in a solid mass, but as one large, essentially transparent volume.

The spirit behind the Fagus factory was essentially that of Schinkel, a rational, pragmatic Classicism filtered through the prism of modern technology. Another, more romantic, group of German architects tried to align the new glass architecture with a Gothic spirit which was thought to have mystical kinship with the German past. One of the most striking attempts to give these ideas form was the small circular pavilion designed by Bruno Taut (1880–1938) for the Werkbund Exhibition held in Cologne in 1914 (FIG. 3.6). This, with its pointed dome, was, according to Taut, designed to prove the kinship between Gothic and contemporary work. The pavilion bore inscriptions taken from the work of the contemporary poet, Paul Scherrbart, who saw architecture made of glass as the key to a utopian future which would outstrip both bourgeois culture and the materialism of the industrial state.

The immediate future of progressive architecture was predicted by Gropius and Meyer. Taut's pavilion, though apparently without direct issue in the immediate postwar years, was a significant early tribute to the idealistic, utopian strain which was to infect twentieth-century architecture, not always with the happiest practical results.

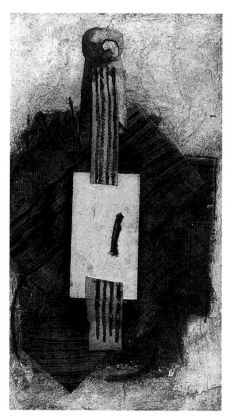

3.8 Pablo Picasso, *Construction: Violin*, 1913. Gouache, charcoal, pastel on board, 20½ x 11¾ x 1½ in (52 x 30 x 4 cm). Musée Picasso, Paris.

The necessary flatness of *papiers collés* finally eliminated illusionistic space altogether, although spatial relationships could be indicated by overlapping.

Painting

The Invention of Collage

Because Cubism represented what was in intention at least a return to tangible reality, its creators became increasingly troubled by the visual complexity which their method seemed to entail. In a first attempt to solve this problem, Picasso and Braque began to use stenciled letters in their canvases. These served as an affirmation of the material existence of the painting as an object in its own right. Soon, however, they saw that they could go further than this. In 1912 they started to introduce actual fragments of reality into their designs—fragments of newspaper, small pieces of woodgrained paper. This was the invention of what came to be called collage (FIGS. 3.8, 3.9).

In fact, the technique was novel only in terms of high art. Scissors-and-paste techniques of various sorts had long been popular with amateur artists and hobbyists, many of them women. By making use of these methods, the pioneer Cubists were seeking to demystify art, to bring it back to earth again. They were also thumbing their noses at the whole idea of painterly facility. Another attractive aspect of the technique was that it provided many opportunities for visual and verbal punning. This was very much in tune with the spirit of the time. The Parisian theater, for example, was being swept by a passion for revues—comic entertainments which were witty, quick-moving commentaries on the political events, trends, fashions, and gossip of the day. Simultaneously, advertising was beginning to make a huge impact on the urban and suburban environment. The revue-writers were keenly aware of this, and frequently concerned themselves with brand names and marketing schemes. Cubist collages, in a somewhat similar way, made mischievous use of what had begun life as commerical material. By employing labels and newspaper headlines in fragmentary form, Braque and Picasso were able to suggest that the whole of contemporary life was subject to rupture and change. Collage offered an ironic commentary on the situation, while conforming to the spirit of the times. Both this aspect and the use of readymade materials were to have great significance for the future of the visual arts.

3.9 Georges Braque, *Violin and Pipe (le Quotidien)*, 1913–14. Mixed media on canvas, 29⅛ x 41¾ in (74 x 106 cm). Musée National d'Art Moderne, Paris.

This is an example of the way in which the Cubists imported fragments of "real life" into art, through the use of collage. The *papier collé*—a composition made with pieces of pasted paper—was invented by Braque in 1912.

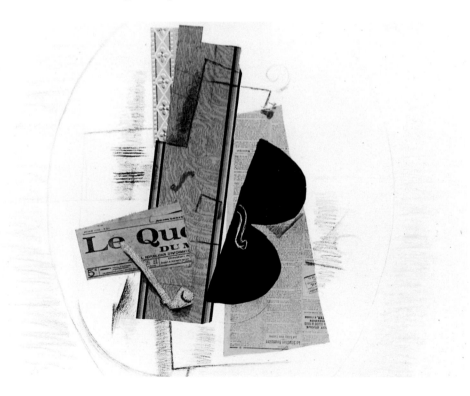

Synthetic Cubism: Juan Gris

The pasted paper fragments employed in collage suggested a new way of organizing the picture space. The intricately faceted compositions typical of the first phases of Cubism were gradually simplified, becoming at the same time more abstract. Typically, the design was now made up of floating, overlapping planes seen against a shallow, but indeterminate, space. The "shallow space" of late Cubism was to be one of the most influential aspects of the style, and was to be adopted as a basic pictorial device by a wide variety of other artists. Picasso and Braque had reached this stage by the outbreak of war in 1914, and had been joined in their exploration of Cubist possibilities by another artist, Juan Gris (José Vittoriano González, 1887–1927).

Born in Madrid, Gris came to Paris in 1906 and lived in the same group of studios as Picasso (the so-called "Bateau Lavoir" at 13 rue Ravignan). He did not begin to paint seriously until 1910. The discovery of collage gave a new direction to his work. His Synthetic Cubist paintings, many produced during the turmoil of the war years, less complex than those of the originators of the style, have a cool lucidity which makes them unique (FIG. 3.10). They are the forerunners of some of the classicizing experiments made by artists in the 1920s and 1930s, and

3.10 Juan Gris, *Fantômas*, 1915. Oil on canvas, 23½ x 28⅞ in (59.8 x 73.3 cm). National Gallery, Washington, D.C.

Gris was largely responsible for introducing light and color into Cubism, thus anticipating the later Synthetic Cubism of Picasso and Braque.

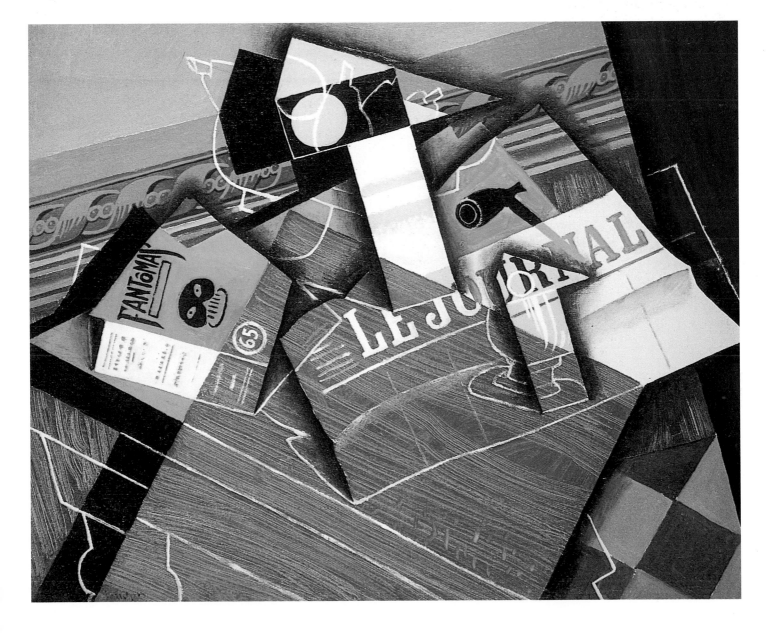

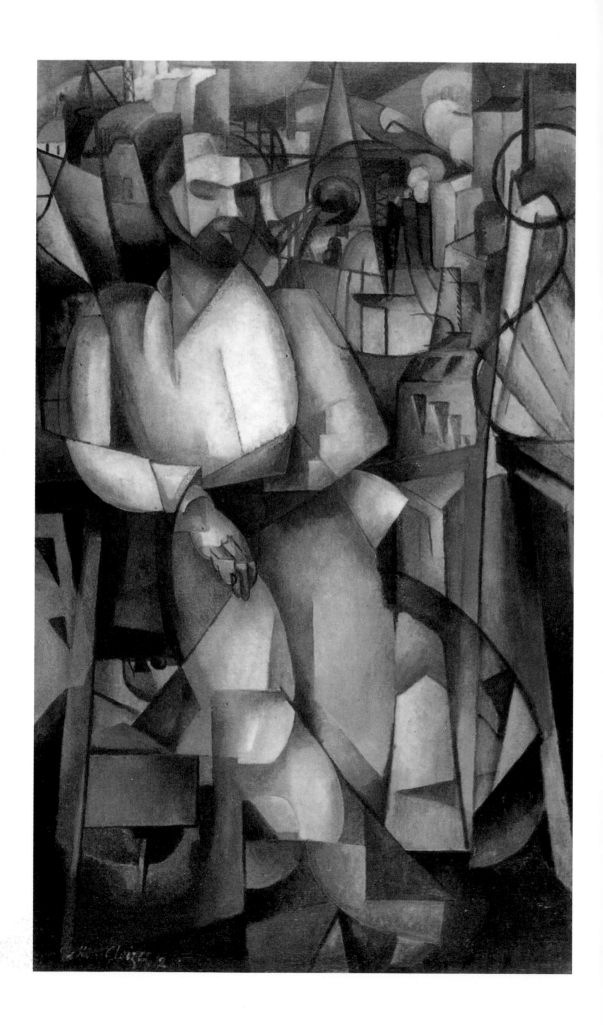

3.11 (*opposite*) Albert Gleizes, *Man on a Balcony*, 1912. Oil on canvas, ⁓ ⁓ ⁓ ⁓ ⁓ ⁓ ⁓ ⁓ ⁓ ⁓ ⁓ (1.33 x 1.15 m). Philadelphia Museum of Art, Pennsylvania.

Although not a progenitor of the Cubist style, Gleizes' work was among the first regularly to appear on public display.

3.12 (*right*) Jean Metzinger, *Composition*, 1917. Oil on canvas, 36¼ in x 25⅝ in (92 x 65 cm). Private collection.

With Gleizes, Metzinger co-authored an explanatory, theoretical text, *Du Cubisme*, which failed in large measure to pre-empt the generally bemused critical reception given to the new style.

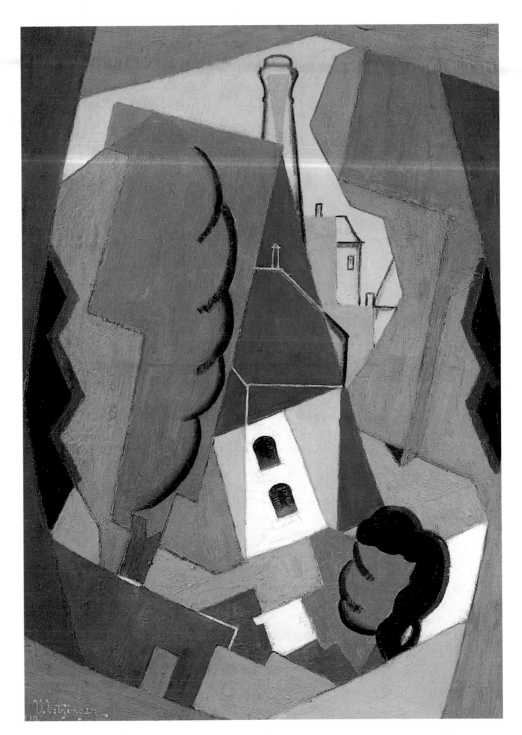

demonstrate that Cubism, despite its revolutionary ambitions, retained roots in the Old Master tradition.

Minor Cubists

It was a peculiarity of Cubism that most of its early *réclame* came from artists who were not the progenitors of the style. Picasso and Braque did not exhibit in the major salons of the prewar epoch, though their work could be seen in the hands of dealers such as Kahnweiler and the shrewd German aesthete, Wilhelm Uhde. Their place was taken by artists of minor talent, such as Albert Gleizes (1881–1953) (FIG. 3.11) and Jean Metzinger (1883–1957) (FIG. 3.12), authors of the book, *Du Cubisme* (1912), which did much to publicize the new direction in painting. They showed assiduously in the Salon des Indépendants and the Salon

d'Automne. Critics thought that the major exhibitions of 1910 and 1911 were dominated by the new style and Cubism became so notorious that in 1912 an attempt was made in the Chambre des Deputés to prevent the Cubists from exhibiting at the Salon d'Automne. "It is absolutely inadmissible," one member cried, "that our national palaces should be used for manifestations of such an obviously anti-artistic and anti-national kind."[3] Since neither supporters nor detractors were seeing Cubism in the hands of its inventors, contemporary reactions to Cubism have to be viewed with a degree of caution.

Orphism: Robert Delaunay

One artist who profited from Picasso's absence from the scene, and who possessed a measure of originality, was Robert Delaunay (1885–1941). Delaunay was at his most original in paintings which reverted to bright colors in their attempt to celebrate the excitement of a new age. He transformed the typical structure of Cubist painting by turning the prisms into facets shot through with transparent hues. Apollinaire coined the word "Orphism" to describe this new development, and aligned Delaunay's work with a progression toward abstraction. In his book, *Les Peintres Cubistes* (1913), he speaks of Orphism as "the art of painting new

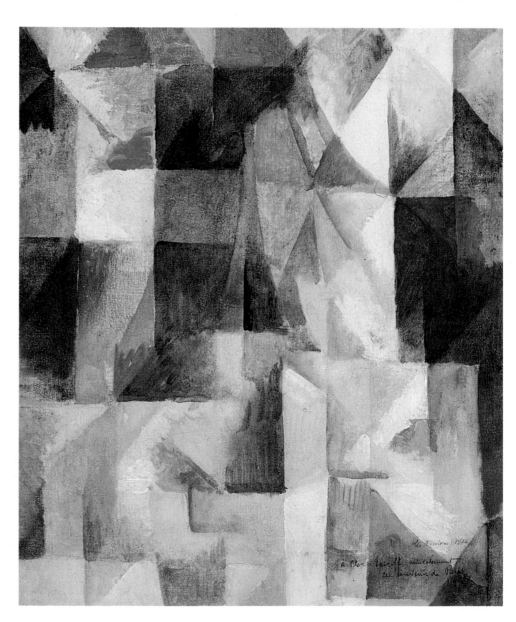

3.13 Robert Delaunay, *Simultaneous Open Windows*, 1912. Oil on canvas, 18 x 14¾ in (45.7 x 37.5 cm). Tate Gallery, London.

Delaunay and his wife, Sonia Delaunay-Terk, called their style "Orphic Cubism" or simply "Orphism" because their interest in prismatic colours marked off their canvases (which have the overlapping planes of Cubism) from the almost monochromatic canvases that Braque and Picasso were producing at the time.

3.14 Sonia Delaunay-Terk, *Simultaneous Contrasts*, 1912. Oil on canvas, 17⅞ x 21⅝ in (45.5 x 55 cm). Musée National d'Art Moderne, Paris.

Delaunay-Terk's use of abstract pattern was suggested by her activity as a needlewoman, and by her interest in the Russian folk heritage, something she shared with Goncharova (see FIG. 2.23).

structures out of elements which have not been borrowed from the visual sphere but have been created entirely by the artist." In fact, by the time this was written, Delaunay had already progressed to painting entirely abstract pictures—for example, the series *Simultaneous Discs* (FIG. 3.13), which was begun in 1912.

Sonia Delaunay-Terk

An influence on Delaunay's development was, probably, the work of his wife, the Ukranian-born Sonia Delaunay-Terk (1885–1979). Delaunay-Terk's strong sense of dramatic and decorative color was derived in part from childhood memories of Russian folk-art. She therefore drew on sources which were also influential for Larionov and Goncharova (see FIGS 2.23 and 2.24). Her first fully abstract work was not a painting, but a patchwork crib cover made in 1911 for her son. Delaunay-Terk said that when she made it she was consciously following the tradition of Russian peasant women, who were accustomed to use up scraps of material in this way. The crib cover suggested her own abstract formulations (FIG. 3.14), which were close to the work her husband was producing. Delaunay-Terk has received insufficient attention, partly because much of her effort was diverted into decorative work, such as the design of "simultaneous" costumes and decors. Whereas Delaunay's creativity faltered after World War I, Delaunay-Terk continued to be productive until the very end of her long life.

Der Blaue Reiter

Delaunay, like Matisse a few years earlier, made an immediate impact in Germany. Matisse's work had been influential in Dresden; Delaunay attracted artists in Munich. In 1912 he was asked to exhibit with a new avant-garde grouping which had made its appearance there, Der Blaue Reiter. The group took its name from the "Blue Rider" almanac published earlier the same year under the editorship of Vassily Kandinksy (1866–1944) and Franz Marc (1880–1916). Though the group is usually categorized as a branch of German Expressionism, the interests of the artists connected with Der Blaue Reiter were on the whole very different from those who came together to form the original Expressionist group in Dresden. In any case, the leading artistic personality in Munich was not German, but Russian.

Kandinsky, who had been a lecturer in law at Moscow University, was another late starter as a painter. He arrived in Munich to study art in 1896. His interests were then largely Symbolist, reinforced by the fact that he was also an accomplished amateur musician. On hearing Wagner while still a very young man he thought: "I could see all my colors; I realized painting had the same power as music." The first major influence on his work was Jugendstil, the restrained German form of Art Nouveau, a style which had as much to do with the decorative arts as it did with painting. At this time he was also both curious and restless. Between 1903 and 1911 he traveled in Italy, the Netherlands, and North Africa.

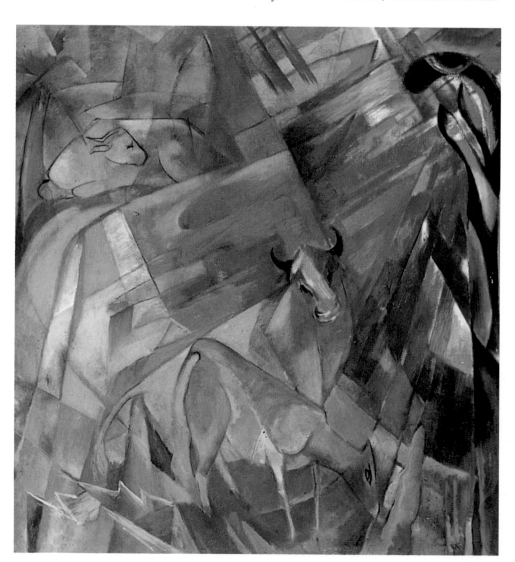

3.15 Franz Marc, *Animals in a Landscape*, 1914. Oil on canvas, 4 ft 1¼ in x 3 ft 3⅜ in (1.25 x 1 m). Detroit Institute of Art, Michigan.

The element of mysticism in Marc's work was inherited from the German Romantic artists of the early nineteenth century. His search for symbolic ways of conveying his emotional identification with animals led him, he said, toward a non-representational art that would portray the "absolute rhythms of nature."

From 1905 to 1908 he concentrated on Paris and showed his work at the Indépendants.

Franz Marc

Kandinsky's seniority and his wide experience of the world made him the dominant figure in the Munich group. There were, however, others of near-equal importance, Franz Marc, for example. Marc's career, prematurely cut short by his death in World War I, demonstrated his debt to the German version of nineteenth-century Romanticism—to a mystical, inward way of apprehending reality and trying to construct a pictorial equivalent for it. In 1908 he wrote to a friend: "I am trying to intensify my feeling for the organic rhythm of all things, to achieve pantheistic empathy with the throbbing and flowing of nature's bloodstream—in trees, in animals, in the air." These feelings found their fullest expression in the paintings of animals which are now his best-known achievement (FIG. 3.15). The splintered, faceted forms inherited from Cubism and from Delaunay's Orphism are here used to create a visionary transmutation of nature.

Gabrielle Münter

The work of Gabrielle Münter (1877–1962) (FIG. 3.16), Kandinsky's companion during his years in Munich, introduces a number of preoccupations which were to become important to artists in the twentieth century. Münter was interested in the Bavarian folk tradition of making paintings on glass. Perhaps more importantly, she was perhaps the first Modernist artist to take a close interest in children's drawings. Her work has been accused of "mannered naivety,"[4] but it is clear that she saw these source materials as models for the creation of an expressive art that was unburdened by tradition. As such she deserves an honored place as a pioneer.

Kandinsky and the Birth of Abstraction

Kandinsky enjoys a place of special importance in the annals of the Modern movement because of his claim to be the inventor of a purely abstract art. If taken literally, this claim is exaggerated. By 1909 or 1910 it was clear that art had been moving toward abstraction for some time. The decorative arts of late Symbolism predicted its appearance, as did the stained glass and other architectural features designed at the beginning of his career by Frank Lloyd Wright. Critics such as Apollinaire saw Cubism as a first step toward an art that would be entirely abstract. A non-figurative art had suddenly become possible; from this it was just a step to actually making it. Kandinsky was, however, the artist who most clearly envisaged where pure abstraction would stand (see FIG. 3.17). Unlike Apollinaire, he opposed Cubism to Abstract (=Absolute) painting. For him, the former was a last effort to render reality in all its complexity, while the latter had broken free of all restraints and occupied a realm of its own.

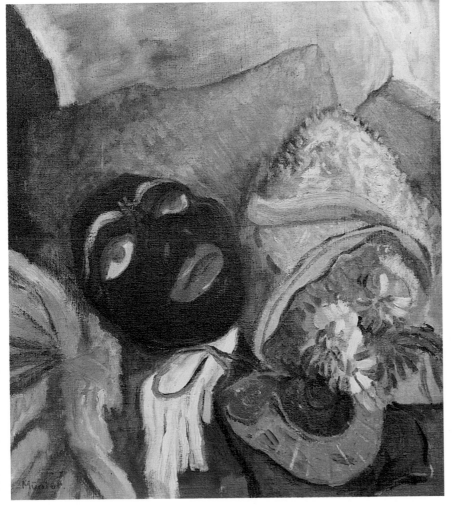

3.16 Gabrielle Münter, *Black Mask amid Roses*, 1912. Oil on canvas, 22¼ x 19¼ in (56.4 x 49 cm). Private collection.

Vassily Kandinsky: *Composition IV*

For Kandinsky, the discovery of abstraction was a kind of epiphany, and it is best to let him describe the crucial moment (which occurred in around 1909) in his own words:

> Once while in Munich I underwent an unexpectedly bewitching experience in my studio. Twilight was falling: I had just come home with my box of paintings under my arm after painting a study from nature. I was still dreamily absorbed in the work I had been doing when, suddenly, my eyes fell upon an indescribably beautiful picture that was saturated with an inner glow. I was startled momentarily and quickly went up to this enigmatic painting in which I could see nothing but shapes and colors and the content of which was incomprehensible to me. The answer to the riddle came immediately: it was one of my own paintings leaning on its side against a wall. The next day, by daylight, I tried to recapture the impression the picture had given me the evening before. I succeeded only half-way. Even when looking at them sideways I could still make out the objects, and that fine coat of transparent colour, created by last night's twilight, was missing. Now I knew for certain that the subject-matter was detrimental for my paintings.*

Kandinsky's conversion to abstraction was, however, neither so radical nor so immediate as this account suggests. He had already anticipated a development of this type, and his earliest "abstract" paintings contain many recognizably figurative elements. As early as 1904, he had written to his mistress, Gabrielle Münter, that the content of his work was not meant to be observed immediately, but only "felt" slowly, and that it would remain inaccessible to people who were insensitive to finer things.† *Composition IV* (FIG. 3.17) seems at first glance to be entirely abstract, but on closer examination reveals itself to be a landscape with figures. In the center is a blue mountain crowned with a castle. Three figures in cloaks stand in front of the mountain. To the left is a rainbow and the rudimentary outline of a large horse. In the

text in which he described his conversion to abstraction, Kandinsky also wrote: "Painting is like a violent and thunderous collision between diverse worlds that are destined to create a new world by fighting one another, the new world being the work of art."§

It is an interesting aspect of Kandinsky's earliest abstract works, which date from 1910–11, that they are much freer in form than those made later in his career, in the 1920s and 1930, where strictly geometrical elements are more prominent.

*Vassily Kandinsky, *Sturm Album*, Berlin, 1913, p. xv.
†Peg Weiss, *Kandinsky in Munich: The Formative Jugendstil Years*, Princeton, 1979, p. 90.
§Kandinsky, *op. cit.*, p. xix.

3.17 Vassily Kandinsky, *Composition IV*, 1911. Oil on canvas, 5 ft 2¾ in x 8 ft 2⅝ in (1.6 x 2.5 m). Kunstsammlung Nordrhein Westfallen, Düsseldorf, Germany.

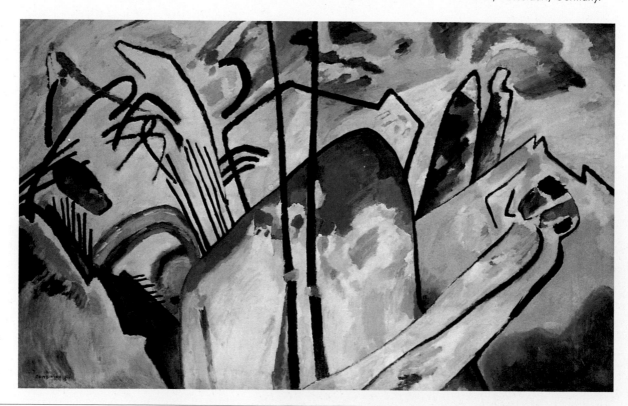

Futurism

Delaunay's work, with its emphasis on color, dynamism, and interpenetrating forms also has a relationship to Italian Futurism—a fact which was obvious at the time, and which was to be the cause of hard feelings, not least because Apollinaire, when called upon to review Futurist exhibitions, was apt to denigrate them for the benefit of his protégé.

Though the conditions which created the Futurist movement were peculiarly Italian, it was in fact launched in Paris, not with an exhibition but with a document, "The Founding and Manifesto of Futurism," published in *Le Figaro* on 20 February, 1909. This document was the work of a literary firebrand called Filippo Tomasso Marinetti (1876–1944), who had a great gift for turning a striking phrase. The manifesto contains phrases which seem to sum up the whole meaning and atmosphere of an art which was still to be made:

> We affirm that the world's splendor has been enriched by a new beauty, the beauty of speed. A racing car whose hood is adorned with great pipes, like serpents of explosive breath—a roaring car that seems to ride on grapeshot—is more beautiful than the "Victory of Samothrace."

It seems probable that Marinetti had initially hoped to recruit other writers to the cause. In the event, his most important recruits were young artists, chief among them Umberto Boccioni (1882–1916), who was one of the co-signatories of the "First Manifesto of Futurist Painting," which was launched in Turin in March, 1910. It was followed in April by a more substantial "Technical Manifesto," which gave a specific description of what the new art was to be like: "Gesture, for us, will no longer be a single moment within the universal dynamism brought to a sudden stop: It will be, outrightly, dynamic sensation given permanent form."

In practice, Futurist art was a strange mixture. It was based on a revolt against the weight of the Italian past, and also against Symbolism. The innovations which it celebrated were things imported into Italian culture from elsewhere—compared with more developed nations, such as Great Britain, France, the United States, and Germany, Italy remained industrially backward—but the movement was at the same time fiercely nationalist. Despite their condemnation of Symbolist vagueness, love of complication, decadence, and passivity, the Futurists remained fascinated by a number of things which had interested the Symbolists. There is, for instance, an occultist strain in the work of Boccioni, which is still more powerfully present in the work of his colleague and rival, Giacomo Balla (1871–1958).

Futurism and Photography

Another paradox concerns Futurism's relationship to photography. Futurist art often records phases of movement. In Balla's celebrated *Dynamism of a Dog on a Leash* (FIG. 3.18) the leash, swinging in catenary curves, obviously derives from the experimental photographs made in the 1880s by the French scientist, Etienne-Jules Marey (1830–1904). Balla and other Futurist artists were, however, fiercely scornful of photography and hostile to the work

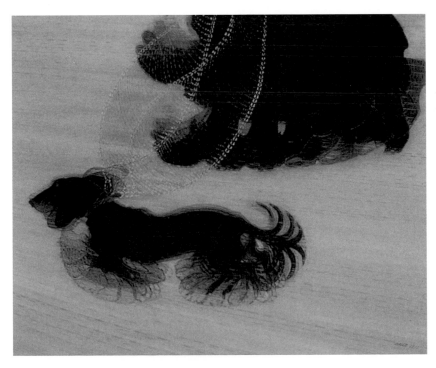

3.18 Giacomo Balla, *Dynamism of a Dog on a Leash*, 1912. Oil on canvas, 35½ x 43⅜ in (90 x 110 cm). Albright-Knox Art Gallery, Buffalo, New York.

This painting, in which the Italian Futurist, Balla, sought to represent movement through time, clearly demonstrates the influence of the experiments made with simultaneous photography of successive phases of movement recorded on a single negative—by pioneers like Etienne-Jules Marey.

3.19 Anton Giulio Bragaglia, *The Smoker*, 1913. Gelatin silver print. Private collection.

Bragaglia is the only specifically Futurist photographer. The Futurist painters disliked his work, perhaps because it indicated too clearly that there were elements derived from photography in their own art.

3.20 Umberto Boccioni, *States of Mind: Those Who Stay*, 1911. Oil on canvas, 27⅞ x 37¾ in (70.8 x 95.9 cm). Museum of Modern Art, New York (Nelson A. Rockefeller Collection).

Boccioni tried to demonstrate that Futurist methods could convey emotional states in addition to representing physical movement. This is one of three paintings linked under the title, *States of Mind*. "These young men," Apollinaire wrote of the Futurists, "want to move away from natural forms and to be the inventors of their art."

of the one important photographer closely connected with the Futurist movement, Anton Giulio Bragaglia (1890–1960), later a theater and film director. This was despite the fact that Bragaglia's youthful experiments with *Fotodinasmismo*, as he described it, were financially supported by Marinetti. One of the striking things about Bragaglia's photographs, and the chief way in which they differ from the work of Marey, is that they aim to record a mood, not merely successive phases of movement (FIG. 3.19). This is also true of the best work of Boccioni, who was the most gifted of the Futurist artists. A painting like *States of Mind: Those Who Stay* (FIG. 3.20) is designed to evoke, not merely successive phases of motion, but the emotions in which the figures are caught up.

Though never very successful in establishing itself in Paris, Futurism was widely influential elsewhere, thanks to Marinetti's gifts as a publicist and to his substantial personal fortune. Futurism was the first avant-garde group to have an organizational infrastructure. It was also the first to lay stress on the importance of public manifestations.

The Russian Avant-garde: Cubo-Futurism

A new stage in the development of the Russian avant-garde was marked by the "Donkey's Tail" exhibition, which opened in Moscow in March, 1912. The participants were Larionov, Goncharova, Kasimir Malevich (1878–1935), and Vladimir Tatlin (1885–1953). The exhibition was intended to be a conscious breakaway from Europe, but the paintings showed strong influences from both French Cubism and Italian Futurism. Malevich's *Taking in the Rye*, one of the most radical works on display, combines Cubist volumes with brilliant color and the Russian peasant subject-matter that Larionov and Goncharova had already made popular (FIG. 3.21). Tatlin's paintings of the same period, such as his *Self-portrait as a Sailor* (FIG. 3.22), show similar influences. In the period just before and after the 1917 revolution, Tatlin and Malevich were the representatives of the two main tendencies in Russian avant-garde art, Suprematism and Constructivism. Apparently similar, these two differed widely in their fundamental philosophies.

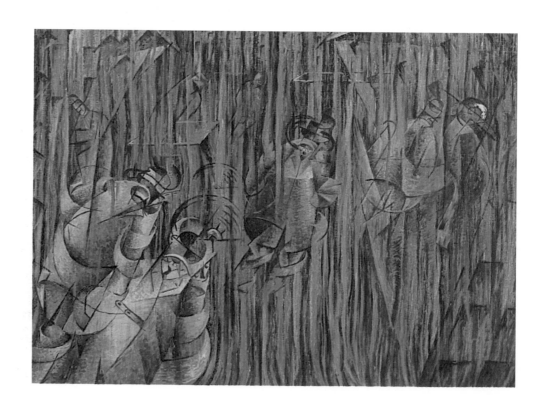

3.21 Kasimir Malevich, *Taking in the Rye*, 1912. Oil on canvas, 28⅜ x 29⅜ in (72 x 74.5 cm) Stedelijkmuseum, Amsterdam.

In one of a series of paintings of Russian peasant life, Malevich combined influences from *lubok*, or Russian folk prints, with ideas taken from Cubism. The curved planes gain emphasis from their brilliant hues and contrasting tones.

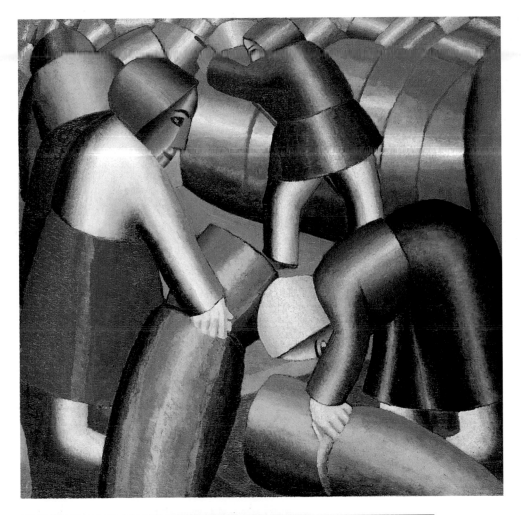

3.22 Vladimir Tatlin, *Self-portrait as a Sailor*, 1911. Tempera on canvas, 28⅛ x 28⅛ in (71.5 x 71.5 cm) Russian Museum, St. Petersburg.

Tatlin ran away to sea at the age of eighteen. The organic, curved surfaces of this painting, derived from Cubism, prefigure the relief constructions that were to come. A circular motif as the organizing principle of his compositions (here around the head) was a Tatlin trademark.

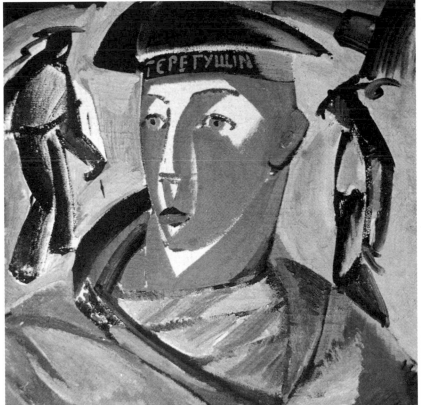

Malevich and Suprematism

Malevich first exhibited Suprematist works in December, 1915, though he afterwards claimed that he had begun to paint them more than two years earlier. They consisted of radically simplified compositions, featuring entirely abstract shapes. The most extreme was a black square on a white ground, which he claimed to have painted in 1913. By 1916, however, Malevich had begun to introduce more complex arrangements of geometrical shapes, set off by delicate shadows. Later still, the shapes once again become very simple, but often fade into the ground, as in the beautiful *Suprematist Painting (Yellow Quadrilateral on White)* (FIG. 3.23). These later paintings are attempts to create a visionary art which exists in its own, independent, purely abstract terms. Malevich wrote in a manifesto, issued in December, 1915, that he envisaged a world in which "things have disappeared like smoke before the new art culture. Art is moving towards its self-appointed end of creation, of domination of the forms of nature."[5]

Constructivism

Malevich completely dominated Suprematism. It is difficult to think of any other artist who made a major contribution to Suprematist philosophy. It was, however, Constructivism that, for a while, became the dominant artistic idiom within the Russian avant-garde. While the term itself did not come into general use until about 1920, the general approach to art which it embodied was already well understood. Constructivism stemmed from the experiments with "real materials in real space" which Tatlin had begun to make in the winter of 1913–14, immediately after paying a flying visit to Picasso in Paris. Picasso was at that point making Cubist constructions, and Tatlin was inspired to push the implications he found in these still further. Most of his constructions have perished, but some have been reconstructed from old photographs (FIG. 3.24), and two survive in the collection of the Tretyakov Art Gallery in Moscow. What Tatlin had begun to do in these reliefs was to study the properties of basic materials—wood, wire, pieces of cardboard, metal plates—through configuring them into a series of related geometric forms. Superficially, the results looked in some ways rather similar to Malevich's Suprematist paintings, but the underlying intention was very different. Tatlin and his associates wanted to make art which dispensed with all illusionistic devices, which reshaped the existing world so as to impart an aesthetic element.

The artists who espoused the new Constructivist philosophy were hostile to the idea that art had to conform to the old categories imposed on it by bourgeois society. Art, they felt, should permeate the whole of the environment, rather than being the almost exclusive concern of a small, moneyed class. These preoccupations made the Constructivist group sympathetic to the new Bolshevik government, which, in turn, was, at first, happy to accept their support, and to offer them, within the limited resources available, fairly free rein as official artists for the new Soviet society.

The leading Russian Constructivists included both men and women—a striking difference from the Italian Futurists who had originally inspired them. (The Futurists were heavily influenced by Nietzsche, who had been violently hostile to the idea of female creativity, whereas Nietzsche's philosophy had much less impact in Russia than it did elsewhere.) There were several practical reasons why

3.23 Kasimir Malevich, *Suprematist Painting (Yellow Quadrilateral on White)*, 1917–18. Oil on canvas, 41¾ x 27¾ in (106 x 70.5 cm). Stedelijksmuseum, Amsterdam.

Malevich said that he meant by the term, Suprematism, the "supremacy of feeling in creative art." This painting is one of a number consisting of blocks of rectangular color on a contrasting ground, in which, he said, all "ordinary objective life" is abandoned, and "nothing is real except feeling."

women played a prominent role in the Russian avant-garde of the revolutionary years. One was that the Revolution shook Russian society to its foundations, and all social norms were therefore abrogated. More important, in a subtle way, was that Constructivism, by stretching the boundaries of the visual arts, drew artistic practice into areas, such as textile design, which were thought of as legitimate female territory. Lyubov Popova (1889–1924) was a distinguished textile designer, and her architectonic paintings of 1917–18 show why this was so, with their interweavings and interactions of color (FIG. 3.25).

The two most important male Constructivists, apart from Tatlin, were Aleksandr Rodchenko (1891–1956) and El Lissitzky (1890–1947). In typical

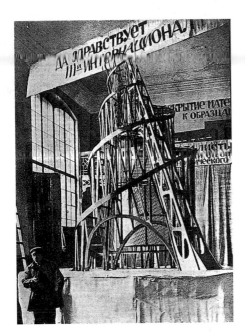

3.24 (above) Vladimir Tatlin, *Monument to the Third International* (model), 1920. Museum of Modern Art, Stockholm.

Tatlin's *Monument to the Third International* is the most famous of a number of unrealized and perhaps unrealizable Constructivist projects which combined aspects of sculpture and architecture. Had it been built, it would have been a new and more daring version of the Eiffel Tower (see FIG. 1.3), containing a congress hall and a radio station. The various elements were intended to revolve at different speeds.

3.25 Lyubov Popova, *Painterly Architectonics*, 1918. Oil on cardboard, 23⅜ x 15½ in (59.4 x 39.3 cm). Dallas Museum of Art, Texas.

This painting demonstrates that the line between Malevich's Suprematism and the Constructivism of a younger generation of his Russian followers was almost invisible. Constructivism was eventually denounced by the Soviet authorities as "the expression of the deepest decline of bourgeois culture in the period of the general crisis of capitalism."

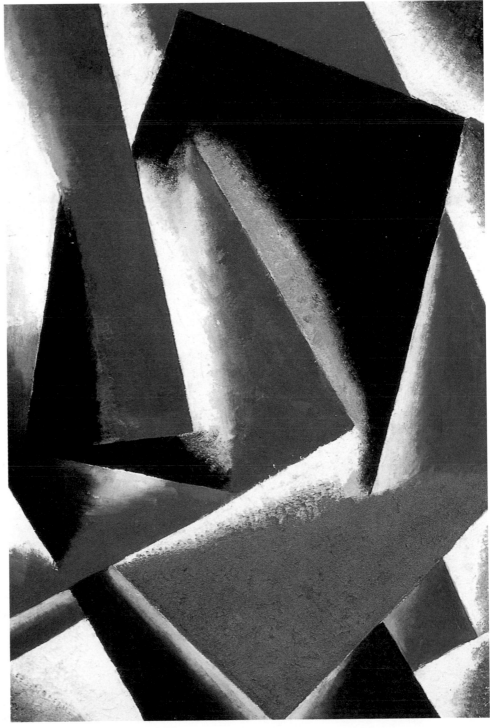

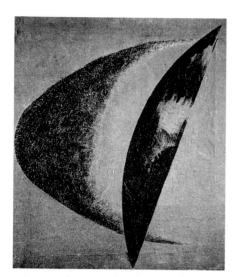

3.26 Aleksandr Rodchenko, *Black on Black, no. 82*, 1918. Oil on canvas, 24⅜ x 20⅞ in (62 x 53 cm). Regional Art Museum, Kirov.

This is one of a series of paintings which Rodchenko intended as an ironic retort to Malevich's *White on White*. In 1920 he declared that painting was dead and turned his attention to typography and industrial design.

Constructivist fashion, both took their activities well beyond the sphere of easel-painting. Rodchenko, who had begun as a follower of Malevich, painting a *Black on Black* canvas (FIG. 3.26) in answer to Malevich's *White on White*, later experimented with "spatial constructions," and pioneered the notion of environmental art with the decor which he, Tatlin, and Georgy Yakulov (1882–1928) created for the Café Pittoresque (early 1917), a bohemian hangout much favored by Moscow artists. Unfortunately, only descriptions of this interior survive. Later, Rodchenko turned to three-dimensional constructions, some of which, made to hang suspended from the ceiling, were the first mobiles, anticipating the work of Alexander Calder.

De Stijl

Another artistic movement which tended to think of easel-painting as only a part, and not necessarily the most important part, of a whole design cosmos was the Dutch group De Stijl, named after the Dutch magazine of aesthetics and art theory founded by Theo van Doesburg in 1917. Van Doesburg (C.E.M. Küpper, 1883–1931) was first a poet, later a painter and architect. He was an energetic propagandist for the Modern movement in general and in the 1920s had a considerable impact on the development of industrial design. In the early years of De Stijl, his closest collaborator was the Dutch painter, Piet Mondrian (1872–1944). Like many of the pioneering Modernist artists, Mondrian was a Theosophist, and in this sense belongs to the "visionary" wing of early Modernism. His mature paintings, nevertheless, are among the most severely systematic and rational of their type.

Piet Mondrian's Early Work

One factor in Mondrian's development was his cultural isolation during the war years. Mondrian, who had been living in Paris, where he had been well acquainted with what the Cubists were doing (he already considered them insufficiently

3.27 Piet Mondrian, *Pier and Ocean Composition, No. 10*, 1915. Oil on canvas, 33½ x 42½ in (85 x 108 cm). Kröller-Müller Museum, Otterlo, The Netherlands.

Mondrian's series of *Pier and Ocean* canvases, which evolved from his earlier landscapes, was clearly influenced by Cubism in its embrace of a subdued palette and geometrical semi-abstraction. The oval shape suggests the globe.

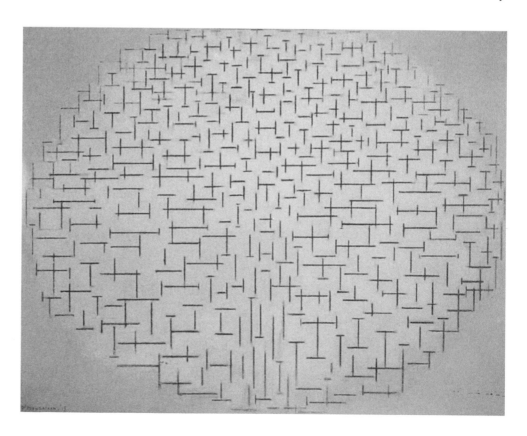

3.28 Oskar Kokoschka, *Knight Errant*, 1915. Oil on canvas, 35¼ × 70¾ in (89.5 × 100.1 cm). Solomon R. Guggenheim Foundation, New York.

This picture reflects both the artist's feelings about the end of his love-affair with Alma Mahler and his forebodings about the outcome of the war and his own part in it.

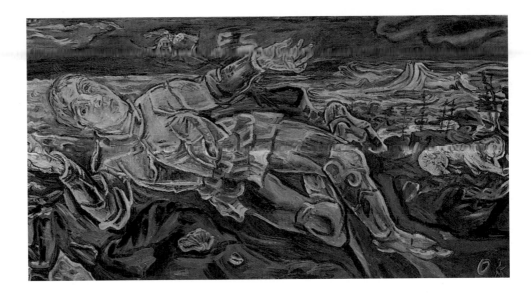

abstract) returned home in 1914 and remained there till 1919. His *Pier and Ocean* series (FIG. 3.27), painted in the early war years, still contained references to nature—their broken, delicately dislocated grids echo the rippling of the waves— but in 1917 his art entered a new phase. First the composition was reduced to an arrangement of colored rectangles. Then the rectangles were brought together, so that the canvas, divided into a grid, became a wholly self-sufficient pattern, rather than a plane with separate items floating in front of it. Mondrian increasingly sought to remove all traces of the brush stroke, or of an individualized technique. The color-range was deliberately disciplined—white, black or grey, plus the three primaries, red, yellow, and blue. Lines were either horizontal or vertical, and invariably met at right angles.

This stringent, wholly rational art, combined with things taken from the more dynamic work of the Russian Constructivists, seemed to offer a form of universal visual language, and many artists sought to build on Mondrian's discoveries after the war. Other members of the international avant-garde, however, reacted more directly to the catastrophic events of 1914–18.

THE WAR YEARS

The war did not have a simple impact on the visual arts. Artists on both sides of the fence were often seized with patriotic ardor. Some artists had premonitions of disaster. The allegorical *Knight Errant* (FIG. 3.28) was the last picture painted by the Austrian Expressionist, Oskar Kokoschka (1886–1980) before he joined up. It seems to reflect both the unhappy ending of his love affair with Alma Mahler, the widow of the composer, Gustav Mahler (1860–1911), and his own impending fate—he was severely wounded on the Russian front in August, 1915, and was lucky to escape with his life. In war, other artists simply found a new range of subject-matter. Egon Schiele. (1890–1918), the other major representative of Austrian Expressionism, was conscripted in 1915, after vainly trying to secure a position as an official war artist. He was set to guarding Russian prisoners of war. One of the most brilliant draughtsmen of all time (perhaps Picasso's only genuine rival in this field in the twentieth century), he is perhaps best-known for his cruelly erotic drawings (FIG. 3.29). Ambitious portrayals of the horror and evil of war by Modernist painters came, for the most part, after the conflict was over. Official war artists found themselves constrained by the demand that their work be "accessible"—which meant recognizably figurative—and by the authorities' understandable skittishness about images which seemed to push horror too far.

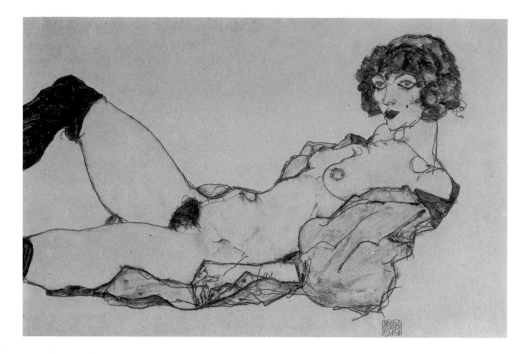

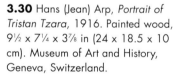

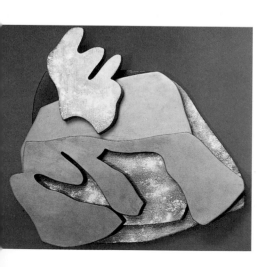

Dada: Marcel Duchamp

It is usual to identify the nihilistic spirit of Dada, which was perhaps in the long run the most important art movement of the period 1914–18, with feelings of disgust and revulsion inspired by the war. This is to endow Dada with a moral dimension which many of its leading participants would have rejected outright.

The name Dada was probably not French. It was invented in Zurich in 1915, and may derive from a childish German word for a hobby-horse. Nevertheless, the actual spirit of Dada had deep roots in prewar French culture, specifically in the poker-faced ironic jesting which had long been typical of bohemian life in Paris. The contribution made by this ironic spirit to Cubist collage was to be taken much further by the Dadaists, especially by Marcel Duchamp (1887–1968). Duchamp, one of three artist brothers, all of them originally connected in one way or another with Cubism, was the chief inheritor of the spirit of what was called "blague." In an article published in *La Grande Revue* on 1 March, 1902, Jules Wogue defined it thus: "Above all, *blague* is an overthrower, and when it is successful it has a certain critical value. It attacks all forms of illusion; beneath the mirages that it dispels, it reveals the sadness of things."

As early as the 1870s and 1880s, ideas which were to become associated with Duchamp and his Dadaist peers had been common currency among Parisian satirists. In 1877, for example, the immensely successful boulevard playwrights, Meilhac and Halévy, offered a play called *La Cigale* at the Théâtre des Variétés. Among the characters is a young bourgeois amateur painter with a private income. His *Forest of Fontainebleau in the Fog* is an all-gray canvas, to which is attached a knife to show how thick the fog is. This was very much in the spirit of Duchamp, who was perhaps the first artist to turn the avant-garde weapons of confrontation and contradiction against the avant-garde itself. Duchamp's chief tool was the readymade (see FIG. 3.31), a banal object plucked from the surrounding environment and designated by the artist as a work of art.

Zurich and the Cabaret Voltaire

During the war years, the city of Zurich, in neutral Switzerland, became a place of refuge for a number of avant-garde figures. One of these was the musician and experimental writer, Hugo Ball (1886–1927), who established the Cabaret Voltaire

Marcel Duchamp: *Fountain*

The most notorious of Marcel Duchamp's "readymades" is the *Fountain* (FIG. 3.31), a urinal selected from a hardware supplier, signed with the pseudonym "R. Mutt" and submitted to a non-juried exhibition in New York, where Duchamp was then living—the perfect *reductio ad absurdum* of supposedly democratic principles in art. While Duchamp's immediate purpose was to provoke his colleagues and expose the hypocrisy of their supposed liberal attitudes (*Fountain* was duly rejected, even though the show to which it was submitted supposedly had no selection process), he had other, longer-term objectives as well. The readymades were Duchamp's answer to artistic overproduction on the one hand, and institutionalized avant-gardism on the other. Through them, Duchamp argued that much of the avant-garde art being produced, even at this very early period in the development of Modernism, was in fact rubbish, of less significance, in terms of formal impressiveness, than many objects of everyday use. All that was required was to remove these everyday objects to a different context, that of the art gallery, so that their qualities as forms to be contemplated could be revealed. He also argued that the avant-garde, far from being experimental, was beginning to rely on formulae—in other words, it was itself becoming academic. The rebellion represented by the readymades was, however, a purely intellectual one—they are best regarded as precursors of the Conceptual Art movement of the 1960s. Though some of the most significant were produced during the war years, they had nothing to do with the war itself. Their significance was not that they echoed a mood of hopelessness and despair, but that they offered a new definition of the artist, as a person who manipulated the context as a way of changing perceptions, rather than as someone who was primarily a maker of objects. At the same time, Duchamp offered a new and subversive definition of originality, the *sine qua non* of all successful art since the epoch of the Romantics. He thus began to separate Modernism from its tenacious nineteenth-century roots.

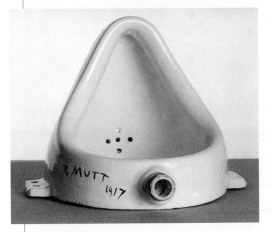

3.31 Marcel Duchamp, *Fountain*, 1917. Found porcelain object, height 24 in (61 cm). Museum of Modern Art, New York.

at No. 1 Spiegelgasse. This became a focus for a group of poets and other writers, among them the Romanian, Tristan Tzara (1886–1963) and the German, Richard Hulsenbeck (1882–1974). Though the cabaret was primarily literary, it attracted artists such as Marcel Janco (1895–), who was a compatriot of Tzara, and Jean Arp (1887–1966). The emphasis at the Cabaret Voltaire was on gleefully nonsensical performances designed to shock and astound the Swiss bourgeoisie. Arp left a lively account of one of these events:

> On the stage of a gaudy, motley, overcrowded tavern there are several weird and peculiar figures representing Tzara, Janco, Ball, Hulsenbeck and your humble servant. Total pandemonium. The people round us were shouting, laughing and gesticulating. Our replies are sighs of love, volleys of hiccups, poems, moos and miaowings of medieval Bruitistes. Tzara is wiggling his behind like the belly of an oriental dancer. Janco is playing an invisible violin and bowing and scraping. Madame Hennings [a singer, and Ball's mistress], with a Madonna face, is doing the splits. Hulsenbeck is banging away non-stop on the great drum, with Ball accompanying him on the piano, pale as a chalky ghost.[6]

Arp was one of the very few members of the group who produced actual art works (FIG. 3.30). He began what was to be a distinguished career as a sculptor by making a series of painted wooden reliefs. The forms of some of these were determined by using chance procedures—sometimes their configurations would be

fixed by throwing torn-up pieces of paper on to the floor.

The Cabaret Voltaire did not retain its energy for long. In 1917, Hugo Ball left to work as a journalist in Berne, and Richard Hulsenbeck returned to Berlin. All the participants, however, seemed to feel that the brief period of anarchic euphoria in Zurich had equipped them to carry the Dada gospel to other regions of Europe as soon as conditions allowed. While there were other Dada centers on the periphery of World War I, notably in Barcelona and New York, where Duchamp had arrived in 1915 (he was exempted from war service because of his poor health), the most immediate impact was felt in Berlin.

Berlin Dada

Richard Hulsenbeck arrived back in Berlin just before German society began to crumble under the stresses of the war. He gave his "First Dada speech in Germany" (an event modeled on some prewar Futurist manifestations) in February, 1918, and issued a Dada manifesto the following April. Given the social

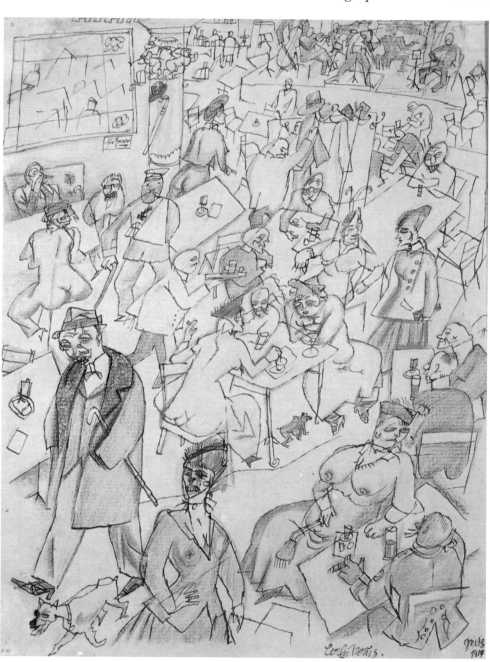

3.32 George Grosz, *Café Scene*, 1914. Crayon, ink, pencil on paper, 11 x 8½ in (28 x 21.5 cm). Private collection.

conditions then prevailing in Germany, it was inevitable that the movement would take on a political complexion which it had not possessed previously. Hulsenbeck's recruits to the cause included John Heartfield (Helmut Herzfelde, 1891–1968), who was to become famous during the 1920s for his caustic photomontages, and George Grosz (1893–1959). Grosz was already celebrated for his satirical drawings, which had begun to be published in 1915. (FIG. 3.32). He later recalled his stylistic models at this period:

> In order to attain a style which would render the blunt and unvarnished harshness of my objects, I sought out the crudest manifestations of the artistic urge. In public urinals I copied the folkloristic drawings; they seemed to me to be the most immediate expression and the most succinct translation of strong feelings. Children's drawings, too, stimulated me because of their lack of ambiguity. Thus it was that gradually I came to use the hard-as-nails drawing-style which I needed to transfer on to paper my observations which, at that time, were dictated by absolute misanthropy.[7]

Grosz was attracted to Dada by its sheer rebelliousness. His artistic sources, some of them already well known to members of prewar groups such as Die Brücke and Der Blaue Reiter, were selected without aid from the new movement.

Pittura Metafysica

The contrast between Dada and the Pittura Metafysica, ("Metaphysical Painting"), which flourished in Italy during the war years, could not, at least upon the surface, have been more absolute. Nevertheless they had surprising things in common—they owed something to prewar Futurism (in Dada's case to Futurism's noisy public manifestations; in that of Pittura Metafysica, to the visionary element), and they both led toward Surrealism. Pittura Metafysica was essentially the creation of Giorgio de Chirico (1888–1978), who, with his associate, Carlo Carrà (1881–1966) coined the term for the calm, empty architectural scenes enlivened by incongruous objects which they both painted after 1910.

De Chirico, born in Greece of Italian parentage, and trained partly in Munich, had been heavily influenced in his youth by two German late Romantics, both with a distinctly Symbolist tinge—Arnold Böcklin (1827–1901) and Max Klinger (1857–1920). He had already begun to paint recognizably "metaphysical" pictures as early as 1911, and these brought him to the attention of the French avant-garde, notably to Apollinaire, who became his champion. De Chirico wanted to find a way of representing alienated states. As he noted, "an inexplicable state X can exist both behind and in front of a painted, described, or imagined thing, but above all within the thing itself."[8] De Chirico's deserted piazzas, his strange conjunctions of ordinary objects, are represented in what is on the surface a straightforward, slightly naive style which owes something to genuine "primitives" like Henri Rousseau (see FIG. 2.10). Part of their effect, as the spectator only gradually discovers, springs from the artist's subtle distortion of traditional systems of perspective (FIG. 3.33). The Berlin Dadaists shouted that something was seriously wrong with the world. De Chirico forced his audience to the same conclusion by slyly disorienting them.

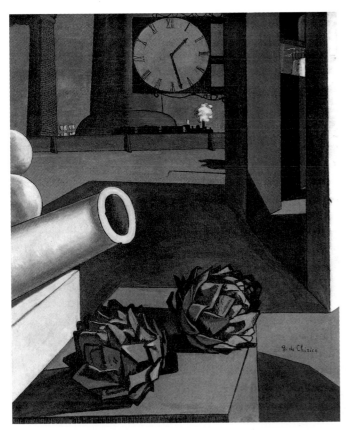

3.33 Giorgio de Chirico, *The Philosopher's Conquest*, 1914. Oil on canvas, 49¼ x 39 in (125 x 99 cm). Art Institute of Chicago (Joseph Winterbotham Collection).

Menacing, empty spaces were a recurrent theme of De Chirico's paintings, suggesting the disoriented world of nightmares. The title of the piece may derive from the painter's use of the word "metaphysical" to describe the dislocation of dreams.

3.34 (opposite) Henri Laurens, *Bottle, Glass, and Newspaper*, 1916–17. Wood and painted cloth, 20⅛ x 15¾ x 8⅝ in (51 x 40 x 22 cm). Stedlijksmuseum, Amsterdam.

3.35 Umberto Boccioni, *Unique Forms of Continuity in Space*, 1913. Bronze (cast 1972), 43⅞ x 34⅞ x 15¾ in (111.4 x 88.6 x 40 cm). Tate Gallery, London.

Sculpture was a more suitable medium than painting for the Futurist ambition to represent movement in time. The forward movement of Boccioni's striding is suggested by the sequence of surface planes.

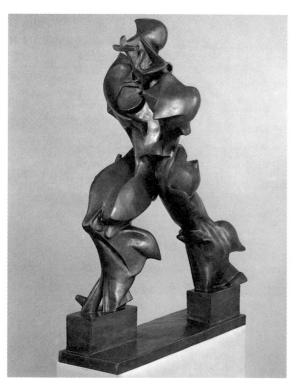

PAINTING IN THE UNITED STATES

The Armory Show

The Modernist revolution, which had begun in Europe, received its consecration with the great Armory Show, held in New York in February and March of 1913, and afterward seen in Chicago and Boston. About 1,600 exhibits were included, and though the impulse to organize the exhibition came from the circle surrounding Robert Henri, the emphasis was firmly on members of the Ecole de Paris, from Symbolists and Postimpressionists through to the Fauves and the Cubists. The show was a stunning public success, and was seen by at least 300,000 visitors. Its effect on art in the United States was paradoxical. The Ashcan School, largely responsible for creating the exhibition, was cast into the shade. Though leading American Modernists such as Joseph Stella (1877–1946), who had been in contact with the Futurists, were included among the exhibitors, they too were eclipsed by the glamor of the foreign stars. It took patient work by entrepreneurs like Stieglitz, who was now showing painters rather than photographers at 291, to keep American Modernism alive. At the same time, the Armory Show established Modernism itself in the American consciousness—in a single step it became part of American culture. Similar, but less ambitious, exhibitions arranged in Great Britain by the painter and critic, Roger Fry (1866–1934), such as the Postimpressionist Exhibition of 1910 and the Second Postimpressionist Exhibition of 1912, attracted a certain amount of attention but signally failed to accomplish the same thing. It was the beginning of a significant divide in the visual culture of the two chief English-speaking nations.

Sculpture

Cubist and Futurist Sculpture

Picasso's attempts to translate the conventions of Cubism into three dimensions were followed up by a number of other artists, men who were primarily sculptors. None of them surpassed their mentor in originality. This was not surprising—Cubist painting was essentially a way of representing in two dimensions the structure of three-dimensional forms. In sculpture this effort became superfluous, and Cubist faceting became no more than a decorative convention. The two artists who made best use of this convention were the Lithuanian-born Jacques Lipchitz (1891–1973), who, in his best work, showed the influence of Juan Gris, and Henri Laurens (1885–1954). Laurens, in his Cubist phase, made solid, block-like sculptures, where the forms were articulated with broad, flat planes (FIG. 3.34). They are, despite their solidity, generally meant to be seen frontally, rather than in an unfolding series of views, and this makes them more like reliefs than true sculptures. Both Lipchitz and Laurens abandoned Cubist conventions in the 1920s.

More dynamic and exciting sculptures were made by artists who had been touched by the doctrines of Futurism, and who, in particular, were interested in applying Futurist ideas about simultaneity. Unfortunately the two most promising artists working along these lines were killed during the war. One was the painter, Boccioni. He made few sculptures and fewer still survive. The most impressive is *Unique Forms of Continuity in Space* (FIG. 3.35), whose motif is a striding figure. Boccioni contrives to suggest that, as the figure moves forward, it carries "blocks of atmosphere" (his own phrase) along with it. The

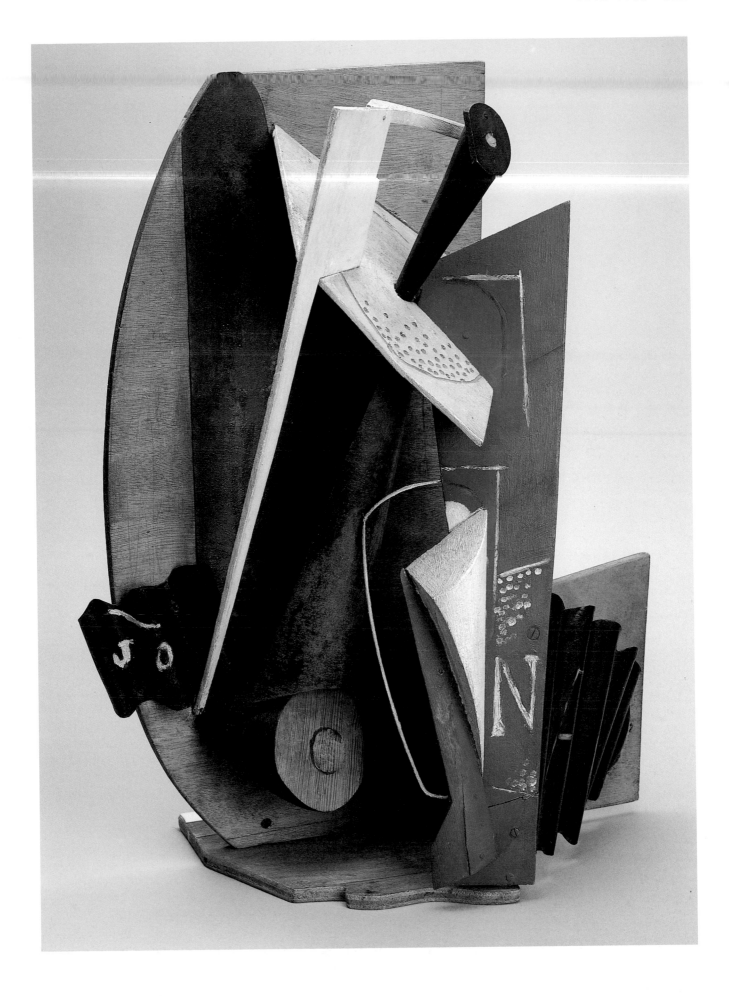

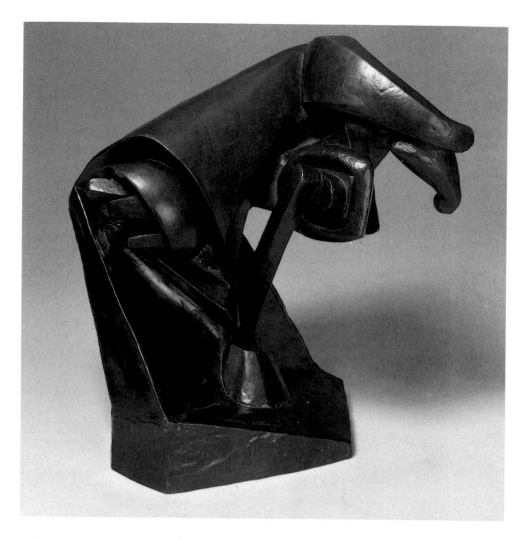

3.36 Raymond Duchamp-Villon, *Horse*, 1914. Bronze, 17¼ x 15¼ x 11¾ in (43.7 x 38.9 x 29.7 cm). Hirshhorn Museum and Sculpture Garden, Smithsonian Institution, Washington, D.C. (Gift of Joseph H. Hirshhorn).

Duchamp-Villon's semi-abstract representation of the movements of a leaping horse crackles with energy and punningly suggests mechanical horsepower. The sculpture is clearly in tune with Futurist ideas about movement.

other was an older brother of Marcel Duchamp, Raymond Duchamp-Villon (1876–1918), whose *Horse* is a semi-abstract diagram of the motions of a leaping animal (FIG. 3.36).

Constantin Brancusi and Amedeo Modigliani

The most original purely sculptural talent to emerge during the second decade of the century was the Romanian, Constantin Brancusi (1876–1957). Of peasant stock, Brancusi ran away from home at the age of eleven. He left Romania in 1902 and settled in Paris in 1904. His early work was made under the influence of Rodin, who was sufficiently impressed to offer the young artist a place in his studio. Brancusi refused, saying "Nothing ever grows well in the shade of a big tree." His mature sculpture was, in fact, to be a retort to everything Rodin had stood for. His aim was to reduce the subject to its simplest, most generic form. This is true, for example, of the different versions of *The Kiss* (FIG. 3.37), which shows two lovers locked in the same block. Rodin worked largely in bronze. When he did work in marble he followed standard nineteenth-century practice and called in specialist carvers to do the work from a plaster model. Brancusi, close to the artisan tradition of eastern European folk-art, reintroduced the practice of direct carving, and his example was to have immense impact on many Modernist sculptors during the opening decades of the century.

Brancusi's sculptures have frequently been described as "abstract." This impression has been reinforced by a case fought in the American courts in 1926–8, when one of Brancusi's works was classified by U.S. Customs as an industrial

3.37 Constantin Brancusi, *The Kiss*, c. 1912. Limestone, 23 x 13 x 10 in (58.4 x 33 x 25.4 cm). Philadelphia Museum of Art, Pennsylvania (Louise & Walter Arensberg Collection).

Carved from a single block of stone, this deeply affecting sculpture, Brancusi's first major work, reveals his ability to reduce forms to a great simplicity of volumes and planes.

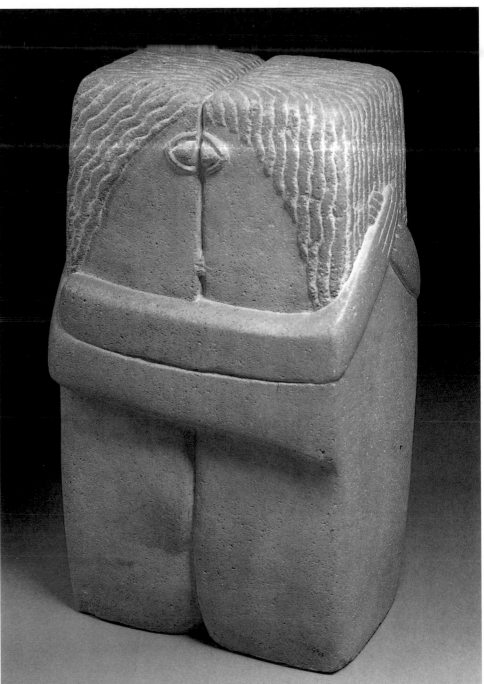

3.38 (*below*) Amedeo Modigliani, *Female Head*, c. 1911–12. Stone, 25 x 3⅞ x 13¾ in (63.5 x 12 x 35 cm). Tate Gallery, London.

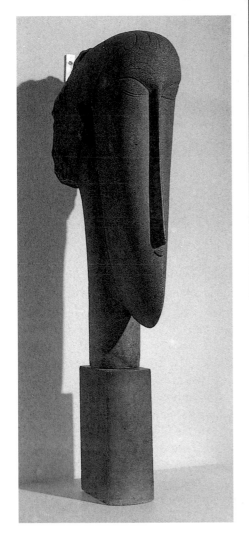

object, rather than as a duty-free work of art. In fact, even his most apparently abstract works have their roots in natural appearances—they never strive to be completely independent of these like the mature work of Mondrian or that of the Russian Constructivists. In this sense, Brancusi was less radical than he seems at first sight.

Amedeo Modigliani (1884–1920), Brancusi's only direct pupil, is now best remembered as a painter and draughtsman, but his real ambition was to be a sculptor. Chronic poverty prevented him from achieving it: his few sculptures, mostly heads, were made from blocks of stone scavenged from the building sites which abounded in Paris at that time. In addition to being influenced by Brancusi, these heads show clear evidence of the impact made on Modigliani by the African carvings he saw in the Musée de l'Homme in Paris (FIG. 3.38).

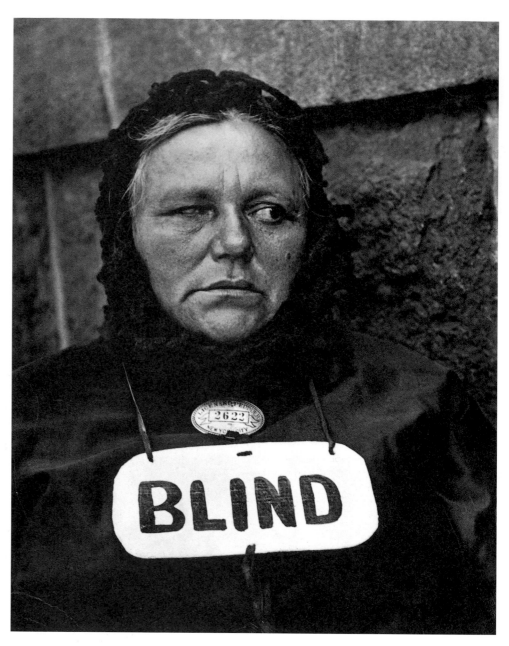

3.39 Paul Strand, *Blind Woman, New York*, 1916. Platinum print, from enlarged glass plate negative. Paul Strand Archive, New York.

This unsparing, intrusive close-up is a strong example of Strand's opposition to the pictorialist photographers. He believed in making his images "without tricks of process or manipulation through the use of straight photographic methods."

Photography

The Reaction against Pictorialism

The war years witnessed a reaction, chiefly in the United States, against the pictorialist ethos in photography. Behind this reaction lay the impact made by the Armory Show—quite specifically its effect on Stieglitz—and the continuing hostility expressed by avant-garde painters and critics who regarded Pictorialism (and photography in general) as a feeble attempt to imitate a kind of art which was already old-fashioned.

After 1910, Stieglitz's gallery at 291 more and more became a showcase for avant-garde painting and sculpture. Among the artists he exhibited were Cézanne, Matisse, Picasso, and Braque. From 1910 until the closure of the gallery in 1917 he showed very few photographs. The one new photographer he favored was Paul Strand (1890–1976). Strand advocated an aesthetic governed by the nature of photography itself:

The photographer's problem is to see clearly the limitations and at the same time the potential qualities of his medium, for it is precisely here that honesty no less than intensity of vision is the prerequisite of living expression. This means a real respect for the thing in front of him expressed in terms of chiaroscuro … through a range of almost infinite tonal values which lie beyond the skill of human hand.[9]

Strand applied his own doctrine in two different ways. One was by making deliberately "raw" documentary photography, such as his brutal close-up of a blind beggarwoman, made in 1916 (FIG. 3.39). Looking at it, one recalls that Strand had been a pupil of Lewis Hine, but it goes beyond Hine's indignant documentation of injustice and becomes almost a piece of psychological banditry, a deliberate intrusion into another existence. The other was by making photographs of quotidian reality in such a way that the image becomes a quasi-abstract arrangement of forms. In *Chair Abstract, Twin Lakes, Connecticut* (FIG. 3.40), the inspiration is clearly Cubist collage. The use of extreme close-up, combined with a raking viewpoint, was to be taken up by many other photographers during the period between the wars.

3.40 Paul Strand, *Chair Abstract, Twin Lakes, Connecticut*, 1916. Palladium print. San Francisco Museum of Art, California.

Strand was one of a number of photographers (another was Florence Henri) inspired by Cubism. He took photographs of still lifes as a means of producing decorative compositions in planes and forms that become almost abstract.

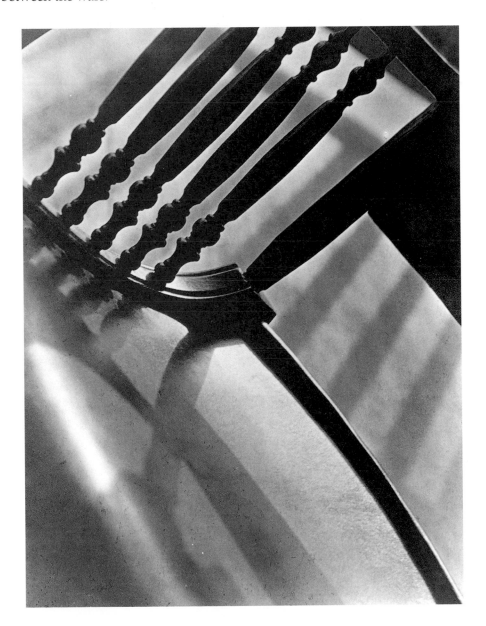

1920	1921	1922	1923	1924

GENERAL EVENTS

1920	1921	1922	1923	1924
• Foundation of League of Nations • 19th Amendment gives American women the vote • Colette publishes *Chérie* • Gandhi launches civil disobedience campaign in India	• Beginning of hyper-inflation in Germany • Beginning of US stock-market boom • End of Mexican revolution • Sacco–Vanzetti murder trial in the United States • Luigi Pirandello stages *Six Characters in Search of an Author*	• Soviet states unite to form USSR • Mussolini's "March on Rome" leads to formation of Fascist government, Italy • Irish Free State officially proclaimed • James Joyce publishes *Ulysses* • Louis Armstrong's first recording	• German mark at 4 million to US$1 • Hitler mounts *coup d'état* in Munich, which fails • Greta Garbo's film debut • John Maynard Keynes publishes *A Tract on Monetary Reform*	• Death of Lenin • First Winter Olympics, Chamonix, Switzerland • George Gershwin composes *Rhapsody in Blue* • E. M. Forster publishes *A Passage to India* • Hitler writes *Mein Kampf* while in prison

SCIENCE AND TECHNOLOGY

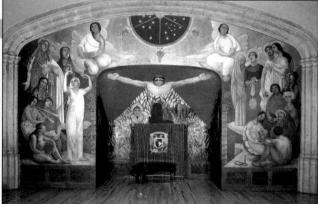

Rivera, *Creation*: see p.135

1920	1921	1922	1923	1924
• Swiss psychiatrist Hermann Rorshach invents "Rorschach" ink-blot test • Thompson submachine gun patented • Structure of the Milky Way demonstrated for the first time through the use of photography	• First tuberculosis vaccine • Insulin discovered • Albert Einstein wins the Nobel prize in physics	• Insulin first given to diabetics • Discovery of Vitamin E	• Continuous hot strip-rolling of steel invented • Diphtheria vaccine discovered	• First use of insecticides • 25 million radios in use in United States

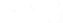

Le Corbusier

ART

1920	1921	1922	1923	1924
• Death of Amedeo Modigliani • Dada exhibition at the Winter Brasserie, Cologne	• Diego Rivera returns to Mexico from United States • Constantin Brancusi, *Bird in Space* (1st version) • Fernand Léger, *Three Women* • Max Ernst, *The Elephant of the Celebes*	• "Semana de Arte Moderna" held in São Paolo, Brazil • Pablo Picasso, *Women on the Beach* • Marc Chagall and Vassily Kandinsky leave Russia for Germany	• "Grosser Berlin Kunstausstellung," exhibition in Berlin • Max Beckmann, *The Trapeze* • Marcel Duchamp, *The Bride Stripped Bare by Her Bachelors* • The American collector Albert C. Barnes buys 100 works from Chaim Soutine	• First Surrealist manifesto published, Paris • Stuart Davis, *Odol* • Fernand Léger directs *Mechanical Ballet*

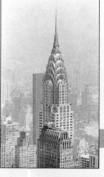

Van Alen, Chrysler Building: see p.120

ARCHITECTURE

1920	1921	1922	1923	1924
• Edwin Lutyens, Finsbury Circus façade of Britannic (now Lutyens) House, London	• Erich Mendelsohn, Einstein Tower, Allenstein, Germany • Ludwig Mies van der Rohe develops a skyscraper project in glass, the birth of "curtain wall" construction	• Auguste Perret, Notre Dame church, Le Raincy, France • Rudolf Schindler, Lovell Beach House, Los Angeles (–1926)	• Le Corbusier publishes "Vers une Architecture"	• Gerrit Rietveld, Schröder House, Utrecht, the Netherlands • J.J.P. Oud, Hook of Holland housing estate (–1927)

1925　　1926　　1927　　1928　　1929

- Stalin ousts Trotsky from power
- Christiania, the Norwegian capital, renamed Oslo
- Sergei Eisenstein directs *The Battleship Potemkin*
- F. Scott Fitzgerald writes *The Great Gatsby*

- "Hitlerjugend" (Hitler Youth) founded, Germany
- General Strike in Britain
- Fritz Lang directs *Metropolis*
- T. E. Lawrence (Lawrence of Arabia) publishes *The Seven Pillars of Wisdom*

- German economy collapses
- Trotsky expelled from the Soviet Communist party
- Charles Lindbergh flies solo non-stop from New York to Paris
- Civil war breaks out in China

Schindler, Beach House: see p.120

- Chiang Kai-shek elected president of China
- Amelia Earhart becomes first woman to fly the Atlantic
- D. H. Lawrence publishes *Lady Chatterley's Lover*
- First performance of Bertolt Brecht's *The Threepenny Opera*, with music by Kurt Weill

- Stock Market crash in New York on 2 October precipitates world economic crisis
- Trotsky expelled from the USSR
- "Talkies" replace silent films in popularity
- Death of Sergei Diaghilev

- Russian scientist I.V. Pavlov publishes *Conditioned Reflexes*
- 15 million Model T Fords produced by this date

- Alexander Fleming discovers penicillin
- George Eastman exhibits first color motion pictures
- The Geiger counter is invented

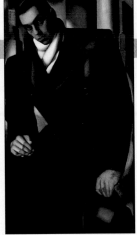

De Lempicka, Tadeusz de Lempicki: see p.139

- Quartz-crystal clocks introduced

- John Logie Baird transmits recognizable human features by television
- First Leica camera
- First solar eclipse in New York for 300 years

- First liquid-fuel rocket
- Kodak produces first 16 mm photographic film

Sironi, Solitude: see p.124

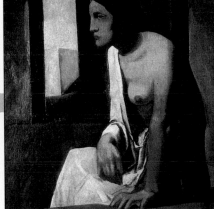

- Bauhaus accused of Bolshevism and degeneracy—forced to leave Weimar for Dessau, Germany.
- Mario Sironi, *Solitude*
- First Surrealist exhibition

- First Novecento group exhibition, Rome
- Paul Klee, *Neighborhood of the Italian Villas*
- Georges Grosz, *Pillars of Society*
- Otto Dix, *Sylvia von Harden*
- First exhibition of Max Ernst's frottages in Paris

- René Magritte, *The Murderer Threatened*
- Ernst Barlach, *Güstrow Angel*
- Death of Juan Gris

- Tarsila do Amaral, *Abaporu*
- André Breton publishes *Surrealism and Painting*

- Piet Mondrian, *Foxtrot B*
- Charles Sheeler, *Upper Deck*
- Inauguration of MOMA, New York
- Salvador Dalí and Louis Bunuel direct the surrealist film fantasy *Un chien andalou*

- Exposition des Arts Décoratifs, Paris
- Walter Gropius, Dessau Bauhaus (–1926)

Key Surrealists (from left to right): Georges Malkine, André Masson, André Breton, Max Morise, and Georges Neveux

- Death of Antonio Gaudí

- Inauguration of the Bauhaus building in Dessau

- Johannes Brinkman and L.C. van der Vlugt, Van Nelle Tobbaco Factory, Rotterdam, the Netherlands
- William van Alen, Chrysler Building, New York

- St. Vitus's Cathedral, Prague, completed (begun in 1397)
- Le Corbusier produces designs for "The City of Tomorrow"

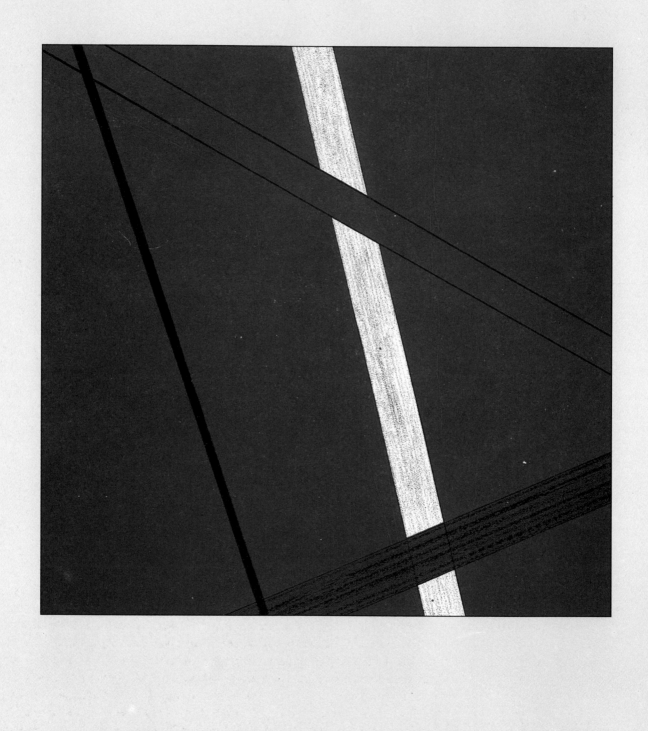

1920–1929

The 1920s have often been seen as an epoch of renewed caution and conservatism in the arts. This is true up to a point. Conservative forces manifested themselves in the great democracies—France, Great Britain, and the United States—and also in the Soviet Union, where the alliance between the avant-garde and the new Soviet regime proved increasingly fragile and difficult. In Italy, the rise of Mussolini's Fascism brought with it a rather self-conscious return to Classical imagery and supposedly Classical values. Yet the current did not flow in one direction only. The birth of the Surrealist movement in 1924 represented the beginning of an entirely new path, in which the conscious mind was devalued in favor of the operations of the unconscious. In one sense, Surrealism represented a victory for the ideas of Sigmund Freud. In another sense, it was entirely radical and novel—not least in its attack on the moral preoccupations which had long been placed at the center of many kinds of artistic activity. When André Breton (1896–1966), the founder of the Surrealist movement, issued his first manifesto, one of the things he stressed was the absence, not only of traditional aesthetic concerns, but of moral ones as well.

Ludwig Wittgenstein

There is a strange link between this aspect of Surrealism and the philosophical investigations of Ludwig Wittgenstein (1889–1951), whose first major philosophical work, the *Tractatus Logico-Philosophus*, was published in 1921. The *Tractatus* consists of only 20,000 words, but it was to effect a major shift in Western philosophy. According to Wittgenstein, the objects which philosophy had traditionally set itself, such as giving guidance about how to live the good life, were, because of the nature of language, forever out of reach. The chief task which the philosopher could hope to accomplish was that of clarifying propositions, rather than delivering judgments about them.

The Weimar Republic

Though Paris remained, as it had from the beginning of the century, the unchallenged metropolis of the visual arts, the social and intellectual conflicts of the decade were more sharply focused in the Weimar Republic, the weak and struggling state which had taken the place of the Imperial Germany defeated in 1918. Crippled by the war reparations imposed by the victorious Allied powers, and prey to savage political factionalism, Weimar democracy stumbled from one crisis to the next, until it was brought down by the worldwide economic recession which began in 1929. Yet it was the creator of a more complete and coherent approach to the visual arts and their place in twentieth-century society than was formulated elsewhere. That achievement owed much to the prewar activities of the Deutsche Werkbund, in whose ambit leading figures in the arts had begun their careers. One salient difference, however, was that, while the Werkbund had generally been thought of as a way of rationalizing Germany's industrial production and of giving the nation as a whole a better chance to compete with its rivals, the Werkbund's successors, most notably the artists and architects identi-

fied with the Bauhaus, were perceived as the partisans of the left. It was this perception which forced the transfer of the institution from Weimar to Dessau in 1925, and which earned it the unremitting hostility of the National Socialist Party led by Adolf Hitler.

Architecture

ARCHITECTURE IN EUROPE

The Netherlands: J.J.P. Oud

Despite the ravages of the war, it was Europe which took the lead in architecture during the 1920s. The foremost architects of the time did not always get the opportunity to realize their more visionary plans, but they created a new architectural language. The three most potent forces were the architects associated with the Bauhaus in Germany, those associated with the group called De Stijl in Holland, and Le Corbusier (Charles-Edouard Jeanneret, 1887–1965) in France.

The new impulse in Dutch architecture came from architects linked to the magazine *De Stijl*, founded in 1917. Though the Netherlands remained neutral during World War I, economic conditions were difficult, and architects had little opportunity to put their principles into practice until after the conclusion of hostilities. The theoretical basis of De Stijl was the use in art of completely basic forms—intersections of horizontal and vertical lines, a method labeled Neo-plasticism. These principles were more easily applied in architecture than they were in painting and sculpture, especially as there were already some existing prewar examples, such as the Fagus factory by Gropius and Meyer at Alfeld-an-der-Leine (see FIG. 3.7). The more notable achievements of the architects associated with the group include the small Schröder House in Utrecht by Gerrit Rietveld (FIG. 4.1) and the housing estate built at the Hook of Holland by J.J.P. Oud (FIG. 4.2). The Schröder house was an application to full-scale architecture of principles Rietveld had evolved when designing furniture. His buffet of 1919 is an assemblage of wooden spars and planes, doweled together so as to create a form which is rectilinear but not closed. The Schröder House, though built in traditional brick and

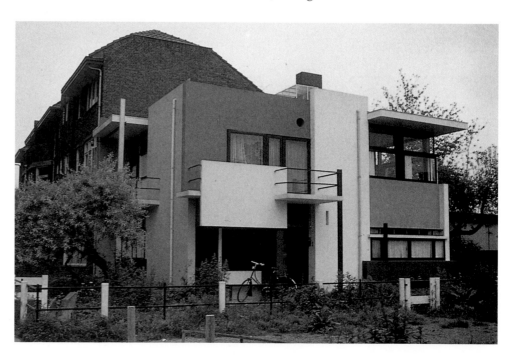

4.1 Gerrit Rietveld, Schröder House, Utrecht, The Netherlands, 1924.

This small house is an almost perfect translation to architecture of the De Stijl style that Rietveld had already used in his furniture designs. Its open-plan interior and projecting planes link it to the houses of Frank Lloyd Wright in the United States (see FIG. 2.4).

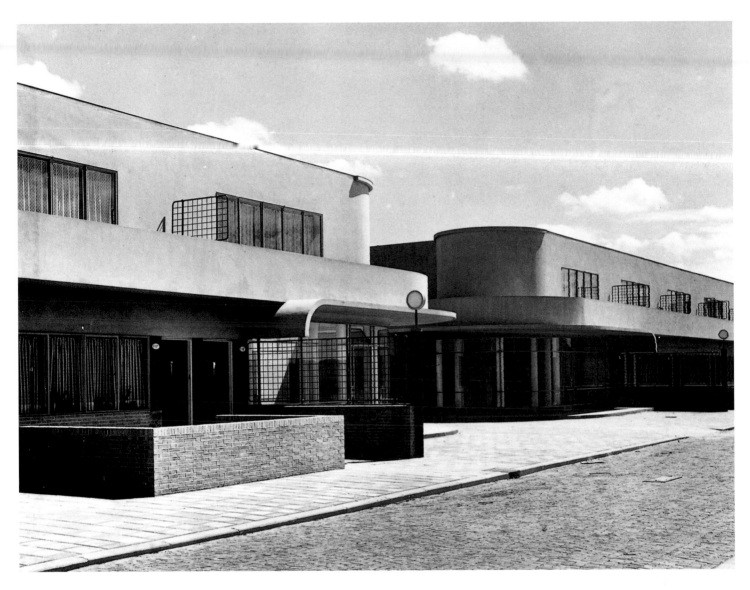

4.2 J.J.P. Oud, Housing Estate, Hook of Holland, 1924–7.

This building bears several hall-marks of De Stijl: flat roof, clean lines, bare façades. Its influence went far beyond mere architectural appearance, since it was a model of well-designed, low-cost housing.

timber, has a similar dynamism and openness. The upper floor, which is the main living space, has no fixed partitions, and can be configured by the inhabitants as need and fancy dictate.

Oud's small housing estate—it consists of only two terraces with shops at their ends—created a new idiom for popular, low-cost housing. In his search for refinement Oud departed from the strict principles laid down by De Stijl. The terraces have rounded ends and the position of the commercial units is defined by a canopy—a cantilevered slab bent down at the ends. Modern architecture here becomes a statement about changing social needs, and the duty of the architect to create buildings which are in step with these changes.

Germany: The Bauhaus Architects

The De Stijl movement exercised a direct influence on the Bauhaus through the activities of its founder, Theo van Doesburg, who went to teach in Weimar in 1922. The Bauhaus (the name was deliberately suggestive of the *Dombauhütte*, or cathedral building lodges, of the Middle Ages) was originally, despite the presence of a celebrated architect, Walter Gropius, as its director, oriented more towards crafts than architecture. The economic crisis in Germany led to a change: craftwork was now seen not as an end in itself, but as a preparation for design for mass production. Doesburg was largely responsible for this shift of direction. In

Walter Gropius: *The Bauhaus*

The politically enforced move of the Bauhaus from Weimar to Dessau gave Walter Gropius, the director of the institution, an ideal opportunity to create an "exemplary" building, in which the new principles of architectural design would be given practical expression. The Dessau Bauhaus (FIG. 4.3) has a pinwheel floor plan, with different departments and functions spinning outward from a central nexus. Among its most striking features are the four-storey studio block—a glass box derived from the prewar Fagus facto-

ry designed by the same architect (see FIG. 3.7) and from Behrens's building for AEG (see FIG. 2.7; Gropius had worked in Behrens's office in the years immediately before World War I)—and the cantilevered ferro-concrete bridge joining this to the administration building. Gropius achieved unity by careful use of visual rhythms, and also by using parts of identical size and shape in different configurations. The building combines features which were to become the hallmarks of the new Modernist architecture with oth-

ers which derive from German Neoclassicism, especially from the work of Schinkel. Distinctively Modernist are the absence of any form of architectural ornament, the treatment of the containing walls as smooth, planar surfaces, and the flat roof without gutters—the last feature was often a source of trouble in buildings of this type, especially in wet northern climates. The pinwheel plan is, however, more traditional than it looks—Schinkel used it for some of the small Italianate villas he designed toward the end of his career, when a purely "Greek" style gave way to ideas borrowed from the Italian Renaissance. The striking appearance of the Bauhaus and its undoubted architectural virtues made it, with the handful of luxurious private houes designed by Le Corbusier at about the same time, one of the touchstones of the emergent International Style. Because the ideas it embodied were applicable to a wider range of building types, it was probably more immediately influential than Le Corbusier's early work. It remains one of the most important buildings of the first half of the twentieth century.

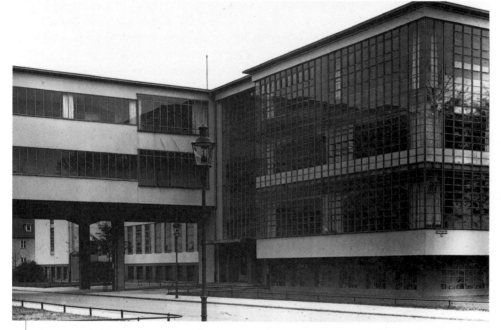

4.3 Walter Gropius, The Dessau Bauhaus, Dessau, Germany, 1925–6.

an essay published in 1923 he argued that the Bauhaus must seek contracts with industrial enterprises "for the sake of mutual stimulation." The move from Weimar to Dessau gave Gropius the opportunity to design a radically new building, the Dessau Bauhaus (see FIG. 4.3), still one of the most celebrated of twentieth-century buildings.

Postwar Germany had an even greater need for low-cost housing than the Netherlands, and the Bauhaus architects made notable advances in this field. Perhaps the best scheme was the block of flats designed by Mies van der Rohe for the Werkbund Exhibition of 1927 in Stuttgart (FIG. 4.4), of which he was directior. With its lines of broad window bands and flat, not pitched, roof, it created an idiom which continued to be used for similar projects until the 1950s and beyond. Though such buildings were put forward as essentially "styleless"—practical solutions to practical problems—they now seem to possess a definite style.

Mies was responsible for another, very different building—one which now

4.4 Ludwig Mies van der Rohe, Block of flats for the Werkbund Exhibition, Stuttgart, Germany, 1927.

The Bauhaus devotion to a prescribed style has been criticized for ignoring practical issues: the insistence on flat, as opposed to pitched, roots, for example, seemed to take little account of the rainy climate of northern Europe.

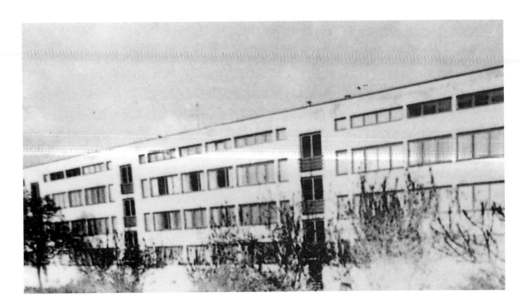

seems to summarize the most creative tendencies in the architecture of the decade. This was the exquisite German Pavilion for the International Exhibition held in Barcelona in 1929. It consists of a raised travertine base with a rectangular reflecting pool occupying part of its area. The other part is occupied by the pavilion itself, essentially a rectangular roof-slab supported by a few chromium-clad metal columns. The internal space was divided by opaque and transparent glass panels, and by screens of highly polished marble (FIG. 4.5). All of these stood apart from the internal supports. These assymetrically placed screens have much in common with the moveable partitions used by Rietveld on the upper floor of the Schröder House in Utrecht. The Barcelona Pavilion, with its extreme refinement,

4.5 Ludwig Mies van der Rohe, German Pavilion for the International Exhibition, Barcelona, Spain, 1929.

Now destroyed—it was intended to be temporary—Mies's exquisite pavilion was a showpiece of minimalism, its flat roof supported by a few stone and steel piers that also served as the only "partitions" in an open, flexible space.

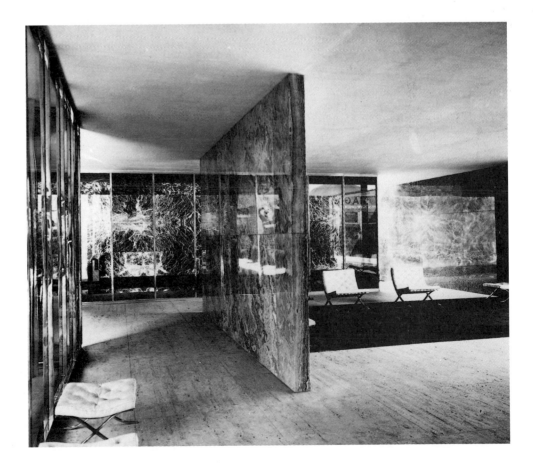

serenity, and apparent simplicity was an assertion that the new architecture initiated just before World War I was fully mature, and ready to undertake any task presented to it.

France: Le Corbusier

In France, the development of a new style of architecture was associated with a single personality, Le Corbusier. The first houses built by Le Corbusier, all in his native Switzerland, were variants of the prewar Arts and Crafts manner. They were followed by buildings influenced by the Deutsche Werkbund. Le Corbusier also acquainted himself with building in ferro-concrete. The decisive moment in his career came in 1916, when he moved to Paris and was introduced to the painter, Amedée Ozenfant (1886–1956). He and Ozenfant evolved a new form of machine aesthetic, which they dubbed "Purism." They also founded a magazine to propagate their ideas, *L'Esprit Nouveau* (1920–5). Essentially, Purism revolved

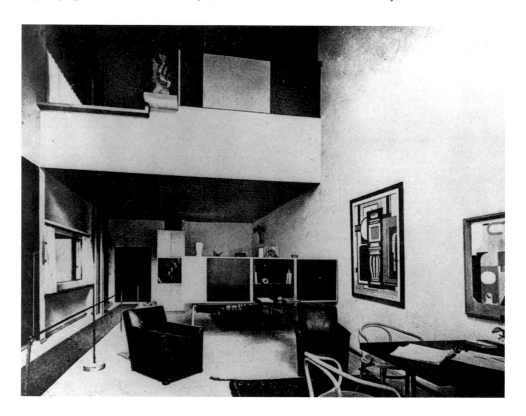

4.6 Le Corbusier, Pavilion de l'Esprit Nouveau, Paris, 1925.

A retort to the excesses of the Art Deco style, the Pavilion de l'Esprit Nouveau (featured at the Paris Universal Exhibition of 1925) was a model apartment that demonstrated what Le Corbusier meant by his description of a house as a "machine for living"—not a soulless space, but a rationally organized habitation whose practical efficiency did not exclude the presence of such nonfunctional items as the paintings on the walls.

around two polarities—practical need, which could be satisfied only through functional forms which evolved empirically in response to that need; and the search for archetypes, ideal shapes which would stimulate both the senses and the intellect.

Le Corbusier first made his mark in France, not through what he actually built, but through projects and theoretical writings, notably the essay "Vers une Architecture" published first in *L'Esprit Nouveau*, and then as a book in 1923. Among the things which interested Le Corbusier at this time were a project for an absolutely basic house, the "Maison Citrohan"—so called in tribute to the Citroen motorcar— and one for the ideal modern city, the "Ville Contemporaine." Projects for both of these were shown at the Salon d'Automne of 1922. In 1925, the Pavilion de l'Esprit Nouveau (FIG. 4.6), featuring a version of the Maison Citrohan, rehandled as an apartment with adjoining terrace rather than as a separate house, formed part of the great Paris Exposition des Arts Décoratifs. It was a sharp retort to the luxurious Deco style which prevailed throughout most of the

4.7 Le Corbusier, Villa Savoye, Poissy, France, 1928–30.

The Villa Savoye, Le Corbusier's most celebrated building of the inter-war years, bears a number of the hallmarks of his functionalism—large, open spaces resting on stilts, elongated horizontal windows, and completely unornamented concrete façades.

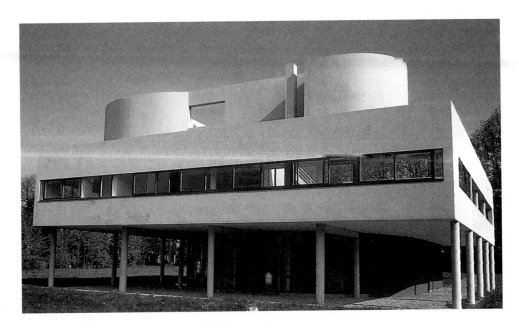

exhibition, and served as a summary of things which Le Corbusier had already written in "Vers une Architecture":

> If we eliminate from our hearts and minds all dead concepts in regard to houses and look at the question from a critical and objective point of view, we shall arrive at the "House Machine," the mass production house, healthy (and morally so too) and beautiful in the same way that the working tools and instruments that accompany our existence are beautiful.[1]

During this period, however, Le Corbusier's most notable buildings were luxurious villas for wealthy bourgeois clients, above all the Villa Savoye in Poissy, just outside Paris (FIG. 4.7). In all of the villas, the main body of the house is raised off the ground by the use of pilotis, or slender concrete pillars. There are no load-bearing walls—the weight is carried on columns, as in Mies's Barcelona Pavilion (see FIG. 4.5). The asymmetry of the façade, though the building itself always has an overriding rhythm, expresses the freedom with which the plan is arranged—though the whole building is generally contained within a single rectangle. Other signature elements were the long horizontal windows and the roof gardens, which gave back, or in a Corbusian sense "restored," the area of ground occupied by the building.

The Villa Savoye, and other buildings of the same type, seemed to offer the prosperous and progressive a means of aligning themselves with the new civilization of the machine age, without wholly surrendering the privileges they possessed. As such, they embodied one of the salient paradoxes of the first phase of twentieth-century Modernism—instinctive elitism uneasily combined with would-be democratic ideals.

ARCHITECTURE IN THE UNITED STATES

The boom years of the 1920s produced architecture in the United States which was almost wholly out of step with developments in Europe. Almost the sole exception to this rule was the group of private houses built in and around Los Angeles by the emigré architects, Rudolf Schindler (1887–1953) and Richard Neutra (1892–1970). Both men had been trained in Vienna, and were influenced by Otto Wagner and Adolph Loos. Both felt the impact of Frank Lloyd Wright. The buildings they produced are, at first glance, quite close in style to Le

4.8 Rudolf Schindler, Beach House for Dr. Philip Lovell, Los Angeles, California, 1922–6.

This model of concrete-façaded functionalism, with its graceful openwork, was the first masterpiece of the International Style to be built in the United States. The glass wall at the end of the two-storey living room is notable.

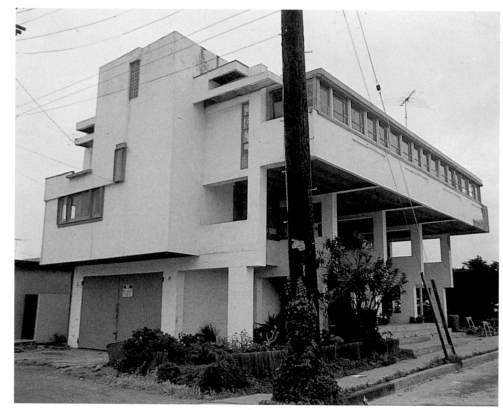

4.9 (*below*) William van Alen, Chrysler Building, New York, 1928–30.

Although the Art Deco style took its name from the 1925 Exhibition of Decorative Art in Paris, it found its highest expression in architecture in New York, most notably in the flamboyant skyscraper for Chrysler Motors.

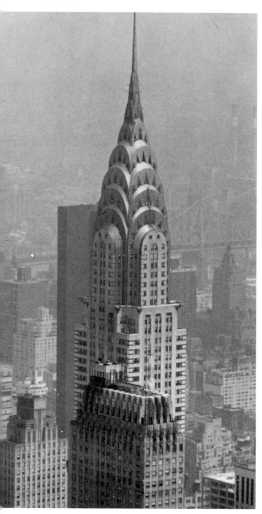

Corbusier's villas, but they have a more irregular rhythm, seen clearly for example in Schindler's Beach House for Dr. Philip Lovell (FIG. 4.8), which used massive concrete frames—five in all—to raise the main structure from the ground. Here the interrupted parapet is especially un-Corbusian, and gives the building a nervous, quasi-Expressionist quality.

Neutra's houses, among them one for the same client, are blander in appearance. Their originality lies in the application of advanced building techniques. His Lovell House (1927–9) is a prefabricated structure with steel casement windows integrated into a steel skeleton. It was erected in only forty hours.

These buildings made much less impact in their own day than the great skyscrapers going up in New York, which transformed the appearance of the city, and made it the ideal modern metropolis. The form of these buildings was largely determined by the New York zoning law of 1916, which required that buildings be progressively set back, so as to allow more light into the streets below. Many of these skyscrapers were embellished with Art Deco ornament. The best-known example is the Chrysler Building (FIG. 4.9), designed by William van Alen (1883–1934) and distinguished by its telescoping aluminum top. It dates from 1930, but its whole conception belongs to the confident boom years of the twenties, not to the crash that followed.

Equally typical of the period, but in a different fashion, was San Simeon, the lavish California mansion built for the newspaper magnate, William Randolph Hearst, by the most prominent female architect of the time, Julia Morgan (1872–1958). Morgan incorporated into its fabric a wide range of architectural fragments that Hearst had acquired in Europe, ranging in date from Roman antiquity to the Baroque period in Spain and Italy. San Simeon, once despised by architectural historians, but now regarded with a certain grudging respect, is, despite these features, redolent of its period—it displays a mixture of financial confidence and residual cultural uncertainty which make it more fascinating than many buildings which are stylistically more coherent.

Painting

PAINTING IN EUROPE

The conservative impulse which seemed to overtake painting at the end of World War I has been widely misunderstood. It was not simply, or even mainly, a turning-away from Modernist experiments. One artist who exhibits the complexity of the situation is André Derain, who had made his reputation as a leading Fauve, but who now advocated a reconciliation between Modernism and the great art of the past. His *The Italian Model* (FIG. 4.10) is a homage to two nineteenth-century painters, Camille Corot (1796–1875), whose previously neglected figure-paintings were starting to be appreciated, and the great mid-nineteenth-century realist, Gustave Courbet (1819–77). The full, richly rounded forms which Derain favored, and his consistently warm color-schemes, can also be seen as a tribute to the late work of the great Impressionist, Auguste Renoir.

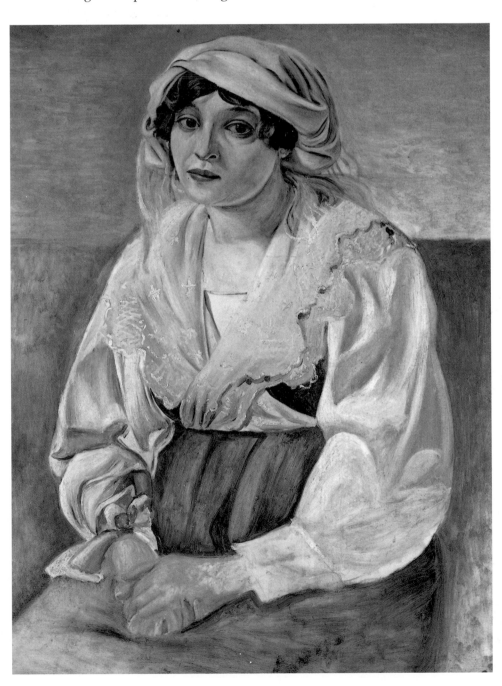

4.10 André Derain, *The Italian Model*, 1921–2. Oil on canvas, 36 x 29 in (91.5 x 73.6 cm). Walker Art Gallery, Liverpool, England.

This painting was executed in homage to two nineteenth-century French artists, Camille Corot and Gustave Courbet, both of whom made similar paintings.

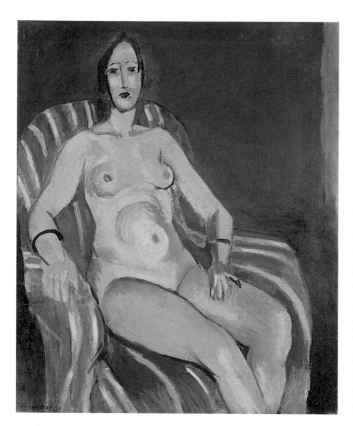

The Artists of the Côte d'Azur

Renoir (1841–1919) spent the final years of his career living and working on the Côte d'Azur. He was one of the first artists to settle in the region, but he was soon followed by others, notably Bonnard and Matisse, who settled permanently in Nice in 1917. Once arrived in Nice, Matisse abandoned any remaining trace of austerity in this work, and settled down to painting a long series of opulent, sun-drenched interiors, often featuring female nudes seen against densely patterned backgrounds. *Seated Nude* (FIG. 4.11) is an impressive example.

Matisse, who had been deeply impressed, like Delacroix before him, by a visit to Morocco, generally chose to give these nudes an Eastern atmosphere. What attracted other artists to the Mediterranean was the Arcadian atmosphere of the region. It provided the basis for fantasies of an idyllic, hedonistic world unspoilt by the ravages of war. Bonnard's reaction was the most direct. Living at Le Cannet, on the Mediterranean coast, he painted a series of sun-saturated landscapes, which showed what he had learned both from Impressionism and from the Synthetism practiced by Gauguin and his followers. These landscapes fit no pattern of movements or trends, but are nonetheless among the most impressive achievements of twentieth-century art.

4.11 Henri Matisse, *Seated Nude*, 1925. Oil on canvas, 29⅛ x 24 in (74 x 61 cm). Musée National d'Art Moderne, Paris.

A work typical of Matisse's production after 1916, when he began to spend the winter months of each year at Nice, on the Mediterranean.

The Classical Revival

No one conveyed the fantasy of an ideal hedonistic world better than Picasso, during his brief Neo-classical period of the early 1920s, though he did it in a more detached, intellectual way. *Women Running on the Beach* (FIG. 4.12) is small in scale, but monumental in effect, so much so that Serge Diaghilev, the impresario of the Ballets Russes, later had it enlarged to make a vast drop-curtain for the ballet, *Le Train Bleu* (1924), which took the hedonism of the Riviera as its subject.

4.12 Pablo Picasso, *Women Running on the Beach*, 1922. Watercolor and gouache on paper, 12⅞ x 16⅛ in (32.5 x 41 cm). Musée Picasso, Paris.

An enormously enlarged version of this small gouache was used as a drop curtain for the production by the Ballets Russes of *Le Train Bleu* (1924), whose subject was hedonistic life on the Riviera.

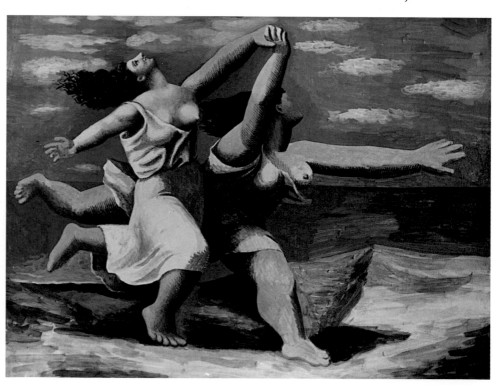

4.13 Fernand Léger, *Three Women*, 1921. Oil on canvas, 6 ft ¼ in x 8 ft 3 in (1.84 x 2.51 m). Museum of Modern Art, New York.

Léger commonly created complex patterns out of geometrical shapes, rarely varying his limited palette. This is one of his most successful efforts, less cold than most of his output, and suggestive of domestic intimacy.

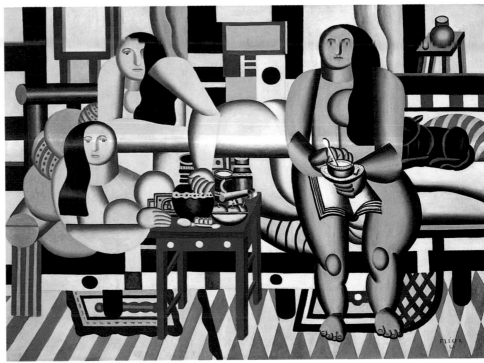

4.14 (*below*) Georges Braque, *Canephora*, 1922. Oil on canvas, 71⅝ x 28⅞ in (180.5 x 73.5 cm). Musée National d'Art Moderne, Paris.

One of a series of paintings depicting classical basket bearers, symbolic of the abundance of the earth.

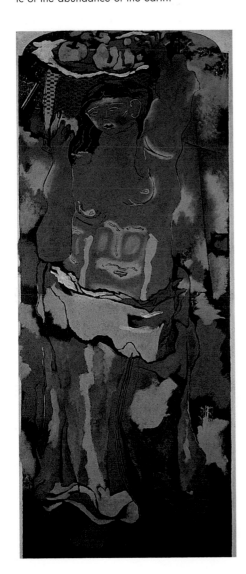

When Picasso adopted the Neo-classical style, he altered it to suit his own purposes. His figures are often exaggeratedly massive, and this massiveness asserts their difference from academic work using the same idiom, as well as emphasizing the contained energy of his compositions. Other painters who had passed through the experience of Cubism reacted in a similar fashion. In the early 1920s Braque painted a series of *Canephorae*, classical female figures bearing baskets upon their heads who symbolized the abundance of the earth, using stylistic conventions carried over from the original Cubist analysis of form (FIG. 4.14) Fernand Léger (1881–1955), in his ambitious composition, *Three Women* (FIG. 4.13), combined individual shapes which hinted at the primacy of the machine (his females are beautiful robots) with a composition which shows the unmistakable impress of the great French Neo-classicist, Jacques-Louis David (1748–1825). David had in 1913 been the subject of a major retrospective exhibition which impressed the whole Parisian art community. By turning back to Neo-classical themes Picasso, Braque, and Léger claimed a place in a pictorial tradition founded in the Renaissance, and at the same time demonstrated that Cubism had from the beginning embodied a search for a rational art, composed from a repertoire of ideal forms.

Italy: The Rise of Fascism

Arcadian Classicism in France was not without its nationalist implications, since it stressed the primacy both of Latin civilization in general and of the strongly developed Classical tradition in French art. This nationalist element was even stronger in the classicizing art which now began to be produced in Italy. Though the appearance of this art was intimately linked to the rise of Fascism, Mussolini's regime never developed a coherent cultural policy of the kind that prevailed in Nazi Germany under Hitler, or in the Soviet Union under Stalin. The artistic movement closest to the regime was the Novecento ("The Twentieth Century"), founded by Mussolini's mistress, the art critic and curator, Margherita Sarfatti (1880–1961). In 1926, Mussolini attended in person to open the "Prima Mostra del Novecento Italiano," which Sarfatti had organized in Rome.

4.15 Mario Sironi, *Solitude*, 1925.
Oil on canvas, 40⅞ x 34 in (103.5
x 86 cm). Galleria Nazionale
d'Arte Moderna, Rome.

Sironi was the most prominent mem-
ber of the pro-Fascist Novecento
Group. This painting shows his use
of bold classical forms.

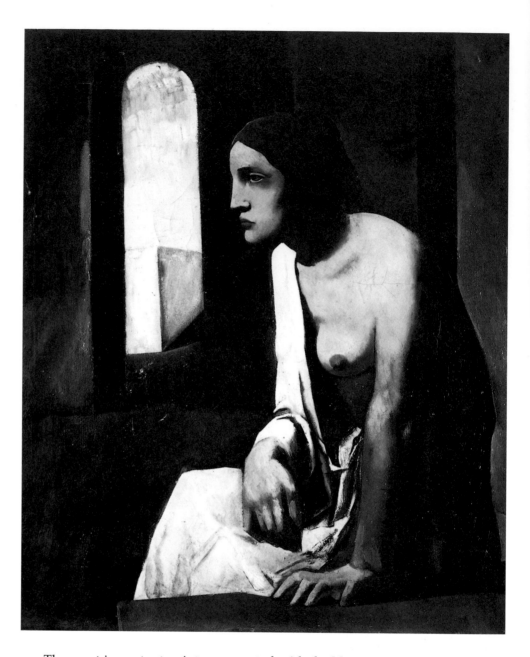

The most important painter connected with the Novecento group was Mario
Sironi (1885–1961). Deeply committed to the regime, Sironi was a prolific carica-
turist for the official Fascist newspaper, *Il Popolo di Italia*, and later, in the 1930s,
an active painter of murals and bas-reliefs for official buildings. The deep melan-
choly of his painting, *Solitude* (FIG. 4.15), is therefore at first sight surprising. It
breathes a nostalgia for past glories, rather than overwhelming confidence in
Italy's future.

Other Italian painters had tenuous or nonexistent political connections.
Giorgio Morandi (1890–1964) participated in the Novecento exhibition of 1926,
and in another similar event in 1929, also organized by Sarfatti, but he was fun-
damentally opposed to Fascist grandiosity. His modest still lifes (FIG. 4.16), often
featuring groups of bottles, are an endorsement of the regional and rustic aspects
of Italian culture, though they clearly owe debts to the eighteenth-century French
painter, Jean-Baptiste Chardin, and to Cézanne. Morandi deliberately opted out
of all artistic movements. He showed that it was possible to make valid art with-
out subscribing to any of the prevailing Modernist schools.

4.16 Giorgio Morandi, *Still Life*, 1929. Oil on canvas, 24 x 25¼ in (61 x 64.1 cm). Private collection.

Morandi started as a member of the Pittura Metafysica group (see p. 103), but his still lifes owe much to the example of the French eighteenth-century painter, Jean-Baptiste Chardin.

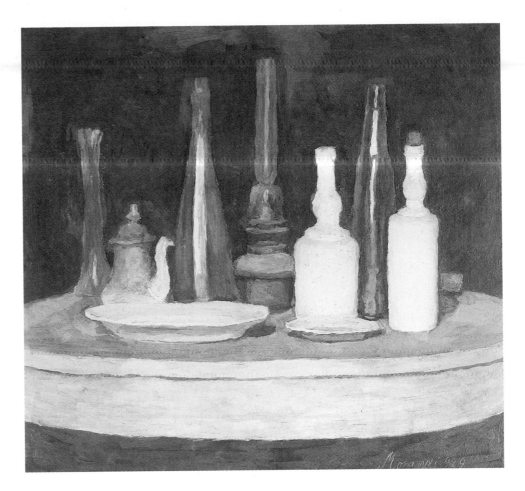

4.17 Piet Mondrian, *Composition*, 1925. Oil on canvas, 19¼ x 16¾ in (49 x 42.5 cm). Krefeld Kaiser Wilhelm Museum, Germany.

Mondrian's geometric paintings of the 1920s, increasingly relying on stark black lines and blocks of hard color, were a step toward his goal of making art an "actual plastic reality," entirely independent of the environment or the world of nature.

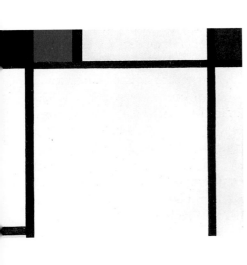

The Netherlands: Piet Mondrian and Neo-Plasticism

In 1919, Piet Mondrian, aged forty-seven and a fully mature artist, left the Netherlands and returned to Paris. The style of painting which he evolved during the 1920s bears, at first sight, little resemblance to the Classical figurative compositions made by a number of celebrated Modernists during the same period. His canvases no longer made any reference to nature, but had become wholly abstract designs made up of interlocking rectangles separated by heavy black lines. From the mid-1920s onward the only colors Mondrian allowed himself were the three primary hues, red, yellow, and blue. *Composition* is a typical work of this period (FIG. 4.17). There is, however, an underlying affinity with the more overtly Classical work which was being produced by Mondrian's contemporaries. Here, too, one sees a search for order, for balance and harmony, which seems to be a direct reaction to the chaos of the war years.

The Soviet Union: Developments in Constructivism

Mondrian's creative effort went into making easel-paintings—objects detached from their surroundings. Some of these paintings, it is true, suggested that the design could be continued beyond the edges of the canvas. Mondrian's studio, meticulously arranged, took on the aspect of an independent three-dimensional artwork. However, Mondrian never attempted to carry his domestic experiments into society at large—a fundamental difference between him and the Russian Constructivists, who in the 1920s emerged as the dominant force in Soviet art.

The Constructivists of the second phase saw the nonutilitarian experiments which had been made in the previous decade—things like Vladimir Tatlin's *Corner Reliefs*—as "laboratory work" which, though undertaken without utilitarian purpose, led logically to practical solutions. The catchphrase of the new, fully

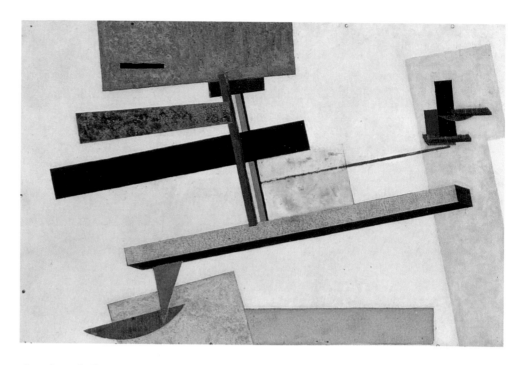

4.18 El Lissitzky, *Construction Proun No. 2*, 1920. Oil on canvas, 23⅝ x 15¾ in (60 x 40 cm). Philadelphia Museum of Art, Pennsylvania.

In his series called *Prouns*, El Lissitzky carried the geometrical blocks of hard color that were the trademark of Constructivism into three-dimensional constructions.

4.19 László Moholy-Nagy, *Construction, Work 4*, 1923. Lithograph, 19 ft 8⅝ in x 14 ft 5¼ in (6 x 4.4 m). Private collection.

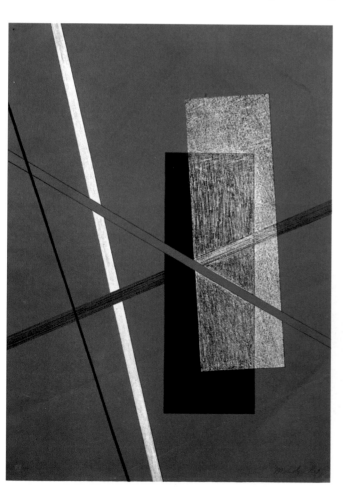

developed Constructivism was "production art," which stood for involvement with mass-produced industrial objects and a deliberate breaking-down of established artistic categories through cooperation with industry.

El Lissitzky developed the concept of the "Proun" (the word is probably an acronym of the phrase "Project for the Affirmation of the New" as this appears in Russian), as "a half-way station between architecture and painting" (FIG. 4.18). He designed a Proun Room—one of the first steps toward the contemporary concept of the environment—for the Great Berlin Art Exhibition in 1923. He also became an innovative typographical designer. Thanks to his visits to Germany in the early 1920s the influence of his typography spread throughout Europe.

Germany: The Bauhaus

Similar ideas of "total" art, closely linked to industry, were to be found at the Bauhaus, which maintained contact both with Russian Constructivists and with men linked to De Stijl, most notably Theo van Doesburg.

The essential part of the Bauhaus syllabus was the general preliminary course which every student was required to take. This made no distinction between the fine and the applied arts, but aimed to give experience of as many media and techniques as possible. Students were encouraged to play with textures, colors, and tones in both two and three dimensions, using whatever materials came to hand. Exercises of this kind are now a commonplace of art education, but at the time they were revolutionary. Though the students were encouraged to make drawings from nature, as a means of sharpening their powers of observation, the main bias was toward the study of abstract form, and particular emphasis was placed on the way in which form interacted with color.

Not surprisingly, the Bauhaus counted among its staff a number of distinguished abstract painters. Chief among these

were Kandinsky, who had returned to Germany from Russia after the war, and the Hungarian, László Moholy-Nagy (1895–1946), a self-taught follower of the Russian Constructivists. Moholy-Nagy, whom Gropius put in charge of the preliminary course in 1923, was a brilliant jack-of-all-trades—a printmaker, typographer, photographer, and designer, as well as a painter (FIG. 4.19). Other Bauhaus teachers offered variants of the Expressionist tradition, among them the Swiss-born Paul Klee (1879–1940), formerly an associate of Kandinsky in the Blaue Reiter group in Munich. Klee's small-scale compositions, whimsical and witty, are a brilliant exploitation of graphic processes. They are not simply representations of something seen or imagined; they arise directly from the act of drawing. An intricate composition such as *Neighborhood of the Florentine Villas* (FIG. 4.20) makes

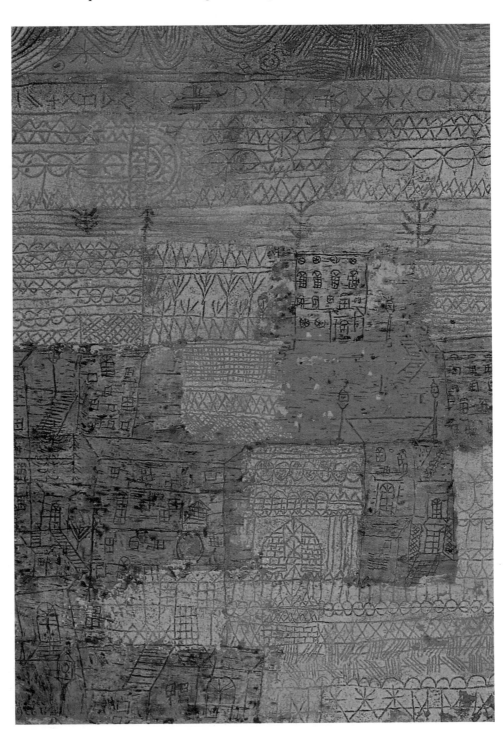

4.20 Paul Klee, *Neighborhood of the Florentine Villas*, 1926. Oil on card, 19½ x 14⅜ in (49.5 x 36.5 cm). Musée National d'Art Moderne, Paris.

This is an example of Klee's skillful exploitation of line and texture on a small scale. What finally emerged in Klee's canvases was so much the product of the actual drawing process itself, that he once remarked that, when he came to teach, he was "obliged to make clear to myself what I did for the most part unconsciously."

it clear that for him drawing was a form of writing. The composition, though it has a subject, is not a representation in any conventional sense, but an accumulation of graphic signs. Despite his apparent divorce from any of the things the Bauhaus stood for, Klee's professional connection with it was very close. He taught there for eleven of the fourteen years the school was in existence, and more than half of the 9,000 works in his *oeuvre* were done during this period.

Germany: The Neue Sachlichkeit

While the Bauhaus may have been hospitable to a wide range of artistic styles, it offered little or no place for realism. Despite this, realist painters became a powerful force in Weimar Germany, and it was they—exponents of what came to be called the Neue Sachlichkeit ("New Objectivity")—who now seem to sum up the atmosphere of the time. The artists of the Neue Sachlichkeit, like the Neo-classicists who appeared at the same moment in France and Italy, looked beyond Modernism to artists of the past. But whereas the Neo-classicists looked to David, to the Italian masters of the Renaissance, and beyond these to the Greeks, the

4.21 Otto Dix, *The Journalist, Sylvia von Harden*, 1926. Oil on canvas, 47¼ x 34⅝ in (120 x 88 cm). Musée National d'Art Moderne, Paris.

Dix here offers an unforgettable likeness of a typical Berlin personality of the Weimar epoch, with its "degenerate" night life and sexual ambiguities. It exhibits his declared aim of producing a neutral and impassive art.

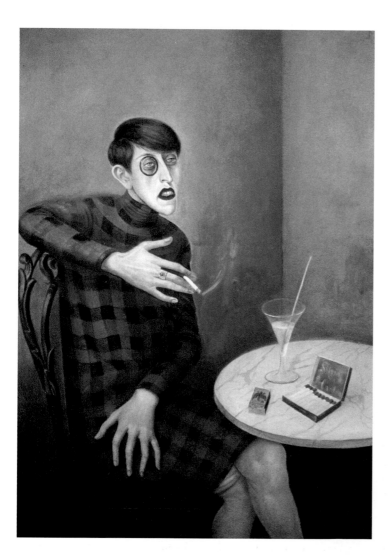

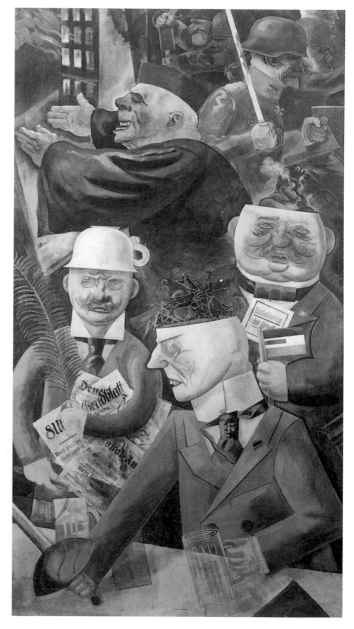

4.22 (right) George Grosz, *Pillars of Society*, 1926. Oil on canvas, 78¾ x 42½ in (200 x 108 cm). Staatliche Museen zu Berlin—Preussischer Kulturbesitz Nationalgalerie, Germany.

Grosz called this savagely fantastic satire on the corruption of postwar German society a "modern history painting."

German realists were inspired by specifically national sources—the German masters of the late fifteenth and early sixteenth centuries.

The most important artists of the group were Otto Dix (1891–1969) and George Grosz (1893–1959). They arrived at realism by rather different routes, but for both men the major factors in their experience were the horrors of World War I and its bitter economic and political aftermath. Dix served in the German army throughout the war. Beginning as an Expressionist, he moved from a position where he identified wholly with what he saw to one where he maintained a coolly detached, cynical view of events around him. His portrait of the journalist, Sylvia von Harden, is savagely unflattering, but it sums up the daring and the decadence of the new intellectual society which emerged in Berlin during the postwar years (FIG. 4.21).

Grosz was also an early volunteer for the fighting, but his constitution was frail and his war service more intermittent than that of Dix. Discharged as unfit for service in 1915, he was again called up in 1917, but assaulted a sergeant and finished up in a mental hospital. Grosz's early, savagely satirical drawings show the impact made on him by Italian Futurism, and by his close connection during the war years with the Berlin Dada group. In the 1920s, his satirical prints kept him in constant hot water with the authorities, until he emigrated to the United States in January, 1933. His paintings veer between the fantastic (FIG. 4.22) and the more stringently realistic. Grosz and Dix are paradoxical artists: on the one hand, they reassert German identity; on the other, they offer a brutally critical view of conditions under the Weimar Republic.

Germany: Max Beckmann

Max Beckmann (1884–1950) was another leading German figurative painter who was influenced by horrific experiences during the war. Having volunteered for service as a medical orderly, he suffered a nervous breakdown in 1915. Though his urban scenes are closely linked to the work of Neue Sachlichkeit artists, his painting has a phantasmagoric quality, as well as a breadth of handling, which mark it off from that of the committed realists. In the 1920s Beckmann often used circus or carnival scenes as a metaphor for the futility of human existence, and the decadence of German society. In *The Trapeze* (FIG. 4.23) the figures, far from swinging freely and joyfully in the air, seem to obstruct one another's movements in a space too small and low for them. Their vacuous expressions reinforce the impression of constraint. The symbolic element in Beckmann's work, already clearly visible here, was to become stronger in the last twenty years of his career, when he was forced into exile by the Nazis, first in Amsterdam, then in the United States.

Germany: Kurt Schwitters

Kurt Schwitters (1887–1948) also ended his life as an exile, but his work, unlike that of Gross or Beckmann, has no political or social content. Schwitters, who lived and worked in Hanover, was the associate of many of the leading German Dadaists, and his most typical works are those in the *Merz* series—collages and eventually ambitious constructions made from torn-up scraps of paper and "found" objects of all kinds. The term itself derives from the German word, *Kommerz* ("Commerce")—Schwitters made one of the first of his collages in 1918, employing a scrap of paper which had formed part of an advertisement for the German *Kommerz und Privatbank*. Schwitters was quick to see the irony of associating this with his own thoroughly uncommercial activities.

Schwitters's collages can be seen as having their roots in the collages made by the Cubists, but he pushed the technique much further than they did. Somewhat

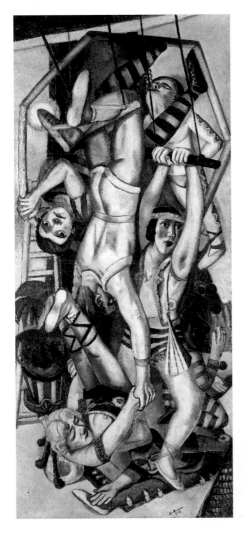

4.23 Max Beckmann, *The Trapeze*, 1923. Oil on canvas, 77⅜ x 33⅛ in (196.5 x 84 cm). Toledo Museum of Art, Ohio.

Beckmann often used circus or carnival scenes as metaphors for the futility of human existence. His works had a moral sternness that reflected his statement that "art is creative for the sake of realization, not for amusement; for transfiguration, not for the sake of play."

4.24 (*above*) Kurt Schwitters, *Small Sailors' Home*, 1926. Mixed media, 26½ x 20½ in (67.5 x 52 cm) Kunstsammlung Nordrhein-Westfalen, Düsseldorf, Germany.

This is a work from Schwitters's *Merz* series.

isolated in its own time, his work (FIG. 4.24) looks forward to activities and attitudes which became important after World War II—to environmental art, to the "combine paintings" of the American Neo-Dadaist, Robert Rauschenberg, and to the Arte Povera which flourished in Italy during the 1960s and 1970s.

PAINTING IN THE UNITED STATES

Precisionism

At first glance, Precisionism looks like the American equivalent of the Neue Sachlichkeit in contemporary Germany. In reality, the two styles had very different roots. Rather than embodying a criticism of American society, Precisionism was a celebration of national self-confidence. Sometimes Precisionist paintings took industry and industrial artifacts as their subject-matter. This is the case with what is perhaps the most celebrated of all Precisionist images, *Upper Deck* (FIG. 4.25) by Charles Sheeler (1883–1965), a complex composition of ventilators and manifolds, based on a photograph made on board the liner *S.S. Majestic*. Sheeler's photographic work is in many respects as important as his painting, and it was his skills with the camera, just as much as his ability as a painter, which helped to integrate him with the rapid development of American industrialism. He worked for the Ford Motor Company (one of the industrial giants of the day), and then, in the next decade, for the Henry Luce organization, publishers of *Time*, *Fortune*, and *Life* magazines. Far from being alienated from the society which surrounded him, as Grosz and Dix were in Germany, he actively celebrated what was happening in America. A similar identification with social processes can be found in *Pittsburgh* (1927) by Elsie Driggs (1898–1982), in which factory smokestacks take on the power and presence of totemic objects (FIG. 4.26).

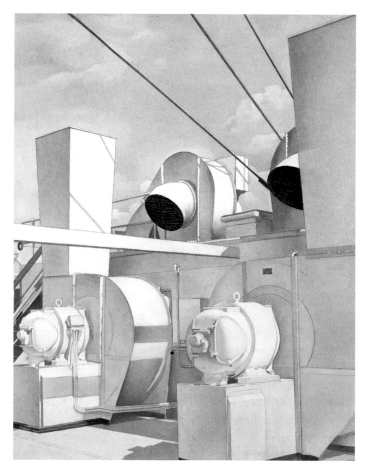

4.25 (*left*) Charles Sheeler, *Upper Deck*, 1929. Oil on canvas, 28¾ x 21¾ in (73 x 55.2 cm). Fogg Art Museum, Harvard University, Cambridge, Massachusetts (Louise E. Bettens Fund).

Charles Sheeler was fascinated by the geometric shapes of unpeopled, industrial sites, which he painted with a fidelity and clarity that links him to the Precisionists. This is his most famous image, based on a photograph that he took for a German shipping company's advertising brochure.

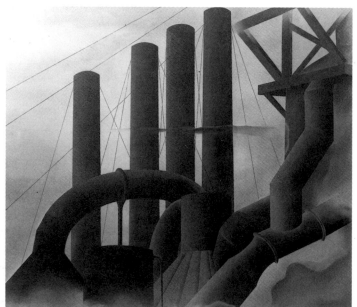

4.27 Georgia O'Keeffe, *Black Iris III*, 1926. Oil on canvas, 36 x 29⅞ in (91.4 x 75.9 cm). Metropolitan Museum of Art, New York.

O'Keeffe's enormously enlarged flowers can be read as sexual metaphors. They are obviously influenced by photography, especially by the camera's frequent distortions of scale through blowing up small items to apparently monumental proportions, while at the same time excluding anything from the image that might suggest the true size through visual comparison (see FIG. 4.51).

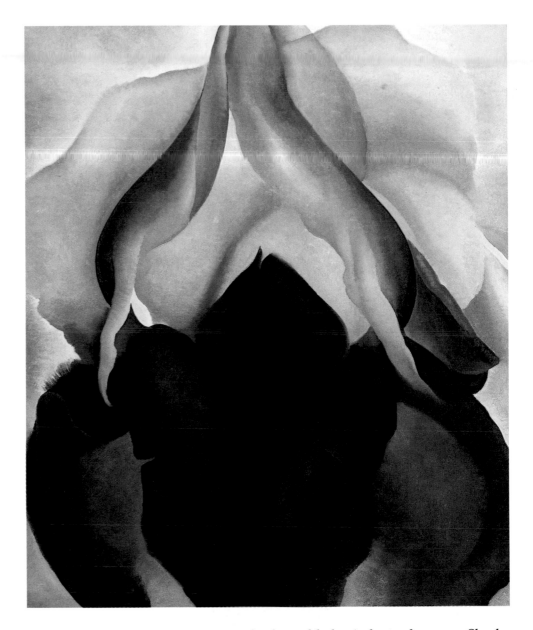

4.26 (*opposite*) Elsie Driggs, *Pittsburgh*, 1927. Oil on canvas, 34¼ x 40 in (87 x 101.6 cm). Whitney Museum of American Art, New York (Gift of Gertrude Vanderbilt).

The visionary quality of this image derives from the artist's memory of passing through Pittsburgh at night, aboard a train.

Precisionist artists were not completely wedded to industry, however. Sheeler painted interiors showing the simple American objects he had learned to love and collect, and Georgia O'Keeffe (1887–1986) depicted landscapes and objects associated with New Mexico as well as the glistening skyscrapers of New York (see FIG. 4.28). *Black Iris III*, an immensely enlarged image of a single flower, is equally "photographic" in the way in which it plays tricks with scale (FIG. 4.27). In their close involvement with the camera, the Precisionists differ radically from contemporary realists in Europe, but nevertheless cling to an important part of the American tradition, which embraces the work of artists otherwise as different from one another as Thomas Eakins (1844–1916) and William Harnett (1848–1892). It was they, rather than remoter ancestors like Dürer and David, who had helped to form a specifically American way of perceiving the world.

Stuart Davis and American Cubism

Some American artists of the period, chief among them Stuart Davis (1892–1964), wanted to find ways of combining what was specifically American with what they had learned from European Modernism—in Davis's case, specifically from Cubism. He wrote in a notebook entry for 20 November, 1920: "I too feel the thing

Georgia O'Keeffe: *The Shelton with Sunspots*

The Shelton with Sunspots (FIG. 4.28) belongs to a small series of paintings celebrating the city of New York painted by Georgia O'Keeffe in the mid-1920s. It depicts the new residential hotel near Grand Central Station where she and her husband, Alfred Stieglitz, occupied a suite on the thirtieth floor. Thanks to Stieglitz's efforts on her behalf, O'Keeffe had already become famous for her paintings of flowers and other natural objects, and some of her admirers were shocked when she turned to urban themes. O'Keeffe would have none of this. "You have to live in today," she said briskly. "Today the city is something bigger, more complex than ever before in history."* Her city paintings celebrate urban life in a very different way from those produced some ten and more years earlier by members of the Ashcan School. Theirs are full of the bustle of the streets; hers are cool and detached. What is peculiarly modern about her work is the impact made on it by the camera—perhaps not surprisingly in view of the fact that she was married to

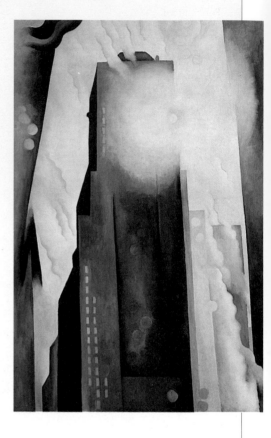

the most celebrated of all American photographers, who had already taken skyscrapers such as New York's Flatiron Building as part of his subject matter. In *The Shelton with Sunspots*, the lighting effects are typical of the way in which the camera records an image when the photographer is looking directly toward the source of light. Like her Precisionist contemporary, Charles Sheeler, O'Keeffe owes comparatively little to European Modernism (she never set foot in Europe until she was sixty-five, and then refused to meet Picasso on the grounds that she spoke no French and he no English), but much to the new photographic way of seeing pioneered by Stieglitz and by slightly younger photographers such as Paul Strand.

*Quoted in Laurie Lisle, *Portrait of An Artist: A Biography of Georgia O'Keeffe*, New York, 1980, p. 150.

4.28 Georgia O'Keeffe, *The Shelton with Sunspots*, 1926. Oil on canvas, 48½ x 30¼in (123.2 x 76.8 cm). Art Institute of Chicago, Illinois (Gift of Leigh B. Block).

4.29 Stuart Davis, *Odol*, 1924. Oil on cardboard, 24⅜ x 17⅝ in (62 x 44.7 cm). Cincinnati Art Museum, Ohio.

In this Cubist-influenced work Davis anticipates Pop art preoccupations.

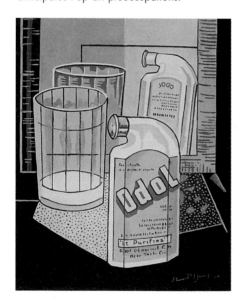

Whitman felt and I too will express it in pictures—America—the wonderful place we live in."[2] A number of his paintings feature commercial packaging in a way that foreshadows the Pop Art of the 1960s. An example is *Odol* (FIG. 4.29), which celebrates the distinctive bottle and logo of a popular brand of mouthwash.

PAINTING IN LATIN AMERICA

The 1920s were the years in which Modernism became something close to a worldwide phenomenon. Having made their impact in North America, Modernist ideas now started to make themselves felt elsewhere in the western hemisphere. In Latin America, where artists were ready for new ways of thinking, the 1920s saw a series of significant artistic events. One was the "Semana de Arte Moderna" ("Week of Modern Art") held in São Paolo in 1922. The Semana was a mixture of things: music, literature, and poetry, as well as art. An important part of it was the desire to assert a new cultural nationalism, since the event coincided with the centenary of Brazilian independence. One of the participating artists, Vicente do Rego Monteiro (1899–1967) signaled one of the directions the future was to take. His paintings of the 1920s, for example, *Deposition* (FIG. 4.30), are a strange mixture of indigenous influences and sophisticated European Art Deco. Questioned about his artistic influences, Rego Monteiro, who had been trained in Paris, supplied a long list: "Futurism, Cubism, Japanese prints, black art, the Parisian School, Brazilian Baroque and above all the art of the American Indians on the island of Marajo."

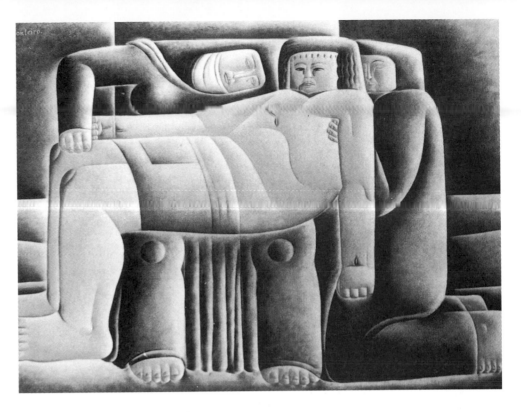

4.30 Vicente do Rego Monteiro, Deposition, 1924. Oil on canvas, 3 ft 0½ in x 4 ft 4¾ in (1.09 x 1.34 m). Museu de Arte Contemporanea da Universidade de São Paolo, Brazil.

4.31 Tarsila do Amaral, *Abaporu*, 1928. Oil on canvas, 33½ x 28¾ in (85 x 73 cm). Private collection.

This is the first painting in Tarsila's Anthropophagist series.

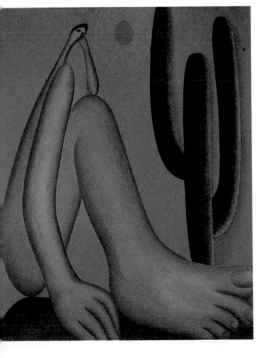

Brazil: Tarsila do Amaral

Rego Monteiro's interest in Amerindian cultures links him to a more important artist, Tarsila do Amaral (1886–1973), "the Brazilian painter who best achieved Brazilian aspirations for nationalistic expression in a modern style." Tarsila, always so called in Brazil, did not exhibit at the Semana because she was in Paris when it took place. She studied with the minor Cubists, André Lhote and Albert Gleizes, and also with Fernand Léger. On her return home in December, 1923, she began to explore the popular culture of Brazil and to paint in a style which mingled the influence of local naive art with that of Léger. By 1928 she had entered her most creative period, that of Anthropophagy or Cannibalism, so named from the manifesto, *Antropófago*, published by her husband, the poet and critic, Osvaldo de Andrade. The central tenet of Anthropophagy was that the Brazilian artist must devour outside influences, digest them, and make them into something new. Her attitudes were akin to those of Stuart Davis, but she turned to indigenous legend for her source material, rather than to mass-market products in order to find a distinctively Brazilian imagery. Tarsila's first painting in her new manner was *Abaporu* (FIG. 4.31), given to Andrade as a birthday gift in January, 1928. In the Tupi-Guarani language "Abaporu" means "man who eats," and the painting represents a single monstrous figure, with a tiny head and enormous hands and feet which, resting on the ground, signify intimate contact with the earth. Stylistically the painting combines ideas taken from Léger with others which parallel things to be found in the work of the French Surrealists. There is also a brutally primitive element which is entirely Tarsila's own. The tendency to combine apparently incompatible European styles with indigenous elements was to be a characteristic of Latin American Modernism taken as a whole.

Modernism in Argentina

The formal appearance of Modernism in Argentina lagged only a little behind the Semana de Arte Moderna, despite the fact that cultural conditions there were very different. Far from having an ethnically mixed culture, as Brazil did, Buenos Aires had a population which was 90 per cent white and only 10 per cent mestizo. The hero figure, for liberal intellectuals, was not the Indian, the "noble savage," but the gaucho, freely roaming the pampas. Martín Fierro is the central figure in the

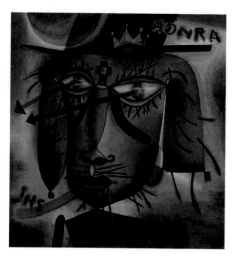

4.32 Alejandro Xul Solar, *Honorable Chief*, 1923. Watercolor and crayon on board, 11 x 10¼ in (28 x 26 cm). Jorge and Marion Helft Collection, Buenos Aires.

The letters and signs belong to an invented pictorial language that the artist called *criollismo*.

gaucho epic of the same name, and Martín Fierro was the name taken by the avant-garde review founded in Buenos Aires in 1924 which served as a rallying-point for the new Argentinian avant-garde. The most interesting artistic figure to emerge from this milieu was Alejandro Xul Solar (Schultz Solari, 1897–1963). Xul Solar has attracted less attention then he deserves because he worked on a small scale, often in watercolor. He was widely traveled, and his work, like Tarsila's, shows many signs of European influence—he was affected by Cubism, as can be seen from the faceted and fragmented forms which appear in his work, and he may also have been influenced by the early drawings of George Grosz and those of Paul Klee, with whom he shares a vocabulary of graphic signs. Xul Solar developed these letters and signs to create a pictographic language he called *criollismo*, based largely on Spanish and Portuguese, rather than on anything pre-Columbian. This is not wholly surprising since Argentina was never the seat of a great Indian civilization. Nevertheless the intention—as in *Honorable Chief* (FIG. 4.32)—was to create a completely new pictorial language, able to express a non-European reality.

The Beginnings of Mexican Muralism

The artistic effort which was to attract most attention outside Latin America happened in Mexico. In 1921, the Mexican painter, Diego Rivera (1886–1957), who had been working in Paris, returned to his native country. He arrived at a crucial moment in Mexican history. The Mexican revolution, which had first broken out in 1910, was just over, and there was a will to rebuild the country. Rivera had been an easel-painter in Paris, a minor Cubist, but now he was drawn into the government mural program planned by a remarkable Minister of Education, José Vasconcelos. It is sometimes thought that the characteristic Mexican mural style sprang fully formed from Rivera's head, and that it was essentially a Mexican invention, derived from pre-Columbian forms. Neither of these notions is true. Before Rivera left for Mexico he made a crucial trip to Italy, where he studied the work of Giotto, Uccello, Piero della Francesca, Mantegna, and Michelangelo. In Modernist terms, his earliest murals, for example, *Creation* (FIG. 4.33), at the National Preparatory School, are a step backward from the Cubist paintings he had been doing in France. The style is a version of what would come to be called Art Deco. Rivera had good reasons for adopting this stylistic conservatism—he wanted to make himself understood by a broad public. Gradually he was to move toward a more recognizably "Mexican" style. The dominance of Mexican Muralism in the visual culture of Latin America was not immediately established, as has often been assumed. In the Latin America of the 1920s, a wide variety of Modernist approaches were possible. It was only in the following decade that Rivera and his fellow Muralists were to develop into something resembling an artistic dictatorship.

THE BIRTH OF THE SURREALIST MOVEMENT

The postwar developments so far discussed were all in their various ways rooted in the past. The most important new artistic movement of the decade was Surrealism, which first announced itself in the Surrealist Manifesto of 1924. Surrealism represented a coming together of several tendencies to produce something visibly novel. One parent was Sigmund Freud, especially for his researches into the significance of dreams and the power of the unconscious mind. Another was Dada. A number of leading Zurich Dadaists, among them Tristan Tzara, moved to Paris as soon as political and material circumstances allowed. Surrealism discarded the frivolity and cynicism of Dada, but allied itself with the Dadaist rejection of logic and decorum as an instrument of research into human

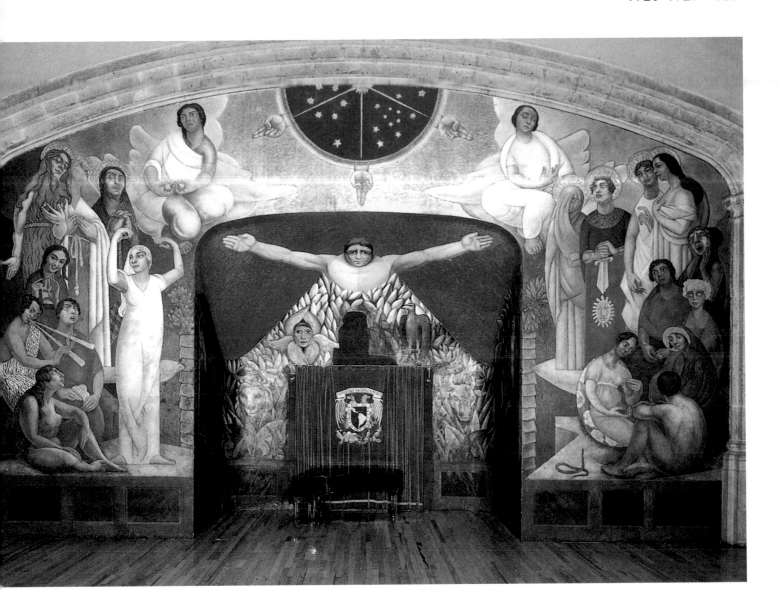

4.33 Diego Rivera, *Creation*, 1922–3. Mural, encaustic and gold leaf, 23 ft 2¾ in x 39 ft 11⅞ in (7.08 x 12.19 m). Bolivar Amphitheater, National Preparatory School, Mexico City.

"What," Rivera asked, "is revolution but a restatement of man's eternal will to be free, written out in his own blood? And what is art but a perpetual struggle to express again, in newer, fresher terms, the old ideals of beauty? A century of violence, of experimentation, is not given in vain if at the end it flowers in a single achievement of victorious creation."

behavior. A further contributory factor in the formation of Surrealism was the Symbolist fascination with the occult. The Surrealist Movement was indeed "new," but it did not wholly escape from aspects of the nineteenth century.

The chief organizer and legislator of Surrealism was the writer, André Breton (1896–1966), who had trained as a medical student and was familiar with Freud's ideas. It was Breton who, in the *Surrealist Manifesto*, offered an authoritative definition of Surrealism itself:

> SURREALISM. n.m. Pure psychic automatism through which it is intended to express, either verbally or in writing, the true functioning of thought. Thought dictated in the absence of all control exerted by reason, and outside any aesthetic of moral preoccupation…. Surrealism is based on the belief in the superior reality of certain forms of association neglected heretofore, in the omnipotence of the dream, in the disinterested play of thought.

Breton was thinking in terms of literature, not the visual arts, and the periodical which served as the chief vehicle for Surrealist ideas during the formative period was called simply *Littérature*. Breton and his allies, chief among them the gifted poet, Paul Eluard, soon recognized, nevertheless, that the principles they espoused could be extended to the visual arts.

Max Ernst

The artist who had the closest links to literary Surrealism was the German-born Max Ernst (1891–1976) who, with Eluard's help, settled in Paris in 1922. Ernst's work, even before the official birth of the Surrealist movement, showed his skill in manipulating dream-like images. *The Elephant of Celebes* (FIG. 4.34), one of Ernst's most haunting paintings, dates from as early as 1921. It brings together various inanimate objects in order to create a monstrous, quasi-mechanical creature. Like many Surrealist works, the painting has an off-color subtext, a scatological children's rhyme:

> The elephant of Celebes
> Has sticky yellow bottom grease,
> The elephant from India
> Can never find the hole, ha, ha.

Extremely good at devising new techniques, Ernst invented "frottage," rubbings made by laying pieces of paper or even canvases over objects such as piles of tangled string or well-worn floorboards—a way of working which provided an

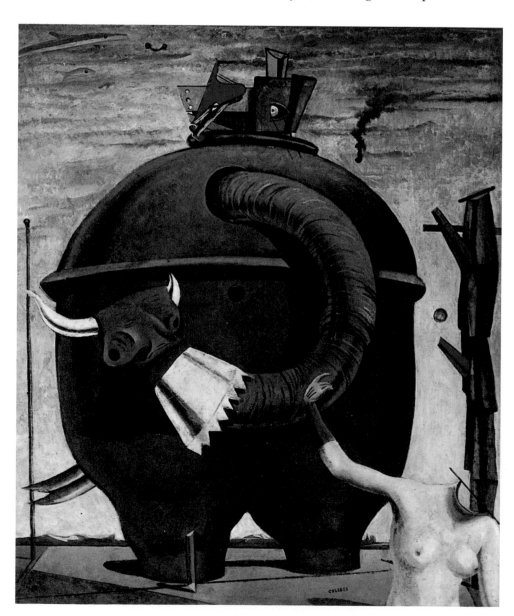

4.34 Max Ernst, *The Elephant of Celebes*, 1921. Oil on canvas, 4 ft 1 in x 3 ft 6 in (1.24 x 1.07 m). Tate Gallery, London.

This monstrous quasi-mechanical beast, put together from various inanimate objects, displays the sense of the comic that Ernst brought to Surrealism. A tiny pencil serves as a potential plinth, or pedestal, for the huge elephant.

equivalent for the Surrealist literary technique of automatic writing, where words were written at random, without conscious control. The rubbings provided vague suggestions of form which could afterwards be developed into romantic land scapes or monstrous creatures.

Ernst employed collage in an entirely different fashion from the way in which it had been used by its Cubist inventors, cutting up Victorian engravings and rearranging them to create dream-like narratives. The most famous of these is *La Femme 100 Têtes* (FIG. 4.35). The title in French is a pun—the word *cent* ("100") has the same pronunciation as *sans* ("without")— which aptly sums up the ambiguity of the actual images.

René Magritte and Joan Miró

Whereas literary Surrealism was in its beginnings specifically French, Surrealism in the visual arts was always international. Two of the artists who were drawn into the new movement were the Belgian, René Magritte (1898–1967), and the Catalan, Joan Miró (1893–1983). Magritte's work was marked from the beginning by a deliberate literalism of style. The blunt, matter-of-fact quality of his technique emphasized the hallucinatory nature of his imagery, which often relied on incongruous juxtapositions of various kinds. In paintings like *The Murderer Threatened*, Magritte, like Ernst, reverts to a pre-Modernist world, but presents it in a distorting mirror (FIG. 4.36). The bowler-hatted figures that appear in the painting are especially typical, alter-egos for the artist's own deliberately bourgeois persona.

Miró seems to have been influenced by the Surrealist practice of making *cadavres exquis*. These "exquisite corpses," based on an old children's game, were drawings made on sheets of paper successively folded over, so that each participant added to the figure without being aware of what the other players had done. Miró elaborated from this a series of cunningly distorted images. Instead of presenting the strange and unfamiliar in a deliberately flat, matter-of-fact fashion, as Magritte did, he reshaped what was basically familiar so as to give it an alien

4.35 Max Ernst, *Défais ton sac, mon brave*, illustration from *La Femme 100 têtes*, 1929. Engraving. Private collection.

In 1929 Ernst produced a collage "novel" containing 149 of what he called "readymade realities"—collages constructed from several sources, chiefly nineteenth-century engravings and woodcuts used as book illustrations, and juxtaposed according to the free association of images beloved of Surrealists.

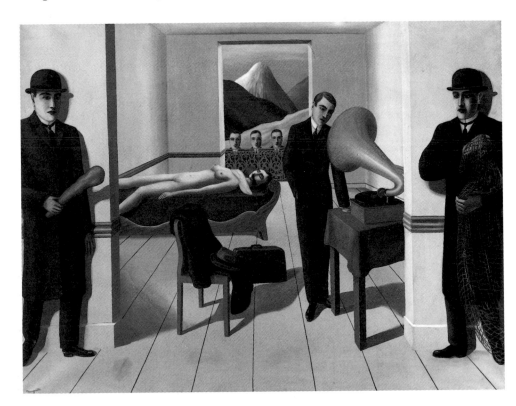

4.36 René Magritte, *The Murderer Threatened*, 1927. Oil on canvas, 4 ft 11¼ x 6 ft 4⅞ in (1.5 x 1.95 m). Museum of Modern Art, New York (Kay Sage Tanhuy Fund).

The inspiration for this painting, which is given the slick manner of advertising images, was undoubtedly illustrations for crime magazines of the 1920s. An impression of claustrophobia, of the figures trapped in the narrative *and* trapped by the canvas, is wonderfully evoked.

4.37 Joan Miró, *Dutch Interior I,* 1928. Oil on canvas, 36⅛ x 28¾ in (91.8 x 73 cm). Museum of Modern Art, New York (Mrs. Simon Guggenheim Fund).

This Surrealist paraphrase of a genre painting by a minor seventeenth-century Dutch painter, H. M. Sorgh, completely transforms the composition, distorting all the basic shapes found within it.

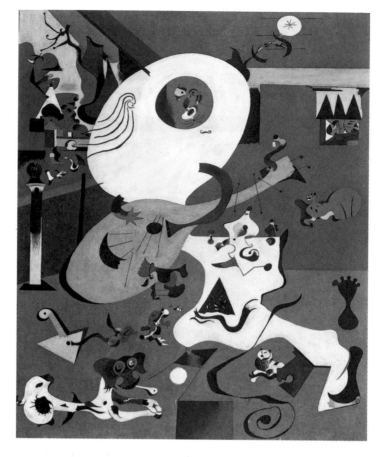

4.38 (*right*) Chaim Soutine, *Pageboy at Maxims,* c. 1926. Oil on canvas, 51 x 26 in (129.5 x 66 cm). Albright-Knox Museum, Buffalo, New York (Edmund Hayes Fund).

Soutine made much of his dislike of the contemporary art around him and said that he sought to emulate the Dutch masters. In his portraits of valets and pastry cooks, however, the free brushwork, derived from Van Gogh, gives the canvases an Expressionist turbulence.

4.39 (*far right*) Marie Laurencin, *Portrait of Madame Paul Guillaume,* 1924. Oil on canvas, 36¼ x 28¾ in (92 x 73 cm). Musée de l'Orangerie, Paris (Jean Walter & Paul Guillaume Collection).

Madame Guillaume was the wife of the successful art dealer Paul Guillaume, who at this time represented both Derain and Giorgio de Chirico.

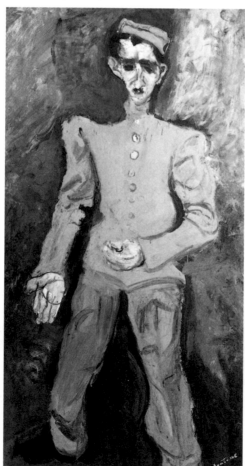

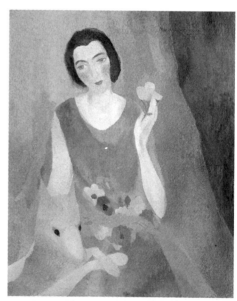

quality. An example is his *Dutch Interior I* (FIG. 4.37), a paraphrase of a genre scene by the minor Dutch artist, Hendrik Maertenz Sorgh, dated 1661. Though the method was different, Miró's aim was basically the same as that pursued by Magritte and Ernst—the spectator was to be cast adrift, and brought into contact with the workings of his or her own unconscious mind through a process of displacement.

THE ECOLE DE PARIS

Chaim Soutine

The success of the Modernists made Paris a mecca for artists of all kinds. Many of the most important were not French by birth. Some attached themselves to no school, but still managed to make their presence felt. One such was the Russian Jew, Chaim Soutine (1894–1943), practitioner of a form of Expressionism which owed little or nothing to the German variety. Soutine's paintings are an insistent externalization of his emotions, his fears, and terrors. Even when he depicted a subject which belonged to the hedonistic life of the day, such as the *Pageboy at Maxim's* (FIG. 4.38), Soutine imbued it with his own troubled sensibility. While his lack of confidence made him reluctant to exhibit, and his farouche manners put off many potential patrons, he did not remain entirely unrecognized. One of his most important patrons was the wealthy and eccentric American collector, Dr. Albert Barnes, who in 1923 bought no fewer than one hundred of his canvases in a single purchase.

Marie Laurencin and Tamara de Lempicka

Another favorite with American buyers, but a much wider spectrum of them, was Marie Laurencin (1885–1926), once the mistress of Apollinaire. Laurencin had exhibited with the Cubists before the war, but was never accepted, despite Apollinaire's efforts on her behalf, as a genuine member of the movement. After the war she turned out a large number of delicately pretty paintings in a color scheme of gray, pink, blue, and rose, for example *Portrait of Madame Paul Guillaume* (FIG. 4.39). Her work attracted a fashionable public—so much so that Diaghilev commissioned her to provide the costumes and decors for one of the most characteristic theatrical entertainments of the period, the ballet, *Les Biches* (1924), a witty analysis of contemporary sexual attitudes choreographed, like *Le Train Bleu*, by Bronislava Nijinska (1881–1972)—but she was never accepted as a ranking member of the avant-garde.

Another successful woman painter, with a very different background as well as a very different style, found herself in a similar situation. This was the Polish-born Tamara de Lempicka (1898–1980). Lempicka arrived in Paris as a refugee from Poland and apprenticed herself to the minor Cubist, André Lhote (1885–1962). Within a short space of time she had made a place for herself as a fashionable portraitist, first painting aristocratic refugee members of the bohemian demi-monde like herself, then a fashionable international clientele. A good example of her portrait style is her likeness of her estranged first husband, Tadeusz de Lempicki (FIG. 4.40), painted at the height of her fame in 1928. Lempicka's style was in complete contrast to that of Laurencin—a forceful amalgam of ideas taken from Cubism and from Italian Mannerists such as Jacopo Pontormo (1494–1557) and Agnolo Bronzino (1503–1572). Both her portraits and her subject paintings are now eagerly collected, as they seem to enshrine the spirit of the decade, but while she was alive her work, like that of Laurencin, was completely outside the main currents of artistic development.

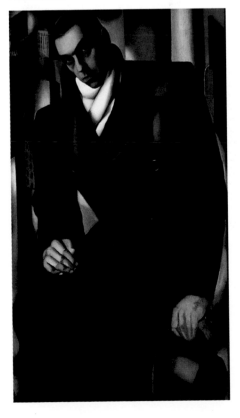

4.40 Tamara de Lempicka, *Tadeusz de Lempicki*, 1928. Oil on canvas, 49⅝ x 32¼ in (126 x 82 cm). Musée National d'Art Moderne, Paris.

Lempicka painted her estranged husband in a style that mixes Cubism and early-sixteenth-century Italian Mannerism.

4.41 Henri Laurens, *Woman with Her Arm Lifted*, 1928. Stone, height 24⅝ in (62.5 cm) Kunstmuseum, Berne.

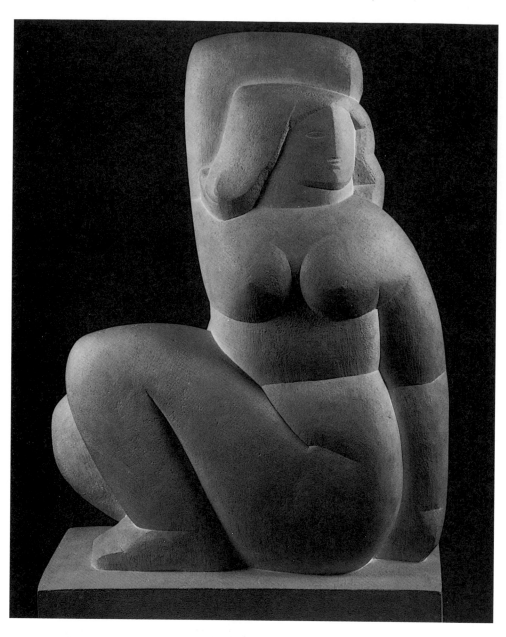

4.42 Jacques Lipchitz, *Reclining Nude with a Guitar*, 1928. Bronze, 16⅛ x 29⅝ x 12¾ in (41.1 x 75.3 x 32.3 cm). Hirshhorn Museum and Sculpture Garden, Smithsonian Institution, Washington, D.C. (Gift of Joseph H. Hirshhorn).

After 1916 Lipchitz made Cubist constructions in stone, bronze, and wood. This sculpture marks the point of departure toward a more personal expressiveness.

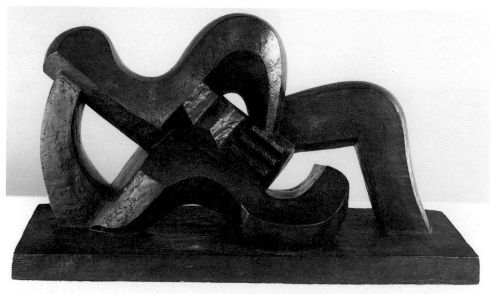

Sculpture

SCULPTURE IN EUROPE

Classicism and Decorative Cubism

The 1920s were not a markedly original period for sculpture. Innovation continued to move at a much slower pace than it did in painting, though Henri Laurens (1885–1954) and Jacques Lipchitz (1891–1973) began to turn Cubist conventions to purely decorative use, in conformity with the influential Exposition des Arts Décoratifs held in Paris in 1925. Good examples of this are Laurens's *Woman with Her Arm Lifted* (FIG. 4.41), where the underlying convention used for the figure is borrowed from Maillol, and Lipchitz's *Reclining Nude with Guitar* (FIG. 4.42). Brancusi, meanwhile, continued to refine forms originally observed in nature. The first *Bird in Space* (FIG. 4.43) was made in 1921. The shape of the bird's wing, and the trajectory of its motion, are expressed in a single propellerlike flange.

Naum Gabo

Contructivism offered the most progressive sculpture of the period, though the Russian-born Naum Gabo (1890–1977) and his brother, Antoine Pevsner (1886–1962), sustained a somewhat uneasy relationship with the more doctrinaire members of the Constructivist movement. Gabo, in particular, was fiercely opposed to the idea that artists should devote themselves to the design of mass-produced objects. In 1920 he published a *Realist Manifesto* (put up in the streets in poster form, like the political proclamations of the time) in which he insisted that "the realization of our perceptions of the world in the forms of space and time is the only aim of our pictorial and plastic art." This manifesto, also signed by his brother, was rightly interpreted as an attack on Tatlin and his allies. Both brothers left Russia in the early 1920s. Gabo, who lived in Berlin, did not wholly sever his connection with the Soviet regime. Always experimental in his use of materials—he was perhaps the first sculptor to make use of plastics—he had by the 1920s begun to compose with pure geometric planes, intersecting with one another and creating forms which were both open and, thanks to his ingenious use of both plastic and glass, transparent and apparently weightless, for example, *Construction in Space with Balance on Two Points* (FIG. 4.44).

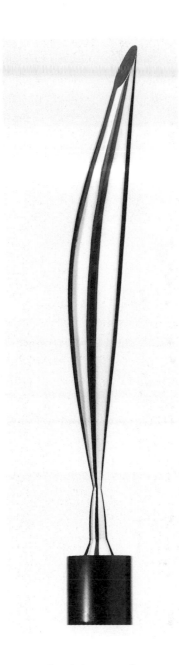

4.43 (*above*) Constantin Brancusi, *Bird in Space*, 1921. Bronze, 54 x 8½ x 6½ in (137.2 x 21.6 x 16.5 cm). Philadelphia Museum of Art, Pennsylvania.

Brancusi said that simplicity in art was not an end in itself, but that "we arrive at simplicity in spite of ourselves as we approach the real sense of things."

4.44 (*right*) Naum Gabo, *Construction in Space with Balance on Two Points*, 1924–5. Plexiglass, 10⅝ x 14⅝ in (27 x 37 cm). Graham Williams Collection.

In the 1920s Gabo pioneered the use of new materials, especially plastics.

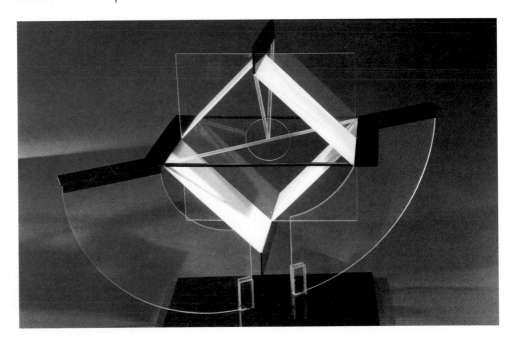

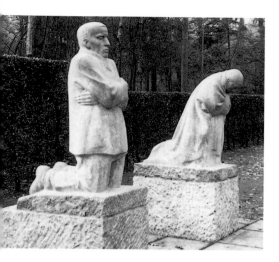

4.45 Käthe Kollwitz, *Memorial to the Fallen*, 1926–32. Stone, life-sized. Cemetery at Vladsloo-Praedbosch, Belgium.

Deeply personal, this memorial commemorates Kollwitz's son, who was killed in World War I, and the mourning woman is the sculptor herself.

Käthe Kollwitz and Ernst Barlach

The contrast between Gabo's work and that of sculptors like Ernst Barlach (1870–1938) and Käthe Kollwitz (1867–1945) is extreme. The content of Gabo's work is purely aesthetic—it was the impact upon art of the new political regime which caused him to leave the Soviet Union. Kollwitz and Barlach on the other hand were figurative artists deeply involved with political and moral issues of their day. In 1920, both were middle-aged. Neither can be regarded as formally innovative. Barlach found new ways of updating the Gothic tradition; Kollwitz, who began her career as a printmaker, looked back to masters such as Daumier and Goya. They were, nevertheless, perhaps the two artists who most effectively expressed the legacy of grief left by the war. Kollwitz's *Memorial to the Fallen* (FIG. 4.45), two granite figures of grieving parents made for the war cemetery in Belgium where her son was buried, is deeply personal—as she noted in a letter written when she visited the cemetery soon after the figures were set up, the mourning woman is a self-portrait. Barlach's *Güstrow Angel* (FIG. 4.46), especially made for Güstrow Cathedral, was removed by the Nazis, but a recast model is now restored to its former position. It is an extraordinary work, heavy yet soaring, compassionate yet aloof. The decade cannot be judged solely by its most self-consciously "advanced" creations.

4.46 Ernst Barlach, *Güstrow Angel*, 1927. Bronze, 28 x 29⅜ x 85⅜ in (71 x 74.5 x 217 cm). Güstrow Cathedral, Germany.

This war memorial, made for Güstrow Cathedral, was destroyed by the Nazis, but later recast from the surviving model. It draws inspiration, like much of Barlach's work, from medieval carving in wood.

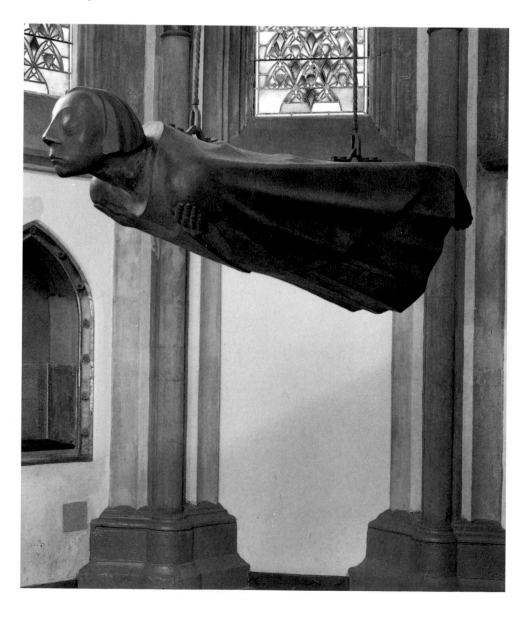

Photography

Experimental Techniques

In the 1920s photographers felt that the medium should try to catch up with the experiments which had already been made by painters and sculptors, and that it should at the same time evolve a recognizable language of its own, using techniques and imagery in step with the new technological age.

Sometimes the frontier between photography and other forms of artistic creation was almost invisible. Photographs, for example, provide obvious material for collage. Man Ray (1890–1976), an American photographer closely associated with the new Surrealist group, offered a typically Surrealist visual pun in his *Violon d'Ingres*[3]—he has superimposed on an image of the naked back of his mistress, Kiki of Montparnasse, the f-shaped apertures of a violin (FIG. 4.47).

Man Ray and others, among them the Bauhaus Constructivist, Moholy-Nagy, also experimented with cameraless images. These had also been made by Victorian photographic pioneers, for example by William Henry Fox Talbot (1800–77), inventor of the negative-to-positive process. Fox Talbot thought of the technique as a way of allowing nature to speak for itself. For Moholy-Nagy, it was a way of rendering the mysterious dynamism of modern life (FIG. 4.48). The object was represented only by the transitory shadow it cast upon the sensitized paper.

4.47 (*below*) Man Ray, *Violon d'Ingres*, 1924. Partial rayograph, Ludwig Museum, Cologne, Germany.

Man Ray said of his work: "In whatever form it is finally presented, by a drawing, by a painting, by a photograph, or by the object itself in its original materials and dimensions, it is designed to amuse, bewilder, annoy or to inspire reflection, but not to arouse admiration for any technical excellence usually sought for in works of art. The streets are full of admirable craftsmen, but so few practical dreamers."

4.48 (*right*) László Moholy-Nagy, *Untitled (Photogram)*, 1922. Gelatin silver print. Art Institute of Chicago, Illinois (Julien Levy Collection).

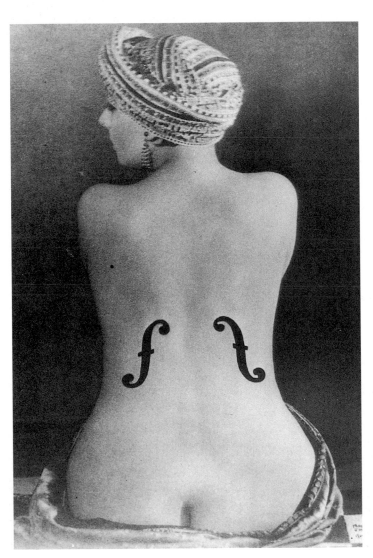

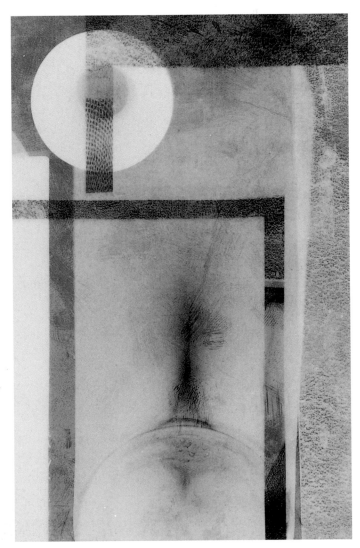

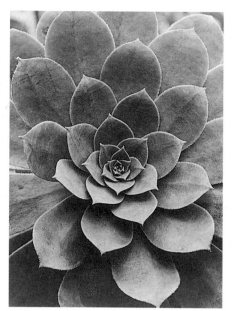

4.49 Albert Renger-Patzsch, *Sempervivum percaneum*, c. 1922. Gelatin silver print. Folkwang Museum, Essen, Germany.

Renger-Patzsch eschewed the manipulations of Man Ray and Moholy-Nagy (the use of double exposures, for example) to produce straightforward photographs of objects. But the details, often greatly enlarged, are so sharp that the result is frequently an exercise in patterns.

4.50 Aleksandr Rodchenko, *At the Telephone*, 1928. Gelatin silver print. Museum of Modern Art, New York (Mr. and Mrs. John Spencer Fund).

As the Communist government made life difficult for avant-garde artists in the Soviet Union, the Constructivist painter, Aleksandr Rodchenko, more and more turned to photography. He delighted in unusual points of view. Here the figure is seen from directly above.

The Alienated Eye

One of the points which the leading photographers of the period wanted to make with their images was that the camera had a different way of perceiving reality from that of the unaided human eye. Photographers such as Rodchenko deliberately adopted unexpected points of view, photographing scenes and objects in a raking perspective, or directly from above (FIG. 4.50). The German photographer, Albert Renger-Patzsch (1897–1966), made close-up photographs of natural forms which were intended to call attention to the analogies which existed between these and industrially produced objects (FIG. 4.49). The images have a decorative aloofness which separates them from their quotidian context.

This tendency was marked especially clearly in American photography. Edward Weston (1888–1958), who made stunning images of simple objects deliberately removed from an explanatory framework (FIG. 4.51), was influenced by

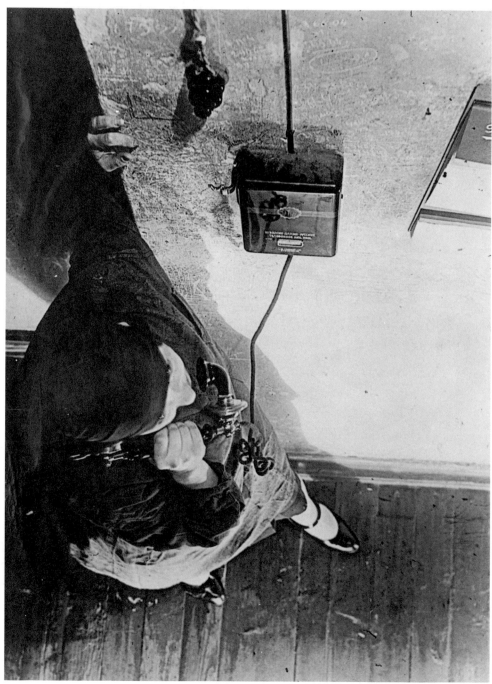

4.51 Edward Weston, *Shell*, 1927.
Gelatin silver print. Center for
Creative Photography, University of
Arizona, Tucson.

In the 1920s a number of leading
photographers made images of
both natural and manufactured
objects deliberately removed from
any explanatory framework.
Weston's close-ups of animal and
vegetable matter—which detach the
objects from reality and present
them as shapes and patterns—bear
some resemblance to the flower
paintings of Georgia O'Keeffe (see
FIG. 4.27).

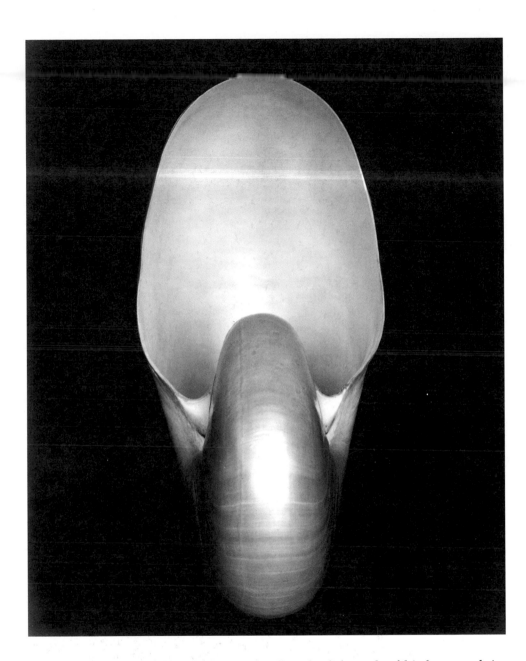

4.52 Paul Outerbridge, *Marmon
Crankshaft*, 1923. Platinum print.
Art Institute of Chicago, Illinois
(Julien Levy Collection).

The emphasis on shape, pattern,
and texture in this image was char-
acteristic of photographers of the
1920s, who liked to make geometri-
cal compositions, shot close-up and
sharply focused.

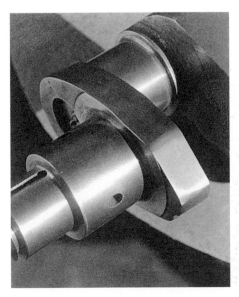

Stieglitz, whom he met in 1922, but significantly did much of his best work in
California, where photography met with much less competition from traditional
forms of expression.

American photographers did not confine themselves to natural forms, but
were equally fascinated by the camera's vision of industrial objects. A good
example of an image of this sort is Paul Outerbridge's *Marmon Crankshaft* (FIG.
4.52). The impact originally made by photographs of this type, which seemed to
provide a kind of justification for the work of the Russian Constructivists and
even for the radical Neo-Plasticism of Mondrian, has been considerably softened
by the fact that they very soon began to influence the look of American advertis-
ing. At the time when *Marmon Crankshaft* was made, it was more daring in its
treatment of abstract form than anything available in the American painting of
the period.

Documentary Photography

Despite these experiments, photography still retained its purely documentary
function. The veteran French photographer, Eugène Atget (1857–1927), continued

4.53 Eugène Atget, *Fête du Trône*, 1925. Art Institute of Chicago, Illinois (Julien Levy Collection).

Atget's photographs of once familiar but now vanishing aspects of Paris were admired by the Surrealists for their strange juxtapositions.

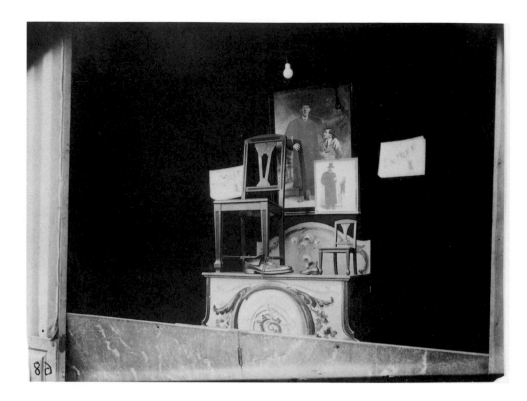

4.54 August Sander, *Pastry Cook, Cologne*, 1928. Gelatin silver print. Sander Gallery, New York.

In each of his photographs in his projected anthology of all human types, Sander had his subject look straight into the camera in a pose chosen by the subject, so that the result would approach to a "self-portrait."

to make the documentary photographs of Paris and its environs which he had been producing since the 1890s. Atget was an avid reader of the great French nineteenth-century "realistic" novelists who made Paris and its population a large part of their subject-matter, and his aim seems to have been to preserve aspects of the city which were rapidly vanishing. His late images of shop windows and fairground accoutrements (FIG. 4.53) attracted the attention of the Surrealists because of the way in which they seemed to distill the strangeness of ordinary life.

In Germany, August Sander (1876–1964) had embarked on an even more ambitious attempt to document "Man in 20th Century-Germany." His project was eventually cut short by the Nazis, who found that the human diversity he presented ran contrary to their own official teachings about class and race. Sander's surviving images, for example, *Pastry Cook, Cologne* (FIG. 4.54), have an unpretentious truthfulness which transcends the politicized vision of the artists of the Neue Sachlichkeit.

In a certain sense, Sander and Atget represented the end rather than the beginning of something. As photographic technique developed, documentary photography lost its neutrality and became more deliberately didactic. This tendency was accelerated by the violent and tragic events of the following decade.

1930	**1931**	**1932**	**1933**	**1934**

GENERAL EVENTS

• Nazi party wins 107 seats from center parties in German elections	• Collapse of Austrian Credit-Anstalt bank leads to financial crisis in Central Europe	• Nazi party wins 230 seats in German elections	• Hitler appointed German Chancellor	• Civil Works Emergency Relief Act passed in United States
• Name of Constantinople, Turkey, changed to Istanbul	• First woman elected to US Senate	• Franklin D. Roosevelt elected president of United States	• Nazis build first concentration camps. Boycott of Jewish businesses begins in Germany	• Assassination of Kirov in Leningrad. Stalin begins purge of Communist Party
• Joseph von Sternheim directs *The Blue Angel*, starring Marlene Dietrich	• Ezra Pound publishes *The ABC of Reading*	• First Venice film festival	• United States recognizes USSR	• "Night of the Long Knives" in Germany: up to 1,000 of Hitler's political opponents killed by the SS
• France begins building the Maginot Line across its frontier with Germany				
• W.H. Auden publishes *Poems*				

Rivera, *The Conquest of Mexico*: see p.157

Marsh, *Young Woman on a Merry-go-round*, see p.163

SCIENCE AND TECHNOLOGY

• Human blood groups identified	• Cyclotron invented			
• Photo flashbulb comes into use	• Using x-rays, P.J.W. Debye investigates molecular structure			
• The planet Pluto is discovered		• Discovery of the positron and neutron, and of Vitamin D	• Electronic television developed (a system different from Baird's)	• Cargo refrigeration process devised
• First transatlantic airmail service			• Vitamin C synthesized	• Death of Marie Curie

ART

• Suicide of Vladimir Mayakovsky, figure-head of the Russian avant-garde	• International Colonial Exhibition, Paris	• Alexander Calder invents the mobile	• Hitler closes the Bauhaus	• First public exhibition devoted to interior design, "The Chair," held in the Netherlands
• Grant Wood, *American Gothic*	• Abstraction-Création Group founded	• Otto Dix completes his triptych *The War*	• Edward Hopper exhibition at MOMA, New York	• "The Machine," exhibition at MOMA, New York
	• Inauguration of the Whitney Museum of American Art, New York		• Henry Moore exhibition at the Leicester Galleries	
			• Balthus, *The Street*	

Hepworth, *Three Forms*: see p.172

ARCHITECTURE

• R. Hood designs Daily News Building, New York	• Rockefeller Center begun, New York (–1940)			• Cass Gilbert, architect of the Woolworth Building, New York, dies
• Le Corbusier completes Villa Savoye, Poissy	• Empire State Building and Chrysler Building completed, New York	• Frank Lloyd Wright sets up the Taliesin Fellowship foundation for the study of architecture	• The Tecton group, Highpoint flats, Highgate, London	

1935 1936 1937 1938 1939

- Nazis repudiate Versailles Treaty. Compulsory military service reintroduced in Germany

- Show trials in USSR

- Italy invades Abyssinia

- Penguin publishers in London launch the first "paperback" format books

- Spanish Civil War begins. The dramatist and poet Federico Garcia Lorca is one of its first victims, killed by the Francoist militia

- Hitler and Mussolini proclaim Rome–Berlin Axis

- Italy annexes Abyssinia

- China declares war on Japan

- Abdication of Edward VIII, in order to marry the American divorcee, Wallis Simpson

- Japanese troops capture Peking and Nanking. Chiang Kai-shek unites with Communists under Mao Tse-tung

- Spanish Republicans move capital to Barcelona

- Bombing of Guernica, Spain

- German civilians move into the Sudetenland, Czechoslovakia

- British prime minister Neville Chamberlain meets Adolf Hitler at Berchtesgarten to resolve crisis

- Germany annexes Austria

- End of Spanish Civil War

- Germany invades Poland and annexes Danzig

- Britain and France declare war on Germany. World War II begins

Lange, *Migrant Mother*: see p.175

Mukhina, *Worker and Collective Farm Woman*: see p.169

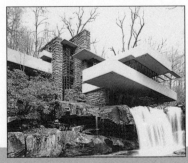

- Radar invented

- The liner *The Normandie* breaks the speed record for an Atlantic crossing

- Richter scale developed

- Boulder Dam on Colorado River completed

- Regular television broadcasts initiated for the first time in Germany

- Frank Whittle builds first jet-engine

- Patent granted for the manufacture of "nylon"

- Walt Disney directs the first full-length animated cartoon, *Snow White and the Seven Dwarfs*

- Ball-point pen invented

- Atomic fission achieved

- DDT invented

- Igor Sikorsky builds first helicopter

- Death of Sigmund Freud

- Death of Kasimir Malevich

- The Ten, group of American painters, formed

- International Surrealist Exhibition, London

- Under the aegis of Sigmund Freud, first art-therapy school opened in London

- Salvador Dalí, *Soft Construction with Boiled Beans (Premonition of Civil War)*

- Vera Mukhina, *Worker and Collective Farm Woman* (sculpture)

- Pablo Picasso, *Guernica*

- Nazi "Degenerate Art" exhibition, Munich

- Raoul Dufy's *Le Fée Electricité* (300 x 60 ft, and the largest painting in the world) is exhibited at the International Exposition, Paris

- *Plastic Art and Pure Art*, essays by Piet Mondrian

- International exhibition of Surrealism in Paris

- Marcel Duchamp, *The Box*

- Death of the art dealer Ambroise Vollard

- Max Ernst interned by the French authorities

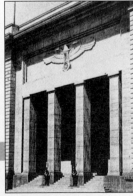

Speer, Reichs Chancellery: see p.152

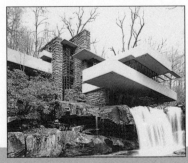

Wright, Falling Water: see p.154

- Eduardo Torroja, stands of Zarzuela Racetrack, near Madrid

- Frank Lloyd Wright, Falling Water, Bear Run, PA

- The Crystal Palace in London, venue for the Great Exhibition of 1851, is destroyed by fire

- The Golden Gate Bridge in San Francisco Bay is opened to traffic

- Walter Gropius is appointed to Harvard Chair of Architecture

- Frank Lloyd Wright, Taliesin West, Phoenix, AZ

- Walter Gropius and Marcel Breuer, Haggerty House, Cohasset, MA.

- Albert Speer, Reichs Chancellery, Berlin

- Albert Speer unveils plans for the rebuilding of Berlin as the capital city of Europe

- Philip Goodwin and Edward Stone remodel MOMA, New York

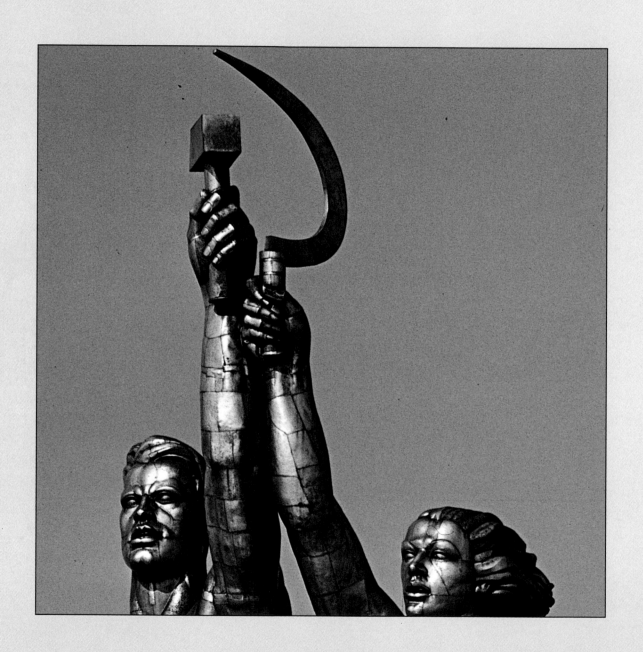

1930–1939

The decade leading to the outbreak of World War II saw the rise of dictatorships, and in particular the triumph of the Nazi Party in Germany. As had been the case before World War I, a series of lesser conflicts preceded the major conflagration. The most serious and bitterly fought of these conflicts, and the one which most preoccupied the artists and intellectuals of the time, was the Spanish Civil War, which broke out in 1936 and ended with the defeat of the Republican cause in 1939. There were, however, other conflicts as well, such as the Italian conquest of Abyssinia, and the Japanese invasion of China. Although many artists looked to the Soviet Union as a social ideal, and a bulwark against the ambitions of Hitler and Mussolini, conditions there deteriorated sharply. The assassination of Stalin's henchman, Kirov, in Leningrad (formerly St. Petersburg) in 1934 triggered off a series of show trials and purges in Russia which were to continue until the end of the decade.

The visual arts continued to show an increasing tendency towards pluralism, with abstraction and figuration, Surrealism and Constructivism, in vigorous rivalry with one another. A major feature of the time was increased emphasis on the links between the arts and society, and on the role of the visual arts as an instrument for social change. In the United States, this emphasis seemed to be sanctioned by the various visual arts programs connected with the WPA (Works Project Administration) which had been created to alleviate some of the worst effects of the Depression. These programs had the effect of creating a real community of artists in New York, of a kind which had not existed previously. This community offered fertile ground for ideas carried to the United States by emigrants from Europe.

Architecture

ARCHITECTURE IN EUROPE

The rise of the dictatorships in Europe brought with it a reversion to traditional styles. Architecture was seen, less as the embodiment of a way of life in which man and machine were brought into harmony with one another, more as a mirror for nationalist ambitions.

Italy

Italian Fascism, the oldest of the dictatorial regimes, went furthest toward an accommodation with the Modern movement in architecture. During the 1920s, Mussolini's architects had made attempts to reconcile the stripped-down simplicity of Modernist architecture with the myth of a New Rome. Mario Piacentini (1891–1960), an architect much favored for important government commissions, proposed a new, vestigially Classical style as a working compromise between two essentially irreconcilable philosophies. This style can be seen at its most typical in the buildings which he and his supporting team designed for the new University City in Rome. Here architectural ornaments are reduced to a minimum, but the

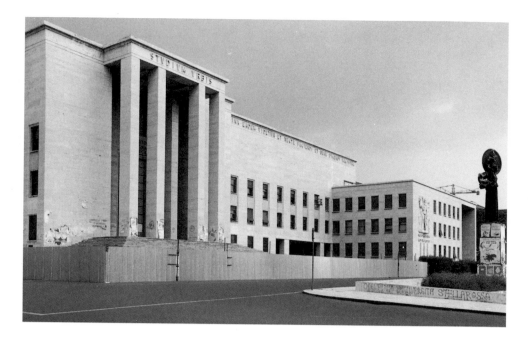

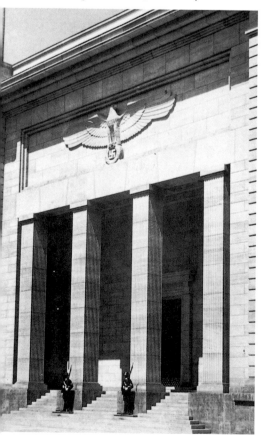

Classical derivation is stressed through the use of colonnades, bas-reliefs, and large-scale inscriptions, often used as friezes (FIG. 5.1).

The Soviet Union

The Soviet regime in Russia, reacting against the Constructivist projects of the early revolutionary epoch (nearly all of which remained unrealized for lack of funding), looked back nostalgically to the Classicism of the era of Catherine the Great. Despite its Tsarist associations, this manner symbolized a period when Russia had played a major role in world affairs. This was a part which the Soviet Union under Stalin now hoped to play again. Unlike its drastically simplified Italian equivalent, architecture in the Soviet "wedding-cake" style tended to be lavishly festooned with ornament. Aspects of Soviet architecture have, nevertheless, been defended by architects and historians of architecture not at all in sympathy with these cumbersome stylistic trappings. They find in certain buildings qualities reminiscent of old imperial Russia: breathtaking scale, a feeling for great open spaces, and grandly confident ensembles. In a slightly ironic way, Soviet architecture calls our attention to strong elements of continuity in Russian culture.

Germany

Similar qualities can be found in some of the most characteristic architectural products of Hitler's Third Reich. Hitler's preferred architect was Albert Speer (1905–81), later to be Minister for Production during the war years. A typical example of Speer's work was the new Reichs Chancellery in Berlin (FIG. 5.2), designed to serve as a headquarters for the Führer himself. Like the Bauhaus architects before him, Speer owed much to the great German Classicist, Karl Friedrich Schinkel. The difference was that he applied Schinkel's ideas in a much more direct and literal way, looking beyond him to visionary French architects of the late eighteenth century, such as Etienne-Louis Boullée (1728–89). Boullée's design for a cenotaph for Isaac Newton (1784), a hollow sphere 500 feet (152 m) in diameter, was unrealizable. Speer, with the resources of the Reich at his disposal, believed for a time that he could bring similar projects to fruition. The Reichs Chancellery, overbearing in scale and unremittingly severe in detail (though more orthodox in its Classicism than Piacentini's creations), was supposed to be a mere foretaste of what was to follow.

5.3 Alvar Aalto, Villa Mairea, Noormarkku, Finland, 1938–9.

This villa was built for Aalto's principal patron, Mrs. Gullichsen, heiress to a timber fortune.

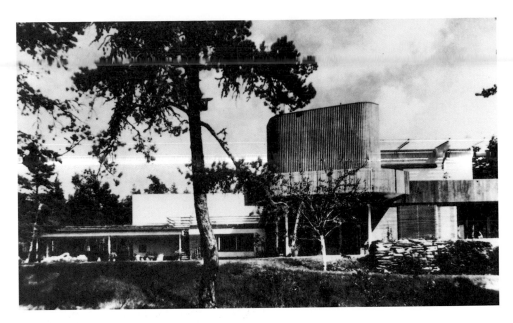

The Nazi regime, however, was pluralist in its approach to architectural form. Nazi cultural theorists advocated the use of different architectural styles for different purposes. The experiments in mass housing made by the Bauhaus architects were derided as the equivalent of primitive flat-roofed Arab villages. Housing estates were now built in what was called the *Heimatstil* ("Home Style"), with whitewashed walls and pitched roofs inspired by traditional German villages. The functionalist manner continued to be employed for factory buildings. This division was to root itself in later architectural practice, though critics and theorists often remained blind to its origins.

Alvar Aalto and the Scandinavian Tradition

Another region where the Modernist impulse was being reconsidered, though in a much less doctrinaire way, was Scandinavia. Here a romantic nationalist style, using Classical and sometimes even Gothic elements, had flourished throughout the first two decades of the century. Scandinavia produced an architect of genius in the Finn, Alvar Aalto (1898–1976).

Aalto went into practice on his own in 1922, and by the late 1920s was firmly established as a distinguished practitioner of functionalism, somewhat in the Bauhaus manner, but with a distinctive local accent. A change of direction in his work was brought by his close connection with the Finnish timber industry, initially through his patrons, Harry and Mairea Gullichsen. Mrs. Gullichsen was the heiress to a large timber, paper, and cellulose concern. She commissioned Aalto to design a range of plywood furniture for mass production (the Artek range, still available today), and close acquaintance with the material led him to think of timber as, in many circumstances, a rival to reinforced concrete as a primary material for modern building. The Villa Mairea (FIG. 5.3), a summer home built for Mrs. Gullichsen, makes subtle use of brickwork, masonry, and timber siding, arranged not only to define the different areas of the house—sauna, public rooms, and private ones—but to evoke connections with Finnish traditions and underline the organic relationship between the building and the landscape surrounding it.

ARCHITECTURE IN THE UNITED STATES

During this decade the functional style associated with the Bauhaus in Germany and with Le Corbusier in France began to make an impact in the United States. One powerful influence was the "Modern Architecture" exhibition mounted by

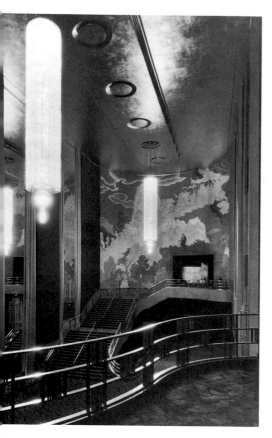

5.4 Edward Durrell Stone (architect) and Donald Deskey (interior designer), Radio City Music Hall, New York, 1932.

This building was the most spectacular example of the so-called "moderne" style of the 1930s in the United States—a modification and popularization of the Art Deco of a decade earlier.

5.5 Frank Lloyd Wright, Falling Water, Bear Run, Pennsylvania,1935–42.

Wright's most romantic house, with his characteristic blocks jutting out in all directions, is a prime example of what Wright meant by "organic architecture." The house merges with its rocky location.

the Museum of Modern Art in New York in 1932. The joint organizers were the architectural historian, Henry-Russell Hitchcock, inventor of the term "International Style," which came to signify functionalism and its claims to universal hegemony, and the architect Philip Johnson (1906–). The emphasis was heavily on European buildings and the message was simple: modern architecture now possessed an assured language of its own, destined to be universal, against which the old pluralist styles could not hope to stand firm.

Despite this much-debated event, American buildings in a fully developed European functionalist manner remained scanty. The Depression had slowed down construction in the United States, and those major projects which continued, like the Rockefeller Center in New York (1931–40) had been conceived in the more prosperous 1920s. A major feature of the Rockefeller Center was its theater, Radio City Music Hall (FIG. 5.4). The auditorium, focused on a vast stage with a proscenium of huge semi-circular arches, epitomized the "moderne" style of the period: an Americanization of Art Deco for mass consumption. The "moderne" and functionalism both claimed to embody the spirit of the twentieth century, but from very different angles. For the architects and designers who made use of the "moderne," the contemporary spirit could be expressed in a purely decorative and romantic way.

Frank Lloyd Wright in the 1930s

The new ideas about utility, as exemplified in the prophetic, but never fully practical, Dymaxion House (1927) of Buckminster Fuller (1895–1983), more engineer than architect, influenced Frank Lloyd Wright, who was gradually making his presence felt again in American architecture. His Usonian houses, the first of which was completed in 1937, try to make maximum use of small suburban lots by turning the back of the building to the street and organizing it as an L-shape enclosing a courtyard (an idea which somewhat resembles the plan adopted by

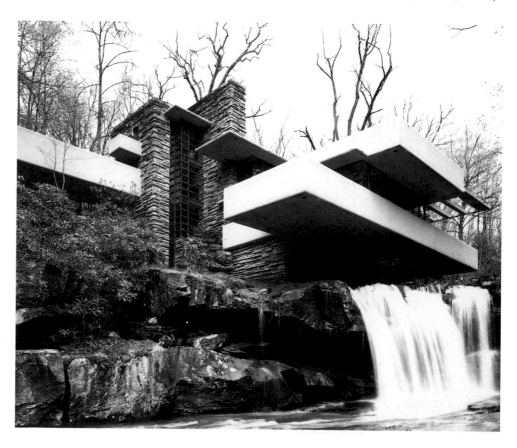

Aalto at the Villa Mairea). The walls were easily installed, composite panels, laid out on a two-by-four-foot grid; the floors were lightweight slabs which contained steam or hot water piping for heating. There was no separate dining room, but a kitchen linked to a small dining area.

Wright's major concerns were utility, economy, and harmony with nature. The last of these received a dramatic statement in his most spectacular house of the period, "Falling Water" at Bear Run, Pennsylvania (FIG. 5.5). The building consists of a series of balconies and terraces cantilevered over a waterfall—interlocked and overlapped planes which open out into the surroundings. Though "Falling Water" is a much grander gesture than anything by Aalto, its rough stone walls link it to the Villa Mairea. Their organic quality is accentuated by courses of different thicknesses. Like Aalto, Wright eschewed the smooth impersonality of finish favored by International Style architects.

Like the Nazi *Heimatstil*, the buildings produced by Wright and Aalto during the 1930s heralded the revival of interest in vernacular idioms for architecture which was to recur after World War II.

Painting

"REALIST" PAINTING

Painting and National Socialism

Hitler's rise to power in Germany was followed by an immediate campaign against all forms of art variously described as "Bolshevist," "Marxist," "Jewish," and "Degenerate." The Nazi party employed two theoretical ideas to attack Modernism. One, derived from Max Nordau's *Entartung* ("Degeneration"), published in 1893, was to apply the idea of biological degeneration to cultural matters. The other was that German identity could be reasserted only by a return to the German Classical culture of figures like Goethe, Schiller, and Beethoven. Hitler shrewdly focused on the internationalism of the Modern movement and its subjection to fashion. In a speech made in 1937 he noted that "art as such is [now] not only completely dissociated from its national origins, but it is also the product of a given year." The first phase of the National Socialist war against Modernism culminated in the immense Exhibition of Degenerate Art staged in Munich in 1937. Among the German artists whose work was included in it were Max Beckmann, Otto Dix, and George Grosz, together with Franz Marc, Paula Modersohn-Becker, and the sculptors, Ernst Barlach and Käthe Kollwitz. The exhibition, crammed into a few crowded rooms, attracted more than 1,500,000 visitors. It was only one wing of a diptych. Simultaneously on view, in much more spacious conditions, was a display of Great German Art—paintings and sculptures which had official approval. Significantly, this section drew only 600,000 visitors.

The painting of the Nazi epoch has now been almost entirely banished from view, to the point where its absence represents a real gap in the cultural history of the epoch, even though many examples still exist in German state collections. One painting which has recently surfaced in a number of international exhibitions is *The Sower* (FIG. 5.6) by Oskar Martin Amorbach. The ideological message is clear: what is being sown is National Socialist doctrine. Despite this, the painting is in many respects close to the work of the banned Otto Dix. Like Dix's portraits, it looks back to northern European art of the sixteenth century, but in this instance to Pieter Brueghel the Elder rather than to Dürer. The link to Brueghel's *Fall of Icarus* in the Musée des Beaux-Arts in Brussels is particularly strong.

5.6 Oskar Martin Amorbach, *The Sower*, 1937. Oil on wood, 8 ft 3¾ in x 5 ft (253.5 x 152.5 cm). Collection of the Federal Republic of Germany (Weimar Archive).

5.7 Isaac Brodsky, *Lenin in the Smolny Institute*, 1930. Oil on canvas, 6 ft 6 in x 10 ft 6 in (1.98 x 3.20 m). Tretyakov Gallery, Moscow.

The Smolny Institute was a school for aristocratic girls in St. Petersburg which became Lenin's headquarters during the first phase of the Bolshevik Revolution.

Socialist Realism in the Soviet Union

By the mid-1920s, the Constructivist impulse in Russia had begun to exhaust itself. There had for some time been a strong realist tradition in Russian painting, founded on the work of the so-called Itinerants, or Wanderers—a group of artists formed in the 1870s to express opposition to the prevailing academic climate, and to organize touring art exhibitions beyond the confines of the capital, St. Petersburg. One sign of the revival of realist, figurative art was the foundation of OST (the Association of Easel Painters) in 1925. It held four exhibitions between that year and 1928, and it soon became apparent that the authorities felt more comfortable with work of this type than with Constructivism. Controversy raged about "Formalism"—a term which originated in an assertion made by the Constructivists that "a new form gives rise to a new content, since form and being determine consciousness and not vice-versa." Formalism became a catch-all term of abuse for everything in modern art which attracted official disapproval. The attack on Modernism culminated in a resolution of the Communist Party passed in 1932 to establish the Union of Soviet Artists as an instrument of artistic control. Membership was essential for any artist who wished to make a career within the boundaries of the Soviet Union. In 1934 Stalin imposed the principle of Socialist Realism, summarized as "the truthful depiction of reality in its revolutionary development." In other words, only an easily assimilated, academic realist style was permissible.

There are obvious similarities between Russian and German official art of the 1930s. Both, for example, aimed to direct the spectator's attention away from the style of the work, and toward its content, which in each case tends to have a collective rather than a personal meaning. Typical of the period are the paintings which heroize the early years of the revolution. *Lenin in the Smolny Institute* (FIG. 5.7), painted by Isaac Brodsky (1884–1939) four years before the imposition of Socialist Realism but still representative of its aims, portrays the Bolshevik leader quietly at work in the girls' school which served as the party headquarters in Petrograd during the October Revolution. The painting recalls David's *Napoleon*

5.8 Aleksandr Deineka, *Pilots of the Future*, 1938. Oil on canvas, 4 ft 4¾ in x 5 ft 3⅜ in (1.34 x 1.61 m). Tretyakov Gallery, Moscow.

Deineka's work—though more sentimental—is sometimes reminiscent of that of the American realist Edward Hopper (see FIG. 5.17).

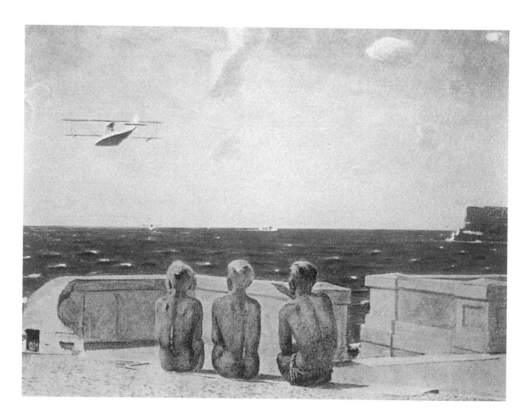

in His Study, commissioned in 1812. In both, a solitary and dedicated leader is ~~shown working for the people.~~

The idea of modernity was not entirely abandoned by Socialist Realism, but Soviet artists tended to bind it up with technological and material progress. A charming if rather sentimental result was *Pilots of the Future* (FIG. 5.8) by Aleksandr Deineka (1899–1969), in which three boys look with longing and admiration at a seaplane skimming over the water. There is a nineteenth-century parallel in Sir John Everett Millais's once-celebrated *The Boyhood of Raleigh*, which exploited youthful adventure to similar patriotic effect, but Deineka set his scene in the present because anything earlier than 1917 was associated with Tsardom.

Mexican Muralism

The 1930s were the heyday of the muralist effort in Mexico, and marked the highpoint of Mexican influence throughout Latin America and in the United States. Rivera was joined by two colleagues, José Clemente Orozcó (1883–1949) and David Alfaro Siqueiros (1898–1974). Though these three are usually grouped together—Mexicans call them *los tres grandes* ("the three great ones")—they were in fact very different from one another both in style and in temperament. By the beginning of the 1930s, Rivera had arrived at his mature style, a decorative fusion of many elements—Cubism, Gauguin, the Douanier Rousseau (who falsely claimed that he had fought in Mexico as a soldier under Emperor Maximilian), fifteenth-century Italian fresco painting, and pre-Columbian narrative reliefs. This style is seen at its most attractive in the series of murals which Rivera painted for the Palacio de Cortès in Cuernavaca (FIG. 5.9). There is a certain irony attached to

5.9 Diego Rivera, *The Conquest of Mexico*, (detail), 1929–30. Fresco. Palacio de Cortès, Cuernavaca, Mexico.

Rivera's most celebrated series of murals, commissioned by the American ambassador to Mexico, Dwight D. Morrow, recounted the history of Cuernavaca and Morelos in a less nationalistic and less aggressively political manner than his earlier work.

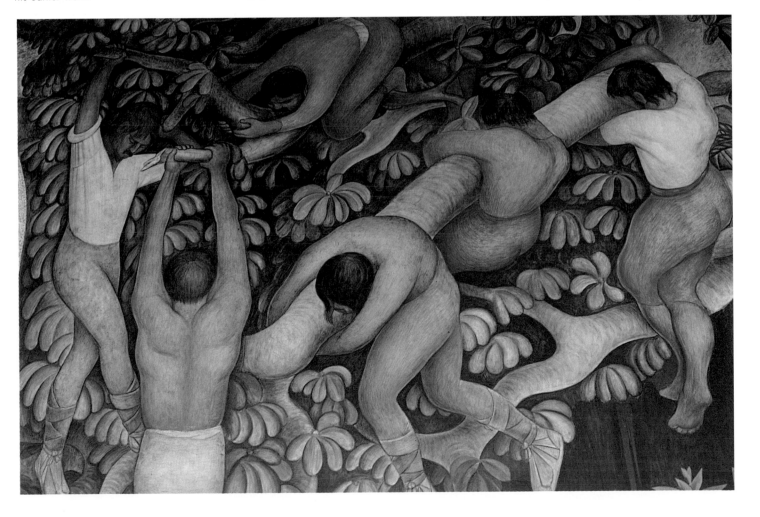

José Clemente Orozcó: Murals in the Hospicio Cabañas

The Hospicio Cabañas was designed by the Spanish-born architect and sculptor Manuel Tolsá (1757–1816), and the ensemble is probably the most important group of Neoclassical buildings in Mexico. The spaces in the church come close to being pure geometric forms. Orozcó made them a foil for vehement scenes in which the Indian world is perceived as cruel and savage, but the Spanish conquest as even more harsh (FIG. 5.10). The murals take off from ground level, where tones of olive and gray predominate, and ascend into the vaults, where brilliant hues are employed.

The bold, quasi-Expressionist style shows a number of influences, but little impact from pre-Columbian art, the supposed inspiration of the Mexican mural movement in general. Orozcó responded strongly to Michelangelo, El Greco, and Goya (in contrast to Diego Rivera, who was influenced by early Renaissance painters such as Piero della Francesca). One can also see the effect produced on Orozcó by the Mexican engraver, José Guadalupe Posada (1852–1913), who in Orozcó's youth ran a workshop in Mexico City that produced popular broadsides. In his autobiography, Orozcó records that Posada's work was "the push that first set my imagination in motion and impelled me to cover paper with my earliest little figures; this was my awakening to the art of painting."*

Another important source was nineteenth- and early twentieth-century political caricature. During Mexico's revolutionary years—the second decade of the century—Orozcó himself worked as a caricaturist for a left-wing paper, *The Vanguard*. A number of these apparently conflicting elements can be found in the scene which fills the dome of the Hospicio, an allegory of the natural elements, which are symbolized by four Michelangelesque figures (some only partly visible)—the men of Earth, Air, Fire, and Water. Notable is the way in which the figures overfill the avail-able space, and seem to protest against the constraints imposed by Tolsa's rational architecture. Orozcó's work is ultimately superior to that of Rivera because of its inventive design and wonderful kinetic energy.

*José Clemente Orozcó, *An Autobiography*, Austin, Texas, 1962, p. 8.

5.10 José Clemente Orozcó, *The Four Phases of Man*, 1936. Fresco. Hospicio Cabañas, Guadalajara, Mexico.

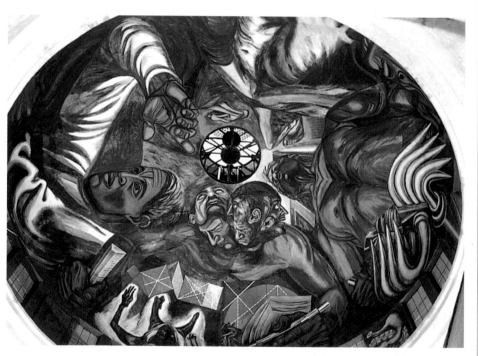

the location of these murals—a building associated with the Spanish conqueror of Mexico—and also to the commission itself, which came from the American ambassador to Mexico, Dwight D. Morrow. Despite the great acclaim he received in the United States, Rivera was a lifelong opponent of American influence in his native country.

Rivera wished to construct a coherent narrative which would speak directly to the whole Mexican people. To achieve this he had to abandon much that was typical of modern art, such as fragmentation of images and disguise of appearances. He was brilliantly successfully in Cuernavaca. The murals in the Palacio de Cortès are a kind of dream or fantasy formed from historical materials. They speak eloquently of the Mexican past, not as it really was, but as Rivera would like it to have been.

Orozcó was born and spent most of his youth in Guadalajara, Mexico's second city. His early work shows the influence of the European Symbolists—some of his early drawings are not unlike those which the young Picasso made in Barcelona. He worked with Rivera in the National Preparatory School in the 1920s, but seems to have been overwhelmed by the latter's personality and much greater knowledge of European art. In 1927 Orozcó left for the United States, where he remained until 1934. In the late 1930s he resettled in Guadalajara, where he had been offered a series of commissions by Everado Topete, governor of the state of Jalisco. Orozcó's most important fresco cycle in Guadalajara (see FIG. 5.10) was for the deconsecrated church of the Hospicio Cabañas, once an orphanage.

While Rivera claimed that his murals were pre-Columbian in inspiration, Orozcó, in whom the spirit of contradiction was always strong, insisted otherwise. In 1947 he wrote: "Having studied the themes of modern Mexican painting, we find the following facts: all the painters begin with scenes derived from traditional iconography, either Christian or Frankish, and very often literally copied from them ... To all this outdated religious imagery, very nineteenth-century liberal symbols are added. Freedom with its Phrygian cap and the indispensable broken chains."[1]

Siqueiros, the youngest of the group, had the most erratic career, being often distracted from painting by politics. During the 1920s he was secretary of the Communist Party of Mexico and president of the National Federation of Mineworkers. In the 1930s he spent much time in the United States (in 1936 he ran an experimental group for young painters in New York, one of whom was Jackson Pollock). He also fought in the Spanish Civil War. It was not until the late 1930s that he completed a major mural in his own country. His *Portrait of the Bourgeoisie* (FIG. 5.11), in the headquarters of the Electricians Union in Mexico City, shows the flamboyant nature of his style, and his liking for twisted perspectives which make it seem as if the various figures and groups are about to detach themselves from the walls.

5.11 David Siqueiros, *Portrait of the Bourgeoisie* (detail), 1939. Pyroxaline on cement. Electricians Union Headquarters, Mexico City.

Because of his political activities, Siqueiros produced few murals in the 1930s. This very large mural covers 1,000 ft² (305 m²). It is outright political propaganda against the middle classes, whose very temple, dedicated to Liberty, Equality, and Fraternity, is in flames.

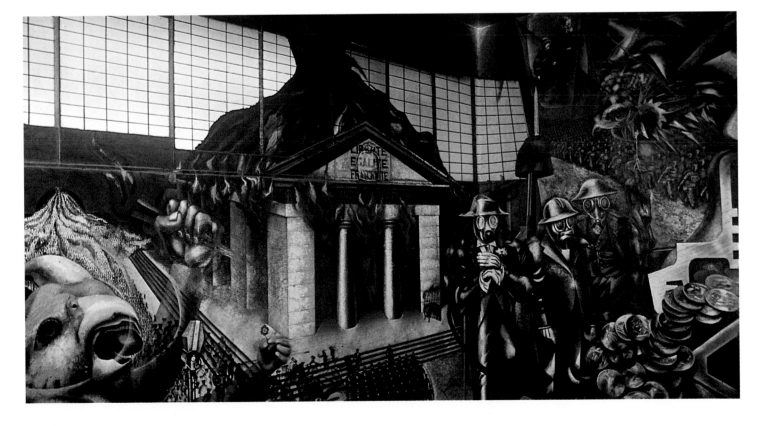

Siqueiros is less important as an individual creator than as an ambassador for Muralism. Most of his major mural projects belong to the last thirty years of his life, when Muralism was being seriously challenged, in Mexico and throughout Latin America, by other styles and other ways of thinking.

Regionalism in the United States

Mexican Muralism enjoyed a stylistic, but not necessarily a political, influence in the United States. Like Mexican Muralism, Regionalism represented a nationalist impulse, but its roots were conservative rather than radical. The self-appointed leader of the Regionalist movement was Thomas Hart Benton (1889–1975). Midwestern in origin—he was born in Missouri—Benton had pursued a varied and adventurous career before deciding to return to his roots. After a period in Paris, he based himself in New York, but spent much of his time during the 1920s traveling in the west and southwest. His great opportunity came in 1933 when he was offered a major mural commission for the Indiana Pavilion at the Chicago World's Fair. Benton had long aspired to paint vast mural cycles on the Mexican model, and the Indiana series established him not merely as a man capable of handling work on the most ambitious scale, but as one whose interest lay in depicting things which were specifically American. In December, 1934, *Time* magazine exhibited its new ability to illustrate stories in color by doing a major story on American art and printing a self-portrait of Benton on its cover. Benton's reaction to this success, which catapulted him over the heads of better-known contemporaries, was to attack the narrow circle of New York tastemakers, Alfred Stieglitz in particular, and to shake the dust of New York from his feet. He took a job teaching at the Kansas City Art Institute in Missouri and embarked on a set of murals for the Missouri State Capitol Building in Jefferson City. The cycle, *A Social History of Missouri* (FIG 5.12), is Benton's greatest achievement and one of the most ambitious enterprises ever undertaken by an American artist. Criticized locally

5.12 Thomas Hart Benton, *Arts of the West*, 1935–6. Tempera on wood with oil glaze, 8 x 13 ft (2.4 x 4 m). New Britain Museum of American Art, New Britain, Connecticut (Harnet Russell Stanley Fund).

The American Regionalist, Thomas Hart Benton, here attempted to rival the achievements of the Mexican Muralists. Benton, one of Jackson Pollock's teachers, famously remarked that "it took me ten years to get all the modernist dirt out of my system."

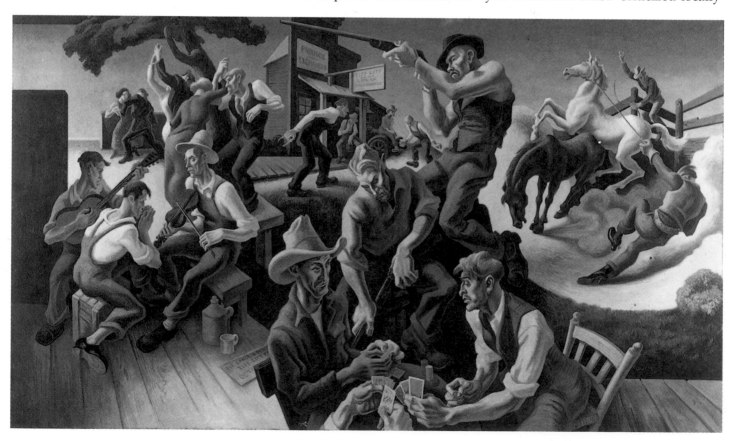

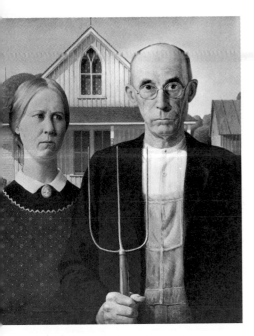

5.13 Grant Wood, *American Gothic*, 1930. Oil on beaver board, 29⅞ x 24⅞ in (75.9 x 63.2 cm). Art Institute of Chicago, Illinois.

5.14 John Steuart Curry, *Tragic Prelude*, 1937–42. Oil and tempera, 31 x 11½ ft (9.45 x 3.51 m). Kansas State House, Topeka, Kansas.

An apocalyptic image celebrating the activities of the anti-slavery campaigner John Brown in the Kansas Territory, then a frontier region which had not yet become a state.

for their "crudeness and lack of feeling"—in other words for their lack of idealization—the murals offer a lively panorama of life in Benton's home state. Like Rivera's work, they are eclectic: the influences range from Italian Mannerist painting of the sixteenth century to contemporary newspaper layouts featuring illustrations and comic strips.

Two other painters, Grant Wood (1891–1942) and John Steuart Curry (1897–1946), enjoyed a national reputation as Regionalists. It was Wood, not Benton, who really established the idea of Regionalism—not with a mural cycle but with one small painting, *American Gothic* (FIG. 5.13). The painting was a nostalgic celebration of aspects of rural America which were fast vanishing, with a composition based on portrait photographs made by itinerant photographers of the Civil War period. The painting struck an instant chord, and retained its popularity even after the excitement aroused by the Regionalist movement was long forgotten. No American painting has been more often paraphrased or parodied, and even today the image remains instantly recognizable.

Curry was probably the weakest artist of the three, but he, too, landed himself a major mural commission, a set of paintings for the Kansas State House in Topeka. The most memorable of the images he devised for this, *Tragic Prelude* (FIG. 5.14) celebrates the anti-slavery campaigner, John Brown, who had been mixed up in the slavery quarrel in Kansas Territory in the 1850s. Inspired by this tenuous link, Curry created a towering God-the-Father-like figure, brandishing a Bible in one hand and a rifle in the other.

Though Regionalism aroused a good deal of public interest and excitement, its success in the American art world was essentially factitious. All three of the chief protagonists died embittered and disillusioned men. None ever achieved the hold over the national imagination gained by Diego Rivera and his colleagues in Mexico.

Urban and Social Realism in the United States

Whereas the Regionalists tended to celebrate rural America, there was also a group of American artists who tried to depict the urban reality of the time—often,

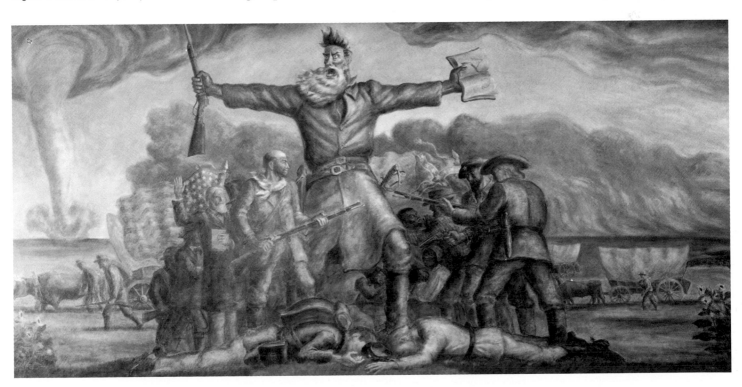

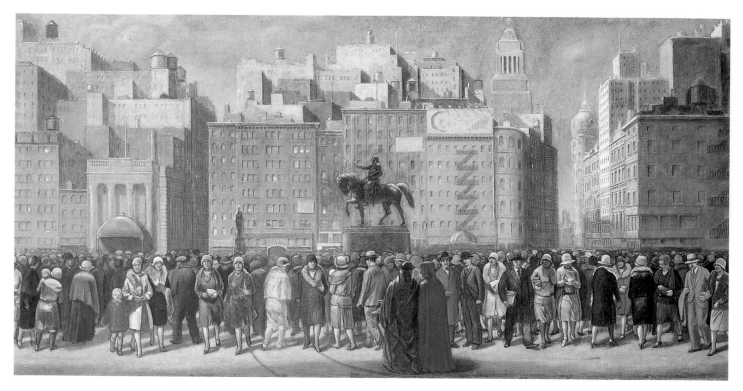

5.15 Isabel Bishop, *Dante and Virgil in Union Square*, 1932. Oil on canvas, 27 x 52⅜ in (68.6 x 133 cm). Delaware Art Museum, Wilmington, Delaware (Gift of the Friends of Art).

A leading American realist compares the street-life of New York to Dante's *Inferno*.

though not invariably, the impact of the Depression in New York. The two most interesting painters of this group are Reginald Marsh (1898–1954) and Isabel Bishop (1902–88). Both came from cultivated and prosperous backgrounds—Marsh's grandfather made a fortune in the Chicago meat-packing industry—but both were fascinated by what they saw in the grimy streets around their studios. In *Dante and Virgil in Union Square* , Bishop suggests that New York is a modern version of Dante's *Purgatorio*, but the mood is more sorrowful than indignant (FIG. 5.15). One of the most accomplished of the American artists of her time, with a particular gift for drawing, Bishop deserves more attention than she has so far been accorded.

Marsh's paintings are much more rumbustious, and reflect his background as a caricaturist—in 1923, when the *New Yorker* was founded, he was one of the first makers of satirical drawings to be recruited by the magazine. *Young Woman on a Merry-go-round* (FIG. 5.16) is a typical work by this very prolific artist—its composition stacked up vertically and offering no means of escape for the eye. Like Bishop, Marsh was not motivated by moral indignation. An unreflective artist, his desire was simply to celebrate what he saw.

Edward Hopper

The most considerable American realist of the period was the essentially unclassifiable Edward Hopper (1882–1967). Hopper established his style by the mid-1920s, and continued to paint in the same manner until his death. He came into his own in the 1930s. His specialty is the evocation of loneliness, and of a sense of dislocation. Many of his best paintings, like the famous *Early Sunday Morning* (FIG. 5.17), are unpopulated. When figures are present, they generally seem to have no real psychological link to one another. Hopper's apparently blunt-edged technique has great subtlety—his surfaces both collect and absorb light in a way that is reminiscent of the work of the Italian, Giorgio Morandi. The decade offers few better examples of the power of "pure" painting. Hopper demonstrates that, even before its period of international success, American art was already a force to be reckoned with.

5.16 Reginald Marsh, *Young Woman on a Merry-go-round*, 1938. Tempera on wood, 35¾ x 29⅞ in (91 x 76 cm). Springfield Museum of Art, Illinois.

Marsh frequently took the rumbustious blue-collar beach resort of Coney Island as the subject for his realistic canvases. He particularly liked the attractive young girls he saw enjoying themselves there. His rendering of them foreshadows aspects of the Pop art of nearly three decades later.

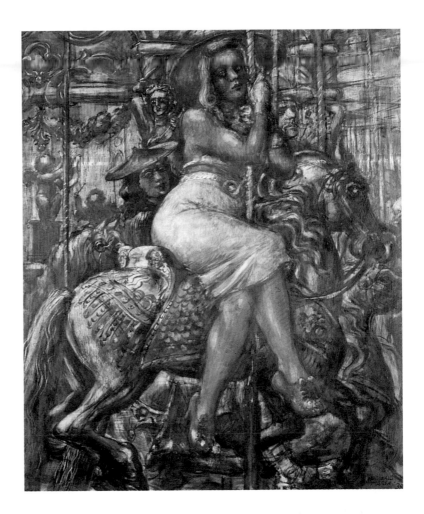

5.17 (*below*) Edward Hopper, *Early Sunday Morning*, 1930. Oil on canvas, 35 x 60 in (88.9 x 152.4 cm). Whitney Museum of American Art, New York.

Hopper's celebrated images of urban loneliness, with their mastery of composition, were painted with affectionate understatement. Hopper denied any association with the American Regionalists, or "American Scene" painters, such as Thomas Hart Benton (see FIG. 5.12). "I think the American Scene painters caricatured America. I always wanted to do myself."

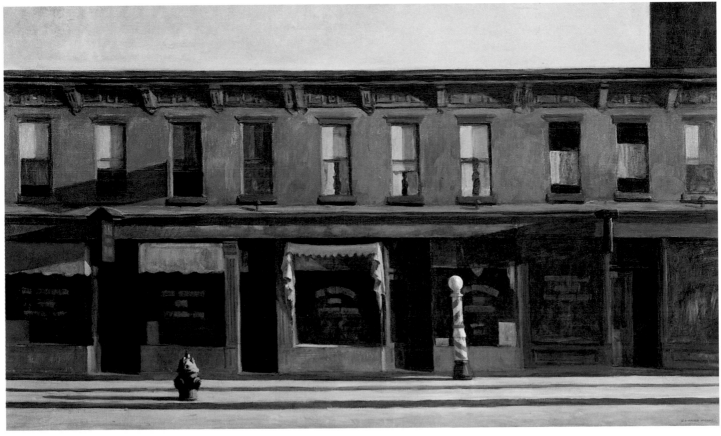

Balthus

The period also saw the emergence of one important realist or quasi-realist painter in Paris, where the climate was much less favorable to such enterprises than it was in the United States. Balthus (Balthasar Klossowski, 1908–) was born in Paris of Polish ancestry. He passed much of his youth in Berlin and in Switzerland, where he became the protégé of the poet, Rainer Maria Rilke. Rilke, who had once been the secretary of Rodin, was connected with the Paris art world, and Balthus was able to use his connections when he returned to Paris to live in 1924. He joined no group but was subject to a number of the prevailing artistic influences of the time, ranging from Surrealism (then all-pervasive) to the Italian fifteenth-century master, Piero della Francesca, who had had an impact on painters otherwise as different from one another as Diego Rivera and Tamara de Lempicka. In Balthus's early masterpiece, *The Street* (FIG. 5.18), the blank façades of the background have something in common with Hopper's vision of urban life, but the figures are updated versions of those found in Italian Renaissance frescos. There is also an element of the blunt-edged "popular" realism one finds in Magritte, something which can be traced to figurative inn and shop signboards and to the painted decorations found at fun fairs (the latter were photographed by Atget and fascinated the Surrealists). Balthus, who seems isolated, thus stands at the crossroads of many of the cultural currents of his time. What is especially his own is the obsessive eroticism of his imagery, which is focused on pubescent girls. The figure on the extreme left of *The Street*, who has grabbed hold of a young girl, originally made an explicitly obscene gesture. This was changed by the artist at the request of the owner, in order to make it acceptable to the Museum of Modern Art in New York, to which it was to be bequeathed.

Yannis Tsarouchis

There is a kinship between the work of Balthus and that of the Greek painter, Yannis Tsarouchis (1911–89). Brought up on the fringes of the European art world,

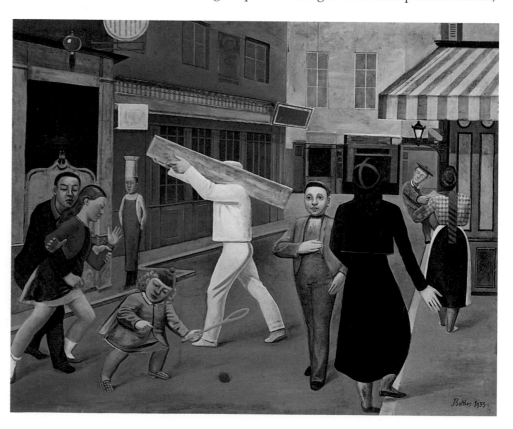

5.18 Balthus, *The Street*, 1933–5. Oil on canvas, 6 ft 4 in x 7 ft 8½ in (1.93 x 2.35 m). Museum of Modern Art, New York.

In this painting Balthus combines source material taken from nineteenth-century popular prints with the influence of the fifteenth-century Italian master, Piero della Francesca.

Tsarouchis imported ideas from both popular and traditional Greek sources into his art—he was influenced by icon paintings and the decors painted for puppet shows featuring the hero Karaghioz (the Greek equivalent of Punch, in Punch and Judy). He also looked at Greek and Roman antiquity, finding inspiration in the Fayoum funerary portraits made in Egypt in Roman times. These elements he put at the service of a homoerotic personal mythology in which the young sailors and soldiers whom he met in the bars of the Piraeus played a prominent part (FIG. 5.19). As with Balthus, the spectator is conscious that the apparently "naive" surface of the work only half-conceals a complex sensibility.

NON-REALIST PAINTINGS: SURREALISM AND ABSTRACTION

Salvador Dalí and Veristic Surrealism

In the 1930s Balthus's work was appreciated by a small circle of connoisseurs and Tsarouchis's by even fewer, most of them in his native Greece. The avant-garde artist most in the public eye was the Catalan, Salvador Dalí (1904–1989), who joined the Surrealist group in the summer of 1929, and immediately added an even more turbulent element to its lively discussions. A provocateur by instinct, Dalí homed in on the movement's internal divisions. Conspicuous among these were its uneasy relationship with the Communist Party (the Surrealists wanted to be Communists, but on their own terms) and the rifts caused by Breton's dictatorial nature and his horror of homosexuality (despite the fact that Surrealism insisted on complete sexual freedom). *The Enigma of William Tell* (FIG. 5.20) alludes to all these sore points. Its basic theme is Dalí's revolt against the authority of his father (Breton can be seen as a substitute father-figure in this context). The father, however, is given Lenin's likeness. He holds a baby, Dalí himself. On the baby's head, instead of the apple of the William Tell story, is a raw cutlet—a sign of the father's cannibalistic intentions. Lenin's enormously elongated right buttock, supported by a forked stick, resembles a gigantic phallus.

Dalí's paintings, according to the artist, were a direct transcription of things envisioned in a dream-like or trance-like state. Despite this declared reliance on the unconscious mind, however, they made knowing use of images drawn from standard textbooks on psychology. Though not realistic in any conventional sense, the imagery was rendered in a meticulous technique borrowed from the academic painters of the nineteenth century. Work of this sort was calculated to

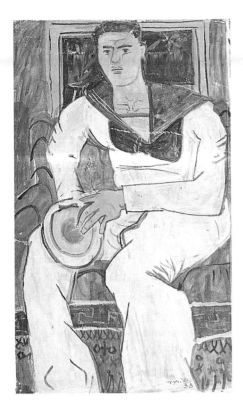

5.19 Yannis Tsarouchis, *Sailor with a Pale Face*, 1938. Gouache on canvas, 28⅜ x 16¾ in (72 x 42.5 cm). Yannis Tsarouchis Foundation.

The leading Greek painter of the years immediately before and after World War II, Tsarouchis combined ideas taken from icons and Greek popular painting with the influence of Matisse.

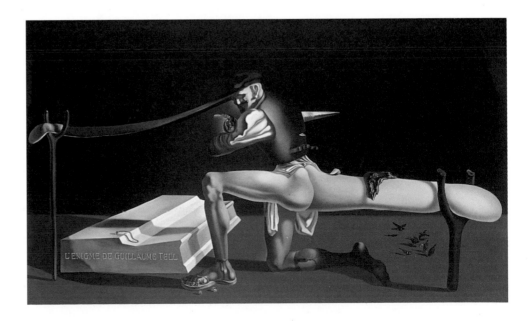

5.20 Salvador Dalí, *The Enigma of William Tell*, 1933. Oil on canvas, 6 ft 7⅜ in x 11 ft 4⅜ in (2.02 x 3.47 m). Museum of Modern Art, Stockholm.

The chief theme of this Surrealist work—known to us only because Dalí said so—is the painter's rebellion against his father, portrayed as William Tell in Lenin's likeness.

shock the avant-garde itself, perhaps more thoroughly than it shocked the bourgeois public. Dalí became fashionable and rich, earning the envious anagrammatic nickname, "Avida Dollars", from Surrealist colleagues, who eventually cast him out of the official Surrealist movement. In 1941 Breton concluded that [Dalí's] work "has become engulfed in academicism which claims, on its own authority alone, to be Classicism, and which, in any case, from 1936 onwards has had no interest whatsoever for Surrealism."[2] Nevertheless Dalí was the major Surrealist influence, very visible in the late 1930s, on peripheral art forms such as advertising, the design of shop windows, and fashion. He was the chief figure in the era of Surrealist popularization.

Picasso's *Guernica*

In the 1930s, Picasso, ever alert to new developments, was strongly affected by the Surrealists. He did not, however, commit himself wholly to the movement. His paintings retained elements from Cubism, to which he had partially reverted after the Neoclassical phase of the early 1920s. More and more, however, they ceased to be analyses of form, and became reflections of Picasso's own psyche, although the most important canvas he produced during the decade was a public, highly political statement, the vast *Guernica* (see FIG. 5.22) of 1937.

Surrealism versus Geometric Abstraction

Surrealism became an international movement in the 1930s, publicizing itself through a series of major exhibitions which continued into the 1940s. The locations were various: 1931, New York; 1935, Copenhagen and Prague; 1936, London; 1937, Tokyo and Osaka; 1938, Paris and Amsterdam. Artists of fourteen nations were represented. Everywhere these exhibitions created a *succès de scandale*. Many are remembered for particular incidents: in 1936 in London, for example, Dalí attempted to make a speech while wearing a diver's helmet and suit, and nearly asphyxiated himself as a result. Surrealism's only rival as an international movement was geometric abstraction. Abstract painters of various nationalities, usually linked to but not necessarily living in Paris, came together to form various groupings, first Cercle et Carré (Circle and Square), founded in 1930, which at one time had a membership of 400, then the Abstraction-Création group founded in February, 1931. *Composition of Circles and Overlapping Angles* (FIG. 5.21), by the Swiss-born Sophie Taeuber-Arp (1889–1943), wife of the sculptor, Jean Arp, is a good example of what became a well-established idiom. Many distinguished artists, among them Mondrian and Naum Gabo, belonged to one or other of these groupings, but, despite the connection with France, the majority of them were not French. The French cultural authorities therefore tended to neglect them in favor of native sons such as André Derain. For many members of the art community, however, geometric abstraction seemed to represent the future—what would survive after the products of cultural nationalism were forgotten. History has not been in complete agreement with this verdict.

5.21 Sophie Taeuber-Arp, *Composition of Circles and Overlapping Angles*, 1930. Oil on canvas, 19½ x 25¼ in (49.5 x 64.1 cm). Museum of Modern Art, New York.

Pablo Picasso: *Guernica*

Spain had become embroiled in a bitter civil war in 1936, and the beleaguered Republican government was eager to have a contribution to the Spanish pavilion in the Paris International Exhibition of the following year from the most celebrated living Spanish artist. Picasso was willing to do something for them, but the subject of his painting was decided only after he had accepted the commission. The decisive act was the bombing of the historic Basque town of Guernica by German squadrons on 28 April, 1937. Picasso set to work with feverish speed, and by 4 June the painting was virtually completed. The pavilion was inaugurated on 12 July.

Guernica (FIG. 5.22) is a work entirely in black and white. This removes any suggestion that it is meant to be a realistic representation of the bombing, and gives it a bold, newspaper-cartoon-like character. Many of the images Picasso uses already had personal significance for him: the bull, the wounded horse (for Picasso always a symbol of the female), the fallen warrior, and the weeping woman. Two visits which the artist paid to Spain in 1933 and 1934 had renewed his interest in the ritual of the Spanish bullfight. In other paintings of the period the weeping woman offers a reflection of his frequently stormy relationship with his current mistress, the painter and photographer, Dora Maar. The bull, often transformed into a man-bull or minotaur, was one of Picasso's symbols for himself, but here it seems to indicate the presence of the triumphant enemy: Spanish nationalist forces occupied Guernica two days after the air-raid.

The painting, long Picasso's most celebrated work, and now a Spanish national icon, is ambiguous both in its historical position and in its effect on the spectator. It is ambiguous historically because it is the first major work of official art produced by a leading Modernist, and Modernism had its roots in an entrenched opposition to all forms of official culture. It is ambiguous in the impact it makes because its narrative is not wholly clear—though the pain and horror which it expresses are evident. The personal subtexts are often in conflict with the public statement—Picasso's use of the bull is a case in point. Marxist critics both in the Soviet Union (where the art world was in the iron grip of official Socialist Realism) and elsewhere were from the beginning lukewarm about *Guernica*, and sometimes openly hostile, despite the fact that the Republican government enjoyed Soviet support. A group of leftist Spanish politicians described it as "an anti-social and ridiculous picture, totally inadequate for the wholesome mentality of the proletariat,"* and demanded its removal from the Spanish exhibit. Despite *Guernica*'s worldwide celebrity, which has made it for many people the quintessential modern painting, some later, non-Communist critics have seen it as representing the start of a steep decline in Picasso's creative powers.

*Wilhelm Boeck and Jaime Sabartès, *Picasso*, New York, 1955, p. 232.

5.22 Pablo Picasso, *Guernica*, 1937. Oil on canvas, 11 ft 5½ in x 25 ft 5⅝ in (3.49 x 7.77 m). Museo del Prado, Madrid.

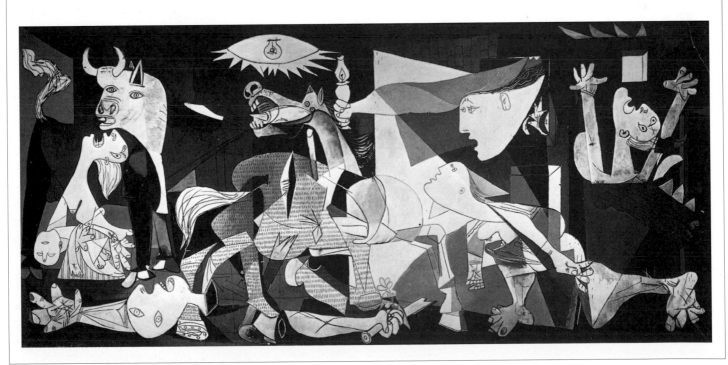

Sculpture

DEVELOPMENTS IN SCULPTURE

During the 1930s, the prospects did not look good for progressive sculpture. The chief demand for public monuments was in the dictatorships. Arno Breker (1900–91) supplied figures of heroic warriors and athletes for Hitler's new Reichs Chancellery in Berlin (FIG. 5.23). Vera Mukhina (1889–1953)) created a gigantic stainless steel group of a worker (brandishing a hammer) and a collective farmer (holding aloft a sickle) for the Soviet Economic Achievement Exhibition of 1936 (FIG. 5.25). It was shown at the Paris International Exhibition of 1937, as the crowning element on the Soviet pavilion and so impressed itself on Soviet consciousness that it became almost the Russian equivalent of the Statue of Liberty.

Orthodox Surrealism was more interested in objects and assemblages than it was in creations in which the manipulation of three-dimensional form was an integral part of the effect rather than an incidental bonus. It is therefore surprising to discover how solid the sculptural achievement of the decade really was. Sculpture began to find that it had a separate contribution to make to the development of Modernism, and that this contribution had as much to do with the manipulation of form as it did with actual subject-matter.

Pablo Picasso and Julio Gonzalez

In 1928 Picasso initiated a sculptural collaboration with the Catalan metalsmith and sculptor, Julio Gonzalez (1876–1942), who had, like Picasso himself, settled in Paris as a young man. What interested Picasso was Gonzalez's mastery of oxy-acetylene welding, acquired when he took work in a factory to support his efforts as an artist. The two men worked together on openwork, linear sculptures—a new kind of drawing in space. Their first collaboration was a proposal of wire maquettes for a monument to Guillaume Apollinaire which Picasso had been commissioned to make. The proposal was rejected by the memorial committee, but the collaboration eventually resulted in the two versions of *Woman in a Garden* (FIG. 5.24). Gonzalez went on to create works of his own in the same style, such as

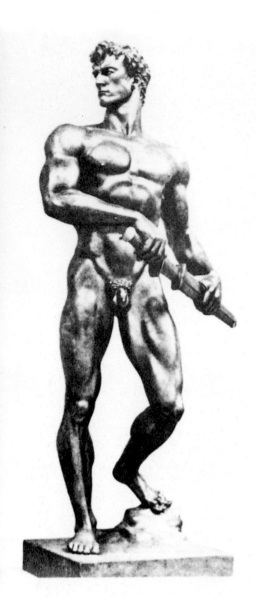

5.23 (*above*) Arno Breker, *Man with a Sword*, 1938. Bronze, over lifesize.

Made for Hitler's new Reichs Chancellery in Berlin and designed by Albert Speer, this statue was destroyed, along with the building itself, in World War II.

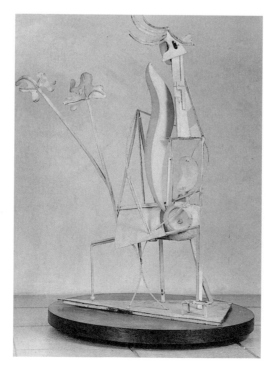

5.24 Pablo Picasso, *Woman in a Garden*, 1929–30. Bronze, height 8⅝ in (22 cm). Musée Picasso, Paris.

This delicate, free-flowing construction in welded iron—a technique taught to Picasso by Julio Gonzalez—is characteristic of Picasso's sculpture in the early 1930s. He and Gonzalez were the first artists to produce direct-metal sculptures.

5.25 Vera Mukhina, *Worker and Collective Farm Woman*, 1936. Bronze, over lifesize. Moscow.

This group, the very quintessence of Socialist Realism's patriotic optimism, so much impressed itself on the nation's consciousness that it became the Soviet equivalent of the Statue of Liberty

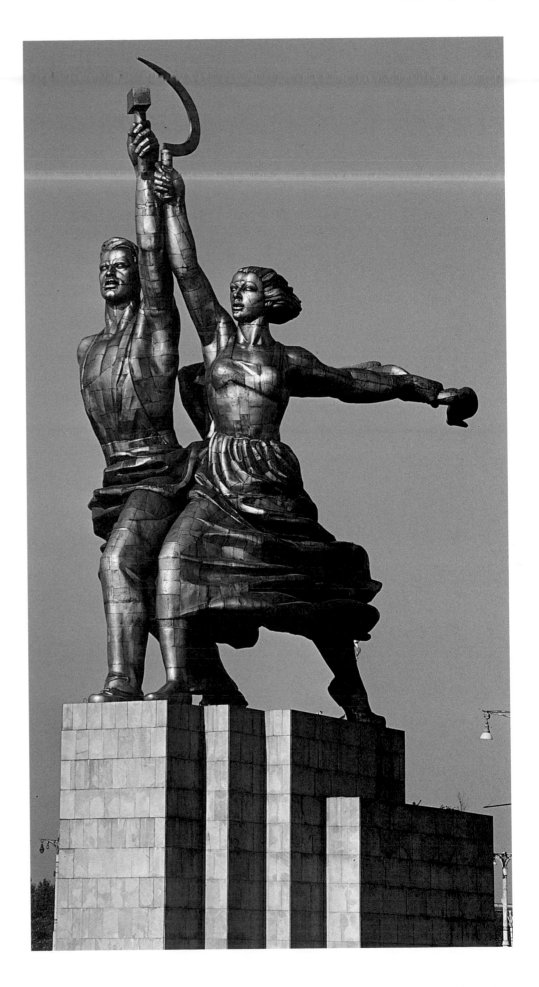

5.26 Julio Gonzalez, *Woman with a Mirror*, c. 1936–7. Iron, forged and soldered, 80¼ x 26⅜ x 14⅛ in (204 x 67 x 36 cm). Ivan Center Julio Gonzalez, Valencia, Spain.

The welded sculptures of Gonzalez and Picasso had a decisive influence on the great American sculptor, David Smith, who first saw them in about 1930: "I learned that art was being made with steel—the material and machines that had previously meant only labor and earning power."

5.27 (*below*) Alberto Giacometti, *Woman with her Throat Cut*, 1932 (cast 1949). Bronze, 8⅝ x 34½ x 21 in (22 x 87.5 x 53.5 cm). Scottish National Gallery of Modern Art, Edinburgh.

Giacometti was briefly drawn into Surrealism and this is one of the best-known sculptures of his Surrealist phase, and, indeed, one of the few wholly successful Surrealist sculptures. Sexual violence is given an elegant and fantastical treatment.

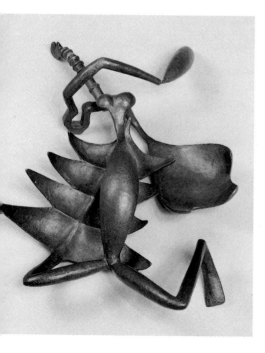

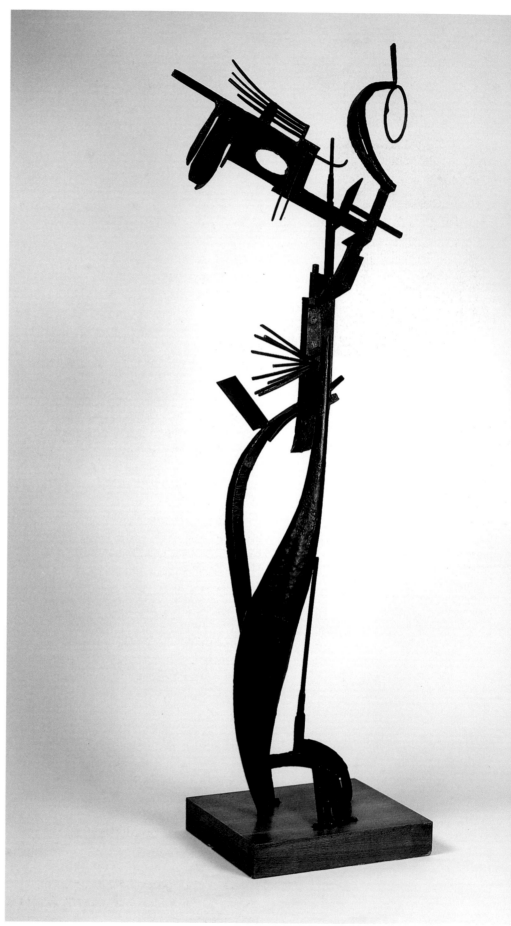

his *Woman with a Mirror* (FIG. 5.26). The capricious, intermittent forms of these openwork sculptures, their teasing reliance on visual information deliberately left incomplete, suggested a bold, new approach to sculptural form.

The Early Work of Alberto Giacometti

Another artist who experimented with similar forms during the early 1930s was the Swiss-born Alberto Giacometti (1901–66). The work he made in the early 1930s, during the period when he participated in a number of Surrealist exhibitions, is extremely various—some blocky and dense, with forms apparently suggested by the Bronze Age art of the Greek Cycladic islands, some like architectural models with various enigmatic objects added to them. What these pieces all have in common is that they are imagined forms, with only symbolic references to things seen in nature. The culmination of Giacometti's activity as a Surrealist is an openwork piece, *Woman with Her Throat Cut* (FIG. 5.27). Here the shape given to the sculpture carries meanings which are more than aesthetic. The skeletal form conjures up the reality of death, in a piece freighted with misogynistic feeling. Shortly after it was completed, Giacometti felt the need to work again from the model, and for this heresy he was cast out of the Surrealist group.

Jean Arp

Jean (otherwise Hans) Arp (1886–1966) followed a career pattern which oscillated between Surrealism and the very different world of Abstraction-Création. He had begun his career as a member of the Dadaist group in Zurich, having taken refuge in that city because he had been born in Alsace, then German territory, and had no wish to serve in the German army during World War I. His early work, sometimes done in collaboration with Sophie Taeuber, whom he married in 1922, is often in a style related to Mondrian's Neo-plasticism, though there were other works with a strong Dadaist element, dependent for their forms on chance operations. Arp, however, soon became interested in biomorphic forms with free, irregular contours suggested by things found in nature, such as branches, roots, and pebbles. In the mid-1920s he and his wife settled in Paris, and in 1929 they visited Carnac in Brittany, where he was greatly impressed by the prehistoric dolmens and menhirs (standing stones). The three-dimensional *Human Concretions* made in the 1930s, including the *Pre-Adamic Torso* (FIG. 5.28), are responses to this experience. Arp, like Brancusi, and also like Giacometti in some of the early sculptures influenced by Cycladic art, was trying to link the modern to the archaic. Intellectually, the 1930s witnessed a reassessment of attitudes towards ancient civilizations. The perspective became much broader than it had been in the nineteenth century, and there was intense interest in human origins. Arp's most ambitious works respond to this, and at the same time reflect the fluid, changeable nature of contemporary sensibility. His forms are not only biomorphic but seem inherently unstable, always on the verge of some radical act of transformation. It is this which makes him one of the most original sculptors of the period.

Henry Moore and Barbara Hepworth

Another sculptor affected by the idioms of the remote past was the Englishman, Henry Moore (1898–1986), the first sculptor with an international reputation to emerge in Great Britain since John Flaxman (1755–1826). Moore was inspired by the technical characteristics of early sculpture, as well as by its actual forms. He felt that sculpture, rather than being modeled—the universal practice in the nineteenth century, even when the finished work was to be made in marble or other stone—should be carved directly from the block. He also felt that it should take into account the whole history of early sculpture, from paleolithic times to the

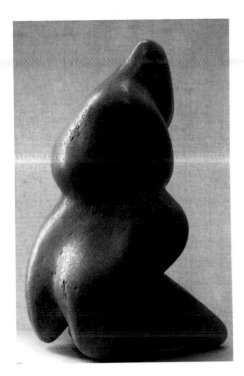

5.28 Hans (Jean) Arp, *Pre-Adamic Torso*, 1938. Limestone, 19⅛ × 12¼ in (48.5 × 31 cm). Offentliche Kunstsammlung, Basle, Switzerland.

This is a figure from Arp's series of *Human Concretions*, inspired by prehistoric monumental stones, called menhirs, in Brittany. "Concretion," Arp wrote, "signifies the natural process of condensation, hardening, coagulating, thickening, growing together...Concretion is something that has grown. I wanted my work to find its humble place in the woods, the mountains, in nature."

5.29 Henry Moore, *Four-Piece Composition: Reclining Figure*, 1934. Bronze, 5 ft 9 in x 15 ft x 7 ft 8 in (1.75 x 4.57 x 2.03 m). Tate Gallery, London.

The reclining figure, especially female, was a favorite subject of Henry Moore. Here it brings to mind a mountainous landscape. "The human figure is what interests me most deeply," he said, "but I have found principles of form and rhythm from the study of natural objects."

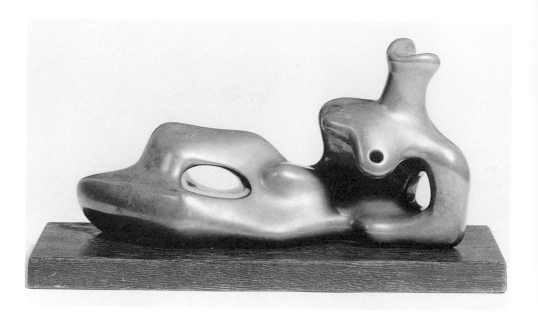

5.30 (*below*) Barbara Hepworth, *Three Forms*, 1935. White marble, 7⅞ x 21 x 13½ in (19.5 x 53.3 x 34.3 cm). Tate Gallery, London.

Hepworth's sculpture is just sufficiently nongeometric to suggest a connection with the natural world. The sculpture is a miniature landscape, yet at the same time suggests a female nude even more abstracted than Henry Moore's *Reclining Figures* (see FIG. 5.29).

Gothic. Aztec sculpture was an important influence on Moore's work, especially the reclining figures called "chacmools." The reclining figure became a major motif in his work. One of the ways in which Moore varied it was by splitting the figure into parts (FIG 5.29), making it a metaphor for landscape. The separated forms also seemed like miniature versions of the prehistoric dolmens which had impressed Jean Arp.

Moore's close associate at this period was Barbara Hepworth (1903–75). Her stone carvings often resemble his, but are generally more simplified, and closer to

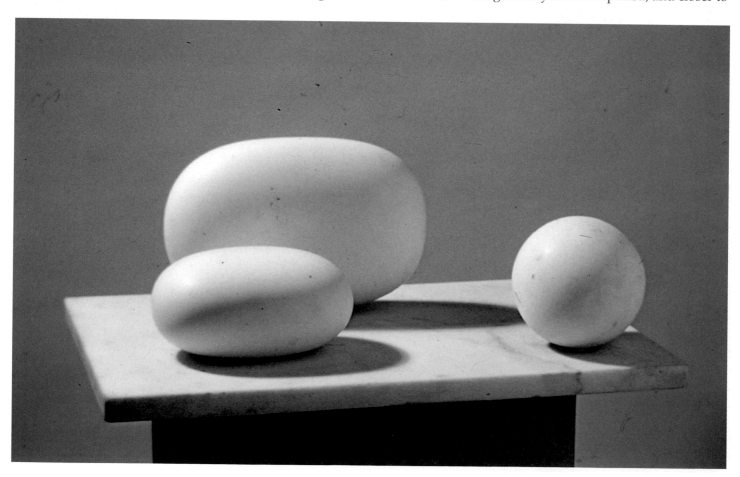

geometric archetypes (Hepworth was invited in 1933 to become a member of the international Abstraction-Création group, whereas Moore participated in the international Surrealist exhibition held in London in 1936). Hepworth's *Three Forms* (FIG. 5.30) can nevertheless be read both as an extremely simplified reclining figure and as a landscape, and it is suffused with the romantic feeling for nature which is typical of Moore.

Alexander Calder

Another sculptor who wavered, rather like Arp, between the attractions of Surrealism and those of geometric abstraction was Alexander Calder (1898–1976), the first American Modernist to win a major international reputation for himself. Calder's mobiles—the word was coined by Alexander Duchamp—have multiple sources. The use of abstract forms derives both from the artists of Abstraction-Création and from the Surrealist, Joan Miró. Calder, who spent much of the decade in Paris, was well known to many of the leading members of the Parisian avant-garde of the period. The random motion of his wire-and-metal sculptures also has links to the Dadaist (and Surrealist) fascination with chance operations of all kinds. There is, however, a specifically American element in Calder's work—its link to American folk art. Calder began his career as a maker of sculptures which were also elaborate toys, the most elaborate being his *Circus* (FIG. 5.31), made during the late 1920s and used originally to give performances for his

5.31 Alexander Calder, *Circus*, 1926–31. Mixed media, 4 ft 6 in x 7 ft 10 in x 7 ft 10 in (1.37 x 2.4 x 2.4 m). Whitney Museum of American Art, New York.

The antecedent of Calder's mobiles was the wire circus that he built in 1926 as the basis for performances that he gave, chiefly in Paris, until 1930. He performed on his hands and knees, making animal sounds and manipulating some of the performers—sword-swallowers, clowns, acrobats etc.—while some moved by mechanical devices.

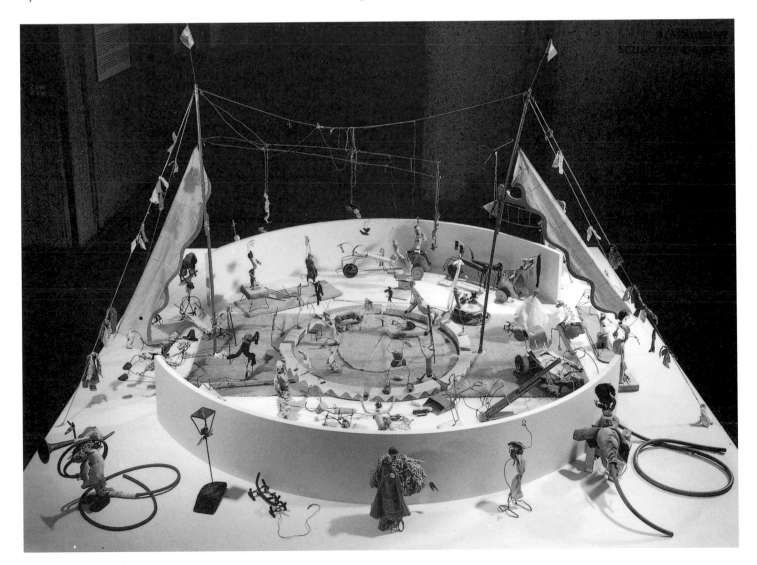

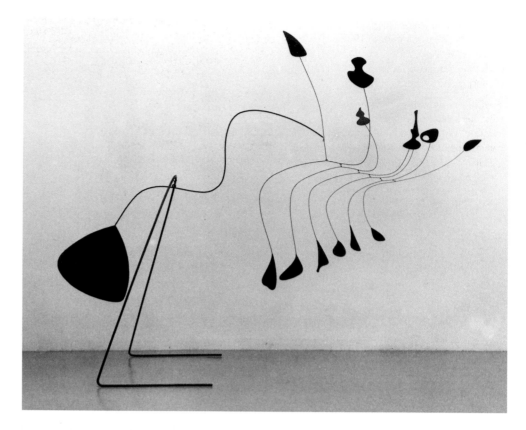

friends. A mobile from the end of the decade, *Spider* (FIG. 5.32), still possesses a playful, toy-like quality. While it does not represent the spider directly, the pattern of motion Calder has imparted to the piece subtly suggests the movement of the insect as it sets about making its web. Calder's work gives a twist to the idea of open form which is present in so much of the innovative sculpture of the 1930s.

Photography

A CHANGE OF CLIMATE

The status of photography changed radically in the 1930s. The changes came about as a result of technical advances, linked to shifts in social conditions. There was a much greater emphasis on photoreportage. This was not an innovation in itself. Photography had been in use as a reporting tool since the mid-nineteenth century, when Roger Fenton (1819–69) recorded aspects of the Crimean War, and Matthew Brady (1823–96) did the same for the American Civil War. The camera's power to report was greatly facilitated, however, by the appearance on the market of small, lightweight photographic equipment. The 35mm roll-film Leica was launched in 1925, and the rather larger twin-lens Rolleiflex in 1930. Widespread use of these cameras prompted the acceptance of a very different kind of photographic image, often extremely imperfect by traditional standards—casually composed, sometimes blurred, and grainy. These became vehicles for a new kind of authenticity; it was the rawness of the image which often seemed to guarantee its veracity.

At the same epoch a new generation of illustrated magazines became, not only the chief market for ambitious photographers, but the primary context for the photographic image. Exhibitions of the kind favored by elitist groupings like the Linked Ring lost ground to newsstand publications such as *Life*. By 1939, only three years after its first appearance, *Life* had three million readers.

5.33 Dorothea Lange, *Migrant Mother, Nipomo, California,* 1936. Gelatin silver print. Dorothea Lange Collection, Oakland Museum, California. (Gift of Paul S. Taylor.)

In what has become perhaps the most celebrated photographic image of the 1930s (one of a series commissioned by the Farm Security Administration), Lange provided a social document of poverty, but, transcending that, a tribute to individual strength of spirit.

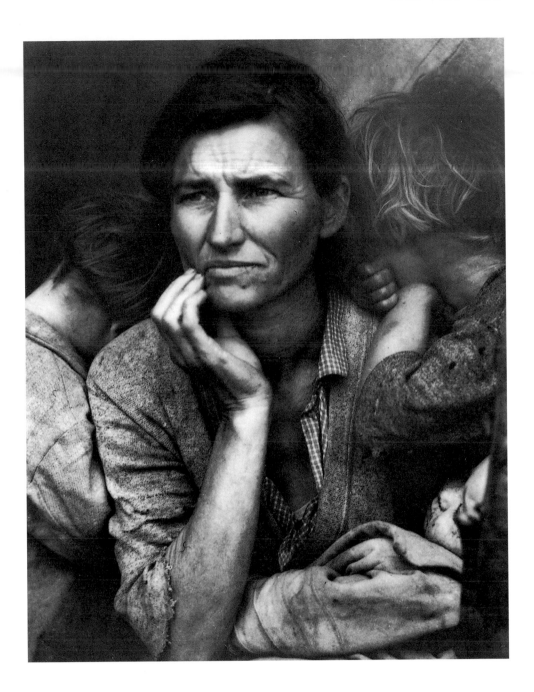

The American Depression and the Spanish Civil War

Two events which supplied much material for reportage were the Depression in America and the Spanish Civil War in Europe. The documentation of the Depression and its consequences for rural America was sponsored by the U.S. government under the auspices of the Historical Section of the Farm Security Administration. Perhaps the most famous image generated by this enterprise was *Migrant Mother, Nipomo, California* (FIG. 5.33), photographed by Dorothea Lange (1895–1965) in 1936. Like many images made for the FSA, the photograph was unplanned. The photographer was nevertheless able to make it the vehicle for a universal message.

Equally impressive, but totally different in style, are the photographs made by Walker Evans (1903–75) under the auspices of the same program. His austere, poignant views and interiors, usually taken with an 8 × 10 view camera, offer proof that good reportage photography does not have to be spontaneous. A comparison can be made between the quiet pessimism of some of Evans's images,

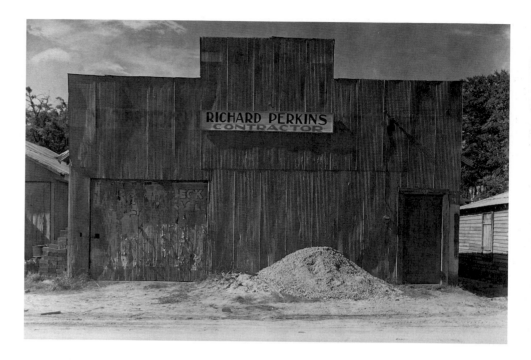

5.34 Walker Evans, *Corrugated Tin Façade, Moundville, Alabama,* 1936. Gelatin silver print. Library of Congress, Washington D.C.

Walker Evans was strongly influenced by the photographs of Atget, which he especially admired for their ability to suggest the passage of time, and by Precisionist painters and photographers, notably Charles Sheeler.

such as *Corrugated Tin Façade, Moundville, Alabama* (FIG. 5.34), and the atmosphere distilled by the paintings of Edward Hopper (see FIG. 5.17).

The best-known war photograph of the period is undoubtedly *Death of a Loyalist* (FIG. 5.35) by Robert Capa (1913–54). Capa, Hungarian-born, believed that the war photographer must be prepared to risk himself totally. He once said that "if your pictures are not good enough, you're not close enough," and he was eventually killed, after recording every major conflict to happen in his lifetime, on a battlefield in Indo-China. There is thus a certain irony in the fact that the authenticity of *Death of a Loyalist* has recently been challenged. It is alleged that the image was staged for the camera.

5.35 Robert Capa, *Death of a Loyalist*, 1936. Photograph. Magnum Photos, London.

The recent accusation that this celebrated photograph from the Spanish Civil War was posed raises the question whether, if so, the dramatic message that is conveys is necessarily thereby weakened.

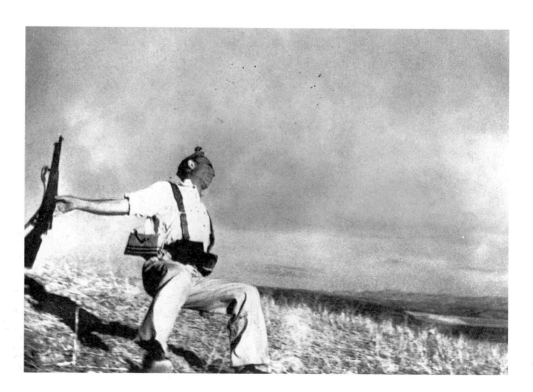

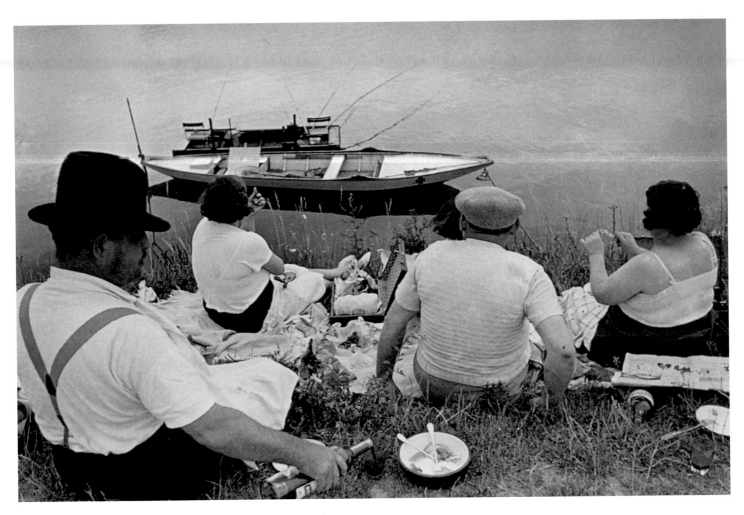

5.36 Henri Cartier-Bresson, *Sunday, Bank of the Marne*, 1938. Gelatin silver print. Art Institute of Chicago, Illinois.

This is a striking exemplification of Cartier-Bresson's doctrine that photography was "at one and the same time the recognition of a fact in a fraction of a second and the rigorous arrangement of the forms visually perceived which give to that fact expression and significance."

Henri Cartier-Bresson

A rather different aspect of the prevailing documentary impulse appears in the candid photographs taken by Henri Cartier-Bresson (1908–). Cartier-Bresson put his point of view with admirable clarity in the preface to a 1968 collection of his photography:

> Photography is an instantaneous operation, both sensory and intellectual—an expression of the world in visual terms, and also a perpetual quest and interrogation. It is at one and the same time the recognition of a fact in a fraction of a second and the rigorous arrangement of the forms visually perceived which give to that fact expression and significance.[3]

Cartier-Bresson is widely traveled, but some of his most striking images of the 1930s are studies of French working-class and petit-bourgeois life, for example, *Sunday, Bank of the Marne* (FIG. 5.36).

John Heartfield and Hans Bellmer

The photomontages of John Heartfield (Helmut Herzfelde, 1891–1968) offer a totally different approach to photography from that of the documentarists. A founder-member of the Berlin Dada Group in 1918, then director, with his brother, Wieland, of the left-wing Malik Verlag publishing house, Heartfield was a well-known figure in the Berlin avant-garde in the 1920s. His most powerful photomontages were made in the 1930s—often satirical portraits of Hitler and other members of the Nazi leadership. *Swallows Gold and Utters Base Metal* (1932) is a

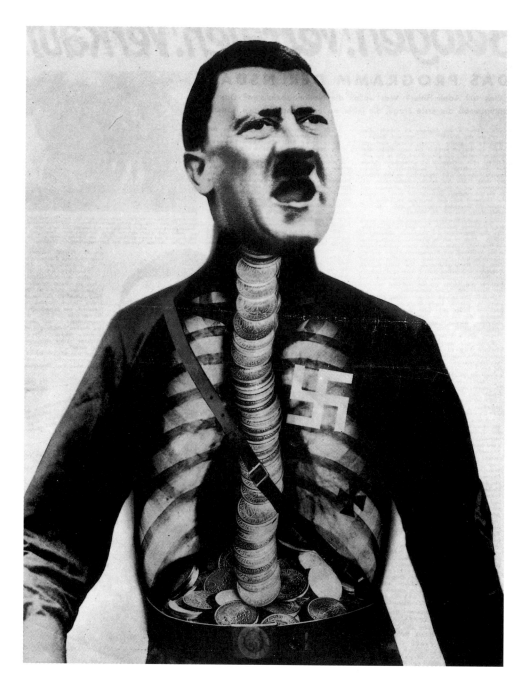

5.37 John Heartfield, *Swallows Gold and Utters Base Metal*, 1932. Photo-collage. Academie der Kunst, Berlin, Germany.

This is one of John Heartfield's striking anti-Nazi satires—the transparent torso of the Führer is filled with capitalist money—which called into question the long-accepted notion that photography was a medium for recording objective truth.

satire on Hitler's connection with a cartel of German industrialists (FIG. 5.37). The Führer-to-be has a transparent torso, stacked with coins. In some of his montages Heartfield makes his points by simple juxtaposition; in the more accomplished examples, he manipulates the photographic source-material so as to produce a completely coherent image.

Hans Bellmer (1902–75), born in Silesia, threw himself into the exciting bohemian milieu of 1920s Berlin as soon as the opportunity offered itself. There he became acquainted with not only Heartfield, but Otto Dix and George Grosz. His artistic activity was intermittent, however, until the fateful year 1933, when, after a personal crisis, he decided to renounce all forms of commercial activity in favor of art. The symbol of this revolt was a transformable doll or mannequin figure. Bellmer's photographic documentation of this object rapidly took on a momentum of its own and became the work with which he is immediately identified. Some of the images (FIG. 5.38) appeared in a privately printed book, *Die Puppe*, published in 1934. The Paris-based Surrealist group took Bellmer up with

5.38 Hans Bellmer, *Doll (La Poupée)*, 1932–45. Wood, paint, hair, socks and shoes (photographed). Musée National d'Art Moderne, Paris.

Bellmer's "dolls" were made with disconnectable joints, so that the parts could be rearranged in any order. The resulting photographs constitute a record of erotic obsession, with sadistic and misogynistic overtones typical of much Surrealist art.

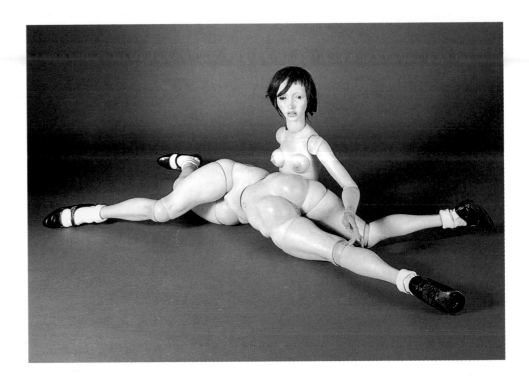

enthusiasm, and in 1936 he transferred himself to France: he was featured in the international Surrealist exhibitions of the 1930s.

Bellmer's photographs are a record of erotic obsession, with strong sadistic and misogynistic overtones—they expose the private self of the photographer, rather than proclaim his political convictions, as the photomontages of Heartfield do. Another important difference is that Bellmer's photographs are integral images—it is the doll itself which is "assembled," not the photograph, which simply records its transformations. What Bellmer's work has in common with Heartfield's is the way in which the photograph is used to create a fantastic, deeply disturbing universe, one in which normal perceptions of reality are contradicted at every turn. In this sense Heartfield and Bellmer offer significant opposition to the documentary mode which dominated photography throughout the decade.

1940	**1941**	**1942**	**1943**	**1944**

GENERAL EVENTS

- British forces in Europe evacuated from Dunkirk
- Italy declares war on France
- German troops enter Paris. France concludes Armistice with Germany
- Assassination of Trotsky in Mexico
- Charlie Chaplin directs and stars in *The Great Dictator*

- Germany invades USSR
- Japan attacks United States at Pearl Harbor and invades the Philippines
- United States declares war on Germany and Italy
- Orson Welles directs and stars in *Citizen Kane*

- Japanese troops capture Singapore
- US navy wins the battles of the Coral Sea and Medway
- German advance across USSR halted at Stalingrad

Kosice,
Madí Neon No. 5:
see p.201

- The German commander General Paulus surrenders to Russians at Stalingrad
- German troops surrender in Tunisia
- Allies invade Italy
- Anti-Nazi revolt in the Warsaw Ghetto

- Allied armies reach Rome
- D-Day landings in Normandy
- Red Army occupies Hungary
- Vietnam under Ho Chi Minh declares itself independent of France

SCIENCE AND TECHNOLOGY

- First electron microscope developed
- First successful helicopter flight

- Dacron invented
- Plutonium discovered. Intensive research into the A-bomb (the "Manhattan Project") begins in the United States

- Enrico Fermi splits the atom
- First electronic computer developed in United States
- Magnetic recording tape invented
- First jetplane tested

- Streptomycin discovered

- Success in synthesizing quinine leads to widespread availability of a treatment for malaria

Mies van der Rohe,
IIT Engineering Building:
see p.186

ART

- Death of Paul Klee
- Discovery of the prehistoric cave paintings at Lascaux, France
- Varian Fry opens an office in Paris to arrange for the emigration of intellectuals and artists to the United States
- Henry Moore becomes an official war-artist and begins his "Shelter" sketchbooks

- The paintings of the Expressionist Emile Nolde are banned by the Nazi party
- The Jeu de Paume in Paris is requisitioned as an official exhibition space by the German forces of occupation

- "First Papers of Surrealism" exhibition, New York
- Dubuffet resumes full-time painting
- Jean Fautrier, in hiding, begins work on his *Hostages* series
- Arshille Gorky holds courses on camouflage painting at the Grand Central School of Art

- Jean-Paul Sartre publishes *Being and Nothingness*
- Jackson Pollock's first solo show at the Art of This Century Gallery, New York
- Death of Chaim Soutine
- Alexander Calder retrospective at MOMA, New York

- André Breton meets Arshile Gorky
- Jean Dubuffet's first solo exhibition
- Deaths of Piet Mondrian and Vassily Kandinsky, and of the sculptor Aristide Maillol
- Pablo Picasso paints *Charnel House* in response to the first pictures from the death camps of eastern Europe

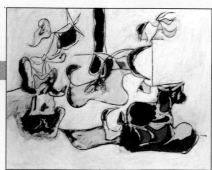

Gorky, *Garden in Sochi*:
see p.190

ARCHITECTURE

- Raymond Hood's Rockefeller Center transforms the Manhattan skyline

- Sigfried Giedion publishes *Space, Time, and Architecture*

- Costa, Niemeyer, and Le Corbusier, Ministry of Education Building in Rio de Janeiro

- Oscar Niemeyer, Church of São Francisco, Pampulha, Brazil

- Pietro Belluschi, Equitable Life Assurance Building, Portland, Oregon (–1947)

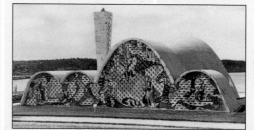

Niemeyer,
Church of
São Francisco
see p.187

1945

- Death of Roosevelt. Harry S. Truman succeeds as US president
- Hitler commits suicide
- Berlin surrenders to Russians, 2 May. War in Europe ends, 8 May
- United States drops atomic bombs on Hiroshima and Nagasaki. Japan surrenders, 14 August

- Vitamin A synthesized
- Sir Alexander Fleming shares Nobel prize for the discovery of penicillin

The British sculptor, Henry Moore

- Foundation of the Madí Group, Buenos Aires
- Mondrian retrospective at MOMA, New York
- Double retrospective of Picasso and Matisse at the Victoria and Albert Museum, London
- Jean Fautrier exhibits his paintings from the *Hostages* series

- Walter Gropius founds the group "The Architect's Collaborative"
- Mies van der Rohe begins work on the Farnsworth House, Fox River, Illinois (–1950)

1946

- First session of UN General Assembly (in London)
- Truman creates Atomic Energy Commission
- First film festival held at Cannes includes Jean Cocteau's *Beauty and the Beast*

- Xerox process invented
- Atomic bomb test at Bikini Atoll in Pacific Ocean
- First electronic computer, at the University of Pennsylvania

- Pablo Picasso, *La Joie de Vivre*
- Scandal of the Van Meegeren Vermeer forgeries is discovered
- André Breton returns to France from the United States with a large collection of Native American masks and sculptures
- Henry Moore wins sculpture prize at the Venice Biennale

- Frank Lloyd Wright unveils the model of his revolutionary spiral design for the proposed Guggenheim Museum, New York
- Mies van der Rohe, Minerals and Metals Research Building, IIT, Chicago

1947

- India proclaims independence and divides into India and Pakistan
- United Nations announces plan to partition Palestine
- Albert Camus publishes *The Plague*
- Premiere of Tennessee Williams's *A Streetcar Named Desire*

- US aircraft is the first to fly faster than sound
- Holography invented

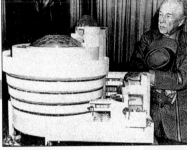

- Pollock begins his "drip" paintings
- Clyfford Still exhibits first color-field abstractions
- Opening of the Musée Nationale d'Art Moderne in Paris
- Death of Pierre Bonnard
- Closure of the Art of This Century Gallery

- Le Corbusier, Unité d'Habitation, Marseilles (–1952)
- Alvar Aalto, Baker House, MIT, Cambridge, Mass (–1948)
- Richard J. Neutra, the Kauffman House, Palm Springs

1948

- Gandhi assassinated
- Communist *coup d'état* in Czechoslovakia
- Foundation of the State of Israel
- Berlin airlift begins
- Harry S. Truman elected president of United States for second term
- Beginning of anti-Communist "witch hunts"

- Long-playing record invented
- Transistor invented at Bell laboratories
- Alfred Kinsey publishes *Sexual Behavior in the Human Male*

Frank Lloyd Wright with the model of his Guggenheim Museum, New York

- Cobra Group founded
- Arshile Gorky commits suicide
- Georges Rouault publicly burns 315 unfinished paintings following a law-suit with the heirs of the dealer Ambroise Vollard
- Asger Jorn, *The Face of the Earth*

- Mies van der Rohe, Lakeshore Drive apartments, Chicago (–1951)
- Sigfried Giedion publishes *Mechanization Takes Command*
- Harrison *et al*, United Nations Secretariat, NYC

1949

- Chiang Kai-shek retreats to Taiwan. The Chinese People's Republic proclaimed under Chairman Mao
- Vietnam and Indonesia become independent states
- Berlin airlift ends
- Simone de Beauvoir publishes *The Second Sex*

- Cortisone discovered
- USSR tests its first atomic bomb
- First performance of John Cage's *Sonatas and Interludes*

- Death of the Expressionist pioneer James Ensor
- Lucio Fontana experiments with perforating the canvas of his paintings

Asger Jorn, *The Face of the Earth*, 1948. Private collection, Paris

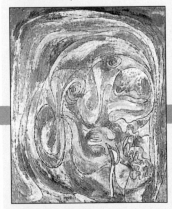

- Alison and Peter Smithson, Secondary School, Hunstanton, Norfolk (– 1954)

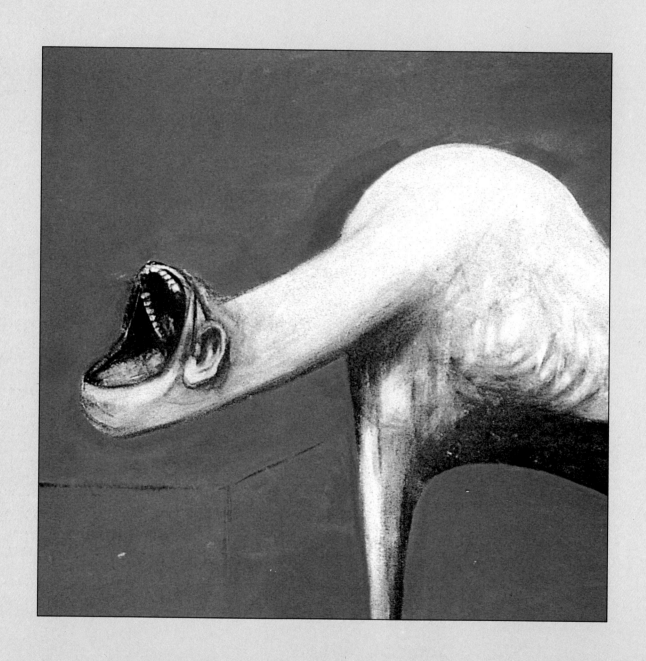

1940-1949

World War II, though fully as destructive as its predecessor, had different psychological effects. It did not induce the widespread cynicism, the brutally nihilistic sense of irony, which had often infected the arts after World War I. Nor was there the feeling, commonplace in the 1920s, that a whole elaborate civilization had crumbled into ruins, leaving a legacy of estrangement and alienation. There was, however, despair and horror. The full extent of the Holocaust became visible; it was no longer possible to deny the reality of the Nazi concentration camps, nor that of the whole mechanism of genocide which the Nazis had created. The dropping of atomic bombs on Hiroshima and Nagasaki was publicly justified by the American authorities as the sole means available for bringing the war in the Pacific to a swift conclusion, but the unprecedented power of this new weapon, as well as its long-term effects on those victims who were not killed outright, produced a feeling of oppression which was later to be intensified by the nuclear arms race between the two superpowers, the United States and the Soviet Union. The Holocaust and the bomb became frequent subjects for art in the immediate postwar epoch, though both artists and critics often declared that these subjects were too vast and too intractable for any artistic venture to encompass.

Meanwhile, the effects of a massive emigration began to be felt. Many leading artists and architects left Europe for the safety of the United States. Their impact on American culture was profound. They were not, however, solely responsible for the American primacy in the visual arts which now unmistakably asserted itself. This was due to other factors as well. One was American economic supremacy, now visible for all to see. Another was the fact that the comparatively brief hiatus in cultural exchanges imposed by the war had enabled American artists to take stock of their own potential. Abstract Expressionism, the major new artistic style of the 1940s, was the result of increasing confidence in a peculiarly American attitude toward the relationship between human beings and society—it involved a subjective reinterpretation of a peculiarly American myth, that of the frontier, and of the way in which the individual was empowered to push that frontier forward according to the dictates of his or own will.

Architecture

A CHANGE OF CLIMATE

A world at war was clearly not a good place for architects, and it is not surprising that many fewer important buildings were completed during the 1940s than the 1930s—despite the worldwide economic slump. Nevertheless, the decade witnessed an important theoretical shift, a change in the balance of power away from those architects who clung to the idea of traditional forms toward those who regarded themselves as committed Modernists.

There were several reasons for this shift. One was the departure from Europe of leading architects, among them most of the chief practitioners of the International Style. Walter Gropius, formerly head of the Bauhaus, left Germany

in 1934, and in 1937 became Chairman of the Department of Architecture at the Harvard Graduate School of Design. Gropius, who had first visited America in 1928, saw Americans as being more at home in small communities than in large bustling cities. The architect's task, in his view, was to reconcile this small-town impulse and the new urbanism created by technological progress. His influence led to the creation of research programs into how buildings were actually used, and also into the impact made by new technology. Two influential books by Sigfried Giedion, *Space, Time and Architecture*, published in 1941, and *Mechanization Takes Command*, published in 1948, laid the foundations for a debate which continued into the next decade.

Much architectural thinking, both in the United States and elsewhere, was dominated by experience garnered in the prewar epoch, but not yet put to full use. This experience seemed to point in the direction of standardization and collectivism. It also seemed to point toward the creation of a new kind of city, where functions which had hitherto existed cheek by jowl would be rigorously separated. In *Space, Time and Architecture*, Giedion foresaw the demise of the traditional street, with its mixture of uses and building types, and its intermingling of motor traffic and pedestrians. Cities, he thought, should consist of zones, each devoted to a particular function. Within these zones buildings need not conform to a street line, but might float freely within the available space. This was an idealized version of what was in fact to happen, once the war was over. In America, and increasingly in Europe, as the automobile became the main method of transport, the city center ceased to be the primary focus of activity. Retail areas, as well as many industrial and administrative activities, moved to the periphery, often occupying their own enclosed sites. The most logical form of urban habitation, in the minds of the majority of progressive architects and urban planners, became a cluster of apartment towers, within a carefully landscaped setting.

The dispersal of functions, and the urge to bring similar functions together in the same place, with plenty of free space both around buildings and between zones of different character, led to an increase in urban scale. Two things reinforced the new direction. One was that the International Style in architecture was now identified with the idea of democracy, simply because of the unremitting hostility toward it shown by the representatives of totalitarian regimes. The other was that the integrated groups of highly trained craftspeople needed to produce finely detailed and highly ornamented buildings were no longer easily available. The stripped simplicity of the Bauhaus architects seemed to be the logical answer to prevailing conditions.

It has often been said that buildings in the new International Style lacked symbolic force. They seemed to commit themselves wholly to the industrial and mechanical. The paradox was that the most conspicuous and durable of them did, in the end, require skillful handcrafting to make their full effect, and duly received it despite the shortage of trained personnel. Their commitment to the industrial ethos was itself more symbolic than real—they were the products of an elaborate fiction.

There was a hidden consonance between the brutal classicism of Nazi and Soviet architecture, and the work of the leading architects of the International movement. The debt owed by Bauhaus architects to the arch-classicist, Schinkel, has already been pointed out. The resemblance, however, was not usually immediately

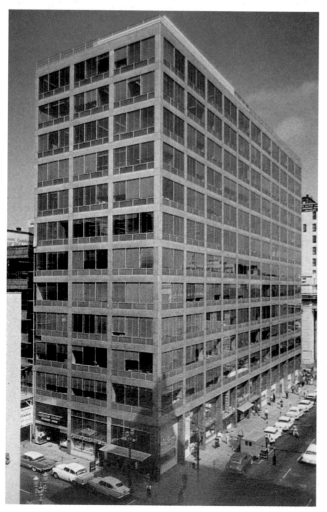

6.1 Pietro Belluschi, Equitable Life Assurance Building, Portland, Oregon, 1944–7.

The refinement and starkness of the flush exterior walls (reinforced concrete clad in aluminum), combined with innovative technology, allowed this building to set new standards for corporate architecture in the United States.

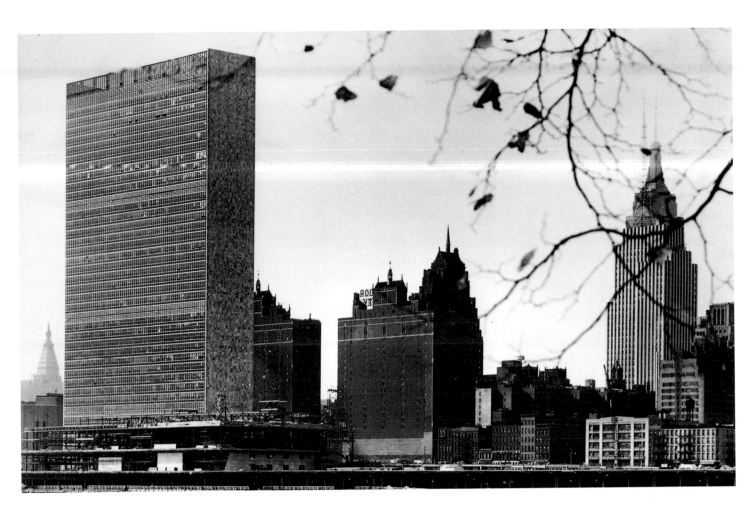

6.2 Wallace K. Harrison, United Nations Secretariat Building (*on left*), New York, 1948–51.

Harrison headed a committee of seventeen architects, of whom the most important was Le Corbusier, who designed this building, the world's first glass-curtain tower. "When you leave the drawing board and start getting your hands dirty," Harrison said, "you stop thinking of buildings as a challenge to create absolute art. You're happy to settle for good buildings that get built, in the hope that they will lead to progressively better buildings."

discernible to the untrained. What the International Style lacked, in the eyes of the public (as opposed to members of the architectural profession), was an easily legible grammar. Its buildings made general statements about modernity, but often failed to communicate any message about the value or even the specific function of a structure within its setting or, for that matter, within its community.

ARCHITECTURE IN THE UNITED STATES

Apart from the attack on Pearl Harbor, the United States was not directly affected by the global conflict. It is therefore natural to assume that architectural progress during the 1940s would be most marked there. This assumption is correct though progress was not always the work of the Bauhaus refugees, who needed time to establish themselves as actual builders, rather than theoreticians, in their adopted country. By the time they began to build again, some of the innovations associated with them had already been put into practice by other architects. Though the use of glass-curtain walling is now closely associated with Mies van der Rohe, he was not the first to use it. It can be found, for example, in the Equitable Life Assurance Building in Portland, Oregon (FIG. 6.1), designed by Pietro Belluschi (1899–), and in the United Nations Secretariat in New York (FIG. 6.2), designed by a team headed by Wallace K. Harrison (1895–1981). Both of these buildings are indistinguishable, in architectural idiom, from the slick, minimalist office towers built during the 1950s and 1960s.

The emigré architect who established himself most successfully in America, and who in return exercised the greatest influence on architecture there, was Mies van der Rohe. America offered him opportunities which he had never received in his native Germany. The first important buildings of his American phase were

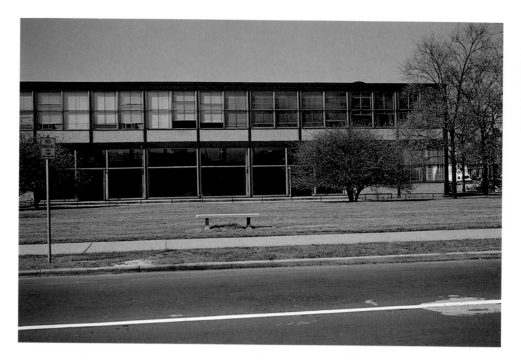

constructed in and around Chicago, traditionally the main center of innovation for American architecture. In 1939 he drew up a preliminary scheme for the campus of the Illinois Institute of Technology, where he was then teaching. One of his early projects for IIT, the Minerals and Metals Research Building (FIG. 6.3), dates from 1942. Its plan, compared with that of his earlier work executed in Germany, is noticeably formal and symmetrical. It is as if the influence of Schinkel strengthened rather than weakened once Mies left Europe. Architectural theorists have also put forward the idea that this change in Mies's work—one of nuance rather than actual direction—sprang from a difference in available materials. In Europe, for the Barcelona Pavilion of 1929, for example (see FIG. 4.5), Mies had used cruciform steel columns as supports. Now he switched to the I-beam column, generic to American building technology. These I-beams tended to suggest a single axis of symmetry, rather than being, like cruciform supports, omni-directional. Yet there was more to it than this. Mies's IIT campus is a celebration of American power and wealth, and of the way in which these are directed towards idealistic ends, such as education.

ARCHITECTURE IN EUROPE

Not surprisingly, there was scarcely any major construction in Europe during the war years. Perhaps the most significant building was Le Corbusier's Unité d'Habitation in Marseilles (FIG. 6.4), projected in 1946 but not completed until 1952. Built quite a long way from the center of the city, this is essentially a self-contained community, within a single tall slab. Halfway up the slab is a storey devoted entirely to shops, and there are also communal facilities on the roof. The Unité carries forward prewar ideas about mass housing. Despite the double-height living rooms which Le Corbusier provided, the accommodation is essentially minimalist in spirit, with no unnecessary frills.

Le Corbusier built, not in steel and glass, but in reinforced concrete, and he used the material in a new way. Instead of the smooth finishes he had favored for his prewar villas, such as the Villa Savoye, all the concrete surfaces were left rough just as they came from the wooden forms. The concrete sunbreaks which shade the flats are faced with rough pebble-aggregate. These techniques were supposedly an accommodation to the shortage of skilled builders, but they exer-

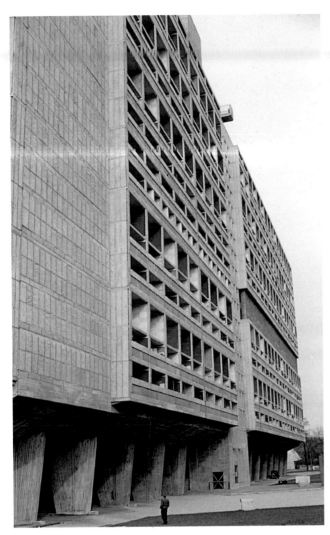

6.4 Le Corbusier, Unité d'Habitation, Marseilles, France, 1947–52.

This vast apartment block, built with relatively inexpensive concrete slabs, was Le Corbusier's response to a postwar European social crisis: the need to provide low-cost mass housing amid planned green space. The tower-blocks of the 1950s and 1960s, now much derided, sprang up in imitation in all the major cities of Europe.

cised such a fascination over other architects that they soon became a kind of independent language. The assertive architecture of the postwar period in Europe—very different in spirit from the work produced by Mies and his disciples—was to be described in the 1950s as "the New Brutalism."

ARCHITECTURE IN LATIN AMERICA

One region which profited, rather than suffered, from the war was Latin America, which, with its immense natural resources, grew rich supplying food and raw materials to devastated Europe. It also fed the booming industries of the United States. While the Modern movement in art had made sporadic progress in the region since the early 1920s, modern architecture only began to make its mark at the end of the 1930s. An important step was Le Corbusier's work as a consultant on the new building for the Ministry of Education and Public Health in Rio de Janeiro, a project begun in 1937 and completed in 1942. The Brazilian architects who executed the project were Lúcio Costa (1902–) and Oscar Niemeyer (1907–). It was the first building in which projecting concrete sunbreaks were used to shade the large expanses of glass which had become one of the hallmarks of contemporary architecture (Le Corbusier later repeated the device in Marseilles Unité d'Habitation). These gridded screens had an aesthetic as well as a practical effect, leading modern architecture toward a much greater concern with plasticity. The cool classicism of Mies's buildings was challenged by something much more vigorous and, in a broad sense, Baroque.

This Baroque influence can be seen clearly in Niemeyer's buildings of the 1940s, for example his church of São Francisco at Pampulha, Brazil (FIG. 6.5). The exuberant, curved concrete roofs, and the walls clad in traditional *azuelhos*, or pictorial tiles, are a reinvention of an idiom familiar to worshipers from the numerous seventeenth- and eighteenth-century Baroque churches in Brazil. Using a totally different range of materials, Niemeyer achieved something similar to what Aalto had done in Finland in the 1930s—a reconciliation between a distinctive national idiom and the Modernist spirit.

6.5 Oscar Niemeyer, Church of São Francisco, Pampulha, Brazil, 1943.

The walls of this church are clad in *azuelhos*, or pictorial tiles, a method of decoration found in Brazilian churches of the colonial period.

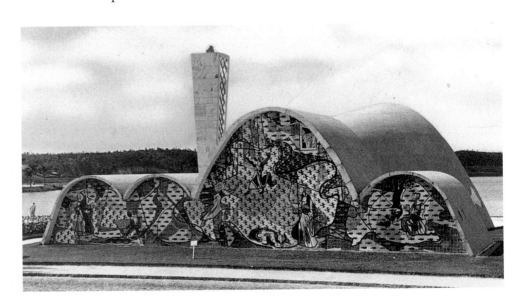

Painting

The 1940s are generally, and to some extent rightly, regarded as a turning-point in the history of the postwar avant-garde. Nevertheless the nature of the change has been misunderstood. It is an oversimplification, for example, to celebrate the war years as the moment at which New York took the place of Paris as the focal point of innovation. There were important innovations elsewhere which had little to do with what was happening on the East Coast of the United States, and these developments have had more durable, if less immediately visible, effects. Jean Dubuffet's experiments with *art brut* in Paris and the new direction taken by Latin American Constructivists (which led directly to the Minimalism of the 1960s and 1970s) are still making their presence felt in the art being made at the end of the century. American Abstract Expressionism, on the contrary, is frozen in time, and can now be viewed with the same detachment as the Cubism of Juan Gris or the Surrealism of Salvador Dalí.

PAINTING IN THE AMERICAS

In any case the Abstract Expressionism of the 1940s was not only almost unknown outside of America itself (at least until the very end of the decade) but was rather different in character from the version which became internationally celebrated during the decade that followed. It was more closely linked to Surrealism, had a more prominent figurative element, and was more concerned with an exploration of American roots. Both the major exhibition of Mexican art held at the Museum of Modern Art, New York, in 1940 and the ambitious survey of American Indian art which opened to the public in the following year had a big impact on artists, who now saw themselves as engaged in a search for American roots of a more thoroughgoing and fundamental kind than had preoccupied the Regionalists during the Depression years. In this sense Abstract Expressionism, during its early years, was one movement among several which manifested themselves more or less simultaneously in different parts of the world, each with an independent genesis.

6.6 Matta, *A Grave Situation*, 1946. Oil on canvas, 4 ft 7⅛ x 6 ft 5⅛ in (1.40 x 1.96 m). Private collection.

Matta mixed turpentine into his pigments to thin the paint, thus enhancing the flow of the brush and fostering the free association of ideas and images. Here the apocalyptic imagery is derived from Surrealist automatic processes.

Matta and Wifredo Lam

The bridge between what had been happening in the United States during the prewar epoch and what was to happen in the 1940s was partly built by two artists who came from the New World but were not American—the Chilean, Matta (Roberto Matta Echaurren, 1911–), and the Cuban, Wifredo Lam (1902–82).

Matta's impact was personal and direct. He left Chile in 1932 to go to Paris, and came into contact with the Surrealist group in 1936. Some of his drawings appeared in a Surrealist exhibition in 1937, and in 1938 he started to paint. The following year he left for New York. The earliest paintings he made in the United States (FIG. 6.6) offer apocalyptic imagery appropriate to the times, but are also quite clearly derived from Surrealist automatic processes, in a much more direct way than, for example, the polished imagery of Salvador Dalí. One of the first American artists with whom Matta came into contact on his arrival in New York was Arshile Gorky (see FIG. 6.8) and Matta's influence was to be decisive both upon Gorky personally, and on the direction taken by Abstract Expressionism.

Lam, born in Cuba, was the son of a Chinese shopkeeper from Canton and a mulatto woman with some Amerindian blood. He, too, had come into contact with the Surrealist group in Paris in the late 1930s, after fighting on the Republican side in the Spanish Civil War. In 1941 he left France to return to Cuba, where he lived for the next few years. Though based in Cuba, he exhibited in New York, at the prestigious Pierre Matisse Gallery, run by the son of Henri Matisse. The most important painting he showed was *The Jungle* (FIG. 6.7). This makes use of a polymorphism which associates human, animal, and vegetable life, and it

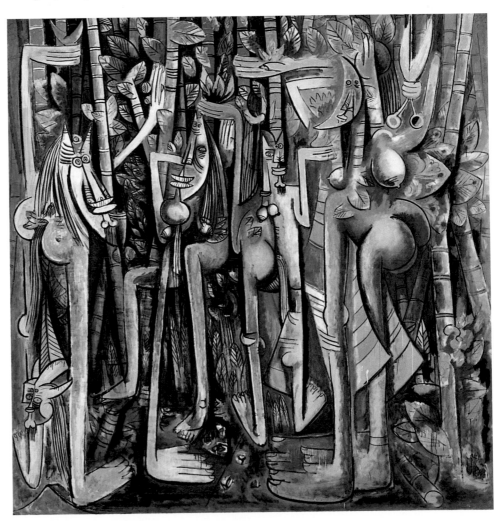

6.7 Wifredo Lam, *The Jungle*, 1943. Gouache on paper mounted on canvas, 7 ft 10¼ in x 7 ft 6½ in (2.39 x 2.29 m). Museum of Modern Art, New York.

The imagery of Lam's best-known painting combines human, animal, and vegetable life, and also alludes to traditional African and Oceanic art. The treatment, however, is distinctly modern, especially in the dreamlike, surreal quality of the figures.

Arshile Gorky: *Garden in Sochi*

Garden in Sochi (FIG. 6.8) marks the transition in Arshile Gorky's work from the biomorphic version of Surrealism to Abstract Expressionism. The difference between the two is that biomorphic Surrealism makes use of natural forms which, while combined in an arbitrary way, remain fairly solid and three-dimensional, whereas Abstract Expressionism is more interested in free, non-representational calligraphy. The painting is the third and last in a series of compositions celebrating a childhood memory which Gorky brought with him when he emigrated as a child from his native Turkish Armenia—that of the Holy Tree bedecked by worshipers with strips of cloth. The painting also commemorates another Armenian folk-custom—that of attempting to divine the future by listening to the rustling leaves of poplar trees. The Armenian word for poplar is *sosi*. Exercising his gift for obfuscation—he was always concerned to spread confusion about his origins—Gorky changed this to the name of a Russian Black Sea resort, which he had certainly never visited. These are not the only coded elements to be found in the painting. Its swelling forms are also breasts and buttocks, metaphors for the female body. The link between the tree and its leaves and the female body is the idea of natural fecundity.

In this final version of the composition Gorky does something revolutionary in a technical sense—he allows the meandering lines which define the forms to become almost completely detached from the areas of color which they enclose. That is, the painting is visibly the product of a series of spontaneous automatic gestures, more so than any Surrealist painting produced in Europe. It was this aspect of his work which earned him André Breton's whole-hearted support. Though Breton was the founder of the Surrealist movement in France, he was not interested in American painting which simply repeated familiar effects, like the use of biomorphic forms, as a basis for abstraction. Forced into exile in America, he was looking for something which expressed the radically energetic spirit of the New World, while still embracing Surrealist principles. Gorky's work seemed to embody this concept.

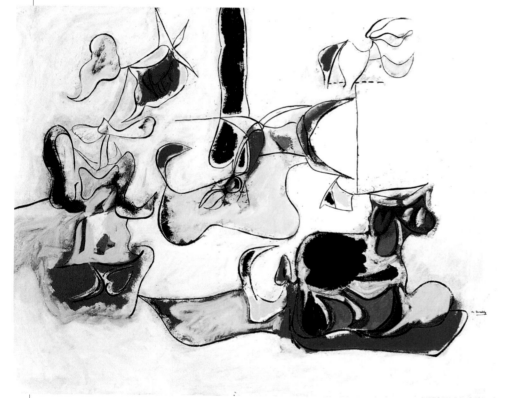

6.8 Arshile Gorky, *Garden in Sochi*, c. 1943. Oil on canvas, 31 x 39 in (78.7 x 99 cm). Museum of Modern Art, New York.

also makes obvious allusions to African art, particularly African masks. The dense, frieze-like composition helps to create a picture-space which is simultaneously claustrophobic and disturbingly undefined. The direct ancestor of *The Jungle* is Picasso's *Les Demoiselles d'Avignon*, but Lam demonstrated that Picasso's inventions could be used in a different way, one which had direct relevance to the culture of the New World. This, too, was a lesson that the creators of Abstract Expressionism were not slow to absorb.

Arshile Gorky

Arshile Gorky (Vosdanik Manoog Adoian, 1904–48) was largely self-taught. Through the 1920s and 1930s he had sedulously recapitulated the chief Modernist styles, to the point where his devotion to Picasso became a subject for ridicule. By the mid-1930s he had evolved a vocabulary of biomorphic shapes which owed something to Picasso and something to Miró. These predilections provided fertile ground for what Matta had to offer. The truly decisive influence on Gorky, however, was his encounter with other leading members of the French Surrealist group, who had emigrated from Europe en masse. The Surrealists were notoriously clannish, and American artists were often alienated by the avowedly literary quality of French Surrealism, which seemed alien to their own preoccupations. Gorky was one of the few artists who became close friends with Breton (who arrived in New York in 1941) and his colleagues. By accepting him, they validated his fascination with the School of Paris and gave him the confidence to make the final leap into an entirely personal style (see FIG. 6.8). He learned from them, as his dealer, Julien Levy, wrote, "that his most secret doodling could be very central. He found his fantasy legitimized, and discovered that his hidden emotional confusions were not only not shameful but were the mainsprings for his personal statement, and that what he thought had been his work had been just practice, and what had been his play was closer to his art."[1]

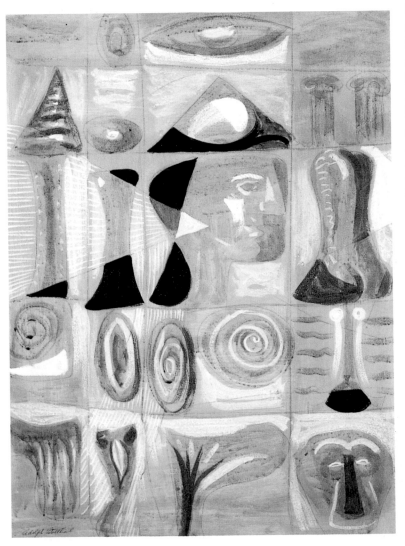

6.9 Adolph Gottlieb, *Illuminated Crypt*, 1946. Gouache on paper, 31 x 22¼ in (78.7 x 56.5 cm). Manny Silverman Gallery, Los Angeles, California.

In his pictographic paintings, Gottlieb developed a highly personal manner, derived from Freud and Surrealism, but also from Klee and Mondrian. On an irregular grid he painted images drawn from the earliest art of mankind and from human anatomy.

Adolph Gottlieb

Gorky's references were to nature and childhood memories. Other New York-based artists took a more intellectual approach. Among these were a number of painters who were later to be leading members of the Abstract Expressionist group. In the mid-1940s Adolph Gottlieb (1903–74) was producing assemblages of pictographs which looked back to the earliest art of mankind (FIG. 6.9). Orthodox Surrealism disapproved of "escapism through myths," but Gottlieb and his colleagues were impressed by Karl Jung's theory of universal archetypes. As Gottlieb himself said:

> If we profess kinship to the art of primitive man, it is because the feelings they expressed have particular relevance today. In times of violence, personal predilections for niceties of color and form seem irrelevant. All primitive expression reveals the constant awareness of powerful forces, the immediate presence of terror and fear, a recognition of the brutality of the natural world as well as the eternal insecurities of life.[2]

Jackson Pollock and Clyfford Still

Another painter who was much impressed by the potential importance of the artist's role as mythmaker was Jackson Pollock (1912–56). Pollock had begun his career as a protégé of the leading Regionalist, Thomas Hart Benton, and had later been influenced by the Mexican Muralists. He worked at Siqueiros's workshop in New York (1936) and he was

6.10 Jackson Pollock, *Cathedral*, 1947. Enamel and aluminum paint on canvas, 71½ x 35 in (181.6 x 88.9 cm). Dallas Museum of Art, Texas (Gift of Mr. and Mrs. Bernard Reis).

One of the earliest of Pollock's "drip" paintings, this canvas, with its shallow space and predominance of black and white, reminds us that Pollock was essentially a master of line drawing.

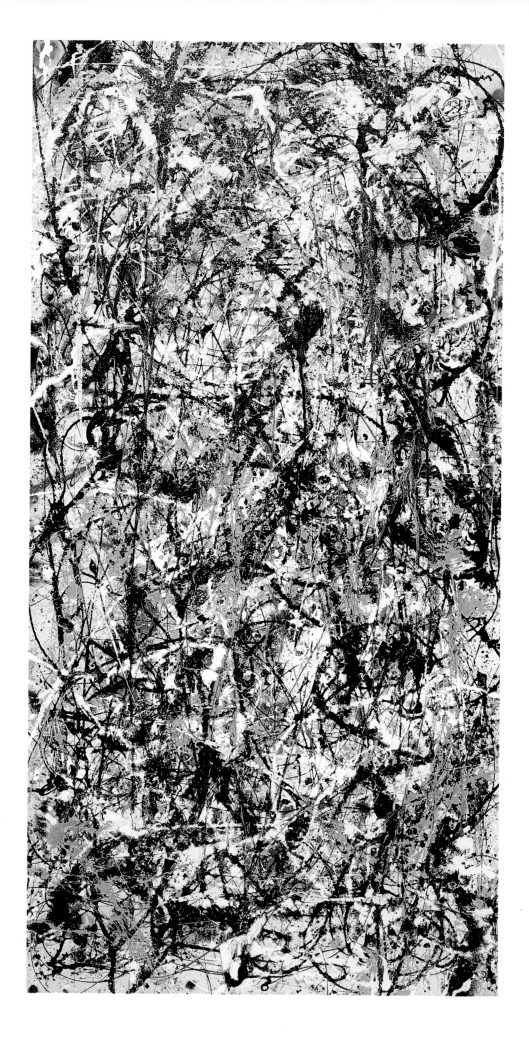

taken by the murals Orozcó painted at the New School of Social Research in New York and at Dartmouth College, New Hampshire. He was also acquainted with Jungian theory, since he had entered a course of Jungian analysis in 1939.

Pollock, like Gorky, was deeply impressed by Picasso, but he was ambivalent about the authority of the European Modernists in general. His paintings of the early 1940s retain figurative elements, and conventional elements of pictorial architecture. In the late 1940s, Pollock made a decisive breakthrough, producing the first of the "drip" paintings on which his reputation now rests. Here the work itself becomes ritual, rather than simply representation. It is the product of a series of gestures, which leave their traces on the canvas.

The more closely one looks at the drip paintings, even so, the more one perceives figurative elements shrouded in the swirls of paint. In *Cathedral* (FIG. 6.10), for example, there is the ghost of what might be a monolithic upright figure. And the swirls of paint do not cling to the flat surface of the canvas; they seem to float in front of it, creating the equivalent of the ambiguous shallow space of Cubism.

Clyfford Still (1904–80) is generally paired with Mark Rothko (1903–70), because the two artists were close friends. In the mid-1940s, however, he had more in common with Pollock, and was in some respects even more thorough in his rejection of tradition. *Untitled* (FIG. 6.11) gets rid of any residual geometrical

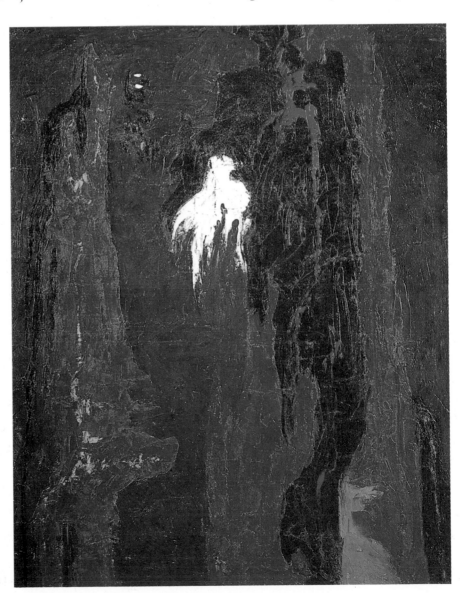

6.11 Clyfford Still, *Untitled*, 1945. Oil on canvas, 42⅜ x 33⅝ in (107.6 x 85.4 cm). Whitney Museum of American Art, New York (Gift of Mr. and Mrs. R. H. Friedman).

Clyfford Still, like Jackson Pollock, denounced European Modernism and sought, in his color-field paintings, to express the individualism of the American spirit. He applied paint so thickly that his canvases sometimes become almost reliefs, and some critics have seen in them a reflection of the American northwest, where he grew up. Still repudiated the idea: "I paint only myself, not nature."

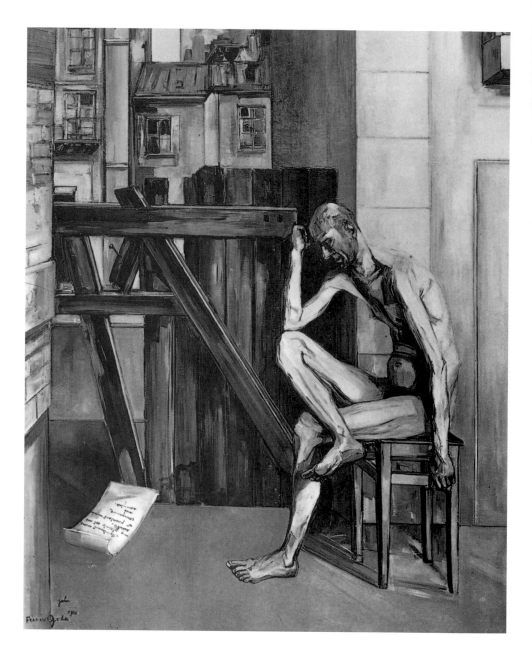

6.12 Francis Gruber, *Job*, 1944. Oil on canvas, 5 ft 3 in x 4 ft 3¼ in (1.6 x 1.3 m). Tate Gallery, London.

This work, an allegory of what the people of Paris had endured under the Nazi occupation, is an assertion of traditional values in painting. Throughout his career Gruber remained almost entirely untouched by the influence of contemporary artists.

apparatus, until then thought of as part of the necessary baggage of abstract art. The heavily trowelled surfaces renounce any attempt to be decorative. And although there are hidden figurative elements in Still's painting—a man standing upright on the prairie, the duality and opposition of male and female figures—they are more thoroughly concealed than Pollock's. The American art historian, Irving Sandler, phrases it well when he says that Still's abstractions "convey more strongly their break with tradition than their continuity with it."[3]

PAINTING IN FRANCE

Francis Gruber

Despite the Nazi persecution of avant-garde art, many intelligent Europeans thought, during the dismal war years, that art should demonstrate that it was socially responsible, and that it should reassert the traditional values of European civilization. Hence the enthusiastic reception given to Francis Gruber (1912–48) when his *Job* (FIG 6.12) was shown at the first Salon d'Automne following the Liberation in 1944. This painting was intended both as an assertion of traditional

6.13 Jean Fautrier, *Head of a Hostage, No. 1*, 1943. Oil on paper, 14 x 10½ in (35.5 x 26.6 cm). Museum of Contemporary Art, Los Angeles, California (Panza Collection).

During World War II Fautrier occupied a studio near some woods that were the scene of Nazi executions. The shots, and the cries of the victims, inspired his series of *Hostages*, vague human forms or faces built up in a paste of cement, plaster, and paint with a palette knife.

values in painting and as an allegory of what the people of Paris had endured under the occupation. At the model's feet lies a piece of paper with a quotation from the Book of Job: "Now, once more my cry is a revolt, and yet my hand suppresses my sobs."

Jean Fautrier

More successfully even than Gruber, Jean Fautrier (1898–1964) summed up the mood in France in the mid-1940s. He was not a newcomer, but had made some reputation as an artist during the 1920s, before being forced by the Depression to abandon painting and earn a living as a ski-instructor and hotel proprietor in the French Alps. He returned to Paris and began painting again when war broke out. In 1943, having been arrested by the Gestapo (but released through the intervention of the German sculptor, Arno Breker) he took refuge in the grounds of a mental clinic on the outskirts of Paris, using a former dovecot as a studio. The woods around the clinic were used by the German forces for torturing prisoners and carrying out summary executions, and Fautrier often heard the cries of the victims. The result was a series of small panels which the artist called *Otages* ("Hostages") (FIG. 6.13). Made from a thick paste, applied in layers to a base of rag paper on canvas, these showed half-obliterated images of human faces. They were exhibited in 1945 at the René Drouin Gallery, then the most progressive commercial gallery in Paris. André Malraux, who wrote the preface for the exhibition catalogue, praised them as "the first attempt to dissect contemporary pain, down to its tragic ideograms, and force it into the world of eternity."[4] It was not merely Fautrier's imagery which impressed French intellectuals. They saw in his technique continual allusions to sperm and filth,[5] which reflected the new philosophical attitude, arising from the terrible events of the war, that reality was essentially formless, incoherent, and ambiguous. For the leading French critic of the day, Michel Tapié (1909–87), Fautrier represented one of the two chief standard bearers of what he labeled *art autre*, the "other" or "alienated" art of a radically altered Modernism.

Jean Dubuffet

The second standard-bearer was Jean Dubuffet (1901–85), who, like Fautrier, was middle-aged when he came to the fore. Well acquainted with leading French artists and writers of the interwar years, especially those belonging to the Surrealist group, Dubuffet had made his living as a wine merchant and did not commit himself to art until 1942. What made this change of career possible was the substantial fortune he accumulated smuggling wine from the Unoccupied to the Occupied Zone during the war. His first one-person exhibition took place in 1945 at the René Drouin Gallery. It provoked great controversy, because the work shown seemed to flout all the ideas about the importance of *belle peinture* ("beautiful painting") which remained entrenched in French culture.

Effectively, what Dubuffet did was to take Surrealist ideas to new extremes. Surrealists had stressed the importance of the unconscious mind, and the alienation of the artist from the work. Following the example of Freud and other psy-

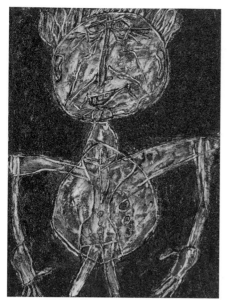

6.14 Jean Dubuffet, *Limbour as a Crustacean*, 1946. Oil and sand on canvas, 45⅝ x 35 in (116 x 88.8 cm). Hirshhorn Museum and Sculpture Garden, Smithsonian Institution, Washington, D.C (Gift of Joseph H. Hirshhorn).

This portrait of the Surrealist writer, Georges Limbour, was inspired by urban graffiti, a spontaneous form of expression which, along with the scribblings of children and pychotics, Dubuffet listed as the sources of *art brut*.

choanalysts, they had interested themselves in visual representations made by the mentally ill, by untrained artists, and by children. Photographers linked to the Surrealists recorded the graffiti in which Paris abounded. Some of Dubuffet's most effective early works were portraits of his friends, intellectuals such as the Surrealist writer, Georges Limbour (FIG. 6.14), done in a style derived from wall graffiti. Dubuffet attempted to reproduce the texture of the wall itself, as well as the brutal concision of this type of drawing. The effectiveness of the portraits depended partly on the artist's choice of a style so apparently at odds with the sophisticated personalities whom he portrayed. Dubuffet was also fascinated by materials which seemed inappropriate to the uses he made of them—in the following decade he made collages of butterflies' wings, and sculptures from lumps of coal, sponges, or crumpled silver paper. From these experiments he evolved an influential philosophy of *art brut*, or "art in the raw," which was to take postwar figurative art in a new direction, one hostile to any idea of smoothness or fine finish of the sort that had been momentarily revived by Dalí.

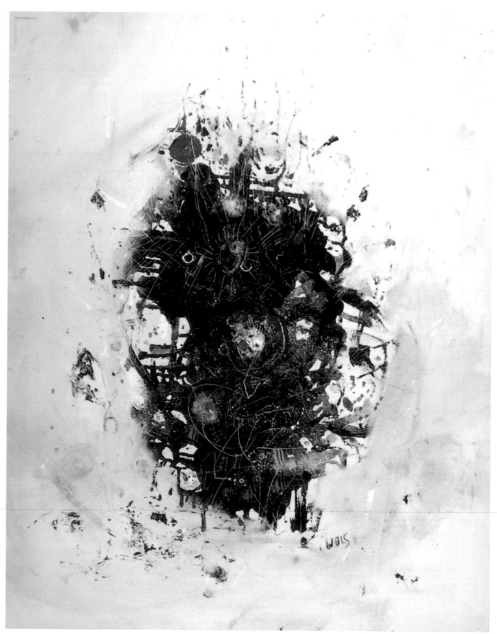

6.15 Wols, *Untitled*, 1946–7. Oil on canvas, 31⅞ x 25⅝ in (81 x 65 cm). Private collection.

There is a close resemblance between Wols's work and the drip-paintings of Jackson Pollock (which Wols did not know at the time). The brushwork is free, gestural, and unplanned.

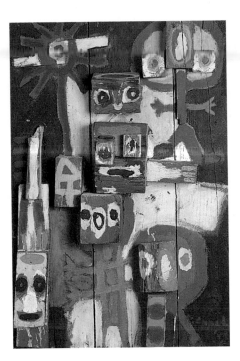

6.16 Karel Appel, *Children with Questions II*, 1947. Wooden reliefs nailed to wooden board, painted in oil, 33⅝ x 22⅛ in (85 x 56 cm). Musée National d'Art Moderne, Paris.

Appel's early paintings show the impact made on him by the work of Picasso and Miró, but are still basically Expressionist in style.

Wols

In the fateful year of 1945, Drouin exhibited another artist who was to affect the postwar development of European art, though to a much lesser extent than Dubuffet. This was Wols (Alfred Otto Wolfgang Schulze, 1913–51), who had emigrated from Germany in 1933, both to escape the Nazi regime and to get away from a stiflingly bourgeois family background. In the 1930s he made a career as a photographer affiliated to the Surrealists; but he was interned on the outbreak of war. After his release, he lived from hand to mouth, mostly in the south of France, and began to make small paintings and drawings inspired by nature, but less and less specific in their imagery. Though more modest in scale than the paintings being made by the emerging Abstract Expressionists in America (which he did not know), Wols's compositions of the mid-1940s (FIG. 6.15) look astonishingly like Pollock's work of the same period or a little later. They prepared the way for the acceptance of Abstract Expressionism in Europe.

EXPRESSIONISM IN NORTHERN EUROPE

The Cobra Group

In the 1940s, the European artists who—apart from Wols—offered the closest parallel to what was taking place in New York were those who came together to form the short-lived Cobra Group, founded in 1948. The name was taken from the cities the members came from—Copenhagen, Brussels, and Amsterdam. Among the members were the Dane, Asger Jorn (1914–73), and the Dutchman, Karel Appel (1921–). While the Cobra Manifesto published in the Dutch periodical, *Reflex*, in 1948 specifically rejected "Western Classical culture" and called for its replacement "by a system whose laws are based on the immediate demands of human vitality,"[6] Cobra was visibly linked to the development of Modernism in the first decades of the century. The difference between Cobra painting and what was happening in America was that, while the Cobra artists, like their American colleagues, believed in giving free rein to subconscious fantasy, their work remained more firmly in the old Expressionist tradition, which traced its line of descent directly to Edvard Munch. There was, in fact, to be a continuity in the development of figurative Expressionism in northern Europe which easily withstood the challenges to which Abstract Expressionism would eventually succumb. Appel's early work also owes something to what Picasso and Miró had been doing in the 1930s, adding to these touches of childlike spontaneity (FIG. 6.16). Jorn, the first Danish artist to make a major impact on the international scene since the beginning of Modernism, is more mystical and more somber.

PAINTING IN GREAT BRITAIN

Great Britain was never invaded, as most of the rest of Europe was (Switzerland, Sweden, and the Iberian peninsula were the other exceptions), nor did it become subject to an enemy power. On the other hand, its geographical closeness to the European continent meant that for most of the war years it was a country under siege. Before the war, the British school, under the tutelage of critics such as Roger Fry (1886–1934) had consistently looked across the Channel for inspiration. Now communication with Paris was cut off, and the British remained unaware of the revolution which was taking place in America. For the first time for many years, British art was thrown back entirely on its own resources.

Stanley Spencer

There were a few British painters of the senior generation whom this suited very well, chief among them Stanley Spencer (1891–1959). An eccentric, mystical neo-

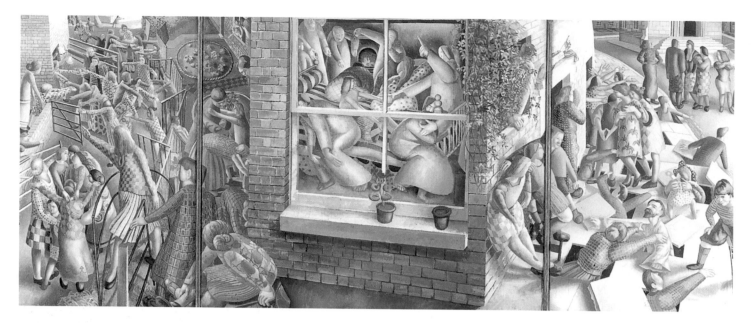

6.17 Stanley Spencer, *The Resurrection with the Raising of Jairus's Daughter*, 1947. Oil on canvas, [center] 30¼ x 34⅜ in (76.8 x 87.4 cm), [wings] 30¼ x 20 in (76.8 x 50.8 cm). Southampton Art Gallery, England.

Stanley Spencer liked to place episodes from the Bible in contemporary settings. The controversy his religious canvases provoked was heightened by the distortions of his style. Highly idiosyncratic, Spencer belonged to no school and inspired no followers.

primitive, Spencer was generally placed, by Fry's converts and other supporters of Modernism, on the academic wing of British art. It has only gradually come to be realized that he was the greatest British painter of his time, a true successor to the equally eccentric poet-painter, William Blake.

At the beginning of the war Spencer was, at his own request, given official employment as a war artist, and he spent much time during the war years recording the wartime shipbuilding industry at Port Glasgow, on the Clyde. The paintings were an immediate success with his official employers, but Spencer hankered to produce something which was truly his own. The theme of the Resurrection had always been full of meaning for him, and, once the war was over, he decided to return to this theme. In his triptych, *The Resurrection with the Raising of Jairus's Daughter* (FIG. 6.17), the former inhabitants of Stonehouse, a small town near Port Glasgow, are seen rising from under the paving stones in the village street, while Jairus's daughter is seen through the sash window of a terraced house. Spencer added contemporary relevance to the scene: "I put over the doors the usual 'Welcome Home' signs and flags and bunting they put up for the soldiers returning from the war."[7]

Graham Sutherland and Francis Bacon

The feelings of less-established British artists about the conflict were more complicated, and expressed more obliquely. Graham Sutherland (1903–80) had established a reputation before the war, first as a printmaker, then as a neo-Romantic painter, influenced by Samuel Palmer (1805–81), whose work evoked feelings of empathy between man and nature. Sutherland worked as an official war artist, though with much less distinction than Stanley Spencer, producing somewhat theatrical images of bombed buildings. His most striking contribution to the imagery of the conflict was a small series of paintings and watercolors made in Pembrokeshire, Wales, in the mid-1940s after he had been released from official duties. The Roman Catholic Sutherland's vivid response to the desolate landscape was an intense series of paintings and drawings of *Thorn Trees* and *Thorn Heads*, metaphors for the tortured and crucified Christ (FIG. 6.18). Not merely men and women but all nature, Sutherland seemed to be saying, had been tortured by the events of the war.

Francis Bacon (1909–92), though not a believer, also made effective use of Christian iconography in the work which established his reputation, *Three Studies*

6.18 Graham Sutherland, *Thorn Tree*, 1945–6. Oil on canvas, 4 ft 2 in x 3 ft 4⅛ in (1.27 x 1.02 m). British Council Collection, London.

The thorn tree is a metaphor for the tortured and crucified Christ, but it also brings to mind the twisted iron debris and barbed wire of World War II battlefields. Sutherland had been an official war artist.

6.19 (*below*) Francis Bacon, *Three Studies for Figures at the Base of a Crucifixion*, c. 1944. Oil on board, 35⅜ x 29⅛ in (90 x 73.7 cm). Tate Gallery, London.

Bacon's three tormented, grotesque figures are representations of the Greek Furies, the most intensely evil of all characters in Greek mythology. Torment and suffering, rendered in demonic swirls of paint, remained a preoccupation of Bacon throughout his career.

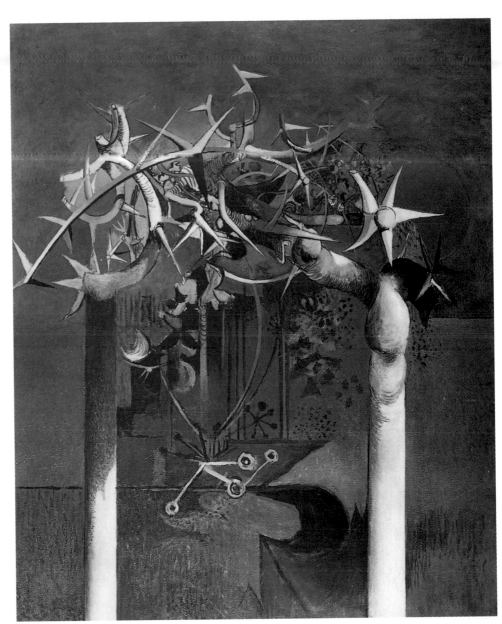

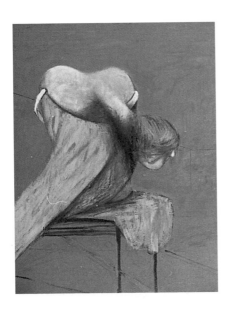
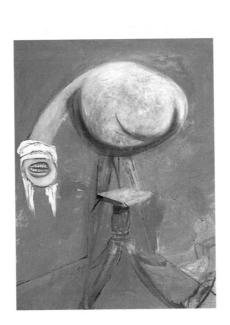

for the Base of a Crucifixion (FIG. 6.19). The three ravening, supremely evil entities caused a sensation when the triptych was exhibited in London a year after it was completed. Bacon, entirely self-taught as an artist, and until that moment virtually unknown, had summed up all the feelings of primal guilt evoked by the war—though the painting is too early to have been inspired, as is sometimes alleged, by the dropping of the atomic bomb on Japan.

PAINTING IN LATIN AMERICA

Latin America was one of the few regions of the world untouched by conflict between 1939 and 1945. Partly as a result, Latin American art underwent a species of transformation during the 1940s, one which, although artists still sought to give an indigenous feeling to their work, had nothing to do with Muralism and was in many ways opposed to it.

Joaquín Torres-García

One of the moving spirits in this transformation was the veteran Uruguayan Constructivist, Joaquín Torres-García (1874–1949), who in 1934 had returned to Montevideo after living in Europe and the United States for more than forty years. During his time in Paris, Torres-García had been one of the leading lights in the Cercle et Carré group, but had found himself less in sympathy with Abstraction-Création, which succeeded it. Abstraction-Création exalted purely abstract art, while what Torres-García painted was often figurative. Much of his work featured grids whose compartments were filled with glyphs, or symbols—long before similar formats were adopted by Adolph Gottlieb. When Torres-García returned to Uruguay looked more closely at pre-Columbian art, as an alternative to the cultural dependence on Europe which he found in Montevideo.

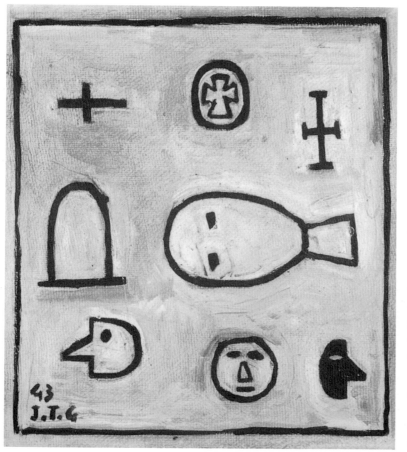

6.20 Joaquín Torres-García, *Animated Forms*, 1943. Oil on board, 17⅛ x 17 in (43.5 x 43 cm). Joan Miró Foundation, Barcelona, Spain.

The simplified glyphs seen here were inspired by pre-Columbian art. Torres-García called his style "Constructivist," though it had nothing to do with the Russian movement of that name.

His late paintings, such as *Animated Forms* (FIG. 6.20), are often collections of simplified glyphs, without even a grid to contain them, inspired by pre-Columbian relief carvings.

In this last phase of his career, Torres-García was a controversial teacher, whose doctrines flatly contradicted those of Muralism. He opened the Torres-García Workshop in 1943 to instruct young artists in Constructivist ideas and techniques, and issued a Constructivist magazine, called *Circulo e Cuadrado* ("Circle and Square"), that attracted articles from leading international figures such as Mondrian and Van Doesburg.

The Madí Group in Buenos Aires

The first avant-garde groups of the new epoch in Latin America, Madí and Arte Concreto-Invencíon, were founded in Buenos Aires in 1945. Both were derived from European Constructivism, but Madí in particular was also the forerunner of attitudes which did not appear in the United States or Europe until the foundation of the Fluxus Group in the 1950s. The word "Madí" has sometimes been explained as a contraction of the phrase "MAtérialisme DIalectique" and thus as the artists' way of thumbing their noses at the right-wing dictatorship then in power in Argentina. In fact, it

6.21 Gyula Kosice, *Madí Neon No. 5*, 1946. Neon and wood, 22 x 16 x 7 in (56 x 41 x 18 cm) Musée de Grenoble, France.

This is probably the earliest example of the use of neon in art. Kosice, who was a forerunner of the Fluxus group, loved experimentation for experimentation's sake.

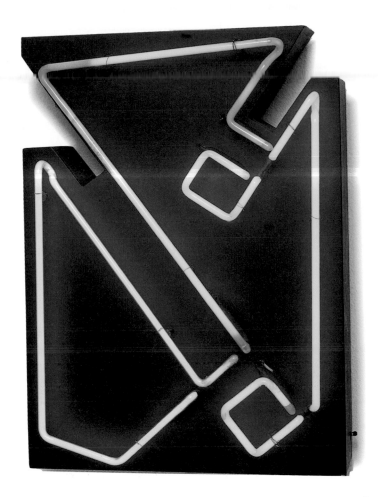

appears to have been a made-up designation, designed to mystify, like Dada. Compared with the typical products of European Constructivism, Madí art, like Dada, delighted in caprice. According to the Madí Manifesto, written by the artist, Gyula Kosice (1924–), and published in 1946, paintings were to have "uneven and irregular frames" and "articulated surfaces with lineal, rotating and changing movements." Sculptures, too, were to rotate. Madí was thus the precursor of the international Kinetic Art movement of the 1960s. In 1946 Kosice made what was probably the first work of art to incorporate neon tubing (FIG. 6.21). Unjustly neglected in histories of modern art which focus attention on events in the United States and Europe, Madí stands at the beginning of a whole series of developments in the postwar era.

Mexico: Rufino Tamayo and Frida Kahlo

In Mexico itself, the heartland of the Muralist movement, there were also signs of change. Central to the debate about the future of Muralism was the personality of Rufino Tamayo (1899–1991), who belonged to the same generation as the three major Muralists. Born in Oaxaca, of Zapotec parents, Tamayo began his career in 1921 as head of the drawing section of the Archeological and Ethnographical Museum in Mexico City, a post which brought him into intimate contact with pre-Columbian art and the rich folk culture of Mexico. From 1928 to 1930 he taught, under Diego Rivera, at the National School of Fine Arts and at the Academy of San Carlos. Tamayo was nevertheless unconvinced of the value of Muralism, which he thought was too picturesque, too "careless of the really plastic problems." His reaction was to distance himself from the Mexican milieu, spending much time in New York and exhibiting very little in Mexico. In New York he was in contact with a wide spectrum of artists, among them Stuart Davis, and he was

able to see important exhibitions, including the Picasso retrospective of 1939–40 at the Museum of Modern Art. As a result he evolved a style which synthesized what he had learned from the Modernists—Picasso, Gauguin, Cézanne, Matisse, and Miró—and elements taken from Mexican folk culture. His work was full of references to Mexican life in the present, rather than to the tragic events of the past, and usually it renounced the didactic element so prominent in Muralism. Typical of his work in the 1940s is *Watermelons* (FIG. 6.23). This alludes to the richness of form and hue to be found in Mexican markets, and to Tamayo's own direct experience of these as an adolescent, when he sold fruit in one of the markets in Mexico City.

Frida Kahlo (1907–54) was another Mexican painter whose work went against the grain of Muralism (see FIG. 6.22). She was the wife of Diego Rivera, who called her "the only woman who has expressed in her art the feelings, functions and creative power of women."[8] There was a certain irony in this, since Kahlo's painting arose largely out of her personal suffering, and much of that suffering was caused by the philandering of her husband, in addition to her constant ill-health and her inability to bear a child.

Frida Kahlo: *Self-portrait*

Frida Kahlo's sense of personal anguish was often expressed through self-portraiture. *Self-portrait with Thorn Necklace and Hummingbird* is a typical example (FIG.

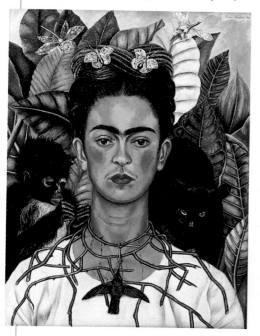

6.22 Frida Kahlo, *Self-portrait with Thorn Necklace and Hummingbird*, 1940. Oil on canvas, 24½ x 18¾ in (62.2 x 47.6 cm). Harry Ransom Humanities Research Center, University of Texas, Austin, Texas.

6.22). Taking her cue from popular religious images showing the head and shoulders of the suffering Christ, Kahlo depicts herself wearing a necklace of thorns, as an equivalent for Christ's Crown of Thorns. Yet the image is also syncretistic, seeking to combine Christian and pre-Christian elements. From the thorn-necklace is suspended a dead hummingbird. Aztec belief was that the spirits of dead warriors returned in the form of hummingbirds, and Kahlo is here alluding to the pre-Columbian past, as her husband did in many of his murals. For the most part, however, her main sources were in contemporary Mexican folk art especially in the votive paintings called *retablos*, which belonged to a tradition dating back to the colonial period. The work of journeymen artists, they were put up in churches to recall some peril which the dedicator had survived, thanks to the intervention of some holy person or saint, most often the Virgin herself. Hayden Herrera, Kahlo's biographer, aptly describes the *retablo* as "both a visual receipt, a thank-you note, for the delivery of heavenly mercy, and a hedge against future dangers, an assurance of blessing."* Herrera also notes the "reportorial directness" of

these paintings, and their narrative thrust. These qualities recur in Kahlo's art.

Kahlo's life story, and the strongly autobiographical quality of her art (something which she shares with Paula Modersohn-Becker and Käthe Kollwitz), have turned her into a feminist icon since the publication of Herrera's vividly sympathetic account of her life in 1983. However, she is important for other reasons as well. More than any other artist, she demonstrated that Latin American art did not have to be a collective expression: artists could legitimately express an individual sensibility. Her use of folk sources was also important, and many parallels can be found for it throughout the history of twentieth-century Modernism—for example, in the use made by Russian artists such as Larionov and Goncharova of *lubok*, or popular prints, and in Gabrielle Münter's interest in children's drawings and Bavarian paintings on glass. Kahlo's paintings, in spite of their reduced scale, are more experimental and had more importance for the immediate future of art than the vast surfaces covered by her husband.

*Hayden Herrera, *Fri: A Biography of Frida Kahlo*, New York, 1983, p. 15.

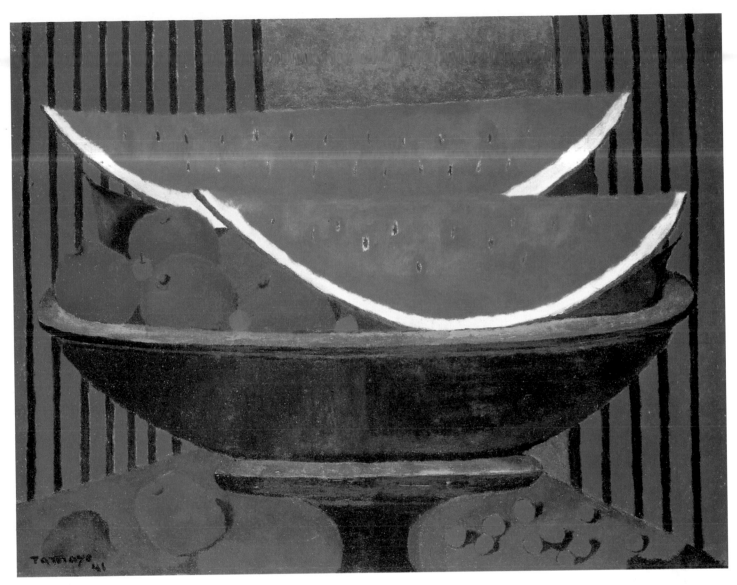

6.23 Rufino Tamayo, *Watermelons*, 1941. Oil on canvas, 16½ x 21¾ in (41.7 x 55 cm). Olga and Rufino Tamayo Foundation, Mexico.

Tamayo rejected the muralists' politically committed use of Mexico's heritage, preferring instead a painterly approach to contemporary Mexican life. Here he exploits the rich forms and colors to be found in the street markets where he had once been a vendor.

Sculpture

The contrast between American and European art in the immediate postwar period was more pronounced in sculpture than in painting. However, whereas American painting of the 1940s was revolutionary in its originality, this was not true of American sculpture, which for the most part remained fixed in stylistic postures inherited from Europe. If one looks through a standard reference work of the period, one finds few names which are truly familiar today. The striking exceptions are Alexander Calder and David Smith, though the latter did not produce his most important work until the 1950s and 1960s. That Henry Moore and Alberto Giacometti were able to make major reputations in the United States in the late 1940s was partly thanks to the absence of local competition.

SCULPTURE IN THE UNITED STATES

Isamu Noguchi

Isamu Noguchi (1904–88) is probably the sculptor most closely linked to the first phase of Abstract Expressionism, through his close friendship with Arshile Gorky. Noguchi, half-Japanese by birth, was far more cosmopolitan than any of the leading Abstract Expressionist painters, with the possible exception of Hans

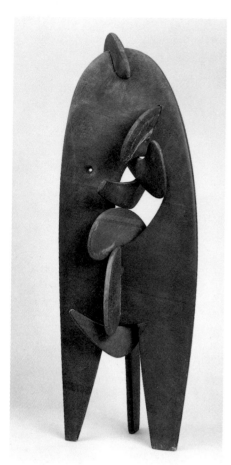

6.24 (*above*) Isamu Noguchi, *Humpty Dumpty*, 1946. Ribbon slate, height 58¾ in (149.2 cm). Whitney Museum of American Art, New York.

Thin slabs of slate, carved from material originally meant to be used for facing buildings, are joined together without fastenings, in a way suggested by traditional Japanese carpentry.

6.25 Alberto Giacometti, *Man Pointing*, 1947. Bronze, 69½ x 35½ x 24½ in (176.5 x 90.2 x 62.2 cm). Tate Gallery, London.

Giacometti made his figures skeletal, almost to vanishing-point, in order to suggest his own feelings of alienation. At the same time, however, he was interested in purely optical effects. The rough surfaces of his sculptures suggest the atmospheric vibration that surrounds something we see in the far distance, and seems to create a garment of light around their forms which, in part at least, compensates for their lack of physical bulk.

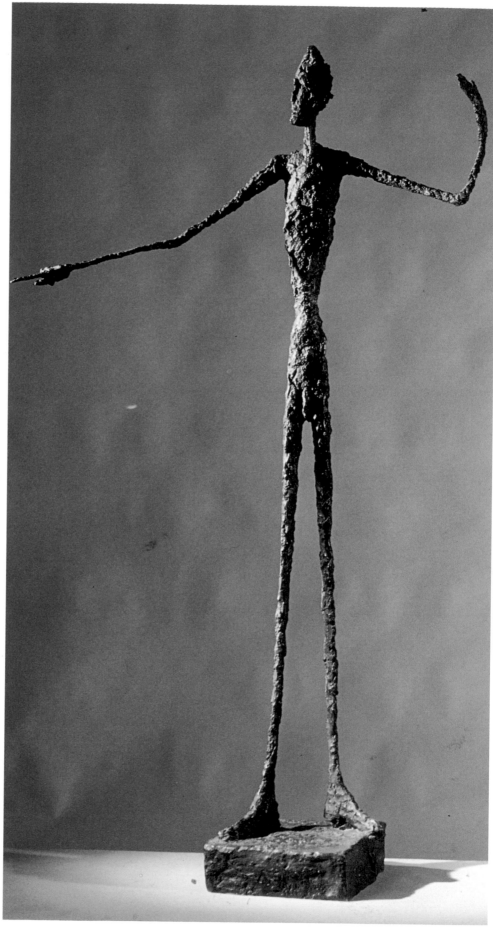

Hofmann. Brought up partly in Japan and partly in the United States, he had visited Paris in the late 1920s, where he served as studio assistant to Brancusi. In 1930–32 he traveled to China and Japan, and later in the decade he had a brief involvement with Mexican Muralism. His friendship with Gorky seems to have been based on a shared alienation from American society. Just as Gorky was nostalgic for the Armenia to which he could never return, so Noguchi longed for closer contact with his father, a Japanese writer and nationalist. Embarrassed by his partly Caucasian offspring, Noguchi senior kept his son at arm's length.

The sculptures Noguchi made in New York during the 1940s often seem to echo the biomorphic shapes found in Gorky's paintings of the time. Unable to find a ready source for the large blocks of stone used by Moore and other carvers, Noguchi made his sculptures from thin slabs of marble or slate used as facings in the American building industry (FIG. 6.24). These slabs are joined together without artificial binders using techniques suggested by traditional Japanese carpentry. Though made of stone, they anticipate the assembled sculptures of welded metal which were to be typical of American sculpture during the next decade. In their own way they are just as much a product of the American industrial ethos.

SCULPTURE IN EUROPE

Whereas the whole of American art veered toward abstraction in the 1940s, European sculpture, which was almost precluded by World War II, showed, in the second half of the decade, a strong bias towards the figurative, more especially in Italy than in France.

Alberto Giacometti and Germaine Richier

Giacometti had returned to making drawings from life in 1935, and during the next five years he had concentrated almost entirely on drawing. The war years he spent in Switzerland. He did make sculpture there, but struggled constantly with the problem of scale. His figures grew steadily more minute and when at last he returned to Paris, his entire output was packed in the pockets of his overcoat. In Paris he began, at long last, to make sculptures of more considerable size, such as *Man Pointing* (FIG. 6.25). Though the figures were now taller, they were exceedingly thin. Giacometti used this convention to express his own feeling of alienation, his sense that an insurmountable distance kept him apart from his models, even though his most frequent subjects were intimately known to him—his brother, Diego, who acted as his studio assistant, and his wife, Annette. The emaciation of Giacometti's figures was often interpreted by his contemporaries as emblematic of despair and hardship. When he held his first one-person show in New York in 1948, the reviewer for *Art Digest* described them as "fugitives from Dachau."[9] This political meaning was never Giacometti's intention, but the misunderstanding helped to gain rapid international acceptance for his work.

Germaine Richier (1902–59) also spent the war years in Switzerland, in the company of her Swiss-born husband. Unlike Giacometti, she had a busy and successful career as a sculptor there, but grew increasingly dissatisfied with what she was doing. Deciding that she needed to be less analytic and more visceral, she turned to the fusion of human, plant, and animal imagery which appears in her sculptures from the mid-1940s until her premature death. She nevertheless always felt she needed the presence of the model. "The imagination needs a point of departure," she once said. "It is thence possible to plunge straight into poetry … I invent more easily when contemplating nature—its presence makes me independent."[10] Her striking *Storm Man* (FIG. 6.26) is based on the appearance of an eighty-year-old professional model called Nardone, who had originally posed for Rodin's *Balzac*.

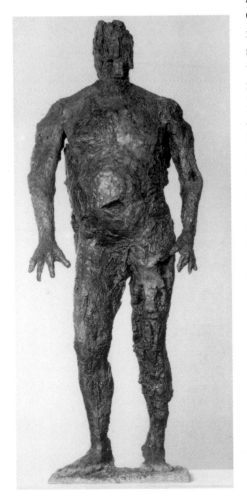

6.26 Germaine Richier, *Storm Man*, 1947–8. Bronze, height 6 ft 6¾ in (2 m). Galerie H. Odermatt, Paris.

The model for this sculpture, which offers a metaphor for natural forces, was an eighty-year-old Italian who had originally posed for Rodin. Richier's richly expressive use of bronze places her in direct descent from the French master.

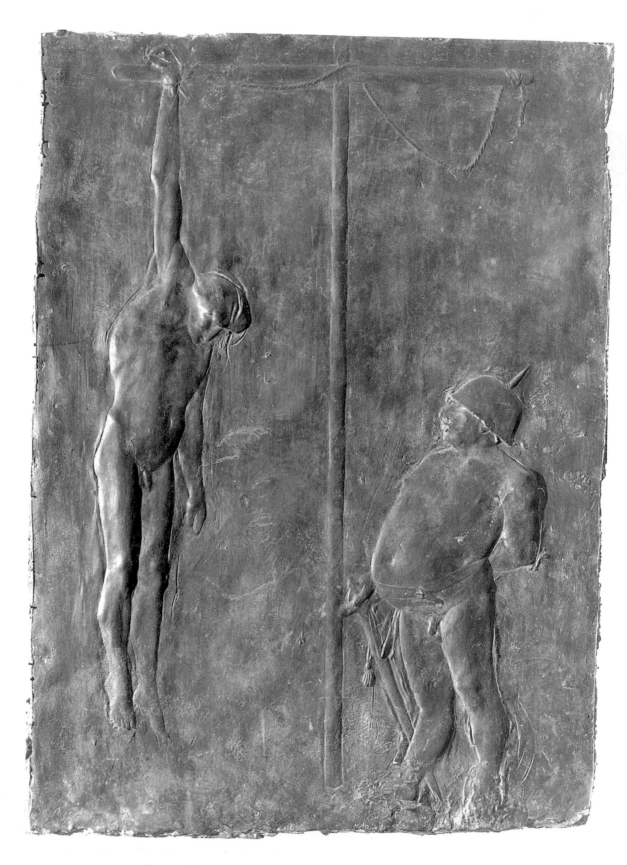

6.27 Giacomo Manzù, *Christ with General*, c. 1947. Bronze bas-relief, 28 x 20⅛ in (71 x 51 cm). Galeria Nazionale d'Arte Moderna, Rome.

Scenes like the one on this panel (modeled in relief in clay and cast in bronze) were commonplace in Fascist Italy. Manzù's lifelong theme was human suffering and torment and his reliance on traditional methods and materials made him a somewhat isolated figure in the midst of Modernism.

Richier had once been a pupil of Emile Bourdelle, and was therefore a direct heir of the Rodin tradition. Her work deals in states of transformation—her sculptures show beings whose physical entities are perpetually subject to change. As essentially apolitical in outlook as Giacometti, she nevertheless mirrors, like him, an important aspect of the postwar sensibility.

Marino Marini and Giacomo Manzù

In Italy two sculptors, both artistic heirs of Medardo Rosso, used Classical elements to express their feelings about the terror of the times. The more eclectic, and slightly older, of the two was Marino Marini (1901–90). In the late 1940s, one of Marini's most important themes was that of the *Horse and Rider* (FIG. 6.28). His equestrian figures belong to an ancient tradition—one which stretches back to the celebrated equestrian figure of the Emperor Marcus Aurelius in Rome, and which passes through the work of great Renaissance sculptors such as Donatello and Verrocchio. Marini cannily freed himself from the weight of these influences by looking for inspiration to the pottery grave figures of T'ang dynasty China, and also to Etruscan art. Whereas his Roman and Renaissance forebears had used the horse and rider as a symbol of power, Marini saw them as an emblem of terror. In an interview given in the 1950s, he commented: "If you look back on all my equestrian figures of the last twelve years, you will notice that the rider is each time less in control of his mount, and that the latter is increasingly more wild in its terror but frozen stiff, rather than rearing or running away. This is because I feel that we are on the eve of the end of the whole world."[11]

A similarly pessimistic spirit inspired the reliefs made by Giacomo Manzù (1908–91), which eventually grew into the Gates of Death made for St. Peter's, Rome. One of the earliest reliefs in the series, the *Christ with General*, shows a pathetic corpse, hanging by one arm from a cross, and being complacently surveyed by a brutal figure in a spike helmet (FIG. 6.27). The scene is clearly inspired by atrocities committed against the partisans during the war, while the technique—that of exquisitely modeled, very low relief—is borrowed from Donatello.

The technical virtuosity of these two Italian sculptors makes a striking contrast with Dubuffet's exploration of the deliberately clumsy and inept, and demonstrates the wide polarities that could be found in the art of the immediate postwar years.

Photography

PHOTOGRAPHY AND THE WAR

World War II was a rich quarry for documentary photographers, and every aspect of it, in every theater of conflict, was covered by the camera. The photographers often showed extraordinary enterprise, as well as bravery, in getting the images they wanted. Some were entirely unexpected personalities, none more so than the expatriate American, Lee Miller (1907–77), who had first established herself in Europe as the model and darkroom assistant of Man Ray. At the beginning of the war Miller was living in London, with Roland Penrose, a minor Surrealist painter and major patron of the arts. In the early 1940s she made remarkable photographs of the London Blitz. In 1944, shortly before the Normandy landings, she succeeded in getting herself accredited as an American war correspondent, and proceeded to accompany the American army across France into Germany. Some of her most memorable images were made in the German concentration camps at Dachau, which she saw the morning after it was liberated, and Buchenwald. Her images helped to bring home the true reality of the Holocaust to the British and

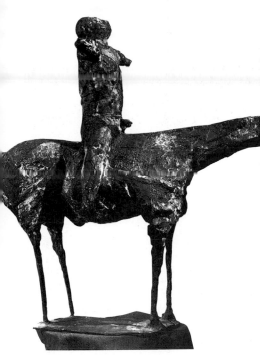

6.28 Marino Marini, *Horse and Rider*, 1949. Bronze, 16⅞ x 7 x 5½ in (43 x 18 x 14 cm). Museo Marino Marini, Milan, Italy.

Marini's *Horse and Rider* series was inspired by the mounted peasants watching for hostile aircraft in the fields during World War II. Here the reared, screaming head of the horse and the despairing posture of the rider give compassionate expression to the suffering of all creation.

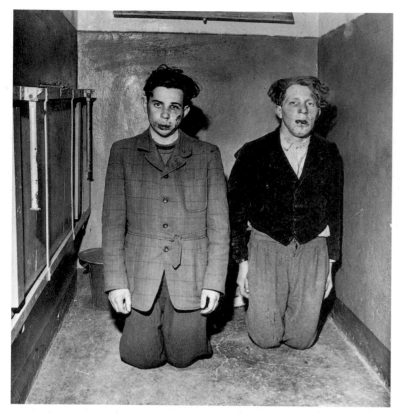

American public. Her searing pictures are not of starving prisoners, nor of piles of corpses, but of concentration camp guards who had been beaten by their victims and then locked up by the allies (FIG. 6.29). As the critic and curator, Jane Livingston, remarks, these photographs have "a character of monumentality, and, ultimately, a kind of unflinchingness, that separates [them] from others of their kind."[12]

Weegee in New York

On the other side of the Atlantic, the news photographer, Weegee (Arthur Fellig, 1899–1968), was making a rather similar documentation of the dark side of a modern metropolis. His book, *Naked City*, was published in 1945. Weegee had a police radio in his car, which enabled him to rush to the scene of an accident or crime almost as soon as it had taken place. His glaring and brutal images, most often made at night, and lit with a pitiless photographic flash (FIG. 6.30), offer an apparently raw, uncensored vision of life which is a vehicle for savage criticism of American society.

6.29 Lee Miller, *Captured Prison Guards, Buchenwald*, 1945. Gelatin silver print. Burgh Hill House, Chiddingly, England.

This is a typical Miller photograph—stark, direct, uncompromising, forcing the viewer to confront the reality of human savagery in the twentieth century.

Visionary Photographers

While photographers such as Miller and Weegee reacted directly to the terror of their times, there were others who tried to supply positive images as an emotional counterbalance to all-pervasive violence. In the 1940s Ansel Adams (1902–84) made what are perhaps the best-loved landscape images in the history of American photography—images like the famous *Moonrise, Hernandez, New Mexico* (FIG. 6.31). His influences included the work of Stieglitz, of Edward

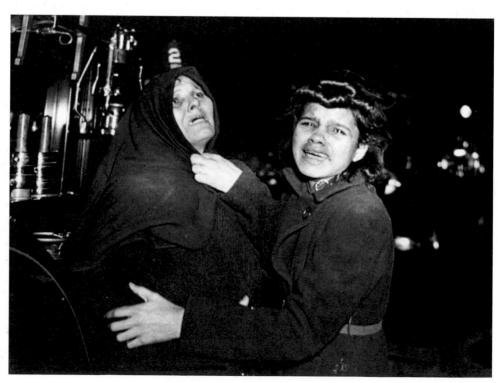

6.30 Weegee, *Fire in Harlem—her kids are still in the burning building*, 1942. Gelatin silver print, International Center of Photography, New York.

Weston, and also of the great nineteenth-century topographical photographers such as Timothy H. O'Sullivan (1840–82)—the men who first showed America to itself. In the Canyon de Chelly in Arizona, for instance, Adams often used almost exactly the same points of view that O'Sullivan had employed. Adams was also influenced by the literary tradition of Walt Whitman and Edward Carpenter. It was Carpenter who wrote:

> It seems to me that the only way in which an artist can make his work durable and great is by seeking to arrive at the most direct expression of something actually felt by himself as a part of his own, and so part of all human experience. He must go to the root of all Art, namely the conveyance of an emotion or impression with the utmost force and directness from himself to another person.[13]

Minor White (1908–76) was also influenced by Stieglitz (whom he visited in New York in 1946), by Ansel Adams (whom he succeeded in his teaching post at the California School of Fine Arts), by Edward Weston (with whom he became close friends), and by the poetry of Whitman. His range of imagery is wider than that

6.31 Ansel Adams, *Moonrise, Hernandez, New Mexico*, 1941. Polaroid land photograph.
© Trustees of the Ansel Adams Publishing Rights Trust. All rights reserved. Carmel, California.

This is one of Adams's most widely circulated images. He was fascinated by dramatic, rugged landscape, and liked to capture its beauty with a wide-plate view camera of the kind very popular in the United States in the mid-nineteenth century.

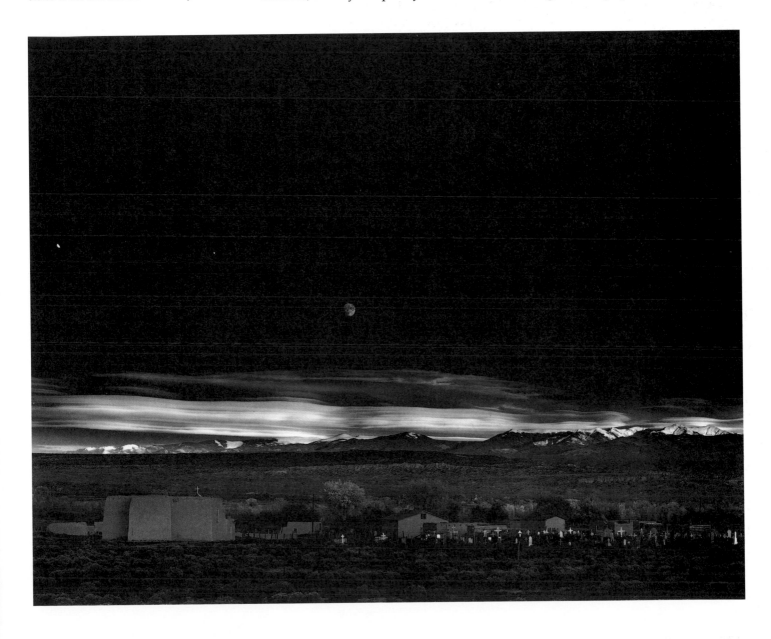

6.32 Minor White, *San Mateo County, California*, 1947. Gelatin silver print. Princeton University, New Jersey.

Close-ups of landscape details were typical of White's style in the 1940s. This photograph, from a series called *Song without Words* (after Mendelssohn), typically uses the natural forms of the California coastline to evoke images of human sexuality.

of Adams—it includes a number of homoerotic images made in the late 1940s which remained unpublished and unexhibited during his lifetime. Many of his most typical photographs of the 1940s are close-up landscape details (FIG. 6.32). These have an obvious kinship with the work being done by the emergent Abstract Expressionist painters at the same period. The likeness to the paintings of Clyfford Still is especially striking.

Another photographer making radically abstract images during this epoch was Harry Callahan (1912–), also a disciple of Stieglitz and Adams. A study of *Weeds in Snow* (FIG. 6.33), made in Detroit in 1943, offers a kind of abstraction which is more radical than anything the Abstract Expressionists had achieved up to that point. Quite apart from its intrinsic merits, the photography done in the 1940s by White and Callahan is historically important because it marks the moment at which photography and other forms of artistic expression began to approach one another in a way which was eventually to make them to all effects and purposes indistinguishable.

6.33 Harry Callahan, *Weeds in Snow*, 1943. Gelatin silver print. © Harry Callahan, PaceWildensteinMacGill, New York.

Many of Callahan's sparse photographs, especially of weeds against sky and snow, bear resemblance to the colour-field aesthetics of Abstract Expressionism. Here Callahan seems to anticipate aspects of Jackson Pollock's "drip" paintings.

1950	**1951**	**1952**	**1953**	**1954**

GENERAL EVENTS

• Communist Chinese army occupies Tibet • North Koreans invade South Korea. UN troops land in South Korea	• United States signs peace treaty with Japan • 22nd Amendment limits US presidents to two terms	• Dwight D. Eisenhower elected US president • The Iron Curtain divides Berlin • Elizabeth II succeeds George VI	• Death of Stalin. Malenkov becomes Soviet Premier • Korean armistice signed • Edmund Hillary and Tenzing are first to climb Everest	• Dien Bien Phu taken by Vietnamese Communists, who occupy Hanoi • Algerian War of Independence begins (–1962) • US Supreme Court rules that segregation by color in public schools is illegal

Saarinen,
TWA Terminal:
see p.219

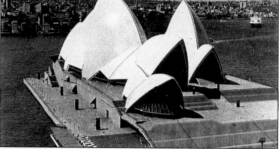

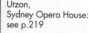
Utzon,
Sydney Opera House:
see p.219

SCIENCE AND TECHNOLOGY

• Miltown comes into use as a tranquillizer • Antihistamines introduced against colds and allergies	• Electric power first produced from atomic energy • First color-television broadcast in the United States	• First US hydrogen bomb exploded at Eniwetok Atoll in Pacific Ocean • Mass production of the IBM computer 701	• Discovery of DNA by Crick, Watson, and Wilkins • Alfred Kinsey publishes *Sexual Behavior in the Human Female*	• Polio vaccine developed at the Pasteur Institute

ART

• The "Irascibles" in New York demand to be recognized by the American avant-garde • Matisse awarded the grand prize at the Biennale in Venice • Franz Kline's first exhibition	• *Massacre in Korea* by Picasso • André Malraux publishes *The Voices of Silence*	• "Unknown Political Prisoner" competition held by Institute of Contemporary Arts, London • Foundation of the Daur al Set Group in Barcelona • Publication of *Un art autre* by Michel Tapié	• Georges Braque's ceiling painting in the Louvre • Scandal over Pablo Picasso's *Portrait of Stalin*	• Formation of Gutai Group, Japan • Death of Henri Matisse • Jean Arp, Max Ernst and Joan Miró win grand prizes at the Biennale in Venice

ARCHITECTURE

• Lever House by Skidmore, Owings, and Merrill (Gordon Bunshaft) gets underway in New York (–1952) • Building begins on Bruce Goff's Bavinger House, Oklahoma (–1955)	• Bruce Goff begins work on the Bavinger House, Oklahoma (–1955) • Nehru commissions Le Corbusier to build Chandigarh	• Walter Gropius, Back Bay Center, Boston • Inauguration of La Cité Radieuse by Le Corbusier in Barcelona	• Buckminster Fuller's geodesic dome	• A. and P. Smithson, Secondary School, Hunstanton, Norfolk, England (begun 1949)

Le Corbusier, Chapel of
Nôtre-Dame du Haut:
see p.217

1950–1959

1955	1956	1957	1958	1959

- Malenkov resigns as Soviet Premier and is succeeded by Bulganin
- Bus boycott against racial segregation in Montgomery, Alabama

Frink, *Winged Figure*: see p.245

- Nasser elected President of Egypt, and seizes Suez Canal. Anglo-French forces invade. Israel invades Sinai. British and French troops withdraw
- Uprising in Hungary against Soviet domination put down by USSR
- Martin Luther King emerges as a leader against racial segregation

- Israeli forces withdraw from Sinai and hand over Gaza Strip to United Nations
- Segregation crisis in Little Rock, Arkansas
- Six European nations sign the Treaty of Rome, forming the EEC

- Fidel Castro begins war against the Batista government in Cuba
- Nikita Khruschev succeeds Bulganin as Soviet Premier

- Fidel Castro seizes power in Cuba
- Charles de Gaulle becomes president of the Fifth Republic in France

De Staël, *Les Martigues*: see p.239

- Transatlantic cable telephone service inaugurated
- Oral vaccine developed against polio

- USSR launches Sputnik I and II, the first earth satellites

Chillida, *The Anvil of Dreams, XII*: see p.244

- Stereophonic recordings come on to the market

- The Russian rocket *Lunik* reaches the moon
- Launching of the first American nuclear-powered merchant vessel

- Death of Albert Einstein

- Jasper Johns produces first *Flag* paintings
- *Yellow Manifesto* by Victor Vasarely
- Clement Greenberg defines color field painting

- Death of Jackson Pollock in a car accident
- *Cysp I* by Nicolas Schöffer, the first autonomous cybernetic sculpture

- Hans Hartung exhibits throughout Germany
- Ad Reinhardt publishes *Twelve Rules for a New Academy*
- Death of Constantin Brancusi

- Mark Rothko paints canvases for the Rothko Chapel, Houston
- Group Zero formed in Düsseldorf

- Groupe de Recherche d'Art Visuel founded in Paris
- First "Happenings" in New York

- Le Corbusier's Ronchamp Chapel, near Belfort, is opened
- Inauguration of General Motors research center by Eero Saarinen

- Mies van der Rohe and Philip Johnson, Seagram Building, New York (–1958)
- Frank Lloyd Wright, Guggenheim Museum, New York
- Jørn Utzon, Sydney Opera House (–1973)
- Eero Saarinen, TWA Building, Kennedy International Airport, New York (–1962)

- Le Corbusier, Dominican monastery of La Tourette, Eveux-sur-l'Arbresle, France (–1961)

Louis, *Tet*: see p.230

- Paul Rudolph, Art and Architecture Building, New Haven, Connecticut (–1964)
- Expo 58 in Brussels: the return of metal architecture

- Louis I. Kahn, Salk Institute, La Jolla, CA (–1965)

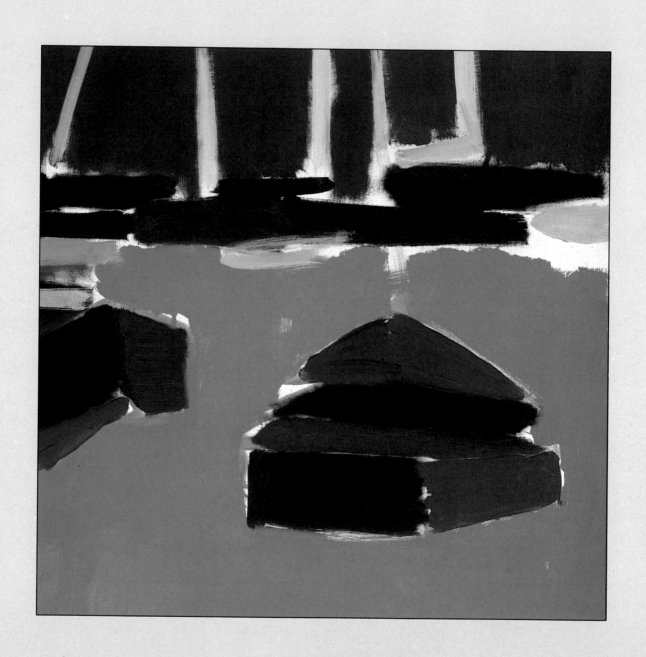

1950–1959

The 1950s still seem to many people to represent an era of stability. The glow of nostalgia for an apparently more innocent time colors and distorts both the memories of those who lived through the decade, and the perceptions of those who did not. In fact, it was a time of profound, often savage, conflicts. The Korean War marked American involvement in the political affairs of Asia. McCarthyism, which fed off the paranoia bred by the Cold War between America and the Soviet Union, produced a climate of fear amongst American intellectuals. In general, throughout American society, there was an intensification of pressures to conform. The exception was the beginnings of the Civil Rights movement, focused on the struggle to desegregate America's education system.

European nations, Great Britain and France in particular, were attempting to come to terms with the postcolonial epoch. French forces in Indochina, later to be called Vietnam, were crushingly defeated by nationalist and Communist insurgents at the siege of Dien Bien Phu. The British and French attempt to check Egyptian nationalism after Nasser's seizure of the Suez Canal ended in a humiliating withdrawal of their forces from the Canal Zone.

While Stalin's death in 1953 seemed to bode well for at least a slight liberalization of Soviet rule, the abortive Hungarian uprising of 1956 proved that the Soviet Union was by no means ready to surrender the empire she had acquired in eastern Europe.

The avant-garde arts in the United States and in western Europe nevertheless had a unitary character which was to be shattered in the 1960s, and never afterwards recovered. The decade can be regarded as the high noon of the Modernist spirit, as this had been developed and interpreted throughout the first half of the century. It is only hindsight which indicates that this apparent state of equilibrium was, in part at least, the product of the Cold War. Modernism had become the official expression of Western, especially American, culture, as opposed to the Socialist Realist dogmas which prevailed in the Soviet Union.

Existentialism

In Europe the strongest intellectual influence was the existentialism of Jean-Paul Sartre (1905–80), set out in his 1943 treatise, *Being and Nothingness*. Sartre's doctrines, though they formed what was perhaps the only philosophical system of the twentieth century to gain popular currency, have not worn well. Their popularity as well as their lack of staying power can be attributed to the fact that they were based on a series of rather simplistic oppositions and paradoxes. Sartre, for example, thought that, while all actions were subject to moral interpretations, there were no objective moral principles. Freedom lay in making choices, yet these choices could be neither rational nor deliberate. One of the things he stressed most strongly was the necessity for commitment or engagement. It was this alone—commitment to something outside themselves—which could relieve human beings of the burden of their own non-existence. As interpreted by his followers, this led to a rather factitious interest in social and political causes of various kinds, and a drift toward Marxism, even though Sartre was, in theory, the

declared enemy of Marxist determinism. Existentialism thus often seemed to ally itself to the political line put forward by Communist fellow-travellers within Western society. In a broader sense, however, it represented an undercurrent of resistance to the conformism which seemed to be overtaking Western culture—a conformism which, at certain points, affected even those manifestations which presented themselves as avant-garde. More overt resistance to conformism came from the Beat writers in the United States, such as Allen Ginsberg and Jack Kerouac. As yet, however, the culture of the Beats was that of only a tiny minority within American society.

Architecture

THE DOMINANCE OF MIES VAN DER ROHE AND LE CORBUSIER

In America during the 1950s, the new Miesian version of the Bauhaus aesthetic, as developed in his buildings in and around Chicago, appeared at first to sweep all before it. The paradigmatic expression of the late phase of the International Style is the Seagram Building in New York (FIG. 7.1), designed by Mies in collaboration with the American architect, Philip Johnson (1906–). The intention was from the beginning to produce a prestige building which would be the "crowning glory of everybody's work"—that of the client and the general contractor as well as the architect.[1] Mies decided to preserve nearly half of the immensely valuable site as open space and the materials used for the tower were luxurious—in the lobby, which is 24 feet (8m) high, the elevator cores are sheathed in polished Roman travertine. The building is enclosed in a skin of glass tinted topaz-gray, set in bronze frames with bronze mullions and spandrels. The combination of simple form, rich materials, and (for a building of this type) unprecedentedly large areas of open space gave Mies's tower a monumental character without equal in either the religious or civic architecture of its time. It immediately became the symbol of American corporate success, and of the vast economic power of the United States. Lewis Mumford sarcastically likened it to a "pyramid—a building that exhausts every resource of art and engineering to create an imposing visible effect out of all proportion to its human significance."[2]

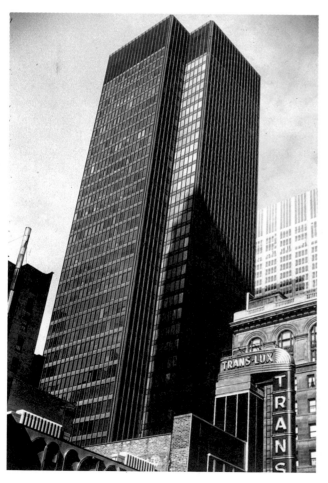

7.1 Philip Johnson and Ludwig Mies van der Rohe, Seagram Building, New York, 1956–8.

In this most celebrated prestige building of its era, the most famous glass-curtain-walled skyscraper in the world, the International Style invented in the 1920s reached its culmination.

Le Corbusier at Chandigarh

The other genius presiding over the architecture of the 1950s, whose influence on intellectuals and theoreticians was even more powerful than that of Mies, was Le Corbusier. At the beginning of the decade, after the architect originally appointed had been killed in an air-crash, Le Corbusier was offered an opportunity of a kind which had always eluded him in Europe, that of designing a city virtually from scratch. As a result of the partition of India in 1947, that part of the Punjab which had remained within India needed a new administrative capital, since the historic capital city of the province, Lahore, was now in Pakistan. Le Corbusier arrived in Chandigarh, the chosen site, in February, 1951, and was ultimately responsible for a number of major buildings (FIG. 7.2) which formed the administrative core—the High Court of Justice (1950), the Secretariat (1958), and the Assembly Building (completed in 1961). He also radically modified the city plan drawn up by the American civil engineer and town planner, Albert Mayer.

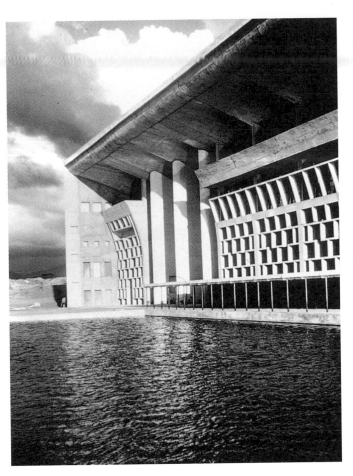

Le Corbusier's buildings for Chandigarh, built of rough concrete in the style he had pioneered for the Unité d'Habitation in Marseilles, were much admired for their spectacular effect, and are still praised, particularly by his European and American fans, for their imaginative use of space. In *The Le Corbusier Guide* (1987), Deborah Gans remarks of the Palace of Justice: "The unity of the building arises not from an internal, hierarchical system of lobbies and corridors related to the seats of justice, but from the activity of the citizens as they move from plaza to courtroom to portico."[3] Recent Indian opinion is less favorable. "The building still looks beautiful and impressive, but fails to meet the needs of its users. The design of the courtrooms fails to take into account the Indian judicial process, and the 1' 6" (1.4m) deep brise-soleil does not prevent the brilliant morning sunshine from streaming through the transparent rear facade. Further, because of the open character of the stairways and corridors the ushers cannot move around the building during the monsoon without getting wet."[4] Madhu Sarin, author of *Urban Planning in the Third World: The Chandigarh Experience*, grew up in the city, and he is critical both of Le Corbusier's use of "Western" materials—concrete, steel, and glass—which are unsuited to the local extremes of heat and cold, and of his abilities as a town planner: "Nobody dreams about making Chandigarh a beautiful place; they always dream about moving away."[5]

7.2 Le Corbusier, High Court of Justice, Chandigarh, India, 1951.

This is one of Le Corbusier's most complex buildings, with its rich counterpoint of a variety of geometrical forms and curves, dominated by the central assembly hall modeled on an industrial water-cooling tower.

The Chapel of Nôtre-Dame du Haut

If Chandigarh must be regarded as, in the long run, a failure, or at best only a partial success, Le Corbusier did, in his late period after World War II, produce buildings which are acknowledged masterpieces. One of the most surprising is the small pilgrimage chapel at Ronchamp, in France (FIG. 7.3) which houses a miracle-working statue of the Virgin. Le Corbusier explained its function thus:

7.3 Le Corbusier, Chapel of Nôtre-Dame du Haut, Ronchamp, France, 1950–5.

This small pilgrimage chapel is a tribute to the rich variety of Le Corbusier's architectural imagination, its irregular curves and almost biomorphic forms miles removed from the International Style orthodoxy of his only slightly earlier Unité d'Habitation (see FIG. 6.4).

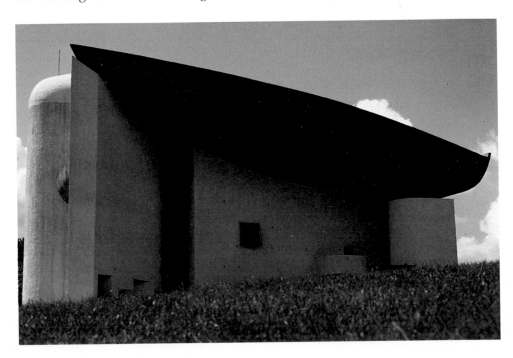

"Inside, a little talk with oneself. Outside, 10,000 pilgrims before the altar."[6] Far from being a machine for worshiping in, the building is full of allusions to nature and the past. The thick, battered walls evoke both Romanesque churches and the primitive mosques which the architect had seen on trips to north Africa, the curved roof is designed to recall a seashell, and the tiny apertures in the altar wall recall the stars twinkling in the heavens. Ronchamp is an expression of the transcendental strain which manifested itself in much of the art of the 1950s; despite the fact that it is now often regarded as a supremely materialistic decade. The work of Mark Rothko (see FIG. 7.10) is another example of the same phenomenon.

Bruce Goff and the Bavinger House

One major theme in the architecture of the period, announced clearly at Ronchamp, is that of unity with nature. In America, the furthest extreme from the monumentality of Mies van der Rohe's Seagram Building is represented by the work of Bruce Goff (1904–82). Goff, born in the Midwest, was never a mainstream architect, though a number of his designs were widely published. The most celebrated is the Bavinger House, designed for a colleague at the University of Oklahoma (FIG. 7.4). The house, built partly by the owners themselves, and partly with student labor, is reputed to have cost only $5,000. Placed in a natural clearing beside a ravine, some miles outside the town of Norman where the university is situated, this is a spiral construction with an enclosing wall built of rough sandstone. Five circular rooms within the central volume are suspended at different levels from a mast over 50 feet (16 m) high. "The entire interior," as Goff himself remarked, "is a continuous flow of space wherein neither walls nor floor nor ceiling are parallel."[7] The concepts put forward by Frank Lloyd Wright in Falling Water during the mid-1930s are here carried much further, but with additional elements which were significant for the future. Goff was a great advocate of recycling materials, such as the supporting ribs used for wartime Quonset huts, and using found objects, such as cake-tins or glass ashtrays, as part of his vocabulary of ornament. His indeterminate treatment of space was also prophetic.

Eero Saarinen and Jørn Utzon

At Ronchamp, Le Corbusier demonstrated that reinforced concrete could be used in a romantic and symbolic way. This approach to concrete also manifested itself in more easily accessible buildings by other architects. The TWA Terminal at

7.4 Bruce Goff, The Bavinger House, 1951–7. University of Oklahoma, Norman, Oklahoma.

Five circular rooms at different levels are suspended from a mast over fifty ft (16 m) high in this spiral of a house that imaginatively fuses organic and prefabricated materials.

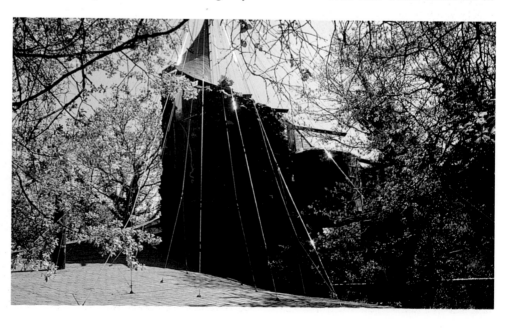

7.5 Eero Saarinen, TWA Terminal, Kennedy Airport, New York, 1956–62.

Saarinen turned the TWA Terminal into a romantic metaphor for flight. He is one of the few designers of an air terminal to have risen above conventionality. The interior spaces, defined in sinuous curves, are remarkably graceful and airy.

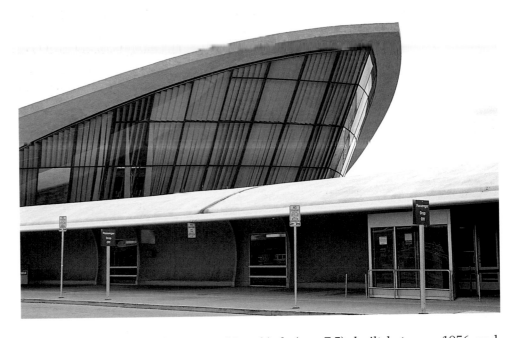

7.6 Jørn Utzon, Sydney Opera House, Australia, 1956–73.

Utzon's fantastic creation, the most celebrated building in Australia, surmounts a structure of huge dimensions above a complex of terraces. The reinforced concrete shells rise 200 ft (61 m) above ground level.

Kennedy (then Idlewild) Airport, New York (FIG. 7.5), built between 1956 and 1962 to the designs of Eero Saarinen (1910–61) belongs to an age when transatlantic flights were only just becoming commonplace. The bold sculptural forms of the building were made possible by new engineering techniques. They were used by the architect with a double intent—to facilitate passenger-flow by means of unobstructed spaces and to offer an architectural allegory of flight.

The Sydney Opera House (FIG. 7.6) by the Danish architect, Jørn Utzon (1918–), who worked for several months in the office of Alvar Aalto, possesses an even more dramatic curving silhouette. From its wonderful site in the middle of

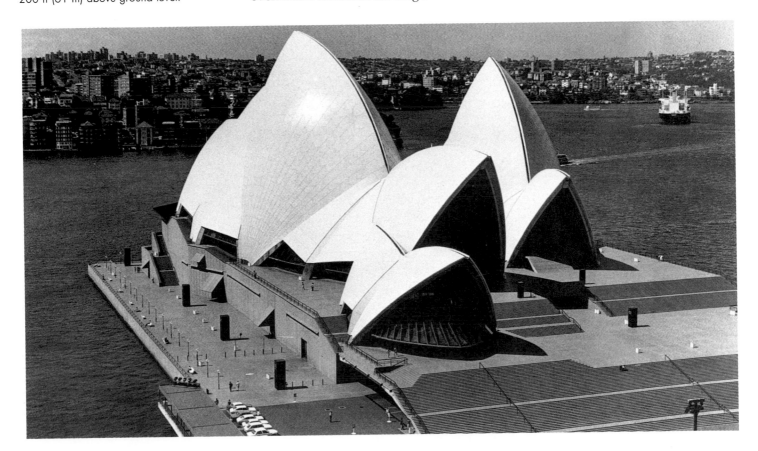

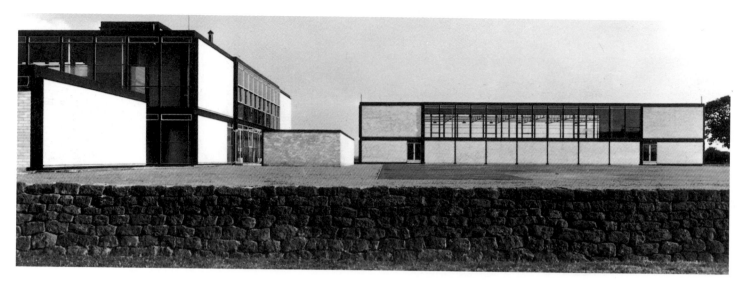

the harbor, it serves as the symbol of Australia's largest city. The shell forms appropriately suggest both sails and the upturned hulls of boats. The technical demands made by a vividly imaginative design stretched the technical resources available to the point where Utzon fell out with his consulting engineers, and was dismissed from the job. The interiors of the building are not his work.

The New Brutalism

Le Corbusier's influence also operated in a completely different way. His Unité d'Habitation in Marseilles, with its rough concrete construction, was the progenitor of what came to be called the New Brutalism. The origin of the phrase has been disputed—it seems to have been invented in the offices of a Swedish architectural firm in 1950 and taken up in Great Britain in the mid-1950s. By common consent the most typical New Brutalist building is the school at Hunstanton in Norfolk (FIG. 7.7), designed by the husband and wife team of Alison (1928–93) and Peter (1923–) Smithson. Here ideas taken from both Le Corbusier and Mies are put at the service of a puritanical aesthetic, in tune with the climate of economic austerity which then prevailed in Great Britain. The building is eloquent of the architects' determination to make every feature of it plain and comprehensible. This applies to the formal clarity of the plan, to the full glazing of all working areas, so that whatever happens within them remains visible, and to the conduits and electric pipe-runs, which are left exposed throughout the structure.

When the Brutalist style was used in a less stringent economic climate, it rapidly developed into a form of mannerism. It is seen at its worst in the lowering Art and Architecture Building at Yale University (1958–63) designed by the chairman of the School of Architecture, Paul Rudolph (1918–). The rough external and interior surfaces are not the product of the formwork used to shape the concrete, but are laboriously hand-hammered. The building overwhelms its surroundings and, though solidly constructed, has aged·poorly. The internal plan, with its many changes of level, has frequently been altered to meet student needs.

Japan and Mexico

As it spread throughout the world in the 1950s, the International Style began to adapt itself to local needs in the hands of indigenous architects. In Japan, despite the American occupation, the tradition followed was that of Le Corbusier, not Frank Lloyd Wright or Mies van der Rohe. The most prominent Japanese architect in the immediate postwar years was Kenzo Tange (1913–). Tange's first important work was the Hiroshima Memorial Peace Center (FIG. 7.8). It combines

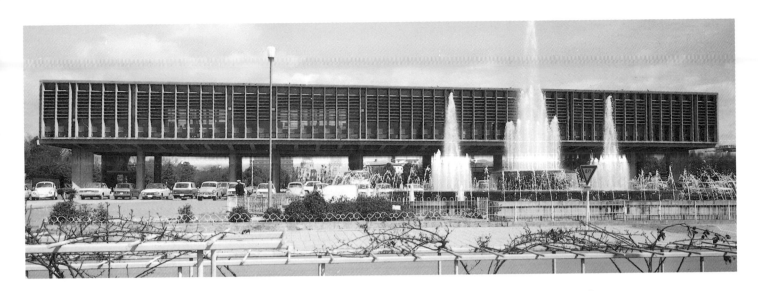

7.8 Kenzo Tange, Peace Memorial Museum, Hiroshima, Japan, 1950–6.

In this building there is a blending of Japanese and Modernist elements, but the influence of Le Corbusier's late brutalist manner is predominant.

modern and traditionally Japanese elements—reinforced concrete for the construction, in the Corbusian manner, with a daring parabolic arch, with others which are specifically Japanese, such as the use of an elevated platform for the main floor of the Memorial Gallery itself.

Luis Barrágan (1902–88) became celebrated for his luxurious suburban developments, high on the volcanic rim that confines the vast conurbation of Mexico City. In these structures, such as the Eduardo López Prieto House (FIG. 7.9), Barrágan combines Corbusian forms with Mexican vernacular architecture, creating pristine shapes which are enlivened with the use of strong color. The hues are the same as those in paintings by Tamayo of the same epoch. Barrágan's materials were often fragile, and much of the work he did in the decade has been altered or allowed to decay. His vision, however, has been preserved in the superb photographs taken by Armando Salas Portugal. The images suggest—and here the essentially romantic character of much of the architecture of the 1950s surfaces once again—that contemporary Mexico offered the possibility of creating a modern Eden.

7.9 Luis Barrágan, Eduardo López Prieto House, Mexico City, 1950.

Barrágan's elegant houses show a sophisticated use of bright color.

Painting

PAINTING IN THE UNITED STATES

The Development of Abstract Expressionism: Mark Rothko

By the beginning of the 1950s, Pollock had already achieved his "breakthrough" into the drip-painting technique which was to make him famous, and Still had achieved something resembling his mature manner. Mark Rothko (1903–70), the third member of this senior generation of Abstract Expressionists, also moved away from his quasi-figurative, Surrealist-influenced style of the 1940s, and began to produce completely abstract canvases featuring soft-edged blocks of intense color floating against a darker or lighter ground. These color blocks, like Pollock's skeins of paint, occupied an ambiguous, though narrow, spatial zone; they did not cling to the surface of the canvas. As critics recognized at the time, this treatment of space was part of the legacy of Cubism. In other respects, Rothko's work—for example, *Green and Maroon* (FIG. 7.10)—was very different from what had been done previously in Europe, most radically in its attitudes

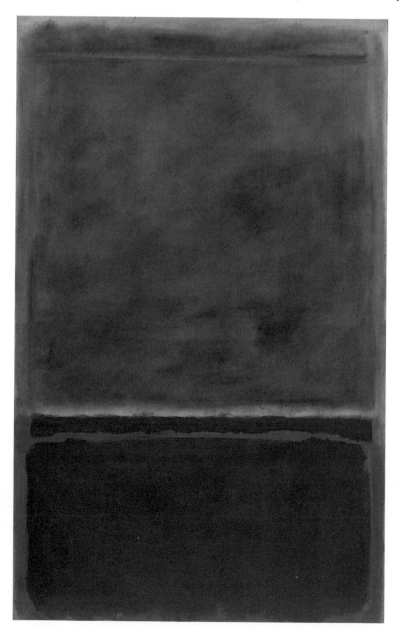

7.10 Mark Rothko, *Green and Maroon*, 1953. Oil on canvas, 7 ft 7⅜ x 4 ft 6¾ in (2.32 x 1.39 m). Phillips Collection, Washington, D.C.

This is a typical painting of Rothko's mature period, with floating, soft-edged blocks of luminous color produced by allowing veils of thin pigment to wash over the canvas and soak into it.

toward composition. Even Kandinsky, in his early abstract canvases, had seen the painter's job as being to make a dynamic arrangement of colors and forms within a rectangle. Rothko's symmetrical designs seemed to abandon any such intention. Attempts have been made to equate what he did with the mystical, simplified landscapes painted in the early nineteenth century by artists such as the German, Caspar David Friedrich (1774–1840). Comparisons, perhaps suggested by the fact that Rothko was born in Russia, have also been made with the centralized, stereotyped compositions used for Russian icons. The effect of Rothko's mature paintings has been well described by the German art historian, Werner Haftmann, writing within a decade of the creation of the earliest of them:

> The picture became a screen, illumined by dark light, articulated only by a few colored fields which rise from the ground and sink back into it. These screens of light have nothing more in common with framed pictures; they symbolize the great, unlimited, universal space surrounding us, in which the numen has its place. Only the suggestive, hypnotic power of color determines the idea and content.[8]

Rothko spoke of the paintings in directly religious terms: "I'm not interested in the relationship of color or form or anything else. I'm interested only in expressing basic human emotions—tragedy, ecstasy, doom and so on … The people who weep before my pictures are having the same religious experience as I had when I painted them."[9]

Robert Motherwell

American artists accepted the new revolutionary style with remarkable rapidity. The question simply became what individual artists would do with it. Two of the most interesting of the New York School of artists in this respect were Robert Motherwell (1915–91) and Franz Kline (1910–62). Motherwell has sometimes been described as the real "organizer" of Abstract Expressionism, despite the fact that he was very different from most of his colleagues in temperament—more intellectual, keenly interested in the history of the Modern movement. Like Arshile Gorky, who was ten years his senior, he began his career under the influence of the Surrealists. His mature work, however, belongs to the 1950s. It was then that he began to paint what is now his best-known series, the *Elegies to the Spanish Republic* (FIG. 7.11). These are nostalgic meditations on the recent history of

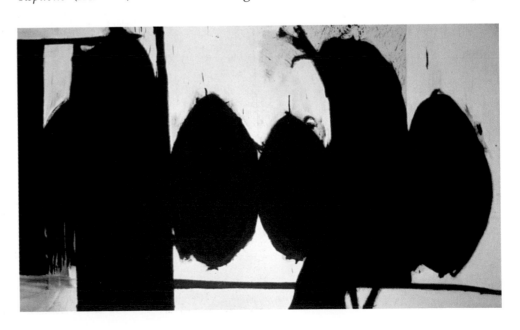

7.11 Robert Motherwell, *Elegy to the Spanish Republic, No. 70*, 1961. Oil on canvas, 5 ft 8⅞ in x 9 ft 4¼ in (1.75 x 2.85 m). Museum of Modern Art, New York.

In his best-known series of paintings, *Elegies to the Spanish Republic*, which he began in 1949 and finished in 1965, more than a hundred canvases later, Robert Motherwell alluded to the increasingly distant Spanish Civil War in an oblique, nostalgic way. Usually in black on white, Motherwell called them "general metaphors for life and death."

Franz Kline: *Mahoning*

Franz Kline's paintings have frequently been compared to oriental calligraphy—some, like *Mahoning* (FIG. 7.12), look like Chinese characters blown up to mammoth scale. Their origins are somewhat less exotic. Some time in the late 1940s Kline took a small drawing of a favorite chair, and out of idle curiosity used a Bell-Opticon machine to project an image of it on to a blank canvas, on a scale so large that the image overlapped the edges of the stretcher. The result was powerful and completely abstract, and the artist was so impressed by what he saw that he decided to abandon representation altogether. He did not, however, abandon his previous practice as a painter. Like the other black-and-white canvases which made Kline's reputation, *Mahoning* was carefully planned and slowly and deliberately painted. A preliminary drawing exists, in which the design is already fully worked out and identical to that found in the large canvas. Like Kline's other preliminary sketches, this drawing is made in oil paint on a page torn from a telephone book.

Kline had his first one-person exhibition at the Egan Gallery in New York in 1950. It was made up of paintings in his new manner. They were well received, and during the 1950s Kline's reputation grew rapidly. He was recognized as the leader of a "second generation" of Abstract Expressionist painters, whose work belonged entirely to the new decade and had nothing to do with the Surrealist influences of the 1940s.

Kline is a quintessentially urban artist. One hidden stimulus for his work was the transformation of New York during the boom years of the 1950s, when much of the city was torn down and rebuilt. In this sense they form a fascinating contrast with Georgia O'Keeffe's skyscraper paintings (see FIG. 4.28), done some thirty years earlier at a time when New York was in the grip of an earlier building boom. O'Keeffe interested herself in the result; Kline was fascinated by the actual process. Many of his shapes seem to have been inspired by scaffolding, and by the new high-rises in various stages of construction (*Mahoning*, for example, looks like a fragment of scaffolding). Like his contemporary, Robert Motherwell, however, Kline in his mature work avoided specific figurative references, though they remain present below the surface of the abstract design. In a philosophical sense, he seems to have been influenced by French Existentialism. He often, for example, spoke of a painting as a "situation," and of the first strokes of paint on the canvas as "the beginning of the situation." In some respects, his attitudes combine Pollock's thinking with that of Rothko. Like Pollock, he thought of the canvas as an arena, a place where an event occurred. Like Rothko, he put great emphasis on unfettered feeling: "The final test of a painting," he once said, "...is: does the painter's emotion come across?"*

*Seldon Rodman, *Conversations with Artists*, new York, 1957, p. 106.

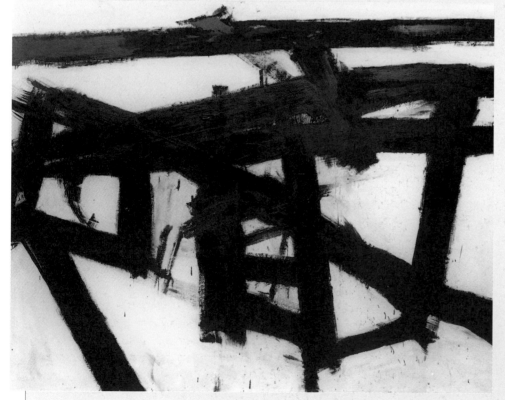

7.12 Franz Kline, *Mahoning*, 1956. Oil and paper collage on canvas, 6 ft 8 in x 8 ft 4 in (2.03 x 2.54 m). Whitney Museum of American Art, New York (Gift of Friends of the Whitney Museum).

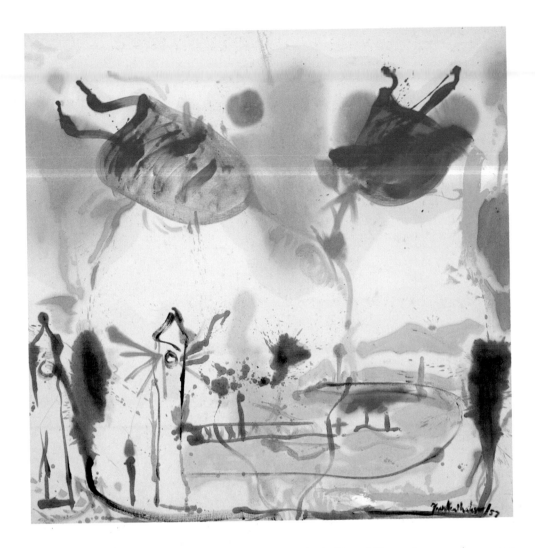

7.13 Helen Frankenthaler, *Round Trip*, 1957. Oil on canvas, 5 ft 10¼ in × 5 ft 10¼ in (1.78 × 1.78 m) Albright-Knox Art Gallery, Buffalo, New York (Gift of James I. Merrill).

Frankenthaler's paintings are seldom totally abstract, but make use of landscape imagery.

Europe, and they are couched in characteristically oblique terms—far more oblique than those used in Picasso's *Guernica* (see FIG. 5.22). Without the titles, it would be impossible to guess that these large, somber canvases are intended to refer to the Spanish Civil War. The *Elegies* are, nevertheless, composed in a much more traditional, and indeed conservative, way than Rothko's color fields. The shapes, though abstract, fit together in a way which recalls long-accepted methods of pictorial composition. Motherwell's *Elegies* are largely exercises in black-and-white, and so too are the best-known canvases of Franz Kline (see FIG. 7.12).

Helen Frankenthaler and Joan Mitchell

Younger artists, such as Helen Frankenthaler (1928–) and Joan Mitchell (1926–93), expanded upon and varied Pollock's and Kline's discovery that an abstract painting could also be a kind of place—not a representation of a landscape, but a landscape equivalent. Frankenthaler was originally deeply impressed by Pollock's new visual language and by his technical method, which she thought could be taken still further by pouring thinned paint on to unsized cotton duck. Pollock's paint was thick, and sat on top of the canvas; hers soaked into it, creating a luminous, disembodied effect. Many of her paintings of the 1950s (FIG. 7.13) look like late Turner watercolors blown up to an enormous scale. In most there is at least a suggestion of landscape.

Mitchell was inspired not only by Gorky and Kline, but, in paintings like *Hemlock* (FIG. 7.14), by the fluid improvisations on landscape themes which Kandinsky had made in 1910–11 (the works which represented the true begin-

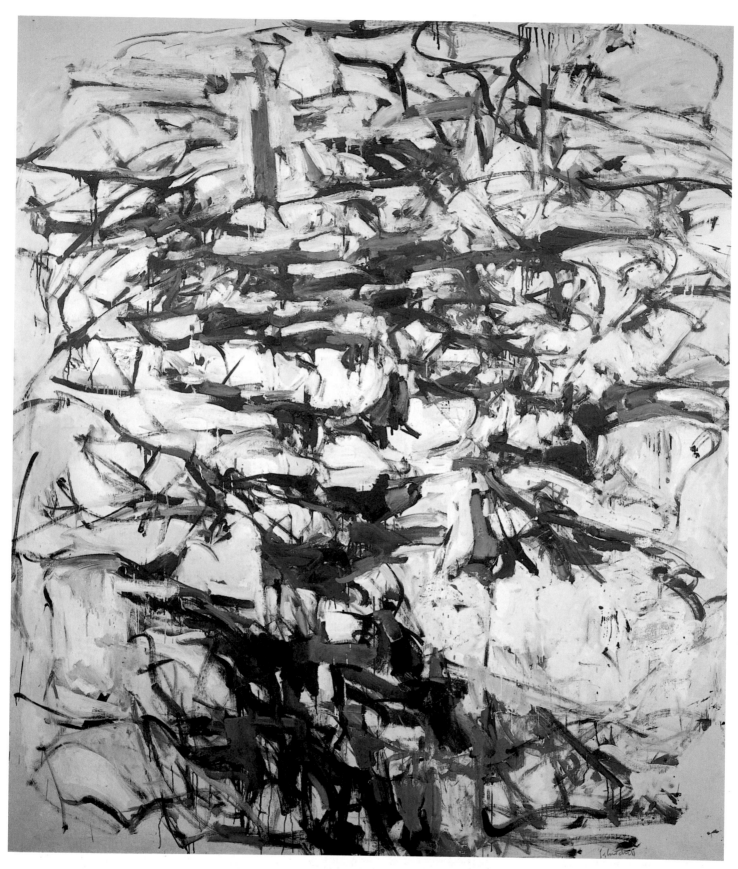

7.14 Joan Mitchell, *Hemlock*, 1956. Oil on canvas, 7 ft 7 in x 6 ft 8 in (2.31 x 2.03 m). Whitney Museum of American Art, New York (Gift of Friends of the Whitney Museum).

Joan Mitchell always denied that there were specific landscape references in her paintings of this period, but critics have often discovered them. Mitchell used brushwork and poured paint to produce this grand painting, gestural, yet also, especially with its restricted palette, an echo of a Cubist grid.

7.15 Hans Hofmann, *Smaragd, Red and Germinating Yellow*, 1959. Oil on canvas, 4 ft 7 in x 3 ft 4 in (1.40 x 1.02 m). Cleveland Museum of Art, Ohio.

Hofmann often, as he does here, made use of irregularly grouped rectangles against freely brushed backgrounds in his color-field paintings. "I hold my mind and my work free from any association foreign to the act of painting," he said, in describing how he worked. "I am thoroughly inspired and agitated by the actions themselves which the development of a painting continuously requires."

nings of a purely abstract art). Her work also seems to look back to the very late canvases of Claude Monet, and is largely responsible for the widespread theory that Abstract Expressionism is in some way derived from Impressionism, whereas its true roots are Surrealism and Cubism. Mitchell always denied that landscape references, if they in fact existed in her work, were in any way specific, saying on one occasion for example: "There is no tree in *Hemlock*. It's figure-ground painting."[10] What she meant was that it was closely related to the teachings of Hans Hofmann.

Hans Hofmann and Willem de Kooning

Two painters in New York, both immigrants from Europe, occupied an intermediate position between the new American attitudes and established European ones. Hans Hofmann (1880–1966) was already a mature artist when he arrived in the United States. He had known Braque and Picasso in the years before World War I (though there are doubts about how close these friendships were), and it is said to have been Matisse who encouraged the important Berlin-based dealer, Paul Cassirer, to give Hofmann a one-person show in 1910. During the Weimar Republic he ran an art school in Munich, and in 1933 he moved to New York, where he opened a new school. Hofmann was so preoccupied with teaching that he did not have his first one-person show in the United States until 1944, when he was in his mid-sixties. In 1958 he closed his school in order to devote himself full-time to painting. Hofmann's late canvases (FIG. 7.15) are encounters between a Constructivist (European) and an Abstract Expressionist (American) ethos. A frequent scheme is one in which rectangles of color, irregularly grouped, float before freely brushed backgrounds which are reminiscent of the work of Still.

Willem de Kooning, born in Rotterdam, arrived in the United States as a stowaway, and for a time during the 1930s shared a studio with Arshile Gorky. Like other leading Abstract Expressionist painters, he began to make an impact in the late 1940s. In 1951 his painting, *Excavation* (FIG. 7.16), now generally considered

7.16 Willem de Kooning, *Excavation*, 1950. Oil on canvas, 6 ft 9⅛ in x 8 ft 5¼ in (2.06 x 2.57 m). Art Institute of Chicago, Illinois (Gift of Mr. and Mrs. Noah Goldowsky and Edgar Kaufmann, Jr.; Mr. and Mrs. Frank G. Logan Purchase Prize).

In one of his best-known paintings, De Kooning buries figurative motifs in a jigsaw of anatomical bits and pieces, so that the division between figure and field (or picture space) entirely disappears.

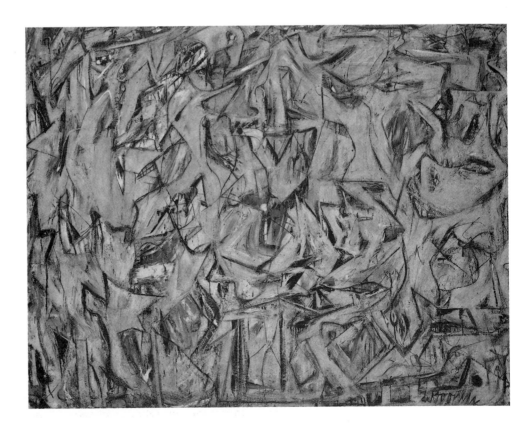

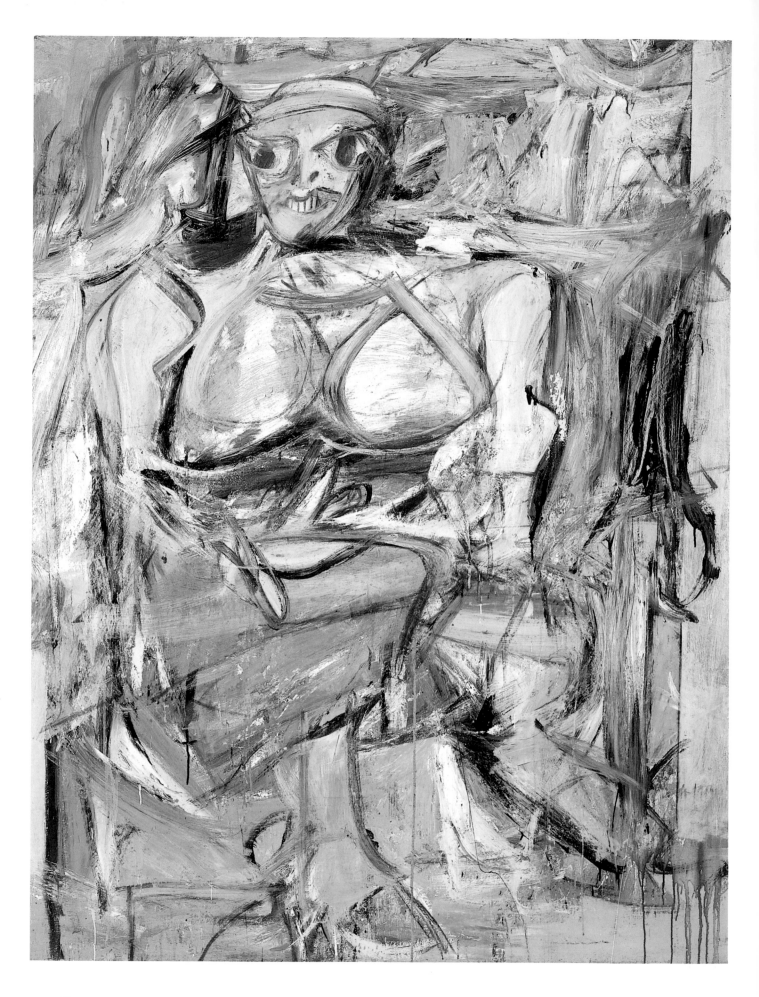

7.18 Barnett Newman, *Vir Heroicus Sublimis*, 1950–1. Oil on canvas, 7 ft 11⅜ in x 17 ft 9¼ in (2.42 x 5.14 m). Museum of Modern Art, New York.

In this vast painting, Barnett Newman anticipated the Minimal art of the 1960s. Any notion of the sensuous handling of paint is forsworn, and along with it pictorial elements. The tranquillity and sheer awesome quality of paintings like this depend, as many of Rothko's do, on the monumental size of the canvas.

7.17 (*opposite*) Willem de Kooning, *Woman I*, 1950–1. Oil on canvas, 6 ft 3⅞ in x 4 ft 10 in (1.93 x 1.47 m) Museum of Modern Art, New York.

This is the first in a series of figurative paintings by De Kooning which celebrate women as agents of destruction and creation, both grotesquely ugly and surprisingly seductive.

one of the key works in the evolution of Abstract Expressionism, won the Logan Medal and Purchase Prize at the Sixtieth Annual of American Painting and Sculpture in Chicago. *Excavation* is in most respects typical of what the new style was supposed to be about. More densely worked than Pollock's drip paintings, it has the same "all-overness," a rhythm which covers the whole canvas. It hints at the buried presence of figurative motifs, but avoids specific representation. And it is to all intents and purposes monochromatic.

It was at this point that de Kooning chose to go in an entirely different direction. In 1950–1 he painted *Woman I*, (FIG. 7.17), the first of a series of canvases showing powerful, rather gross, female figures. De Kooning's *Women* have, not surprisingly, been a focus of controversy. Some critics have seen in them a celebration of the female; others have discerned a violent misogyny. The *Women* do indeed have something of the Hindu goddess, Kali, about them—they are presented as agents both of creation and destruction, the destructive element emphasized by the slashing brushstrokes with which they are built up. The passage of time has made it increasingly clear that one source for the *Women* series is the pin-up. These are females observed, not directly, but through the prism of popular culture. In this sense, *Woman I* and her sisters, despite their Abstract Expressionist pedigree, are among the forerunners of Pop Art.

Barnett Newman

At the beginning of the 1950s, yet another painter who has been classified as an Abstract Expressionist, Barnett Newman (1905–70), made the breakthrough into his mature style. During the 1940s Newman had been a well-known member of the Abstract Expressionist milieu, but he functioned chiefly as a critic, not as a painter. His first solo exhibition, held at the Betty Parsons Gallery in 1950, was perhaps even more of a shock to his Abstract Expressionist colleagues than it was to the public at large. Throughout the decade, Newman's work continued to be controversial in the New York art world, even after he won the support of the man who was probably the most influential writer on art of the period, Clement Greenberg (1909–94). The reason for this was its radical reductivism. Newman's *Vir Heroicus Sublimis* (FIG. 7.18) consists simply of a single enormous color field bisected at intervals by narrow vertical stripes which the artist called "zips." All

7.19 Morris Louis, *Tet*, 1958. Synthetic polymer on canvas, 7 ft 11 in x 12 ft 9 in (2.41 x 3.89 m). Whitney Museum of American Art, New York.

Louis here uses the so-called 'soak-stain' technique (extremely dilute paint flooded on to unprimed canvas) pioneered by Helen Frankenthaler (see FIG. 7.13) to express a delight in random areas of pure color.

pretense of creating an illusion of depth is abandoned—the painting is simply a colored surface, activated by the contrasting hues of the stripes, and so large that it tends to overwhelm the spectator's perception that it has boundaries. Color— and color alone—is the experience Newman offers.

Morris Louis

The Washington-based Morris Louis (Morris Louis Bernstein, 1912–72) made a different kind of attempt to break away from established ideas concerning what art should be about and how it should be made. His starting-point was the work of Frankenthaler, which he saw on a visit to New York when she had just started to use her new soaking and staining technique. In the mid-1950s Louis took this idea much further, staining unprimed and unstretched canvases with thin, quick-drying acrylic paint poured over an uneven surface. The color in *Tet* (FIG 7.19) marks the weave with diaphanous, flame-like configurations, which merge into one another without hard edges. When Louis showed paintings of this type in New York in 1959 at French & Co., under the curatorial aegis of Clement Greenberg, critics admired them for the way in which, as Barbara Rose said, the forms seemed "to appear like natural phenomena emerging from a mist." What seemed like hidden references to nature made them easier to assimilate than the paintings being made at the same period by Newman, and acceptance for Louis's work was accordingly much swifter. Later, critical attitudes were to shift, and Louis's work, with its complete integration of color and ground, was interpreted in a less romantic way, as an attempt to make paintings which were totally self-sufficient, non-referential objects.

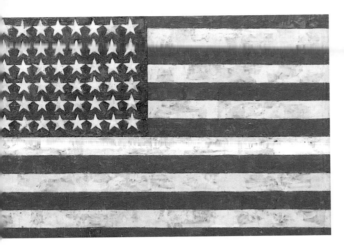

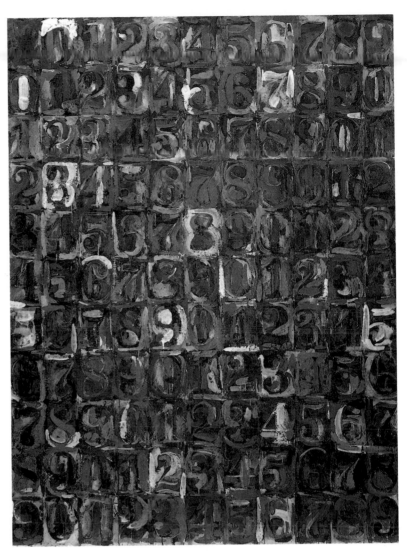

7.20 (*above*) Jasper Johns, *Flag*, 1954–5. Mixed media, 3 ft 6¼ in x 5 ft ⅝ in (1.07 x 1.54 m). Museum of Modern Art, New York.

Johns took the flag, the most emotive symbol of American culture, and reduced it to the status of a flat pattern, deprived of emotional charge—and raised the question, is it a flag or a painting of a flag?

7.21 (*right*) Jasper Johns, *Numbers in Color*, 1959. Encaustic and collage on canvas, 5 ft 6½ in x 4 ft 1½ in (1.69 x 1.26 m). Albright-Knox Art Gallery, Buffalo, New York (Gift of Seymour H. Knox).

By giving everyday objects an impersonal, apparently banal treatment, Johns tilted at the self-congratulatory stance of the Abstract Expressionists and their assertions of the primacy of individual self-expression.

Jasper Johns and Robert Rauschenberg

The *Flag* paintings of Jasper Johns (1930–), which many critics regard as the most significant artistic product of the decade, offer a rather different sort of reductionism from that of Newman and Louis. Painted in 1954–5, but not exhibited until 1958, Johns's *Flags* (FIG. 7.20), and the related series of *Targets* and *Numbers* (FIG. 7.21) were a gesture of contempt and defiance directed at the over-heated rhetoric of Abstract Expressionism. Johns seized upon the American flag as the most emotive symbol of American culture, and reduced it to an abstract pattern without emotional charge. He gave his flags a seductive surface by using the very old technique of encaustic, in which pigments are mixed with hot wax, which acts as a binder. The technique was used in antiquity to produce portable paintings on board: the most familiar examples are the Fayoum mummy portraits made in Egypt during the period of Roman Imperial rule.

Johns's work of this period studiously avoids emotion and any kind of physical dynamism—the "push-and-pull" effects which Abstract Expressionist painters try to give their surfaces. (The term was coined by Hans Hofmann to describe the dynamic variations in pictorial depth found in abstract paintings made up of many juxtaposed patches of strong color.) Johns was influenced not merely by Marcel Duchamp—in taking the design of the flag as a "given" like Duchamp's readymades—but by the composer, John Cage (1912–92), an advocate of aleatory or chance procedures in both musical composition and performance.

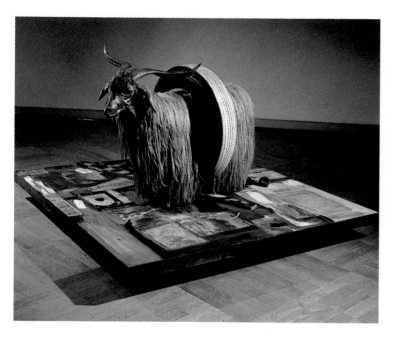

7.22 Robert Rauschenberg, *Monogram*, 1955–9. Mixed media, 4 x 6 x 6 ft (1.22 x 1.83 x 1.83 m). Statens Konstmuseer, Stockholm.

In Rauschenberg's "combine-paintings," made of disparate materials, the artwork becomes a kind of labyrinth, full of multiple possibilities. In the painting on which the goat stands metal and wood are mixed with broad brushstrokes.

During his most innovative period, Johns worked closely with Robert Rauschenberg (1925–). Rauschenberg's most potent invention was the "combine painting"—the most notorious example is probably *Monogram* (FIG. 7.22), which makes use of both a stuffed goat and a car tire. The combine paintings take off from Duchamp and Kurt Schwitters, and have earned Rauschenberg the label neo-Dadaist. Though Dada did undoubtedly play a part in what Rauschenberg did (somewhat to Duchamp's discomfort, since he found the results anti-intellectual and overblown) the most important thing about the combine paintings was not so much their emphasis on things chosen rather than made, but their assault on the idea that there was some sort of hierarchy of materials—that paintings must be created, for example, using primarily paint and canvas. For Rauschenberg, paintings could be made out of whatever came to hand, somewhat in the manner of Dubuffet, who was equally interested in making art from apparently unsuitable substances. Rauschenberg carried things much further, however, bringing together totally disparate objects and making the artwork, not the direct statement of an idea, but a kind of labyrinth, full of possibilities, which the spectator's imagination can inhabit.

Larry Rivers and Grace Hartigan

Though the work of Johns and Rauschenberg contained figurative elements, they did not think of themselves as figurative artists. The mid-1950s did nevertheless see a figurative revival in New York led by the irrepressible Larry Rivers (1923–), who had begun his career as a jazz musician, and who in the 1940s had enrolled in the summer school which Hans Hofmann ran in Provincetown, Mass. Always attracted to representational art, though this seemed entirely against the

7.23 Larry Rivers, *Washington Crossing the Delaware*, 1953. Oil, graphite, and charcoal on linen, 6 ft 11⅝ x 9 ft 3⅝ in (2.12 x 2.83 m). Museum of Modern Art, New York.

Rivers's painting is a parody of an academic work by the nineteenth-century painter, Emmanuel Leutze. It uses an Abstract Expressionist manner to reintroduce "banned" high-art subjects into American painting. It was thus doubly subversive, both of the American realist tradition and of the ascendancy of abstraction in the New York School.

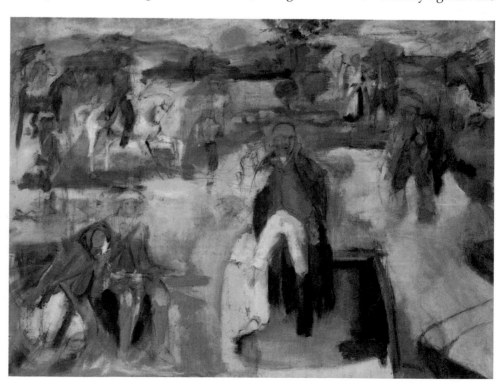

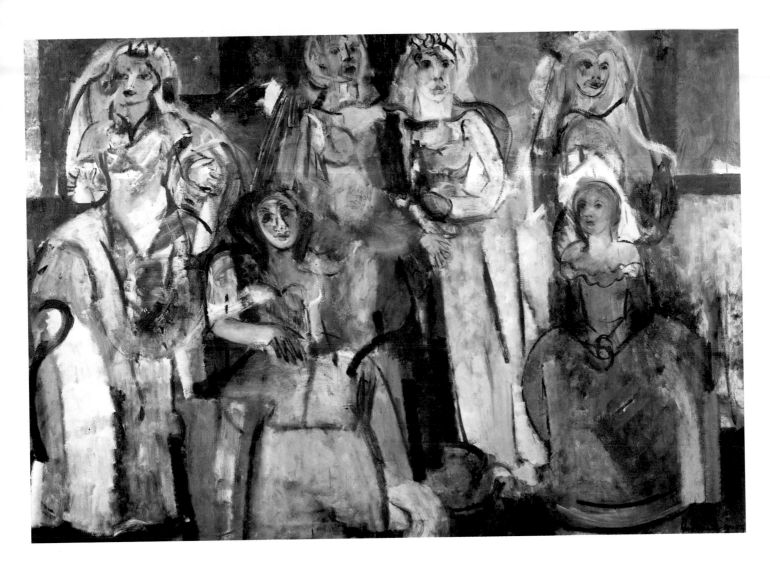

7.24 Grace Hartigan, *Grand Street Brides*, 1954. Oil on canvas, 6 ft x 8 ft 6½ in (1.83 x 2.6 m). Whitney Museum of American Art, New York.

Grace Hartigan was one of the generation of painters strongly influenced by the gesturalism of Abstract Expressionism who used the manner in the service of a somewhat occluded figurative style.

trend of the times in the United States, Rivers searched for ways to link traditional modes of representation with Abstract Expressionism. A trip made to Europe in 1950, in the course of which he discovered the work of the great nineteenth-century realist, Gustave Courbet, had a decisive impact on him. Rivers realized that, within the context of the New York art world, straightforward realist representations were unlikely to make much impression. One of his solutions was to paint new versions of familiar academic paintings, such as the melodramatic *Washington Crossing the Delaware* (FIG. 7.23) by Emmanuel Leutze (1816–68). Rivers's version of this was intended to outrage the artistic establishment. It was, as Rivers himself said, "another toilet seat, not for the general public as it was in the Dada show, but for the painters."[11] In its reliance on irony and use of appropriated imagery, this work strikingly anticipated developments to come.

Grace Hartigan (1922–) began her career as an abstract painter under the influence of Pollock and then of de Kooning. Like Rivers, she became preoccupied with the past, and began, as she put it, to "paint my way through art history." Unlike Rivers, she also became preoccupied with the urban environment. *Grand Street Brides* (FIG. 7.24), one of the best-known paintings of this phase, seems to look for suggestions to the work of an unlikely combination of influences—Goya, Isabel Bishop, and the French photographer, Atget. In 1957, Hartigan moved out of New York and once again became an abstract or quasi-abstract painter. This shift of direction has tended to rob her of the recognition which is her due, as one of the most original and powerful American painters of the 1950s.

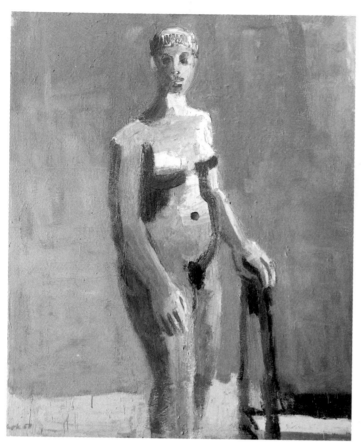

Bay Area Figuration

There was also a reaction in California against free abstraction, perhaps triggered by the overwhelming personality of Clyfford Still, who had been teaching at the California School of Fine Arts in San Francisco since 1946. One of the first to react was his fellow-instructor, David Park (1911–60), who, after a period under Diego Rivera's influence, had been working as an abstractionist. He became increasingly dissatisfied with what he was doing, and in 1949 he loaded his car with all his abstract paintings and took them to the town dump. As he said in an interview some four years later, this was a reaction not only against his own work, but against the pretentiousness and portentousness of the ideals professed by members of the new consensus, which was based on abstraction as a kind of morality for art. For the remainder of his brief career, Park painted broadly-brushed figurative works—market scenes, domestic interiors and male and female nudes. His chief exemplar was Pierre Bonnard, whose late works (FIG. 7.25) were now beginning to have a marked influence in the United States.

Another Californian artist who fell under Bonnard's spell for a while was Richard Diebenkorn (1922–93), rated at the beginning of his career as the most promising Californian abstractionist of his generation. His *Girl and Three Coffee Cups* (FIG. 7.26) is just as much under Bonnard's influence as anything by Park. Diebenkorn maintained this figurative manner for about ten years, before reverting to abstraction.

7.25 David Park, *Nude—Green*, 1957. Oil on canvas, 5 ft 8⅛ in x 4 ft 8⅜ in (1.73 x 1.43 m). Hirshhorn Museum and Sculpture Garden, Smithsonian Institution, Washington, D.C. (Gift of Dr. and Mrs. Julian Eisenstein).

Working on the west coast of the United States, David Park painted figurative works in reaction against the apparently universal success of Abstract Expressionism and the New York School.

7.26 Richard Diebenkorn, *Girl and Three Coffee Cups*, 1957. Oil on canvas, 4 ft 11 in x 4 ft 6 in (1.50 x 1.37 m). Yale University Art Gallery, New Haven, Connecticut.

Diebenkorn was another leading West Coast painter whose work became figurative for a while, though in its slapdash brushwork it retained the gestural manner of Abstract Expressionism.

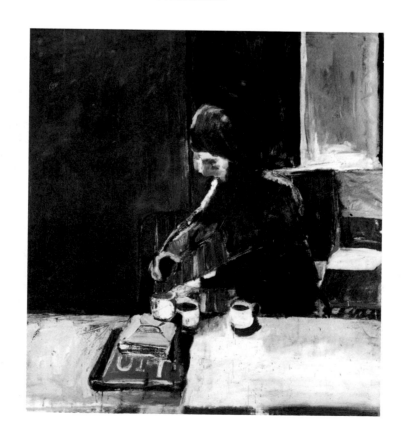

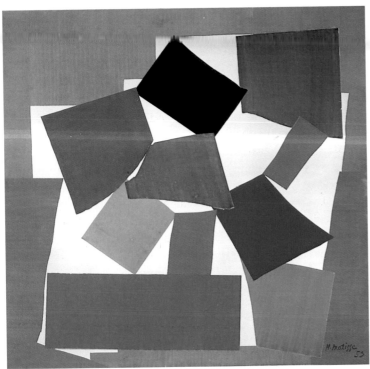

7.27 Henri Matisse, *The Snail*, 1953. Gouache on cut and pasted paper, 9 ft 4¾ in x 9 ft 5 in (2.86 x 2.87 m). Tate Gallery, London.

After an abdominal operation weakened his stomach muscles and prevented him from standing for long periods, Matisse switched from painting on canvas to making large-scale collages from cut or torn pieces of brightly-painted paper. They retain pencil traces, creases, pinholes, and thumbprints.

PAINTING IN EUROPE

Modernist Old Masters

Bonnard's prestige on the West Coast is a sign of how tenaciously the artists of the Ecole de Paris retained their hold over the imagination of painters everywhere. In the final phases of their careers, certain of them, such as Matisse, Braque, and Fernand Léger, were producing some of the most ambitious work of their entire careers. Matisse, after an abdominal operation during the war years which seriously weakened his stomach muscles and left him unable to stand at an easel for long periods of time, began, in 1948, to make large-scale paper collages as a substitute for oils on canvas. He cut the forms he wanted from huge sheets of paper tinted to his specifications, and then maneuvered them into position with the help of assistants. The results are sumptuously decorative, but emotionally inert (FIG. 7.27). Yet one cannot deny the virtuosity of Matisse's handling both of color and form—this is visual art pushed as far as it can be pushed, if hedonism is its only aim.

Braque had throughout the interwar period practiced a modified and loosened variation of Cubism, one which made room for coloristic effects. Between 1948 and 1955 he painted a series of large *Ateliers* ("Studios") which tried to sum up everything he had learned about the organization of still compositions (FIG. 7.28). Enthusiastically praised at the time of their creation, the canvases in this series now seem labored, and cluttered with shapes whose relationship to one another is not always as precisely calculated as it should be.

7.28 Georges Braque, *Atelier IV*, 1949–50. Oil on canvas, 4 ft 3⅛ in x 6 ft 4¾ in (1.30 x 1.95 m). Galerie Maeght, Paris.

The series of large *Ateliers*, executed between 1949 and 1956, was Braque's attempt to summarize everything he knew about painting still lifes, though the objects are so dissolved and fragmented that the term may be thought scarcely to fit.

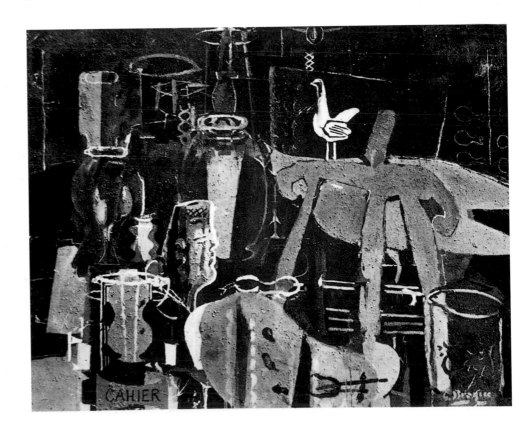

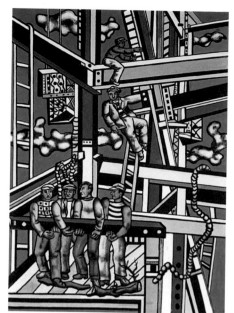

7.29 Fernand Léger, *The Constructors*, 1950. Oil on canvas, 9 ft 10⅛ in x 6 ft 6¾ in (3 x 2 m). Musée Fernand Léger, Biot, France.

This painting, a celebration of the working class in a manner that retains elements of Léger's early Cubism, was inspired by the Classical compositions of the late-eighteenth-century French master, Jacques-Louis David.

Léger struck out in an entirely different direction. Paintings like *The Constructors* (FIG. 7.29) are intended as homage to the great French Neoclassicist, Jacques-Louis David, and to the French working class. What united these, in the painter's mind, was his own faith in Communism, to which he had converted. David had, after all, been the chosen painter of the French Revolution before he transformed himself into a propagandist for Napoleon's Empire. Léger, however, cannot prevent his brawny workmen from turning into robots, something which David's Classical figures, for all their idealization, manage to avoid. *The Constructors* looks all too much like something taken from a comic strip, without the saving irony which Roy Lichtenstein was to bring to genuine comic-strip material in the 1960s (see FIG. 8.12).

Picasso, another Communist convert, paid occasional homage to the party line, but much of his energy at this period went in another direction—into versions, often hostile and rivalrous rather than admiring, of the work of the great masters of the past. A good example is the *Women of Algiers* series (FIG. 7.30), based on the Delacroix painting of the same title. Since the concept of deconstruction had not yet entered the language of philosophy, much less that of art, paintings of this type were generally regarded as self-indulgent, and Picasso's reputation sank accordingly, though only with an inner circle of experts. With the general public he enjoyed a superstar status never before accorded to a twentieth-century artist.

"Art Autre"

The European answer to what was happening in America was what the leading French critic, Michel Tapié, dubbed *art autre*—"other art." While the concept had already been formulated after the first showings of work by Fautrier and Dubuffet (see FIGS 6.13 and 6.14), Tapié did not publish his influential book, *Un art autre*, until 1952. By then, ideas of what a new European art should be like had been modified by knowledge of what was taking place in America, and the balance had swung heavily toward the idea that it should not only be abstract but

7.30 Pablo Picasso, *Women of Algiers*, 1955. Oil on canvas, 3 ft 8⅞ in x 4 ft 9½ in (1.14 x 1.46 m). Norton Simon Museum, Pasadena, California.

This painting is one of a series of paraphrases of the famous painting of the same title by the nineteenth-century French Romantic, Eugène Delacroix.

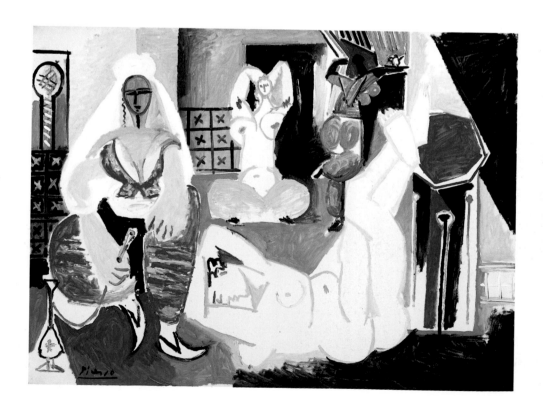

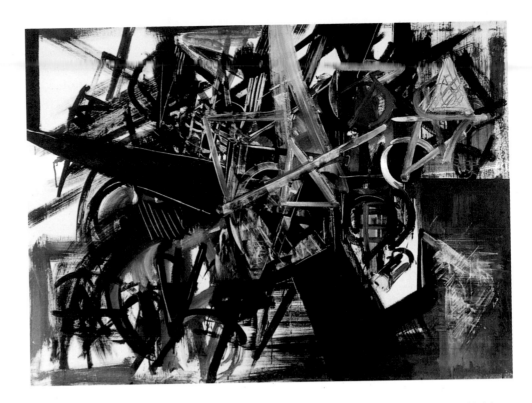

7.31 Emilio Vedova, *Idea of Time (Barricade)*, 1951. Tempera on canvas, 4 ft 3⅜ in x 5 ft 8¾ in (1.30 x 1.74 m). Guggenheim Foundation, Venice.

Vedova was one of the few artists in the fifties who sought to express his radical political commitment through wholly abstract means.

7.32 Serge Poliakoff, *Composition Begun*, 1968. Oil on wood, 36 x 28½ in (91.5 x 72.5 cm). Staatliche Museen zu Berlin—Preussischer Kulturbesitz Nationalgalerie, Germany.

Poliakoff owed much to the work of his fellow-Russian, Vassily Kandinsky.

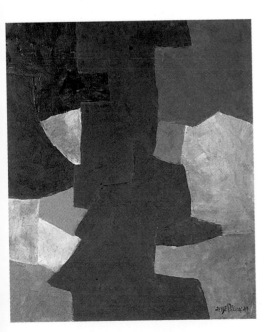

informel—"without form"—which meant without the rigid geometric scaffolding the interwar Constructivists had applied to their compositions.

A good example of the way in which European art echoed the new American developments, but on its own terms, is supplied by the work of the Italian painter, Emilio Vedova (1919–). In 1946 Vedova had been a founder member of the Fronte Nuovo delle Arte, a left-wing grouping concerned with social issues, of a kind also expressed in Roberto Rossellini's "new realist" films of the same period (*Rome, Open City*, 1945). He had also been a student of the spatial organization of Cubist and Futurist painting. Rapidly, however, his interests turned toward the free brushwork of the new American art, then becoming known on the other side of the Atlantic. His *Idea of Time (Barricade)* (FIG. 7.31) is an attempt to give Abstract Expressionist brushwork a kind of moral narrative. The heavy black brushstrokes are intended to suggest, not personal anguish, but social evils with which the painter continues to struggle. Significantly, the painting was acquired by Peggy Guggenheim, the most important of Jackson Pollock's early patrons.

Equally typical of European attitudes toward shaping a new form of abstraction was the work of the Russo-French painter, Serge Poliakoff (1906–69). Poliakoff was born in Russia, into a prosperous family, and after fighting for the Whites in the civil war that followed the October Revolution, he escaped to Paris, where for many years he earned a living as a guitar player in the Russian night clubs which were fashionable in the city. From about 1929 onward he was a serious student of painting, working in various "free" ateliers such as La Grande Chaumière by day, and earning his living as a musician at night. His first solo exhibition took place in 1945, but he did not achieve his mature style until around 1950. Essentially this style was based on the early abstractions of Kandinsky, and, like Kandinsky, he owed much to traditional Russian art, especially to icon-painting, which seems to have suggested many of his typical color schemes (FIG. 7.32). Poliakoff's compositions are very different from those of the American Abstract Expressionists. Their work pays little attention to the edge: the motifs float in a field whose dimensions are essentially approximate. Poliakoff always worked from the edge inward, adjusting his irregularly shaped color areas as he pro-

7.33 Antoni Tàpies, *Gray Relief on Black*, 1959. Latex paint and marble dust on canvas, 6 ft 4¾ in x 5 ft 6⅞ in (1.95 x 1.7 m). Museum of Modern Art, New York (Gift of G. David Thompson).

The richly textured work of the Catalan painter, Antoni Tàpies, lays heavy emphasis on the "materiality" of the artwork. Like Dubuffet, Tàpies wished, not only to widen the expressive scope of painting, but to attack the conventions of "fine art."

gressed. His compositions therefore have a controlled, tightly packed, assymetrical character which is opposed to the American way of doing things.

Curiously, the artists who best exemplified Michel Tapié's theories about what a new European art should be like were not French. One, with whom Tapié became very friendly, was his near-namesake, the Catalan Antoni Tàpies (1923–). Tàpies came from Barcelona, a city which had always been opposed to the repressive Franco government, and he grew up in the lean times during and after the Spanish Civil War. Nevertheless his progress on the international scene was remarkably rapid, once he had broken out of the Spanish environment. His first one-person exhibition took place in Barcelona in 1950, which was also the year in which he first went to Paris. In 1953 he went to New York and came into contact with American Abstract Expressionism. In 1955 he was again in Paris and the French milieu seems to have had much more impact on him than anything he discovered in the United States. In the second half of the 1950s, he combined the study of Marx (a forbidden topic in Franco's Spain) with that of Far Eastern philosophies—Vedanta, Taoism, and Zen Buddhism—finding a mysterious link between the two spheres, which he located in Marx's insistence on materialism. Perhaps for this reason, and perhaps too because of the long-standing Spanish commitment to craftsmanship, to a close feeling for the substances of which art was made, Tàpies created sumptuously textured works, often made of "poor" or discarded materials, thus combining the Spanish tradition of craft with ideas inherited from the German Dadaist, Kurt Schwitters. Some of these works (FIG. 7.33) were entirely abstract and some figurative, but none was sufficiently specific in content to disturb the Spanish authorities, who were content to see him represent his country in the Venice Biennales of 1954 and 1958.

The Italian, Alberto Burri (1915–94), worked in a somewhat similar way, making, from 1952 onward, richly textured works in which sacking was one of the primary materials (FIG. 7.34). It has sometimes been said that these were inspired by the roughly bandaged wounds which Burri had to deal with during World War II, when he worked as a doctor in a prisoner-of-war camp in north Africa. The basic impulse, however, seems to have been less specific. In an interview Burri noted: "I've always been interested in making something beautiful from poor materials."[12]

The interesting things about Tàpies and Burri at this period are first, the considered, richly worked quality of what they produced, which points in a very different direction from Abstract Expressionist spontaneity; and second, the existence of a covert political subtext, of a sort which is absent from the American painting of the same period.

Against "Art Autre": Nicolas de Staël and M. Elena Vieira da Silva

Trying to reconcile a desire for figurative imagery with the prevailing critical orthodoxy, which seemed to insist that only abstract art was now permissible, engaged some artists of the Ecole de Paris just as much as it did Larry Rivers in New York and the Bay Area school in San Francisco. Two of the artists most conspicuously linked to this enterprise were Nicolas de Staël (1914–55), who was, like

7.34 Alberto Burri, *Sack and White*, 1953. Sackcloth and oil on canvas, 4 ft 11 in x 8 ft 2½ in (1.50 x 2.50 m). Musée National d'Art Moderne, Paris.

Burri, the most important Italian exponent of *art informel*, characteristically used sacking as a "poor" painting material, thereby shifting attention away from the representation of objects to the objects themselves.

7.35 (*below*) Nicolas de Staël, *Les Martigues*, 1954. Oil on canvas, 4 ft 9½ in x 3 ft 2¼ in (146 x 97 cm). Kunstmuseum, Winterthur, Germany.

De Staël found that he was unable to commit himself either to figuration or to abstraction. Most of his canvases can be seen both as arrangements of form and color and as atmospheric landscapes.

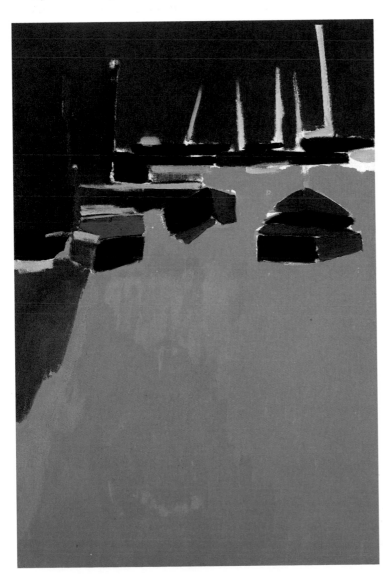

Poliakoff, of White Russian stock, and the Brazilian Portuguese painter, Maria Helena Vieira da Silva (1908–94). Perhaps one of the reasons that figuration attracted them both was the need they felt to create a sense of place. Born in St. Petersburg, the son of a Russian general, de Staël was brought up in Brussels and settled in Paris in 1943. He had made a certain reputation as an abstract painter by the late 1940s—his painting, *Nord*, was purchased for the Phillips Collection in Washington D.C. in 1949—but in the early 1950s, inspired first by a floodlit football match which he saw in March, 1952, at the Parc des Princes stadium near Paris, he began to experiment with figurative imagery. Staël's aim, especially in the last pictures painted shortly before his suicide in 1955, was to find an equivalence between observed reality and abstract design. In *Les Martigues* (FIG. 7.35), the intensely colored surface can be read in two completely different ways—as an arrangement of color patches somewhat in the manner of Poliakoff, and as a night-time harbor scene. The brilliant orange Staël used for the water is an inspired invention, symbolic of the scattered reflections which might appear in nature. Among Staël's influences, in paintings of this kind, were clearly the late paper cutouts of Matisse, but Matisse's easy decorativeness is here replaced by a profound sense of unease.

Maria Elena Vieira da Silva, daughter of a Brazilian diplomat, had settled in Paris before the war, but during the war years left for Lisbon, then for Rio de Janeiro. She did not return to France until 1947. Her style changed in the 1950s, but not so drastically as that of Staël, and in the opposite direction. During the war years she had painted complex scenes, often with multiple figures seen within architectural frameworks. In the late 1940s these inhabitants disappeared, and only the framework itself remained. The aptly named *The Invisible Stroller* is an

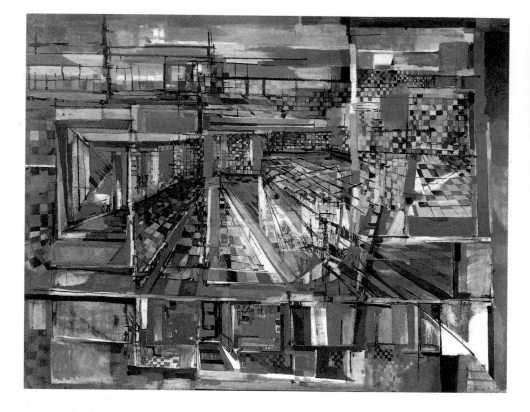

7.36 Maria Elena Vieira da Silva, *The Invisible Stroller*, 1951. Oil on canvas, 4 ft 4 in x 5 ft 6⅜ in (1.32 x 1.69 m). San Francisco Museum of Art, California. Gift of Mr and Mrs Wellington S. Henderson.

7.37 David Bomberg, *Vigilante*, 1954. Oil on board, 28¼ x 23⅝ in (71.8 x 60 cm). Tate Gallery, London.

Bomberg's late work was an important source for younger British painters.

early example of this process (FIG. 7.36). Like de Staël's color patches (see FIG. 7.35), Vieira da Silva's linear webs can be read as either abstract or figurative—the content and meaning of the work oscillate according to the particular mind-set of the spectator.

Figurative Painting in Great Britain

The one country where the majority of painters remained stubbornly attached to figurative idioms was Great Britain. There the Modern movement had never struck deep roots. The young artists of the so-called "Kitchen Sink" School were warmly greeted by British critics, among them John Berger in the *New Statesman*, the leading left-wing weekly of the day.[13] Their work, which made much of the miserable living conditions which prevailed in postwar England, has a certain historical interest, since it featured things such as modern commercial packaging which were to play a starring role in Pop Art. The trouble was that it did so in an idiom feebly derived from prewar Expressionism.

Far more powerful, and more genuinely Expressionist, were the late paintings of David Bomberg (1890–1957). Bomberg had been a leading member of the short-lived Vorticist group, an offshoot of Italian Futurism which had flourished briefly in Great Britain in the years 1913–15. During the interwar years Bomberg evolved a markedly personal style, with forms modeled in thick impasto. This method he passed on to pupils at the Borough Polytechnic in London, where he began to teach in 1945. Some of these pupils later formed the core of what came to be called the School of London. Bomberg's final period was spent in the Spanish town of Ronda, where, fighting continual misfortune and ill-health, he did some of his most powerful work (FIG. 7.37). Despite the rise of Pop Art, Bomberg's work lingered in the collective memory of the British art world as something which offered a viable alternative to the developments of the 1960s.

Meanwhile Francis Bacon continued working during the 1950s in his own wholly individual manner. This was the decade in which he painted his long series of Popes (FIG. 7.38), based on Velásquez's portrait of Pope Innocent X.

7.38 Francis Bacon, *Head Surrounded by Sides of Beef*, 1954. Oil on canvas, 4 ft 3½ in x 4 ft (1.3 x 1.22 m). Art Institute of Chicago, Illinois (Harriott A. Fox Fund).

The series of popes painted by Francis Bacon was based on the portrait of Innocent X by the seventeenth-century Spanish painter, Diego Velásquez. Bacon's tortured figures are almost always shown in isolation, and the blurred technique suggests the constantly shifting, stressful circumstances of a human being's existence. Bacon's expressive use of paint is made all the more powerful by leaving empty spaces to offset the violence of his brushstrokes.

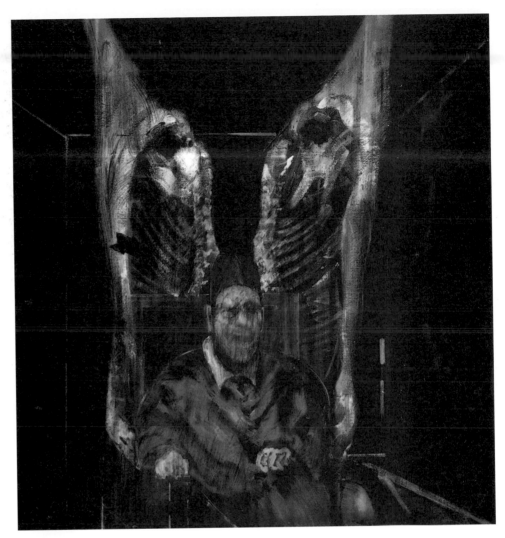

7.39 Jiro Yoshihara, *Painting*, 1959. Oil on canvas, 5 ft 3¼ in x 4 ft 3⅛ in (1.62 x 1.3 m). Galerie Stadler, Paris.

Jiro Yoshihara was founder of the Japanese Gutai group.

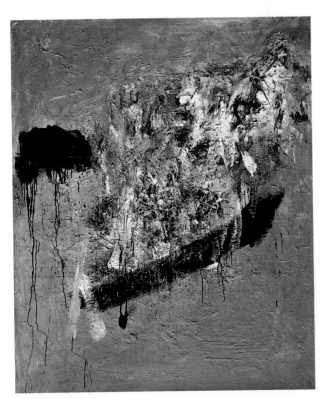

These, which distilled a unique sensation of terror, became the signature images of a decade which quailed under the threat of the atomic bomb.

The Gutai Group in Japan

Japan, slowly recovering from crushing defeat in World War II, offered not only a contribution to the development of modern architecture, with the work of Kenzo Tange, but a general upsurge in avant-garde activity. The focus for this was the Gutai Art Association, more generally known as the Gutai group, founded in 1954. The central figure in Gutai was Jiro Yoshihara (1905–72), a wealthy industrialist and a talented painter. It was largely Yoshihara's money which sustained the group as a collective entity—its other members were much younger and less prosperous—and his death brought about its collapse. Yoshihara's paintings (FIG. 7.39) are a sophisticated mixture of Eastern and Western modes. They mingle Zen, and Zen versions of traditional oriental calligraphy, with things learned from American Abstract Expressionism. Some of the most interesting artworks by Gutai members, however, broke completely with conventional formats, Eastern and Western. In the early days of the group, much of its energy went into site-specific works in the open air, and ephemeral installations

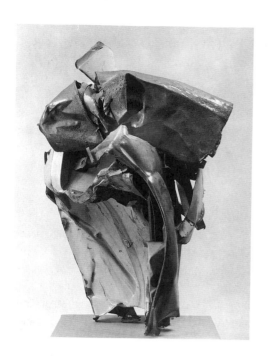

in galleries. These looked back to Dada—Yoshihara described them as "Dada without the packaging,"[14]—and often anticipated similar work done in the United States and Europe during the 1970s, with an especially close link to Italian Arte Povera. Works of this type now usually survive only in contemporary photographs.

Sculpture

SCULPTURE IN THE UNITED STATES

David Smith and John Chamberlain

The most important American sculptor of the period was David Smith (1906–65). Smith had originally trained as a painter, and among his associates at this period were leading Abstract Expressionists such as Gorky and de Kooning. The example of Julio Gonzalez and work as a welder in the American defense industry during the war years led him to make sculptures (see FIG. 7.40) of welded metal. Though David Smith made use

KEY WORK

David Smith: *Tank Totem V*

David Smith began his career as a painter, and always said that he saw little real difference between sculpture and painting. Pieces made in the early fifties are like openwork drawings made of metal, without any feeling of volume. Later in the decade, the sculptures grew in size and began to seem more aggressively industrial. *Tank Totem V* (FIG. 7.40) is an early example of this transformation. It consists of industrial elements put together in such a way as to hint at the presence of a figure. It is clear that essentially only two views count—from more or less directly in front or from behind. "For a sculpture," Smith once said, "I see it from five different angles at once, I see one view. The round is only a series of fronts."*

From this time onward, Smith's sculptures offer a striking contrast between radical and relatively traditional elements. The techniques used to fabricate them, notably the sculptor's use of arc-welding, and his employment of aggressively industrial materials, link them to modern technological society, as did Smith's virtual abolition of the pedestal. Sculptures shown outdoors, as here, were

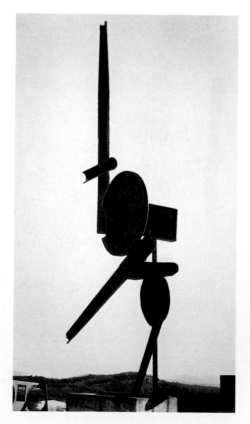

displayed on a concrete base set almost flush with the ground. The rapidity with which the work was executed, and its own improvisatory nature, with various preexisting components being moved and juggled around until a satisfactory configuration was achieved, link it to the American abstract painting of the same epoch. Despite this, the figurative element persists. In *Tank Totem V* we can recognize two arms, two legs, an abbreviated torso, and a head. Rather than the single unitary form of carved or modeled sculpture, however, there is a complex dance of different forms, each with its own identity. Though Smith's sculptures do not move, they offer a second look at some of the things Alexander Calder had begun to explore in his mobiles.

*Quoted in E.A. Carmeau Jr., David Smith, Washington 1982, p45.

7.40 David Smith, *Tank Totem V*, 1953–6. Steel, 8 ft ¾ in.x 4 ft 4 in (2.46 x 1.32 m). Whitney Museum of American Art, New York.

7.41 (opposite) John Chamberlain, *Untitled*, 1958–9. Painted and welded metal, 32½ x 26½ x 24 in (82.8 x 67.3 x 61 cm). Cleveland Museum of Art, Ohio (Andrew R. and Martha Holden Jennings Fund).

Chamberlain used fragments of crashed automobiles to make what were sometimes called his "Neo-Dadaist" or "junk" sculptures, because of their use of "found objects." Like much Pop Art of the time, they carried an implied reproach against the wastefulness of modern industrial, consumer society.

7.42 Louise Nevelson, *Tropical Garden II*, 1957. Fifteen wooden boxes, painted black, 7 ft 6⅛ in x 9 ft 6½ in x 2 ft 7 ins (229 x 291 x 31 cm). Musée National d'Art Moderne, Paris.

In the late 1950s Nevelson began to make assemblages of boxes or boxlike panels containing recycled fragments of demolished buildings, painted a single color, almost always black, white, or gold.

both of discarded fragments of machinery, and of readymade steel parts, such as sections of tubing, his work has a less emphatically industrial look than that of his younger contemporary, John Angus Chamberlain (1927–). Chamberlain's sculptures are also more fully abstract (FIG. 7.41). Their billowing forms, inspired in part by Abstract Expressionist painting, also come from the fact that they are put together from parts of crashed cars. Chamberlain, rather than trying to disguise the original color of the bent and battered fenders and body shells he uses, makes this contribute to the final effect.

Louise Nevelson

What Chamberlain did with wrecked cars, Louise Nevelson (1900–88) did with architectural fragments and furniture parts, the product of the rapid transformation of New York. Though she had been exhibiting since the early 1940s, Nevelson began to gain general recognition only in the mid-1950s. Where Chamberlain's sculptures are exuberant, Nevelson's are generally still and mysterious. In the most successful, the fragments she used are assembled within boxes, and the boxes in turn are put together to make walls, giving the sculptures the scale of the most ambitious Abstract Expressionist paintings (FIG. 7.42). To unify her forms, Nevelson painted them matt black, though later she sometimes varied this by painting them white or gold. Nevelson was the first American woman to gain recognition as an important Modernist sculptor.

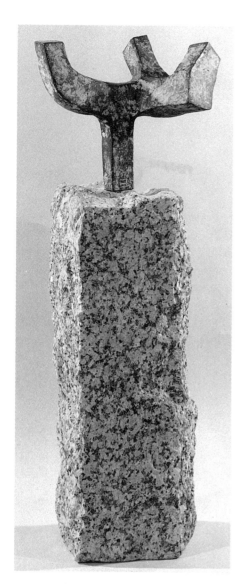

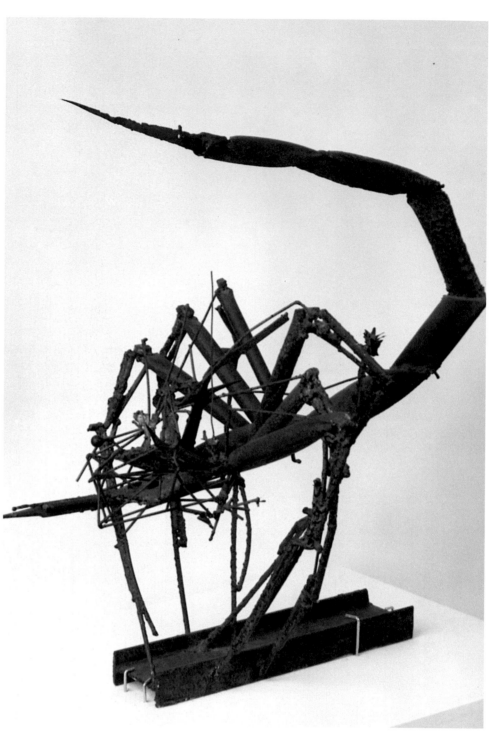

7.43 (*above*) Eduardo Chillida, *The Anvil of Dreams, XII*, 1954–62. Iron and granite, 26 x 6 x 9 in (66 x 15.2 x 22.8 cm). Tasende Gallery, La Jolla, California (Mr. and Mrs. Rudolf B. Schulhof Collection).

7.44 (*right*) César, *Scorpion*, 1955. Welded iron, 25⅝ x 31½ x 12⅝ in (60 x 80 x 32 cm). Private collection.

SCULPTURE IN EUROPE

Eduardo Chillida and César

Interest in forged and welded metal sculpture was also strong in Europe during the 1950s, though the results tended to be more artisanal than industrial in atmosphere. The Spaniard, Eduardo Chillida (1924–) continued the tradition of Gonzalez, making forged and welded sculpture in metal, but he omitted any figurative element (FIG. 7.43). In France, César (César Baldaccini, 1921–), in the first and most attractive phase of his career, made amusing sculptures of animals from assembled industrial parts. His sculpture, *The Scorpion*, is a good example of this phase of his activity (FIG. 7.44).

7.45 (*right*) Eduardo Paolozzi, *Japanese War God*, 1958. Bronze, 64¼ × 22 × 13 in (160.0 × 55.9 × 33 cm). Albright-Knox Art Gallery, Buffalo, New York (Gift of Seymour H. Knox).

Paolozzi's early sculptures were often inspired by the toy robots made in Japan for the European market. Paolozzi's semi-abstract, figurative sculptures of the 1950s seem to combine human and mechanical traits, almost in a Surrealist vein.

7.46 (*far right*) Elisabeth Frink, *Winged Figure*, 1959 (edition of six). Bronze, height 24 in (61cm). Private collection.

Frink's sculptures of birds and birdmen were partly inspired by the warplanes she saw flying over her family home in Suffolk during World War II.

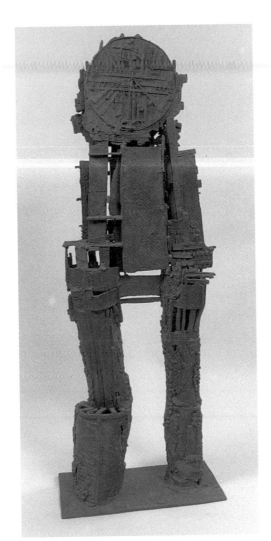

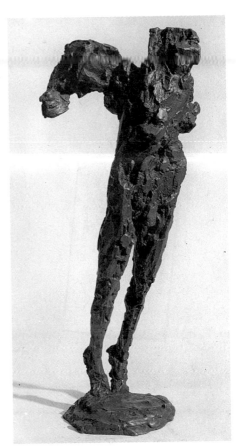

Eduardo Paolozzi and Elisabeth Frink

In Great Britain, younger sculptors reacted against the dominant influence of Henry Moore, but their work in metal still remained within the spectrum of traditional techniques. In typically British fashion, it tended to be emphatically figurative. The most technically innovative of these new sculptors was Eduardo Paolozzi (1924–). Interested both in Surrealism, particularly its use of collage, and in the new popular culture he sensed at work in America, he made grotesque robot-like figures often inspired by Japanese toys made for the American market. An example is *Japanese War God* (FIG. 7.45). This and other Paolozzi sculptures of the same epoch are cast in bronze, but the model for the bronze was made by forming the figure from sheets of wax imprinted with small mechanical parts.

Elisabeth Frink at the same epoch was making figures of *Birds* and *Birdmen* (FIG. 7.46) which echoed her experiences as an adolescent during the war years—her family home was situated near the wartime airfields in Suffolk. Her images were built up rapidly in plaster over a wire armature, in a technique which combined modeling and carving. Both Frink's images and Paolozzi's often have a maimed, anguished air which reflected not only recent European experience but the threat of an atomic holocaust and the strained political climate which was the result of the Soviet takeover in eastern Europe. British sculpture, with its fondness for myth and allegory, and also, on occasion, for emphatic political and social statements, was far removed from its American counterpart. In America, such statements were still generally considered to be the province of photography.

The enormously popular "Family of Man" exhibition tended to sentimentalize the human condition.

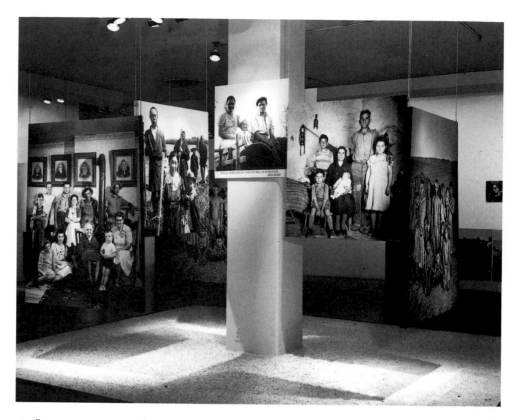

Photography

"The Family of Man"

The triumph of the avant-garde could not disguise the increasing prominence of photography as the chief disseminator of images. One sign of this was the rise of the illustrated art book and its perhaps even more effective sibling, the illustrated art magazine. People increasingly got their ideas about art, not from originals, but from photographs of originals. This had particular importance in areas such as Latin America, where the museum system was not strong. Meanwhile, photographic exhibitions had an enormous impact on the public. The most important of these photographic shows was without question "The Family of Man" exhibition of 1955 (FIG. 7.47). On the cover of the catalogue this touted itself as "the greatest photographic show of all time—503 images from 68 countries." The curator, Edward Steichen, once a collaborator of Stieglitz, noted that he and his collaborators had looked at more than two million photographs in order to arrive at the final selection. In a swellingly romantic introduction, Carl Sandburg wrote of "a camera testament, a drama of the grand canyon of humanity, an epic woven of fire, mystery and holiness."[15]

Steichen's choice offered photographs by the famous and the unknown, not all of them absolutely contemporary—there was a Lewis Carroll portrait of a little girl and Dorothea Lange's photograph of sharecroppers from the Depression era. The emphasis was on basic human emotions—lovers embracing, mothers with their babies, the dignity of manual labor. Though the show, designed to tour worldwide, was quintessentially the product of a technological, highly industrialized society, nearly all of the photographs showing men or (far fewer) women at work concentrated on rural occupations.

Because the exhibition offered the public such an idealized image of themselves, it was an immediate and enormous success, and set the terms in which photography would be judged until well into the following decade.

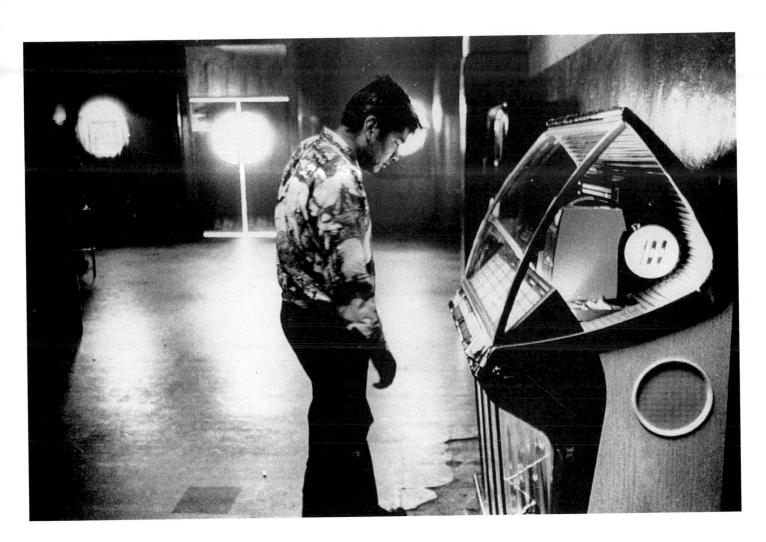

7.48 Robert Frank, *Bar, Las Vegas, Nevada*, c. 1955. Gelatin silver developed-out print. © Robert Frank, PaceWildensteinMacGill, New York.

Robert Frank's series, *The Americans*, offered an abrasive view of life in the United States in photographs which, apparently of a random, "snapshot" character, are actually carefully composed to highlight the futility and loneliness of many people's lives in modern American society.

Robert Frank

One dissenter from this point of view was the Swiss-born photographer, Robert Frank, who at the end of the decade offered America a very different vision of itself. His book, *The Americans*, did not at first find a publisher in America but appeared in France (1958)—the photographs were accompanied by a series of texts chosen by the poet, Alain Bosquet. In 1959 it appeared in the United States, stripped of these additions, but now with an introduction by the Beat writer, Jack Kerouac. Critics, rendered complacent by the trend toward idealized photography, were generally acerbic:

> Frank has managed to express, through the recalcitrant medium of photography, an intense personal vision, and that's nothing to carp at. But as to the nature of the vision I found its purity too often marred by spite, bitterness and narrow prejudices just as so many of the prints are flawed by meaningless blur, muddy exposure, drunken horizons and general sloppiness.[16]

Frank's pictures, thematically arranged, offer recurring themes or groups of themes—the American flag, the automobile, popular music (usually symbolized by the presence of a juke box). These themes were later to be recognized as part of the very texture of American blue-collar life. By focusing on them with such intensity Frank contradicted the easy platitudes offered by "The Family of Man," and created a new way of looking at American culture, full of implications for the future (FIG. 7.48).

1960	**1961**	**1962**	**1963**	**1964**

GENERAL EVENTS

• Massacre by white troops of black schoolchildren at Sharpeville, South Africa • Formation of Organization of Oil Exporting Countries (OPEC)	• US Bay of Pigs, attempted invasion of Cuba, fails • Berlin Wall constructed • Joseph Heller publishes *Catch 22* • Günter Grass publishes *The Tin Drum*	• Cuban missile crisis • First black student admitted to the University of Mississippi, protected by 3,000 US troops • Execution of Adolf Eichmann in Israel	• Britain's application to join the Common Market rejected • President John F. Kennedy assassinated • Nelson Mandela begins a sentence of life imprisonment in South Africa	• Escalation of US military involvement in Vietnam • Martin Luther King awarded the Nobel Peace Prize • Greek/Turkish Cypriot War • Palestine Liberation Organization (PLO) founded • Mary Quant invents the mini-skirt

Ruscha, *Burning Standard*: see p.262

SCIENCE AND TECHNOLOGY

• First weather satellite launched by United States • First laser constructed in California	• Russian cosmonaut Yuri Gagarin orbits Earth in a satellite • The contraceptive pill becomes available on prescription	• The anti-nausea drug "Thalidomide" is identified as a cause of major birth defects	• First use of an artificial heart to take over the circulation of the blood during heart surgery • Color version of Polaroid Land Camera goes on sale	• First close-up photos of the moon's surface • China explodes its first A-bomb

Stirling, Engineering Department, University of Leicester: see p.254

ART

• Andy Warhol, first comic strip painting (*Dick Tracey*) • Pierre Restany publishes his New Realist Manifesto • Performance in Paris of Yves Klein's *Anthropometries* • Claes Oldenburg "Happening": *Snapshots from the City*	• "Art of Assemblage" exhibition at MOMA, New York • Joseph Beuys begins teaching at the Düsseldorf Kunstakademie • Roy Lichtenstein creates his first works based on comic strips • The term "concept art" is coined by Henry Flynt	• "Nuevia Presencia" group (opposed to Mexican Muralism) founded in Mexico • Warhol holds his first solo exhibition at the Ferus Gallery, Los Angeles • BBC television screens the film "Pop Goes the Easel" • Pop Art covered by *Time*, *Life*, and *Newsweek* • "Fluxus" group formed • Death of Yves Klein	• Death of Piero Manzoni • Dan Flavin produces the first of his sculptures using fluorescent light • *Leben mit Pop* exhibition held in Düsseldorf, Germany • George Segal, *Cinema* • First solo exhibition for R.B. Kitaj at the Marlborough Gallery, London	• "Post-Painterly Abstraction" exhibition at the Los Angeles County Museum. Edward Kienholz's *Backseat Dodge '38* is met with official outrage when exhibited at the same venue • "Amerikanst Pop-Konst," Moderna Museet, Stockholm • "The Shaped Canvas," Guggenheim Museum, New York • Carolee Schneemann performs *Meat Joy*

Herron (Archigram), *Walking City*: see p.252

ARCHITECTURE

Foundation of Brasilia as the new capital of Brazil, with buildings by Oscar Niemeyer	• Nicolas Schöffer erects a "cybernetic and echoing" tower at the International Exhibition in Liege	• Philip Johnson begins work on the New York State Theater at the Lincoln Center, New York	• Ralph Rapson, Tyron Guthrie Theatre, Minneapolis • James Stirling completes his Engineering Building, Leicester University, England	• "Architecture without Architects," exhibition at MOMA, New York • Kenzo Tange designs pavilions and the Olympic area for the Olympic Games in Tokyo

EIGHT 1960–1969

1965

- Malcolm X, Black Muslim leader, assassinated. Race riots in the Watts district, New York
- National Endowment for the Arts (NEA) founded in the United States
- White government of Rhodesia declares independence from the Commonwealth

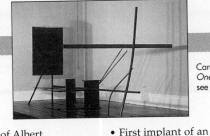

Caro, *Early One Morning*: see p.275

- Death of Albert Schweitzer
- Noam Chomsky publishes *Aspects of the Theory of Syntax*

- Andy Warhol's first retrospective is held at the University of Pennsylvania
- Salvador Dalí, *The Perpignan Railway Station*
- "New Generation" exhibition at the Whitechapel Gallery, London

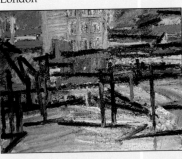

Auerbach, *Mornington Crescent, Winter*: see p.271

- Death of Le Corbusier
- Founding of the International Group of Prospective Architecture

1966

- Cultural Revolution begins in China (–1968)
- Strasbourg students and the Situationist Internationale group publish "On Student Poverty"
- Truman Capote publishes *In Cold Blood*
- Premiere of *Blow-Up*, directed by Michelangelo Antonioni

- First implant of an artificial heart
- "Soft" landings on the moon by both USSR and US spacecraft

- "Primary Structures" exhibition, Jewish Museum, New York
- "Systematic Abstraction," Guggenheim Museum, New York
- First "Hairy Who" group show, Hyde Park Center, Chicago

- Opening of the new Whitney Museum of American Art, designed by Marcel Breuer

1967

- Six Day War between Israel and the Arab nations
- Che Guevara killed in Bolivia
- 50,00 people demonstrate against Vietnam War at the Lincoln Memorial, Washington D.C.
- Abortion and homosexuality decriminalized in Great Britain

- First heart transplant operation performed by Dr Christiaan Barnard in South Africa
- Death of Robert Oppenheim, the inventor of the A-bomb
- Synthetic DNA produced for the first time

- Birth of "Arte Povera" marked by an exhibition at the Galleria la Bertesca, Genoa
- "Funk" exhibition, University of California, Berkeley
- Peter Blake creates the cover for The Beatles's "Sergeant Pepper" album
- Death of René Magritte
- Robert Motherwell completes his *Elegy to the Spanish Republic*

- International Expo '67 showcases pavilions by Buckminster Fuller (US), and Frei Otto and Rolf Gutbrod (Germany), and *Habitat '67* by Moishe Safdie

1968

- Martin Luther King assassinated
- Student rioting in Paris
- Liberalization in Czechoslovakia leads to Soviet invasion
- Richard Nixon elected president of United States
- Stanley Kubrick directs *2001: A Space Odyssey*

- BMW unveil its 2002 saloon
- James D. Watson publishes *The Double Helix*

- "Earthworks" exhibition, Dwan Gallery, New York
- "Art and the Machine" exhibition at MOMA, New York
- Christo wraps the Kunsthalle, Berne
- Death of Marcel Duchamp

- Jean Balladur creates the resort town of La Grande-Motte over 110 acres in the Languedoc-Rousillon, France

1969

- First US troops withdrawn from Vietnam
- British troops sent to Belfast to quell rioting
- Woodstock music festival, New York State
- Riots after the police raid on the Stonewall Inn, New York, precipitate the founding of the Gay Rights movement
- Charles Manson murders in the United States

- Concorde, the Anglo-French supersonic passenger aircraft, makes its first test flight
- US government bans the use of DDT as insecticide
- Neil Armstrong becomes the first man to walk on the moon

Nutt, *Why Did He Do It?*: see p.263

- Robert Smithson begins work on *Spiral Jetty* at the Great Salt Lake, Utah
- First issue of *Art & Language* published
- Theft of the Penrose collection, including major works by Pablo Picasso and Giorgio de Chirico, in London

Arbus, *Young Man in Curlers*: see p.292

- Skidmore, Owings, and Merrill, the John Hancock Center, Chicago

EIGHT 1960–1969

If the 1950s are popularly regarded as an era of stability, the 1960s are perceived as an epoch of revolution—the great cultural divide which marks off the early Modern and high Modern epochs from their fragmented late Modern successor. This perception is perhaps more typically American than European, and it might also be disputed by representatives of the hybrid, only partly European, cultures which were then beginning to make a mark outside their own particular spheres of influence.

In the United States, the 1960s were the time of the Cuban missile crisis, of President Kennedy's assassination, of the struggle for Civil Rights under the leadership of Martin Luther King Jr., another victim of the violence endemic in American society, and of war in Vietnam and escalating protests against it. In Europe, there was no such dramatic series of events—the most notable signs of the rebellion of the young against the old were the student riots in Paris in 1968, which led to the resignation of General de Gaulle in the following year.

The culture of the 1960s is associated in the popular imagination with the triumph of Pop Art. This was the first new Modernist style to make an immediate impact on the popular imagination since the time of the Surrealists, who had been as adept as the leading New York Pop artists in seizing the attention of the news media. Pop nevertheless was a deeply ambiguous phenomenon. It was as much concerned with the language, or the multiple languages, of visual representation as with what was actually represented. In this respect it was allied, rather than opposed, to its elitist rival, Conceptual Art. Pop celebrated aspects of Western society against which there was soon to be a violent reaction—the triumph of consumerism, without a thought for its impact on an increasingly fragile environment, and a stereotypical view of the roles and relationships of men and women. There was much about the decade which now seems outmoded and remote.

Architecture

In the 1960s the International Style established before World War II headed toward a philosophical crisis whose effects would be felt for the rest of the century. Its success could be judged by the extent to which the idioms established by the Bauhaus architects and Le Corbusier had become, though sometimes in distinctly debased form, the common language of architecture throughout the world. Even in the Soviet Union, which had remained resistant to Modernism throughout Stalin's rule, a version of the Bauhaus style replaced the rhetorical Classicism favored from the mid-1930s until the mid-1950s. An especially significant example was the sleek, stylistically neutral Palace of Congresses, built within the very walls of the Kremlin and completed in 1961.

In the West, however, difficult questions were being asked, and problems were being encountered to which there seemed to be no convincing Modernist solutions. Both the exhibition "Architecture Without Architects," organized by Bernard Rudofsky at the Museum of Modern Art in 1964, and Robert Venturi's

8.1 Archigram, Capsule Dwellings, Design at Japan World Exposition (Expo '70), 1969–70.

The futurist fantasies of Archigram were influenced by American and Russian space-exploration programs and, in their borrowing from urban technological and consumer products, had something in common with Pop iconography.

8.1 Archigram, Capsule Dwellings, Design at Japan World Exposition (Expo '70), 1969–70.

The futurist fantasies of Archigram were influenced by American and Russian space-exploration programs and, in their borrowing from urban technological and consumer products, had something in common with Pop iconography.

8.2 Ron Herron (Archigram), *Walking City*, 1964.

Buildings, traditionally conceived in Western culture as permanent, were to become expendable, even mobile, in Archigram's brave new world. Herron's *Walking City* crawls on telescopic tentacles.

polemical book *Complexity and Contradiction in Architecture*, published in 1966, called into question the programatic rationality of the International Style. Rudofsky put forward the idea that successful architecture could be instinctive, could be created in the way that birds build their nests or bees build a hive. Venturi suggested, even more heretically, that architecture actually benefited from the presence of things that did not at first sight seem to fit into the rational pattern established by Modernist theory.

The crisis showed itself first in housing. Immediately after the war, national governments and local authorities had realized that there was a pressing need to replenish the existing housing stock, especially in war-ravaged Europe, and to upgrade it to meet contemporary expectations. By the 1960s the material resources had at last become available to attempt to do this. The model which attracted most progressive architects was Le Corbusier's Unité d'habitation or something resembling it—a tall building or a group of tall buildings set in a green space. Le Corbusier's example was doubly attractive because of his commitment to reinforced concrete, rather than to masonry, glass, and metal, after the manner of Mies van der Rohe. Concrete did not demand a refined finish—Le Corbusier had in fact found ways of turning roughness of surface into an architectural virtue. It did not seem to require skilled labor, which was still in short supply. In addition, it lent itself to various systems of construction, whereby buildings could be partly prefabricated off-site, then assembled simply and rapidly.

One of the countries where Le Corbusier's principles were appiied most rigorously was Great Britain, especially by the architects employed by the London County Council and its equivalent in other large cities. Though the need for housing was acute, it gradually became apparent that the tower blocks built by local

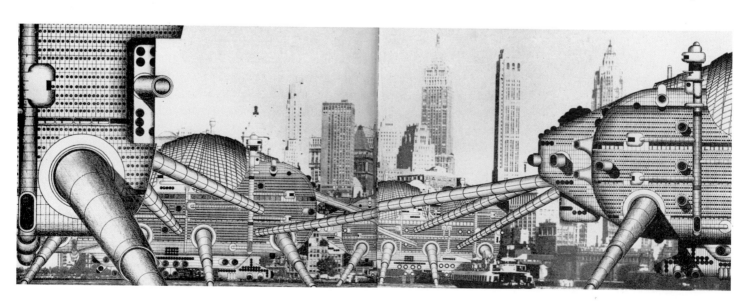

authorities were all too often unpopular with their working-class inhabitants, who preferred the crowded, neighborly streets they had previously lived in. In addition, standards of workmanship were often shoddy, and the social stresses caused by the new tower blocks led to widespread vandalism, and often to petty crime as well. Revulsion against the new way of building came to a head in 1968 after the partial collapse of the Ronan Point tower block in the working-class London borough of Newham, in which a number of its inhabitants were killed. The collapse was the result of a gas explosion, but the extensive damage done to the building was also attributed to the prefabricated panels used to create it.

Tower blocks were not abandoned altogether, either in Great Britain or the United States, since the need to make the best use of expensive urban sites was so great, but it was no longer possible to see housing on the Corbusian model as the way of realizing a Utopian dream. Ambitious architects shifted their focus of interest away from these, and also away from office towers (whose problems seemed to have been so completely solved that there was little more to be added) to "prestige projects"—buildings for universities and research institutes, theaters, and concert halls, and, perhaps most of all, museums. By the end of the decade museums had become the means whereby great architectural reputations were made.

Archigram

There was another side to the architecture of the 1960s—visionary schemes of almost willful impracticability, best typified by the ideas put forward by the British group, Archigram (1961–74—the members were Warren Chalk, Peter Cook, Dennis Crompton, David Greene, Ron Herron, and Michael Webb). Among the most important concepts put forward by Archigram were those of the "capsule dwelling" (FIG. 8.1)—a basic plug-in living-space that could be slotted into a framework which provided the necessary services, such as lighting and sewerage—and the *Walking City* (FIG. 8.2), where the framework was itself movable, and allowed the city to expand, contract, or move to a different location at will. These concepts were in part inspired by Russian Futurist projects of the early years of the century, in part by American and Russian space-exploration. Members of the group visited Cape Canaveral, and were greatly impressed by the immense movable structures they found there. "Capsules for living" were versions of the space-capsules used by the first cosmonauts. Archigram's theories found realization, not in actual buildings, but in drawings and collages inspired by the Pop Art of the period. If Archigram had any practical impact, it was not felt till the next decade, with the construction of buildings like the Centre Georges Pompidou in Paris. The activities of the group were, however, of immediate significance because they helped to intensify discontent with modern architecture, and to amplify the challenge to the International Style.

Robert Venturi and James Stirling

The most significant buildings of the decade were rarely prestigious commissions on major sites. Philip Johnson's New York State Theater at the Lincoln Center (FIG. 8.3) attempted to combine the doctrines of International Modernism with the kind of decorativeness considered appropriate in a building whose function was entertainment. The result was a feeble compromise. In retrospect, it does not have anything like the significance for the future

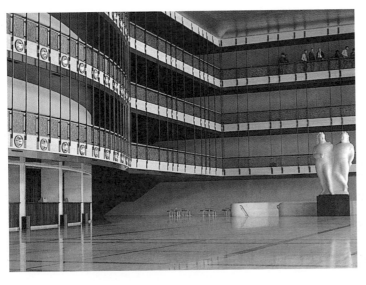

8.3 Philip Johnson, Theater at the Lincoln Center, New York, 1964.

Philip Johnson's Theater at the Lincoln Center tries unsuccessfully to find a compromise between what he had come to see as the sterility of the International Style in which he was raised and a monumental Classicism.

8.4 Robert Venturi and John Rauch, Guild House, Philadelphia, Pennsylvania, 1965–6.

This modest building—housing for the elderly—was one of the most influential structures of the decade. It combines "kitsch" elements, like the overscale lettering, with ideas—the lunette crowning the central portion and the white marble band defining the top storey as an attic—taken from High Renaissance architect Andrea Palladio (1508–80).

8.5 (*below*) James Stirling, Engineering Department, University of Leicester, England, 1959–63.

This famous building alludes to Victorian industrial architecture—which is appropriate given its intended function as an engineering facility. Architecture, Stirling said, was "not a question of style of appearance," but "how you organize spaces and movement for a place and activity."

of Venturi and Rauch's Guild House in Philadelphia (FIG. 8.4), a practical exemplification, on a modest scale, of the theories put forward in Venturi's book. In this block of apartments for the elderly, Venturi alluded to Palladio, one of the founding fathers of Renaissance Classical architecture, specifically to one of Palladio's most celebrated buildings, the Villa Malcontenta. Simultaneously, in his use of overscale lettering for the building's name, Venturi alluded to the crassest kind of

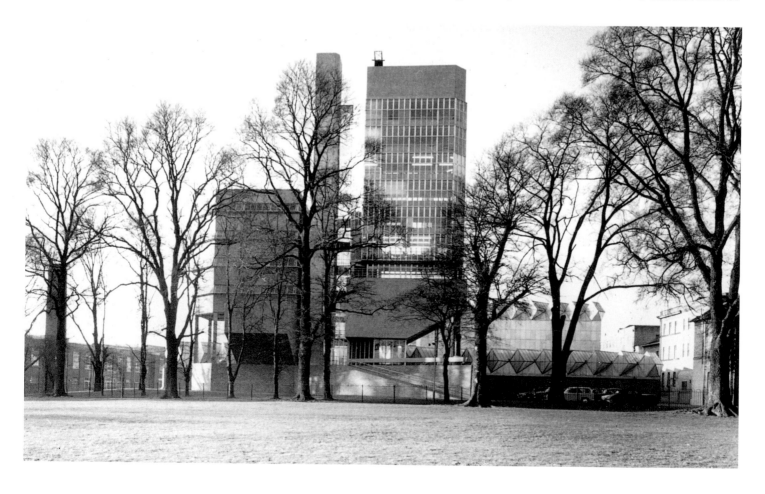

commercial signage, a world away from the intellectual concerns of Renaissance architects. The outsize column which masks the front entrance offers a different, but equally striking, gesture of contradiction. It functions as an exclamation point, marking the position of the main door, yet seems to block entry or exit.

James Stirling (1926–92) was already an established architectural name in the 1950s, but the commission which made him internationally celebrated was his group of buildings (FIG. 8.5) for the engineering department of Leicester University. Here Stirling quotes from what was already thought of as the "heroic" period of modern architecture—Le Corbusier and Frank Lloyd Wright are present in some of the details—but rams these allusions together with other features borrowed from Victorian industrial architecture. The result has been described as "mannerizing,"[1] and the comment is appropriate in the sense that it describes its extreme self-consciousness. The engineering complex serves a practical purpose, but it is also a text which only the initiated can read. The idea of buildings as commentaries upon themselves was to become increasingly prevalent in the architecture of the 1970s and 1980s.

Louis Kahn and the Kimbell Museum

Undistinguished as the architecture of the decade was in general, it produced one building which is generally considered a masterpiece: the Kimbell Museum at Fort Worth by Louis Kahn (FIG. 8.6). Begun in 1966 and completed in 1972, the Kimbell set a standard in both aesthetic and practical terms for the many new

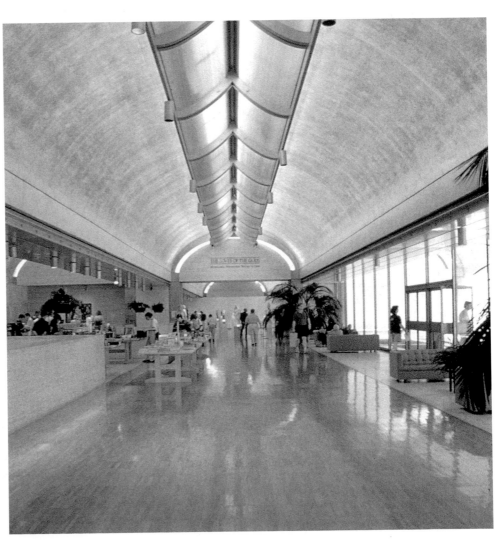

8.6 Louis Kahn, Kimbell Museum, Fort Worth, Texas, 1966–72.

Modeled on an ancient Roman warehouse, with barrel vaults of reinforced concrete broken by skylights, the Kimbell Museum, surprisingly airy and light, was the most highly praised museum building of the period.

museum buildings which opened to the public in the next twenty years. Like Paul Rudolph, Kahn can be thought of as an American follower of Le Corbusier, but he absorbed and used the master's influence in a much more positive and subtle way. The Kimbell looks back to Le Corbusier in its use of concrete, but also forward to aspects of the Postmodernism of the 1970s. Essentially it consists of a series of parallel spaces or halls, each covered with a barrel-vault, and in this respect resembles ancient Roman warehouses. Thanks to modern building techniques, however, Kahn was able both to slit the barrel vaults lengthwise to admit natural light (diffused throughout the galleries by means of reflectors) and to support them on very thin columns placed at their corners. The Roman warehouse thus acquires a kind of dynamism and restlessness at odds with the apparently static plan of the building. The balance of conflicting elements is beautifully judged. The Kimbell offers an invigorating space and one which, unlike Frank Lloyd Wright's Guggenheim Museum, is completely practical for the display of works of art.

Painting

The 1960s are associated with Pop Art and the activities of a small group of artists who carried the Pop label on both sides of the Atlantic. In fact, there is probably no decade in the whole of the twentieth century whose art has established such a grip upon the imagination of a broad, non-specialist public. In this sense, the Pop Movement can be seen as more significant than any of the artistic movements spawned by the first phase of Modernism—Cubism, Expressionism, Surrealism. In retrospect, the whole culture of the 1960s seems flavored by manifestations of the Pop sensibility. In many ways this is curious. Though Pop was treated, when it first appeared, as a betrayal of the most cherished tenets of Modernism—among its most impassioned opponents were American critics such as Clement Greenberg and Harold Rosenberg, who had been the chief intellectual supporters of Abstract Expressionism—it was in important respects a manifestation of the Modernist tradition in its most esoteric and recalcitrant guise. It marked a continuation of the Dadaist tradition founded by Marcel Duchamp, and its affinity for the conceptual rather than for the perceptual approach to making art is not difficult to detect.

What made Pop Art's fortune was its use of immediately recognizable imagery, at a time when art seemed to be loosening its grip on the figurative. A public starved for contemporary art with which it could form an immediate relationship took Pop—based on the common currency of everyday urban living—to its bosom. Pop's capacity to offend the intelligentsia counted for, not against, it, as it seemed to offer a guarantee that this surprisingly accessible new development was nevertheless "revolutionary," in the fashion demanded of avant-garde artists.

POP ART IN GREAT BRITAIN

The Pop impulse manifested itself earlier in Great Britain than it did in the United States, though its consequences for British art were to be much less profound than they were in America. It grew out of a series of discussions held at the Institute of Contemporary Arts in London in the early and

8.7 Richard Hamilton, *Just What Is It That Makes Today's Homes So Different, So Appealing?*, 1956. Collage on paper, 10¼ x 9¾ in (26 x 24.8 cm). Collection, Kunsthalle Tübingen, Sammlung Zundel, Germany.

This small collage, made for the exhibition "This Is Tomorrow" is generally regarded as the first example of Pop Art. Hamilton listed the ingredients of the style: "Popular (designed for mass audience); Transient (short term solution); Low Cost; Mass Produced; Young (aimed at youth); Witty; Sexy: Gimmicky; Glamorous; Big Business."

mid-1950s by members of the Independent Group. Among the participants were the sculptor Eduardo Paolozzi, the architects Alison and Peter Smithson, the critics Peter Reyner Banham and Lawrence Alloway, and the painter Richard Hamilton. They were all fascinated by the new urban popular culture that was manifesting itself in America after the deprivations of World War II, and their sensitivity to what was taking place in the United States was heightened by the feeling, deeply implanted in a British society pinched by rationing and economic austerity, that America was an Eldorado of all good things, from nylon stockings to automobiles.

Richard Hamilton

In 1956 the Independent Group organized an exhibition at the Whitechapel Art Gallery called "This is Tomorrow." The main part of the exhibition consisted of twelve environmental sections, designed to draw the spectator into different aspects of the new popular culture. Its most significant item, however, was a very small collage picture at the entrance provided by Hamilton (1922–), entitled *Just What Is It That Makes Today's Homes So Different, So Appealing*? (FIG. 8.7). This collage incorporated many elements which were afterward to be recognized as typically Pop, among them a pin-up girl, a bodybuilder, and examples of up-to-the-minute consumer goods and packaging. The muscle-man even carries a large lollipop, with the word "POP" emblazoned on it in large letters.

Peter Blake and David Hockney

Hamilton's later paintings, made in the 1960s, were to make use of similar elements—of all the members of the Independent Group he is the only one who can be classified without qualification as a Pop artist. A number of younger British contemporaries, however, began to make use of similar materials at the beginning of the 1960s. One of these was Peter Blake (1932–); another was David Hockney (1937–). Blake and Hockney both began their careers as students at the Royal College of Art, which nurtured a generation of British Pop artists, but their attitudes toward the materials they used were in many ways diametrically opposite. Blake's work of the 1960s—for example, his series of portraits of wrestlers (FIG. 8.8)—incorporates all kinds of "pop" materials, such as badges, stick-on labels, and small toys, but its atmosphere is determinedly nostalgic, and its references are to the ambience which surrounded his own youth. His technique as a painter is traditional, a revival of the laborious methods of the nineteenth-century Pre-Raphaelites. In recent years Blake has tended to reject the Pop label as too simplistic, and to describe himself simply as a realist.

Hockney, born and brought up in Bradford, began his career as the *Wunderkind* of British art, becoming famous almost as soon as he arrived at the Royal College, dyeing his hair blond and donning a gold lamé jacket. He made a major impact on the London art scene with the work he exhibited at the Young Contemporaries exhibition of 1961—the date, rather than 1956, that marks the real emergence of British Pop.

Hockney's work of the 1960s has three major themes. One is an analysis of conventions of representation—that is,

8.8 Peter Blake, *Klarence Haus*, 1963–5. Oil on panel and enamel on wood with letters and toys, 18⅝ x 15 x 2⅝ in (47.3 x 38 x 6.7 cm). Waddington Galleries, London.

One of a series of small paintings representing wrestlers. The frame, an integral part of the work, is decorated with a group made of children's toys.

of the formulae artists use to render complex phenomena such as water rippling in a swimming pool. Another is his celebration of his homosexuality. Paintings like *Domestic Scene, Los Angeles* (FIG. 8.9) are a defiant assertion that the homosexual way of life is, within its own terms, perfectly normal and unremarkable. Linked to this defense is the third theme, Hockney's delighted discovery of America, especially the hedonistic lifestyle of southern California (FIG. 8.10). Hockney's depictions of swimming pools, palm trees, and modern buildings sheathed in glass offer a collective portrait of a never-never land where the European artist can throw off the shackles of convention.

R. B. Kitaj

Another exhibitor at the 1961 Young Contemporaries was the American-born but British-domiciled R.B. Kitaj (1932–). Kitaj and Hockney became close friends as students at the Royal College, and have remained so ever since, despite the fact that their careers seem to have gone in opposite directions. In this early phase of his career Kitaj used complex

8.9 (*above*) David Hockney, *Domestic Scene, Los Angeles*, 1963. Oil on canvas, 5 x 5 ft (1.52 x 1.52 m). Private collection.

Hockney's painting, executed in a characteristically childlike style, was one of the first to treat homosexual subject-matter in an entirely straightforward, undemonstrative way, in order to assert the ordinariness of gay life.

8.10 David Hockney, *A Bigger Splash*, 1967. Acrylic on canvas, 8 ft x 8 ft (2.43 x 2.43 m). Tate Gallery, London.

The pool was a favorite subject of Hockney to celebrate the pure pleasure of life in southern California. The painting was based on a Polaroid print and the acrylic sheen gives it the feel of a photograph, though the exuberant splash itself is a wonderful example of Hockney's painterliness.

8.11 R.B. Kitaj, *Isaac Babel Riding with Budyonny*, 1962. Oil on canvas, 6 ft × 4 ft 11⅞ in (1.82 × 1.52 m). Tate Gallery, London.

configurations of Pop imagery to express esoteric literary themes. *Isaac Babel Riding with Budyonny* (FIG. 8.11), for example, refers to the Russian Jewish short-story writer who rode with Marshal Budyonny's Red cavalry in the civil war that followed the October Revolution (1917).

Hockney and Kitaj share an innate romanticism combined with an interest in narrative. These themes also figure prominently in the work of Peter Blake and they help to define the differences which separate British from American Pop Art.

AMERICAN POP PAINTING

American Pop painting had very different preoccupations from British work of the same name. It was concerned, as Jasper Johns had been in his *Flag* paintings of the mid-1950s, to identify the essence of Americanism, the lowest common denominators of contemporary American culture. It was also eager to discover a new mode of figurative painting, one which would have the immediate impact of Barnett Newman's "zips" (see FIG. 7.18) and Mark Rothko's floating blocks of color (see FIG. 7.10). Simplified, often centralized, composition—one of Abstract Expression's most potent novelties—was something which Pop painters were loath to abandon. The Pop artists had other preoccupations as well. While they painted immediately recognizable things—packaging, celebrity portraits, pin-ups, frames borrowed from comic strips—they were interested in this material in a rather specialized kind of way. For them, the image was usually a "given," a found object rather in the manner of Marcel Duchamp's readymades and, still more so, of Jasper Johns's *Flags*. They examined the visual grammar of the way in which images of this type were usually presented, rather than trying to recreate them with paint on canvas.

Roy Lichtenstein and Andy Warhol

The two Pop painters who eventually became the most influential and celebrated were Roy Lichtenstein (1923–) and Andy Warhol (1928–87). Though very different in temperament, they both started from the same place—so much so that Leo Castelli, the dealer who launched Lichtenstein's career, initially refused to represent Warhol on the grounds that his work was too similar.

Lichtenstein's earliest series of paintings, those which established his reputation, were greatly enlarged frames from comic strips (see FIG. 8.13). Lichtenstein's work later developed into a critique, not of popular culture, but of the sacred cows of Modernism. He began to apply the comic-strip conventions he had studied to material borrowed from other Modernists (who were now virtually canonized by art critics). His *Brushstrokes* series (FIG. 8.12), painted in the second half of the 1960s, brutally called Abstract Expressionist spontaneity into question by making meticulous, frozen versions of marks which a genuine Abstract

8.12 Roy Lichtenstein, *Yellow and Green Brushstrokes*, 1966. Acrylic on canvas, 9 ft x 15 ft 1¾ in. Museum für Moderne Kunst, Frankfurt, Germany.

In his brushstroke series Lichtenstein made fun of the conventions of Abstract Expressionism, though he said that this was done without hostility. "I don't dislike the work that I'm parodying ... The things that I have apparently parodied I actually admire."

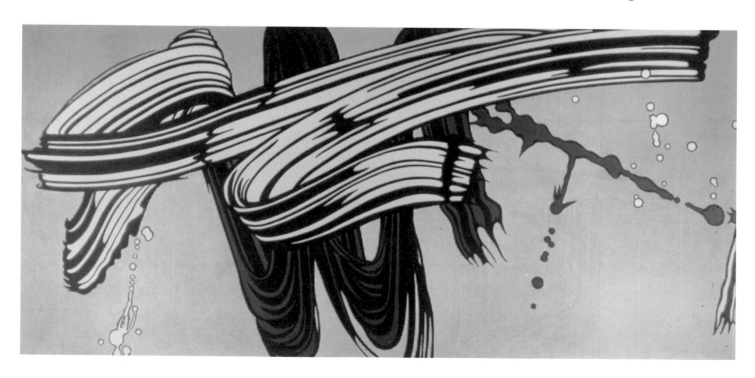

KEY WORK

Roy Lichtenstein: *Whaam!*

Roy Lichtenstein's earliest series of paintings, those which established his reputation, were enormously enlarged frames from comic strips. These achieved instant success because they seemed to typify the new infatuation with popular, mass culture. *Whaam!* (FIG. 8.13) shows an American jet-fighter shooting down an opponent. The scene is recreated with a meticulous imitation of the characteristic effects produced by cheap color-printing—hard outlines, areas of flat color, patches of absolutely regular hatching or shading. In other paintings of the same type, Lichtenstein also reproduces the regular screen of dots typical of comic-strip images, something which becomes doubly noticeable when the pictures are blown up to a very large scale. Other features, which have nothing to do with the

realist impulse are also striking—the stylized burst of flames surrounding the doomed aircraft as it explodes, and the expressive lettering which renders the sound of the explosion.

Responding to an interviewer at the time of his first success, Lichtenstein spoke of the difficulty in contemporary circumstances of making "a painting that was despicable enough so that no one would hang it," and then said:

I think my work is different from comic strips—but I wouldn't call it transformation… What I do is form, whereas the comic strip is not formed in the sense I am using the word; the comics have shapes, but there has been no effort to make them intensely unified. The purpose is different, one intends to depict and I intend to unify. And my work is

actually different from comic strips in that every mark is really in a different place, however slight the difference seems to some.[*]

In fact, as the later development of Lichtenstein's art has shown, his work is much more about mechanisms of perception, and about the way in which representations of people and things are coded, than about popular culture, which he simply takes as a contemporary "given."

*Answers given to G.R. Swenson, *Art News*, November, 1963, New York.

8.13 Roy Lichtenstein, *Whaam!*, 1963. Acrylic on canvas, 2 ft 2⅞ in x 5 ft 3¼ in (68 x 160 cm). Tate Gallery, London.

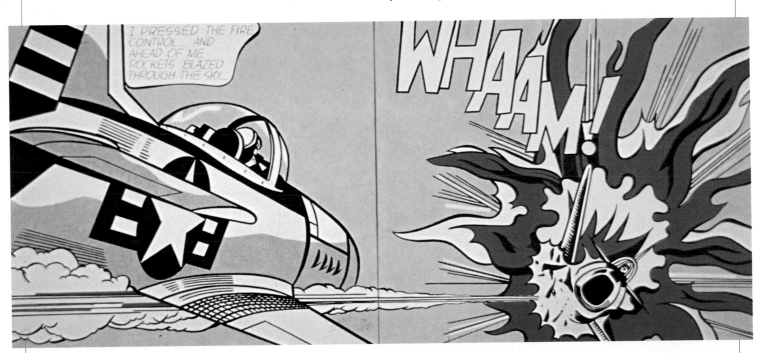

Expressionist might have made with a single gestural sweep of the brush.

Warhol's work also called established notions into question, by undermining the idea that there was a necessary link between the artistic impulse and spontaneous emotion. This is the real point of his much-quoted declaration that he wanted to be a machine. In his catalogue introduction to the first Andy Warhol retrospective, held in Philadelphia in 1965, Samuel Adam Green remarked:

8.14 *Andy Warhol, Race Riots,* 1964. Oil, silkscreened on canvas, 30 x 32⅞ in (76.2 x 83.5 cm). Rhode Island Museum of Art, Providence.

The image is taken directly from a news photograph, enlarged and silkscreened on to canvas. Warhol was accused of killing painting. His dealer, Leo Castelli, responded to the charge that by promoting Pop Artists he had killed off the Abstract Expressionists: "But they were dead already. I just helped remove the bodies."

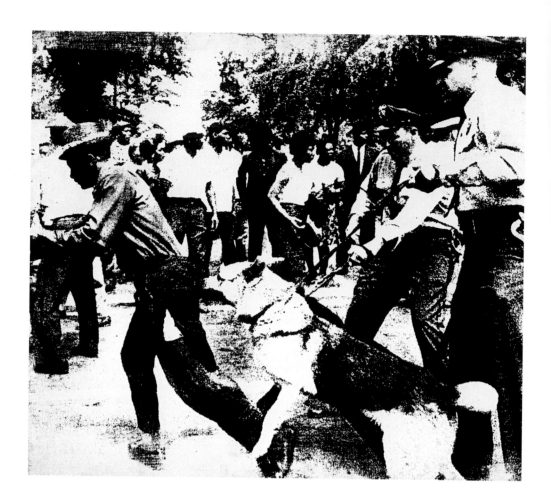

8.15 (*below*) Ed Ruscha, *Burning Standard,* 1965–8. Oil on canvas, 20¼ x 39 in (51.2 x 98.7 cm). Private collection.

Ruscha's images of gas stations look back to similar imagery in the work of Edward Hopper. The cool finish and perfection of design is also akin to Pop Art, although, unlike Pop painters, Ruscha invented his own commercial language.

[Warhol's] pictorial language consists of stereotypes. Not until our time has a culture known so many commodities which are absolutely impersonal, machine-made and untouched by human hands ... Warhol accepts rather than questions our popular habits and heroes. By accepting their inevitability they are easier to deal with than if they are opposed ... We accept the glorified legend in preference to the actuality of our immediate experiences, so much so that the legend becomes commonplace and, finally, devoid of the very qualities which first interested us.[2]

This interpretation is not radical enough. Warhol's art has not only a willed passivity, but a fundamental coldness. This observation applies both to his images of popular heroines (a series of paintings about Marilyn Monroe was begun immediately after her suicide; another series, featuring Jacky Kennedy, was inspired by newspaper images showing her in the hours and days immediately after the assassination of her husband), and to the *Disasters*, *Race-Riots*, and *Electric Chairs* which many critics now consider to be Warhol's best work (FIG. 8.14).

Pop in California

Another striking characteristic of the Pop Movement, viewed in retrospect, is that, despite its claims to have a universal message, it changed content and tone according to location. In addition to the differences between British and American Pop Art, there were striking differences between the work done by artists based in New York and what was produced by American artists working elsewhere. Closest to the New Yorkers in attitude were artists based in southern California. Nevertheless, there were some immediately detectable differences. The paintings of Ed Ruscha (1937–) were blander and more impersonal in surface than anything found in New York. His series of *Gas Stations* (FIG. 8.15), a motif taken, perhaps, from the veteran American realist, Edward Hopper), was emblematic of the restless impermanence and breezy materialism of the Californian lifestyle.

The Hairy Who

The ideas and motifs of Pop also made their appearance in the Midwest. Work of the members of the Hairy Who (their first group show was held in Chicago in 1966), and other, similar groupings of Chicago artists, was rougher and more Expressionist than that of the painters associated with New York. There was influence from "outsider" art of the kind which had influenced Jean Dubuffet in the 1940s and 1950s. Other influences included the Surrealist art of the 1930s, in which Chicago public and private collections were particularly rich, the psychedelic posters issued by the rock bands of the late 1960s, and the imagery of television. Typical of the Chicago style of the epoch were the bold caricature-like compositions in flat colors, often executed in acrylic on plexiglass (FIG. 8.16), by Jim Nutt (1938–), and the intricate watercolors, with interlaced, ribbon-like figures, produced by his wife, Gladys Nilsson (1940–).

8.16 Jim Nutt, *Why Did He Do It?*, 1966–7. Acrylic on plexiglass, 60⅝ x 35½ in (154 x 90 cm). Artist's collection.

Despite the slickness of surface produced by working in acrylic on plexiglass—a hallmark of Pop Art—the imagery here is closer to caricature than it would have been in New York Pop.

8.18 (*above*) Fernando Botero, *The Nuncio*, 1962. Oil on canvas, 47 x 38 in (119.3 x 96.5 cm). Private collection.

In the 1960s Botero frequently used his so-called "fat" style to make fun of the Latin-American political and religious establishment. The swollen forms identify his subjects as gross and excessive. In this painting both the background and the subject are pushed forward, so that there is little feeling of space.

8.17 Martial Raysse, *A Sweet and Simple Picture*, 1965. Mixed media/collage on canvas, 6 ft 4¾ in x 4 ft 3¼. Collection André Mourgues, Paris.

This is a parody of a sentimental painting showing the mythical lovers, Cupid and Psyche, by the French Neoclassical artist Pierre-Paul Prud'hon. It is tame by comparison with the best American Pop, underlining the fact that the Pop manner never really took root in Europe.

POP PAINTING IN CONTINENTAL EUROPE

Pop art did not travel successfully outside the borders of the United States. Attempts to create an equivalent for it in Europe (except for the independent Pop style which flourished for a while in London) were in general weak and compromised, when compared with American originals. The work of French Pop painters such as Martial Raysse (1936–) was extremely self-conscious and the imagery, more often than not, was a limp parody of established icons of high culture. *A Sweet and Simple Picture* (FIG. 8.17), one of Raysse's best-known paintings, is a version of a celebrated work by the Neoclassicist, Pierre-Paul Prud'hon (1758–1823), which shows Cupid embracing Psyche. Raysse attempts to lend a touch of Modernist zip to this mythological scene by giving Cupid a small heart in neon tubing to hold.

POP ART IN LATIN AMERICA

Latin America was also unpropitious soil for Pop, though for slightly different reasons. The nations of Latin America in the 1960s still enjoyed an essentially preindustrial culture. Even those goods which were produced in series, and in quantity, tended to be made by hand, in small workshops, rather than by machinery, in factories. There are, however, two important Latin American artists who, if not fully and undoubtedly Pop, made work with a Pop flavor. One is the

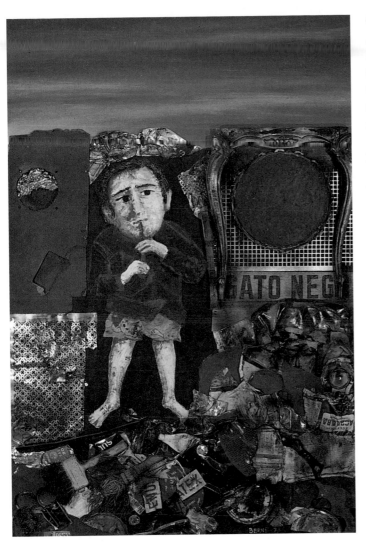

8.19 Antonio Berni, *J. Playing the Flute*, 1973. Collage, 5 ft 3 in x 3 ft 5⅜ in (1.6 x 1.1 m). Private collection.

This ambitiously scaled collage painting comes from Berni's most famous series, which shows scenes from the life of Juanito, a poor boy from the slums of Buenos Aires.

Colombian, Fernando Botero (1932–), another the Argentinian, Antonio Berni (1905–81). Since Botero lived in New York for ten years, starting in 1960, it is not surprising that his work was affected by the Pop ethos. His "fat" figures (FIG. 8.18) were at this stage in an early phase of development, and his handling of paint was freer and looser than it was to be subsequently. Some of his compositions derived from European masterworks, such as Rubens's portrait of his wife, Helene Fourment, and from Latin American paintings of the colonial period, but he also produced images based directly on Latin American contemporary life. In all of these the swollen, rubbery quality of the figures seems to be not purely and simply a formal device (which Botero's statements might lead one to believe), but an instrument of democratization. It helps to break down the barrier between "high art" and its demotic siblings—for example, the representations found in newspaper caricatures. In this respect there is a kind of cousinhood between Botero and Lichtenstein. Botero's fatness serves the same purpose as the conventions Lichtenstein borrowed from comic strips—it supplies a pictorial grammar, and is at the same time an effective vehicle for irony.

Berni, who spent his career largely in Argentina, though with a period of study in Europe in the late 1920s, had a career which passed through many phases, from Surrealism to Social Realism. His final phase began in 1958 with the invention of two fictional characters, Juanito Laguna, a poor boy from the slums, and Ramona Montiel, a prostitute. Their experiences and adventures were represented in a series of elaborate collage-paintings, which make use of rags, slats from old packing-cases, crushed cans, and rusty bits of metal (FIG. 8.19). By surrounding his protagonists with industrial detritus—the legacy of the industrial nations of the world to Latin America—Berni dramatized the relationship between the two cultures. His work is popular in the sense that it is directly communicative—Juanito even became the hero of tango-lyrics—but quite unlike the art of, say, Andy Warhol, because of its strong element of moral indignation.

OTHER AMERICAN PAINTING

Photorealism

Pop Art's predestined successor seemed to be the Photorealism (sometimes also called Super Realism) which flourished in the United States in the late 1960s. Like Pop painting, Photorealism was a figurative style which depended, not on direct observation of the external work, but on photographic source material. Imagery was meticulously reproduced, either from high-quality color printing (postcards, for instance, or illustrations found in travel brochures) or from actual photographs.

The Photorealist approach to figuration was more complex than it seemed at first sight. There were three elements. First, the artist could decide to treat his source as a kind of "readymade" in the manner of Duchamp, and reproduce it as literally as he could. This was the choice made by Malcolm Morley (1931–), whose method was to square up his canvas, cover all the areas except the one he

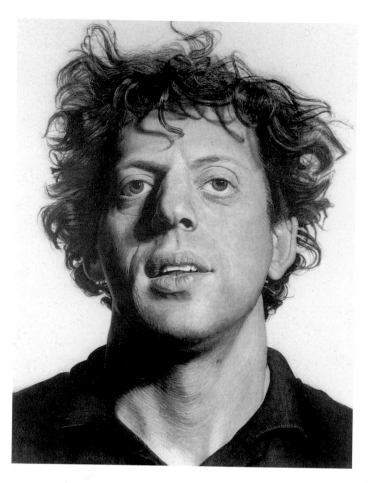

was actually working on, then reproduce his chosen image square by square, never knowing how accurate the result would be until the painting was finished.

Chuck Close (1941–) made paintings which were greatly enlarged versions of snapshot photographs of friends—heads shown frontally (FIG. 8.20). In painting these heads, Close was careful to reproduce all the aberrations peculiar to the camera, such as the way in which, when a wide aperture is used, the volume of the head is divided into separate zones of focus. This led commentators to suggest that Close was "much more involved with the systematization and codification of information than he [was] with the actual image."[3] The artist himself, however, rejected this, retorting that "the way in which you choose to make something influences the way it looks and therefore what it means." His aim, he said, was simply "to rip the imagery loose from the context"[4]—to challenge the spectator's vision of reality.

Other Photorealists, such as Ralph Goings (1928–), admitted that the actual subject-matter was indeed primary in their work. Brought up and trained in California, Goings's earliest Photorealist paintings (a series begun in 1969) were of pick-up trucks (FIG. 8.21). The first was made in response to a request for a view of Sacramento for a group show. A pick-up truck in a supermarket parking lot seemed to him a perfect reflection of the locality and its lifestyle. Behind this, however, lay a more general impulse to "step back and let the thing stand for itself."[5]

Photorealism enjoyed a brief international success (it was heavily featured in the Kassel Documenta exhibition of 1972) and then moved out of the mainstream to become an isolated sub-style, favored by many private collectors, but little discussed by critics. It still flourishes in the 1990s.

8.20 (above) Chuck Close, *Phil*, 1969. Synthetic polymer on canvas, 9 x 7 ft (2.74 x 2.13 m). Whitney Museum of American Art, New York. Purchase with funds from Mrs. Robert Benjamin 69.62.

This Photorealist image is based on a greatly enlarged snapshot of the composer, Philip Glass. The consistent elements of Close's style have been largeness of scale and a strict adherence to "warts and all" veracity.

8.21 Ralph Goings, *Burger Chef*, 1970. Oil on canvas, 3 ft 4 in x 4 ft 8 in (1.02 x 1.42 m). O.K. Harris, New York.

Goings was inspired to paint pick-up trucks because he saw them as typical of an aspect of American middle-class life. The paintings were made from photographs and they retain a photographic clarity of surface.

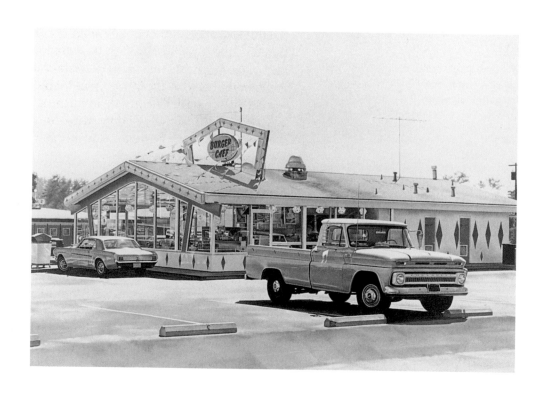

8.22 Frank Stella, *Fez*, 1964. Acrylic on canvas, 7 ft 4½ in x 7 ft 4¼ in (2.24 x 2.23 m). Leo Castelli Gallery, New York.

In the first years of his career Frank Stella painted nothing but hard-edged stripes, sometimes, innovatively, on shaped canvases. He was inspired, he said, by Jasper Johns's flag paintings. "The thing that struck me most was the way he stuck to the motif ... the idea of stripes—rhythm and the interval—the idea of repetition. I began to think a lot about repetition."

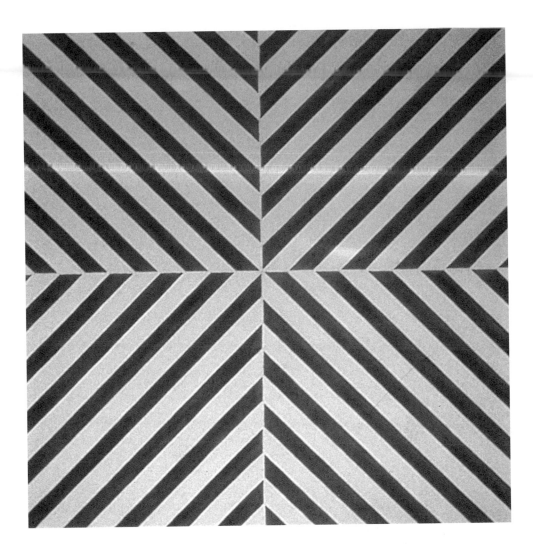

Minimal Abstraction: Frank Stella

In retrospect, the tendency toward Minimal Abstraction in painting was as important a feature of the American art of the 1960s as the proliferation of Pop imagery. One example of this new Minimalism, born simultaneously with Pop, can be found in the early work of Frank Stella (1936–). The paintings which established Stella's reputation were shown in a survey exhibition entitled simply "Sixteen Americans," held at the Museum of Modern Art in 1960. They were all black, patterned with parallel stripes of uniform width—2½ inches (6.35 cm)—chosen to echo the width of the wooden strips used for the picture support. A little later, Stella executed further series of stripe paintings (FIG. 8.22), typically in aluminum, copper, and magenta paint. With these, Stella sometimes made use of shaped supports. This emphasized the idea already present in the black paintings, as it had been in the work of Morris Louis, that the works were completely independent, nonrepresentational objects, added to a world already filled with objects, which now had to move over to make a place for them.

Robert Ryman and Agnes Martin

A striking feature of Stella's early paintings is the narrowness of their discourse—they do have a "subject" of a kind, but this subject is aesthetic perception and the way in which it operates. There is a similar narrowness in the work of other American abstractionists of the time. Robert Ryman (1930–) in his all-white canvases (FIG. 8.23) concerned himself with the quality of the paint itself, and the way in which it reacted to different surfaces. He has used a wide variety of materials

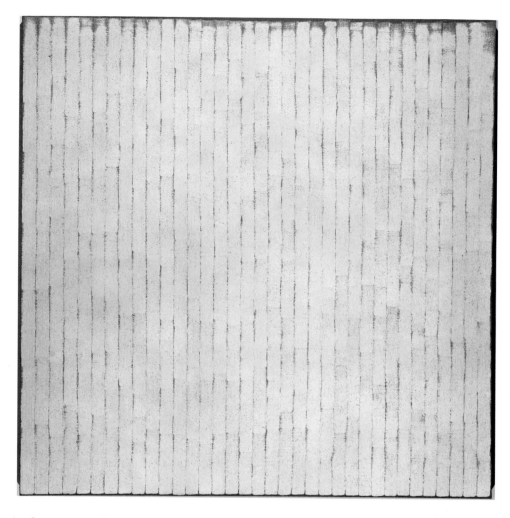

8.23 Robert Ryman, *Windsor 6*, 1965. Oil on linen, 6 ft 4 in x 6 ft 4 in (1.92 x 1.92 m). Courtesy of Marc Blondeau, Paris.

Ryman took Minimalism almost to its outer boundaries, abandoning any interest in composition, forms, or colors for pure experimentation with the very material and texture of paint itself.

8.24 (*below*) Agnes Martin, *Night Sea*, 1963. Gold leaf and oil on canvas, 6 x 6 ft (1.8 x 1.8 m). Private collection.

in the course of this search for elusive nuances—unstretched as well as stretched canvases, handmade rag paper, plastic, matt paint on steel, baked enamel on copper. Agnes Martin (1908–), though much older than either Ryman or Stella, was a late starter, and did not hold her first solo show until 1958. Her all-over grid paintings fit the ethos of the 1960s better than they do anything that happened earlier. Her fine lines, pencilled on monochrome oil or acrylic grounds, are at first glance barely perceptible—the spectator's difficulty in focusing on them, that is, in really "seeing" them, is a large part of their point, since their true subject is perception itself, the reaction the surface of a painting produces on the retina (8.24).

OPTICAL PAINTING

Josef Albers

Martin's work, though never officially classified as such, is close to what the critics of the 1960s labeled Op Art—in their eyes Op was a kind of abstract equivalent for Pop. In fact, it was never an art movement in the same sense as Pop, though it was a way of making paintings with a rich and interesting pedigree of its own—one which stemmed from experiments made at the Bauhaus forty years earlier. One of the chief links between the world of the Bauhaus and avant-garde developments in the post-World War II period was Josef Albers

8.25 Josef Albers, *Green-Gray Shield* (from *Homage to the Square*), 1959. Oil on hardboard, 24¼ x 24¼ in (61 x 61 cm). Musée National d'Art Moderne, Paris.

In a long series of paintings and prints entitled *Homage to the Square*, begun in 1949, Albers conducted a minute investigation into color and color relationships, turning out exquisite compositions in tightly controlled space.

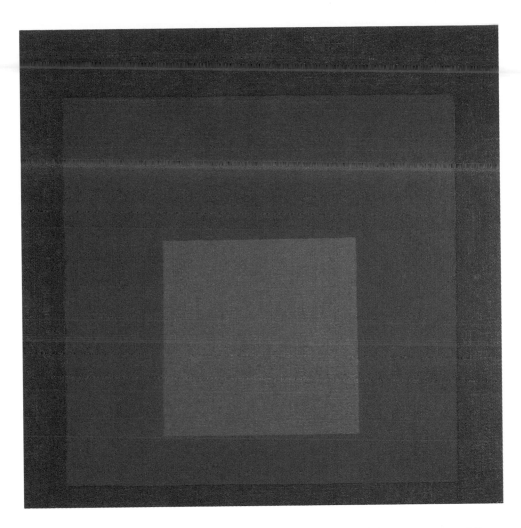

8.26 (*below*) Bridget Riley, *Current*, 1964. Synthetic polymer on board, 4 ft 10¼ in x 4 ft 10⅝ in (1.48 x 1.49 m). Museum of Modern Art, New York.

Bridget Riley's early optical canvases are in black and white (though illusions of color are created), but they nevertheless contain echoes of events in the natural world, such as the movement of wings or water.

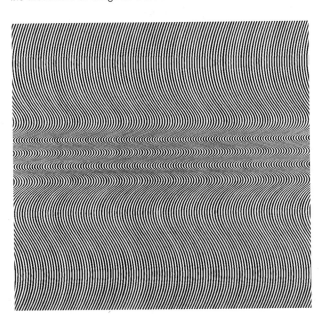

(1888–1976), first a student at the Bauhaus and then one of the instructors. Albers emigrated to the United States in 1933, and in the 1940s he became increasingly interested in the effects which could be produced by the manipulation of color. By the 1960s he had embarked on the long-drawn-out *Homage to the Square* series (FIG. 8.25), which is his final achievement.

These compositions are in one sense formally inert. Each consists of one square set within another, in a square canvas. Albers gives them dynamism by exploiting the laws of color harmony and color contrast, so that the innermost square seems either to advance or recede. Often the relationship of hues is manipulated so that the central area switches unpredictably from advancing to receding.

Bridget Riley

Similar effects can be found in the black-and-white canvases done in the 1960s by the British artist, Bridget Riley (1931–). Riley's sources included not only the experiments made at the Bauhaus, but Italian Futurist painters such as Boccioni and Balla, and the great French Neoimpressionist, Georges Seurat, of whose work she made an intensive study when she was a student. Unlike that of Albers, her work often seems to render natural forces, such as the flow of water, without making specific landscape references. Unlike American Minimal Abstraction, Riley's paintings bring to mind ideas and sensations which go well beyond the boundaries of pure aesthetic theory (FIG. 8.26).

THE REVIVAL OF FIGURATIVE PAINTING IN EUROPE

In this sense, Riley was more in step with events in Europe than with what was happening in the United States. In Europe, the decade saw a revival of a much more traditional kind of figurative painting than the blank, unemotional figuration association with Pop. This initially escaped the attention of American critics because it took place most powerfully in Germany. The art of the German Democratic Republic (DDR) was considered to be in thrall to Marxism, therefore intrinsically negligible; that of the larger and more prosperous Federal Republic (FDR) was still thought of as hopelessly eclectic.

The Communist-controlled DDR looked, after the war, for a kind of official art which was untainted by Nazism. This prevented the cultural authorities from opting for Socialist Realism, the only kind of pictorial expression officially permitted in the Soviet Union. Instead, they backed a tepid revival of Expressionism, on the grounds that it had been the style most reviled by the Nazis.

Georg Baselitz

Such was the backdrop for the emergence of Georg Baselitz (Georg Kern, 1938–). Born in East Germany, Baselitz studied painting in East Berlin, at the Hochschule für Bildende und Angewande Kunst, before moving to the Western sector of the city in 1957. Rebellious in an East German context, Baselitz proved equally so in the Federal Republic, issuing two "Pandemonium" manifestos (jointly with the painter, Eugen Schönbeck), and exhibiting brutally erotic paintings which (in 1963) led to a prosecution under the local obscenity laws. The most notorious of these canvases, *Big Night Down the Drain* (FIG. 8.27), shows a male figure, perhaps intended as a self-portrait, masturbating.

Baselitz's work at this period "sets out to combine extreme physicality with disintegration."[6] It shows the influence, not only of German Expressionism of the years before World War I, but of sources which had influenced Jean Dubuffet—graffiti and the art of the mentally insane. Its literary sources, equally important, were the hallucinatory writings of the French poet, Lautréamont (a mentor of the Surrealists) and of Antonin Artaud, the theoretician of drama responsible for the phrase "the Theater of Cruelty." Violent, literary, and totally subjective, Baselitz's work of the 1960s stands at the opposite extreme to the cool emotional detachment of Pop Art.

Frank Auerbach

Equally opposed to Pop was the quasi-Expressionist work being done in Great Britain by a group of painters who had been pupils of David Bomberg. The most prominent of these was Frank Auerbach (1931–). Born in Germany, Auerbach arrived in Great Britain as one of the Jewish children rescued at the last minute from the Holocaust. He came without his family, whom he never saw again and now scarcely remembers. His work (FIG. 8.28), especially in these early years, is about feelings of isolation, and about the impossibility of seizing reality. Giacometti reacted to similar feelings by whittling the figure away until it became ghostlike, as immaterial as it was possible for a sculpture to be (see FIG. 6.25). Auerbach went in the opposite direction, piling up his paint in thick, tangled skeins:

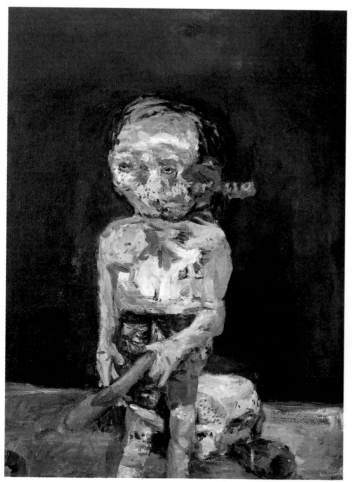

8.27 Georg Baselitz, *Big Night Down the Drain*, 1962–3. Oil on canvas, 5 ft 3¾ in x 4 ft 3¼ in (1.62 x 1.3 m). Museum Ludwig, Cologne, Germany.

The violence of Baselitz's brushwork and the unrelieved emotionalism of his paintings reveal a debt to the paintings of Die Brücke artists such as Nolde and Kirchner (see FIGS 2.20 and 2.21).

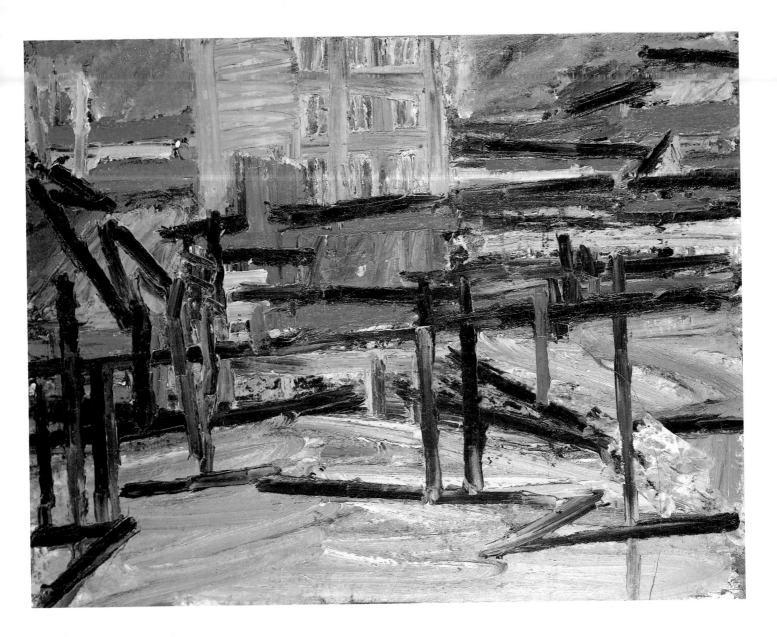

8.28 Frank Auerbach, *Mornington Crescent, Winter*, 1967–9. Oil on board, 3 ft 9¼ in x 4 ft 7½ in (1.15 x 1.41 m). Private collection.

Auerbach's views of Mornington Crescent in London are reminiscent of the work of Walter Richard Sickert (1860–1942), leader of the Camden Town School, and of David Bomberg (see FIG. 7.37).

The sense of corporeal reality [Auerbach once said], that's what matters. English twentieth-century paintings tends to be thin, linear and illustrative. I wanted something different; I wanted to make a painting that, when you saw it, would be like touching something in the dark.[7]

The desire to make something with real solidity meant that Auerbach was an extremely slow worker. Some paintings of this period in his career required more than three hundred sittings.

OTHER MOVEMENTS OF THE SIXTIES

Expressionism in Latin America

Art in parts of Latin America also went through an Expressionist phase during the 1960s. In Mexico, this was part of the long-delayed revolt against the Muralist movement (though it is possible to see Expressionist elements in the work of Orozcó and Siqueiros).

The artistic champion of the anti-Muralist cause, and initiator of the so-called "Ruptura" which changed the nature of Mexican art, was José Luis Cuevas

(1934–). Cuevas was supported by the Colombian critic, Marta Traba, founder of the Museum of Modern Art in Bogota, and author of the influential book, *Los cuatro monstruos cardinales* ("The Four Cardinal Monsters"), published in Mexico City in 1965. Her four "monsters" were Cuevas himself, de Kooning, Bacon, and Dubuffet, and the intention of the book was to wrench Latin American art away from the "indigenist" tradition and return it to the European and North American mainstream.

Cuevas, primarily a draughtsman rather than a painter, worked in the tradition of Goya. His drawings rendered what he saw around him—the poor, homeless, diseased, and disfigured inhabitants of a rapidly growing Third World metropolis—in a style which pushed what he took from Goya toward Expressionist subjectivity (FIG. 8.29).

Argentina and "Otra Figuracíon"

In Argentina, the Expressionist cause was taken up by a group of young painters called "Otra figuracíon" ("Other Figuration"), founded in 1961. Here, too, the influence of "traditional" Expressionism seemed to mingle with that of de Kooning, Bacon, and Dubuffet. The most gifted, and most experimental, member of the group was the short-lived Jorge de la Vega (1930–71). His work has two striking features. In the first place he makes use of radical distortion, so that the imagery is often only barely legible at first glance. One series of paintings, made in the 1960s, is called *Anamorphosis*, an anamorphosis being an image which is recognizable only when it is viewed from a particular, oblique angle. The artist may have taken the idea for this from Old Master sources, such as the German Renaissance master, Hans Holbein, and he may also have been influenced by the artists of the northern European Cobra Group—Argentinian art maintained at least as many contacts with Europe as it did with the United States. The other highly original element in De la Vega's paintings was

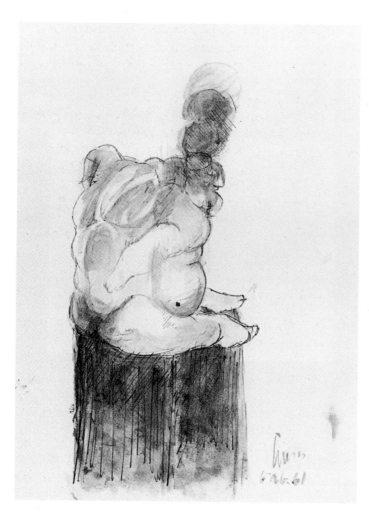

8.29 (above) José Luis Cuevas, *Man on a Stool*, 1961. Ink on paper, 9 x 6¾ in (22.8 x 17.1 cm). Tasende Gallery, La Jolla, California.

Cuevas's paintings and drawings of the 1960s show the poor, diseased, and disfigured inhabitants of Mexico City—a continuation of the socially committed tradition of Mexican Muralism.

8.30 Jorge de la Vega, *And Even in the Office*, 1965. Oil, mixed media on canvas, 4 ft 3¼ in x 6 ft 7½ in (1.3 x 2.02 m). Jorge and Marion Helft Collection, Buenos Aires.

De la Vega's work brings together disparate elements in a way that is reminiscent of Robert Rauschenberg's "combine-paintings" (see FIG. 7.22).

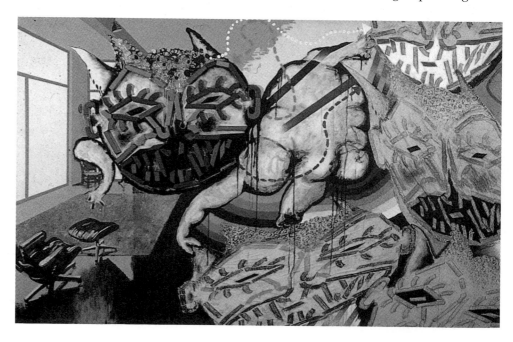

his use of collage (FIG. 8.30), which he employed in a way quite different from that used by his compatriot, Berni, bringing together unexpected and disparate elements in a manner reminiscent of Robert Rauschenberg's combine paintings.

"New Realism" in France and Yves Klein

The detritus produced by modern urban civilization was also an important feature of the work of a number of leading artists who belonged to the "New Realism" group founded by the French critic, Pierre Restany, in 1960. At the time, this group was seen as a European equivalent for North American Neo-Dada, also perhaps as a last desperate effort to snatch the leadership of the avant-garde from New York and return it to what still seemed (especially to Frenchmen) its rightful habitat in Paris. Arman (Pierre Armand, 1928–) made his reputation with accumulations of everyday objects, first chosen apparently at random, then featured as examples picked from a single category. The results were rather simplistic condemnations of the consumer society, even though Restany announced in his founding manifesto that "the new realism registers the sociological reality without any controversial intention."

In hindsight, a much more important figure in the group was Arman's childhood friend, the short-lived Yves Klein (1928–1962). Klein's work is Dadaist in the sense that it contains an element of nihilism. In 1958, for example, he staged an exhibition which consisted of a completely empty gallery, with hired Republican Guards stationed outside the door for the opening. It does not, however, have many obvious links with Pop. Much of what he did originated from distinctly esoteric sources. He was, for example, fascinated by the Rosicrucians. He was also an expert in judo (which he studied very seriously in Japan), and through judo became interested in the doctrines of Zen Buddhism. It is Zen which seems to have inspired his wish (as he put it) to "get away from the idea of art." Klein said:

> The essential of painting is that something, that "ethereal glue," that intermediary product which the artist secretes with all his creative being and which he has the power to place, to encrust, to impregnate into the pictorial stuff of the painting.[8]

He translated this doctine into a series of monochrome paintings, often featuring the hue he patented as "International Klein Blue" or IKB. The powdery surfaces of these works (FIG. 8.31) suggest a different, more transcendental, approach to the idea of minimality than that found in the early work of Stella, or even in the white paintings of Robert Ryman.

Klein was a gadfly and all-round provocateur. His notoriety was greatly enhanced by such things as the public "painting ceremonies" he organized. In these, nude girls smeared with blue paint flung themselves, under the artist's direction, on to canvases spread on the floor, accompanied by Klein's *Monotone Symphony* in which a single note sustained by twenty musicians for a period of ten minutes alternated with ten minutes' silence.

Piero Manzoni

Another short-lived provocateur who flourished in the early 1960s was the Italian, Piero Manzoni (1933–63). Manzoni's *Lines* (FIG. 8.32)—single unbroken brushstrokes on long strips of paper, afterward rolled up and stored in cardboard tubes—can be seen either as expressions of the strengthening Minimalist impulse, or as playful satires on it. His series, *Merda d'artista*—tins of his own excrement, signed and labeled—offers a direct criticism of the Modernist cult of personality in art.

Neither Klein nor Manzoni made much immediate impression in the United States. Yet they, far more than the stars of Pop, were the true precursors of much that was to take place in the decades that followed. They revived, not merely individual ideas taken from Dada, but its thoroughgoing aesthetic nihilism—a far more radical version of this than one can discover, for example, in the work of Warhol.

Sculpture, Conceptual Art, and Performance

8.32 Piero Manzoni, *Line, 1961*, 1961. Ink on paper, 23⅜ x 19⅜ in (59.7 x 49 cm). Herning Art Museum Collection, Denmark.

Manzoni's paintings have an inherent ambiguity. Are they genuinely Minimalist or do they—in the same way that Roy Lichtenstein's "Brushstrokes" series (see FIG. 8.15) may be read as satires on Abstract Expressionism—poke gentle fun at Minimalism?

The most important development to take place in the 1960s was probably not—at least in the long run—Pop Art, but a radical reassessment of the nature and possibilities of sculpture. Despite the achievements of sculptors such as Brancusi, Henry Moore, Giacometti, and David Smith, sculpture had remained a secondary form of artistic expression. Often, indeed, the most inventive sculpture had been the work of artists, notably Picasso and Matisse, who thought of themselves primarily as painters. Now, it gradually eased itself into a position of artistic leadership. As it did so, it shed certain characteristics, or at any rate de-emphasized them, and put increasing stress on others. Above all, the accepted definition of sculpture became more and more inclusive. By 1969, when Gilbert and George (Gilbert Proesch, 1942– ; George Passmore, 1943–) created *Underneath the Arches* (FIG. 8.33), a piece they described as "a singing sculpture," the word could be applied to almost any form of artistic creation or activity. *Underneath the Arches* consisted of the two artists, both in stiff business suits with their faces and hands painted gold, standing on a table and moving with stiff, marionette-like gestures to the sound of a tape-recorder placed underneath it, which played the Flanagan and Allen song of the title. Gilbert and George said that there was no boundary between art and life, and that all their everyday activities counted as "sculpture."

Assemblage

The sculpture of the 1960s pursued a somewhat tortuous course to reach this point. One major step forward was the "Art of Assemblage" exhibition at the Museum of Modern Art, New York, in 1961. In his catalogue introduction, the curator of the exhibition, William Seitz, remarked that:

The current wave of assemblage … marks a change from a subjective, fluidly abstract art towards a revised association with the environment. The method of juxtaposition is an appropriate vehicle for feelings of disenchantment with the slick international idiom that loosely articulated abstraction has tended to become, and the social values that this situation reflects.[9]

Though the artists he was concerned with, such as John Chamberlain, were already established in the 1950s, Seitz offered a new interpretation of what they did.

Anthony Caro

Meanwhile, one British sculptor, with the support of the leading American critic, Clement Greenberg, was making a considerable impact on the world of American art. This was Anthony Caro (1924–). Caro had begun his career as a figurative Expressionist, but was converted to abstraction by the work of David Smith (see FIG. 7.40). In the mid-1960s he spent further periods teaching in America. His sculpture, like Smith's, was made of prefabricated metal parts, welded together, and usually, at this stage of his development, painted some unifying color. His work differed from Smith's in several important respects. Whereas Smith's later work usually (though not invariably) had a vertical emphasis, and often seemed to include vestigial references to the human figure, Caro's was groundhugging, and more purely abstract. The sculptures were set directly on the ground—all traces of the plinth, a traditional feature of monumental sculpture which served to separate it from its environment, disappeared. Unlike the sculptures made by Henry Moore and his followers, Caro's work was most effective in an enclosed setting, where it could control the whole of the visible space, rather than in the open air (FIG. 8.34).

Minimal Sculpture

Despite Caro's success in America his work was strikingly different from most of the native product. American sculpture of the 1960s can be divided into two very different streams of development—Minimal forms, and the Pop object. The pioneer of the unitary, completely Minimal, sculptural object was Tony Smith (1912–), who had

8.33 (*above*) Gilbert and George, *Underneath the Arches (The Singing Sculpture)*, 1970 (first performance, 1969). Mixed media, life-sized. Anthony d'Offay Gallery, London.

This "living sculpture" (a performance piece) first made the two artists notorious. On such "sculptures" Gilbert and George broke down distinctions between art and life and between one art form and another.

8.34 Anthony Caro, *Early One Morning*, 1962. Painted steel, 9 ft 6 in x 20 ft 4 in x 11 ft (2.90 x 6.20 x 3.35 m). Tate Gallery, London.

This work by Caro shows the affinities between his work and that of David Smith.

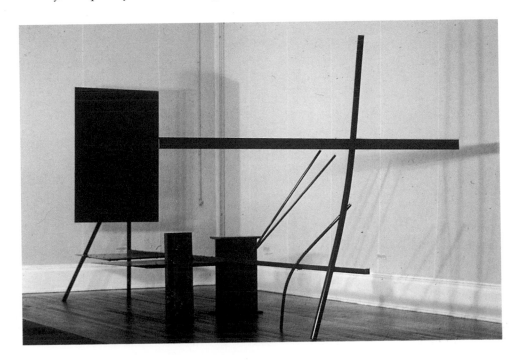

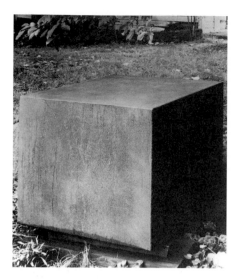

8.35 Tony Smith, *Black Box* (edition of three),1962. Steel, 22½ x 33 x 25 in (56.9 x 83.5 x 63.3 cm). Paula Cooper Gallery, New York.

This is an early example of Minimalism, based on the proportions of a small box for filing cards. Smith was one of a group of sculptors, sometimes called "Primary Structurists," who followed in the footsteps of David Smith (see FIG. 7.40) and produced even more simplified geometric forms seemingly bereft of narrative or spiritual content.

served as the clerk of works in Frank Lloyd Wright's studio, and who continued to practice as an architect until the beginning of the 1960s. He abandoned architecture because he felt that buildings were too impermanent, and too vulnerable to alterations which would betray the creator's intention.

His sculptures are made of very simple forms, usually rectangular boxes fitted together, sometimes linked or varied by using tetrahedrons. Sometimes the box was allowed to stand on its own. The most notorious example is *Black Box* (FIG. 8.35), suggested by a box of index cards seen standing on a friend's desk. Having obtained the dimensions, Smith multiplied these by a factor of five, made a drawing, took it to an industrial welding company, and told them to make it up.

What is significant here is not merely Smith's disregard for the idea of the handmade, but his interest in an object which could be seen as something which existed in isolation, and, simultaneously, as part of a continuous space-grid. "In the latter [he noted], voids are made up of the same components as the masses. In this light they may be seen as interruptions in an otherwise unbroken flow of space."[10]

The idea that the reduced, Minimal form works most powerfully as part of a sequence of forms, real or imaginary, reappears in the work of two of the best-known American Minimal sculptors, Donald Judd (1928–93) and Sol LeWitt (1923–). Judd's work often consists of sequences of rectangular boxes strung out at regular intervals across the surface of a wall (see FIG. 8.37). LeWitt's sculptures characteristically offer variations on the theme of open and closed cubes, arranged in absolutely regular configurations (FIG. 8.36). There was the implication that Minimal sculptures existed more fully in the mind of the spectator, as excerpts from a pattern of ordering that could be extended to embrace the entire world, than they did in reality.

Earth Art

Minimal Art spawned Earth Art, which, in its first phase, was simply Minimalist thinking expressed on a gigantic scale. An example is *Displaced/Replaced Mass* (FIG.

8.36 Sol LeWitt, *Untitled Cube (6)*, 1968. Painted steel, 15¼ x 15¼ x 15¼ in (38.7 x 38.7 x 38.7 cm). Whitney Museum of American Art, New York.

Sol LeWitt's cubes of the mid-1960s—done in painted wood, steel, or aluminum—rely for their effect on the essential ingredient of many Minimalist works: the repetition of identical units.

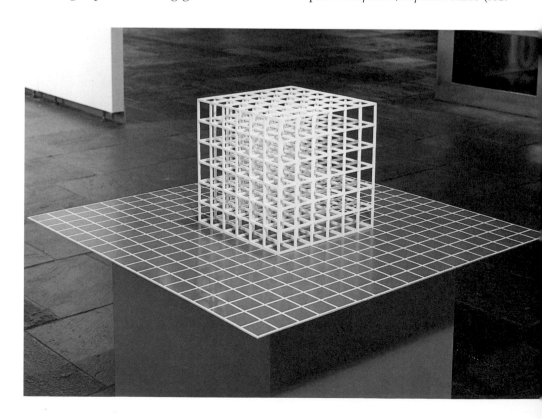

Donald Judd: *Untitled 1967*

The work of the leading Minimal sculptor, Donald Judd, is not individuated in the fashion familiar from more traditional kinds of art. Most of his sculptures (FIG. 8.37) closely resemble one another, and appear to be making identical statements about the nature of the sculptor's activity. A powerful critic and theorist, and an aggressive defender of his own work, Judd championed these sculptures on the grounds that "actual space is intrinsically more powerful and specific than paint on a flat surface,"* —a remark which gained additional cogency from the fact that Judd, like David Smith, had actually begun his career as a painter. Toward another theoretical aspect of Minimalism—the idea that Minimal sculptures existed more fully in the mind of the spectator, as excerpts from a pattern of ordering which could be extended to embrace the entire world, than they did in reality—Judd was less friendly. The notion seemed to contradict two of his most cherished doctrines: that the whole, in any successful artwork, was always greater than the parts, and that the multiplication of elements invariably weakened the effect, unless these elements were so exactly similar as to preclude the idea of contrast. "My things," he said, "are symmetrical because ... I wanted to get rid of any compositional effects, and the obvious way to do it was to be symmetrical."† Judd thought of what he did as something specifically American, and of Minimalism as something which confirmed the hegemony of American art. "I'm totally uninterested in European art and I think it's over with."§ Seen from the more detached perspective of the late 1990s, his work seems to represent the extreme development of the notion that art alone could now provide legitimate subject-matter for art.

* Donald Judd, "Specific Objects," *The Art Digest (Arts Yearbook 8)*, 1965, p. 79.
† Bruce Glaser, "Questions to Stella and Judd," *Art News*, September, 1966, p. 56.
§ *Ibid.*, p. 57.

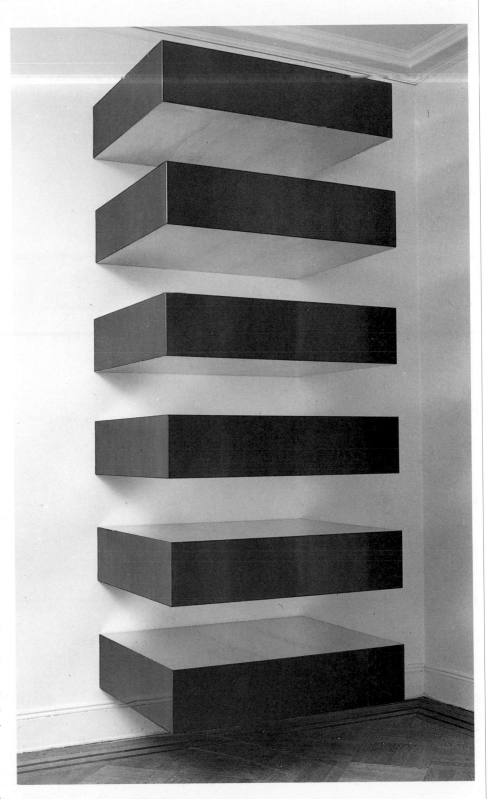

8.37 Donald Judd, *Untitled 1967*, 1967. Galvanized iron, green lacquer on front and sides; 10 units, each 9 x 40 x 31 in (22.8 x 101.2 x 78.4 cm). Leo Castelli Gallery, New York.

8.38 Michael Heizer, *Displaced-Replaced Mass, No.1/3*, 1969. Granite and concrete in playa surface, 100 ft x 800 ft x 9 ft 6 in (30.48 x 243.84 x 2.89 m). Silver Springs, Nevada (dismantled). Commissioned by Robert Scull.

8.38) by Michael Heizer (1944–), where—as the title suggests—an immense block of stone has been excavated from the ground, and then returned to it. Earth Art was not, however, a purely American phenomenon. Because of its direct connection with nature, it exercised a far greater appeal in Great Britain than other aspects of American Minimalism. British artists, such as Richard Long (1945–), made work which had a visible link with British Romanticism, offering a Modernist equivalent to the work of Romantic painters such as Samuel Palmer. Like the original Romantics, Long often concerned himself with transitory effects, altering the landscape in a purely ephemeral way, rather than undertaking the massive works favored by the Americans (FIG. 8.39). These interventions were, during the following decade, to lead to a much more complex interaction with nature, in keeping with a change in the cultural climate which led artists to react against industrial civilization.

8.39 Richard Long, *A Square of Ground*, 1966. Painted plaster, 3⅜ in x 9⅛ x 3⅜ in (8.5 x 23.1 x 8.5 cm). Anthony d'Offay Gallery, London.

Conceptual Art: Joseph Kosuth

The idea of the minimal was taken a step further in the Conceptual installations of Joseph Kosuth (1945–). Kosuth's *One and Three Chairs* (FIG. 8.40) offers a photographic image of a wooden folding chair, a wall panel with the dictionary definition of a chair, and finally the chair itself. Kosuth is here asking his audience where the true identity of the object is to be found—in the representation, the verbal description, or the thing itself. Though there is, obviously, something to be "seen" in this artwork, its essence lies, not in sensual stimulus, or even in a pattern of relationships of form, but in an intellectual design which the artist hopes to create in the mind of the spectator.

8.40 Joseph Kosuth, *One and Three Chairs*, 1965. Wooden folding chair, photographic copy of a chair, and photographic enlargement of a dictionary definition of a chair; chair, 32⅜ x 14⅞ x 20⅞ in (82 x 37.8 x 53 cm); photo panel, 36 x 24⅛ in (91.5 x 61.1 cm); text panel, 24 x 24⅛ (61 x 61.3 cm). Leo Castelli Gallery, New York.

No artist was more purely Conceptual than Kosuth, who in this piece presents its three elements as both representational objects and different interpretations of what is meant by the word "chair." Curiously, Jasper Johns raised similar questions (see FIGS 7.20 and 7.21).

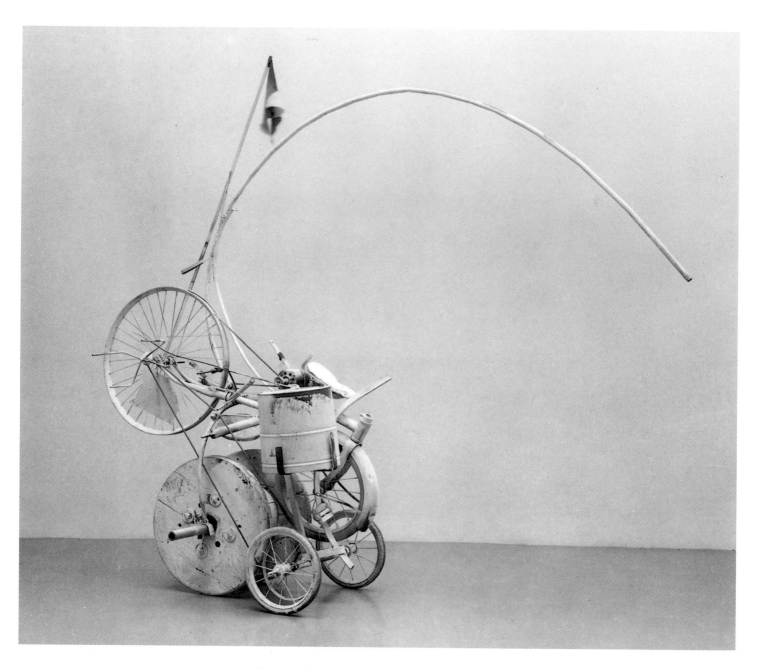

8.41 Jean Tinguely, *Fragment from Homage to New York*, 1960. Painted metal, wood, and cloth, 6 ft 8¼ in x 2 ft 5⅝ in x 7 ft 3⅞ in (203.7 x 75.1 x 223.2 cm). Museum of Modern Art, New York.

This ramshackle kinetic sculpture, many of whose parts were collected from a New York dump, was designed to be auto-destructive. Before it exploded, its moving parts—wheels, an inflatable weather balloon, vials of smoke, and others—gave a performance.

Kinetic Art

Kinetic sculpture, another characteristic product of the 1960s, was like its close relative, Optical Painting, usually identified by the commentators of the period as generically non-American, as a manifestation of the impulse toward complexity which American artists such as Donald Judd roundly condemned.

Kinetic art can be divided into two schools, passive and active—objects which seemed to move, and those which actually did move. Though the two varieties were usually lumped together by the critics of the time, there were in fact huge philosophical differences separating them.

The sculptures which moved could be either machine-powered or, like the mobiles which Alexander Calder was already making in the 1930s (see FIG. 5.32), move at random in response to the wind or other outside forces. The most typical machine-powered works of the period were those of the Franco-Swiss Jean Tinguely (1925–91), whose juddering constructions were satires on the technological world, very much in the spirit of Dada. Tinguely's most notorious work was his *Homage to New York* (FIG. 8.41), a complex machine set up in the courtyard

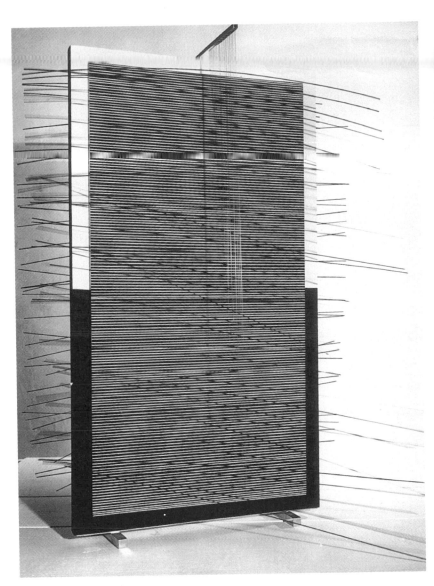

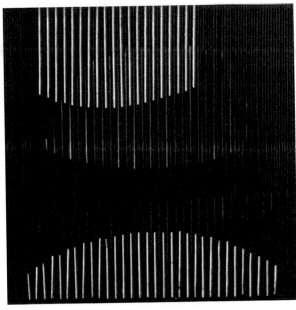

8.42 (*above*) Carlos Cruz-Diez, *Physichromie No. 1*, 1960. Cardboard on wood, 20 x 20¾ in (50.8 x 52.9 cm). Private collection.

8.43 (*left*) Jesús-Rafael Soto, *Sculpture 16*, 1968. Wood and metal, 34 x 18¼ in (86 x 46 cm). Private collection.

of the Museum of Modern Art designed to destroy itself once it was set in motion.

A group of artists of largely South American origin, among them the Venezuelans Carlos Cruz-Diez (1923–) and Jesós-Rafael Soto (1923–), both of whom settled in Paris, made three-dimensional works which relied on purely optical phenomena to create an illusion of movement—by the use of moiré patterns, or hanging screens of thin nylon tubes or rods. These constructions had roots in the Constructivist tradition, which had remained strong in Latin America when it was in decline elsewhere. The reliefs and sculptures made by Cruz-Diez and Soto (FIGS 8.42 and 8.43) differed from the established Constructivist norm, however, because they seemed to dematerialize the abstract object, which shimmered and pulsated as if it were about to dissolve at any moment. Thus one can see Conceptual Art on the one hand, and certain kinds of Kinetic sculpture on the other, as different aspects of the same impulse towards dematerialization.

Dan Flavin

There is an obvious link between Kinetic sculptors such as Soto and Cruz-Diez and at least one of the leading American Minimalists, Dan Flavin (1933–). Flavin's material was neon tubing, arranged in simple linear and rectangular configurations, often inspired by the work of reductionist early Modern artists such as Malevich, Tatlin, and Mondrian. The sculptures, so apparently limited in both

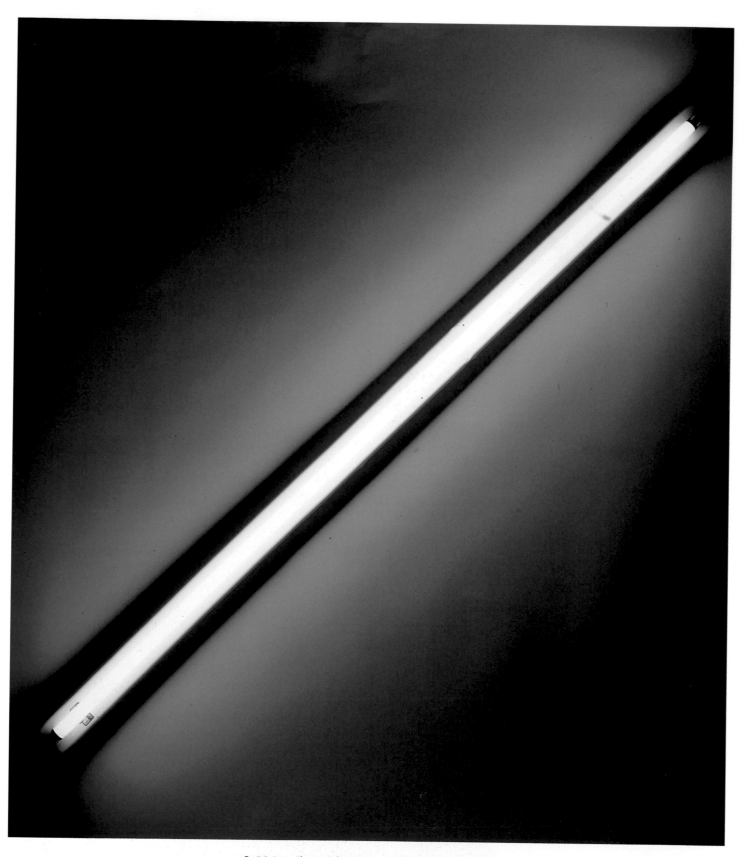

8.44 Dan Flavin, *The Diagonal of May 25, 1963 (To Constantin Brancusi)*, 1963. Green fluorescent light and fixture, 96 x 4½ in (243.8 x 11.4 cm). Margo Leavin Gallery, Los Angeles, California.

Unlike most Minimalist sculptors, who relied on neutral colors like white and gray, Flavin used garish colored light to make sculptures in interior spaces, empty except for chosen fixtures. In comparison to most Minimalist work, they thus achieve an immaterial, evanescent quality.

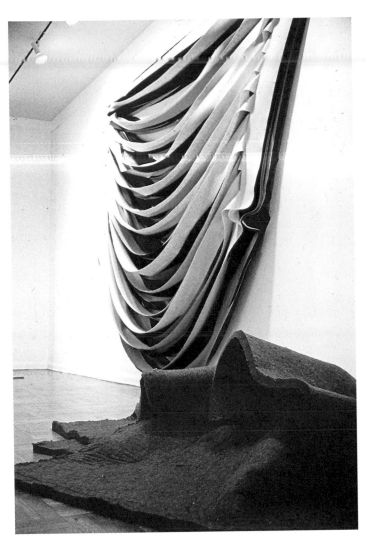

their physical means and their ambitions, look in two different directions. Flavin realized that our perception of light alters our perception of space, and this is the essential subject-matter of his work (FIG. 8.44). Like the kineticists, he trades to some extent in illusion—his sculptures alter the spaces they are in. By using neon, however, illumination associated with advertising signs and urban commercial buildings, Flavin also opened a door between Minimalism and Pop.

Anti-Form

The Minimal impulse in American sculpture soon began to show signs of impatience with the constraints placed upon artists by geometry. Regularity of form itself began to seem like another constraint to be summarily disposed of. One of the artists who moved in this direction was Robert Morris (1931–), with sculptures made of pieces of felt hung up and allowed to find a shape through their own weight (FIG. 8.45). Another was Richard Serra (1939–), who made "corner-pieces" (a term reminiscent of the work of Vladimir Tatlin) out of freely poured molten lead (FIG. 8.46). A similar impulse toward letting the material find its own shape can be found in the art of the German-born, but US-domiciled, sculptor, Eva Hesse (1936–70), whose ladderlike structures, nets, and loops of cord, often combined with other materials such as resin and fiberglass, seem more concerned with metaphorical and psychological allusions than the work of her male colleagues. They reflect a state of mind (often melancholy or anguished) as well as an attitude toward form. The historical links with Constructivism and

8.45 (*above*) Robert Morris, *Hanging Felt*, 1968. Felt, dimensions variable. Leo Castelli Gallery, New York.

This is an example of Minimalist anti-form. Morris does not shape the sculpture himself, or form it, but allows the pieces of felt to find their own forms within the architectural space they inhabit, so that the interior space itself becomes part of the work.

8.46 (*right*) Richard Serra, *Splashing*, 1968. Lead, 18 x 312 in (45.7 x 792.5 cm). Installed Castelli Warehouse, New York, 1968, then destroyed.

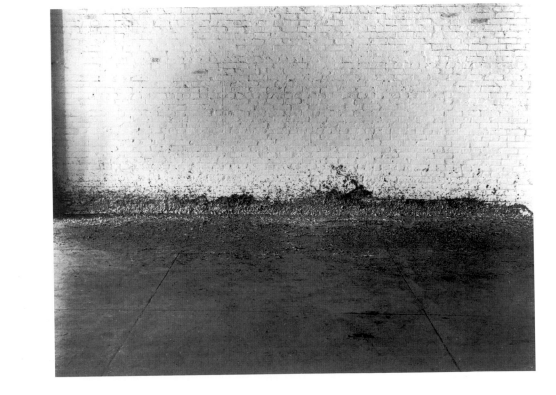

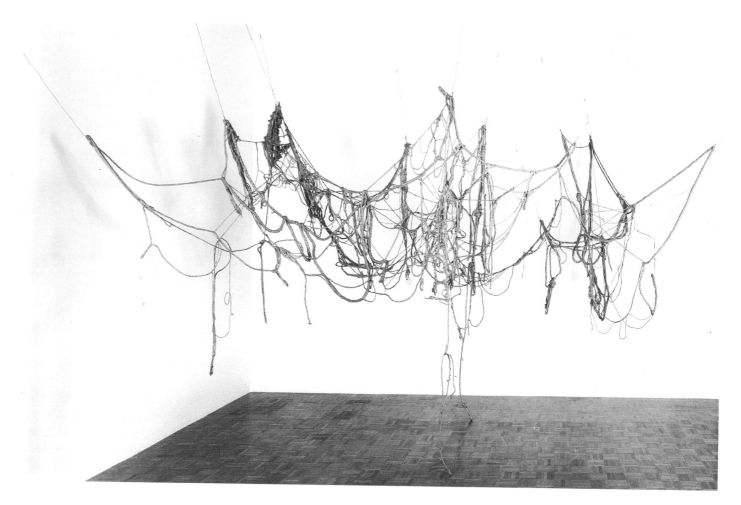

8.47 (above) Eva Hesse, *Untitled (Rope Piece)*, 1969–70. Latex over rope, string and wire, two strands, dimensions variable. Whitney Museum of American Art, New York. Purchased with funds from Eli and Edythe L. Broad, the Mrs. Percy Uris Purchase Fund, and the Painting and Sculpture Committee.

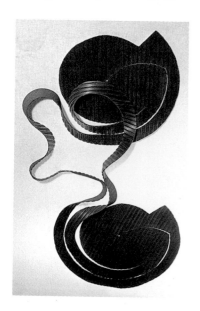

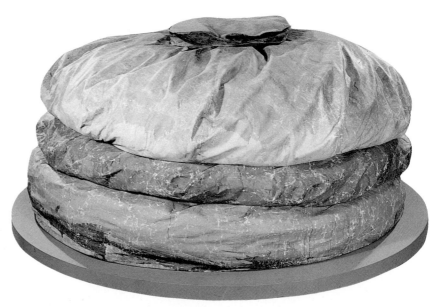

8.48 (left) Lygia Clark, *Rubber Grub*, 1964 (remade by artist in 1986). Rubber, approx. 39⅞ x 15¾ in (100 x 40 cm). Collection Museu de Arte Moderna, Rio de Janeiro, Brazil.

8.49 (above) Claes Oldenburg, *Giant Hamburger*, 1962. Painted sailcloth stuffed with foam, about 4 ft 4 in x 7 ft (1.32 x 2.13 m). Art Gallery of Ontario, Toronto (Purchase, 1967).

Oldenburg felt deeply the need to bring back art into ordinary life after the solemnity and seriousness of Abstract Expressionism. He said: "I am for an art that embroils itself with the everyday crap and still comes out on top."

Futurism, visible in the majority of American Minimal sculptures, is severed, and Hesse seems more like a belated Surrealist (FIG. 8.47).

The metaphorical impulse also shows itself in the sculpture being made in Brazil at this time. The small sculptures produced in the mid-1960s by Lygia Clark (1921–88) are, unlike their American equivalents, completely independent of their setting, and antimonumental as well as being almost infinitely variable in form. Clark made three series of these sculptures (FIG. 8.48), which she called, respectively, *Bichos* ("Machine Animals"), *Repantes* ("Climbing Grubs"), and *Borrachos* ("Rubber Grubs"). The idea was that these sculptures, while remaining completely abstract, were nevertheless living organisms, and that their essentially provisional appearance was part of a collaboration with the spectator, who could interact with the work, and arrange it as he or she pleased.

The Pop Object

The "sculptures" produced by the Pop Art movement look, at first sight, to be very different from those spawned by Minimalism. The giant hamburgers made of vinyl stuffed with kapok produced by Claes Oldenburg (1929–) are related, on the one hand, to objects made by the Surrealists (which, in turn, came from Marcel Duchamp's readymades) and, on the other, to the visual language of American advertising signs (FIG. 8.49). Their function was symbolic; the formal criteria usually applied to sculpture cannot be applied to them, since the value-system they belong to is concerned almost entirely with metaphor and association. Oldenburg was to show himself remarkably adept in manipulating values of this kind. His *Soft Eggbeaters* transforms a familiar domestic appliance into a louche sexual symbol. Despite the apparent gulf between Oldenburg's work and Minimalism, there were certain intriguing links between the two—*Soft Eggbeaters*, for instance, has a similarity to Robert Morris's drooping sculptures in felt.

George Segal

When Pop Art attempted to deal with the human figure in three dimensions, more traditional values returned, despite strenuous efforts to exclude them. George Segal (1924–), though always included in histories of the Pop movement, espoused humanist values which seem absent from the work of other leading Pop artists. His figures are, in one sense, very literal, since his method was to cast them from the life in white plaster and then place them in settings of painstaking literalism (FIG. 8.50). The ghostly whiteness of the figures, however, disrupts the illusion of realism. Segal's message, in these early works at least, seems to be that industrial civilization turns the individual into a wraith, something less substantial than the surrounding world of material objects.

Funk Art: Edward Kienholz

Segal's sculptures gain an "environmental" aspect from the elaborate settings he often devised for them. Indeed the Abstract Expressionist, Mark Rothko, once said, "He does walk-in Hoppers."[11] This aspect is emphasized in the work of Edward Kienholz (1927–94), whose first important environmental piece, *Roxy's*, a reconstruction of a Las Vegas bordello, dates from 1961 (FIG. 8.51). Kienholz was perhaps the most important representative of the tendency known as Funk

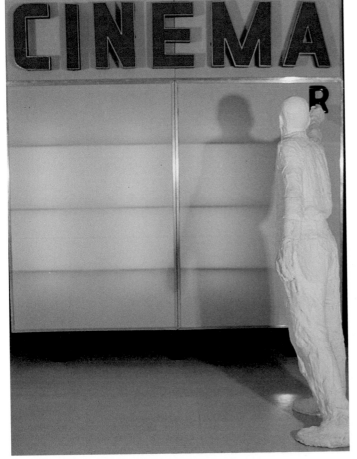

8.50 George Segal, *Cinema*, 1963. Plaster, plexiglass, and aluminum, 9 ft 10⅝ in x 8ft x 3ft 3⅛ in (300 x 243 x 99 cm). Albright-Knox Art Gallery, Buffalo, New York.

Critics initially associated Segal's work with Pop Art, but it has none of that style's brashness nor humor. The effect of his style is to "freeze" the figures (plaster molds made from live models) in a moment of time—a moment that is mundane but poignant.

8.51 Edward Kienholz, *Roxy's*, 1961. Mixed media assemblage, various dimensions. L.A. Louver Gallery, Venice, California.

This is a meticulous reconstruction of a Las Vegas bordello. Like most of Kienholz's environments, it takes bits of American folklore and transmutes them into allegories of the decay and psychological disorientation of American life.

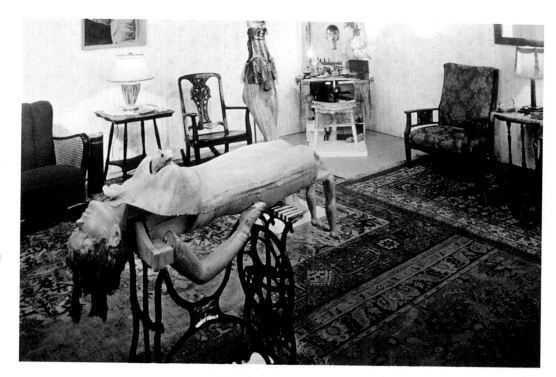

8.52 (*below*) Christo and Jeanne-Claude, *Wrapped Kunsthalle*, Berne, Switzerland, 1968. 32,292 ft² (3,000 m²) of synthetic fabric and 1,200 ft (366 m) of rope. Artists' collection.

The Christos' ambitious outdoor projects—covering fences that stretch for miles or huge buildings in fabric—achieve a kind of monumentality from their sheer scale and take on the feel of theatrical events. The sculptor as impresario.

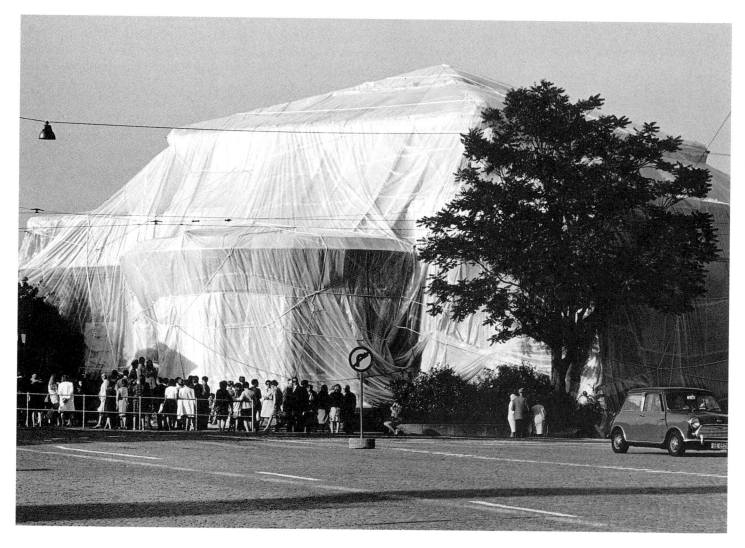

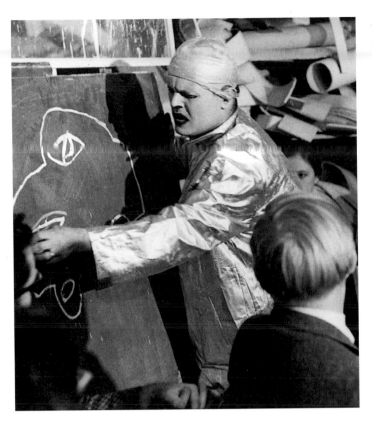

8.53 Jim Dine, *The Car Crash*, 1960. Oil, mixed media, 24¾ x 23⅝ in (63 x 60 cm). Private collection.

This painting was an element in one of the earliest Pop Art happenings.

Art, which was associated with the west coast of America and, more specifically, with northern California. The words "funk" and "funky" are taken from the vocabulary of jazz ("funky" originally meant "smelly" or "dirty") and imply an obsession with the incongruous and the bizarre. In Kienholz's hands, however, Funk Art took on a dimension of moral indignation which was totally foreign to the ethos of Pop.

Christo's and Jeanne-Claude's Wrapped Buildings

Also connected to Pop by many commentators (though the connection is vehemently denied by the artists) were the wrapped or packaged buildings (FIG. 8.52) which the Bulgarian-born Christo (Christo Javacheff, 1935–) began to produce in collaboration with his French wife, Jeanne-Claude, during the 1960s. These projects arose from the smaller-scale objects Christo had produced during the 1950s—the theory behind these being that partial concealment of an object paradoxically focuses attention on its fundamental forms. The Christos' large-scale projects were self-financed, through the sale of studies, preparatory drawings, and other works, and in this sense differ from most ambititious environmental art, which depends on sponsorship. Though the artists claimed that the formal and aesthetic aspect remained paramount in what they did, their activity was prophetic of the more socially involved, community-oriented art which was to emerge in the next decade. Because of their high visibility, the work played an important role in gaining acceptance for a new generation of the avant-garde.

HAPPENINGS AND ACTIONS

Happenings were performances which involved the extension of an "art" sensibility—or, more precisely, a "collage-environment sensibility"—into a situation composed also of sounds, time-durations, gestures, physical sensations, even smells. They differed from traditional theater because the spectators were not supplied with a matrix of plot and character, but were, instead, bombarded with sensations which they had to order for themselves. In America, Happenings were intimately related to the birth of Pop Art. Oldenburg's Pop objects originated as props used in these performances.

Perhaps the best-remembered New York Happening of this period was *The Car Crash* (FIG. 8.53), a performance staged by leading exponent of Pop, Jim Dine (1935–), at the Reuben Gallery in 1960. The violence of Dine's enactment of collision and disaster, which lasted for about twenty minutes, was essentially that of a child at play, and this deliberate childishness briefly endeared the New York artist-performance scene to its audience, until its specific effects were taken over by the experimental wing of American theater, which tidied them up and made them more rational, more disciplined, and more spectacular.

The Direct Action Group

In central Europe during the 1960s, performances, there generally labeled Actions or Events rather than Happenings, took on a more violent and sinister tone. The most sinister were mounted by the Direct Action Group in Vienna. Artists such as Rudolf Schwarzkogler (1940–69) performed acts of self-mutilation, an enactment of the sickness they found in society itself, and also, perhaps, a form of catharsis

8.54 Rudolf Schwarzkogler, *Aktion "o.T."*, 1965. Photographic performance. Galerie Krinzinger, Vienna.

An example of the violent and disturbing work done by members of the Vienna Direct Action Group.

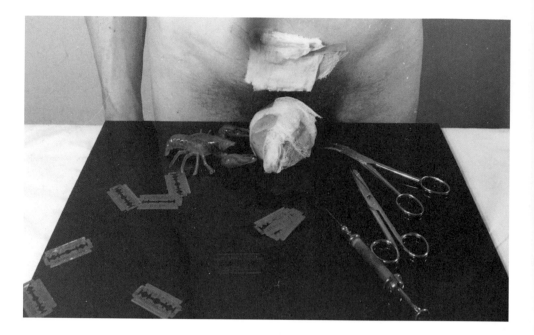

for unexorcised guilts and fears left over from World War II (FIG. 8.54). Despite the stresses of the Civil Rights movement and the agitation against America's involvement in Vietnam, the United States produced nothing comparable in terms of introverted, literally self-destructive art.

Fluxus

An important link between the central European and the American avant-gardes was provided by the avowedly neo-Dadaist Fluxus Group (1962), most of whose activity took place in Germany, though with a large number of American participants. The group was the brainchild of the Lithuanian-American George Maciunas (1931–78), and its personnel were as much identified with experimental music and poetry as with the visual arts. Prominent participants included the American composer, La Monte Young (1935–), who had studied at Darmstadt under Karlheinz Stockhausen, the leading musical experimentalist in Germany at that time. Maciunas also cited the veteran American composer, John Cage, as a major source of inspiration.

Maciunas insisted that Fluxus could not confine itself to one field of activity, not concern itself with traditional ideas about artistic style. One important element in his theory of art was the idea of "concretism":

> Concretists in contrast to illusionists prefer unity of form and content, rather than their separation. They prefer the world of concrete reality rather than the artificial abstraction of illusion. Thus in plastic arts for instance, a concretist perceives and expresses a rotten tomato without changing its reality or form. In the end, the form and expression remain [the] same as the content and perception. The reality of rotten tomato, rather than an illusionistic image or symbol of it.[12]

In terms of performance, this meant a series of apparently meaningless but "real" actions given significance by being

8.55 George Maciunas performing George Brecht's *Drip Music* in Düsseldorf, 1963.

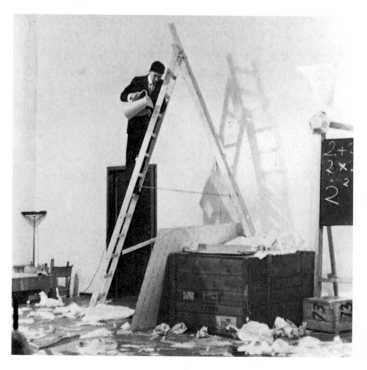

carried out in front of an audience. An example was Maciunas's own rendering of George Brecht's *Drip Music* (FIG. 8.55) at a Fluxconcert held in Düsseldorf in 1963. Here the performer stood halfway up a stepladder, slowly decanting water from a jug.

The heterogenous character of Fluxus, combined with its hostility to an identifiable style, and added to the fact that it was almost entirely performance-based, ensured that, until quite recently, it was given only a very minor role in histories of twentieth-century art. Maciunas's insistence on the concrete, and the way in which he defined it, was nevertheless of seminal importance to the avant-garde during the next two decades. In particular, Fluxus was an assault on the idea that making art was essentially a transformative process. The artist no longer attempted to change the world—he or she simply pointed to elements which already existed within it. This idea admittedly derived from Marcel Duchamp's readymades, but it was pushed much further and turned into an all-embracing theory.

The most immediately identifiable result of the Fluxus initiative was the rise to prominence of the German sculptor and performer, Joseph Beuys. Though Beuys was not a founder-member of the group, the Fluxconcerts of the mid-1960s first gave him visibility.

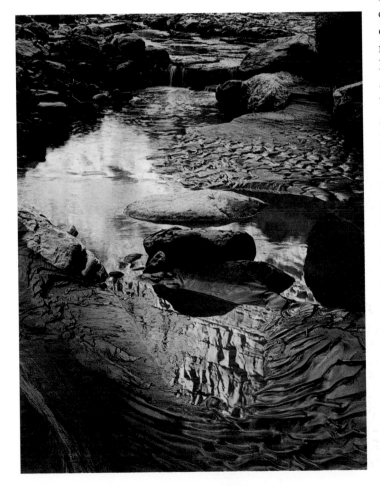

8.56 Eliot Porter, *Dark Canyon, Glen Canyon*, 1965. Dye transfer print. Art Institute of Chicago, Illinois (Anonymous gift in honor of Hugh Edwards, 1980.32).

Eliot Porter's photographs were among the first to make color images aesthetically respectable.

Photography

A CHANGE OF CLIMATE

The turbulent events of the 1960s seemed to offer endless new opportunities to photographers, as did the emergence of a recognizable "youth culture." At the same time, however, photography found itself being subtly challenged. The challenge came from three quite different directions. One was the growth of television. Television news coverage began to make serious inroads into the market hitherto dominated by the picture magazines, such as *Life*, which, in its original form, closed in 1972. Another was the increasing use of photographic imagery by avant-garde painters. Robert Rauschenberg and Andy Warhol pioneered the use of photographic blow-ups, silkscreened on to canvas. Though both artists were enthusiastic photographers, the images they used were generally borrowed from pre-existing sources—in Warhol's case from newspaper or police archives. In general, artists who used photographs in this way preferred that their source material should be without discernible aesthetic content. The third factor was the growth of color. Though color photography had already made its appearance by the end of the nineteenth century, in general it was regarded as the province of the amateur, not worth the attention of the "serious" photographer. In the 1960s, color had became so important within the general photographic context that professional photographers were forced to consider its possibilities.

Eliot Porter

One of the first to do so was Eliot Porter (1901–90), who became celebrated in the 1960s for his color studies of birds, plants, and landscape (FIG. 8.56). Porter's exemplars were Stieglitz (who had offered to show his work in 1938,

Winogrand concentrated on crowded urban street scenes, making dynamic compositions out of sharply contrasting images. He frequently aligned the camera along a vertical, not horizontal, axis, producing what became known as the "Winogrand tilt." The camera was not held in a tilted position.

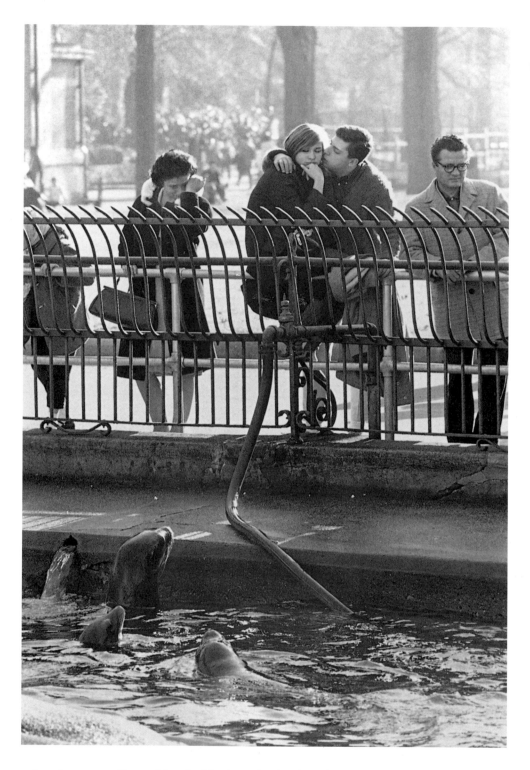

when he was still working in black-and-white) and Ansel Adams. Essentially he translated their method so as deal with the additional demands made by color. His deeply romantic, usually rather formal, images met with a warm welcome from the general public.

Subjectivity in the Streets

Urban life fascinated a number of the most innovative photographers of the time. Basing themselves on the example of Robert Frank (see FIG. 7.48) they shot their pictures from the hip, relying on the inspiration of the moment, often not knowing why they had chosen to record a particular instant until they saw the result.

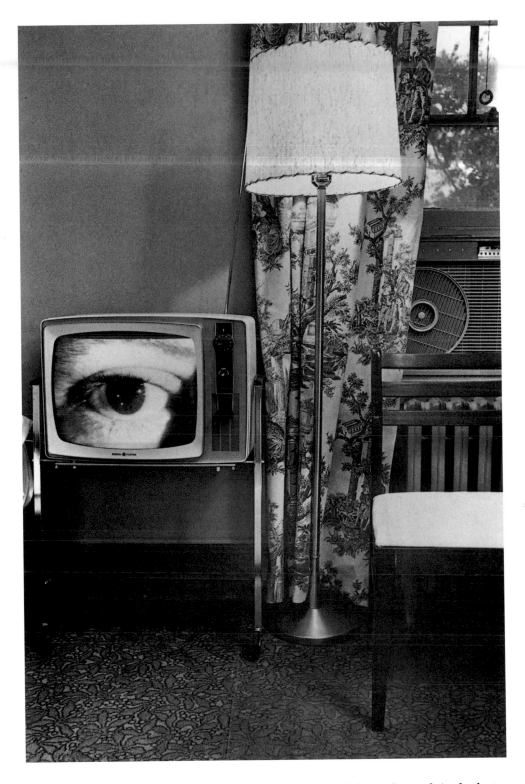

Garry Winogrand (1928–84) made pictures which deliberately exploited photographic ambiguity—they obviously contain a narrative of some kind, but that narrative can be read in alternative ways (FIG. 8.57). Lee Friedlander (1934–) uses photographic ambiguity in a different sense. He concentrates on deliberately oblique images, where the observer and what is observed are elided, to make a single composite image. Some of his photographs show reflections in shop windows, with the photographer as a half-concealed presence; the results resonate with an uneasy urban tension. Here a television set, something which is watched, seems in turn to watch the photographer (FIG. 8.58).

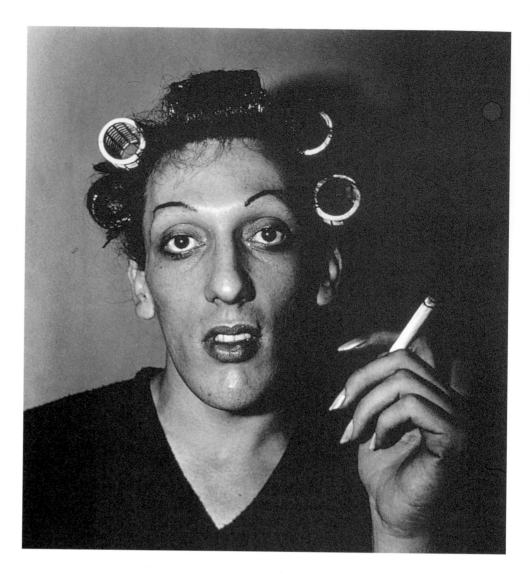

8.59 Diane Arbus, *Young Man in Curlers, West 20th Street, New York*, 1966. Gelatin silver print. Artist's collection.

"My favorite thing is to go where I've never been," Diane Arbus said. Her photographs are frequently of "outsiders" to the mainstream of American life—prostitutes, transvestites, the mentally retarded. "I really believe there are things which nobody would see unless I photographed them."

Diane Arbus

Travel within America is often one of Friedlander's themes. Diane Arbus (1923–71) covered a more restricted territory. She was essentially a photographer of New York and its environs. She adapted the harsh, news-oriented approach of photographers like Weegee to her own purpose, which was to give a dissenting view of contemporary America (FIG. 8.59). It has been said of Arbus that she "approached [her] material without artifice or moral prejudgement."[13] This is obviously untrue. Her work survives, to the point where it has become one of the defining accounts of the decade, because she so brilliantly conveys her own sense of alienation. She herself was of upper middle-class origin (a New York department store heiress). Her attitude to her mostly lower middle-class subjects is contemptuous if they are in any way conformist (she made some savage photographs at pro-Vietnam War demonstrations), but deeply sympathetic if they are freakish or abnormal. Her images of transvestites and circus freaks are memorable for the sense of identification she conveys. Though she is regarded as a major figure in the history of American photography, it would have been very difficult for her to work in the same fashion now, in the age of "political correctness."

The Manipulated Image

In marked contrast to the work being done by Friedlander, Winogrand, and Arbus were the images being produced by Jerry N. Uelsmann (1934–). Uelsmann

spent the 1960s teaching art at the University of Florida. His images, from the early 1960s onward, were deliberately constructed, using two or more negatives. His mirrorlike or otherwise symmetrical images, somewhat in the manner of the Surrealist painter, René Magritte, were in direct contradiction to the asymmetry inherent in photographic naturalism (FIG. 8.60). Uelsmann alludes specifically to Magritte as a source in an image entitled *Magritte's Touchstone*, which shows a great boulder floating in the sky above a recumbent female figure. Other photographs invoke the ominous world of the nineteenth-century English Pre-Raphaelites.

Uelsmann's self-conscious, deliberately unspontaneous, photography marked a reversion to a long-neglected part of the photographic tradition, where the camera was used to create a fictive "truth" rather than apparently recording a truth which was available to everyone. It amounted to an assertion that there was in fact no aesthetic difference between photography and the other visual arts. In terms of the development of the medium seen as a whole, this is a recurrent phenomenon; but in the 1960s, given the recent history of photography, it was a revolutionary thing to do.

8.60 Jerry Uelsmann, *Untitled*, 1969. Silver gelatin print. Art Institute of Chicago, Illinois (Restricted gift of the People's Gallery, 1971.558).

Uelsmann's manipulated images marked a reversion to a photographic tradition in which the camera, far from simply capturing "factual truth," was used to record an art image created by the photographer.

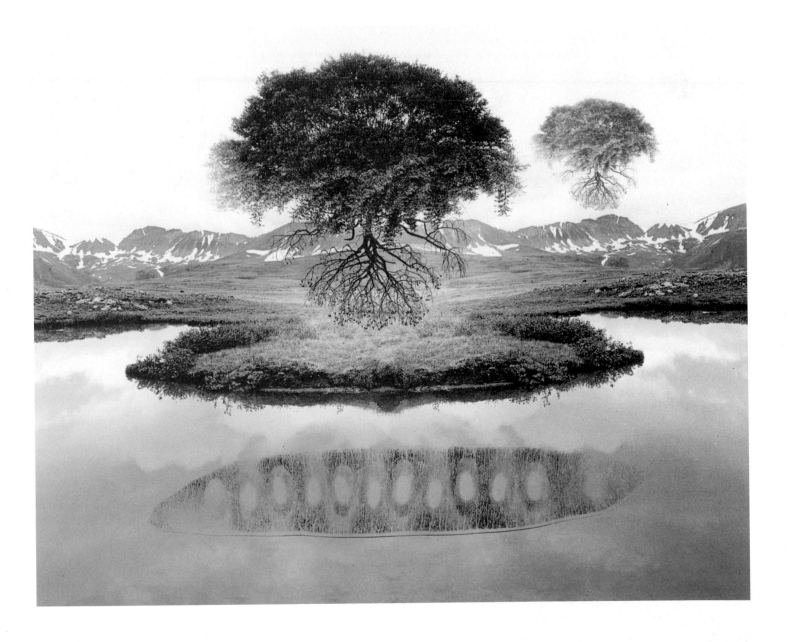

1970	**1971**	**1972**	**1973**	**1974**

GENERAL EVENTS

• Nigerian civil war ends	• Women are granted the right to vote in Switzerland	• Richard Nixon visits China	• Britain joins EEC	• Left-wing revolution in Portugal, resulting in a bloodless coup
• US National Guardsmen shoot dead four student anti-war demonstrators at Kent State University, Ohio	• War breaks out between Pakistan and India. Republic of Bangladesh established	• Eleven members of the Israeli team are killed by Arab terrorists at the Munich Olympics	• President Allende of Chile overthrown by General Pinochet	• President Makarios of Greece overthrown. Turkey invades Cyprus
• Salvador Allende elected president of Chile	• 200,000 people demonstrate in Washington D.C. against Vietnam War	• Five arrested after break-in at Democratic Party headquarters in Watergate apartment complex, Washington D.C.	• Yom Kippur War between Israel, Egypt, and Syria	• Nixon resigns and Gerald Ford becomes US President
• Riots in Gdansk against Communist government of Poland			• Ceasefire in Vietnam	• Patricia Hearst is kidnapped
				• Alexander Solzhenitsyn is exiled from the USSR

Hanson, *Tourists*: see p.323

SCIENCE AND TECHNOLOGY

• Boeing 747 airline begins regular flights	• Microprocessor introduced	• First home video-casette recorders introduced		• Death of Charles A. Lindbergh
• IBM develops "floppy disc" to store computer data	• US space probe *Marine IX* becomes first man-made object to orbit another planet (Mars)	• CAT scans introduced to provide cross-section x-rays of human brain	• Barcodes first used in supermarkets	• Russian space probe lands on Mars
			• First live birth (of a calf) from frozen embryo	
			• Konrad Lorenz is awarded the Nobel prize for medicine	

Congresso de Artistas Chicanos en Aztlán, *We are NOT a Minority!!*: see p.314

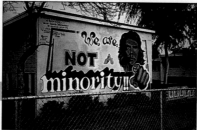

ART

• Deaths of Mark Rothko and Barnett Newman			• Death of Picasso	
• "Conceptual Art, Arte Povera, Land Art," exhibition at the Galleria Civica de Arte Moderna, Turin	• Francis Bacon retrospective in Paris	• Soulages retrospective in the United States	• "Photo Realism," exhibition at the Serpentine Gallery, London	
• Judy Chicago organizes first feminist art course at California State College, Fresno	• "Contemporary Black American Artists," exhibition at the Whitney Museum, New York	• "The New Art," exhibition at the Hayward Gallery, London	• Works by the New York School fetch record auction prices	Saar, *The Liberation of Aunt Jemima*: see p.312
	• Exhibition on the metamorphosis of the object in Brussels	• First still lifes produced by Claes Oldenburg	• First color photocopier marketed (Japan)	• Dalí Museum opens in Figueras, Spain
				• Joseph Beuys performs *Coyote* in New York

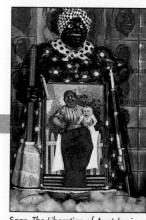

ARCHITECTURE

• Minoru Takeyama, Ichi-Ban-Kan Department Store, Tokyo	• Renzo Piano and Richard Rogers begin work on the Pompidou Center, Paris (–1977)	• Alvar Aalto, Finlandia Hall, Helsinki	• Aldo Rossi's San Cataldo Cemetery opens in Modena, Italy.	• Ralph Erskine completes Byker Wall, Newcastle-upon-Tyne, England
		• Lucien Kroll finishes Medical Faculty for Louvain University, Belgium	• John Portman and Associates, Hyatt-Regency Hotel, San Francisco	• I.M. Pei, East Building of the National Gallery of Art, Washington D.C. (–1978)
		• Louis I. Kahn completes Kimbell Art Museum, Fort Worth, Texas		• Jeremy Mackay-Lewis, Credit-Lyonnais building, London (–1978)

Rogers and Piano, Pompidou Center: see p.300

1975

1976

1977

1978

1979

- Civil war begins in Lebanon
- Khmer Rouge capture Phnom Penh, capital of Cambodia
- Saigon falls to the North Vietnamese
- Death of General Franco

- Mao Tse-Tung dies (China)
- Jimmy Carter is elected President of United States
- Olympic Games held in Montreal
- Israeli raid on Entebbe

- First democratic elections in Spain since 1936
- South African black leader Steve Biko dies in police custody
- Egyptian president Anwar Sadat visits Israel

- Karol Wojtyla, Archbishop of Cracow, elected pope as John Paul II
- Mass suicide of over 900 people in Jonestown, Guyana
- Camp David peace treaty—Anwar Sadat and Menachem Begin share the Nobel Peace Prize

- Fall of Shah in Iran, which becomes Islamic Republic under Ayatollah Khomeini
- Margaret Thatcher becomes Britain's first woman prime minister
- Iranian students seize US embassy in Teheran. President Carter imposes embargo on Iranian oil
- USSR invades Afghanistan

Eggleston, *Memphis*: see p.328

- First warning of possible damage to ozone layer due to aerosols
- First personal computer (PC) marketed
- F-16 fighter plane developed in the United States

- Concorde supersonic airliner begins regular passenger services across Atlantic
- US space probe *Viking I* lands on Mars

- First victims of AIDS reported in New York
- Apple II microcomputer marketed in the United States
- First staffed flight of space shuttle *Enterprise*

- First autofocus camera marketed
- First test-tube baby born (England)
- Two Soviet astronauts orbit the earth for 140 days

- Television broadcasting via satellite launched
- US Surgeon-General publishes a report confirming that smoking causes cancer and is linked to other diseases
- Personal stereo introduced and compact disc developed

- Muralism makes a comeback in the United States
- Roy Lichtenstein retrospective takes place in Paris
- Spain opens itself up to contemporary art

- Christo builds *The Running Fence* in California
- "Women artists: 1550–1950," exhibition at Los Angeles County Museum
- Death of Max Ernst
- Carl Andre's *Bricks* whip up controversy in London

- Opening of Pompidou Center, Paris
- "Unofficial Art from the Soviet Union," exhibition at the Institute of Contemporary Arts, London
- *Heresies* magazine published in New York

- "Bad Painting," exhibition at New Museum of Contemporary Art, New York
- Deaths of Giorgio de Chirico and critic Harold Rosenberg
- "Paris–Berlin," exhibition at the Pompidou Center, Paris

- Joseph Beuys retrospective at the Guggenheim Museum, New York
- Judy Chicago, *The Dinner Party*
- Germaine Greer publishes *The Obstacle Race: Fortunes of Women Painters and Their Work*

- Ricardo Bofill, Walden 7, Barcelona, Spain
- Foster Associates, Ipswich Center (Willis, Faber, and Dumas, insurance brokers), Ipswich, England.
- SITE (James Wine and collaborators), Indeterminate Façade Showroom, Houston, Texas

- Charles Moore, Piazza d'Italia, New Orleans, Louisiana (–1979)

SITE, Indeterminate Façade Showroom: see p.305

- James Stirling, New State Gallery, Stuttgart, Germany (–1984)
- Frank Gehry, the Gehry House, Santa Monica, California (–1978)

- Philip Johnson and John Burgee, AT & T Headquarters, New York
- Norman Foster, Sainsbury Center, University of East Anglia, Norwich, England

- Arata Isozaki, Tsukuba Center Building, Ibaraki, Japan (–1983)
- Michael Graves, Portland Public Service Building, Portland, Oregon (–1982)

Gehry, the Gehry House: see p.304

1970–1979

The 1970s witnessed the sour end of the American adventure in Vietnam, the resignation of President Nixon following the Watergate scandal, the beginning of a bitter civil war in the Lebanon, the overthrow of President Salvador Allende in Chile, the Yom Kippur war between Israel, Egypt, and Syria, the Turkish invasion of Cyprus, the fall of the Shah in Iran, and the Russian invasion of Afghanistan. There were numerous terrorist incidents in Europe—among them those engineered by the IRA in Great Britain, the Baader–Meinhof urban guerrilla group in West Germany, and the Red Brigade in Italy. There was also a severe economic crisis, triggered by a sharp rise in the price of crude oil in 1973, imposed by the primary producers in the Middle East. The sense of alienation which had marked the end of the 1960s persisted into the new decade, and was reflected in avant-garde art, which became more politicized than it had been since the 1930s.

Architecture

POPULISM, CLASSICISM, AND NATIONALISM

Surprisingly, in view of the unfavorable economic climate, the 1970s were a much richer decade for architecture than the 1960s. Many more notable buildings were built, and the creative energies of the period were almost equally divided between the United States and Europe, which, though tortured by factionalism, had now fully recovered from World War II. Though the architecture made on either side of the Atlantic inevitably had much in common, thanks both to the progress of building technology and the speed and efficiency of modern communications, there was a tendency, in Europe at least, to look for modes of architectural expression which would reflect national traditions. This tendency also made itself felt, though less powerfully, in the visual arts in general.

There were two linked, yet apparently contradictory, tendencies which affected architecture almost everywhere. Both had their roots in ideas already put forward by Robert Venturi—that architecture should seek to communicate better with the general public, and that it should look back, across the Modernist divide, to recover parts of the old symbolic language which had fallen into disuse. The first of these aims was emphasized in Venturi's book, *Learning from Las Vegas* (1972). The second found its most significant expression in the writings of the architectural theorist, Charles Jencks (1939–), whose *The Language of Post-Modern Architecture* appeared in 1977. Though Jencks did not confine himself to classicist practitioners of the Postmodern, it was clear where his own sympathies lay. In a broader sense, Jencks's writings put the term "Postmodernism" into widespread circulation, though there were to be many quarrels about how it should be defined (see page 11).

One striking feature of the decade was the scorn for refined quality of finish to be found in some of its most significant buildings—in complete contrast to the care lavished on late International Style monuments like Mies van der Rohe's Seagram Building. The former was an attitude carried over from Le Corbusier's

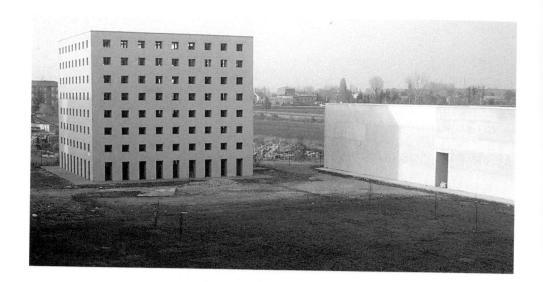

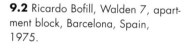

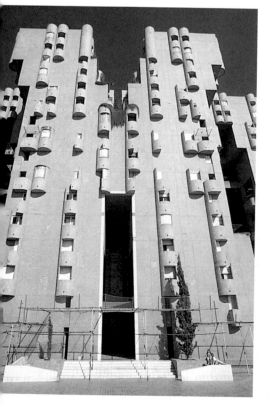

late work in concrete, but also something influenced both by the roughness of some of the Pop Art of the 1960s, and by developments characteristic of the 1970s, such as Arte Povera.

Italy and Spain

The nationalist elements in the architecture of the decade appear most obviously in the work of Italian and Spanish architects, where they can be seen as a return to deep-rooted traditions with much canonical authority behind them. The San Cataldo Cemetery in Modena, Italy (FIG. 9.1), by Aldo Rossi (1931–) owes much to the stripped-down Classicism of the late eighteenth century as practiced by architects such as Etienne-Louis Boullée (1728–99). The 500-feet- (152 m) high sphere, which Boullée wished to build as a monument to the English mathematician, Sir Isaac Newton, finds an echo in the red cube which Rossi made the chief feature of his design: it serves as an ossuary. This severe form is also reminiscent of the more experimental kinds of early Fascist architecture, such as the Casa del Fascio (1932) in Como.

In Spain, and later in France, Ricardo Bofill (1939–), of the Taller de Arquitectura, built spectacular apartment complexes, such as the Walden 7 block in Barcelona, Spain (FIG. 9.2), which alluded sometimes to Classical and sometimes to medieval forms. Walden 7 is like a gigantic but simplified medieval tower rather crudely formed of concrete and painted brilliant pink. Bofill's buildings of this type have been compared, disparagingly, to film sets. Yet it seems plain that one of Bofill's chief purposes was to make it clear that this was not architecture-as-imitation, in the nineteenth-century revivalist style, but architecture-as-fiction. The medievalism is a lightly sketched framework, offering a blank space within it where the spectator's imagination can play. The context for this is the long perspectives offered by European culture.

A Return to the Vernacular: Belgium, Great Britain, and France

The rising tide of criticism against public housing on a Corbusian model led to attempts to break the authoritarian mold for such projects created during the 1950s and 1960s. One of the first experiments of this sort was the housing designed for medical students of Louvain University in Belgium (FIG. 9.3) by Lucien Kroll (1927–). Kroll was the students' own choice as architect for the project, and the approach he took was a self-confessedly "ethnological" one, influenced by Rudofsky's book, *Architecture without Architects* (see pages 251–2). The design system he used—that of a fixed skeleton, with an irregular, enveloping

9.3 Lucien Kroll, Medical Faculty, Louvain University, Belgium, 1968–72.

Kroll's buildings (see upper left) are often described as "organic," partly because they consist of small units knitted together in diverse materials. As in nature, there is very little repetition. The result is that Kroll creates a milieu as much as a building.

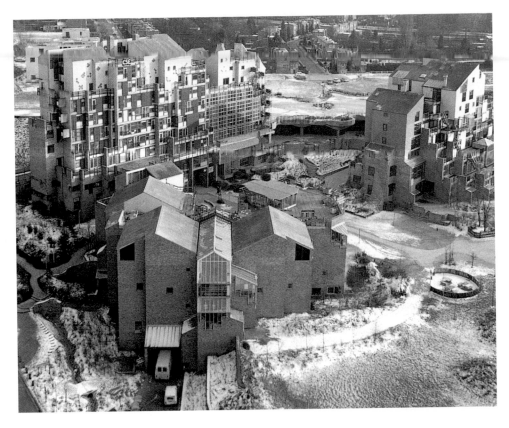

infilling—was also influenced by the theories of Archigram. The result was what the architect himself described as "a big sponge," pierced "with internal, exterior, horizontal, vertical, oblique, underground and rising pathways."[1] The jumbled, disordered nature of the façades, which give the impression that the building is still in progress, was a calculated retort to the smooth, closed forms of International Modernism.

Byker Wall (FIG. 9.4), a vast public housing project in Newcastle-upon-Tyne, England, by the Anglo-Swedish architect, Ralph Erskine (1914–), was also designed in consultation with its future inhabitants. The problem here was twofold—to rehouse a working-class community and preserve its existing family and social links, and at the same time to make it more accessible to the rest of the

9.4 Ralph Erskine, Byker Wall, Newcastle-upon-Tyne, England, 1968–74.

This low-rise, high-density housing complex, with its informal, *ad hoc* design, made Erskine internationally famous—though perhaps more because he opened a site office to discuss the design with its future inhabitants than because of the building itself.

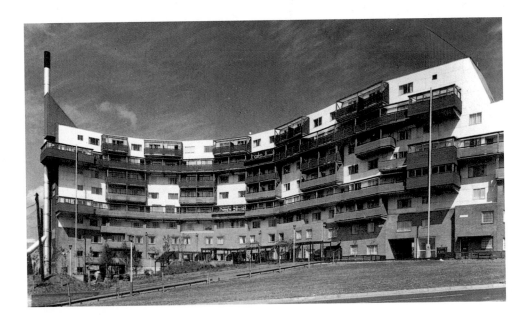

Richard Rogers and Renzo Piano: Pompidou Center

The paradigmatic example of architecture committed to modern technology, one of the leading architectural modes of the 1970s and 1980s, is undoubtedly the Pompidou Center in Paris (FIG. 9.5) by Richard Rogers (1933–) and Renzo Piano (1937–). Rogers and Piano were the winners of an international competition organized by the French government for a vast new cultural center in Les Halles, which attracted 681 entries from all over the world. The building they designed has been described as "a high-tech agora" and as "a literally fantastic fusion of futurism, the seductive but unrealizable imagery of Archigram ... and the most flamboyant traditions of Victorian engineering."* The originality of the building lay not only in its commitment to total flexibility of use, but in the way in which it placed both the skeleton of the building and all its services on the outside. The result was a dramatic visual statement about the compatibility of technology and art, and also a decisive contribution to the democratization of Modernist culture. Originally, the technological element was to have been emphasized still further by the presence of vast videoscreens on the exterior of the building. These would have carried news flashes as well as arts programing. They were banned by the French government, apparently because of fears that they might be put to political, even revolutionary, use. From the moment it opened, the Pompidou Center (or the Beaubourg, as it came to be called) attracted vast crowds: it became the counterpart and rival to another monument to the technology of its time, the Eiffel Tower (see FIG. 1.3). As Rogers himself points out, however, the building remains firmly fixed in a particular epoch. Its vast areas of glass, for example, indicate clearly that it was conceived before the energy crisis of the 1970s, when heat-loss became a factor. In a recent interview, the architect described it as being "above all a naive building, a huge machine astonished at its own existence."†

*Deyan Sudjic, *New Architecture: Foster, Rogers, Stirling*, London, 1986, p. 24.
†Renzo Piano and Richard Rogers, *Du Plateau Beaubourg au Centre Georges Pompidou*, Paris, 1994, p. 44.

9.5 Richard Rogers and Renzo Piano, Pompidou Center, Paris, 1971–7.

This most famous of high-tech buildings reveals all of its structure. The original paint scheme coded its working parts—ducts, pipes, corridors etc.—in colors: red for human passageways, green for water, blue for air conditioning, yellow for electricity.

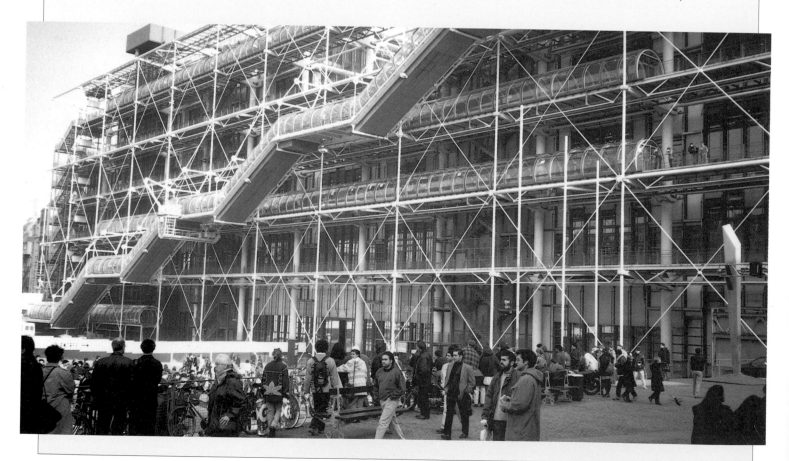

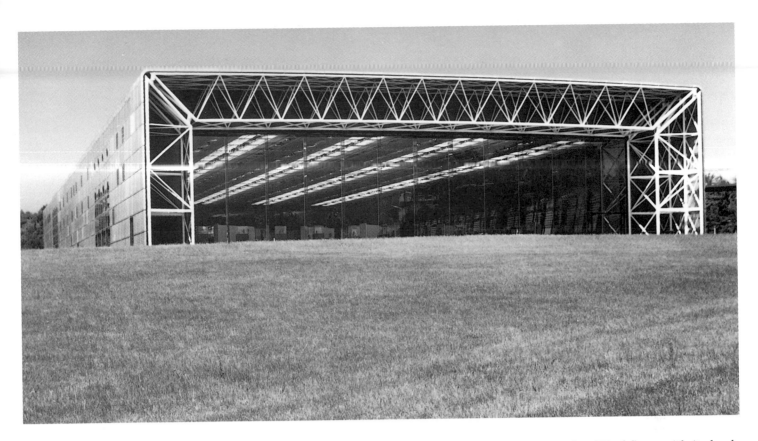

9.6 Norman Foster, Sainsbury Center for the Visual Arts, University of East Anglia, Norwich, England, 1978.

This is essentially a large rectangular shed, clad in vacuum-formed aluminum panels, with the services for the building contained between the inner and outer skins of the long walls.

city. The solution was to build a high-rise perimeter "wall" of flats, with its back turned to a noisy highway, enclosing low-rise housing, with paths, open areas, and gardens. The great mass of the apartment block makes a striking silhouette when seen from a distance. The effect has been described as "dreamlike," but, seen from the walled-in area, an intricate pattern of walkways and boxlike balconies creates an intimate effect.

"High-Tech" Architecture

The most discussed architectural movements of the decade were neither the new populism nor the new nationalism, but so-called "high-tech" architecture on the one hand, notably the Pompidou Center in Paris (see FIG. 9.5), and the deliberately fragmented Postmodernist return to Classical forms on the other. One characteristic of the Pompidou Center which both professional critics and lay visitors found disconcerting was that it was in some respects literally featureless—for example, it has no very obvious main entry. This is also true of the Sainsbury Center for the Visual Arts by Norman Foster (1935–) at the University of East Anglia, Norwich (FIG. 9.6). This is a large, rectangular shed, clad with vacuum-formed aluminum panels, mostly blank on the long sides of the building, but glazed on the short ones. The structure itself is formed of welded steel tubes, and the result has been compared to the wing of modern jet aircraft, "outwardly sleek," but "actually packed full of structural spars, fuel tanks and hydraulic control lines."[2]

Postmodern Classicism in Continental Europe

The approach adopted by Rogers and Foster in these two buildings was much discussed but never dominant. Experiments with Classicism were equally typical of the decade. James Stirling, major practitioner of the high-tech idiom but never wholly committed to it, was, for example, to combine an up-to-the-minute, but concealed, technological infrastructure with Postmodern Classical elements in a

James Stirling, New State Gallery, Stuttgart, Germany, 1977–84.

The bewildering mixture of ingredients in this building—strong primary colors on metal, the banded masonry exterior, the ramps reminiscent of ancient open spaces, the Classical open rotunda, the simplicity of its glass-and-steel elements—justify the architect's description of it as a "collage" of the old and the new.

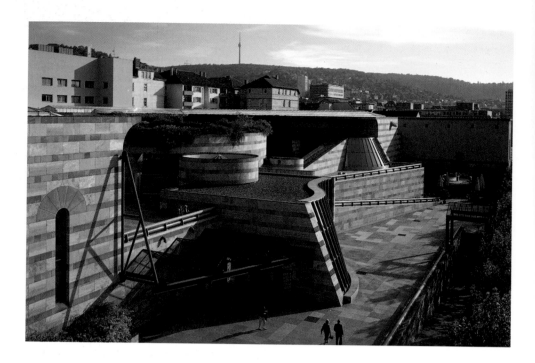

museum building almost as conspicuous as the Pompidou. This was the New State Gallery in Stuttgart (FIG. 9.7), like the Pompidou Center the product of an international competition. One of Stirling's models was the great German Neoclassical architect, Karl Friedrich Schinkel (1781–1841), whose most celebrated creation was the Altes Museum (1823–30) in Berlin. One striking feature of the Altes Museum is the interpenetration of spaces concealed by its regular façade, which consists simply of a long row of Ionic columns. Stirling alludes to this in the open rotunda adorned with Classical statues which stands at the center of his own design. All the services of the museum, such as control of lighting and ventilation, are of the most highly developed kind, perhaps more so than at either the Pompidou or the Sainsbury Center, but the visitor's attention is deliberately focused elsewhere, on the building's complex relationship with the German and European past.

Postmodern Classicism in the United States

The early phase of Postmodern Classicism in America is associated with the ever-volatile Philip Johnson, whose AT & T Headquarters in New York (FIG. 9.8)—the "Chippendale" building, so called from the broken pediment that crowns it—represents the style at its most willfully luxurious. The decorative details are novel, but the attitude is still that which produced the earlier Seagram Building (see FIG. 7.1), where Johnson had been associate architect.

The new Classicism was also the language chosen by a very different personality, Charles Moore (1925–94), whose playful Piazza d'Italia in New Orleans (FIG. 9.9) was designed to provide a focus for the large Italian community in the city. Built of cheap materials and now in a sadly neglected condition, this is an entirely ornamental and symbolic construction—a fountain enclosed by a colonnade which makes use of the five "Italian" orders of architecture. In the admiring commentary on this given in his *Post-Modernism: The New Classicism in Art and Design* (1987), Charles Jencks refers to its "multiple coding." Some idea of what he means can be conveyed by quoting a fragment of his description:

"Italianness" is inevitably a conventional fabrication and it's a mark of Moore's realism that he represents this convention in a consistently dualistic

9.8 Philip Johnson and John Burgee, AT & T Headquarters, New York, 1978.

By the mid-1950s Johnson was turning against the order and rationality of Miesian design, though his desire to overturn the whole Modern movement in architecture did not bear full fruit until this granite-clad building came into being. Though nominally sixty storeys high, it contains, in fact, only thirty-six floors.

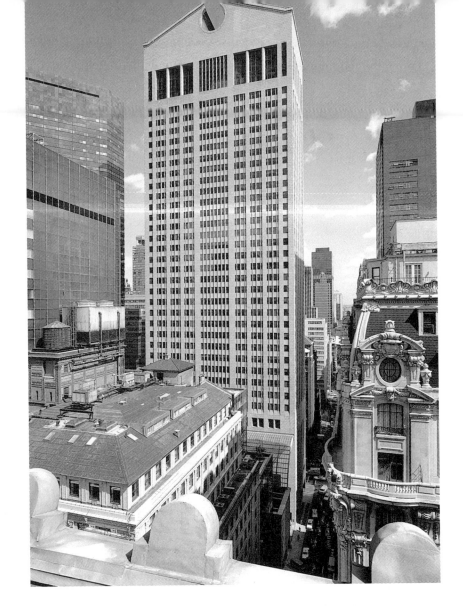

9.9 Charles Moore, Piazza d'Italia, New Orleans, 1976–9.

An ornamental construction celebrating the cultural heritage of the Italian community in New Orleans, this is an early example of the playful Postmodern use of Classical forms.

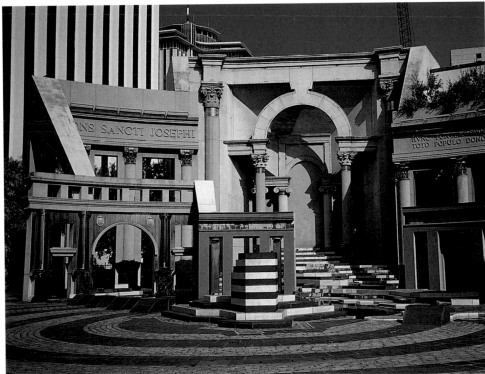

way, blending the serious with the ironic. The Five Orders are thus partly constructed from water and neon, but to lend a certain dignity are also given canonic proportions and a stainless steel and marble finish. Abstract planar elements and black and white paving pull in the Modernist skyscraper to one side, showing that pluralism can even include reductivism.[3]

The fragility of the work, though perhaps not consciously intended, is significant. Symbolic architecture here begins to abandon its ambitions for permanence, and takes on some of the ephemerality of the advertising sign.

The Early Work of Frank Gehry

The element of "tackiness" in the Piazza d'Italia, ambiguous in terms of intention, but now somewhat emphasized by its current poor condition, is an integral part of many early projects by another American architect, Frank Gehry (1929–). In the 1970s Gehry was at the beginning of what has turned out to be an extremely important career. His highly original attitudes to building are exemplified by the now famous house (FIG. 9.10) he built for himself in Santa Monica, California. This used frankly demotic materials, such as corrugated metal, plywood, and chain-link fencing, for sophisticated ends.

The core of the building remains the banal 1920s bungalow which Gehry and his wife decided to remodel—"the viewer can read the old house quite literally through the forms of the new one."[4] While in one sense the house belongs to the "vernacular" tendency present in the work of Kroll and Erskine (see FIGS. 9.3 and 9.4), it is also a piece of deliberate provocation, designed to shock the sensibilities of the viewer.

Although the house itself is modest, it offers many connections to important aspects of contemporary culture. For example, its jagged forms betray Russian Futurist influence, as persistently palpable here as in the various Archigram projects (see FIGS 8.1 and 8.2) and the Pompidou Center. In its use of humble materials, it has a connection to Arte Povera. It also has one further very significant characteristic—a defensive exterior carapace which shuts the living-spaces off from the street. This may have been an unconscious response to the character of the neighborhood—a sniper once took a potshot at the building—but it also makes a decisive move away from the open, flowing spaces of established Modernism.

9.10 Frank Gehry, The Gehry House, Santa Monica, California, 1977–8.

The architect's own residence, this building was developed from a banal 1920s bungalow. "I approach each building as a sculptural object, a spatial container," Gehry has said. "To this container, this sculpture, the user brings his baggage, his program and interacts with it to accommodate his needs. If he can't do that, I've failed."

9.11 SITE (James Wines and collaborators), Indeterminate Façade Showroom, Houston, Texas, 1975.

The SITE-designed showrooms for Best Products are spectacular examples of architectural deconstruction. SITE is an acronym for "Sculpture in the Environment," and the front elevation is indeed treated as if it were sculpture.

The Gehry house serves, with the other buildings and projects cited here, to emphasize the importance of the 1970s as a turning-point for twentieth-century architecture—perhaps the most important turning-point since the 1920s, when the International Style established itself.

SITE and Deconstruction

An important aspect of Gehry's building was its interest in what came to be called "deconstruction"—that is, the breaking-down rather than the building-up of architectural elements, and the exposure of spatial and other contradictions. In the 1980s and 1990s, architectural theoreticians came to associate this tendency with the writings of the French structuralist philosopher, Jacques Derrida, though sometimes the links can seem rather tenuous. One of the chief texts on the subject, Mark Wigley's *The Architecture of Deconstruction: Derrida's Haunt* (1993), cites not one contemporary architect by name in a lengthy index. The most spectacular exponents of deconstruction were the American architectural group who called themselves SITE, which came into being in 1969. It did its best-known work for the firm of Best Products, a discount outlet offering household goods and jewelry, in the 1970s. The retail and storage spaces are rectangular boxes, placed on a parking lot beside a highway. SITE redesigned these showrooms so that the façades became both eye-catchers and commentaries on the fragile and indeterminate nature of consumer culture. The best-known example is the Indeterminate Façade Showroom (FIG. 9.11) in Houston, Texas, where the brick veneer of the façade is extended in a ragged profile beyond the logical edge of the roofline. A breach in the façade spills a pile of waste bricks on top of a pedestrian canopy. As a result of these devices, the building seems to be growing upward and simultaneously falling down. SITE's work, like Gehry's, has strong vernacular links. It is related to established forms of American popular architecture, such as the hot-dog stand which takes the form of a hot-dog, or (the most celebrated example) the Brown Derby Restaurant (1928) in Los Angeles, which was a building shaped like a man's hat. And here, too, tribute is paid to the aesthetics of the tacky.

THE GENERAL SITUATION OF THE VISUAL ARTS AVANT-GARDE

The Challenge to Traditional Forms

In the 1970s the leadership of the avant-garde seemed to pass decisively from painters (the true pioneers of the Modern movement) to sculptors, the makers of environments, and practitioners in a whole range of nontraditional media, from

9.12 Claire Zeisler, Installation at the Art Institute of Chicago, Illinois, 1978.

body art to video. There were, however, paradoxical elements in this shift of power. The new art of the 1970s tended to be very much a public form of expression, dependent on museums and other official spaces for its display, whereas the early Modernists had been hostile to all official institutions. This innovative art was also dependent on public money, especially in Europe, where it had been long established that museums were the business of the state or, failing that, of local government. Even in the United States, where the tradition of official support for the arts was much weaker, innovative artists became increasingly dependent on quasi-official sources of funding, such as the great foundations. At the same time, however, a two-tier system developed, with smaller arts spaces taking over responsibility for the kind of experimental work which was not at home in major institutions.

The decade saw the beginnings of a cycle which has continued throughout the 1980s and 1990s. When economic conditions are difficult, artists are forced to rely on public patronage; only when there is an economic upswing, as happened in the early 1980s, does private patronage again become important. Inevitably the kind of art which is produced at a particular moment responds to the prevailing economic conditions and hence to the kind of patronage which is available.

The Influence of International Exhibitions

Certain great international exhibitions, notably the Kassel Documentas, Germany, and to a lesser extent the Venice Biennales, have been highly influential in shaping the development of art. The Documenta exhibition, held approximately triennially, was founded in 1955 as a platform for the statement of the superiority of

Western values over those of Communism. The location was significant, since Kassel had been somewhat isolated geographically by the division of Germany. The exhibitions, lavishly funded and extremely ambitious in scale, began as relatively conservative and conventional Modernist surveys. The first Documenta contained art from the entire twentieth century, starting with Aristide Maillol (born in 1861) and Paula Modersohn-Becker (who died in 1907). Gradually, however, the exhibitions came to focus on strictly contemporary art, and thus they increasingly set the agenda for the international avant-garde of the day. Their influence was probably at its height in the 1970s, when they were able to draw vast audiences.

The last time avant-garde art had attracted such massive crowds was, paradoxically, on the occasion of the entirely hostile Degenerate Art exhibition staged by the Nazis in Munich in 1937 (see page 155), which drew over two million visitors. By the 1970s, contemporary art had come to be regarded as a form of officially promoted and sanctioned public entertainment, often imbued with therapeutic moral value. In this respect Modernism was in the process of coming full-circle, since, while their actual content was obviously very different, the Documenta shows functioned in much the same way as the official Salons of the late nineteenth century.

One result of the success of the Documenta exhibitions was an increased emphasis on environmental art and on performances, since these made a greater impact than paintings or even large sculptures in the context of a large international show which had taken on some of the trappings of a World's Fair.

The Craft Revival

Another factor which affected the artistic climate of the 1970s, and which gave the decade a different tone from its predecessor, was the reappearance of the artist-craftsman as a force in Western society, especially in the United States. The craft revival had been gathering strength throughout the 1960s, but it was not until the following decade that the consequences really made themselves felt. The events of the 1960s eventually brought with them a widespread revulsion against industrial society. American universities, during the period since World War II, had known a period of rapid growth, fueled by the provisions of the GI Bill of Rights. At the end of the decade this growth began to slow. Many graduates of visual arts courses who did not wish to plunge into the urban rat-race felt a strong desire to get back to nature and opt out of the system. Their solution was often to try to earn a living through the exercise of craft skills. Craftspeople formed an important part of what came to be labeled the "counter-culture."

Aspirants of this type felt the desire to "make"—that is, to do something directly creative—but were alienated from the world of contemporary art by its metropolitan character, its increasing emphasis on intellectual rather than physical processes and its consequent contempt for hand skills. The world of craft siphoned off much of the private patronage previously available to artists because its products were cheaper, usually domestic in scale, and not ashamed to be decorative. It exercised a particular attraction for women, since it seemed to offer a less competitive environment in which women's creativity was recognized as having a special place. Innovation in textiles, for example, had long been dominated by creative craftswomen—designers such as Dorothy Liebes (1899–1972) and Marianne Strengell (1909–). Textiles had now developed into what came to be called "fiber-art." The products of fiber-artists, the majority of whom were women, were often indistinguishable from, and indeed anticipated, the new painting and the new sculpture. Specific examples of this are the ambitious weavings of Claire Zeisler (FIG. 9.12).

Painting

Lucian Freud

9.13 Lucian Freud, *Naked Portrait*,
1972–3. Oil on canvas, 24 x 24 in
(61 x 61 cm). Tate Gallery, London.

Lucian Freud's nudes, notable for
their lack of idealization, were wel-
comed by friendly critics in the
1970s as evidence of a continuing
tradition of painterly humanism in
European art.

It was in the 1970s that painting first started to be thought of as an inherently con-
servative form of expression. Curiously enough this shift of perception was
accompanied by the discovery or rediscovery of certain, often fairly senior, artists
who had dropped out of view during the preceding decade, and who continued
to work in a recognizably traditional way. One of these was the British painter,
Lucian Freud (1922–). Freud, the grandson of Sigmund Freud, came to Great
Britain as a child, a refugee from the Nazis. His early artistic reputation was made

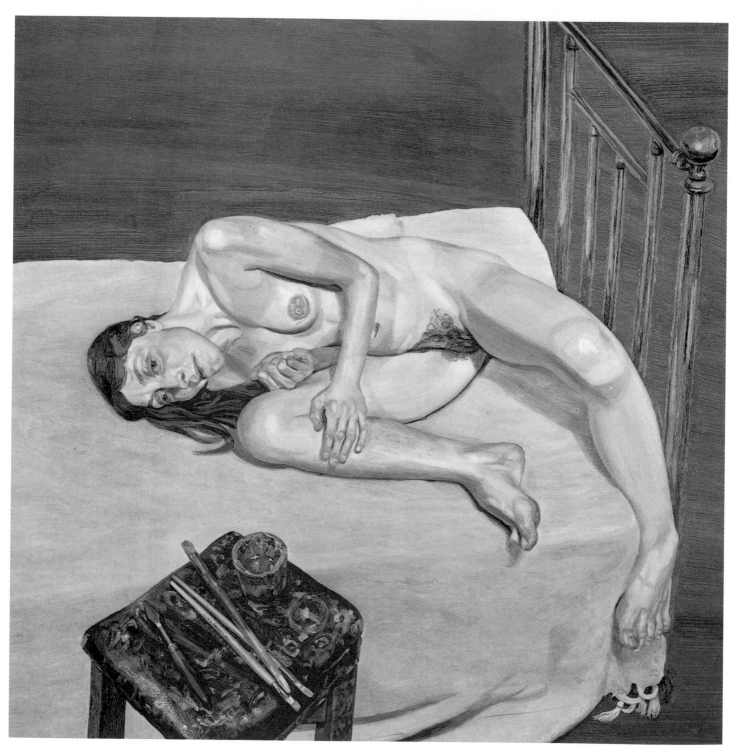

in the 1940s, as a neo-Romantic painter, briefly more celebrated than Francis Bacon, the close friend by whom he was later almost eclipsed. Though Freud enjoyed the support of a small circle of aristocratic patrons and exhibited at regular intervals in London he was, during the 1960s, thought of as a realist painter completely on the margins of modern art. The situation began to change with his Hayward Gallery (London) retrospective of 1974. This revealed him as a studio-based artist of formidable powers. His inclusion the same year in an important group exhibition held at the Palazzo Reale, Milan, "La ricerca di identità" ("The Search for Identity"), led to the rapid growth of his international reputation, consecrated in the following decade by another major retrospective (1987) at the Hirshhorn Museum in Washington, D.C. What people found in Freud was an extraordinarily searching interest in the human condition, expressed through figurative paintings, mostly nudes, executed entirely in the presence of the model (FIG. 9.13). Most of the models were well known to the artist, and this, combined with complete lack of idealization, gave his paintings a specially intimate quality. They were original in another sense: though executed in a traditional way, they were untraditional in being stripped of all the symbolic trappings expected in Western painting. They seemed to portray a world in which humanity was bereft of all external resources, reliant on itself alone.

Alice Neel

The American artist, Alice Neel (1900–84), another rediscovery of the 1970s whose forte was portraits, was honored with a solo exhibition at the Whitney Museum of Art in 1974. Neel's work, for example her group portrait, *The Family (John*

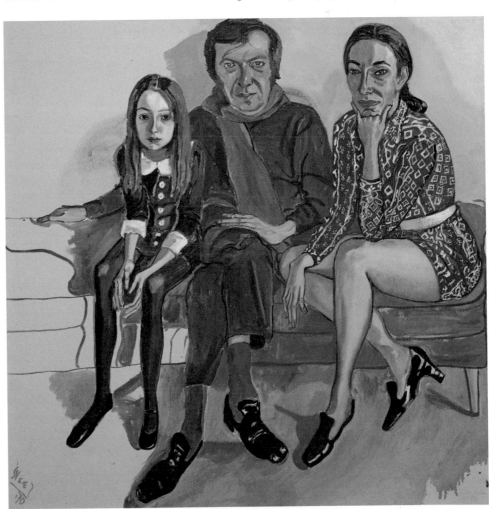

9.14 Alice Neel, *The Family (John Gruen, Jane Wilson and Julia)*, 1970. Oil on canvas, 4 ft 11⅞ in x 5 ft (1.47 x 1.52 m). Robert Miller Gallery, New York.

Alice Neel's late portraits are as unidealized as Freud's nudes. She had little interest in traditional realism or approximation to photography (notice the elongation of the fingers and calves of her sitters): the "realism" of her paintings lies in the truthful rendering of human relationships.

9.15 Susan Rothenberg, *Butterfly*, 1976. Acrylic and matte medium on canvas, 5 ft 9½ in x 6 ft 11 in (1.76 x 2.11 m). National Gallery of Art, Washington D.C.

Susan Rothenberg's series of horse-paintings was done between 1973 and 1979. In them, she said, she painted representational images in a manner consistent with abstraction. "I was able to stick to the philosophy of the day—of keeping the painting flat and anti-illusionistic, but I also got to use this big, soft, heavy, strong, powerful form to make those ideas visible."

9.16 Anselm Kiefer, *Varus*, 1976. Oil on canvas, 6 ft 6¾ in x 8 ft 2⅜ in (2 x 2.5 m). Van Abbemuseum, Eindhoven, The Netherlands.

This painting alludes to an episode in early German history—the defeat of the Roman general, Varus, by the German chieftain Arminius, in the Teutobergerwald in AD 9. Kiefer's "history paintings," unusually in modern times, require historical knowledge to be understood.

Gruen, Jane Wilson and Julia), is more overtly Expressionist in feeling than Freud's, but it has the same intensity of observation, the same conviction that it is the human being alone who matters (FIG. 9.14). Like Freud, Neel tended to draw her models from a small circle of intimate friends.

Susan Rothenberg

There is also an appeal to tradition—though of a much remoter sort—in the work of Susan Rothenberg (1945–). Rothenberg, who had acted as an assistant to the sculptor, Nancy Graves (1940–), and the performance artist, Joan Jonas (1936–), only began to paint in a focused way in the mid-1970s. She found almost immediate success with her large, simplified images of horses, which resemble paleolithic cave-paintings (FIG. 9.15). These images were later, because of their apparent roughness, to be associated with the so-called "bad painting" movement of the 1980s. It is nevertheless clear, both from the artist's own account of how they evolved[5] and from their actual appearance, that they are linked to the quasi-mystical search for roots in nature and prehistory that animated a number of artists during the decade and led to the development of Earth Art.

Anselm Kiefer

A similar appeal to the remote past can be found in the paintings which Anselm Kiefer (1945–) produced in the 1970s. Kiefer began his career as a disciple of Joseph Beuys. His earliest work was Conceptual, and included a series of photographs of himself giving the Nazi salute in various locations. The ambiguity about German history and the lessons which it might have to offer reflected in this series of photographs also surface in the ambitious paintings Kiefer produced in the early and mid-1970s. Those from the beginning of the decade concerned themselves with the early Germanic myths which had been such favorites with

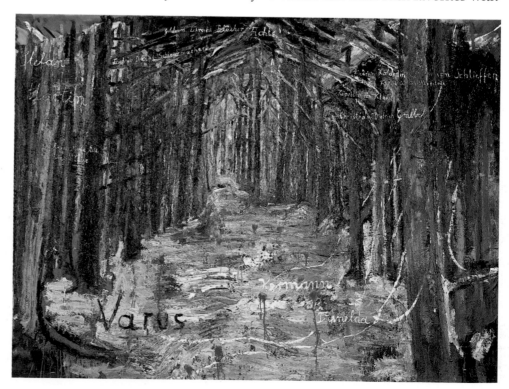

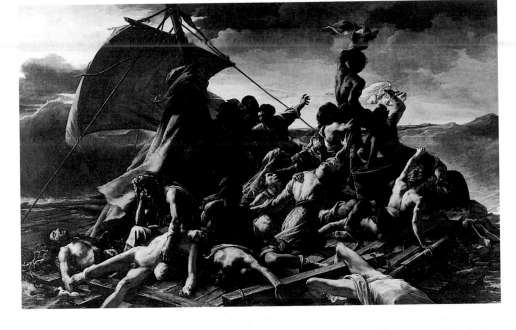

9.17 Théodore Géricault, *The Raft of the Medusa*, 1819. Oil on canvas, 16 ft 1⅛ in x 23 ft 5⅞ in (4.91 x 7.16 m). Musée de Louvre, Paris.

Géricault's *Raft of the Medusa*, one of the quintessential expressions of French Romanticism in the early nineteenth century, has the sweep and passion that is echoed in the best work of Anselm Kiefer.

9.18 Philip Guston, *The Coat*, 1977. Oil on canvas, 5 ft 8 in x 6 ft 7 in (1.73 x 2.01 m). Private collection.

Philip Guston's late style owes much to the caricatural style of sixties and seventies "underground" magazines. His achievement was to fuse elements from American popular culture to the Expressionist ethos. Unlike Pop Art's cool impersonality, however, there is a commitment to rawness, to psychic risk, to a sense of personal exposure.

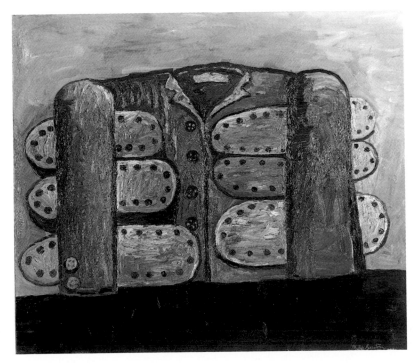

the rulers of the Third Reich—the Edda and the Ring of the Niebelung (the latter being the source for Wagner's cycle of Ring operas, also much relished by the Nazis). A little later, Kiefer turned to more firmly established historical episodes, such as the defeat of the Roman general, Varus, by the German chieftain, Arminius, in the Teutoburgerwald in AD 9 (FIG. 9.16). These paintings were remarkable for their complexity at a time when painting as a means of communication seemed to be in full retreat in the face of more contemporary means of expression. Kiefer's work can be compared to the huge political paintings produced in the early decades of the nineteenth century by French Romantic artists—one example being Théodore Géricault's *Raft of the Medusa* (FIG. 9.17). It is an interesting coincidence that Géricault, like Kiefer, was working in the immediate aftermath of a dictatorial regime, about which he seems to have had mixed feelings.

Philip Guston

A very different and much less traditional kind of figuration appeared in the work of the veteran Abstract Expressionist, Philip Guston (1913–80), who in the late 1960s shocked the American art world by turning to figuration. His late paintings are deliberately bold and rough, with a cartoon-like simplicity of line which reminds one that he had begun his artistic career as a young boy by taking a correspondence course in cartoon-drawing (FIG. 9.18). The cartoons his paintings of the 1970s most resemble, however, are those which were being produced from the mid-1960s onward for "underground" magazines like the *East Village Other*. In these paintings, Guston seemed to reject his own generation in favor of a younger one, while at the same time turning his work into an autobiographical vehicle for his feelings of self-disgust, combined with savage criticism of American society. He reached across the divide which separated "insider" figures like himself from "outsiders" such as a new generation of artists in the African-American community.

African-American Art

In the United States, the kind of art in which politics played the largest part during the 1970s (this despite the generally turbulent political state of the nation taken as a whole) was the emergent art of minority groups, above all that produced by African-Americans. The idea of a specifically African-American art was not new. It had surfaced in the 1920s, in the writings of leading black intellectuals, particularly Alain Locke, a Harvard-educated philosopher who became a professor at Howard University. Locke's essay, "The Legacy of the Ancestral Arts," published in 1925, laid down a program for African-American art, urging it to draw on the tribal art of Africa. The artists of the so-called Harlem Renaissance of the interwar years accepted Locke's support, but prudently ignored many of his urgings.

The Civil Rights movement of the 1960s marked a turning-point. The feeling grew that art produced by African-Americans must pursue the aim of racial liberation to the exclusion of all else—that is, that it should become primarily an instrument of propaganda, rather than one of individual self-realization. One authority on the subject, writing in 1970, defined the situation thus:

> Black art is a didactic art form rising from a strong nationalistic base and characterized by its commitment to (a) the use of the past and its heroes to inspire heroic and revolutionary ideas, (b) to use recent political and social events to teach recognition, control and extermination of the "enemy," and (c) to project the future which the nation can expect after the struggle is won.[6]

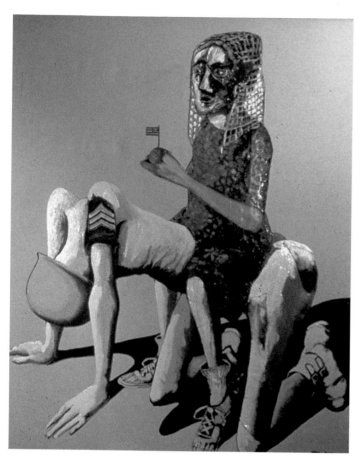

9.19 (above) Benny Andrews, *American Gothic*, 1971. Oil and collage on canvas, 5 ft x 4 ft 2 in (1.52 x 1.27 m). Metropolitan Museum of New York.

A number of artists, such as Benny Andrews (1930–), made African-American propaganda art of a brutally effective kind (FIG. 9.19), taking their cue from the socially committed painting which had flourished in America during the 1930s.

Other artists, such as the Washington-based painter, Sam Gilliam (1933–), utterly rejected the call to arms (FIG. 9.21). His ambition, successfully achieved, was to be accepted as an abstract painter on the same footing as other leading American abstractionists. His closest kinship is not to anything specifically African, but to the work of artists such as Morris Louis.

Finally, there was a third group of artists, often women, whose work acknowledged African-Americans as participants, even if unwilling and disaffected ones, in the contemporary mass culture of the United States. Their work frequently linked feminist concerns to African-American ones. A leading artist in this category was the California-based Betye Saar (1926–). Her hardest-hitting works are collages based on derogatory commercial images of African-Americans, such as the plump, obsequiously grinning black mammy used as a trademark by the Aunt Jemima range of food products. In one work of the series, *The Liberation of Aunt Jemima* (FIG. 9.20), Jemima is transformed into a gun-toting revolutionary.

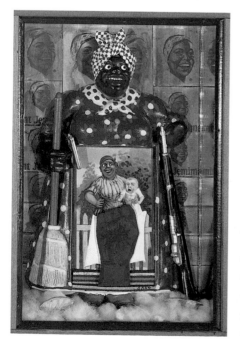

The New Mural Movement in the United States

Though painting sank in the esteem of many avant-garde critics and theorists of the period, the 1970s saw the rise of a new and different kind of mural movement in the United States. Rather than being the work of individuals, these murals were often collective efforts. Their rise was part of the search for self-expression and

9.21 Sam Gilliam, *Coffee Thyme*, 1977. Acrylic on canvas, 7 ft 6⅛ in x 10 ft (2.29 x 3.05 m). Museum of Modern Art, New York.

9.20 (*opposite*) Betye Saar, *The Liberation of Aunt Jemima*, 1972. Mixed media, 11¾ x 11⅞ x 2¾ in (29.8 x 30.3 x 6.9 cm). University Art Museum, University of California, Berkeley; purchased with the aid of funds from the National Endowment of Arts.

Saar almost always works with found objects to create assemblages that reflect black experience in the United States. Here the repeated image of the smiling, happy-go-lucky cook, Aunt Jemima, taken from advertisements for a pancake mix, is sabotaged by the rifle in her left hand.

visible public identity now undertaken by minority groups. Some murals were the work of African-American artists living in the black ghettos of New York and Chicago, but others—in some ways the most striking—were made by Chicanos (Mexican immigrants or people of Mexican immigrant descent) and could be found in Los Angeles.

Chicano art, as an identifiable phenomenon, first appeared in 1965, as part of a community response to labor agitation by the National Farmworkers' Association, led by Cesar Chavez. Soon, however, it became an urban product rather than a rural one. Its sources of inspiration were threefold: the murals painted between the early 1920s and the mid-1940s by the leading Mexican Muralists, Rivera, Orozcó, and Siqueiros (see FIGS 5.9, 5.10, and 5.11); the wallpaintings often found on the walls of *pulqueriàs*, or drinking places, in the Mexican barrios, together with the chromo-lithographic illustrations found in calendars distributed by local traders; and, finally, Cuban revolutionary posters. The Cuban posters were made widely available through a handsome and inexpensive book published at the beginning of the 1970s, *The Art of Revolution, 1959–1970*, with an introduction by the influential critic, Susan Sontag.

The most striking series of Chicano murals are those painted at Estrada Courts, a large public-housing complex in east Los Angeles, between 1973 and 1976. Many were the work of a cooperative of young people who called themselves Los Ninos del Mundo. The imagery is diverse—there are pseudo-Aztec

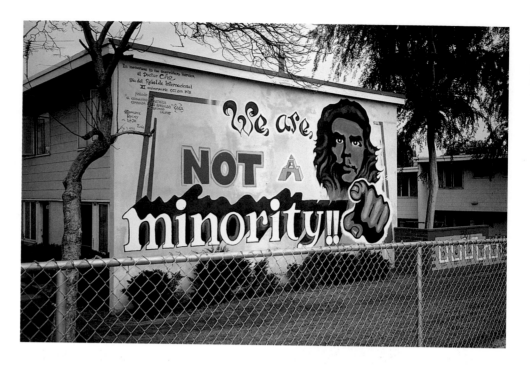

9.22 Congresso de Artistas Chicanos en Aztlán, *"We are NOT a minority!!"*, 1978. Mural, c.20 x 30 ft (6 x 9 m). Estrada Courts Housing Project, East Los Angeles, California.

This features a gigantic portrait of Che Guevara, the Cuban revolutionary leader, combined with imagery derived from a World War I recruiting poster.

designs, images taken from science fiction, and politically inspired images. The best-known mural (the work of the Congresso de Artistas Chicanos en Aztlán) is based on a World War I recruiting poster and features a gigantic head of Che Guevara, killed in Bolivia some ten years previously, plus a huge hand which points accusingly at the viewer and the militant slogan, "We are NOT a minority!!" (FIG. 9.22). This was not completed until 1978. It prefigures some of the militant art of the following decade, but other murals at the site are more interesting in their fusion of "high" and "low" cultural sources, and in their commitment to a kind of visual impact which much avant-garde art had abandoned.

Sculpture, Environments, and Performance

One of the most characteristic products of the avant-garde of the 1970s was "body art." This was at one and the same time an extension of the Environmental and Performance Art which had already made an impact during the previous decade, and an expression of dissatisfaction with the romantic idea of risk, as this had been interpreted by the Abstract Expressionists and the critics and theoreticians who had lauded their work.

Central to the theoretical consensus concerning Abstract Expressionism was that this kind of art involved dangers to the spiritual self because of the artist's effort to incorporate the horrific sublime into his or her work. This was essentially an extension of the doctrines of Romanticism, as first proclaimed by Edmund Burke in his influential essay, *A Philosophical Enquiry into the Origins of our Ideas of the Sublime and Beautiful* (1757), reinforced by events such as the death of Jackson Pollock in an automobile accident (1956) and the suicide of Mark Rothko (1970). Illogically, both artists were thought to have sacrificed not merely their spiritual selves, but their actual physical existence, to their art.

A new generation of artists began to feel that the separation between the ideas of spiritual and physical risk was an artificial one. They also recognized that the use or misuse of their bodies was a quick route to attention, especially from the mass media, fascinated as always by sex and violence. The tendency had already surfaced in the 1960s in Vienna with the work of the Vienna Direct Action Group.

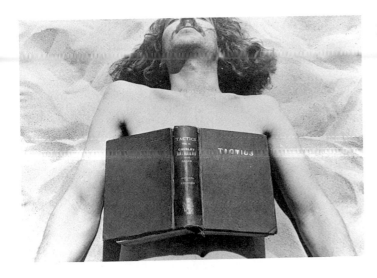

American artists were hard put to exceed what had already been done in Europe, but they tried their best. In 1971 the Californian artist, Chris Burden (1946–), had himself shot in the arm, presenting the action and its result as an artwork.

Vita Acconci and Dennis Oppenheim

The two best-known American exponents of body art were Vito Acconci (1940–) and Dennis Oppenheim (1938–). In the early 1970s, Acconci performed a series of actions involving the body. In *Trademarks* (1970), he stripped and bit different parts of his body so as to leave visible tooth marks. In *Adaptation Study* (1970), he stuffed his hand into his mouth until he choked. His most notorious Performance came in 1972 at the Ileana Sonnabend Gallery in New York. A sloping, ramplike platform was built in the gallery space and Acconci lay beneath it, masturbating, while two loudspeakers transmitted his onanistic fantasies to those who walked above his head.

Oppenheim's best-known body-art piece is one of his simplest. In *Reading Position for Second Degree Burn* (FIG. 9.23), he lay in bright sunshine with an open book on his chest until the unprotected area of skin was painfully sunburned, having a photographic record made of his appearance during and after this. The piece offers an unusual element of irony, since it relies for its effect on an interplay of ideas between the notion of leisure, as represented by the act of sunbathing, on the one hand, and ideas of self-endangerment, discomfort, and sacrifice of however minor a sort, on the other.

9.23 Dennis Oppenheim, *Reading Position for Second Degree Burn*, 1970. Stage I and II. Book, skin, solar energy. Exposure time: 5 hours. Jones Beach, New York.

Oppenheim supplies the following explanation of this work: "The piece has its roots in a notion of color change. Painters have always instigated color activity. I allow myself to be painted … my skin becomes pigment. I can regulate its intensity through control of the exposure time. Not only do the skin tones change, but change registers on a sensory level as well. I feel the act of becoming red."

Joseph Beuys

The most influential artist of the decade, perhaps of the whole postwar period, was the German, Joseph Beuys (1921–86). Beuys first made a reputation through his connection with the Fluxus Group, and by the late 1960s he had a Europe-wide reputation for his Actions, a term he insisted on in preference to Happening or Performance. In the 1970s, Beuys widened his activities so that what had been separate areas came together under a single umbrella—that of his own uniquely seductive and charismatic personality.

There are several things to be said about Beuys before one can fully understand his impact on the European art scene. The context for almost everything he did was the political situation in Germany. The western half of Germany, the Federal Republic, experienced, despite the recession of the 1970s, immense economic success, accompanied by apparent political stability. Nevertheless, the presence of another Germany, the Communist-ruled German Democratic Republic, nagged at the national consciousness. A physically divided country was also politically uneasy: the terrorist Baader–Meinhof gang acquired an emblematic significance out of all proportion to its actual success in creating disruption.

Beuys belonged to a part of German culture which looked back nostalgically to the time when Germany was a unity, and which still retained traces of the mythology of "blood and soil" which had been so vigorously promoted by the Nazis. The official attitudes of the new, sanitized, democratic Germany seemed to Beuys and his followers stuffy and repressive. It seemed impossible to combat this repression and pressure for conformity through the normal channels of left-

wing political opposition, which were blocked by the presence of a militantly Marxist regime in the German territories to the east. Beuys's reaction was to declare that politics could be regarded as an art form, as something which he dubbed "social sculpture." The most striking manifestation of Beuys's political involvement took place at the Kassel Documenta of 1972, when he set up an office space for his Organization for Direct Democracy within the context of the exhibition, and spent a hundred days in succession there expounding his political views tirelessly to all comers.

Beuys's political statements would not have produced an effect, but for the context provided for them by his personality. Beuys was perfectly well aware of his own charisma—he saw himself as a modern shaman, that is, as someone empowered to perform rituals and magical acts for the better health of society. These rituals often involved a degree of physical suffering, or at least of extreme physical discomfort—lying or standing in awkward positions, performing repetitive physical actions for long periods, sometimes suffering actual physical restraint, such as being wrapped in heavy rolls of felt. Felt and fat were materials which played prominent roles in Beuys's work, but it was their symbolic, even talismanic, value which interested him, not their physical appearance. Shot down over the Crimea, when he was a Stuka pilot during World War II, he later claimed that he had been rescued by nomadic Tartars who saved his life by rubbing him with fat and wrapping him in felt. The Tartars had already, by this time, been deported by Stalin from the region.

Implicit in this story was a claim to have died, or to have come so near to death as made no matter, and then resurrected again. It is not surprising therefore that Beuys also saw himself as a reincarnation of Christ.[7] His autobiographical exhibition, *Arena* (FIG. 9.24), first shown in Naples in 1972, which consisted of innumerable cuttings, photographs, and other ephemera arranged in heavy metal frames, was conceived on the model of the Stations of the Cross,[8] and Beuys tended to emphasize this aspect in later showings of the same material—for example, as part of his retrospective (and first major American showing) at the Guggenheim Museum, New York, in 1979. But it was always more important to Beuys that this, and much of the other material he produced, existed, and was known to exist, rather than being physically accessible. At some showings, the frames of

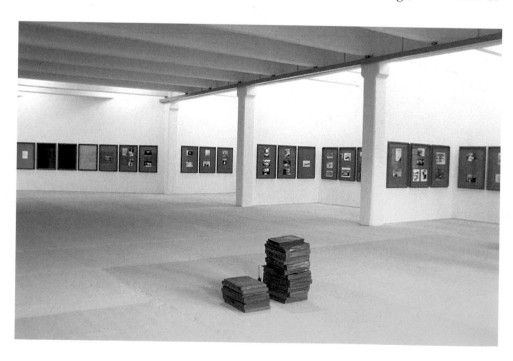

9.24 Joseph Beuys, *Arena—where would I have got if I had been intelligent!*, 1970–2. Installation at the Dia Center for the Arts, New York.

Most of Beuys's work was drawn directly from his own life and the historical experience of the German people. In this installation, a piece of self-projection done with characteristic bravado, he seemed to compare his life to that of Jesus Christ. Beuys's mission, as he saw it, was to offer society a form of moral, social, and psychological therapy, but not necessarily any form of visual stimulus.

Arena were arranged in stacks, so that only a small portion of what they contained was visible. The move away from the specifically visual, always hitherto considered the core of what an artist did, was crucial to the development of Beuys's career and to his impact on the art world. The change in the definition of art which he proposed is still being vigorously debated a quarter of a century later.

It was another, perhaps lesser, part of Beuys's mission to carry a banner for European, as opposed to American, art. Despite the continuing prestige of American art, established first by Abstract Expressionism, then by Pop, from the 1970s onward the American art world no longer enjoyed the international dominance accorded to it in the 1950s and 1960s.

Bruce Nauman

Despite this, the artist who in many ways most closely resembled Beuys was an American, Bruce Nauman (1941–). He was too young to have participated in World War II (a formative experience for Beuys), and American social divisions, though acute, were not as yet considered an essential preoccupation of artists. His work, therefore, has a different tone from Beuys's. Nevertheless, there are many similarities. Among these are the variety of activities they engaged in and the lack of an unmistakable stylistic thumbprint. It is impossible to identify a work by Beuys or Nauman in the way that one can always identify the products of Andy Warhol and Roy Lichtenstein. The emphasis is always on the artist's personality as the core of the work.

Nauman is on record as having said that he is not interested in "adding to a collection of things that are art, but in investigating the possibilities of what art may be."[9] This has led him to experiment with a wide variety of different media—video, neon, variations of Conceptual Art, and Earth Art. One central preoccupation was the body, not just the artist's feelings about it, as represented by the work of Acconci and Oppenheim, but the spectator's or participant's reaction to experiences of confinement, isolation, or both. These works are not always easy to describe or even to illustrate, since the essence of what they offer is not conveyed by words or even pictures. A possible exception is *Double Steel Cage* (FIG. 9.25), where an illustration does convey the simultaneous feelings of exposure and confinement which the work induces. The difference from Beuys is that what the

9.25 Bruce Nauman, *Double Steel Cage*, 1974. Steel, 6 ft 10¾ in x 13 ft 1½ in x 16 ft 4⅞ in (2.1 x 4 x 5 m). Museum Boymans-van-Beuningen, Rotterdam, The Netherlands.

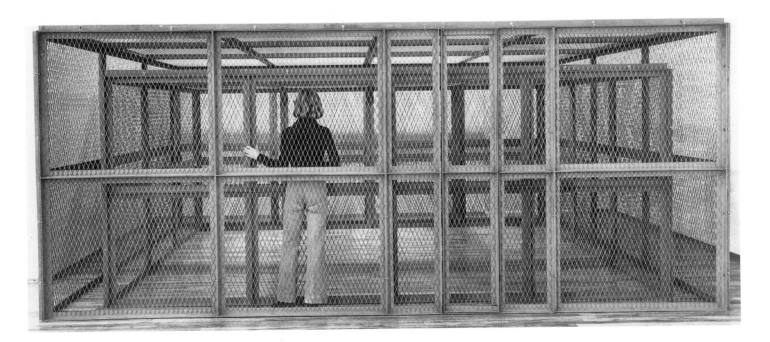

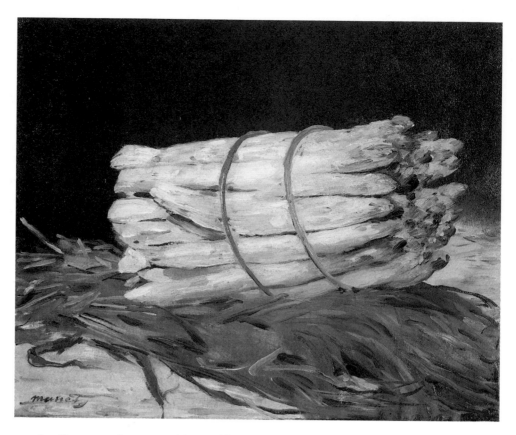

9.26 Edouard Manet, *A Bunch of Asparagus*, 1880. Oil on canvas, 17¼ x 21¼ in (44 x 54 cm). Wallraf-Richartz-Museum, Cologne, Germany.

Manet's still life is the basis for one of Hans Haacke's Conceptual works. He follows the painting from the time it was painted until its acquisition by the Wallraf-Richartz-Museum in Cologne.

work offers remains an end in itself—it does not lead the participant on to reflections about the nature of the society that surrounds him. Beuys, for all his narcissism and fixation on his own myth, almost invariably does this.

Hans Haacke

Socially engaged art during the decade, stripped of the mythological trimmings which Beuys brought to it, is perhaps best represented by the work of another German, Hans Haacke (1936–). At the beginning of the 1970s, Haacke, who was then living in New York, gained considerable notoriety through his analyses of the structure of the contemporary art world, and the connections between this and big business, presented as Conceptual Art works. He was the hero of two major scandals in particular. One was the cancellation of his retrospective at the Guggenheim Museum in 1971, because of his insistence on focusing on the family connections of the trustees of the museum, and their connection with a copper mining company operating in Chile (the radical Salvador Allende had been elected president of Chile in 1970, and the American business community was violently hostile to him). Thomas Messer, the director of the museum, commented: "While the exposure of social malfunction is a good thing, it is not the function of a museum."[10]

In 1974, Haacke's display of the provenance of Manet's painting, *A Bunch of Asparagus* (FIG. 9.26), offered as part of the PROJEKT '74 celebration in Cologne, was banned by the director of the Wallraf-Richartz-Museum because it drew attention to the connections between the Nazi regime and one of the chief benefactors of the museum, the banker, Herman J. Abs. It also made it clear that all the collectors and dealers who had owned the work before Abs bought it for the Wallraf-Richartz had been Jewish.

Two things now give Haacke's work a period flavor. One is that the scandals he stirred up would almost certainly not occur today—the power structures within the art world have become much less sensitive to such challenges. The other is

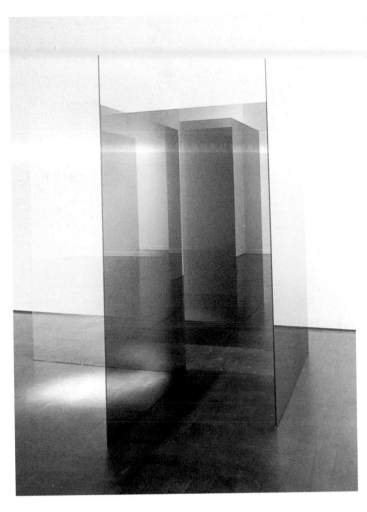

its almost exclusive concentration on the art world itself as a microcosm of society. In the 1990s the situation is much more open.

The Art of Light and Space

Haacke's work was "immaterial" in the sense that it was made entirely of ideas—its embodiment could be a series of placards in a museum, or just as easily a magazine article quoting the same facts and offering the same diagrams, or the pages of a book. A more poetic approach to the notion of the immaterial can be found in what was done by a group of Californian artists who had some links to Bruce Nauman (another Californian) and to the American Minimalists of the 1960s. Perhaps closest to the Minimalists was Larry Bell (1936–), who used the specially coated glass originally manufactured for the space industry to create sculptures which are evanescent in appearance, even if solidly material in substance (FIG. 9.27).

More directly concerned with light and its manipulation was James Turrell (1943–). Turrell's work was first seen at its most magical in his Light Projections and Light Spaces exhibition held at the Stedelijk Museum, Amsterdam, in 1976. Perhaps the most impressive work was *Arhirit*, a succession of four empty chambers, each of which resonated with a different color manufactured solely within the viewer's eye . The hues also changed or deepened as the viewer passed from room to room, and they differed according to the direction of his or her progress through the sequence. As the

9.27 (above) Larry Bell, *Untitled 1971*, 1971. ⅜-in glass panels coated with inconel, 8 x 5 ft (2.44 x 1.52 m) and 8 x 6 ft (2.44 x 1.83 m). Denver Museum of Art, Colorado.

Bell's work, especially in freestanding glass panels, exploits shifts of perception according to movement in space. The variety of reflections, or non-reflections, from the surface (coated at different places with opaque and reflective substances) changes radically what the viewer sees at any one point.

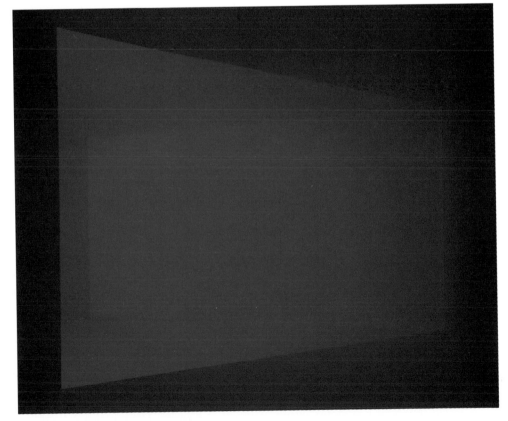

9.28 James Turrell, *Wedgework IV*, as installed at the Hayward Gallery, London, April–June 1993.

An illusory wall of light appears to divide the space diagonally.

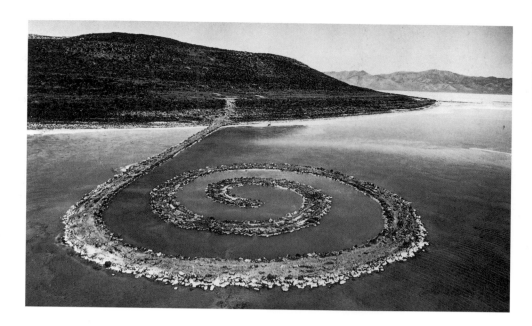

9.29 Robert Smithson, *Spiral Jetty*, 1970. Mud and rocks, about 1,500 ft (457 m) long, 15 ft (4.6 m) wide. Great Salt Lake, Utah.

This mud and rock coil, the most celebrated example of Earth Art, is now submerged by the waters of the Great Salt Lake, on whose shores it was built. Smithson called it an "immobile cyclone." The implication that Earth Art dissolves the distinction between nature and art is apparent in his remark that with *Spiral Jetty*, "one ceases to consider art in terms of an 'object'."

director of the Stedelijk, Edward de Wilde, put it, "the light seem[ed] to hang as some kind of mass."[11] Later works offer identical effects (FIG. 9.28).

Imaginary Archaeology

Turrell has attracted attention with a rather different work, the Roden Crater Project, begun in 1972 and still in progress. The Roden Crater is an extinct volcano in the Arizona desert, which Turrell is excavating so as to provide spaces where cosmic events will take place:

> Every 18.6 years, for example, the moon will appear dead center in the tunnel of the crater—a spectacle that should be virtually overwhelming. At the same time visitors will see a moon-image cast on the back wall of the tunnel—upside down and backwards, as if in a camera obscura. At the time of the summer solstice an image of the sun in its furthermost sunrise will appear on the opposite wall.[12]

This project cannot be thought of purely in terms of the manipulation of light. It has overtones of the primitive, cosmic rituals associated—at least in the popular imagination—with Stonehenge, which many believe to have been a kind of giant perpetual calendar. The tendency to look back to the remote past for inspiration very soon manifested itself in Earth Art, despite its stringent Minimalist beginnings. The best-known example (despite the fact that it now no longer exists, since the lake has risen to cover it) is the spiral jetty built by Robert Smithson (1938–73) on the shores of Great Salt Lake in Utah (FIG. 9.29). Smithson originally thought of this as a mechanism for catching and emphasizing the unique pinkish color of the salt lakes scattered throughout the world. The spiral form, nevertheless, takes on an unmistakable mystic significance, not least because it figures so prominently in prehistoric monuments such as Maes Howe in Ireland.

During the 1970s other artists experimented with forms which seemed related to the new popular passion for archaeology. It was a direction which attracted a number of women sculptors. Particularly notable were the sculptures by Alice Aycock (1946–), Mary Miss (1944–), and Jackie Ferrara (1929–) which seemed to mimic the forms of primitive buildings. An interest in the literally grounded, nourishing quality of the earth, and in ideas of shelter, protection, and domesticity here found expression within an avant-garde context.

Arte Povera

In Europe, the 1970s saw the rise of Arte Povera. This, as the name implies, was an art deliberately made of "poor" materials. Though the tendency had already begun to manifest itself in Italy by the mid-1960s, the term itself was coined by the critic, Germano Celant, who in 1970 organized an influential exhibition under this title at the Museo Civico, Turin. According to Celant:

> Arte Povera expresses an approach to art which is basically anti-commercial, precarious, banal and anti-formal, concerned primarily with the physical qualities of the medium and the mutability of the materials. Its importance lies in the artists' engagement with the actual materials and with total reality and their attempt to interpret that reality in a way which, although hard to understand, is subtle, elusive, private, intense.[13]

This description is so general that further qualifications need to be added. Arte Povera, in addition to being made of self-consciously "poor" and banal materials, is usually environmental and often has a strongly theatrical element. In many cases it resembles the work Beuys was producing in the late 1960s, but without the myth-making and the element of moral fervor. Some work connected with the tendency did, it is true, have a political slant. Examples are various works by Luciano Fabro (1936–) featuring an element in the shape of the Italian peninsula. In one of these, the bootlike outline is hung upside down, as an allusion to the ignominious death of Mussolini at the hands of partisans.

Others are purely poetic gestures. The most celebrated lies just outside the limits of the decade. In 1969, the Greek-born but Italian-domiciled Jannis Kounellis (1936–) tethered twelve horses in the L'Attico Gallery in Rome, and called the result simply *Untitled* (FIG. 9.30). The claim was that the presence of the beasts, their warmth and smell, the sounds they made, in addition to their actual appearance in a gallery context, all added up to create something which could be legitimately classified as a work of art.

Conceptual Art in Argentina

Environmental and Conceptual Art became popular in Latin America during the decade, often for political reasons. Works of this sort became an outlet for covert political messages in countries suffering under repressive regimes, especially Chile and Argentina. In Buenos Aires, during the worst days of the military junta

9.30 Jannis Kounellis, *Untitled*, 1969. Twelve horses, dimensions variable. L'Attico Gallery, Rome.

This installation consisted of twelve horses tethered against the wall of a gallery room, each horse the same distance from its neighbors, as if they were paintings or sculptures. In other words, perhaps, art was no different from anything else found in the world.

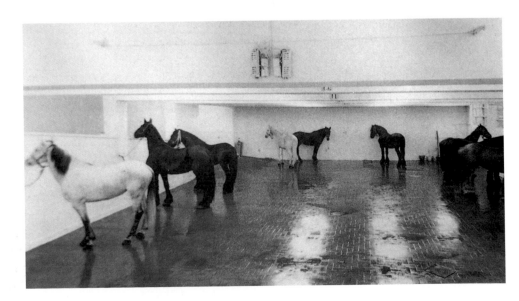

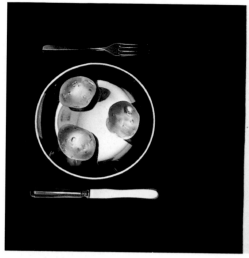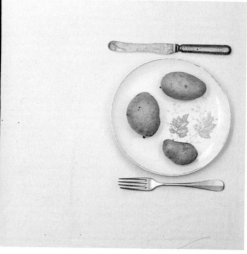

9.31 Victor Grippo, *Analogy IV*, 1972. Mixed media, 29½ x 39⅜ x 21⅝ in (75 x 100 x 55 cm). Ruth Benzecas Gallery, Buenos Aires.

This alludes subtly to the vast gulf between rich and poor in Argentina at the time when it was made.

9.32 Tony Cragg, *Stack*, 1975. Mixed media, 6 ft 6¾ in x 6 ft 6¾ in x 6 ft 6¾ in (2 x 2 x 2 m). Lisson Gallery, London.

This piece, like much of Cragg's work, contains an implied criticism of the romantic pastoralism of contemporary artists such as the British sculptor, Richard Long (see FIG. 8.39). Cragg regularly uses discarded waste products of modern consumer society to build up his sculptures, to explore, as he put it, "man's relationship to his environment and the objects, materials and images in that environment."

which then ruled the country, a lively art scene survived under the aegis of CAYC (Centro de Arte y Comunicación), founded in 1971 by the critic and impresario of the arts, Jorge Glusberg. *Analogy IV* by Victor Grippo (1936–) (FIG. 9.31) is typical of this phase of Latin American art, where even the mildest social criticism was forced to disguise itself in hermetic forms. It consists of a table divided into two sections, a black and a white. On the black section everything is transparent—transparent acrylic cutlery and a glass plate with three transparent plastic potatoes. On the white section everything is "real"—real cutlery, a china plate, actual potatoes. The piece contrasts the natural with the artificial. At the same time it criticizes the luxury and ostentation of those who supported the regime. In the year that it was made inflation in Argentina rose to 60 per cent, and the military ruler, General Alejandro Lanusse, was just about to throw in his hand in despair because of escalating urban terrorism, and recall the exiled populist demagogue, Generalissimo Perón.

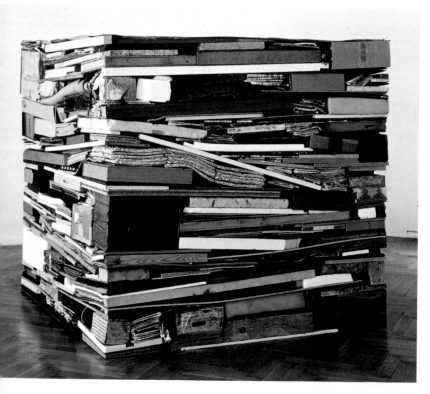

British Sculpture

Sculpture in Great Britain, in full reaction against Henry Moore, also took on some of the characteristics of Arte Povera. The most discussed newcomer of the period was Tony Cragg (1949–), whose early work consisted of piled-up stacks of urban detritus (FIG. 9.32). Using bricks, bits of cardboard, corrugated paper, and pieces of felt, Cragg imposed a provisional order on what was essentially disordered, but without achieving the crisp precision of Minimal shape. Cragg's sculptures of this period contain an implied criticism of the romantic pastoralism of Richard Long (see FIG. 8.39). Long's work appears to tell us that the simple materials used are inherently noble because they are natural, and that the result must therefore be noble too. Cragg applied a version of Long's way of working with materials that man had already spoiled, and came up, by contrast, with a bitter criticism of urban culture—the more effective because it was clear that he was addressing himself to the very audience of urban sophisticates which was Long's principal constituency.

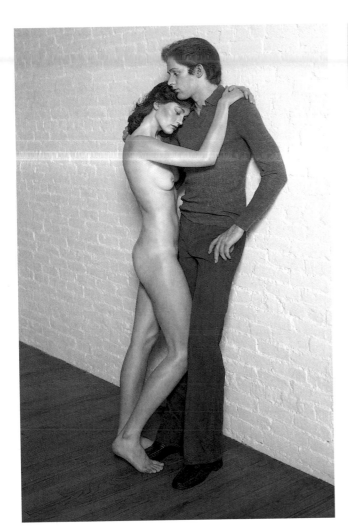

9.33 (*above*) John de Andrea, *Couple (Man Clothed)*, 1978. Cast vinyl, polychromed in oil, life-size. OK Harris Gallery, New York.

9.34 (*above right*) Duane Hanson, *Tourists*, 1970. Polyester resin and fiberglass, painted in oil, Man: 59⅞ x 31½ x 12¼ in (152 x 80.5 x 31 cm); Woman: 63 x 17⅜ x 14½ in (160 x 44 x 37 cm). Scottish National Gallery of Modern Art, Edinburgh.

This startlingly realistic depiction of social types, thoroughly characteristic of Hanson's output, was not, the artist contended, a direct replica of life. All of Hanson's work pays homage to the quiet desperation of ordinary people's lives.

Super Realist Sculpture

The only kind of sculpture made in the 1970s which seemed to go entirely against the grain of the times were the Super Realist figures made by a small group of American artists following in the wake of the Pop sculptor, George Segal. This sculpture developed later than the Photorealist painting with which it is usually connected. The two sculptors most generally cited as Super Realists are John de Andrea (1941–) and Duane Hanson (1928–96). Their range of subject matter is extremely different. De Andrea makes figures which depict the youthful good looks of collegiate Americans, generally shown unclothed (FIG. 9.33). Hanson, as in his celebrated figures of *Tourists* (FIG. 9.34), offers what seem to be satires of contemporary types. What they have in common is the extreme verisimilitude of the result. Hanson's figures in particular are often mistaken for living people, when they are placed in a gallery setting, so perfect is the imitation of life, based not only on a version of Segal's life-casting technique, but on a brilliantly orchestrated choice of accessories. It is this which provides a clue as to the place of these figures within the general development of art during the 1970s. De Andrea and Hanson, though in an entirely different way, concern themselves with the debate about "the real" initiated by Fluxus and continued by the Arte Povera artists in their use of "real," that is, untransformed, materials.

Feminist Art

A work which used "real" elements, but for a very different purpose from either Arte Povera or the Super Realist sculptors was Judy Chicago's *The Dinner Party*

Judy Chicago: *The Dinner Party*

The most celebrated artwork so far thrown up by the feminist movement, Judy Chicago's *The Dinner Party* (FIG. 9.34) is a homage to thirty-nine women whom the artist considered to be major figures in Western history, plus ninety-nine others. A triangular table accommodates thirty-nine place settings, each with a different and specially designed plate, goblet, and runner. The place settings are arranged thirteen to a side, so that the whole assemblage creates the image of a triple eucharist. The table stands on a tiled floor, upon which the names of many further women are inscribed. Accompanying the environment is an illuminated manuscript in five sections which offers a rewriting of Genesis, with a goddess rather than a God as supreme creatrix, and a new vision of the Apocalypse, in which the world is healed and made whole through feminist values.

Judy Chicago first conceived the work in the early 1970s, as a result of her study of china painting, then considered a minor form of craft expression, generally practiced by women rather than by men. Painting plates led to the thought of presenting these plates as part of a complete table-setting, and then as a series of table-settings featuring another skill thought of as typically "feminine"—embroidery.

As the project grew in scope, more and more people, mostly but not exclusively women, became involved, researching the historical figures who were to be included, and contributing their own hand-skills to its execution.

Part of *The Dinner Party*'s significance is that it is a collective creation, although the overall conception is that of a single individual.

Quite apart from this, *The Dinner Party* has a recognizably Conceptual element, very much part of the general artistic climate in the United States during the 1970s, Judy Chicago's statement notwithstanding:

> I don't believe in art simply as a tool of social change. I believe in art as art. One can use art as a tool for social change or one can make art which has as one constituent the changing of social and political circumstances, but after that is over art will continue to exist as beautiful images.*

The Dinner Party was first exhibited at the San Francisco Museum of Modern Art in March, 1979, and remained on view for three months, during which time it attracted 100,000 visitors and excited more controversy. While stressing that the work itself was the most important result of the whole enterprise, Chicago also noted, in her autobiography:

> One of the truly unique aspects of *The Dinner Party* studio was that it provided continuous reinforcement for a feminist perspective and feminist values. I defined these as being woman-centered and supportive of honesty and the open expression of one's vulnerability. Outside the studio, not only were honesty and vulnerability often eschewed, but women and women's concerns were almost always marginalized.†

*Judy Chicago, interviewed by Dinah Dossor, in Hilary Robinson (ed.) *Visibly Female: Feminism and Art, an Anthology*, New York, 1988, p. 43.
† Judy Chicago, *Beyond the Flower: The Autobiography of a Feminist Artist*, New York, 1996.

9.35 Judy Chicago, Virginia Woolf place setting from *The Dinner Party*, 1979. China paint on porcelain, ceramics and needlework, each setting 4 x 4 x 4 ft (1.22 x 1.22 x 1.22 m); total length of work 139 ft 6 in (42.52 m). First exhibited at the San Francisco Museum of Art.

(see FIG. 9.35). The enormous impact made by this ambitious environmental work was the culmination of a long effort to create a viable feminist art, in response to the rise of the women's movement in the 1960s. The first landmark publication was Betty Friedan's *The Feminine Mystique*, published in 1963. It took the visual arts some time to catch up. Stages in this effort were marked by the establishment of the first specifically feminist art course, at the California Institute of the Arts in 1971, under the leadership of Judy Chicago (1939–), and by the survey exhibition held in 1976 by the Los Angeles County Museum of Art, "Women Painters: 1550–1950."

Other feminist art of the time was much more strongly oriented toward the Conceptual rather than the visual. An example is *Post-Partum Document* (FIG. 9.36)

9.36 (above) Mary Kelly, *Post-Partum Document*, 1978–9. Installation, 18 units, mixed media, 14 x 11 in (35.5 x 27.9 cm). Postmasters Gallery, New York.

This feminist analysis of a mother's relationship to her child, from the time of its birth, had many facets, chief among them bodily imprints of the child (on paper, on diapers and other materials) and the mother's diary of her feelings about her offspring. Comments about the child's activities were arranged both to be read and for their visual effect.

by Mary Kelly (1941–), an anthropological analysis of the mother's relationship to her child, from the time of its birth, and of the separation which society imposes. Or, as Lucy R. Lippard puts it, in the book which reproduces the piece in its entirety: "PPD is the story of a cultural kidnapping and of a woman's resistance to it, made active by visual and verbal analysis."[14]

Feminist critics stated that this bias away from traditional media was due to the fact that these media had such a long association with patriarchy.

Magdalena Abakanowicz

Because she works in techniques traditionally associated with women, such as weaving, the Polish artist Magdalena Abakanowicz (1930–) has also found herself promoted into the ranks of specifically feminist creators. In reality, her situation is more complicated. Though she herself comes from an aristocratic family (her father was a direct descendant of a twelfth-century Mongol ruler from Persia, and thus of Genghis Khan), the culture she grew up in is one that made a much less clear distinction between art and craft than is usual in the United States or in Western Europe. The craft and "folk" elements are as strongly present in Polish culture as they are in Finland and the Baltic republics. During the Communist epoch many artists turned to this part of the Polish tradition because it offered an escape from Stalinist aesthetics. The basic materials were, moreover, available and cheap. Abakanowicz has told an American interviewer how she used to collect old sisal ropes from Poland's Baltic harbors, unravel them and dye them before recycling them in her work.[15]

Her first appearance in the West was at the International Tapestry Biennial held in Lausanne in 1962, and she took an important step toward establishing herself internationally when she was awarded the gold medal of the São Paulo Biennial of 1965. Two years later she began to make a series of works that were quickly christened "Abakans" by friends (a name later adopted by the artist).

9.37 Magdalena Abakanowicz, *80 Backs*, 1976–80. Burlap fixed with resin, made after molds of human bodies, each about 23⅝ in x 19¾ in x 21⅝ in (60 x 50 x 55 cm). Museum of Modern Art, Pusan, South Korea.

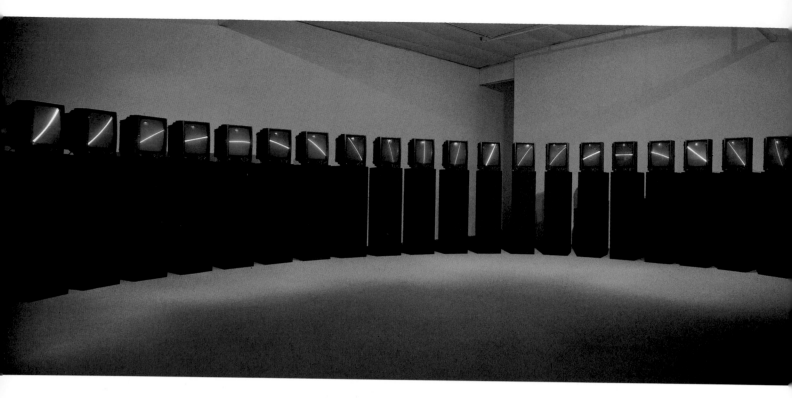

9.38 Nam June Paik, *T.V. Clock*, 1963–81. Installation of 24 color TV monitors, each 81 x 17 x 22 in (205.7 x 43.2 x 55.9 cm). Exhibited at the Whitney Museum of American Art, New York, 1982.

These occupied her through a large part of the 1970s. Originally figures that also functioned as garments, they became independent sculptural figures molded from the body. (FIG. 9.37). One thing which inspired them was the fact that they were easily portable and equally easy to store—despite her growing reputation Abakanowicz had only a very small studio. They were also, however, related to the general move in Europe toward Arte Povera, and to a specifically Polish theatrical tradition represented by the ritualistic work of Jerzy Grotowski, which was then attracting international attention.

Video and Nam June Paik

A major impact was made on the visual arts of the 1970s by the availability of the portable video camera. The first gallery for video as an art form was founded in Hanover in 1969 by the German film-maker, Gerry Schum. Frank Popper, one of the keenest analysts of these new phenomena, sees video as something closely linked to the counter-culture, and in particular to the opposition to all-pervasive commercial television which appeared in the practice of certain avant-garde artists in the early 1960s. He distinguishes at least six different kinds of video art: the use of technological means to generate new visual imagery; the use of video to give performances a more permanent form; what he calls "guerrilla video"— that is, the use of video to distribute images and information likely to be suppressed by the ruling establishment; the use of video-cameras and monitors in sculptural installations; live performances which involve the incidental use of video; and finally, advanced technological manifestations, often involving the use of video with computers.[16]

The boldest early experimenter with video was the Korean artist, Nam June Paik (1932–), originally a member of the Fluxus Group and a collaborator with Joseph Beuys. Paik found means of changing and subverting the video image as it appeared on the monitor, most notably in the *T.V. Cello* which he constructed for use by the avant-garde musician, Charlotte Moorman, and he pioneered the use of monitors as elements in environmental artworks (FIG. 9.38). More recent works play with the *fact* of television and its dominant role in Western culture.

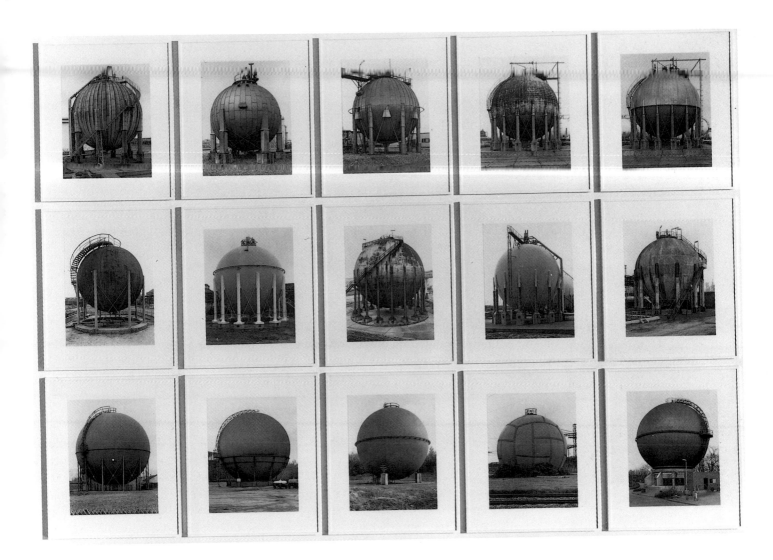

9.39 Bernd and Hilla Becher, *Gas Tanks (Spherical)*, 1963–92. 15 black and white photographs. Sonnabend Gallery, New York.

Hilla and Bernd Becher document aspects of industrial typology. They have said that the question whether what they do is "art" does not much interest them. "Anyway, the audience which is interested in art would be the most open-minded and willing to think about it."

Photography

The 1970s was the moment when the still photographic image was finally pushed out of its central position in popular culture. The symbolic moment was 29 December, 1972, when the last weekly issue of *Life* magazine was published. The closure of *Life* was the moment when television finally displaced photography and the press as the primary medium of information. This, however, strengthened the position of photography within the world of the visual arts:

> Once a medium is no longer essential as a culture's source of information, it turns into an art form. It is not mere coincidence that the decline of photography as a mass medium was accompanied by the rise in photography galleries, history courses, art-school degrees and auction prices for vintage prints.[17]

Bernd and Hilla Becher

One of the ways in which photography asserted its right to be considered simply as art, on a level with other means of artistic expression, was as a vehicle for Conceptual ideas. Examples are photographs of industrial illustrations made by the German husband-and-wife team, Bernd and Hilla Becher (FIG. 9.39). Their photographs are documentations of a fast-disappearing industrial typology, and with it a whole working-class way of life. What seems entirely detached and

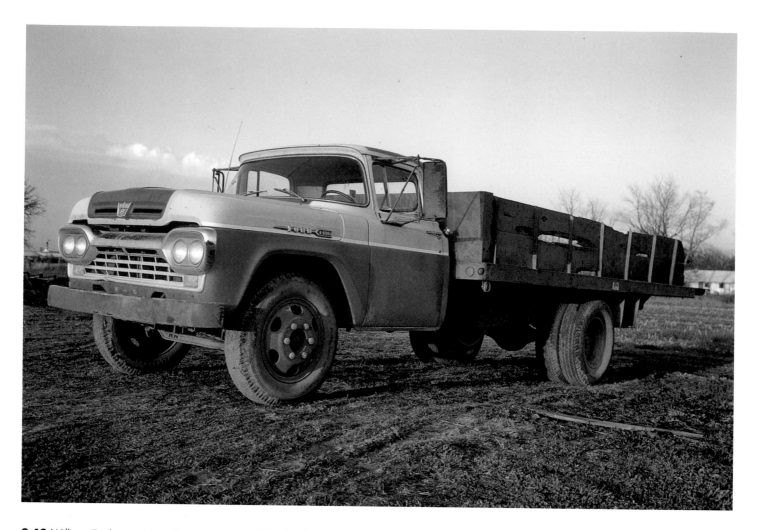

9.40 William Eggleston, *Memphis*, c. 1971. Dye-transfer print. Courtesy A and C Anthology, New York.

Eggleston is famous for his apparently random images, which are vehicles for saturated color.

objective becomes suffused with covert emotion, and contains an only half-hidden political agenda.

William Eggleston

The work of the American photographer, William Eggleston (1939–) is, by contrast, openly subjective (FIG. 9.40). Eggleston is both a radical and a traditional photographer—his mentors include Walker Evans (see FIG. 5.34) and Henri Cartier-Bresson (see FIG. 5.36), but also Lee Friedlander (see FIG. 8.58) and Garry Winogrand (see FIG. 8.57). His photographs nevertheless differ from theirs in several respects. One is in their emphasis on brilliant color. Despite the work done by Eliot Porter in the 1960s (see FIG. 8.56), color remained largely outlawed in the world of high art photography until Eggleston's hugely controversial exhibition, "William Eggleston's Guide," which was held at the Museum of Modern Art in New York in 1976.

Another and perhaps more important aspect of Eggleston's work is its apparent casualness. The brilliant color is captured in apparently random images of places and things which have no intrinsic interest of their own. His most famous image is a drunkenly tilted view of a red ceiling, with electric flexes crudely tacked across its surface. His images have a freewheeling quality, and seem to record the reactions of a sensibility which is almost out of control. Paradoxically, the best of them are firmly rooted in a sense of place. Eggleston is a southerner, and he renders the sleazy eccentricity of aspects of contemporary southern culture with gleeful accuracy. Like Diane Arbus, he has a highly developed feeling for what is ordinary, but at the same time sinister and bizarre.

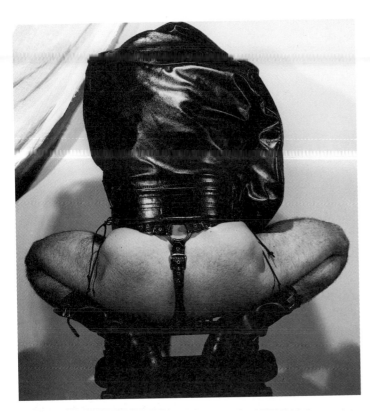

9.41 Robert Mapplethorpe, *Helmut*, 1978–9. Gelatin silver print. The Estate of Robert Mapplethorpe.

One of Mapplethorpe's formally composed images documenting the gay S & M underworld.

Robert Mapplethorpe

The controversial aspects of the work of Robert Mapplethorpe (1946–89) are even more pronounced Mapplethorpe, who died of AIDS, is now indissolubly linked in the public mind with the cause of gay liberation, and more specifically with the censorship controversy which arose after his death in connection with the touring exhibition of his work, *The Perfect Moment*. This controversy eventually led to an obscenity trial in Cincinnati in 1990. The images on which the prosecution was based and others in the same vein had mostly been taken in the late 1970s and they documented Mapplethorpe's involvement with the world of sado-masochistic sex (FIG. 9.41).

In the 1980s Mapplethorpe went on to make further series of photographs—of nude black males, of flowers, of the female boybuilder, Lisa Lyons—but the S & M pictures were the foundation stones of what became considerable celebrity status in the New York art world. He was, in fact, one of the first photographers, certainly since Stieglitz's day, to lift himself out of the specialist category assigned to photography and compete on equal terms with other avant-garde artists. One of the things which helped him to achieve this was his relationship with his patron and lover, the wealthy pioneer collector of historic photography, Sam Wagstaff, whose collection gave Mapplethorpe a thorough grounding in the work of the major photographers of the past. He seems to have been especially attracted to the work of the Art Deco fashion photographers of the 1920s and 1930s.

What gives the S & M pictures their impact is not merely the *outré* subject matter, but the almost willful formality of most of the compositions. Mapplethorpe's aestheticization of supposedly forbidden subject-matter was the chief element of innovation in his work. Technically, he remained extremely conservative, and his work was in this sense much more accessible than many of the other artistic experiments of the decade.

1980	1981	1982	1983	1984

GENERAL EVENTS

• Death of President Tito of Yugoslavia • Poland allows trade unions. Lech Walesa forms "Solidarity" • Iraq invades Iran • Ronald Reagan becomes president of United States	• François Mitterrand elected president of France • President Sadat of Egypt assassinated • Sandra Day O'Connor is the first woman to be appointed to the US Supreme Court	• Argentine troops invade Falkland Islands. British task force recaptures islands • PLO forced to leave West Beirut. Christian massacre, with Israeli connivance of Palestinians in Beirut refugee camps	• US marines invade Grenada • 242 US troops killed by a suicide bomber in Beirut • Chicago elects its first black mayor • Soviets shoot down Korean commercial airliner, killing all 269 passengers	• Indian troops storm Sikh Golden Temple at Amritsar, Punjab • Geraldine Ferraro nominated as US Democratic candidate for vice-president • Indian prime minister Indira Gandhi assassinated by her Sikh bodyguards • Chemical-plant leak in Bhopal, India, kills 2,500 and injures 200,000

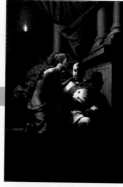

Deacon,
Body of Thought No. 1:
see p.353

Isozaki,
Museum of Contemporary Art:
see p.337

SCIENCE AND TECHNOLOGY

• US space probe *Voyager I* flies past Saturn • Fax machines enter widespread use	• US Center for Disease Control recognizes AIDS as a communicable disease	• Compact-disc players go on sale • First permanent artificial-heart operation	• First successful transfer of human embryo • HIV virus isolated • First US woman travels in space	• Discovery of "genetic fingerprinting" in DNA • Top quark molecule discovered in Geneva

Komar and Melamid,
The Origin of Socialist Realism:
see p.351

ART

• George Baselitz and Anselm Kiefer sensations at the Venice Biennale • Robert Mapplethorpe, *Black Males* series exhibited at Galerie Jurka, Amsterdam • "Picasso's Picassos," exhibition shown in New York	• "A New Spirit in Painting," exhibition at the Royal Academy of Arts, London • The philosopher Roland Barthes's *Camera Lucida* is published • International recognition of the new German art	• "Transavantguardia," exhibition at the Galleria Civica, Modena, Italy • "Zeitgeist," exhibition at the Martin Gropius-Bau, Berlin • Video Art at the Whitney Museum, New York • New French painters in New York	• Julian Schnabel takes the New York art world by storm • "The New Art," exhibition at the Tate Gallery, London • Italo Mussa publishes *La Pittura Colta*, Rome • Balthus retrospective at the Pompidou Center, Paris	• "Content: A Contemporary Focus, 1974–1984," exhibition at the Hirshhorn Museum, Washington D.C. • "Primitivism in 20th Century Art," exhibition at MOMA, New York

ARCHITECTURE

• Richard Meier, High Museum of Art, Atlanta, Georgia (–1983)	• Maya Ling Lin, Vietnam War Memorial, The Mall, Washington D.C. (–1984)	• Michael Graves, Humana Building, Louisville, Kentucky	• Jean Nouvel, Institut de Monde Arabe, Paris (–1987) • I.M. Pei, Pyramid, Musée du Louvre, Paris (–1988) • Ricardo Bofill finishes work on the Palace of Abraxas, an apartment block at Marne-La-Vallée	• Quinlan Terry, Richmond Riverside Development, London (–1987) • Norman Foster, Carré d'Art (Médiatheque), Nîmes, France (–1993)

Eisenman,
Wexner Center
for the Arts:
see p.339

1985 1986 1987 1988 1989

1985

- Mikhail Gorbachev named First Secretary of Russian Communist Party
- Greenpeace ship *Rainbow Warrior* sunk in Auckland harbor by French secret agents
- Major earthquake in Mexico City
- African famine continues

1986

- US space shuttle *Challenger* explodes shortly after take-off. Space flight program suspended
- Revolution in Philippines. President Marcos flees
- Iran-Contra scandal
- American bombing raid on Libya

1987

- Gorbachev offers to dismantle all short- and medium-range missiles in USSR, and introduces *glasnost* and *perestroika*
- Stock markets crash on Black Wednesday
- Iran–Contra hearings take place in Washington D.C.

Sherman,
Self-portrait. see p.359

1988

- Soviet troops begin withdrawal from Afghanistan
- George Bush elected president of United States
- Benazir Bhutto becomes prime minister of Pakistan
- Pan Am Boeing 747 destroyed by terrorist bomb over Lockerbie in Scotland
- Salman Rushdie's *Satanic Verses* causes worldwide controversy

1989

- Oil tanker Exxon Valdez spills 11 million gallons of oil in Prince William Sound, Alaska
- Massacre of pro-democracy demonstrators in Tiananmen Square, Beijing
- Bush and Gorbachev declare end of Cold War
- The Berlin Wall is demolished and Germany unified
- San Francisco earthquake

- Hole discovered in ozone layer over Antarctica
- The wreck of the *Titanic* is detected by underwater robots

- First laptop computer introduced
- First heart, lung, and liver transplant
- Major accident at Chernobyl nuclear power station, Kiev

- Construction of Channel Tunnel between France and Britain begins
- Compact video disc introduced
- A conference in Montreal produces a protocol on CFC emissions

- Transatlantic fiber-optic cable laid
- Developments in DNA fingerprinting revolutionize forensics and paternity testing

- Stephen Hawking publishes *A Brief History of Time*
- US space-probe Magellan launched, to map surface of Venus
- Cordless telephones become widely available

- The Saatchi Gallery, devoted to contemporary art, opens in London
- Christo wraps the Pont-Neuf bridge, Paris, in a huge fireproof canvas
- Deaths of Marc Chagall and Jean Dubuffet

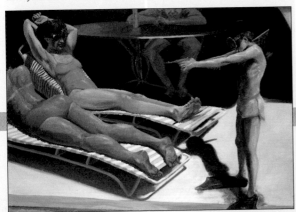

- Death of Joseph Beuys
- Rediscovery of Futurism in Venice
- Ludwig Museum is opened in Cologne

- Deaths of Andy Warhol and André Masson
- Marc Chagall exhibition in Moscow
- Jean Tinguely retrospective in Venice
- "New York Art Now," exhibition at the Saatchi Gallery, London
- "Art of the Fantastic: Latin America, 1920–1987," exhibition at the Indianapolis Museum of Art

- Emergence of Computer Art
- Death of Louise Nevelson
- Three paintings by Vincent van Gogh are stolen from the Kröller-Müller Museum in Otterlo, the Netherlands
- "American/German Art of the Late 80s," exhibition held in Düsseldorf and Boston

- "Black Art: Ancestral Legacy: The African Impulse in African American Art," exhibition at the Dallas Museum of Art
- "Magiciens de la Terre," exhibition at the Pompidou Center, Paris
- Linda Nochlin publishes *Women, Art, and Power and Other Essays*

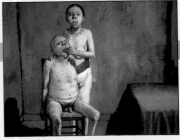

Fischl, *Squirt (for Ian Giloth):* see p.344

- Charles Jencks publishes *Post-Modernism: Neo-Classicism in Art and Architecture*
- Robert Venturi, Sainsbury Wing, National Gallery, London

Rustin, *Woman Putting her Hand in a Man's Mouth:* see p.352

- Kisho Kurokawa, Hiroshima City Museum of Contemporary Art, Hiroshima, Japan

- Aldo Rossi's Palazzo Hotel opens in Fukuoka, Japan

- Peter Eisenman, Wexner Center for Visual Arts, Columbus, Ohio (–1989)

- Arata Isozaki's Museum of Contemporary Art opens in Los Angeles

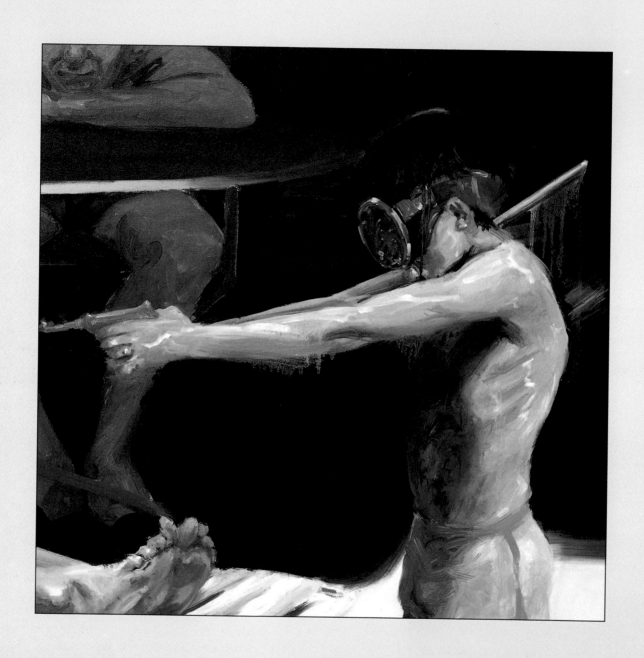

1980–1989

The 1980s saw an economic boom in the United States and western Europe which fueled a great expansion in all the arts. In political, and to some extent in purely technological terms, the decade was full of contradictions. The Falklands War between Great Britain and Argentina was a neocolonialist episode which seemed to mark a reversion to the bad old days of gunboat diplomacy. The same can be said of the American invasion of the small Caribbean island of Grenada. The disaster which befell the Challenger space-shuttle was witnessed by millions of television viewers, and served to check public confidence in continuing technological progress. By contrast, technology continued to make an increasing impact on the home environment, with the introduction, for example, of the CD player and the first fully portable laptop computers.

Where the competition between the two great political systems, Communist and capitalist, was concerned, the Tiananmen Square massacre in Beijing marked a brutal setback for what had seemed like a process of gradual liberalization in China. This was, however, more than counterbalanced by events in eastern Europe and in Germany. The Communist satellite states began to slip from the grip of the Soviet Union, with the electoral triumph of Solidarity in Poland and the "Prague Spring" which culminated in the election of the playwright, Vaclav Havel, as president of a democratic Czechoslovakia. The most profoundly resonant political event was the tearing down of the Berlin Wall in 1989, which heralded the reunification of Germany. Ironically enough, it coincided with an economic downturn in the Western democracies which was the harbinger of the worst economic recession since that caused by the oil crisis of the early 1970s.

Architecture

AN EXPANSIVE CLIMATE

If the 1970s marked a major turning point for twentieth-century architecture, the expansive economic climate of the 1980s probably offered architects the greatest array of opportunities to build, and build boldly, that they had had since the 1950s. It was not the economy alone which gave architectural activity a boost. There were also political and, increasingly, corporate ambitions: the feeling that grand architectural projects were an effective way of asserting identity, and, linked to this, an increasing confidence in the art of architecture itself. There were of course dissidents—on the one hand, a small group of diehard Modernists, who felt that the original spirit of Modernism had now been hopelessly adulterated, and, on the other, an equally diehard group of Classicists, such as the British architect, Quinlan Terry (1937–), and the urban theorist, Leon Krier (1946–), who rejected fashionable varieties of Postmodernism as hopelessly compromised.

"Les Grands Projets"

Because of the unique power of the French presidency in cultural matters, the more ambitious aspects of the architecture of the 1980s are probably best exam-

10.1 (*right*) I.M. Pei, Grand Louvre Pyramid, Paris, 1988.

Pei's glass pyramid forms the entrance hall to an underground expansion of the Louvre and serves brilliantly to expose the shallowness of the argument that new buildings in old settings must always accommodate themselves to the style of their surroundings.

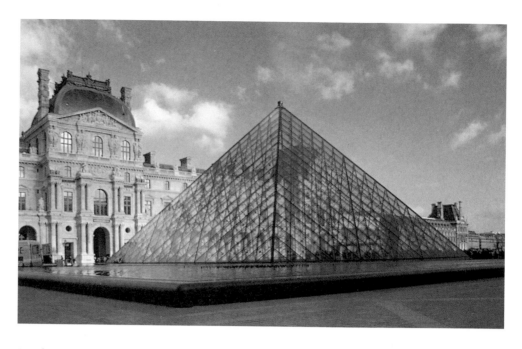

10.2 Jean Nouvel, Institut du Monde Arabe, Paris, 1983–7.

Nouvel's high-tech building (with traditional Islamic influences) has both technological ingenuity—the balcony shutters on the southern side open and close in response to changes of light—and a superb relationship with the surrounding environment.

ined in connection with the series of so-called *grands projets* ("major enterprises") in and around Paris. By no means all of these were the work of French architects. The Pompidou Center, already discussed (see FIG. 9.5), ranks first; it was followed by a series of others, among them the Grand Louvre project (FIG. 10.1) by the American-Chinese architect, I.M. Pei (1917–) and the Institut du Monde Arabe by the most celebrated French architect of the new generation, Jean Nouvel (1945–) (see FIG. 10.2).

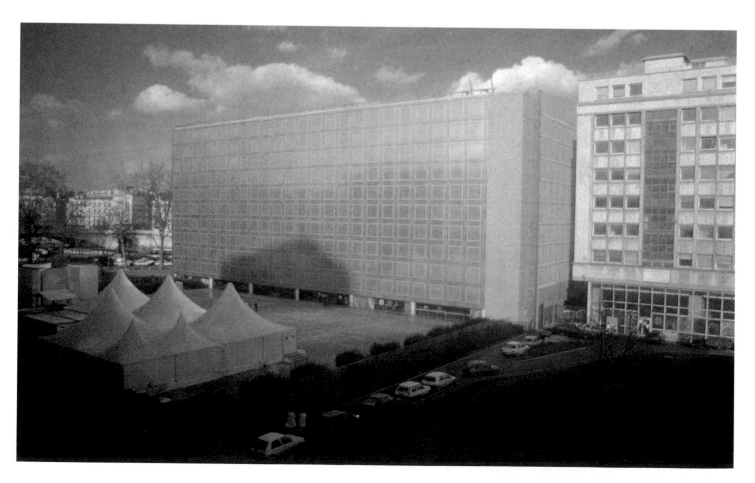

The Louvre "pyramid" shows a close relationship to designs by French "visionary" Neoclassicists such as Boullée which has already been noted in the ossuary for the cemetery of San Cataldo (see FIG. 9.1). Immense unitary forms, already endowed with strong symbolic value, are used to grandiose effect. Pei's pyramid—the new main entrance to an underground expansion of the Louvre—is no more than a vast skylight which combines maximum visibility for the historic palace with minimum occupation of the Cour Carrée in which it is placed. In symbolic terms it is deliberately ambiguous: traditionally a pyramid is solid, dark, a place of seclusion. Here the form is transparent, deliberately immaterial—an example of the psychological and cultural manipulation which became very much the business of ambitious architecture during the 1980s.

Jean Nouvel's Institut du Monde Arabe

An identical comment can be made about Nouvel's Institut du Monde Arabe (FIG. 10.2), placed on a difficult site near the Gare d'Austerlitz. Though built of "cool" materials—predominantly glass and metal—the building is also full of poetic references, both to modern architecture of the early decades of the twentieth century, when the new idioms derived from industrial building techniques were still being explored, and to Arab culture. The most conspicuously "Arabic" feature is a series of 240 glass and aluminum panels, which act as a screen on the side of the building which faces an open square. These panels contain no fewer than 27,000 light-sensitive apertures which act like the shutters of a camera, regulating the intensity of the light. The shadows cast into the interior space resemble those of *masharabieh*, the wooden screens traditionally used in Arabic countries to eliminate glare. This effect exemplifies well Nouvel's guiding principle: "Architecture means introducing values of culture and civilization into the built."[1]

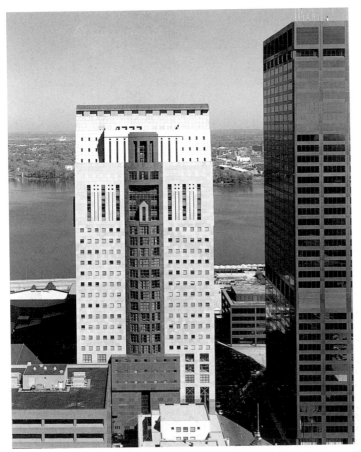

10.3 Michael Graves, Humana Building, Louisville, Kentucky, 1982.

This building, more than any other, set the agenda for Postmodernism in the United States. Its rampant mixture of glass-curtain walls, Classical pilasters, and huge red "keystone" Art Deco decoration pointed the way to what has frequently been an undiscriminating combination of historical styles.

Michael Graves

Despite a complex web of cultural allusions, the architecture of the *grands projets* is considerably less didactic than that of either the American, Michael Graves, or the Englishman, Quinlan Terry. With the support of Charles Jencks in particular, Graves (1934–) was established in the 1980s as the quintessential representative of the classicizing Postmodernist tendency which had already begun to establish itself in the 1970s. However, Graves is more than a simply "Classical" architect. He outlined his position in the introduction to *Michael Graves: Buildings and Projects* (1982):

> The Modern Movement based itself largely on technical expression—and the metaphor of the machine dominated its building form … While any architectural language, to be built, will always exist within the technical realm, it is important to keep the technical expression parallel to an equal and complementary expression of ritual and symbol … This language, which engages inventions of culture at large, is rooted in a figurative, associational and anthropomorphic attitude.[2]

Graves's best-known building of the 1980s is, perhaps surprisingly, not a museum but a 26-storey office tower, the Humana Building (FIG. 10.3), situated in downtown Louisville, Kentucky. Here he provides a fourth, and per-

10.4 Quinlan Terry, Richmond Riverside Development, London, 1984–7.

In this highly controversial development, Terry insisted on a doctrinaire return to traditional classical principles and materials—right down to wooden nails. In consequence he believes that he avoids pastiche.

haps final, element in a sequence which begins with Louis Sullivan (see FIG. 1.4) and passes through Mies's Seagram Building (see FIG. 7.1) and Philip Johnson's AT & T Headquarters in New York (see FIG. 9.8). The building, apart from a sumptuous granite-clad entrance loggia, in a quasi-Egyptian style, is of interest chiefly for its façades. Far from being the blank glass screens favored by Mies, these are articulated so that they read as enormous faces. The south-facing Main Street elevation is particularly striking, with a curved balony at cornice level which forms a beetling brow.

Another feature of this, and of a number of other commissions completed by Graves during the 1980s, is the sumptuous quality of many of the materials and finishes used, which are in striking contrast to the deliberate tackiness of some of the most innovative buildings of the previous decade.

Quinlan Terry

Quinlan Terry works from a much more restricted base than Michael Graves, sticking strictly to the grammar of Classical architecture inherited from the ancient Greeks and Romans via Palladio and his eighteenth-century English disciples such as William Kent (1685–1748) and Richard Boyle, Third Earl of Burlington (1694–1753). In an essay on the classical orders (1983), Terry portrayed the kind of Classicism he practices as having its origins in divine inspiration. It is a mark of the inroads made by Postmodernism, and even anti-Modernist doctrines, in the 1980s that Terry's work, which would have been completely marginal at any epoch between the late 1930s and the end of the 1970s, suddenly found itself moved to center stage.

Terry's most striking large project is the Richmond Riverside Development fronting the Thames, London, which provides offices, shops, apartments, community facilities, and two underground car parks (FIG. 10.4). Terry's scheme, which needed to retain two buildings on the site "listed" for preservation, breaks up and demonumentalizes forms, so that many different buildings seem to be juxtaposed. Details are taken from both British and Italian architects, ranging in date from the sixteenth to the eighteenth centuries—Palladio, Sansovino, Longhena, Nicholas Hawksmoor, William Chambers. There are even some touches borrowed from the Gothic revival of the nineteenth century.

Arata Isozaki: Museum of Contemporary Art, Los Angeles

The Museum of Contemporary Art (FIG. 10.5) in Los Angeles by Arata Isozaki sums up much of the architectural thinking of the 1980s in a number of ways. One is the fact that it is a museum building, and a museum was what every ambitious architect of the period wanted to build. Another typical feature is its use of spatial discontinuity and disrespect for the logic of use.

Surrounded by glittering office-blocks and apartment towers, the museum is visually deceptive. What the visitor sees at first is a courtyard, slightly raised above street level, with two exquisitely detailed structures in red Indian sandstone facing one another across it. One has a high portico with a curved roof and an expanse of glass wall. The other, low-slung and with no immediately apparent entrance, has pyramidal roofs like miniature versions of I.M. Pei's design for the Louvre. It takes a moment or two to realize that the platform has a second and lower level, and that the main museum structure is enclosed in what might originally be thought of as a podium.

The arrangement is thus rather like Mies van der Rohe's National Gallery (1963–8) in Berlin, where the main space is not in the single-story glass pavilion one sees at first, but buried in the plinth (FIG. 10.6). The difference is that Isozaki treats his courtyard rather as if it were an ancient Greek *temenos*, or sacred enclosure. It becomes, not just a platform, but an enclosed space with its own identity. Yet this identity remains an architectural fiction—the portico, which seems to proclaim that this is the more important of the two structures which are visible, leads only to the museum offices, and the glass wall beyond it reveals, not the exhibition galleries, but the museum shop. Under the portico is a freestanding ticket booth which seems like an afterthought, an untidy temporary solution until something better can be found.

Having paid tribute to the doorkeeper gods, the visitor descends an inconspicuous staircase to encounter the mysteries of modern art in the chthonic depths. What matters here is not recognizably "Classical" details, which are not present, but the poetic allusion to Classical building philosophy and ways of thinking. Yet the building is also profoundly anti-Classical in the way that it disappoints the visitor's immediate perceptions.

In purely practical terms, MOCA in Los Angeles suffers from the same disadvantages as Mies's building in Berlin—relatively restricted ceiling heights, and (despite movable partitions) a sense of confinement. Postmodern buildings often suffer from the same disadvantage as their International Style predecessors—the image they are intended to convey is in certain respects a barrier to fullest practical use.

10.5 Arata Isozaki, Museum of Contemporary Art, Los Angeles, California, 1981–6.

10.6 Mies van der Rohe, Nationalgalerie, Berlin, Germany, 1963–8.

The paradox is that an approach supposedly rigidly committed to architectural formality gives a free-form result very similar, seen strictly in terms of planning, to what was advocated by the pioneer Modernists. Gropius's Bauhaus in Dessau (see FIG. 4.3) showed a rather similar spirit, in terms of adapting the ground plan to the envisaged use.

Arata Isozaki

Another architect who can be linked, but in an entirely different way from either Graves or Terry, to the developing discourse of Postmodernist classicism is the Japanese, Arata Isozaki (1931–). Isozaki began his career working for Kenzo Tangye, but soon shook off any lingering Corbusian influences he might have imbibed. He is a self-confessed "mannerist," making use of a huge variety of sources, Eastern and Western, traditional and Modernist. One of the things that marks Isozaki out as a leading figure is the number of museums he has built. The project which attracted most publicity was the Museum of Contemporary Art (see FIG. 10.5) in Los Angeles.

Modernist Mannerism

While his work has links to Postmodernism in its directly classicizing guise, Isozaki can also be regarded as belonging to a group of architects who, in the 1980s, worked in a mannerist version of traditional Modernism. The two best known of these are the American, Richard Meier (1934–), and the Swiss, Mario Botta (1943–). Meier's career began in the 1960s, but the building which fully established his reputation is yet another museum, the High Museum of Art (FIG. 10.7) in Atlanta. Made of fastidiously crisp shapes clad in glittering white panels, the building is constructed in an L-shape, with the center of the L filled by a huge semicircular atrium. The space is entered, then traversed, by means of a long ramp, which, having begun as a diagonal, takes on a semicircular form, following the shape of the atrium, in an obvious allusion to Frank Lloyd Wright's Guggenheim Museum in New York.

One of the things which contributes to the mannerist effect of the High Museum is the pervasive use of white. While some of the galleries are painted in colors, the white, in the brilliant Atlanta light, often blurs distinctions between forms rather than emphasizing them.

Botta has been a creator of buildings devoted to cultural purposes. A striking example is the Mediathèque (FIG. 10.8) in Lyons. A blank façade, striped in gray and white, is split by an entry which rises to the full height of the building. At a lower level, the entry is flanked by two completely plain circular columns, with further windows, spreading out, narrowing, and descending symmetrically on either side. This leads into a semicircular space, lit from a small dome at the top. The elements are "Modernist," but the handling of space is in many ways Baroque—it functions like one of Bernini's or Borromini's domed churches in Rome, but with brittle, sharp-edged forms rather than the swelling, plastic ones of seventeenth-century architecture. Botta's stripes (repeated on the columns which support the rotunda inside) operate rather like the glaring whiteness of

10.7 Richard Meier, High Museum of Art, Atlanta, Georgia, 1980–3.

Meier inherited from Le Corbusier a love of predominantly white architecture, in which gridded and curved elements merge to create glittering, sophisticated structures. They recall Le Corbusier's phrase that architecture involved the "play of masses brought together in light."

10.8 Mario Botta, Mediathèque, Villeurbane, Lyons, France, 1984–8.

Meier's cladding in Atlanta: they make it difficult to apprehend the main form as a coherent whole.

Deconstruction: Further Developments

The mannerizing strain in the architecture of the 1980s achieves extreme form in the work of the American, Peter Eisenman (1932–). Eisenman, head of the New York Institute for Architecture and Urban Affairs from 1975, and a declared rival of Michael Graves, had few buildings of any substance to his credit until the completion of the Wexner Center for the Arts (FIG. 10.9) at Ohio State University, designed in conjunction with Richard Trott. This strikingly exemplifies Eisenman's theory that architecture, far from being unitary and focused on function, can profitably be spatially discontinuous and non-functional—even, to a certain extent, obstructive and hostile to the user. The case is well put in a recent work of architectural reference: "[Eisenman's] architecture attempts to reawaken humanity's dormant awareness of our physical world. He uses discomfort, shock, abrasion and incongruity to achieve his effects, forthrightly designing against the basic comfort and needs of clients."[3] The mannerism of the Wexner Center comes as much from the skewed and obstructed use of space as it does from any of its detailing. In addition, a collision of castellated forms in brick with Minimalist grids in glass and metal sets up a cultural clash typical of the more extreme manifestations of the Postmodernist sensibility. It is a building which, in addition to making few concessions to its users, also seems to require them to bring to it a wide range of cultural references.

10.9 Peter Eisenman, Wexner Center for the Arts, Ohio State University, Columbus, Ohio, 1989.

The fragmented design of this arts center carried deconstructivism right into the actual building. Eisenman described the structure as a scaffold, not a building—and various elements, the glass walls, and the cubic galleries are, indeed, hung on the white grid as if it were a scaffold.

10.10 Maya Ling Lin, Vietnam War Memorial, The Mall, Washington D.C., 1981–4.

Dignified, eloquent, and Minimalist, Maya Lin's monument to those killed in the Vietnam War is one of the most exquisite structures erected in the capital since the Washington Memorial. It focuses quietly on the sense of national loss without alluding to the controversy whipped up by that conflict.

Maya Ling Lin

The Vietnam War Memorial, (FIG. 10.10) designed by Maya Ling Lin, has been aptly described as being "neither sculpture nor architecture."[4] It was the product of an open competition held in 1981 that attracted a vast number of entries—there were 2,573 registrants and 1,421 final submissions. The winner was a young woman who was then still an undergraduate student at the Yale University School of Architecture. The brief given to the contestants was a difficult one. The monument, situated on the Mall in Washington D.C., in view of both the Washington and Lincoln Memorials, was to be free of any political implications, but must provide a place for reflection and incorporate the names of all those who were dead and missing.

Lin's solution has something in common with Pei's solution for the Louvre—very simple geometric form. It has even stronger links with the Minimal art of the 1960s and with examples of Earth Art such as Robert Smithson's *Spiral Jetty* (see FIG. 9.29). But it also has aspects in common with more conventional monuments, particularly in its use of a luxurious material—highly polished black granite. Taking the form of two long granite-clad walls that meet at an angle of just over 125 degrees, the memorial is sunk into the earth in such a way that its presence is scarcely detectable from a distance. On these walls are inscribed the names of 58,156 dead and missing American servicemen and servicewomen. The names appear in the strictly chronological order in which the deaths were recorded.

When the winner of the competition was announced, the choice was hugely controversial, so much so that a more conventional sculptured group (by Frederick Hart) and a flagpole had to be added at the perimeter of the site. However, Maya Ling's work has since proven to be one of the two most heavily visited memorials in the nation's capital, rivaled only by the monument to Lincoln. The area embraced by the triangle is treated as a shrine, and small offerings, letters, and tokens are left in appropriate places at the foot of the wall.

It does, however, raise certain questions. One concerns the inability of contemporary art or architecture to find specific symbols that were sufficiently powerful to encompass the tragedy of Vietnam—the first completely unsuccessful war in America's history. Here the specific element is not in the basic form but in the litany of names. The other issue is how the monument will be read when all the survivors are gone—the veterans, the widows, the children of the fallen. This is a problem already overtaking many of the monuments built to commemorate the fallen of World War I, and one that is likely to be acute in this case, for the design relies heavily on the visitor making an absolutely personal connection.

Painting

THE REVIVAL OF PAINTING

In 1981, the Royal Academy in London played host to a survey exhibition entitled "A New Spirit in Painting." This was deliberately designed to restore painting to the position of centrality from which it had been displaced during the 1960s and 1970s. The artists included in it fell into several very different categories. Some were painters like Balthus and Lucian Freud, who had until then been regarded as eminent but relatively isolated—somehow detached from the activities of the art world regarded as a whole. Some were Minimalists, like the American, Robert

10.11 Markus Lüpertz, *5 Portraits with Mycenean Smiles*, 1985. Oil on canvas: 8 ft 10¾ in x 13 ft 1¼ in (2.7 x 4 m). Michael Werner Gallery, New York and Cologne, Germany.

Like much Modernist art throughout the twentieth century, Lüpertz's painting, with its mystic, ritualistic treatment of the figures, shows a nostalgia for the archaic, but is also reminiscent of the first era of German Expressionism.

10.12 (*below*) Rainer Fetting, *Mabutu Dance*, 1983. Oil on canvas, 9 ft 3 in x 7 ft (2.82 x 2.13 m). Dolly Fiterman Fine Arts, Minneapolis, Minnesota.

The use of violent colors in this painting is one of the ingredients linking it to the Expressionism of Emil Nolde's paintings done just before World War I.

Ryman. The majority, however, were in varying degrees figurative—survivors from the period of Pop Art, like Andy Warhol and David Hockney, combined with a new (or novel to the London audience) generation of figurative Expressionists. These figurative Expressionists, who seemed to dominate the artistic ethos of the 1980s in the same fashion that the Pop artists dominated the 1960s, were German, Italian, and (with a significant cultural shift) American.

Though the exhibition was first seen in Great Britain, a considerable part of the finance came from sources in the Federal Republic of Germany, and the immediate public perception of the show was that it was dominated by a new group of German artists. In fact, as the two previous chapters have shown, a number of these artists had already made considerable careers for themselves in Germany and were becoming known outside. Baselitz, already the patriarch of the group, and Anselm Kiefer are good examples (see FIGS 8.27 and 9.16).

Other, somewhat younger, German painters belong more convincingly to the 1980s. They include Markus Lüpertz (1941–) and Rainer Fetting (1949–). Lüpertz spans the two extremes of German neo-Expressionist practice, painting either quasi-Surrealist war-machines or archaic figures like those which appear in his *5 Portraits with Mycenean Smiles* (FIG. 10.11). Fetting, the youngest member of the group, is the most firmly identified with the German Expressionism of the first two decades of the century. His *Mabutu Dance* (FIG. 10.12) is strongly reminiscent of the paintings made by Emil Nolde in 1913–14, as a result of his participation in a German Colonial Office expedition to New Guinea.

The Italian Trans-Avantgarde

The neo-Expressionist impetus also manifested itself in Italy, under the patronage of the Italian critic, Achille Bonito Oliva, who labeled the new impulse the "Trans-Avantgarde." The artists chiefly identified with it were the so-called "three C's"—Sandro Chia (1946–),

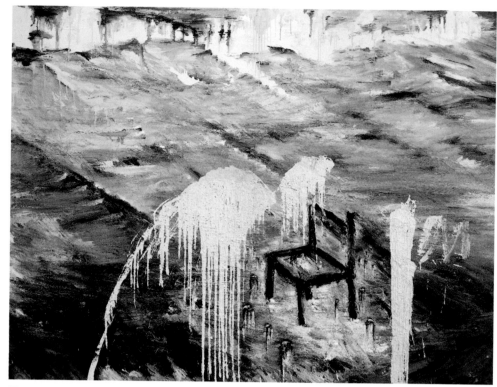

10.13 Enzo Cucchi, *Van Gogh's Chair*, 1984. Oil on canvas, 8 ft 10½ in x 11 ft 5¾ in (2.71 x 3.5 m). Joseph Helman Gallery, New York.

Deeply entrenched in Italy, with its particular landscapes, Cucchi paints with a sensual and Expressionist demeanor, though the self always seems on the point of being swamped by nature. The allusion to Van Gogh stresses his Expressionist heritage.

10.14 Francesco Clemente, *The Magi*, 1981. Fresco, 6 ft 6¾ in x 9 ft 10 in (2 x 3 m). Private collection.

Clemente is grouped among the Neo-Expressionists, but this painting is more Symbolist than Expressionist. The Magi of the gospel story and their symbolic gifts are fused.

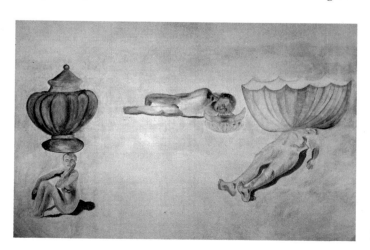

Enzo Cucchi (1949–), and Francesco Clemente (1952–). In Italy, neo-Expressionism was mixed with other, apparently contradictory, impulses. Of the three artists just named, the most genuinely Expressionist is Cucchi, with his use of broadbrushed over-scale forms (FIG. 10.13). The immensely prolific Chia has often seemed less like an Expressionist, concerned with personal *angst*, than a high-spirited parodist, a maker of rather superficial decorative images. Francesco Clemente is different again. Consideration of his work is linked to the vexed subject of European borrowings from other cultures. He spends part of the year in Madras, India, where he has set up a studio, and much of what he does is concerned with ideas derived from Indian philosophy and religion. Works by Clemente of this type can seem rather lacking in visual energy, because too dependent on their original source material. Other paintings, such as *The Magi* (FIG. 10.14), are more eclectic in their use of cultural source material, and correspondingly more vigorous in effect. Nevertheless, Clemente is an artist who raises the issue of "primitivism" in acute form. He claims the right, as European artists have done since Gauguin's visits to the South Seas, to take over and recycle exotic images.

Of all the Italian artists who have been described as Expressionists, the most powerful, Mimmo Paladino (1948–), stands a little aside from the rest. Paladino's images (FIG. 10.15) appeal to the past, but in a more serious way than paintings by Chia; the source seems to be Romanesque fresco painting, more specifically the rather crude Romanesque of southern Italy, which is where Paladino comes from. These historical reminiscences are less calculated than Clemente's references to exotic cultures, since Paladino regards his work as being essentially the product of a psychic explosion, which carries what he feels directly to the canvas. This is the classic Expressionist approach to image-making, and it is interesting that the result nevertheless carries such a strong cultural echo.

10.15 Mimmo Paladino, *Sull'orla della Sera*, 1982–3. Oil on canvas, 7 ft 10¼ ins x 14 ft 5½ ins (2.99 x 4.4 m). Collection Gian Enzo Sperone, Rome.

The painting shows Paladino's debt to the Romanesque frescos of southern Italy. The atmosphere is mysterious and magical.

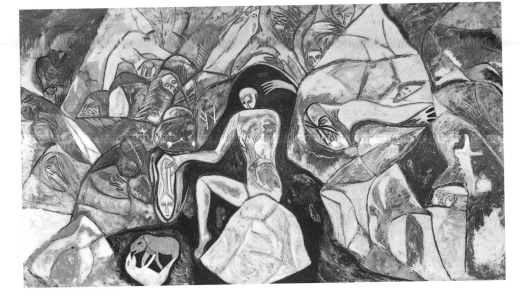

10.16 Julian Schnabel, *The Walk Home*, 1985. Oil, plates, copper, bronze, fiberglass, and bondo on wood, 9 ft 4 ins x 19 ft 4 ins (2.84 x 5.89 m). PaceWildenstein, New York.

An example of Schnabel's use of broken crockery to break up the plane surface and make his imagery both more spontaneous and more difficult to read.

PAINTING IN THE UNITED STATES

American "Bad Painting"

The American painters associated with the neo-Expressionist movement have an affiliation with the original Expressionism which is substantially less clear-cut than that of the Germans or even the Italians. The most publicized, and also the closest to what was happening in Europe at the same time, was Julian Schnabel (1951–). Schnabel's work attained notoriety, not only through the artist's own bombastic pronouncements, but through his eccentric techniques—for example, paintings made on a surface of broken crockery, glued to the surface of the canvas (FIG. 10.16). Schnabel has said that the idea was suggested by the architecture of the Catalan Art Nouveau architect, Antoni Gaudí, who sometimes made use of similar surfaces. He has also said that one reason for creating a surface of this

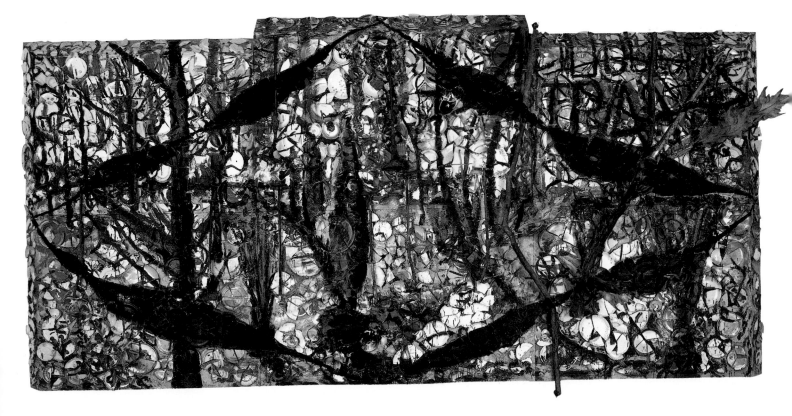

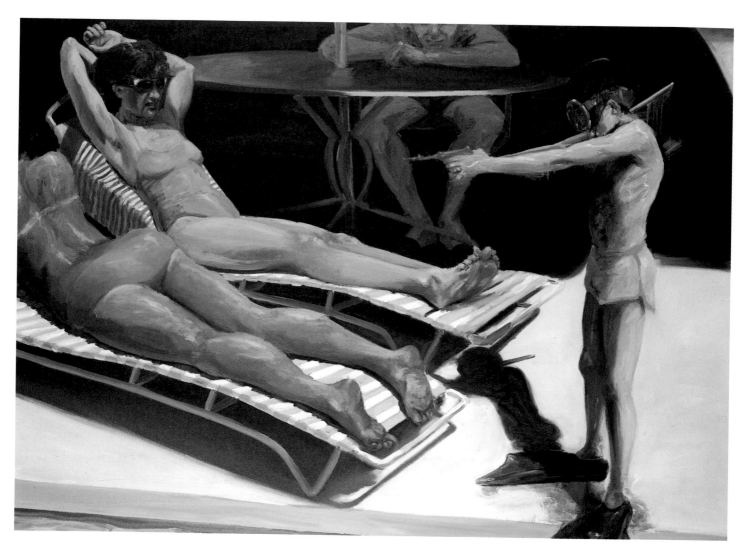

10.17 Eric Fischl, *Squirt (for Ian Giloth)*, 1982. Oil on canvas, 5 ft 8⅛ in x 8 ft (1.73 x 2.44 m). Thomas Ammann Fine Art, Zurich, Switzerland.

Fischl's canvases point up the tawdry quality of much of contemporary American life, and perhaps "bad painting," of which this is a representative example, is deliberately meant to match form and content.

kind is to break up the fluency of his own drawing and thus liberate unconscious impulses. The result is heavily textured, but also decorative, to the point where Schnabel seems to have as many affinities with turn-of-the-century Viennese Symbolists such as Gustav Klimt as he does to the original German Expressionists.

Other American painters bracketed with Schnabel under the label of "bad painting" show influences far removed from what was being done in Europe. The paintings of Eric Fischl (1948–) are a sour commentary, with roots in the work of Edward Hopper, on the lives of the American bourgeoisie. In *Squirt* (FIG. 10.17), a boy in diving-mask and flippers aims a water-pistol at a reclining sunbather. The title is a pun—a "squirt" being, in colloquial parlance, "an insignificant and presumptuous person". What has fascinated critics about Fischl's work is the uncertainty of his technique. Both his drawing and his handling of paint seem tentative and even fumbling—characteristics which have been read as a deliberate mimesis, the visually impoverished reflection of a spiritually impoverished society.

Elizabeth Murray and Jennifer Bartlett

Sometimes, but much less convincingly, linked with the idea of "bad painting" is the work of Elizabeth Murray and Jennifer Bartlett. Indeed, striking shared characteristics in their work are its physical exuberance and air of confidence. The 1980s was the decade in which women artists not only claimed full equality with men in the American art world, but showed much confidence in using tradition-

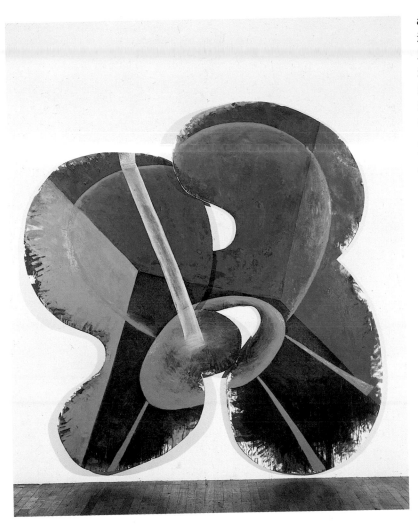

al media. Often, nevertheless, they used these in an interestingly skewed way. Many of the paintings of Elizabeth Murray (1940–) seem to be abstract at first glance. It is only a second look that reveals the fact that a work such as *Deeper Than D* (FIG. 10.18) is actually figurative—a view of an interior, with a table and two chairs. Similarly, *Spiral: An Ordinary Evening in New Haven* (FIG. 10.19) by Jennifer Bartlett (1941–), which takes its title from a poem by Wallace Stevens, shows extraordinary kinetic energy. Figurative elements, like the hexagonal table and the traffic cone, are tossed out of the canvas, and appear a second time on the floor in front of it, as fully three-dimensional forms. The approach to figuration is more radical, less bound by convention, than it is in the work of male contemporaries.

Paula Rego

It is also interesting to contrast the work of these Americans with that of European women painters, such as the Portuguese-born but now British-domiciled Paula Rego (1935–). Rego, who began her career as a Surrealist, now works in an idiom that owes something to Balthus and perhaps something to middle-period works by David Hockney, done in the 1970s. Her work is remarkable not for its technical daring, but its sense of poetic narrative. Paintings like *The Cadet and His Sister* (FIG.

10.18 (*above*) Elizabeth Murray, *Deeper Than D*, 1983. Oil on two canvases, 8 ft 10 in x 8 ft 6 in (2.69 x 2.59 m). The Edward R. Broida Trust, New York.

Murray's work hovers playfully between figuration and abstraction. It takes a moment or two for the eye to notice that what looks at first glance like a painting of an abstract relief construction is actually a domestic interior with a table.

10.19 Jennifer Bartlett, *Spiral: An Ordinary Evening in New Haven*, 1989. Oil on canvas, 9 ft x 16 ft (2.74 x 4.88 m); tables, painted wood; cones, rolled welded steel. Private collection, New York.

This artwork gains energy from the startling contrast between the banality of the objects placed in front of the painting and the stormy chaos of the painting itself. The title is borrowed from a poem by the American writer, Wallace Stevens.

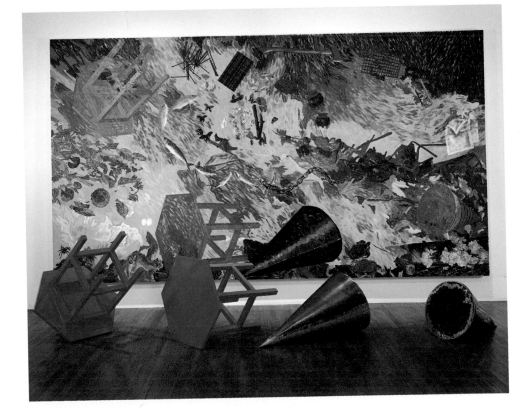

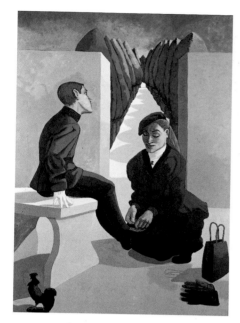

10.20 (*above*) Paula Rego, *The Cadet and His Sister*, 1988. Acrylic on paper laid on canvas, 7 x 7 ft (2.13 x 2.13 m). Private collection.

Rego's understated comments on sexual roles derive their power from the use of potent symbols and fetishes as well as from the charged body language of the characters in her paintings.

10.21 (*right*) Jean-Michel Basquiat, *Untitled*, 1984. Acrylic, silkscreen, and oilstick on canvas, 7 ft 4 in x 6 ft 5 in (2.33 x 1.95 m). Osaka City Museum, Japan.

Basquiat's meteoric career in the New York art world emphasized the populist values of the 1980s. It has similarities to that of the leading black rock musician Jimi Hendrix in the 1960s.

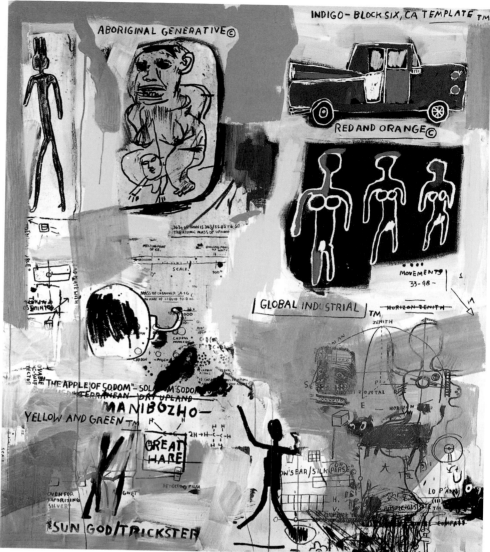

10.20) offer sly commentaries on male–female relationships, portrayed from a recognizably female point of view. Rego's work, which discloses an increased self-confidence among women painters, is the product of an ironic sensibility that is completely sure of its own value and its own right to judge. Women novelists, such as Jane Austen and Edith Wharton, attained this kind of poise earlier and more easily than women painters.

Other American Painters

The boom years of the 1980s threw up a large number of probably ephemeral groups and schools. In New York, which remained the center of the art world, the two which attracted the most attention were the so-called Graffiti Painters, who in theory sprang from the New York subway, and from there made their way into the galleries of a briefly flourishing East Village art scene. The two great survivors (in terms of reputation, since both were short-lived) from this moment in American art were Keith Haring (1958–90) and Jean-Michel Basquiat (1960–88). Though Haring made designs in the subway, using advertising spaces left blank because still unsold, the chief interest of his work is that he evolved a universally recognizable and almost universally applicable graphic handwriting—as much at home on T-shirts, greetings cards, and ceramic vases as it was in paintings (FIG. 10.22). This handwriting offered little possibility of emotional depth, but it

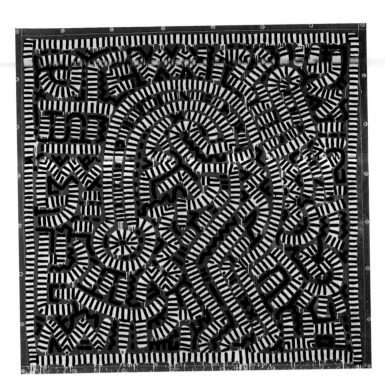

10.22 (above) Keith Haring, *Untitled*, 1983. Vinyl ink on vinyl tarp, 7 x 7 ft (2.13 x 2.13 m). Tony Shafrazi Gallery, New York.

Haring, who began to draw cartoons while a schoolboy, was for a while a graffiti artist on the New York subway. He was the inventor of an instantly recognizable graphic language, almost always placed at the service of a social or political message.

10.23 (above right) Philip Taaffe, *Four Quad Cinema*, 1986. Linoprint collage, acrylic, enamel on canvas, 7 ft 1¾ in x 6 ft 11½ in (2.18 x 2.12 m). Collection Goetz, Munich.

A number of Philip Taaffe's paintings from the mid-1980s appear to be heavily derived from the work of British Op artist, Bridget Riley.

allowed a kind of communication between a supposedly avant-garde artist and a genuinely mass public.

Basquiat is a much more interesting and paradoxical figure. Born of a Haitian father and a Puerto Rican mother, he was technically African-American and made frequent use of "black" imagery in his work. But he remained somewhat apart from the continuing effort to gain status and recognition for African-American art as a separate genre expressing a special kind of consciousness. He was self-taught and got his start among the young people, many either African-American or Chicano in origin, who caught the attention of the New York art world through their unauthorized decorating of New York subway trains. He was nevertheless middle-class in origin, and was aware of the art world and its mechanisms in a way that the other Graffiti Painters were not. From an early stage, for example, he began the courtship of Andy Warhol and his entourage which eventually culminated in a collaboration between Basquiat and the Pop artist.

These collaborative paintings (rather more competitive than actually collaborative in effect) are not Basquiat's best work, which though still essentially "graphic"—that is, as much a kind of large-scale drawing in paint as actual painting—possesses immense energy and a vast range of cultural reference, from contemporary sports stars and traditional African art to the drawings of Leonardo da Vinci (FIG. 10.21). It is perhaps the most fascinating product of the New York art scene during the period.

Neo-Geo

A more self-conscious attempt to sustain New York's hegemony in the arts was made by the painters whose work was labeled "Neo-Geo" by some critics. This description primarily applied to the abstract paintings made by Philip Taaffe (1955–) (FIG. 10.23) in apparent imitation of the early optical canvases of Bridget Riley. It was also affixed to the work of Peter Halley (1953–). Halley's paintings seem at first sight to derive from the tradition of Mondrian, and that of Constructivism in general. Halley himself, however, has said that the most immediate inspiration for his work is the rectilinear architecture of New York, and the

10.24 Peter Halley, *Black Cell with Conduit*, 1988. Day-glo and Roll-a-tex on canvas, 5 x 5 ft (1.52 x 1.52 m). Galerie Bruno Bischofberger, Zurich, Switzerland.

Halley's geometric paintings—and the reference in their titles to cells and conduits—evokes the post-industrial world of semiconductors and microchips. "I don't think of my work as abstract at all," he has said; "instead of using the word abstract I always use the word dia-grammatic."

hidden energy cells and conduits within the city's buildings (FIG. 10.24). These designs, however, usually seem to have much less visual energy than their Constructivist forebears, and Halley's work, like Taaffe's, reads as a rather weary, mannerizing repetition of early Modernist discoveries.

The New Classicism

One interesting aspect of the rise and fall of new styles in New York during the 1980s was that, though they attracted journalistic attention worldwide, they did not travel successfully. In this sense, the centrality of the New York art world was increasingly challenged. The only stylistic impulse, apart from neo-Expressionism, which enjoyed a widespread international currency was a form of Classicism linked to the Classical revival in architecture, and often promoted by the same critics and patrons. The only place where this achieved truly canonical status was in Italy, where it was seen as the chief challenger to the quasi-Expressionist impulse represented by the Trans-Avantgarde. The main theoretical text on the subject, *La Pittura Colta* ("Cultivated Painting"), by Italo Mussa, was published in Rome in 1983. For Mussa and others the chief figure in the new Classicism was Carlo Maria Mariani (1931–), a painter who rather perversely based a good deal of his work on minor north Italian Neo-classicists of the early nineteenth century such as Vicenzo Camuccini (1773–1842), an artist of whom the novelist Stendhal once said, "These large canvases teach one nothing new and leave no remembrance: they are correct, decent and cold." Mariani and Mussa both present this imitation of a past style as being, in essence, a form of Conceptual Art, a statement about the need for rules (FIG. 10.25). Other classiciz-ing painters of other nationalities interpret the notion of the return to a Classical idea in a somewhat looser way. The American artist, David Ligare (1945–), rein-terprets Poussin's landscapes and figure compositions (FIG. 10.26) in a fashion which makes them a celebration of Californian landscapes and of youthful Californian bodies (the figures he paints have a certain resemblance to the Super Realist nudes of John de Andrea; see FIG. 9.33). The British painter, Michael Leonard (1933–), portrays subtly idealized nude figures, usually males, in a way which emphasizes their potential as a basis for abstract design (FIG. 10.27)—it is

10.25 Carlo Maria Mariani, *Prophetic Dream*, 1984. Oil on can-vas, 8 ft 2⅜ in x 6 ft 6¾ in (2.5 x 2 m). Artist's collection.

Mariani is the leading figure of the *Pittura Colta* group in Italy. His sources include obscure early nine-teenth-century Neo-classical artists.

10.26 (*above*) David Ligare, *Landscape for Baucis and Philemon*, 1984. Oil on canvas, 32 x 48 in (81.2 x 121.9 cm). Wadsworth Atheneum, Hartford, Connecticut.

The Californian artist David Ligare has been influenced by Nicolas Poussin, the seventeenth-century French Classicist.

10.27 Michael Leonard, *Man Bending Down*, 1986. Acrylic on masonite, 20 x 20½ in (50.8 x 52.1 cm). Artist's collection.

Leonard's idealized male nudes are preoccupied not only with the body itself, but by the pattern of solids and voids it can be used to create with the rectangle of the canvas.

10.28 Steven Campbell, *Quelle heure est-il?*, 1987. Oil on canvas, 7 ft × 8 ft 10 in (2.13 × 2.69 m). Private collection, Japan.

The quirky figurative scenes of the Scottish painter, Steven Campbell, hint teasingly at the existence of a narrative, without spelling out exactly what the story is.

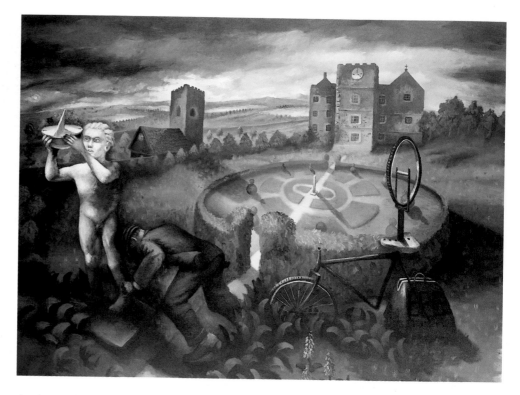

the interplay of solid and void, the relationship between the figure and the actual edge of the canvas, which supplies the pictorial energy. Nevertheless the erotic potential of the subject matter is not ignored, any more than it is in the work of Leonard's compatriot, Lucian Freud (see FIG. 9.13). What differentiates their work is Leonard's penchant for idealization, which in turn relates him to the whole Western Classical tradition, in a fashion which is not true of Freud's very specific depictions of the nude.

PAINTING IN EUROPE

British Figurative Painting

Figurative work was dominant in Great Britain throughout the decade, and often assumed recognizably local forms. There was a strong revival of painting in Scotland, often loosely described as Expressionist by both British and American critics, and certainly much influenced by the German art of the Weimar period. Examples are the paintings of Steven Campbell (1951–). The most striking aspect of these works, however, is not their use of Expressionist distortions, but their complex narrative character, linked to a rather oblique expression of social concerns. Campbell's paintings often have a deliberately distanced character (FIG. 10.28). Clothes and accessories suggest that these mysterious scenes take place, not contemporaneously, but in the 1930s. Campbell's mystifications do, in fact, seem to have a literary source in that period—the early poems of W.H. Auden.

The Art of "Perestroika"

Taking a longer view, the most interesting developments in the figurative painting of the 1980s now seem to have taken place, not in Germany or the United States, though publicity was largely focused on these, but in the Soviet Union and France. After Stalin's death in 1953, Soviet art, which had for more than twenty years been completely cut off from artistic developments in the West, began to have intermittent contact with what was happening outside the country. One major stimulus was the Sixth World Festival of Youth and Students held in

10.30 (*above*) Eric Bulatov, *Perestroika*, 1988. Oil on canvas, 9 ft x 8 ft 10 in (2.74 x 2.69 m). Phyllis Kind Gallery, Chicago.

Perhaps Bulatov's best-known image, this takes as its starting point a well-known sculptural group by Vera Mukhina (see FIG. 5.25), showing a worker and a peasant, and subverts the poster style of Socialist Realism and its missionary purpose. The central "T" and "R" of "perestroika" are a hammer and a sickle, raising the question whether freedom and openness can be made to flourish from such instruments.

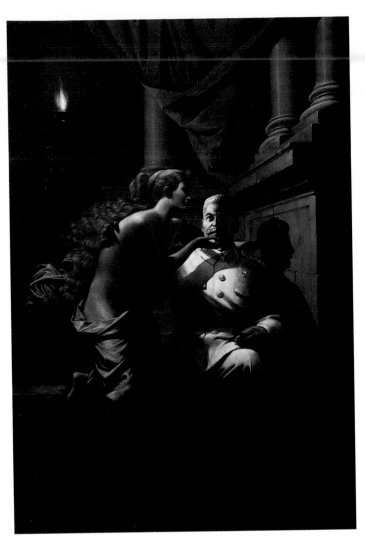

10.29 Vitaly Komar and Aleksandr Melamid, *The Origin of Socialist Realism*, 1982–3. Oil on canvas, 6 x 4 ft (1.83 x 1.22 m). Collection of Frayda and Ronald Feldman, New York.

Komar and Melamid established a reputation by parodying the worst excesses of Soviet official art. Here the attack on the personality cult of Stalin is done in a grand Neoclassical manner derived from David's paintings of the Emperor Napoleon.

Moscow in 1957, which featured an enormous exhibition—over 4,500 works—of painting and sculpture by young artists from fifty-two countries. This led to the growth of an "unofficial art" movement. In January, 1977, a large representative exhibition of Russian Unofficial Art opened at the Institute of Contemporary Arts in London. Similar exhibitions were seen elsewhere.

The reaction of the Western press was one of disappointment. Dissident Soviet work was seen simply as a deeply provincial version of established Western Modernism. The shift in cultural policy within the Soviet Union itself, as a result of Gorbachev's policy of *perestroika*, or "openness," led to the emergence of a very different kind of avant-garde art. Rather than being dependent on the tradition of Modernism in the West, this was essentially a deconstruction of the official Soviet Realist style which had prevailed in the Soviet Union since the 1930s. The first works of this new art to gain widespread fame were produced by two emigrés, Vitaly Komar (1943–) and Aleksandr Melamid (1946–), artistic collaborators who established themselves in New York in the mid-1970s. Paintings like their *The Origin of Socialist Realism*, which shows a semi-nude Classical muse embracing a uniformed Stalin, perfectly caught the new spirit in Soviet painting (FIG. 10.29). This spirit also found an expression among artists who remained in the former USSR, such as Eric Bulatov (1933–), who in *Perestroika* (FIG. 10.30) offered a parody of a Soviet icon, the sculptural group representing a worker and a collective farmer made by the Socialist Realist sculptor, Vera Mukhina (see FIG. 5.25), originally for the Paris Universal Exhibition of 1937.

France: Jean Rustin

One of the more striking phenomena of the period since 1960 has been a steep decline in the international prestige of French art. The death of Jean Dubuffet in 1985 seemed to mark the end of an epoch. Balthus, at this point the last surviving "French" artist with a major international reputation, was in fact of Polish origin, and had spent much of his youth in Germany and Switzerland. French industri-

Jean Rustin: *Woman Putting Her Hand in a Man's Mouth*

The French artist, Jean Rustin (1928–), has had an unusual career. Trained at the Ecole des Beaux-Arts in Paris in the years immediately following World War II, he had a successful period as an abstract painter, culminating in a major retrospective exhibition at the Musée de l'Art Moderne de la Ville de Paris in 1971. The so-called *evénéments* of 1968 (the student-led revolt against the regime of Charles de Gaulle), and their aftermath, combined with stresses in the artist's personal life, then led to an almost complete revulsion against all that he had achieved so far. Rustin retired into his studio and had no substantial exhibitions for more than a decade. When he re-emerged, he had become a particularly challenging

kind of figurative painter. Rustin's personages, usually nude, often apparently in the last stages of physical decrepitude, stare angrily at the viewer from bare cell-like rooms. Sometimes they make explicitly sexual gestures. *Woman Putting Her Hand in a Man's Mouth* (1983) (FIG. 10.31)—the alternative title is *Blanchette Is Having a Good Time*—is a fully mature work from Rustin's second phase, typical in its mixture of the threatening, the erotic, and the desolate, and typical, too, in its deliberately restrained gamut of white, blue-gray and bluish pink.

Unlike much of the painting produced in the 1980s, Rustin's work shows sophisticated skills in handling the painter's traditional materials. The most obvious com-

parisons are with some of the great pre-Modern masters, notably Manet (with whom Rustin's actual technique has much in common), Frans Hals, and Goya. In painterly terms, he is probably the greatest virtuoso of the final decades of the century. His way of "appropriating" some of the methods and values of the past is much subtler than that of the recognized practitioners of appropriation who are his younger contemporaries. The hidden cultural echoes in his work only serve to emphasize its relevance to absolutely contemporary concerns, such as the terror of isolation in a soulless and godless universe. What his paintings seem to symbolize is something much more than purely personal neurosis—they mirror the death of hope, and the collapse of the great ideological systems which sustained so much of twentieth-century thought.

Rustin's work is sometimes linked by critics to the cataclysmic politics of the twentieth century, in particular to the Holocaust. The artist denies that there is any connection to this or any other specific event, just as he denies that the paintings are meant to be portraits of the mentally ill. For him, they reflect, not only his own inner tensions, but the general collapse of value systems. As an artist, he has been compared to Francis Bacon, but there is a wide gap between Bacon's high-pitched, inherently unstable rhetoric of despair, and Rustin's covert Classicism.

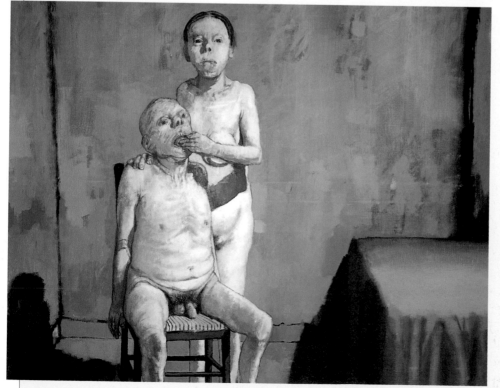

10.31 Jean Rustin, *Woman Putting Her Hand in a Man's Mouth*, 1989. Oil on canvas, 4 ft 3⅛ in x 5ft 3¾ in (1.3 x 1.62 m). Jean Rustin Foundation, Antwerp, Belgium.

al and interior designers, such as Philippe Starck (1949–) and Andrée Putman (1925–), and even French architects, such as Jean Nouvel, enjoyed a more widespread prestige in the 1980s than French painters, sculptors, and makers of installations. The sole, if only partial, exception to this was the painter, Jean Rustin (1928–) (see FIG. 10.31).

Sculpture

Sculpture and environmental work continued along a course already laid out for them since the end of the 1960s. One consequence was an increasing division between truly "public" sculpture, made to be seen in an environment shared with all the great and trivial actions of everyday life, and sculpture which could find its place only in a museum. The makers of permanently installed monumental sculptures increasingly found themselves regarded as old-fashioned. They also found themselves confined to purely abstract forms of expression. Even the monumental late reclining figures of Henry Moore, once regarded as eminently suitable for public sites, now seemed too specific, that is to say, likely to offend some segment of the community.

BRITISH SCULPTURE

One striking phenomenon of the decade was the international attention paid to British sculpture. Whereas British painting was usually figurative, the sculpture of the period was a mixture of abstract and figurative elements, though the figurative ones were often simply Duchampian readymades. The chief influence on artists such as Bill Woodrow (1948–) and David Mach (1956–) was Duchamp himself, filtered through the work of Tony Cragg. These artists often made use of the detritus of industrial civilization, junkyard finds such as old refrigerators and worn-out washing machines, as materials for their work.

Richard Deacon

The work of Richard Deacon (1949–), though usually lumped with that of Cragg, Woodrow, and Mach to form a single British "school," represents a somewhat different approach. Deacon's sculptures, large and essentially abstract, are a continuation of aspects of Antony Caro (see FIG. 8.34)—they use industrial forms and processes to create independent images, in which the association with industry is only incidental. A good example is *Body of Thought No 1* (FIG. 10.32), a writhing openwork structure made of square-section aluminum tubes, themselves made of aluminum plates held together with numerous screws. Deacon's work is much more Baroque in feeling than that of Caro, and his sculptures also seem to have an underground, only half-declared, connection to the surrealist tradition. Though abstract, they hint at figurative meanings. Despite their often monumental scale, they are not objects to be placed out-of-doors. Their relationship with the enclosed spaces in which they are displayed is part of their effect—in this they resemble the otherwise very different Minimal work of American sculptors such as Morris and Judd (see FIGS 8.45 and 8.37).

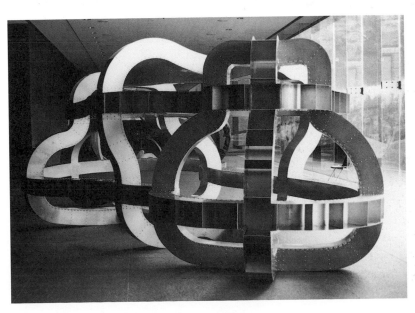

10.32 Richard Deacon, *Body of Thought No. 1*, 1987–8. Aluminum with screws, 9 ft 2¼ in x 27 ft 9⅛ in x 13 ft 9 in (2.80 x 8.46 x 4.19 m). Lisson Gallery, London.

Deacon's sculptures, though abstract, hint at the presence of hidden Surrealist imagery. This piece, crackling with energy, has one of Deacon's trademarks: the presence of bold fixings that deliberately call attention to themselves.

Anish Kapoor

Another, slightly different, facet of British sculpture appears in the work of Anish Kapoor (1954–). Though born in Bombay, of half-Indian, half-Jewish descent, Kapoor has always made it plain that he has no wish to be regarded as a representative of a transplanted culture in Great Britain. Sculptures like his *Mother as a Solo* (FIG. 10.33) do, nevertheless, reflect the increasing impact of multiculturalism on the formerly enclosed British art world. Like most of Kapoor's sculptures it consists of a massive unitary form, which suggests a womb, whose surface is covered with brilliantly hued powder pigment. Like many of the artist's characteristic shapes, it suggests a connection with Indian Tantric art, which uses similarly simple forms as foci for mystic contemplation, and which often has a sexual subtext. Such sculptures, however, can also be related to a transcendental tradition in European art, which includes the work of artists such as Malevich (see FIG. 3.23) and Mark Rothko (see FIG 7.10). Kapoor's mysticism offers a counterweight to the satirical, socially critical approach adopted by artists such as Woodrow and Mach.

10.33 Anish Kapoor, *Mother as a Solo*, 1988. Fiberglass and pigment, 6 ft 8¾ in x 6 ft 8¾ in x 7 ft 6½ in (2.05 x 2.05 x 2.3 m). Musée Saint-Pierre, Lyons, France.

The large, simple form, covered in a single hue of powdery pigment, is very characteristic of Kapoor's work—almost like a Rothko in three dimensions.

10.34 Antony Gormley, *A Case for an Angel*, 1989. Plaster, fiberglass, lead, steel, and air, 6 ft 5½ in x 28 ft 1¾ in x 18⅛ in (197 x 858 x 46 cm). Jay Jopling, London.

This sculpture is first cousin to an ancient Egyptian mummy case, which enfolds a corpse but is designed to procure immortality. Gormley's work sparks off rich historical and metaphysical associations.

Antony Gormley

Different from all of these, because it is not only strongly figurative, but intimately involved with the human body, is the work of Antony Gormley (1950–). Gormley's sculpture has its roots in that of George Segal (see FIG. 8.50). Like Segal, he frequently uses the body (in this case usually his own) as a matrix. His figures are hollow casings. Unlike Segal, Gormley tries to make them completely impersonal and generic, to the point where they remind one of the anthropoid coffins favored by the ancient Egyptians (FIG. 10.34). The effect, therefore, is quite different from Segal, or from Segal's Super Realist successors Duane Hanson and John de Andrea (see FIGS 9.33 and 9.34), who also make use of body-molding techniques. The figures seem like artifacts left by some vanished civilization. This is also true of sculptures where the body-molding process is not used. Gormley and Kapoor, apparently so different from one another, share a mystical, transcendental strain that marks them off from the rest of British sculpture of the same epoch.

Gilbert and George

Two of the most prominent "sculptors" in Great Britain during the 1980s did not make three-dimensional work. The creative duo, Gilbert and George, progressed from the performance-oriented work which has already been described (see FIG. 8.33) to enormous multi-paneled photo-pieces, which they continued to describe as sculpture. The subject-matter of these photo-pieces is almost invariably direct-

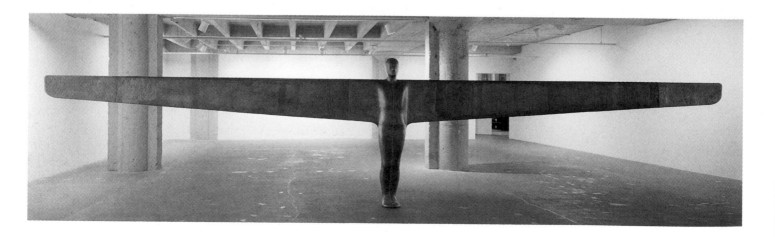

10.35 Gilbert and George, *Live's*, 1984. Photomural, 8 ft 11 in x 11 ft 7 in (2.41 x 3.51 m). Anthony d'Offay Gallery, London.

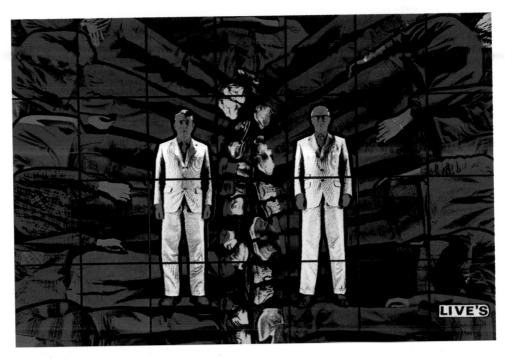

10.36 Jeff Koons, *Popples*, 1988. Porcelain, 29 x 23 x 12 in (73.7 x 58.4 x 30.5 cm). Private collection.

Koons works in series, and the fourth series, from which this meticulous reproduction, on an enlarged scale, of a sentimental soft toy is taken, is called "Statuary." Whatever his intention is in focusing on consumer objects, Koons says that it is not to expose bad taste. "I don't find any ironic quality in the work at all. What it does have for me is a sense of the tragic. My objects aren't cute."

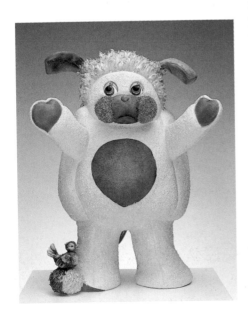

ly autobiographical, and features likenesses of the two artists. In figuring prominently in their own work, it is as though they are living through the troubles of modern life for our moral edification. Their work contains a strong element of social criticism. *Live's* (FIG. 10.35), for instance, focuses on the artists' relationship with the unemployed youths who live round their studio in London's East End, and who often model for them. The composition is dominated by self-portraits of Gilbert and George, who stand upright in the center, while other figures face out away from them toward the edges. Like many of their photo-pieces, it is socially engaged with, but also profoundly ambiguous about, the British class system and the place of the artists within it.

AMERICAN SCULPTURE

Jeff Koons

Gilbert and George's work has a good deal in common with that of one of the most discussed American sculptor of the 1980s, Jeff Koons (1955–). Koons's erotic photo-pieces, made with his then wife, the Italian porn-movie star and erotic performer, La Cicciolina (Ilona Staller), challenge ideas about decorum in art in much the same way as Gilbert and George do. Koons's most significant works, even so, are not these, but three-dimensional pieces in a slick post-Pop idiom. *Popples* (FIG. 10.36) is a scaled-up version in porcelain of a stuffed toy—one of a series of similarly enlarged versions of kitsch ornaments and commercial souvenirs. Koons affects neutrality, but his real aim is to subvert. The impact made by his work on a sophisticated viewer has been well described by the American critic and art historian, Robert Rosenblum:

> I still recall the shock of my initial confrontation with Koons's lovingly hideous and accurate reconstructions of the lowest levels of three-dimensional kitsch, from porcelain *Pink Panthers* and *Popples* to painted wooden bears and angels. We all, of course, have been seeing this kind of stuff for years in every shopping center and tourist trap, but never before have we been forced, as one is in a gallery setting, to look head-on and up-close at its mind-boggling ugliness and deliriously vapid expressions.[5]

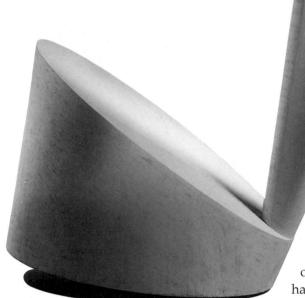

The Conceptual aspect to Koons's work, and its element of intellectual terrorism, are stressed by the fact that he is not the actual maker of his sculptures, which are commissioned from craftsmen who replicate objects selected by the artist. Koons's own role is supervisory, and he has said that he regards his activity as an essentially financial construct, a parody of the economic workings of the art world, inspired by a period he spent as a Wall Street commodities broker.

Martin Puryear

A strong contrast to Koons's activity is offered by the work of the African-American sculptor Martin Puryear (1941–), who also became prominent in the 1980s. Puryear, like Anish Kapoor in Great Britain, is insistent on being judged purely as an artist, not as the generic representative of a minority culture. He is, nevertheless, also one of the few African-American artists with direct experience of Africa, having worked in Sierra Leone as a member of the Peace Corps. Later, his studies took him to Sweden and Japan. Swedish influences—especially what he learned from the master cabinet-maker, James Krenov—and Japanese ones are more immediately visible in his work than African ones, despite strenuous efforts made by critics to align his work with African artifacts. Puryear himself has stated that when in Africa he felt like an outsider. Nor is his work African in any technical sense. Works like *Verge* (FIG. 10.37) make use of intricate laminating, familiar both in Japan and in the European woodworking tradition, but foreign to African methods of working wood, in which objects and sculptures are hewn from a solid block. Like Kapoor, Puryear has links to a continuing surrealist tradition.

Environmental and Conceptual Art

Much of the most interesting Environmental work in the 1980s was the product of women linked to the evolving feminist tradition. Many of these works relied entirely, or to a very large extent, on written text.

10.37 Martin Puryear, *Verge*, 1987. Painted pine and red cedar, 5 ft 7½ in x 7 ft 2 in x 3 ft 11 in (1.71 x 2.18 x 1.19 m). Edward R. Broida Trust.

Puryear, who is trained in woodworking and other crafts, prizes traditional manual skills in the making of his sculptures, which are usually organic or biomorphic in nature.

10.38 Jenny Holzer, *Untitled* (selections from *Truisms*), 1987. Edition of three. Danby royal marble, 17 x 54 x 25 in (43.9 x 137.2 x 63.5 cm). Barbara Gladstone Gallery, New York.

Holzer's series of *Truisms*, mostly made between 1971 and 1979, use words to make catchy, often punning, slogans. She has said that she wanted to compile "Jenny Holzer's *Reader's Digest* version of Western and Eastern thought" in a language that was accessible to ordinary people.

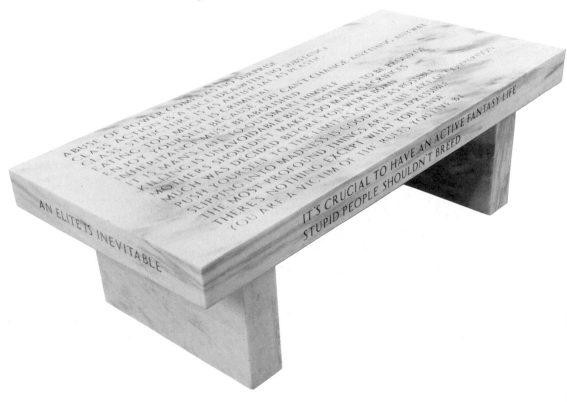

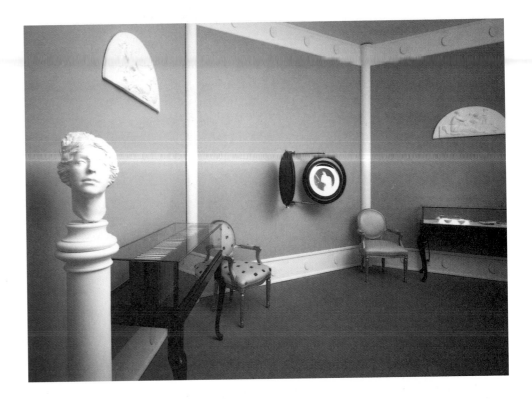

10.39 Barbara Bloom, *The Reign of Narcissism*, 1989. Mixed media, 20 x 20 x 12 ft (7 x 7 x 3.66 m). Museum of Contemporary Art, Los Angeles, California.

Bloom's elegant installation provides a commentary on feminine vanity.

10.40 Robert Gober, *Untitled Leg*, 1989–90. Wax, cotton, wood, leather, and human hair, 12½ x 5 x 20 in (31.7 x 12.7 x 50.8 cm). Private collection.

Robert Gober's disturbing installations have been read, perhaps too simplistically, as a commentary on the AIDS epidemic.

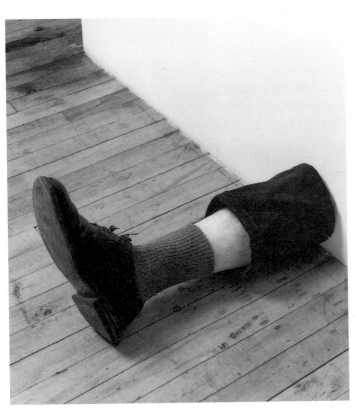

This was true, for example, of the best-known examples, the *Truisms* (FIG. 10.38) of Jenny Holzer (1950–), which appeared first as simple inscriptions, then as ingredients in elaborate installations featuring light diodes. The feminist installations and posters of Barbara Kruger (1945–) effectively combined lettering and photographs, using an idiom which derived from the Russian Constructivist posters designed by the Shternberg brothers in the mid-1920s. The Guerrilla Girls, a group of anonymous feminists who disguised themself with gorilla masks when making public appearances, made use of the statistical techniques pioneered by Hans Haacke (see page 316) to make poster and postcard statements about the unequal treatment meted out to women in the art world. Some of the most elegant feminist installations were the work of Barbara Bloom (1951–). *The Reign of Narcissism* (FIG. 10.39), perhaps in reaction to the self-promotion of certain feminists, was a gentle satire on female self-love and self-preoccupation—a bland Neoclassical salon filled with busts and cameos reproducing her own image, plus imitation Louis XVI chairs upholstered in a pattern showing the artist's signature.

Robert Gober

One American sculptor and maker of environments who admitted a great debt to feminist practice was Robert Gober (1954–). Gober's work is notoriously elusive (FIG. 10.40). Some of its typical ingredients are as follows: realistic models of human legs, sticking out of the wall at about knee-height; a dressmaker's dummy wearing a wedding dress; a paper bag filled with doughnuts, placed on a pedestal; a baby's cot with slanting sides; wallpaper showing a pattern of male and female sexual organs; a repetitive design in which a sleeping man is paired with a lynch-mob victim hanging from a schematic tree. Since Gober is openly gay,

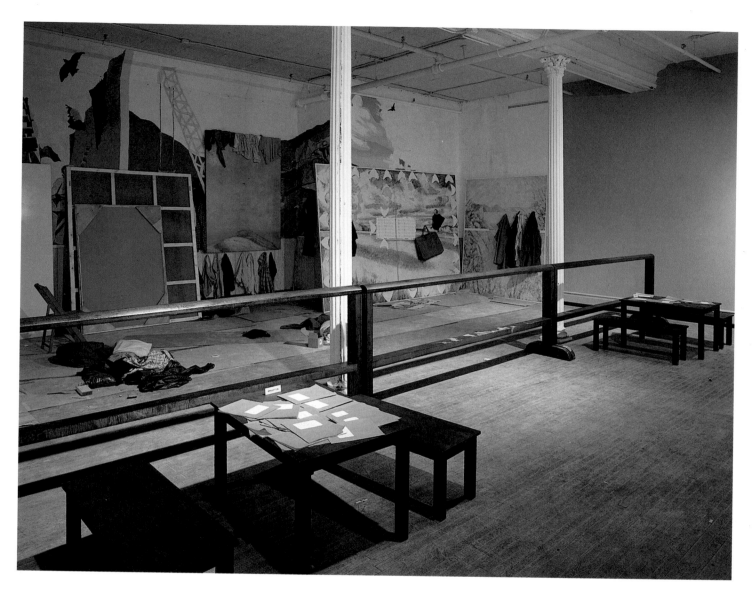

10.41 Ilya Kabakov, *He Lost His Mind, Undressed, Ran Away Naked* (detail), 1983–90. Five Socialist Realist murals, acrylic on paper and masonite panels. Ronald Feldman Fine Art, New York.

Kabakov's installations are powerfully suggestive recreations of living conditions under Soviet Communism. They are deliberately anti-Minimalist. "I use in my installations things that were supplanted during the era of Minimalism: a plot, literature, live speech, human content."

this imagery has been connected by commentators with the impact of AIDS on the New York art world. Examined objectively, however, it seems much less specific. To say flatly that Gober's work is "art about AIDS" requires energetic reading between the lines. What it does undoubtedly convey is a general feeling of disturbance, of restless unease. This comes not from single objects, but from the relationships between them. They have a feeling of muffled lamentation, of obscure grief, which now seems more typical of the artistic climate of the 1980s than the triumphalism proposed by the exhibition, "A New Spirit in Painting" (see page 340).

SCULPTURE IN THE SOVIET UNION

Something of this melancholy also appears in the work of the most important and various of the Soviet Perestroika artists, the maker of installations, Ilya Kabakov (1933–). Kabakov had been closely associated with the Soviet "dissident" movement in art, but he succeeded in making a living during the 1960s and 1970s as a well-regarded children's illustrator. Rather than parodying and deconstructing official Soviet art, like Komar and Melamid or Eric Bulatov (see FIGS 10.29 and 10.30) , Kabakov uses elaborate environments to evoke the realities of late Soviet society (FIG. 10.41). He evokes the all-pervasive hypocrisy, the decay of institutions, the struggle to survive, but at the same time celebrates the resilience of the

10.42 Cindy Sherman, *Self-portrait*, 1983. Color photograph. Art Institute of Chicago.

The various roles of women in society, taken especially from films and the media, are the subjects of Sherman's most arresting photographs, in most of which she is herself the "star." Like Lichtenstein's comic-strip paintings, they have an unsettling deadpan humor.

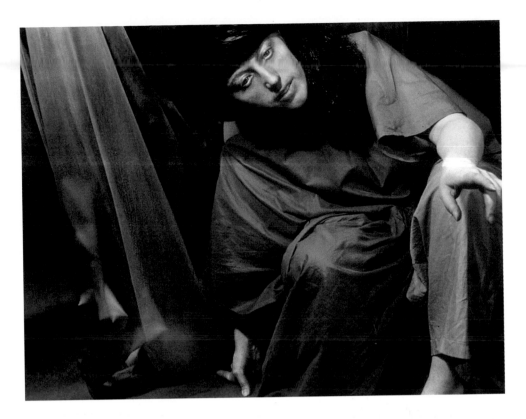

human spirit in the face of so many frustrations and privations. The Constructivist avant-garde which sided with the Revolution had looked forward to a utopian future. For Kabakov, optimism of this sort is no longer possible: "I see this fundamental conflict," he said, "of speech devoid of meaning and of meaning not given any form by speech—in everything that surrounds me, and above all in myself."[6]

Photography

During the 1980s photography completed the process of integration with the general body of avant-garde art first begun in the 1960s and pushed much further in the 1970s. It could be used in a number of different ways. For example, one of the major Perestroika artists, Francisco Infante (1943–), not well known in the West, perhaps because of his puzzlingly un-Russian name, made open-air installations which existed only in order to be photographed. Reduced to purely two-dimensional images by the camera, the objects Infante added to the landscape created puzzling spatial ambiguities. At the same time, the photographs stressed the contribution made by evanescent effects of light. The use of the camera was not merely a matter of convenience, in a social situation still hostile to the production of permanent abstract sculpture, but a method of translating sculpture into another form, with slightly different values. It was Infante's way of placing his imagery at one remove from the viewer, and thus endowing it with a transcendental quality perhaps denied to the objects themselves.

Cindy Sherman

The work of the American artist, Cindy Sherman (1954–), offers an analysis of an entirely different sort—her subject is women's role in society (FIG. 10.42). Perhaps the most famous examples are her long series of self-portraits based on movie stills. In these she enacts a series of roles from imaginary films, using her charades

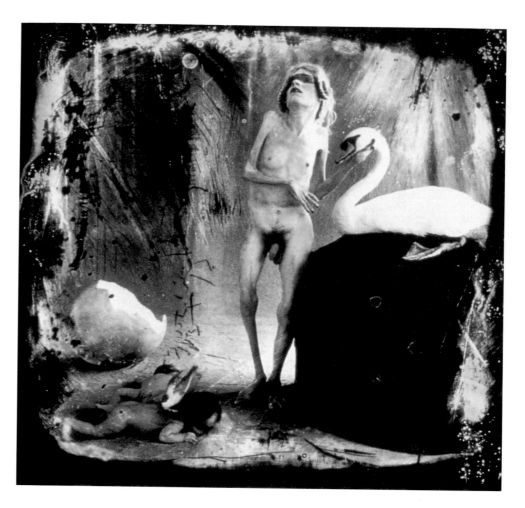

as a means of pinpointing gender-stereotypes. The photographs stress the function in American society of images remembered from films as components in a language which almost everyone shares—far more so than images taken from mythology or religion.

Joel-Peter Witkin

The photography of Joel-Peter Witkin (1939–) seems to represent a complete break with almost everything photography after World War II set out to achieve. It reverts to the ethos of the Victorian and Edwardian photographers who wanted the photographic image to be visibly "art." Among the acknowledged ancestors of Witkin's work are Julia Margaret Cameron, Oscar G. Rejlander (who used multiple negatives to make photographic equivalents for the most elaborate Victorian allegorical paintings), and the American Symbolist photographer, F. Holland Day, who in the late 1890s made an extraordinary series of photographs of himself as Christ, something Witkin describes as "an extreme extension of his private fantasies into art."[7]

Witkin's work can be described using exactly the same phrase. His often nightmarish images offer a world of death and deformity—freaks, cripples, corpses, and horrors of all kinds, presented as components in sumptuous Baroque tableaux. The photographic images are scratched, stained, and otherwise mistreated, so that they acquire some of the patina of nineteenth-century prints. According to the critic, Germano Celant:

The point is to make photographic information "fabulous" (as if out of a "fable") … By modifying the materials of photography, Witkin wants to

"remake" the image, to revolutionize it with gesturality, so that the subjects become presences of an unknown life animated by the spirit of the individual creating them and fecundated by the vital spirit of a sacred, unknown but present existence.[8]

Witkin is perhaps the most extreme example of the Postmodern sensibility at work in late-twentieth-century photography. He has especially close links with the Postmodern Classicism of artists like Carlo Maria Mariani, since he often alludes to or parodies stock Classical themes, like the Three Graces (represented in one of his photographs by three hermaphrodites), Leda and the Swan or Botticelli's *Venus* (represented by yet another hermaphrodite) (FIG. 10.43). His complex web of cultural allusions places him at the opposite extreme from photographers of the here-and-now such as Robert Frank. One Modern rather than Postmodern aspect of Witkin's work, however, is its deliberate flouting of social and sexual conventions. As Robert Mapplethorpe and Diane Arbus discovered before him, it remains easier, in the late twentieth century, for photographers to do this than practitioners in other branches of the visual arts. However much processed or altered, the photographic image still seems to offer a pledge of veracity—we accept that it represents something which took place in "real life."

| **1990** | **1991** | **1992** |

GENERAL EVENTS

- Boris Yeltsin elected president of Russia
- Iraqi troops invade Kuwait
- Nelson Mandela released from prison in South Africa

- Civil War breaks out in Yugoslavia
- Gulf offensive launched by NATO against Iraq
- Rajiv Ghandi assassinated
- Final disestablishment of the USSR

- Bill Clinton elected US president
- Race riots in Los Angeles
- Collapse of Russian-backed Communist regime in Afghanistan

Brown,
This is the last song .
see p.368

SCIENCE AND TECHNOLOGY

- Global warming threat recognized

- First planet beyond the Sun's solar system discovered

Youhan,
Mao and Blonde Girl Analyzed:
see p.370

- "Cosmic ripples" detected in space
- Earth Summit environmental conference in Rio de Janeiro

ART

- Ilya Kabakov, *He Lost His Mind, Undressed , Ran Away Naked* (environmental work, Ronald Feldman Fine Arts, New York)
- "Between Spring and Summer: Soviet conceptual art in the era of late communism," exhibition at the Institute of Contemporary Arts, Boston
- Lucy Lippard publishes *Mixed Blessings: New Art in a Multi-Cultural America*

- Damien Hirst, *The Impossibility of Death in the Mind of Someone Living*
- "CARA: Chicano Art, Resistance and Affirmation," exhibition at the Wight Art Gallery, University of California, Los Angeles
- "Metropolis," exhibition at the Martin-Gropius-Bau, Berlin
- Museum of Contemporary Arts opens in Frankfurt, Germany

- Yu Youhan, *Mao and Blonde Girl Analyzed*
- Bill Viola, *To Pray without Ceasing* (video installation)
- Andres Serrano, *The Morgue* series of photographs
- SoHo Guggenheim Museum opened in New York
- "Helter Skelter: LA Art in the 90s," exhibition held in Los Angeles

Tjapaltjarri,
Possum Man's Dreaming:
see p.372

ARCHITECTURE

- Santiago Calatrava, TGV Railway Station, Lyon-Satolas, France

- Quinlan Terry, Greek Doric Library, Downing College, Cambridge, England

- John Outram, Judge Institute of Management Studies, Cambridge
- Ricardo Bofill, National Theater, Barcelona, Spain

1993

- United States initiates missile attacks on Iraq
- Benazir Bhutto re-elected prime minister of Pakistan
- PLO–Israeli peace agreement announced

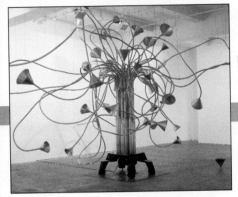

Horn,
The Turtle Sighing Tree:
see p.375

- 130 nations sign treaty banning chemical weapons
- Concept of "information super-highway" promoted
- Internet system links five million users

- Rachel Whiteread, *Untitled (House)*
- "Aratjara: Art of the First Australians," exhibition at Kunstsammlung Nordrhein-Westfalen, Düsseldorf, Germany
- "China Avant-Garde," exhibition at Haus der Kulturen der Welt, Berlin, and Museum of Modern Art, Oxford, England

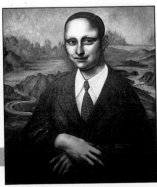

Lee, *Bona Lisa*:
see p.369

- Zaha Hadid, Vitra Fire Station, Weil am Rhein, Germany

1994

- First non-racial elections in South Africa
- Massacre of Tutsi people by Rwandan Hutus
- Russian military offensive against the break-away republic of Chechnya

- Number of HIV cases worldwide estimated to have reached 17 million

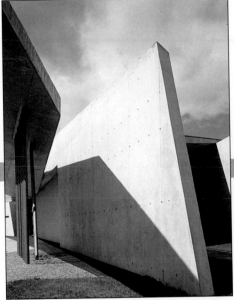

- "Some Went Mad, Some Ran Away," exhibition at the Serpentine Gallery, London
- "Japanese Art after 1945: Scream against the Sky," exhibition at the Guggenheim Museum, New York
- Death of the influential art critic, Clement Greenberg

- Alessandro Mendini and others, Groninger Museum, Groningen, the Netherlands

1995

- Bombing of Federal office building in Oklahoma City
- Yitzhak Rabin, prime minister of Israel, assassinated
- Dayton Peace Agreement halts war in Bosnia

- US space shuttle *Atlantis* docks with Russian *Mir* space station

Hadid, Vitra Fire Station:
see p.367

- "Africa: Art of a Continent," exhibition at the Royal Academy of Art, London
- Damien Hirst wins the Turner Prize
- Joel-Peter Witkin, exhibition of photographs at the Guggenheim Museum, New York

Serrano,
The Morgue:
see p.381

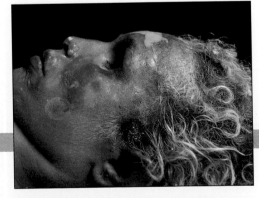

- Mario Botta, Museum of Modern Art, San Francisco

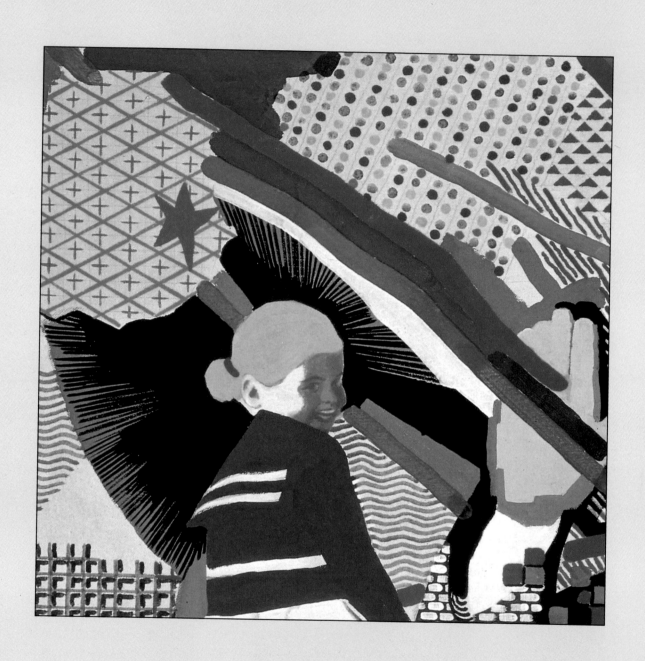

1990–1995

The early 1990s were a period of renewed recession and increasing political instability. The civil wars which had already become endemic in the Third World gained a foothold in Europe with the break-up of Yugoslavia. The Bosnian conflict, as much religious as racial, brutalized the Balkans, and the collapse of Soviet Communism led to the dismemberment of the Russian Empire and to the outbreak of nationalist conflicts in new independent states such as Georgia and Azerbaijan.

In the United States events like the Los Angeles race riots (which followed the acquittal of members of the city's police department charged with beating a black motorist) and the bombing of a government building in Oklahoma City (apparently the work of home-grown right-wing terrorists) seemed to indicate that American society was once more subject to the kind of political and racial strain it had experienced in the late 1960s and early 1970s, at the time of the Civil Rights movement and the protests against the war in Vietnam.

The rise of Islamic fundamentalism continued unchecked, while African governments continued their slide into chaos, with especially horrifying ethnic massacres in the small, densely populated central African state of Rwanda.

There were, however, some signs of hope, notably the fall of apartheid in South Africa, and the installation of that country's first genuinely multiracial government under the leadership of Nelson Mandela, and also the signature on a peace agreement between the Israeli governement and the Palestine Liberation Organization. Hopes for continuing Israeli–Palestinian cooperation were, however, checked by the assassination of the Israeli premier, Yitzhak Rabin, by a young orthodox Jewish settler from the West Bank, opposed to Israeli withdrawal from any of the occupied territories.

Architecture

The Groninger Museum

The architecture of the early 1990s has a characteristic restlessness which seems to reflect the political and economic turbulence of the epoch. Perhaps the most typical building of the first half of the decade is the Groninger Museum (FIG. 11.1), designed by the Italian architect and industrial designer, Alessandro Mendini (1931–), with the help of an international team of collaborators. The building, which floats like a huge ship in a canal in the middle of the Dutch city of Groningen, exemplifies Mendini's non-hierarchical philosophy: "He considers art-historical styles, exotic cultures and kitsch all to be equally important."[1] Split into three separate pavilions, the building is notable both for its bright surface finishes, deliberately contrasted both in texture and in hue, and for "kitsch" details, like the little painted and carved wooden models of trees flanking the bridges that lead to it. The roof of the Fine Art pavilion, a group of apparently random slanting planes designed by the Austrian architectural firm, Coop Himmelblau

This restless building, with its clashing colors and forms, offers a 1990s approach to museum design—the symbolic function of the structure seems to take precedence over the practical uses to which it is to be put.

(Wolfgang Prix, 1942– , and Helmut Swizinsky, 1944–), gives an added touch of instability to the design (FIG. 11.2).

Inside the building, displays designed by Mendini's Italian colleague Michele de Lucchi (1951–), and by the Frenchman, Philippe Starck (1949–), seem more influenced by high-class retailing than by traditional museum-display conventions. The objects on view become elements in a theatrical decor.

Zaha Hadid

Equally restless in effect, though more coherent stylistically, is a smaller building with a humbler purpose, the Vitra Fire Station (FIG. 11.3) at Weil Am Rhein, Germany, designed by Zaha Hadid (1950–). Where Mendini builds in this way because he is anti-hierarchical, Hadid's designs have a social message as well— "her projects are to be seen as illustrations of a shattered, fragmented society, bereft of normality and stability."[2] Her work is heavily influenced by Futurist architects of the early Soviet period, but uses forms which they intended to be seen as optimistic in the service of a much more pessimistic message.

Hadid, born in Baghdad and trained largely in London, is one of the first experimental female architects to make a substantial reputation in the second half

11.2 Coop Himmelbrau (Wolfgang Prix and Helmut Swizinsky), interior of the roof of the Fine Art pavilion, Groninger Museum, Groningen, The Netherlands, 1994.

The roof of the Fine Art pavilion injects an uneasy element of deconstructionism into an otherwise sleek and commercial design.

11.3 Zaha Hadid, *Vitra Fire Station* (detail), Weil Am Rhein, Germany, 1993.

Hadid says that her inspiration derives from Suprematism and this building shows a high sense of individual personality in its restless, dynamic use of space. The question arises whether such bold, sculptural anti-functionalism is suitable to the purpose of the building.

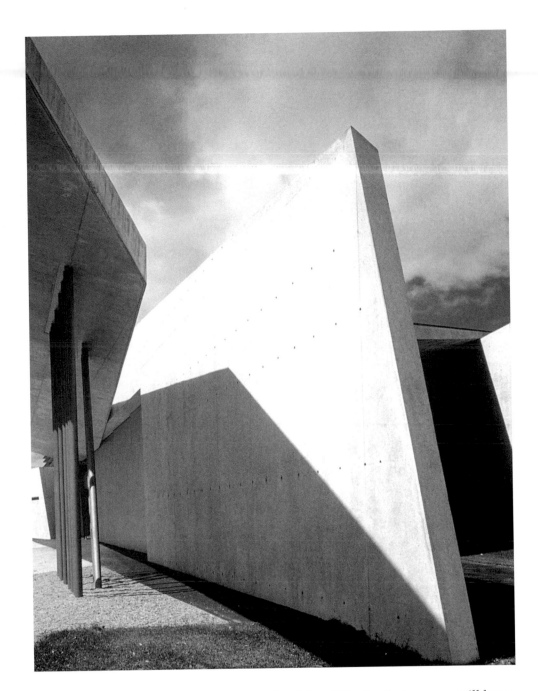

of the twentieth century. It is symptomatic of the difficulty that women still have in establishing themselves in the architectural profession that she is much better known as a theoretician than for her actual buildings—the Vitra Fire Station is her only complete project, though she was also the competition winner for the new opera house in Cardiff, as yet unbuilt.

Painting

The renewal of faith in painting at the beginning of the 1980s was shortlived. The economic recession of the opening years of the 1990s once again turned the attention of the avant-garde to installation work, as experimental art became, as it had been in the 1970s, more the business of institutions than of private patrons. Painting did, however, serve a number of specialized purposes, which at least partly disguised its loss of centrality. These purposes were linked to two things.

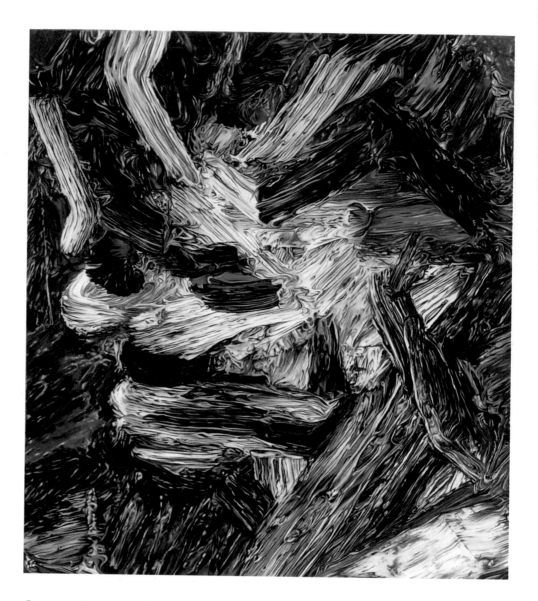

One was the strong historical echo which accompanied any attempt to make art in this form. Another was its convenience and portability—the very things which established oil painting on canvas as a major means of aesthetic expression at the beginning of the sixteenth century (when leading Venetian artists began to export their products throughout Europe, particularly to the royal court in Spain).

Appropriation

The issue of "appropriation"—art which takes over or copies previously existing artworks, often for subversive purposes—remains important in the 1990s. The British artist, Glenn Brown (1960–), makes copies of existing artworks, based on reproductions found in books. The paintings he chooses—Auerbach and de Kooning have been among his models—are often heavily textured (FIG. 11.4), but his reproductions are deliberately flat, illusionist representations of what is in fact three-dimensional. Brown's work is wholly confined to the realm of art, and uses painting itself to compose a lament for painting's demise.

Gay Art

The world of art has become an important forum for the expression of minority views. Homosexual artists have taken as much advantage of this as have various ethnic minorities. They often use a version of appropriation in order to reinforce

their own historical claims. A simple example is *Bona Lisa* (FIG. 11.5), a version of Leonardo da Vinci's *Mona Lisa* by the British artist, Sadie Lee (1967–). Leonardo's famous sitter appears with cropped hair, wearing a collar and tie—an ironic comment on the popular image of a "butch" lesbian, combined with an allusion to Leonardo's homosexuality.

The New Mexican artist, Delmas Howe (1935–), who made his reputation with paintings combining Graeco-Roman myths with the Western legend of the cowboy, has more recently been painting realistic images drawn from the homosexual leather scene. These link an Old Masterly mode of presentation to candid representations of contemporary sexuality, and refer to the paintings of warriors in armor produced by Titian and others in the sixteenth century. If the paintings were not so deliberately traditional, they would be deprived of part of their force. Artistic and social precedent are shown to be indivisible (FIG. 11.6).

New Painting in China

Just at the moment when painting seemed to be losing the battle to survive in the West, a new school of "Western-style" painting arose in China. Most observers date its emergence to the year 1989, when China changed course toward a mar-

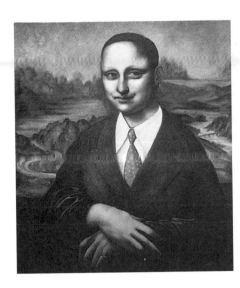

11.5 (*above*) Sadie Lee, *Bona Lisa*, 1992. Oil on board, 23 x 19⅜ in (58.4 x 48.2 cm). Jill George Gallery, London.

Leonardo da Vinci's *Mona Lisa* undergoes yet another transformation—earlier in the century Marcel Duchamp had given her a moustache and goatee—and is presented as a lesbian wearing a collar and tie. "Bona" is British slang for "sexy" or "desirable."

11.6 Delmas Howe, *Liberty, Equality and Fraternity*, 1995. Oil on canvas, 4 x 5 ft (1.22 x 1.52 m). Copeland Rutherford Fine Arts, Santa Fé, California.

The gay artist Delmas Howe uses traditional compositional formulae to depict participants in sado-masochistic sexual rituals. The conservatism of technique tends to puts the emphasis on the challenging nature of the actual subject-matter.

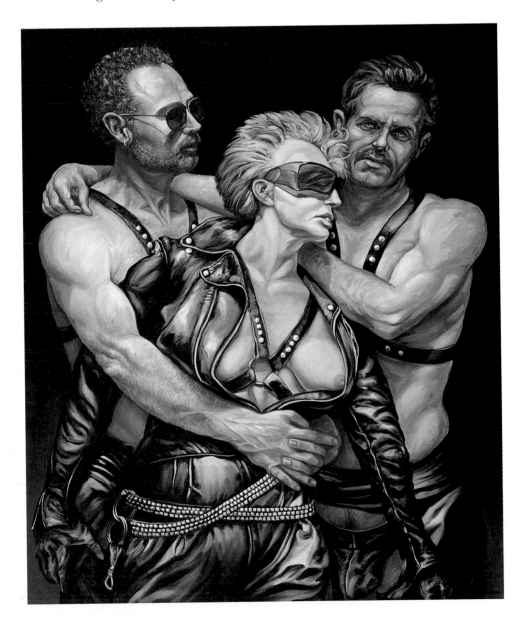

Yu Youhan: *Mao and Blonde Girl Analyzed*

Essentially Yu Youhan's paintings, like *perestroika* art in Russia, require some knowledge of the recent history of his country, and the complexities of ideological coding. *Mao and Blonde Girl Analyzed* (FIG. 11.7) combines elements borrowed from both Socialist Realism and the paintings produced by peasant communes during the Cultural Revolution in China with others related to American Pop. The peasant paintings were approved of in China not only because of their association with the rural cadres who Mao hoped to make the basis of a new kind of economy, but because of their avoidance of individualization. Such works had no single, recognizable author, but were the product of collective effort. They were also in harmony with the new Chinese nationalism promoted by Mao. Unlike the Socialist Realism imported from Soviet Russia, peasant paintings had their roots in a specifically Chinese art form: the naive block prints which had long been produced for popular consumption. It is part of Yu Youhan's intent to point up the irreconcilable conflict between these two officially approved styles. He notes, for example, that Socialist Realism, because it remains an intractably Western product, tends to involve the Westernization of Chinese figures. The intrusive blonde girl of the title has a specific significance. Simply because she *is* blonde, she is intended to be read as an emblem of this involuntary Westernization. Mao's benevolent image, borrowed from the inescapable portraits of the Chinese leader which dominated Chinese art during the Cultural Revolution, is juxtaposed with this example of exotica in a deliberately sarcastic way.

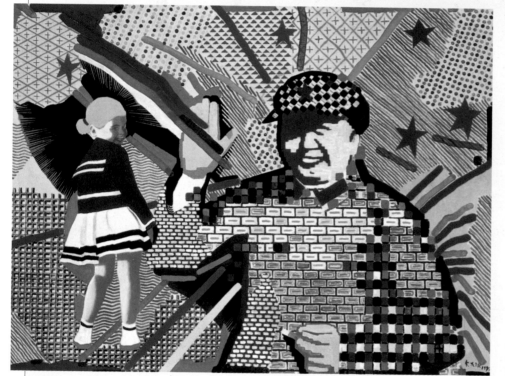

11.7 Yu Youhan, *Mao and Blonde Girl Analyzed*, 1992. Acrylic on canvas, 33⅞ x 45¼ in (86 x 115 cm). Marlborough Fine Art, London.

ket economy. Under Mao, and especially under the Red Guards of the period of the Cultural Revolution, artists were often fiercely persecuted. The old "scholar painting," made with brush and ink, was disapproved of, as was any kind of art which showed Modernist, therefore Western, influence. Only two kinds of art were permitted—the most stringent kind of Socialist Realism, and art of a naively cheerful variety, produced collectively in peasant communes. The new Chinese art regards these peasant paintings with smiling irony, as can be seen in the work of Yu Youhan (1943–)(see FIG. 11.7).

New African Painting

New African art is less sophisticated than its Far Eastern equivalent, but here too, the fact that it offers a painted surface has an ideological significance. Paintings are associated with the West, carvings with traditional Africa.

African painting takes two forms. The first and at the moment somewhat better-known variety is rooted in the new African cities and in African commercial

11.8 Chéri Samba, *Calvary*, 1992. Acrylic on canvas, 35 x 45⅝ in (89 x 116 cm). Annina Nosei Gallery, New York.

Chéri Samba's highly political narrative paintings are rooted in newspaper cartoons and hand-painted advertising signs.

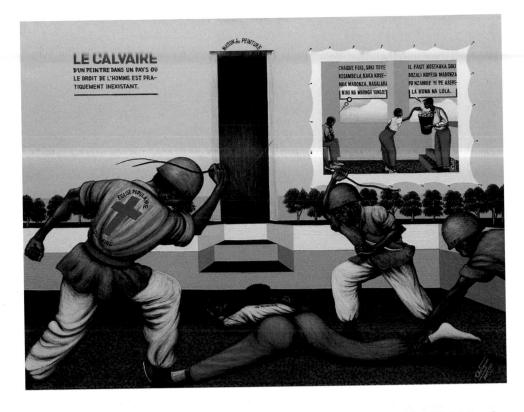

11.9 Cyprien Tokoudagba, *Daguessbu '92*, 1992. Acrylic on canvas, 4 ft 11 in x 7 ft 11⅝ in (1.50 x 2.43 m). Jean Pigozzi Collection.

Tokoudagba's symbols originally appeared on the walls of buildings devoted to African religious cults.

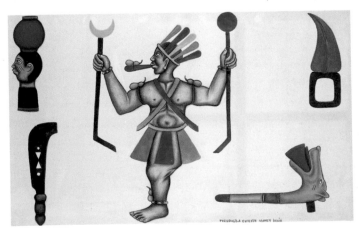
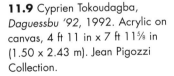

life. The most celebrated exponent of this style is the Zairean artist, Chéri Samba (1956–) (FIG. 11.8). Like the majority of contemporary African artists, he is without formal training. Born in a village in Lower Zaire, he arrived in the capital, Kinshasa, in 1972. Once there, he found employment in a studio which made hand-painted advertising signboards, later setting up on his own in the same line of business, while at the same time drawing strip cartoons for a local newspaper. In 1975, he began to transfer these cartoons to canvas. His paintings are vehicles for outspoken social commentary, and have little to do with traditional African ways of making imagery. They are, nevertheless, profoundly African in their humor, their outspokenness, and their gift for story-telling.

The continuing strength of African religion manifests itself, by contrast, in the paintings of the Benin artist, Cyprien Tokoudagba (1954–), who produces murals for voodoo buildings. His paintings on canvas are an offshoot of these murals. At first glance, the forms may not seem profoundly African, especially to a Western observer, but their meaning could not be more so. Though in a Western format, the paintings are a direct expression of an impeccably traditional aspect of African life (FIG. 11.9).

Australian Aboriginal Art

Much the same thing can be said about the numerous paintings in acrylic on canvas now being produced by Aboriginal artists in the Australian outback, largely for Western markets. The original impulse toward the creation of this new art came from Europeans looking for ways to provide a better life for the Aborigines—in material terms, as well as a renewed sense of tribal identity. The first Aboriginal paintings, as we would now recognize them, were murals made in 1971 for a school at the Aboriginal settlement of Papunya, under the influence of a European art teacher. The painters who made these went on to produce portable paintings for

11.10 Clifford Tjapaltjarri, *Possum Man's Dreaming*, 1992. Acrylic on canvas, 31⅞ x 50 in (81 x 127 cm). Corbally Stourton Contemporary Art, London.

Australian Aboriginal art offers coded maps of tribal ancestry which, by chance, sit comfortably with Western perceptions of what abstract painting ought to be like.

11.11 (*below*) Robyn Kakuhiwa, *Ko Hineteiwaiwa, Ko Hinekorako Ko Rona Whakamau tai*, 1993. Oil, alkyol oil, enamel, and oil stick on loose canvas, 9 ft 10⅛ in x 6 ft 7¾ in (3 x 2.03 m). Museum of New Zealand.

Robyn Kakuhiwa uses Maori imagery in her paintings. Here the influence of Maori woodcarving is strong in the central figures and in the woman's pendant. The artist says that the painting is about "recovering our spirituality—i.e. traditional Maori religion."

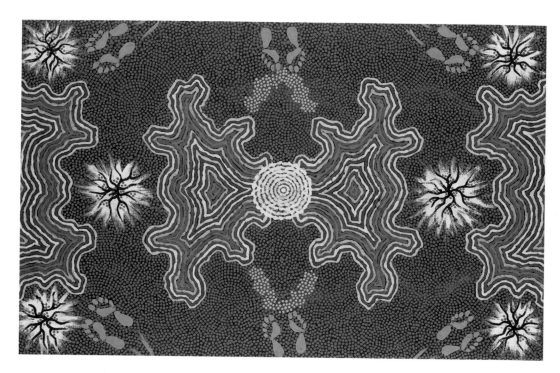

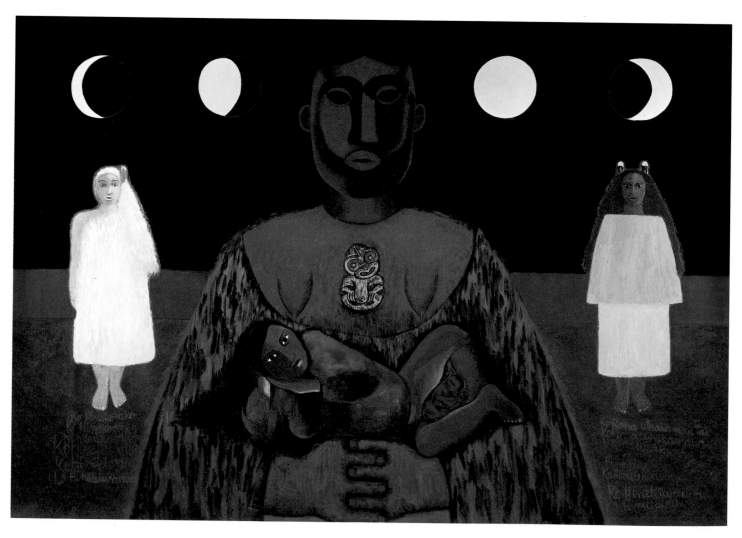

sale, first on small boards, later on canvas, and on a considerably larger scale.

Contemporary Aboriginal paintings derive from the concept of Dreamings, which is central to Aboriginal culture (FIG. 11.10). From Dreamings, which are heritable myths, passed down among families and related groups, stemmed rock paintings, ephemeral ground paintings, and the designs painted on participants' own bodies as part of tribal ceremonies. The representations, which serve as maps as well as mythical narratives, are heavily coded in their original forms, and they have been further coded in the paintings made for sale to outsiders. The resulting works, with their distinctive "dot" style, match Western preconceptions concerning abstract art, but do not necessarily pursue the same agenda. Their congruity with Western culture is a happy accident.

Modern Maori Painting

It is worth contrasting the work of Australian Aboriginal artists with the work of contemporary Maori artists in New Zealand, such as Robyn Kakuhiwa (1940–). Here traditional images, found in Maori carvings, are transferred directly to paintings in Western formats. An example is Kakuhiwa's *Ko Hineteiwaiwa*, in which the central group of mother and child is influenced by the relief carvings one might find on a Maori meeting-house (FIG. 11.11). One untraditional element, however, is the gender of the artist—female, whereas Maori carvings are always the work of men. Her paintings, however, serve the same basic purpose as the Chinese, African, and Aboriginal works already discussed. They are bearers of messages from one culture to another, and their relatively simple and portable physical form—pigment on canvas—is part of their effectiveness.

Sculpture, Environmental Works, and Video

Louise Bourgeois

At a period when traditional forms of sculptural expression were being increasingly thrust to the margin, one veteran sculptor attracted an enormous amount of attention. This was the Franco-American, Louise Bourgeois (1911–), selected in her eighties to be the American representative in the Venice Biennale of 1993. Like many women artists—Agnes Martin is another case in point—Bourgeois won widespread recognition so slowly that her work is difficult to place in its correct historical context. She also describes herself as a "lone wolf," who has never been a joiner of artistic movements. Though she knew the leading members of the Surrealist movement in Paris during the interwar years, she did not mingle with them, as she regarded them as being too self-important and too much interested in self-promotion. Her work, unlike that of male sculptors of the same generation, has never had a consistent stylistic language—she has always been more interested in what she was trying to say than in the way of saying it.

Bourgeois's essential subject matter is entirely personal. "My memories, my sculpture, relate to my life before I married, before I came to America:"[3] She explores and re-explores the consequences of wounds inflicted on her in childhood—by her philandering father and by the hated English governess who was her father's mistress. "My mind, as an artist, was conditioned by that affair, by my jealousy of that dreadful intruder."[4]

Essentially her sculptures are dramatic emblems that represent her psychological states. Her most recent work, made in the 1990s, is ambitious in scale and often quasi-environmental, therefore very much in step with that done by much

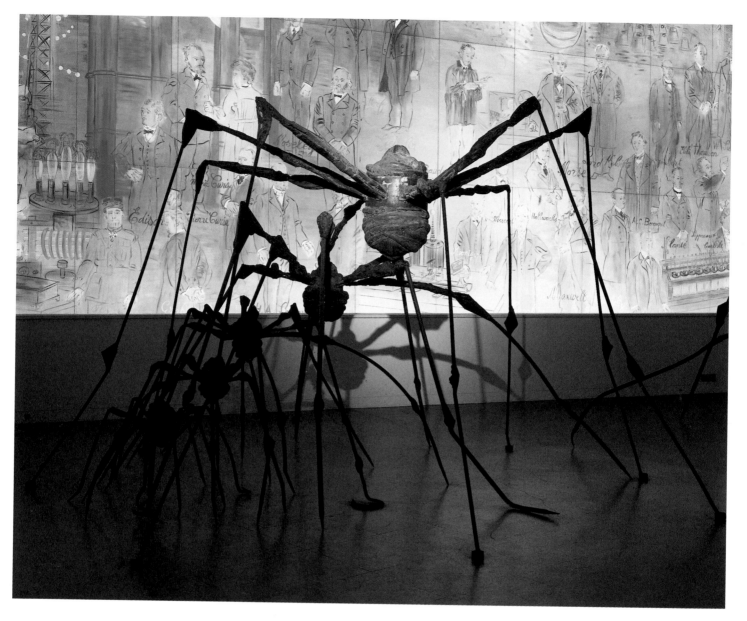

11.12 Louise Bourgeois, *The Nest*, 1994. Steel, 8 ft 5 in x 15 ft 9 in x 13 ft 2 in (2.64 x 4.80 x 4.01 m). Robert Miller Gallery, New York.

younger artists (FIG. 11.12). This is one reason for placing her at the end of this text. Too self-absorbed to summarize the whole spirit of the decade, she nevertheless represents an important aspect of what has happened to art in the concluding years of the century—if it avoided the moralistic tone of many "politically correct" artworks, it was forced back on the purely autobiographical.

Rebecca Horn

Something similar can be said about the sculptures, films, and environmental works of the German artist Rebecca Horn (1944–), which combine features reminiscent of both Magdalena Abakanowicz (see FIG. 9.37) and Louise Bourgeois with others that are purely personal (FIG. 11.13). Though her major international celebrity belongs to the late 1980s and the 1990s, Horn had already begun to establish herself in the 1970s. What she was then making were artworks that were also costumes—the link to Abakanowicz is self-evident. These costumes became the generative element in a series of films. The films, in turn, led to environmental work and to mechanized sculptures, which are strongly expressive of personal feeling. Horn seems to regard them both as extensions of herself and as independent beings. She says, for example: "The tragic and melancholic aspect of

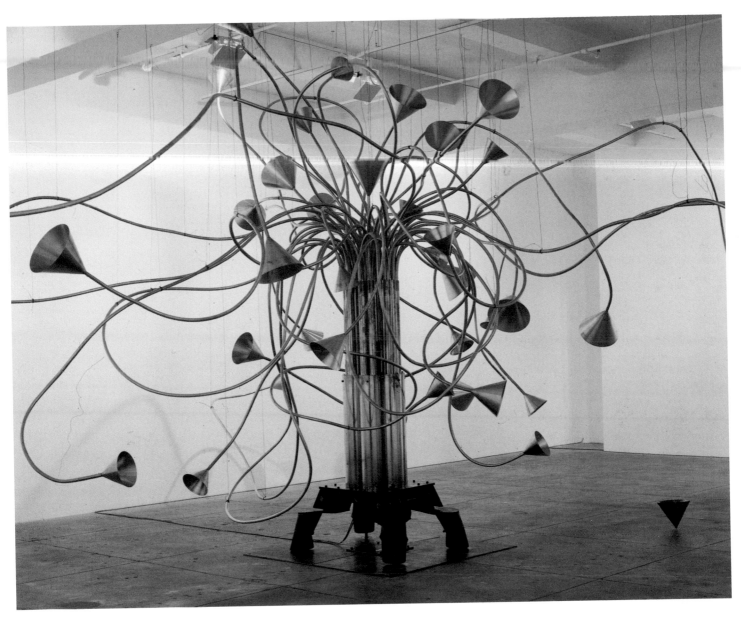

11.13 Rebecca Horn, *The Turtle Sighing Tree*, 1994. Copper, steel, motors, steel wire, audio, 14 x 27 x 31 ft (4.27 x 8.23 x 9.45 m). Marian Goodman Gallery, New York.

machines is very important to me. I don't want them to run forever. It's part of their life that they stop and faint."[5] What she doesn't add is that the machines, as well as being melancholic, often have a strongly threatening, even sometimes a sadistic aspect—rifles that shoot colored liquids, or grand pianos suspended above the spectator's head that suddenly burst open and threaten to shed their viscera. There are also kinetic works adorned with the wings of dead butterflies. These, as they flutter, emanate an unsettling cruelty that may not be what the artist intends. As with Louise Bourgeois, the work seems to offer glimpses of obsessions that have escaped the artist's control.

Artists' Video

Something that makes Horn seem more typical of the 1990s than of any earlier decade is her expertise with film. One of the most typical forms of avant-garde visual expression in the early 1990s has been artists' video, generally placed in an elaborate environmental setting. Some video-pieces are openly political and polemical, in the same fashion as the "guerilla television" of the early days of video. Dara Birnbaum's *Tiananmen Square: Break in Transmission*, for example, is an attempt to look at the role of the news media in the Chinese student uprisings in

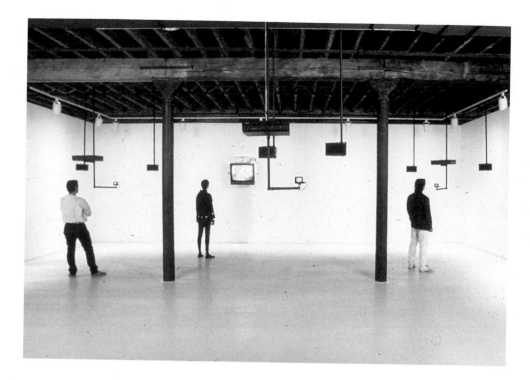

Peking, using video footage which had not been transmitted to the world, as well as images seen by millions (FIG. 11.14).

More commonly, artists' video takes on a quasi-mystical tinge. Perhaps the best example is the work of Bill Viola (1951–). Viola describes video as "a means by which to contemplate reality, and to enter at the same time a world concealed by that reality".[6] *To Pray Without Ceasing* (FIG. 11.15) is a good example of the transcendental strain to be found in his work. According to the artist, it serves as:

A contemporary "book of hours" and image vigil to the infinite day, functioning as an unfolding sequence of prayers for the city. A 12-hour cycle of images plays continuously onto a screen mounted in a window facing the street. The images are projected continuously, 24 hours a day, seven days a

Damien Hirst: *The Physical Impossibility of Death in the Mind of Someone Living*

Unlike the sculptors of the earlier years of Modernism, Damien Hirst offers no consistency of style. Different works are so unlike one another visually that the uninformed spectator has no chance of guessing that they are by the same hand. Hirst has, for example, made paintings which are simply rows of different-colored spots, each spot the same size. He has also made wallpieces which are accumulations of objects on shelves, ordered by category—packages and pill-bottles, for instance, or surgical instruments. These have little to do with his best-known creations, which are animals and fish in tanks of formaldehyde.

Hirst's most celebrated work is entitled *The Physical Impossibility of Death in the Mind of Someone Living* (FIG. 11.16). It consists of a dead tiger-shark floating in a tank of preservative fluid. The shark has been balanced and weighted so that it floats in the middle of its tank, just as if it were still alive and swimming in its native element. There are several references here. One is to museum culture, which takes things which were once alive, culturally and socially, and isolates them in glass cases. Another is to the fact of death itself—death, rather than sex, now being the great unmentionable. It is significant in this case that the object isolated is the corpse of what once was a killing machine: the death-dealer is itself mortal. Hirst offers a melancholy, negative riposte to Bill Viola's brand of life-affirming mysticism (see FIG. 11.15).

The only thing which binds Hirst's creations together is his own assertive personality, which has a great fascination for the media. It is symptomatic that when an article about him appeared in the London *Sunday Times* color supplement, it had six photographic portraits of the artist himself, most of them full-page, but contained no illustration of his sculpture or painting.

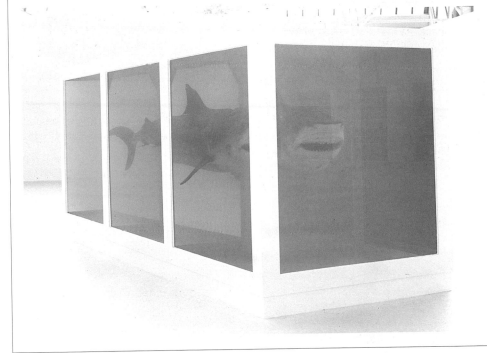

11.16 Damien Hirst, *The Physical Impossibility of Death in the Mind of Someone Living*, 1991. Dead tiger-shark, glass, steel, and 5% formaldehyde solution, 7 x 17 x 7 ft (2.13 x 5.18 x 2.13 m). Saatchi Collection, London.

week. A voice can be heard quietly reciting a text [excerpts from Walt Whitman's "Song of Myself"], audible from speakers mounted above and on each side of the window, interior and exterior.

During the day, sunlight washes out the image and only the voice is present. The video playback is synchronized to the time of day by computer. All images are locked to clock time. The 12 sections or "prayers" in the work vary in length from fifteen minutes to two hours and describe a cycle of individual and universal life.[7]

Damien Hirst and Rachel Whiteread

Video has not been the only medium favoured by installation artists. One British sculptor who has achieved celebrity through the use of extremely unconventional materials is Damien Hirst (1965–) (see FIG. 11.16), widely celebrated as the founder of a new, so-called "Brit-pop" school of art.

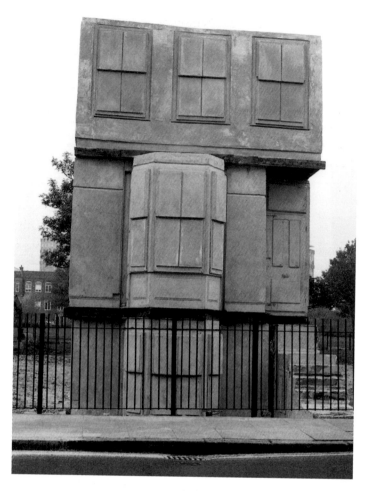

Another artist linked by critics to the Brit-pop school is Rachel Whiteread (1963–), whose *Untitled (House)* (FIG. 11.17) made her almost as talked-about as Damien Hirst. *House* is the most ambitious of a series of works which were casts of negative spaces—the space left under a bed; the volume of a room the artist once occupied. In this case, the piece was the cast of a whole house in the East End of London, scheduled for demolition. According to the artist, the result summed up the memories and feelings of the people who once lived there. Made with temporary planning permission from the local council, the piece was as ephemeral as it was massive. Shortly after its completion, it was destroyed. The consciousness that it was doomed added to a pervasive feeling of melancholy.

Karen Finley

The American performance and installation artist Karen Finley also deals with themes of sorrow and loss, but in a more specific way. Inspired by the plight of the victims of AIDS, her *Memento Mori* is a space for contemplation—a room with a memorial spray of flowers placed on a death bed (FIG. 11.19). The chamber is also filled with loosely piled heaps of sand, which are studded with clusters of lighted candles. Visitors are invited to call up the memory of someone dear to them and now lost, and to write his or her name in the sand before effacing it again. In other installations, Finley has offered a *tableau vivant*, where visitors were shown comforting the suffering. The feeling of melancholy and human tenderness found in these works make a striking contrast to the feminist anger expressed by Finley in some of her performance pieces.

11.17 (*above*) Rachel Whiteread, *Untitled (House)*, 1993. Metal armature and concrete. Grove Road, east London (demolished 1994).

Rachel Whiteread intended this cast of the interior of a London house to act as a memorial to those who had lived their lives in it. The work turns sculpture into a kind of non-human performance art.

Orlan

The 1990s also witnessed a revival of Body Art, notably in the work of the French

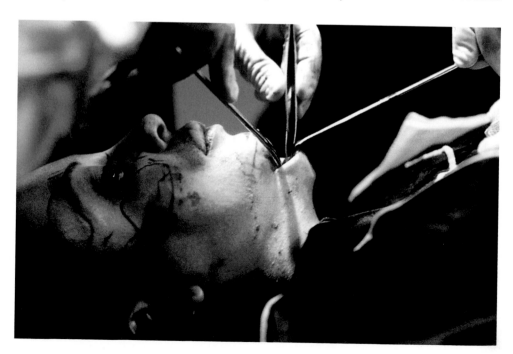

11.18 (*right*) Orlan, *seventh operation/surgical performance*, 21 November 1993, New York.

Orlan has her own body resculptured by plastic surgery to make it conform to the aesthetic ideals found in masterpieces from the past, such as Botticelli's *Birth of Venus*.

performance artist, Orlan (1947–). From the beginning of the 1990s, she has steadily been reshaping her face and body through plastic surgery, selecting desirable features from famous masterpieces of Renaissance and later art (FIG. 11.18). She has, for instance, endowed herself with the forehead of Leonardo's *Mona Lisa* and the chin of Botticelli's *Venus*. The operations are choreographed by the artist as public performances, with musical accompaniment, poetry, and dance. The artist herself directs them, since the surgery is performed under local anaesthetic only, using an epidural block. The sado-masochistic undertone of much of the avant-garde art of the 1990s is here married to a form of "appropriation."

Yukinori Yanagi and Wenda Gu

Far Eastern artists have also been eager makers of installations. The distinguishing mark of what they do, as opposed to their Western counterparts, seems to be

11.19 (*above*) Karen Finley, *Memento Mori* (detail) 1991–3. Mixed media, dimensions variable. Last shown at the Walker Arts Center, Minneapolis, MN.

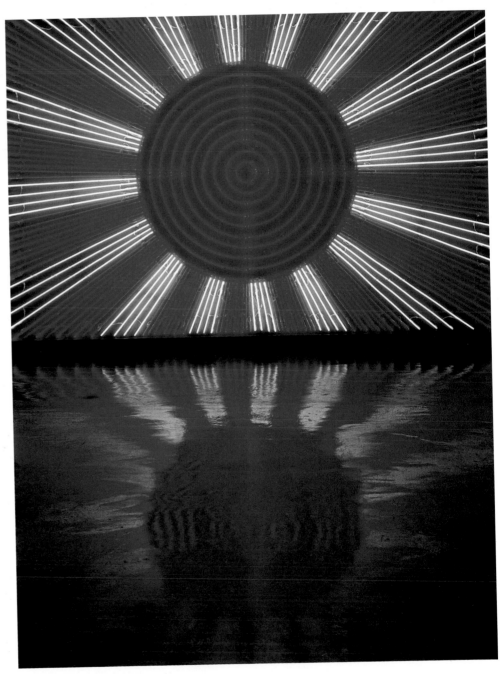

11.20 (*right*) Yukinori Yanagi, *Hinomaru Illumination*, 1992. Neon and painted steel, 9 ft 10⅛ in x 14 ft 9⅛ x 15¾ in (300 x 450 x 40 cm). The Museum of Art, Kochi, Japan.

Here a contemporary Japanese artist offers a comment on her country's nationalism.

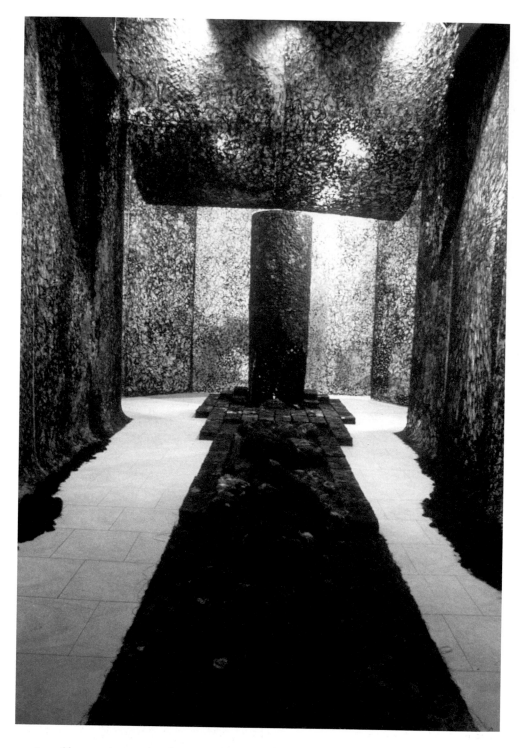

11.21 Wenda Gu, *United Nations, Italian Division: God and Children,* 1993–2000. Installation: Italian hair bricks, curtain walls, and carpets. Enrico Gariboldi Art Contemporanea, Milan, Italy.

The Chinese artist Wenda Gu attempts to capture national identity through ambitious installations made of human hair.

acute self-consciousness about their historical position, as people who are participants in Western culture, but who still remain somewhat apart from it. Sometimes they make direct national references, as the Japanese artist, Yukinori Yanagi (1958–), has done in a series of works devoted to the myth of the Japanese flag (FIG. 11.20). Sometimes, like the emigré Chinese artist, Wenda Gu (1955–), now living in New York, they embark on ambitious international projects. Gu's ongoing *United Nations* (FIG. 11.21) envisages the construction of a giant wall, composed of two thousand oversized bricks made entirely of human hair, to be completed early in the next millennium. In an unpublished thesis, the artist notes:

By utilizing the real hair of the local living population, I'm strongly relating

to their historical and cultural contexts, to create monumental installations and land arts to capture each country's identity, building on profound events in each country's history.[8]

A number of "divisions" of this project—the term is the artist's—have already been completed. They include the Dutch (1994) and the Jewish (1995).

In one sense, Wenda Gu's project, with its all-embracing ambition, relates to European Romanticism—to ideas inherited by the Modernists from the culture of the late eighteenth and early nineteenth centuries. In another sense, it is linked, as he himself points out, to "growing self-awareness of regionalism and otherness."[9] It thus typifies the tensions and deep divisions to be found in the most characteristic artistic expressions of the early 1990s.

Photography

Andres Serrano

The link to the epoch of *Sturm und Drang* ("Storm and Stress") is also visible in the work of the photographer, Andres Serrano (1950–). Serrano's work is symptomatic of several things. One is the way in which photography itself, as a method of image-making, has come to assume equal rank with other, more traditional procedures. Another is the link between photography and Conceptual Art. Serrano, we are told, "regards photography as a false reality, a reality forged and directed by the artist."[10] Yet there is also a link with a relatively remote, supposedly pre-Modern past. Serrano's *The Morgue* (FIG. 11.22), a series of close-ups of details of dead bodies, has a close and not accidental resemblance to the celebrated still lives of piled-up severed body-parts painted in the opening years of the nineteenth century by the Romantic master, Théodore Géricault. The Romantic fascination with death, the desire to make the viewer shudder, is as clearly visible here as in the work of Géricault and some of his contemporaries.

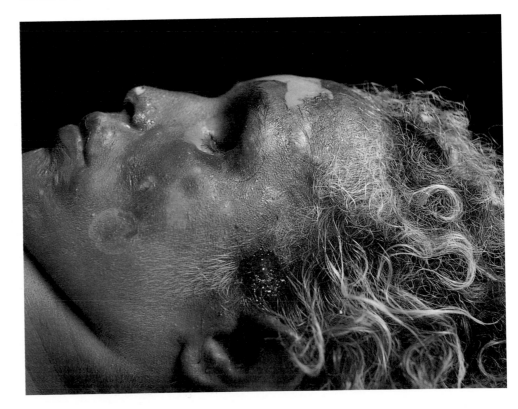

11.22 Andres Serrano, *The Morgue (Jane Doe Killed by the Police)*, 1992. Edition of three. Cibachrome, silicone, plexiglass, wood frame, 4 ft 1½ in x 5 ft (1.28 x 1.52 m). Paula Cooper Gallery, New York.

Serrano's photographs of body parts can be compared to the still-life paintings of fragments of dead bodies made by Théodore Géricault in the early nineteenth century. They emphasize the continuing link between contemporary avant-garde art and the Romantic movement.

At the Millennium

Art has changed a great deal in the years since 1900, or, more accurately, in the time that has passed since the appearance of the Symbolist movement, the immediate ancestor of twentieth-century Modernism, in the 1880s. Basically these changes embrace three things. One is the institutionalization of the avant-garde. Comparisons are still carelessly made between, say, the situation of the Impressionists in the early 1870s and that of supposedly experimental artists today. It is worth emphasizing one significant difference. The Impressionists were completely dependent on private patronage. They gained entry into the official world very late. Any so-called avant-gardist today is almost wholly dependent on official patronage. Even supposedly "alternative" spaces exist thanks to government or foundation money. The avant-garde is inside, not outside, the system.

The reader may ask, quite reasonably, why it is, then, that the activities of experimental artists still meet with such resistance from large sections of the public and from an almost equally substantial segment of the press (though this phenomenon is perhaps more pronounced in Great Britain than in either the United States or continental Europe). The answer is that we have a split society, economically and culturally, and the elitism of the avant-garde and its supporters offers a reflection of this. The art world, from the 1960s onwards, has made periodic raids on the resources of mass, or popular culture, but, despite all claims to the contrary, has never been fully populist—not even in the heyday of Pop Art in the first half of the 1960s.

There has been, nevertheless, a slow process of change, which has progressed further than many commentators on art have cared to notice. With the rapid expansion of the museum system (between 1950 and 1987, for example, the number of art museums in the United States increased from 100 to 542), art has more and more come to be seen, subliminally at least, as part of a system of entertainment which also embraces other media—the theater, the cinema, television. A news report in the London *Sunday Times* for 26 November, 1995, notes, concerning an installation at the Serpentine Gallery (an official gallery run by a trust under the aegis of the Arts Council of England): "The idea was to create an experience, like going to a football match or a musical concert, rather than something lasting, and the whole thing was dismantled after the show."[11]

From this stem a number of other consequences which have also been too little examined. The theater is notoriously an art of mixed materials, not simply mixed forms, and one striking characteristic of the development of art in the twentieth century is that artists have embraced more and more ways of actually making art, employing the newest technology as it became available to them, but also making use of "humble" materials, the detritus of ordinary living, which would formerly have been considered quite unsuitable for the purpose to which they are now put. Two things have followed: first, a rapid breakdown of the distinction between the "fine" and the "applied" arts established under the Renaissance, and, secondly, an increasing impatience with the idea of durability, even in circumstances in which a work is not due to be immediately dismantled at the conclusion of a particular period. The notion of the work of art as a permanent monument or memorial, in the manner of an ancient Egyptian statue, seems to be on its way out. The fact that the technology which enraptures many artists is itself so rapidly outdated seems to reinforce this attitude. Even where more traditional activities are concerned, such as the use of paint on canvas, the technical tradition has been disrupted to the point where the lifespan of the result is increasingly uncertain.

In other respects, however, Western art has been returning to roots in the pre-

Modern era. As has already been pointed out, much of the most recent art is didactic, moralistic, symbolic, and allegorical—though not necessarily all four of these things simultaneously. In this it contrasts with the independent exploration of form and color which was one of the major preoccupations of Modernism in the first half of the century. This moral element is one of the things which has opened the door to art that expresses minority viewpoints, which has recently become such a preoccupation with the institutions which nurture supposedly experimental art.

If art supplies a means for minorities, both ethnic and other, to make themselves heard within and through the official structures of cultural support, it has also become an important medium of cultural exchange—that is, it has become one of the major means through which the new multi-culturalism expresses itself. This development, made inevitable by the range, rapidity, and sophistication of modern communication systems, raises awkward questions about Modernism's past, especially about its predatory or piratical attitudes toward the art produced by non-Western cultures, and about the contempt current among Western artists and critics, at least until comparatively recently, when the borrowing went the other way, and non-Westerners tried to avail themselves of the inventions made by modern art. These questions are still to be resolved.

The main lesson which seems to emerge from a study of the whole span of twentieth-century art is that art is not a fixed quantity, immutably itself, despite stylistic changes. It is, instead, simply another variable within an extremely complex system of aesthetic, social, economic, and even, from time to time, strictly political variables. At the moment, it has moved a long way from the position it occupied in the year 1900.

Notes

Introduction

1. Robert Storr, "An Interview with Ilya Kabakov," *Art in America*, January 1995, p. 67.

Chapter 1

1. Karl Marx and Friedrich Engels, *Collected Works*, vol. 6, London, 1976, p. 489.

2. Robert Twombly, *Louis Sullivan: His Life and Work*, Chicago, 1986, p. 132.

3. Louis Sullivan, "The Tall Office Building Artistically Considered," *Lippincott's Magazine*, March 1896.

4. Frank Lloyd Wright, *An Autobiography* New York, 1943, p. 110.

5. Marc de Montifaud, "Le Salon de 1874," *L'Artiste*, 1 May, 1874.

6. Quoted in J.P. Hodin, *Edvard Munch* (2nd edn), London, 1985, p. 12.

7. Maurice Denis, "De Gauguin et de Van Gogh au classicisme," *L'Occident*, May 1909.

8. Ruth Butler, *Rodin: The Shape of Genius*, New Haven, CT, and London, 1993, p. 181.

9. Helmut and Alison Gernsheim, *The History of Photography*, New York, 1969, pp. 424–5.

Chapter 2

1. Quoted in David P. Handlin, *American Architecture*, London and New York, 1985, p. 132.

2. Werner Haftmann, *Painting in the Twentieth Century*, vol. 1 (2nd edn), London, 1965, p. 55.

3. Quoted in Marcel Giry, *Fauvism: Origins and Development*, New York and London, 1982, p. 104.

4. H. Matisse, *Ecrits et propos sur l'art* (ed. D. Forcade), Paris, 1972, p. 55.

5. John Golding, *Cubism: A History and an Analysis, 1907–1914* (3rd revised edn), London, 1984, p. xiii.

6. Quoted in Douglas Cooper, *The Cubist Epoch*, London, 1971, p. 32.

7. G. Apollinaire, *Les Peintres Cubistes: Meditations Aesthetiques*, Paris, 1913, p. 11.

8. P. Modersohn-Becker, *Letters and Journals*, Metuchen, NJ, 1980, p. 311.

9. Ibid., p. 259. Letter to Otto Modersohn, 23 February 1905.

10. Donald E. Gordon, *Expressionism: Art and Idea*, New Haven, CT, and London, 1987, p. 71.

Chapter 3

1. Antonio Sant'Elia, "Messaggio," in Kenneth Frampton, *Modern Architecture: A Critical History* (3rd revised edn), London and New York, 1992, pp. 87–8. The "Messaggio" was written for the Nuovo Tendenze exhibition of 1914.

2. Quoted in ibid., p. 92.

3. Golding, op. cit., p. 14.

4. Harold Osborne (ed.), *The Oxford Companion to Twentieth Century Art*, Oxford and New York, 1981, p. 392.

5. Quoted in Camilla Gray, *The Great Experiment: Russian Art 1863–1922*, London, 1962, p. 193.

6. Hans Arp, "Dadaland," in Hans Arp, Richard Havelsenbeck et al., *Die Geburt des Dada*, Zurich, 1955, p. 107.

7. Quoted in Uwe M. Schneede, *George Grosz: His Life and Work*, London, 1979, p. 38.

8. Quoted in Haftmann, op. cit., vol. 1, p. 175.

9. *Seven Arts* (11), 1917, pp. 524–5.

Chapter 4

1. Quoted in Frampton, *op. cit.*, p. 153.

2. Quoted in Lowry Stokes Sims, *Stuart Davis: American Painter*, New York, 1991, p. 5.

3. The title alludes to Ingres's passion for music, a hobby the French Neoclassical painter practiced at almost professional level.

Chapter 5

1. José Clemente Orozcó, *Textos de Orozco*, Mexico City, 1955, p. 8.

2. Quoted in Dawn Ades, *Salvador Dalí*, London, 1982, p. 109.

3. Henri Cartier-Bresson, *The World of Henri Cartier-Bresson*, London, 1968.

Chapter 6

1. Quoted in Irving Sandler, *Abstract Expressionism: The Triumph of American Painting*, London, 1970, pp. 52–4.

2. Quoted in ibid., p. 64.

3. Quoted in ibid., p. 162.

4. Quoted in Frances Morris, *Paris Post-War: Art and Existentialism*, London, 1993, p. 89.

5. Quoted in ibid., p. 90.

6. Cobra Manifesto, signed Constant Nieuwenhuys, reproduced in Willemijn Stokvis, *Cobra*, New York, 1988, p. 31.

7. Quoted in Duncan Robinson, *Stanley Spencer*, Oxford, 1990, p. 100.

8. Quoted in Hayden Herrera, *Frida Kahlo: The Paintings*, London, 1991, p. 10.

9. Jo Gibbs, "Attenuated Beauty," *Art Digest*, 1 February 1948.

10. Quoted in Morris, op. cit., p. 161.

11. Quoted in Sam Hunter, *Marino Marini: The Sculpture*, New York, 1993, p. 23. The interview was conducted by Edward Roditi.

12. Jane Livingston, *Lee Miller: Photographer*, London, 1989, p. 82.

13. Edward Carpenter, *Angel's Wings* (7th edn), London, 1923, p. 97.

Chapter 7

1. David Spaeth, *Mies van der Rohe*. London, 1985, p. 87.

2. Lewis Mumford, "Skyline: The Lesson of the Master," *New Yorker*, 13 September 1958, p. 148.

3. Deborah Gans, *The Le Corbusier Guide*, Princeton, NJ, 1987, p. 167.

4. *Chandingarh Forty Years After Le Corbusier* (ANQ Documents) Amsterdam, 1992, p. 29.

5. Ibid., p. 67. Interview with Madhu Sarin.

6. Quoted in Gans, op. cit., p. 76.

7. Quoted in David Gilson De Long, *The Architecture of Bruce Goff*, vol. 1, New York and London, 1977, p. 266.

8. Haftmann, op. cit. vol. 1, p. 369.

9. Selden Rodman, *Conversations with Artists*, New York, 1957, p. 93.

10. Judith E. Bernstock, *Joan Mitchell*, New York, 1988, p. 39.

11. Larry Rivers, "A Discussion of the Work of Larry Rivers," *Art News*, March 1961, pp. 44–6, 53–55. The reference is presumably to Duchamp's *Fountain*, though this too appears to have been directed more against the prejudices of fellow artists than against those of the public at large.

12. Quoted in Claude Marks, *World Artists: 1950–1980*, New York, 1984, p. 125.

13. See Berger in the *New Statesman and Nation*, 19 January 1952.

14. Quoted in Barbara Bertozzi and Klaus Wolbert, *Gutai*, Darmstadt, 1991, p. 113.

15. *The Family of Man*, catalogue of the exhibition held at the Museum of Modern Art, New York, 1955. The exhibition setting was designed by Paul Rudolph.

16. Arthur Goldsmith, in a spectrum of reactions printed by the magazine, *Popular Photography*, and reprinted in the exhibition catalogue, *Robert Frank: New York to Nova Scotia*, Museum of Fine Arts, Houston, 1986, pp. 36–7.

Chapter 8

1. William J.R. Curtis, *Modern Architecture since 1900*, Oxford, 1982, p. 322.

2. Andy Warhol, catalogue of an exhibition at the Institute of Contemporary Art, University of Pennsylvania, 1965.

3. John Arthur, *Realists at Work*, New York, 1983, p. 41.

4. Ibid., p. 43.

5. The artist quoted in Linda Chase, *Ralph Goings*, New York, 1988, p. 20.

6. Andreas Franzke, *Georg Baselitz*, Munich, 1991, p. 21.

7. Robert Hughes, *Frank Auerbach*, London, 1989, p. 86.

8. Quoted in Pierre Descargues, *Yves Klein* (catalogue of a retrospective exhibition held at the Jewish Museum), New York, 1967, p. 18.

9. Quoted in Barbara Rose, *American Art Since 1900*, New York and London, 1967, p. 234.

10. *Tony Smith: Two Exhibitions of Sculpture* (Catalogue of exhibition at the Wadsworth Atheneum, Hartford, CT, and the Institute of Contemporary Art, University of Pennsylvania) 1966–07.

11. William C. Seitz, *George Segal*, London, 1972, p. 16.

12. Draft of an essay/manifesto by George Maciunas, dated 1962, in Clive Philpot and Jon Hendricks, *Fluxus*, New York, 1988, p. 26.

13. Naomi Rosenblum, *A World History of Photography* (revised edn), New York, 1989, p. 518.

Chapter 9

1. Alexander Tzonis and Liane Lefaivre, *Architecture in Europe Since 1968*, London, 1992, p. 44.

2. Ibid., p. 61.

3. Charles Jencks, *Post-Modernism: The New Classicism in Art and Architecture*, London, 1987, p. 285.

4. Frank Gehry and others, *The Architecture of Frank Gehry*, Minneapolis, 1986, p. 32.

5. See Joan Simon, *Susan Rothenberg*, New York, 1991, pp. 27–31.

6. Edmund Barry Gaither, *Afro-American Artists*, Boston, 1970, pp. 3–4.

7. Interview with Lucio Amelio in Lynne Cooke, *Joseph Beuys: Arena—where would I have got if I had been intelligent!*, New York, 1994, p. 37.

8. Ibid., p. 15.

9. Quoted in Coosje van Bruggen, *Bruce Nauman*, New York, 1988, p. 7.

10. *Newsday*, 9 April, 1971, p. 15A.

11. Quoted in Jan Butterfield, *The Art of Light and Space*, New York, 1993, p. 85.

12. Ibid., p. 75.

13. Quoted in Osborne, op. cit., p. 25.

14. Lucy R. Lippard, Foreword to Mary Kelly, *Post-Partum Document*, London, 1983, p. x

15. Michael Brenson, "Magdalena Abakanowicz's 'Abakans'" in *Art Journal*, vol. 54, no. 1, 1994, p.59.

16. See Frank Popper, *Art of the Electronic Age*, London, 1993.

17. Colin Westerbeck, quoted in Sarah Greenough et al., *On the Art of Fixing a Shadow: One Hundred and Fifty Years of Photography*, Washington D.C. and Chicago, 1989, p. 375.

Chapter 10

1. Olivier Boissière, *Jean Nouvel*, Zurich, 1992, p. 19.

2. K.V. Wheeler, P. Arnell, and T. Bickford (eds), *Michael Graves: Buildings and Projects 1966–1981*, New York, 1982, p. 11ff.

3. Les Krantz, *American Architects: A Survey of Award-Winning Contemporaries and their Notable Works*, New York and Oxford, 1989, p. 71.

4. Shirley Nielsen Blum, "The National Vietnam War Memorial," *Arts Magazine*, December 1984, p. 125

5. Jeff Koons, *The Jeff Koons Handbook*, London, 1992, p. 15.

6. Quoted in Matthew Cullerne Bown, *Contemporary Russian Art*, Oxford, 1989, pp. 78–81.

7. Joel-Peter Witkin, "Revolt Against the Mystical," in Germano Celant, *Witkin*, Zurich, Berlin, and New York, 1995, p. 53.

8. Ibid., p. 20.

Chapter 11

1. Brochure issued by the Tourist Office, Groningen.

2. Jan A. Wolff, in Muriel Emanuel (ed.), *Contemporary Architects* (3rd edn), London, 1994, p. 407.

3. Paul Gardiner, *Louis Bourgeois*, New York, 1994, p. 27.

4. Op. cit., p. 19.

5. Quoted in Stuart Morgan, *Rebecca Horn* (exh. cat.), Guggenheim Museum, New York, 1993, p. 27.

6. Quoted in Marie Luise Syring, "The Way of Transcendence: On the Temptation of St. Anthony," in Marie Luise Syring (Bill Viola, ed.), *Unseen Images*, London, 1992, p. 21.

7. Ibid.

8. Wenda Gu, *The Divine Comedy of Our Times* (unpublished thesis), New York, 1995.

9. Ibid.

10. *Identity and Alterity: Figures of the Body* (catalogue of the 46th Venice Biennale), 1995, p. 579.

11. Report by John Davison in the *Sunday Times*, 26 November 1995, p. 5.

Bibliography

General

Ades, Dawn et al, *Art in Latin America: The Modern Era: 1820–1980* (exh. cat.), Hayward Gallery, London, 1989.

Andel, Jaroslav et al., *Russian Constructivism: Art into Life 1914–1932*, New York, 1990

Antliff, Mark, *Inventing Bergson: Cultural Politics and the Parisian Avant-Garde*, Princeton, NJ, 1992

Art in the San Francisco Bay Area, 1945–1980: An Illustrated History, Berkeley, 1985

Baker, Kenneth, *Minimalism: Art of Circumstance*, New York, 1991

Battcock, Gregory, ed., *Idea Art*, New York, 1973

Battcock, Gregory, ed., *Super-Realism*, New York, 1975

Battersby, Christine, *Gender and Genius: Towards a Feminist Aesthetics*, Bloomington and Indianapolis, 1989

Behr, Shulamith, David Fanning and Douglas Jarman, eds, *Expressionism Reassessed*, Manchester and New York, 1983

Black Art: Ancestral Legacy—The African Impulse in African American Art (exh. cat.), Dallas, 1989

Boffin, Tess and Sunil Gupta, *Ecstatic Antibodies: Resisting the AIDS Mythology*, London, 1990

Bonito Oliva, Achille, *Europe–America: The Different Avant-gardes*, Milan, 1976

Bown, Matthew Cullerne, *Contemporary Russian Art*, Oxford, 1989

British Art in the 20th Century: The Modern Movement (exh. cat.), London, 1987

Bronner, Stephen Eric, and Douglas Kenner, eds, *Passion and Rebellion: The Expressionist Heritage*, London, 1983

Broude, Norma, and Mary D. Garrard, eds, *The Power of Feminist Art*, New York and London, 1994

Burgin, Victor, *The End of Art Theory: Criticism and Post-modernity*, Atlantic Highlands, NJ, 1986

Cameron, Dan, *New York Art Now: The Saatchi Collection*, Milan, 1988

Celant, Germano, *Unexpressionism: Art Beyond the Contemporary*, New York, 1988

Chadwick, Whitney, *Women, Art and Society*, London, 1990.

Chase, Linda, *Hyperrealism*, New York, 1975

China's New Art, Post-1989 (exh. cat.) Hanart T Z Gallery, Hong Kong, 1993

Colpitt, Francis, *Minimal Art: The Critical Perspective*, Ann Arbor, 1990

Cooper, Douglas, *The Cubist Epoch*, London, 1971

Cooper, Emmanuel, *The Sexual Perspective: Homosexuality and Art in the Last 100 Years in the West*, London, 1986

Crane, Diana, *The Transformation of the Avant-Garde: The New York Art World, 1940–1985*, Chicago and London, 1987

Dabrowski, Magdalena, *Contrasts of Form: Geometric Abstract Art 1910–1980*, New York 1985

Dachy, Marc, *The Dada Movement: 1915–1923*, New York, 1990

Day, Holliday T. and Hollister Sturges, *Art of the Fantastic: Latin America, 1920–1987* (exh. cat.), Indianapolis Museum of Art, 1987

Deitch, Jeffrey, *Post Human* (exh. cat.), FAE Musée d'Art Contemporain, Pully/Lausanne, 1992

Difference: On Representation and Sexuality (exh. cat.), New Museum of Contemporary Art, New York, 1985

Doubletake: Collective Memory and Current Art (exh. cat.), Hayward Gallery, London, 1992

Dunlop, Ian, *The Shock of the New*, London/New York, 1972

Endgame: Reference and Simulation in Recent Painting and Sculpture (exh. cat.), Institute of Contemporary Arts, Boston, 1986

Fer, Briony, David Batchelor and Paul Wood, *Realism, Rationalism, Surrealism—Art Between the Wars*, New Haven, CT, and London, 1993

Ferguson, Russell, Martha Geyer, Trinh T. Minh-Ha, Cornel West, eds, *Out There: Marginalization and Contemporary Culture*, New York, 1990

Fine, Elsa Honig, *The Afro-American Artist: A Search for Identity*, New York, 1982

Gablik, Suzi, *Has Modernism Failed?* London and New York, 1985

German Art in the 20th Century: Painting and Sculpture, 1905–1985 (exh. cat.), Royal Academy of Arts, London, 1985

Glusberg, Jorge, *Art in Argentina*, Milan, 1986

Golding, John, *Cubism: A History and an Analysis—1907–1914*, 3rd revised edn, London, 1988

Gordon, Donald E., *Expressionism: Art and Idea*, New Haven, CT, and London, 1987

Hertz, Richard, ed., *Theories of Contemporary Art*, Englewood Cliffs, NJ, 1985

Hewison, Robert, *Future Tense: A New Art for the Nineties*, London, 1990

Hewitt, Andrew, *Fascist Modernism*, Stanford, CA, 1993

Hinz, Berthold, *Art in the Third Reich*, New York, 1980

Hobert, Renée Riese, *Magnifying Mirrors: Women, Surrealism and Partnership*, Nebraska and London, 1994

Hughes, Robert, *The Culture of Complaint*, New York and London, 1993

Hulten, Pontus, *Futurism and Futurisms*, London 1990

The Italian Metamorphosis, 1943–1968 (exh. cat.), Guggenheim Museum, New York, 1994

Jencks, Charles, *Post-Modernism: Neo-Classicism in Art and Architecture*, New York, 1987

Joachimides, Christos M., ed., with Norman Rosenthal and Wieland Schmied, *German Art in the 20th Century* (exh. cat.), Royal Academy of Arts/Prestel, London/Munich, 1985

Joachimides, Christos M., and Norman Rosenthal, eds, *American Art in the 20th century* (exh. cat.), Royal Academy of Arts, London, 1993

Kent, Sarah, *Young British Artists* (exh. cat.), Saatchi Collection, London, 1992

Krauss, Rosalind, *The Originality of the Avant-Garde and Other Modernist Myths*, Cambridge, MA, 1986

Kuenzli, Rudolf E., ed., *New York Dada*, New York, 1986

Levin, Kim, *Beyond Modernism: Essays on Art from the '70s and '80s*, New York, 1988

Lippard, Lucy R., *Six Years: The Dematerialization of the Art Object from 1966 to 1972*, New York, 1973

Lippard, Lucy R., *Mixed Blessings: New Art in a Multi-Cultural America*, New York, 1990

Livingstone, Marco, ed., *Pop Art* (exh. cat.), Royal Academy of Arts, London, 1991

Lodder, Christine, *Russian Constructivism*, New Haven, CT, and London 1985

Lucie-Smith, Edward, *Art in the Seventies*, Oxford, 1980

Lucie-Smith, Edward, *American Art Now*, Oxford, 1985

Lucie-Smith, Edward, *Lives of the Great 20th Century Artists*, London, 1986

Lucie-Smith, Edward, *Art in the Eighties*, Oxford, 1990

Lucie-Smith, Edward, *American Realism*, London, 1993

Lucie-Smith, Edward, *Latin American Art of the 20th Century*, London, 1993

Lucie-Smith, Edward, *Race, Sex and Gender in Contemporary Art*, London, 1994

Lucie-Smith, Edward, *Movements in Art since 1945*, revised edn, London, 1995

Lucie-Smith, Edward, *Art Today*, London, 1995

Marinetti, F.T., *Selected Writings*, New York/London, 1972

Meyer, Ursula, ed., *Conceptual Art*, New York, 1972

Moszynska, A., *Abstract Art*, London and New York, 1990

Mount, Marshall W., *African Art—The Years since 1920*, 2nd revised edn, New York, 1989

Munroe, Alexandra, *Japanese Art after 1945: Scream Against the Sky* (exh. cat.), Guggenheim Museum, New York, 1994

Naylor, Gillian, *The Bauhaus Reassessed*, London, 1985

New Art from China: Post–1989 (exh. cat.), Marlborough Fine Art (London) Ltd., London, 1994

Nochlin, Linda, *Women, Art and Power and Other Essays*, London and New York, 1989

Perloff, Marjorie, *The Futurist Movement*, Chicago and London, 1986

Rasmussen, Waldo, *Latin-American Artists of the Twentieth Century* (exh. cat.), Museum of Modern Art, New York, 1993

Raven, Arlene, ed., *Art in the Public Interest*, Ann Arbor, Michigan, 1989

Risatti, Howard, ed., *Postmodern Perspectives: Issues in Contemporary Art*, Englewood Cliffs, NJ, 1990

Rosenberg, Harold, *Art on the Edge*, New York, 1975

Rosenberg, Harold, *Art and Other Serious Matters*, Chicago, 1985

Rosenberg, Harold, *The De-Definition of Art: Action Art to Pop to Earthworks*, New York, 1992

Ross, David A., *Between Spring and Summer: Soviet Conceptual Art in the Era of Late Communism*, Cambridge, MA, 1990

Saltz, Jerry, *Beyond Boundaries: New York's New Art*, New York, 1986

Sandler, Irving, *The New York School: The Painters and Sculptors of the Fifties*, New York, 1979

Shapiro, David, ed., *Social Realism: Art as a Weapon*, New York, 1973

Stokvis, Willemijn, *Cobra: An International Movement in Art after the Second World War*, New York, 1988

Tomkins, Calvin, *Post- to Neo-: The Art World of the 1980s*, New York, 1988

Tufts, Eleanor, *Our Hidden Heritage: Five Centuries of Women Artists*, London, 1974

Vogel, Susan, *Africa Explores: 20th Century African Art* (exh. cat.), Center for African Arts, New York, 1991

Walker, John A., *Art in the Age of the Mass Media*, 2nd revised edn, London, 1994

Wallis, Brian, ed., *Art After Modernism: Rethinking Representation*, New York, 1984

Weinstein, Joan, *The End of Expressionism: Art and the November Revolution in Germany, 1918–1919*, Chicago and London, 1990

Weiss, Jeffrey, *The Popular Culture of Modern Art: Picasso, Duchamp and Avant-Gardism*, New Haven, CT, and London, 1984

Wheeler, Daniel, *Art Since Mid-Century: 1945 to the Present*, New York, 1991

Whitford, Frank, *Bauhaus*, London, 1984

Architecture

Archigram, *A Guide to Archigram 1961–74*, London, 1994

Arnell, Peter, and Ted Bickford, *James Stirling: Buildings and Projects*, New York, 1984

Banham, Reyner, *The New Brutalism: Ethic or Aesthetic*, London, 1966

Boissière, Olivier, *Jean Nouvel*, Zurich, 1992

Botta, Mario, *Mario Botta: Architectures 1980–1990*, Barcelona, 1991

Curtis, William J.R., *Modern Archictecture Since 1900*, Oxford, 1982

De Long, David Gilson, *The Architecture of Bruce Goff*, New York and London, 1987

De Witt, Dennis J. and Elizabeth R. De Witt, *Modern Architecture in Europe: A Guide to Buildings Since the Industrial Revolution*, London, 1987

Gans, Deborah, *The Le Corbusier Guide*, Princeton, NJ, 1987

Isozaki, Arata, *Arata Isozaki: Architecture 1960–1990*, New York, 1991

Jencks, Charles, *The Language of Post-Modern Architecture*, 5th edn, London, 1987

Klotz, Heinrich, *The History of Postmodern Architecture*, Cambridge, MA, and London, 1988

Krantz, Les, *American Architects: A Survey of Award-Winning Contemporaries and their Notable Works*, New York and Oxford, 1989

Loud, Patricia Cummings, *The Art Museums of Louis I. Kahn*, Durham and London, 1989

Meier, Richard, *Richard Meier*, London, 1990

Nichols, Karen Vogel, ed., with Patrick J. Burke and Caroline Hancock, *Michael Graves: Buildings and Projects 1982–1989*, Princeton, NJ, 1990

Pfeiffer, Bruce Brooks, *Frank Lloyd Wright*, Cologne, 1991

Spaeth, David, *Mies van der Rohe*, London, 1985

Sudjic, Deyan, *Norman Foster, Richard Rogers, James Stirling: New Directions in British Architecture*, London, 1986

Tzonis, Alexander and Liane Lefaivre, *Architecture in Europe Since 1968*, London, 1992

Venturi, Robert, Denise Scott Brown and Steven Izenour, *Learning from Las Vegas*, Boston, 1972

Venturi, Robert, *Complexity and Contradiction in Architecture*, New York, 1966

Wigley, Mark, *The Architecture of Deconstruction: Derrida's Haunt*, London and Boston, 1993

Wines, James, and Herbert Muskamp,

SITE, New York, 1989

Zukowsky, John, ed., *Mies Reconsidered: His Career, Legacy and Disciples*, Chicago and New York, 1989

Painting

Arcangeli, Francesco, *Graham Sutherland*, New York, 1975

Arnheim, Rudolf, *The Genesis of a Painting: Picasso's "Guernica,"* 2nd edn, Berkeley, Los Angeles, and London, 1980

Bellonzi, Fortunato, *Sironi*, Milan, 1986

Bernstock, Judith E., *Joan Mitchell*, New York, 1988

Bowlt, John E., *The Quest for Self-Expression: Painting in Moscow and Leningrad 1965–1990* (exh. cat.), Columbus Museum of Art, Columbus, OH, 1990

Brehm, Margrit et al., *Chuck Close: Works 1967–1992*, Stuttgart, 1994

Brooks, Van Wyck, *John Sloan: A Painter's Life*, London, 1955

Bulatov, Eric, *Eric Bulatov: Moscow* (exh. cat.), London, 1989

Castleman, Craig, *Getting Up: Subway Graffiti in New York*, Cambridge, MA, 1982

Chase, Linda, *Ralph Goings*, New York, 1988

Clement, Russell T., *Les Fauves: A Sourcebook*, Westport, CT, and London, 1994

Cockcroft, Eve Spurling and Holly Barnet-Sanchez, *California Chicano Murals*, Venice, CA, 1990

Coen, Ester, *Umberto Boccioni* (exh. cat.), Metropolitan Museum of Art, New York, 1988

Cohen, Jean Lebold, *The New Chinese Painting 1949–1986*, New York, 1987

Coplans, John, *Ellsworth Kelly*, New York, n.d.

Cork, Richard, *David Bomberg*, New Haven, CT, and London, 1987

Corn, Wanda M., *Grant Wood: The Regionalist Vision*, New Haven, CT, and London, 1983

Cowart, Jack, *Roy Lichtenstein, 1970–1980*, New York, 1981

Crichton, Michael, *Jasper Johns*, London, 1994

Davidson, Abraham A., *Early American Modernist Painting, 1910–1935*, New York, 1981

Dunitz, Robin J., *Street Art—Guide to 1000 Los Angeles Murals*, Los Angeles, 1993

Elderfield, John, *Frankenthaler*, New York, 1989

Elderfield, John, *Henri Matisse: A Retrospective* (exh. cat.), Museum of Modern Art, New York, 1992

Flack, Audrey, *On Painting*, New York, 1981

Francis, Richard, *Jasper Johns*, New York, 1984

Franzke, Andreas, *Georg Baselitz*, Munich, 1991

Gaugh, Harry E., *Franz Kline* (exh. cat.), Cincinnati Art Museum/Abbeville, Cincinnati/New York, 1985

Genauer, Emily, *Rufino Tamayo*, New York, 1974

Gilmour, John C., *Fire on the Earth: Anselm Kiefer and the Post Modern World*, Philadelphia, 1990

Giry, Marcel, *Fauvism: Origins and Development*, New York and London, 1982

Godfrey, Tony, *The New Image: Painting in the 1980s*, London, 1986

Goodman, Cynthia, *Hans Hofmann*, Munich, 1980

Gouma-Paterson, Thalia, *Breaking the Rules: Audrey Flack, a Retrospective* (exh. cat.), J.B. Speed Art Museum, Louisville, KY, 1992

Gowing, Lawrence, and Sam Hunter, *Francis Bacon*, London, 1989

Graham-Dixon, Andrew, *Howard Hodgkin*, London, 1994

Graze, Sue, and Kathy Halbreich, *Elizabeth Murray*, Los Angeles, 1987

Gruen, John, *Keith Haring*, Englewood Cliffs, NJ, 1991

Herbert, James D., *Fauve Painting and the Making of Cultural Politics*, New Haven, CT, and London, 1992

Herrera, Hayden, *Frida Kahlo: The Paintings*, London, 1991

Hills, Patricia, *Alice Neel*, New York, 1983

Hobbs, Robert Carelton, and Gail Levin, *Abstract Expressionism: The Formative Years*, Ithaca and London, 1978

Hockney, David, *David Hockney by David Hockney*, London, 1976

Hockney, David, *David Hockney: A Retrospective* (exh. cat.), Los Angeles County Museum of Art, 1988

Hughes, Robert, *Frank Auerbach*, London, 1989

Kingsley, April, *The Turning Point: The Abstract Expressionists and the Transformation of American Art*, New York, 1992

Klein, Yves, *Yves Klein* (exh. cat.), Centre Georges Pompidou, Paris, 1983

Krens, Tomas, ed., with Michael Govan and Joseph Thompson, *Refigured Painting: The German Image 1960–88* (exh. cat.), Guggenheim Museum, New York, 1988

Lampert, Catherine, *Lucian Freud: Recent Work* (exh. cat.), Whitechapel Art Gallery, London; Metropolitan Museum of Art, New York; Museo Nacional Centro Reina Sofia, Madrid, 1993

Lee, Jane, *Derain*, Oxford and New York, 1991

Leja, Michael, *Reframing Abstract Expressionism*, New Haven, CT, and London, 1993

Leonard, Michael, *Paintings*, London, 1985

Levin, Gail, *Edward Hopper—The Art and the Artist*, New York and London, 1981

Leymarie, Jean, ed., *Georges Braque*, New York and Munich, 1988

Lichtenstein, Roy, *Roy Lichtenstein* (exh cat.), Musée d'Art, Lausanne, 1993

Lista, Giovanni, *De Chirico*, London, 1991

Lucie-Smith, Edward, and Celestine Dars, *Work and Struggle*, London and New York, 1977

Lucie-Smith, Edward, Carolyn Cohen and Judith Higgins, *The New British Painting*, Oxford, 1988

Lucie-Smith, Edward, *Jean Rustin*, London, 1991

McEwen, John, *Paula Rego*, London, 1992

McShine, Kynaston, ed., *Andy Warhol: A Retrospective* (exh. cat.), Museum of Modern Art, New York, 1989

Marshall, Richard, *Jean-Michel Basquiat* (exh. cat.), Whitney Museum of American Art, New York, 1992

Martin, Agnes, *Agnes Martin* (exh. cat.), Whitney Museum of American Art, New York, 1992

Mattison, Robert Saltonstall, *Grace Hartigan: A Painter's World*, New York, 1990

Meisel, Louis K., *Photo-Realism*, New York, 1980

Morphet, Richard, et al., *R.B. Kitaj: A Retrospective* (exh. cat.), Tate Gallery, London, 1994

Pacquement, Alfred, *Frank Stella*, Paris, 1988

Paquet, Marcel, *Dubuffet*, Paris, 1993

Percy, Ann and Raymond Foye, *Francesco Clemente: Three Worlds* (exh. cat.), Philadelphia Museum of Art, 1990

Permanyer, Lluis, *Tàpies and the New Culture*, New York, 1986

Poggi, Christine, *In Defiance of Painting: Cubism, Futurism and the Invention of*

Collage, New Haven, CT, and London, 1992

Rand, Harry, *Arshile Gorky: Implications of Symbols*, Montclair, NJ, 1980

Ratcliff, Carter, *Komar & Melamid*, New York, 1988

Restany, Pierre, *Yves Klein*, New York, 1982

Rewald, Sabine, *Balthus*, New York, 1983

Richardson, John, *A Life of Picasso, Vol. 1*, London, 1991

Richter, Gerhard, *Gerhard Richter* (exh. cat.), London, 1991

Riley, Bridget, *Bridget Riley: Works 1959–78* (exh. cat.) Albright-Knox Gallery, Buffalo, NY, 1978

Robinson, Duncan, *Stanley Spencer*, Oxford, 1990

Rubin, William, ed., *Picasso and Braque: Pioneering Cubism*, New York, 1989

Ruscha, Ed, *Edward Ruscha: Paintings* (exh. cat.), Rotterdam, 1985

Russell, Frank D., *Picasso's "Guernica": The Labyrinth of Narrative and Vision*, London, 1980

Russian Painting of the Avant-Garde: 1906–1924, Edinburgh, 1993

Samba, Chéri, *Chéri Samba: A Retrospective* (exh. cat.), Provinciaal Museum voor Moderne Kunst Oostende and Institute of Contemporary Arts, London, 1989

Schjeldahl, Peter, *Eric Fischl*, New York, 1988

Shattuck, Roger, Henri Béhar et al., *Henri Rousseau*, New York, 1985

Simon, Joan, *Susan Rothenberg*, New York, 1991

Sims, Lowry Stokes, *Stuart Davis: American Painter*, New York, 1991

Sironi, Mario, *Mario Sironi*, Milan, 1993

Spies, Werner, ed., *Max Ernst: A Retrospective* (exh. cat.), Tate Gallery/Prestel, London/Munich, 1991

Spies, Werner, *Fernando Botero: Paintings and Drawings*, Munich, 1992

Stella, Frank, *Working Space: The Charles Eliot Norton Lectures 1983–4*, Cambridge, MA, 1986

Sylvester, David, *Magritte: The Silence of the World*, Houston and New York, 1992

Tidholm, Thomas, *Mimmo Paladino*, Stockholm, 1991

Tomkins, Calvin, *Off the Wall: Robert Rauschenberg and the Art World of Our Time*, New York, 1980

Torres-Garcìa, Joaquìn, *Torres-Garcìa* (exh. cat.), Museo de Arte Centro Reina Sofia, Madrid, 1991

Tuchman, Maurice et al., *The Spiritual in Art: Abstract Painting 1890–1985* (exh. cat.), Los Angeles County Museum, 1988

Vogt, Paul, *The Blue Rider*, New York and London, 1980

Waldberg, Michel, *Joan Mitchell*, Paris, 1992

Waldman, Diane, *Mark Rothko: A Retrospective* (exh. cat.), Guggenheim Museum, New York, 1978

Waldman, Diane, *Roy Lichtenstein*, New York, 1993

Sculpture, Environments, Video

Acconci, Vito, *Vito Acconci* (exh. cat.), Museo de l'Arte Contemporaneo, Prato, 1992

Adcock, Craig E., *James Turrell: The Art of Light and Space*, Berkeley, CA, 1990

Altschuler, Bruce, *Noguchi*, Abbeville, New York, 1994

Arman 1955–1991: A Retrospective (exh. cat.). Houston Museum of Fine Arts, 1991

Armstrong, Richard, *Mind over Matter: Concept and Object* (exh. cat.), Whitney Museum of American Art, New York, 1990

Arp, Hans, *Arp* (exh. cat.), Minneapolis Institute of Arts, 1987

Barette, Bill, *Eva Hesse: Sculpture* (catalogue raisonné), New York, 1986

Battcock, Gregory and Robert Nickas, *The Art of Performance: A Critical Anthology*, New York, 1984

Beardsley, John, *Earthworks and Beyond: Contemporary Art in the Landscape*, New York, 1984

Benezra, Neal, *Martin Puryear* (exh. cat.), Art Institute of Chicago, 1994

Berger, Maurice, *Robert Morris: Minimalism and the 1960s*, New York, 1989

Blume, Dieter, *Anthony Caro* (catalogue raisonné), Cologne, 1981 (4 vols) and 1991 (5th vol.)

Borer, Alain et al., *Joseph Beuys* (exh. cat.), Kunsthaus, Zurich; Museo Nacional Centro de Arte Reina Sofia, Madrid; and the Centre Georges Pompidou, Paris, 1993–4

Bourdon, David, *Carl Andre: Sculpture, 1959–1977* (exh. cat.), Laguna Gloria Art Museum, Austin, TX, 1978

Brades, Susan Ferleger, *Gravity and Grace: The Changing Condition of Sculpture 1965–1975* (exh. cat.), Hayward Gallery, London, 1993

Butterfield, Jan, *The Art of Light and Space*, New York, 1993

Celant, Germano, *Arte Povera*, Milan, 1985

Chicago, Judy, *The Dinner Party: A Symbol of our Heritage*, Garden City, 1979

Compton, Susan, *Henry Moore* (exh. cat.), London, 1988

Cragg, Tony, *Tony Cragg* (exh. cat.), Hayward Gallery, London, 1987

Deacon, Richard, *Richard Deacon: Sculptures 1987–1993* (exh. cat.), Hanover, 1993

Deitch, Jeffrey, *Strange Abstraction* (exh. cat.), Touko Museum of Contemporary Art, Japan, 1991

Fabro, Luciano, *Luciano Fabro: Works 1963–1986* (exh. cat.), Fruitmarket Gallery, Edinburgh, 1986

Gober, Robert, *Robert Gober* (exh. cat.), Museum Boymans van Beuningen, 1990

Goldberg, Roselee, *Performance Art: From Futurism to the Present*, 2nd revised edn, New York, 1988

Guse, Ernst-Gerhard, *Richard Serra*, New York, 1988

Halbreich, Kathy, and Neal Benezra, *Bruce Nauman: Catalogue Raisonné* (exh. cat.), Walker Art Center, Minneapolis, 1994

Hall, Doug, and Sally Jo Fifer, eds, *Illuminating Video: An Essential Guide to Video Art*, New York and Berkeley, 1990

Harrison, Charles, *Essays on Art and Language*, Oxford, 1991

Harrison, Michael et al., *Julio Gonzalez* (exh. cat.), Whitechapel Art Gallery, London, 1990

Haskell, Barbara, *Donald Judd* (exh. cat.). Whitney Museum, New York, 1989

Heiss, Alanna, *And the Mind Grew Fingers—Dennis Oppenheim: Selected Works 1967–90*, New York, 1992

Heizer, Michael, *Michael Heizer: Sculpture in Reverse* (exh. cat.), Museum of Contemporary Art, Los Angeles, 1984

Hirst, Damien, *Damien Hirst* (exh. cat.), Institute of Contemporary Arts, London, and Jay Jopling, London, 1991

Hobbs, Robert, *Robert Smithson: Sculpture*, Ithaca, 1981

Holt, Nancy, ed., *The Writings of Robert Smithson*, New York, 1979

Hunter, Sam, *Marino Marini: The Sculpture*, New York, 1993

Jahn, Wolf, *The Art of Gilbert and George*, London, 1989

Kabakov, Ilya, *He lost his mind, undressed,*

and ran away naked (exh. cat.), Ronald Feldman Fine Arts, New York, 1990

Kelly, Mary, *Post Partum Document*, London, 1983

Koons, Jeff, *Jeff Koons* (exh. cat.), San Francisco Museum of Modern Art, 1992

Koons, Jeff, *The Jeff Koons Handbook*, London, 1992

Kosuth, Joseph, *Art after Philosophy and After: Collected Writings 1966–1990.* Cambridge, MA, and London, 1991

Kuthy, Sandor, *Henri Laurens 1885–1954* (exh. cat.), Kunstmuseum Bern, Switzerland, 1985

LeWitt, Sol, *Sol LeWitt: Structures 1962–1993* (exh. cat.), Museum of Modern Art, Oxford, 1993

Linker, Kate, *Vito Acconci*, New York, 1994

Livingstone, Marco, *Duane Hanson* (exh. cat.), Montreal Museum of Fine Arts, 1994

London, Barbara J., J. Holman and Donald Kuspit, *Bill Viola: Installations and Videotapes* (exh. cat.), Museum of Modern Art, New York, 1987

Long, Richard, *Walking in Circles* (exh. cat.), Hayward Gallery, London, 1991

Lord, James, *Giacometti*, Faber and Faber, London, 1986

Marter, Joan M., *Alexander Calder*, Cambridge and New York, 1991

Nagel, Otto, *Käthe Kollwitz*, London, 1971

Nairne, Sandy, and Nicholas Serota, *British Sculpture in the Twentieth Century* (exh. cat.), Whitechapel Art Gallery, London, 1981

Oldenburg, Claes and Coosje van Bruggen, *Large Scale Projects*, London, 1994

Paik, Nam June, *Nam June Paik: Video Time—Video Space* (exh. cat.), Kunsthalle, Basel, Switzerland, 1991

Pincus, Robert L., *On a Scale that Competes with the World: The Art of Edward and Nancy Reddin Kienholz*, Berkeley, CA, 1990

Popper, Frank, *Art of the Electronic Age*, London, 1993

Raye, Helen, *Anish Kapoor* (exh. cat.), Albright-Knox Art Gallery, Buffalo, NY, 1986

Rose, Barbara, *Claes Oldenburg* (exh. cat.),

Museum of Modern Art, New York, 1969

Quin, Philip, *Betye Saar* (exh. cat.), Museum of Contemporary Art, Los Angeles, 1984

Stackelhaus, Heiner, *Joseph Beuys*, New York, 1991

Tsai, Eugenie, *Robert Smithson Unearthed: Drawings, Collages, Writings*, New York, 1991

Vaizey, Marina, *Christo*, Barcelona, 1990

van Bruggen, Coosje, *Bruce Nauman*, New York, 1988

Varnedoe, Kirk, *Duane Hanson*, New York, 1985

Velani, Livia, ed., *Giacomo Manzù*, Milan, 1982

Waldman, Diana, *Anthony Caro*, New York, 1982

Wilkinson, Alan G., *Jacques Lipchitz: A Life in Sculpture* (exh. cat.), Art Gallery of Ontario, 1990

Wilson, Simon, *Picasso: Sculptor/Painter* (exh. cat.), Tate Gallery, London, 1994

Yanagi, Yukinori, *Yukinori Yanagi* (exh. cat.), Lehman College Art Gallery, New York, 1991

Photography

Alinder, James, and John Szarkowski, *Ansel Adams: Classic Images*, Boston, 1986

Bellmer, Hans, *Hans Bellmer: Photographer* (exh. cat.), Centre Georges Pompidou, Paris, 1983

Bosworth, Patricia, *Diane Arbus: A Biography*, New York, 1984

Bunnell, Peter C., *Minor White: The Eye That Shapes*, Boston, 1989

Cartier-Bresson, Henri, *The World of Henri Cartier-Bresson*, London, 1968

Celant, Germano, *Mapplethorpe* (exh. cat.), Louisiana Museum, 1992

Celant, Germano, *Mapplethorpe Versus Rodin*, Milan, 1992

Danto, Arthur C., *Cindy Sherman: Untitled Film Stills*, New York, 1990

Danto, Arthur C., *Cindy Sherman: History Portraits*, New York, 1991

Eggleston, William, *Ancient and Modern* (exh. cat.), Barbican Art Gallery, London, 1982

Enyeart, James L., *Jerry N. Uelsmann:*

Twenty-Five Years—A Retrospective, Boston, 1982

Enyeart, James L., ed., *Decade by Decade: Twentieth Century American Photography*, Boston, 1989

Frank, Robert, *Robert Frank: New York to Nova Scotia* (exh. cat.), Museum of Fine Art, Houston, 1986

Greenough, Sarah, Joel Snyder, David Travis, Colin Westbrook, *On the Art of Fixing a Shadow: One Hundred and Fifty Years of Photography* (exh. cat.), National Gallery of Art/Art Institute of Chicago, Washington DC and Chicago, 1989

Krauss, Rosalind, and Jane Livingston, *L'Amour fou: Photography and Surrealism*, Corcoran Gallery of Art/Abbeville Press, Washington DC/New York, 1985

Laude, André, *Weegee*, London, 1986

Meneguzzo, Marco, *Cindy Sherman*, Milan, 1990

Mitchell, William J., *The Reconfigured Eye: Visual Truth in the Post-Photographic Era*, Cambridge, MA, 1992

Mora, Gilles, and John T. Gill, *Walker Evans: The Hungry Eye*, London, 1993

Newhall, Beaumont, *The History of Photography*, London, 1972

O'Neil, Doris C., ed., *Life—The '60s*, Boston, 1989

Penrose, Antony, ed., *Lee Miller's War*, Boston, 1992

Photography and Art 1946–1986 (exh. cat.), Los Angeles County Museum, 1987

Slemmons, Rod, *Like a One-Eyed Cat: Photographs by Lee Friedlander 1956–1987*, New York, 1989

Smith, Joshua P., and Merry A. Foresta, *The Photography of Invention: American Pictures of the 1980s* (exh. cat.), Smithsonian Institution, Washington DC, 1989

Szarkowski, John, ed., *Callahan*, Museum of Modern Art/Gordon Fraser, New York/London, 1977

Turner, Peter, ed., *American Images: Photography 1945–1980*, London, 1985

Weaver, Mike, ed., *The Art of Photography, 1839–1989*, New Haven, CT, and London, 1989

Picture Credits

Index

Microsoft® Excel® 2010: Data Analysis and Business Modeling

Wayne L. Winston

PUBLISHED BY
Microsoft Press
A Division of Microsoft Corporation
One Microsoft Way
Redmond, Washington 98052-6399

Library of Congress Control Number: 2010934987

ISBN: 978-0-7356-4336-9

6 7 8 9 10 11 12 13 14 LSI 8 7 6 5 4 3

Printed and bound in the United States of America.

Microsoft Press books are available through booksellers and distributors worldwide. For further information about international editions, contact your local Microsoft Corporation office or contact Microsoft Press International directly at fax (425) 936-7329. Visit our Web site at www.microsoft.com/mspress. Send comments to mspinput@microsoft.com.

Microsoft and the trademarks listed at http://www.microsoft.com/about/legal/en/us/IntellectualProperty/Trademarks/EN-US.aspx are trademarks of the Microsoft group of companies. All other marks are property of their respective owners.

The example companies, organizations, products, domain names, e-mail addresses, logos, people, places, and events depicted herein are fictitious. No association with any real company, organization, product, domain name, e-mail address, logo, person, place, or event is intended or should be inferred.

This book expresses the author's views and opinions. The information contained in this book is provided without any express, statutory, or implied warranties. Neither the authors, Microsoft Corporation, nor its resellers, or distributors will be held liable for any damages caused or alleged to be caused either directly or indirectly by this book.

Acquisitions Editor: Rosemary Caperton
Developmental Editor: Devon Musgrave
Project Editor: Rosemary Caperton
Editorial and Production: John Pierce and Waypoint Press
Technical Reviewer: Mitch Tulloch; Technical Review services provided by Content Master, a member of CM Group, Ltd.
Cover: Twist

Body Part No. X17-37446

[2013-03-22]